T0205577

Scientific Visual Representations in History

Matteo Valleriani · Giulia Giannini ·
Enrico Giannetto
Editors

Scientific Visual
Representations in History

 Springer

Editors
Matteo Valleriani
Max Planck Institute for the History
of Science (MPIWG)
Berlin, Germany

Giulia Giannini
Dipartimento di Studi Storici
Università degli Studi di Milano
Milan, Italy

Enrico Giannetto
Dipartimento di Lettere, Filosofia,
Comunicazione
Università di Bergamo
Bergamo, Italy

ISBN 978-3-031-11319-2 ISBN 978-3-031-11317-8 (eBook)
https://doi.org/10.1007/978-3-031-11317-8

Preface

Any output of scientific activity is an external representation of scientific knowledge. Such representations may take multiple shapes: an object (like a model), a text (like an early modern scientific commentary), an image (like a photograph of a plant), or a video (like a meteorological simulation).

This book explores continuity and ruptures in the historical use of images in science, while also considering more recent developments that attest to the unprecedented importance of scientific visualizations—be they video recordings, animations, simulations, graphs, or enhanced realities. The volume collects historical reflections concerned with the use of visual material, visualization, and vision in science from a historical perspective, from antiquity until now and ranging through multiple cultures and disciplines.

Visual representations are fundamental to the scientific endeavor as they belong to the realm of visual reasoning. The present work represents only the first step in a larger research endeavor concerned with the epistemic function of visual representations. The main goal of such a step is to provide a series of case studies focused on the epistemic functions of visual representations. Contrary to most visual studies in the context of the history of science, we also explore the fields of close disciplines, such as art history and anthropology. Moreover, from the very beginning, we decided to develop an approach that would allow us to achieve a *longue-durée* historical overview and therefore included case studies from antiquity through the twentieth century.

Studies concerned with visual representations in science indeed tend to focus on one specific epoch or even one specific geographic area. Our aim, on the contrary, is to search for the more abstract, universal mechanisms that disclose the function of visual reasoning in the sciences and, perhaps, in the process of knowing. We have therefore avoided a chronological, geographical, or disciplinary focus.

We refer to visual representations such as drawings, prints, tables, mathematical symbols, photos, data visualizations, mapping processes, and (on a meta level) visualizations of data extracted from historical sources in order to support, visually, the historical research itself. Continuity and ruptures between the use of visual material in the past and the present are presented against the backdrop of the epistemic functions

of visual material in science. The function of visual material is defined according to three major epistemic categories: *exploration, transformation,* and *transmission* of knowledge.

Visual material is the preferred means for the *transmission* of knowledge due to its highly synthetic character and the ease with which knowledge is perceived and re-worked by its recipients. The visual codification of knowledge can therefore be seen as a historical phenomenon that emerged as a consequence of an increase in knowledge resources, processes of knowledge accumulation, and the demand for scientific knowledge. The use of visual material in science has always had the effect of lowering the threshold of access to knowledge—and therefore remains an indispensable tool in education.

Visualization, moreover, is a means to *transform* and re-shape knowledge. It allows the adaption of knowledge to our methodological, institutional, and cultural expectations and enables the integration of practical and tacit knowledge.

As a means of *exploration*, the process of visualizing is used in the context of scientific discovery. Visualizations allow for the development of new research perspectives and ideas, especially in the framework of modern science and its strong mathematical approach.

Such epistemic functions of visual scientific material are analyzed in their cultural, social, and technological context. The historical actors' opinions and judgments concerning the use of visual material and technological innovations in the media of knowledge transmission—be these clay, paper, or processors—influenced and were influenced by the process of the visual codification of scientific knowledge.

The chapters are organized into three sections that focus on three major conceptual lines, which in turn correspond to the three epistemic functions of visual representations just mentioned: transmission, transformation, and exploration. To be clear, each chapter considers all these epistemic functions and more, but we believe that this order offers an efficient transversal reading of the opinions proffered by the volume's contributors. Within each section, the papers are organized chronologically.

With the term *transmission*, we refer to the capacity of visual representation to transmit scientific knowledge. In this respect, we intend to investigate, first, the act of production of visual representations, as well as the mechanisms of their circulation. Secondly, the chapters focus on the way visual representations transmit knowledge, and therefore on their capacity to work as tools for information management while aggregating, re-appropriating, and actualizing present knowledge and becoming pivots around which the knowledge is fixed and transmitted. In particular, this section discusses the creation and use of visual representations in the educational framework—teaching and learning—as well as in research endeavors.

The epistemic function that we define as *transformation* denotes the capacity of visual representations to transform scientific knowledge. While aware that any form of transmission also implies a form of transformation, we nevertheless distinguished these two functions. In fact, by *transformation* we mean, first, the capacity of visual representations to change the institutional features (authority, identity) of scientific knowledge and, second, the actual scientific meaning of the works that contain such representations. In this respect, therefore, the chapters focus on the evolution of visual

representations and of visual reasoning in general. A particularly well-developed subject in this section is the transformative capacity of visual representation in the context of the text-image relationship. Text and images are often produced together, but they are, simultaneously, ontologically distiguished carriers of knowledge. The image then becomes a means that, in its interaction with the text, fundamentally shapes and informs the scientific meaning, be this by way of description or criticism.

Finally, we consider visual representations as tools of *exploration* for two inter-connected reasons. The first concerns their capacity to combine different domains of knowledge or even of processes to acquire knowledge. Perception, imagination, depiction, observation, quantification, and geometrization are only a few of the acts of knowing that are combined among themselves in all possible ways by means of visual representations. The second concerns the role—the function—and the goal of such matching, which correspond to the need to build scientific arguments. Such scientific arguments are therefore heterogenous, though we consider the most relevant among them to be those whose aim is to demonstrate the truth of the scientific content repre-sented. Visual representations in this respect are tools to describe, explain, measure, calculate, and experiment.

As mentioned, the three sections of this volume are simply a way of organizing the material, but all chapters contribute to the understanding of all three epistemic functions.

The volume's general goal is to investigate the process of evolution of knowledge from the particular perspective of visual scientific material. It discusses the produc-tion, reproduction, and appropriation of knowledge, while considering different orders of knowledge as well. It investigates how we think about thinking and also operates on a more practical level—for example, how we use vision to investigate how vision evolved.

The book also discloses cases of second-order knowledge: diagrams that display logical rules and mathematical objects, images that celebrate knowledge, objects in books that represent objects in the world, maps built upon mental maps, and many other similar cases.

Through a top-down narrative, the volume examines not only images and visual material used to understand the evolution of our knowledge about nature, but also images used to investigate nature itself and its mechanisms. The historical case studies presented in the book offer a long series of examples in this vein: experi-ments rendered through the investigation of images and private drawings, methods of reducing a problem to an image, visual methods and images used to create new ideas, and the idea of "visualization as a question-generating machine."

Images, visualization, and vision explore and therefore create and innovate, for instance when data are turned into visual outputs and "facts" are created. The collec-tion and manipulation of data to create an output always adhere to certain rules of the codification of knowledge. Such rules bridge the knowledge from one kind of external representation to the next, or from one order of knowledge to the next. By means of such rules we explore and therefore transfer, transmit, and translate knowledge, for instance from words to images and vice versa.

Moving from nature to representations of nature, the volume takes into account the relation between reality and the virtual and artificial. Images conceived to display the mechanical plausibility of a cosmological idea—and therefore reality—touch the domain of the ontological value of visualization. Images and vision become a link between abstraction and reality, a way to explain nature's mechanisms by making them visible. In other terms, visualization connects and resolves the real and the artificial within itself. Images both represent the world and become virtual instruments to explore it.

Attendant to forms of visualization is the role of their material aspects. Poor electronic material (such as scans of digitized books), the necessity to reverse photography into woodblocks for publication, incomplete GPS datasets, and limited computer performance in producing simulations are some of the material limits discussed here. Materiality in turn implies technology and its history of innovation in the service of advantages, such as easier replicability and diffusion. The technology of vision also includes the social aspects of the production of visual material.

By considering the epistemic functions and their interplay with material aspects of visualization, the book finally collects case studies that show the functions of such visual material in science, from antiquity until now, moving from the histories of science and art to consider their material, economic, political, pedagogic, and philosophical aspects.

Berlin Wilmersdorf, Germany Matteo Valleriani
Milan, Italy Giulia Giannini
Bergamo, Italy Enrico Giannetto

Acknowledgments

The present volume is the result of a combination of efforts between four research endeavors. The first is located at the University of Bergamo and concerns research on "Material Culture, Science, and Technology"—a joint research project between the University of Bergamo and the Max Planck Institute for the History of Science in Berlin (Bergamo's main investigators are Enrico Giannetto and Franco Giudice; Giulia Giannini, Elena Bougleux, Salvatore Ricciardo, and Audrey Taschini are also members of Bergamo's group). The second concerns the history of early modern scientific academies and in particular the historical process of the establishment of scientific societies in Europe. This project is institutionally located at the Department of Historical Studies of the Università degli Studi di Milano within the frame of the ERC-2018-COG "TACITROOTS—The Accademia del Cimento in Florence: Tracing the roots of the European scientific enterprise" (GA n. 818098) directed by Giulia Giannini. The third is located in Dept. 1 of the Max Planck Institute for the History of Science, directed by Jürgen Renn, whose research focuses on the processes of knowledge evolution, especially concerning Anthropocene studies. The fourth is represented by the project "The Sphere: Knowledge System Evolution and the Shared Scientific Identity of Europe" directed by Matteo Valleriani and situated both at the Max Planck Institute for the History of Science and within the frame of the inter-institutional project BIFOLD (Berlin Institute for the Foundations of Learning and Data) (ref. 01IS18037A), funded by the German Federal Ministry of Education and Research. The project focuses on the processes of homogenization of scientific knowledge.

The framework that enabled this encounter is the institutional cooperation between the University of Bergamo (Rector Stefano Paleari, and then Rector Remo Morzenti Pellegrini) and the Max Planck Institute for the History of Science (Director Jürgen Renn).

We would like to first express our gratitude to all the scholars involved in these four projects and who contributed to the creation of this institutional research agreement. Our profound gratitude goes specifically to Nana Citron and Victoria Beyer, who assisted in the "assemblage" of the present volume at each phase, from the raw contributions to the very final touches in the proofs. The prose was edited by Zachary

Gresham. We would like to thank the library of the Max Planck Institute for the History of Science and especially Urte Brauckmann for her support in securing the permissions to reproduce the images printed in the volume. Finally, we would like to thank Lindy Divarci, the publication manager of the Max Planck Institute for the History of Science, for her general assistance and supervision.

The contributors to the present volume met for the first time at a kick-off workshop over several days in October 2018. We would like to thank the administration of the University of Bergamo for the organization of that meeting.

Berlin, Wilmersdorf Matteo Valleriani
February 2021

Contents

Editors and Contributors

About the Editors

Matteo Valleriani is research group leader at the Department I at the Max Planck Institute for the History of Science in Berlin, an Honorary Professor at the Technische Universität of Berlin, and a Professor by Special Appointments at the University of Tel Aviv. He investigates the relation between diffusion processes of scientific, practical, and technological knowledge and their economic and political preconditions. His research focuses on the Hellenistic period, the late Middle Ages, and the early modern period. Among his principal research endeavors, he leads the project "The Sphere: Knowledge System Evolution and the Shared Scientific Identity of Europe" (https://sphaera.mpiwg-berlin.mpg.de), which investigates the formation and evolution of a shared scientific identity in Europe between the thirteenth and seventeenth centuries. Among his publications, he has authored the book *Galileo Engineer* (Springer 2010), is editor of *The Structures of Practical Knowledge* (Springer Nature 2017), and published *De sphaera of Johannes de Sacrobosco in the Early Modern Period. The Authors of the Commentaries* (Springer Nature 2020). Together with Andrea Ottone, he also published *Publishing Sacrobosco's De sphaera in Early Modern Europe. Modes of Material and Scientific Exchange* (Springer Nature 2022).

Giulia Giannini is an Associate Professor of History of Science at the University of Milan (Italy). She is the principal investigator of the ERC Consolidator research project TACITROOTS—*The Accademia del Cimento in Florence: tracing the roots of the European scientific enterprise* (2019–2024). She worked at the Centre Koyré in Paris and at the Max Planck Institute for the History of Science in Berlin. Her research interests focus on the history of experimentation and on cultural, political, and social studies of science in Early Modern Europe.

Enrico Giannetto graduated from the University of Padova in elementary particle theoretical physics, and then he studied early universe cosmology at the ISAS of

Trieste. He studied the history of science at the *Domus Galilaeana* in Pisa and obtained his doctorate in theoretical physics of condensed matter at the University of Messina. He has been working as a researcher for ten years at the University of Pavia within the History of Science and Science Education Group. There, he taught in particular "General Physics." Since 2001 he is the Full Professor of History of Physics and History of Science at the University of Bergamo, Italy. In Bergamo, he has been teaching many disciplines from "History of Scientific Thinking" to "Theoretical Philosophy," "Epistemology of Complexity," and "Physics." His research is focused on a perspective of a wide history of cultures where mythology, history of religions, anthropology, philosophy, and human and natural science are entangled. In particular, he worked in the following disciplines: quantum chromodynamics; quantum electrodynamics; early universe quantum cosmology; phase transitions in cosmology and condensed matter; special and general relativity; foundations of quantum mechanics; quantum logic; history of quantum physics, of relativity, of chaos physics, of elementary particle physics, of medieval physics, of romantic natural philosophy, of the scientific revolution, and of theoretical physics; history of psychology versus physics, science education; hermeneutics; philosophy of dialogue; anthropology of scientific thinking; and history of primeval Christianity. He has published more than 200 scientific papers and four major books: *Saggi di Storie del Pensiero Scientifico*, Bergamo University Press, Bergamo 2005; *Il vangelo di Giuda—traduzione dal copto e commento*, Medusa, Milano 2006; *Un fisico delle origini. Heidegger, la scienza e la Natura*, Donzelli, Roma 2010; *Sguardi sul pensiero contemporaneo. Filosofia e scienze per cambiare il mondo*, libreriauniversitaria.it, Limena (PD) 2018.

Contributors

Bougleux Elena Università degli Studi di Bergamo, Bergamo, Italy

Bushart Magdalena Technische Universität Berlin, Berlin, Germany

Casini Silvia University of Aberdeen, Aberdeen, Scotland

de Mûelenaere Gwendoline Ghent University, Ghent, Belgium

Giannetto Enrico Dipartimento di Lettere, Filosofia, Comunicazione, Università di Bergamo, Bergamo, Italy

Giannini Giulia Università degli Studi di Milano, Milan, Italy

Hood Stephanie L. UZH - Universität Zürich, Zürich, Switzerland

Kräutli Florian Max Planck Institute for the History of Science, Berlin, Germany

Lockhorst Daan Max Planck Institute for the History of Science, Berlin, Germany

Pantin Isabelle École Normale Supérieure (Paris)-PSL, IHMC (UMR 8066), Paris, France

Ricciardo Salvatore Università degli Studi di Bergamo, Bergamo, Italy

Roby Courtney Ann Cornell University, Ithaca, USA

Schemmel Matthias Universität Hamburg, Hamburg, Germany

Shlomi Noga Max Planck Institute for the History of Science, Berlin, Germany;
Tel Aviv University, Tel Aviv, Israel

Valleriani Matteo Max Planck Institute for the History of Science, Berlin, Germany;
Technische Universität Berlin, Berlin, Germany;
Tel Aviv University, Tel Aviv, Israel

Part I
Transmission

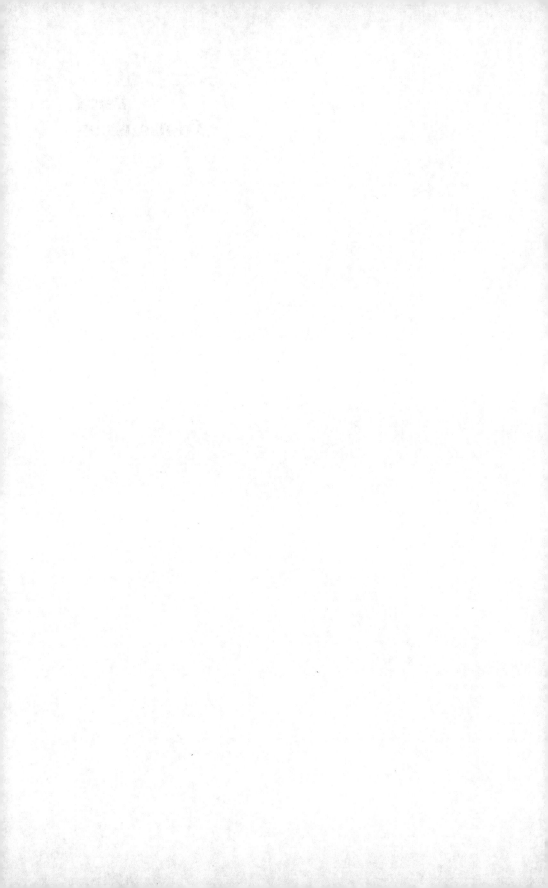

Chapter 1
The Art of Learning: Illustrated Lecture Notebooks at the Old University of Louvain

Gwendoline de Mûelenaere

Abstract The various roles fulfilled by the old University of Louvain, the main institution of higher education in the Southern Netherlands, can be investigated through a collection of dictation notes, or *dictata*, that crosses four centuries. In these handwritten lecture notebooks, the text is often accompanied by title pages, ink drawings, engraved plates inserted between or pasted onto the pages. The well-preserved corpus is representative of the combinatorial art that developed in the early modern visual culture in Europe. My contribution is articulated around two issues. Firstly, it focuses on the rhetorical and visual strategies used to convey scientific contents, and on the learning mechanisms those images implied. Secondly, the essay aims to draw attention to a particular mode of representation employed, the Western tradition of emblematics, which were taken from moral or religious publications and adapted to an academic message. Emblematic devices were favored for the representation of sciences during the early modern period due to their persuasive effectiveness. The framing, pedagogical, and mnemonic functions of such syncretic images inserted in college notebooks are further developed in order to estimate their role in the transmission of traditional university knowledge as well as new ideas.

Keywords Lecture notebooks · University of Louvain · Engravings · Emblematics · Jesuits

1.1 The Tradition of Illustrated Notebooks

The University of Louvain, founded in 1425, was modeled after the universities of Paris and Cologne. Its structure remained widely medieval in the early modern period, offering an education in the form of a scholastic curriculum spread over two years. It was required to complete an academic cycle at the Faculty of Arts before being permitted to carry on with a degree course in one of the higher faculties, in canon and civil law, in medicine, or in theology. The statutes of the faculty, issued

G. de Mûelenaere (✉)
Ghent University, Ghent, Belgium
e-mail: gwendoline.demuelenaere@ugent.be

in 1567–1568, fixed the content of the courses, strictly respecting the tradition of Aristotelian treatises. The training at the Faculty of Arts began with nine months studying logic or dialectic, then eight or nine months studying physics, and four months studying metaphysics and ethics. The program was rounded off with three months of *repetitiones* or repetition exercises (Lamberts and Roegiers 1986, 71). The *Artes* faculty included four "pedagogies," colleges dedicated to public lessons and placed under the direct administration of the faculty: The Lily, the Pig, the Castle, and the Falcon (Van der Essen 1921, 96–97).

If there were major changes in terms of statutes and disciplines taught at the University of Louvain throughout the early modern period, the methodology, didactics, and course materials of university education were similar in the various study fields and remained largely in place until the end of the Ancien Régime (de Ridder-Symoens 2012, 7). A common practice in university teaching was to dictate lessons. Students wrote down the lectures, hence producing an important number of handwritten notebooks, which have been well preserved.[1] This collection was mainly produced within the framework of the four pedagogies, as well as in several other colleges of the *Studium Generale*. In the higher faculties however, professors used printed textbooks instead of dictating the lesson in class. Hand-drawn illustrations already appear in fifteenth-century notebooks in Louvain. In the fifteenth and early sixteenth centuries, the student's focus was mainly on religious subjects. One of the earliest known illustrated lecture notebooks of the University of Louvain (Cambrai, Bibliothèque municipale, Ms. 964, 1482), shows for instance scenes of the *Annunciation*, the *Adoration of the Magi,* and the *Last Judgment* facing commentaries on Aristotle's books of logic (Smeyers 1975). In the sixteenth and seventeenth centuries, it was customary to add vignettes or representations in the form of a horizontal strip at the bottom of some pages. This practice was probably aiming at imitating printed books in which this type of illustration appears in the same way. Subjects such as landscapes, village views, old castles and fortresses, rivers with boats, harbors, and seascapes, but also student life and university environment were often depicted alongside calligraphic lettering (Steppe 1968, 7–8).

In the early seventeenth century, engraved plates began replacing the sketches and ink drawings made by the students themselves. They were inserted between or pasted onto the pages. From the second half of the century, there was a flourishing business for printers and booksellers in Louvain, as the *Artes* faculty in Louvain welcomed about four hundred new students every year. Students were encouraged to ornament their volumes with such printed materials (Smets 2014, 205). The practice continued until the suppression of the university in 1797.

The handwritten notebooks produced at the old university (1425–1797) were progressively dispersed throughout the Southern Low Countries and abroad, since the students brought them back home. The preservation of these documents in private hands allowed them to escape destruction in the fire of the university hall of Louvain

[1] The practice also developed in Parisian institutions such as the Grand Couvent des Cordeliers, see (Berger 2017; Schmutz 2008).

on August 25 and 26, 1914,[2] as well as in the bombing of the university library on May 16, 1940. After the war, however, a great effort was made to build up a collection of student notebooks, which was divided between the KULeuven and the UCLouvain after the university split up in 1970. Most of them came from donations from seminaries, secondary schools, or individuals (often clergymen or professors belonging to families descending from the first owners), or were acquired at book-shops (Mirguet and Hiraux 2003, 72–73). Several other public institutions such as the Royal Library of Belgium (KBr) and the university archives of Ghent and Liège have accumulated important collections of *dictata* in the twentieth century. About 570 of these volumes have been digitized and can be consulted online.[3]

In the lecture notebooks, different kinds of images coexist within a single space. They range from scientific imagery, mainly made of abstract forms, to an iconography inspired by figurative languages of an allegorical, emblematic, descriptive, religious, historical, mythological, moral, or satirical nature, and not always related to the academic content (Opsomer 2000, 156). Notebook illustrations can be classified into four categories:[4] The first set of images includes logical tables of oppositions, classical diagrams, schemes of syllogism, and tree structures. They are closely related to the scholastic teaching provided by the faculty in the early modern period. The second category embraces very heterogeneous kinds of figurative compositions, such as engraved title pages that were personalized by the students, symbols of one of the four pedagogies of the *Artes* faculty, portraits of philosophers (Aristotle, Plato, Socrates) or patron saints, personifications and attributes of the academic fields (logic, astronomy, geometry, armillary spheres), and emblematic devices, which will be discussed later. The third category includes portraits of rulers, biblical episodes, views of the city of Louvain, and scenes of students' everyday life (Papy 2017, 68–70). Even those not directly connected to the scientific content of the volumes can provide valuable information about political preoccupations, social habits, or cultural practices of the time. Finally, the fourth category concerns Cartesian representations and, from the second half of the eighteenth century onwards, images taken from experimental philosophy.

[2] A list of the archives destroyed in 1914 indicates the presence of nine notebooks, see (de Moreau 1918, 97–98, nos. 109–116).

[3] See the collaborative project *Magister Dixit* led by the KULeuven, and its website: http://lectio. ghum.kuleuven.be/lectio/magister-dixit-project. Accessed 9 May 2022. Most examples discussed in this article can be found in this database. There are 217 manuscripts held at the KBr (164 of which are illustrated), 127 volumes are preserved in the archives of the UCLouvain (seventy-three illustrated), 204 manuscripts can be found in the archives of the KULeuven (149 of which are illustrated), 15 volumes are in the Abdij van Berne Heeswijk, five notebooks are held in private collections, and one manuscript is at the M Museum of Louvain. Furthermore, forty-three illustrated *dictata* are in the collection of manuscripts of the ULg (Liège), and seven volumes are held in Den Haag and Leiden (Smets 2014). Notebooks preserved in other institutions are listed in (Mirguet and Hiraux 2003, 75–79).

[4] In an article published in 2000, Carmelia Opsomer suggested a slightly different classification: firstly, a traditional "university iconography," secondly, the reuse of an emblematic tradition, and thirdly, a Cartesian imagery (Opsomer 2000).

Around 1670, a set of fifty-five scientific engravings was produced by two printers and booksellers based in Louvain, Michael Hayé (died 1676) and Lambert Blendeff (1650–1721).[5] These can be found in college notebooks until the middle of the following century. They range from representations of the Ptolemaic, Tychonic, and Copernican systems to anatomical plates and images of mechanical instruments, of the rainbow, of the passage of light through a prism, etc. As Carmelia Opsomer (2000) and then Geert Vanpaemel (2011) have shown, many of the illustrations were taken from Cartesian textbooks.[6]

The engraving *Cor humanum* ("human heart") executed by Blendeff (signed *Apud L. Blendeff*) is copied from that inserted in the Latin edition of *De homine* published by Florent Schuyl (1619–1669) in 1662 (Opsomer 2000, 167; Berger 2017, 134–135). Other Louvain notebooks include engravings of the same composition made by other printers, Hayé or Petrus Denique (1683–1746), and bear one of their signatures (*Apud Michaëlem Hayé Louanij prope Predicatores Hybernos*; *Apud P. Denique Lovanii*). In several college *dictata*, this image took the form of a *fugitive sheet*, i.e. an innovative assemblage of printed cut-outs and paper flaps (Fig. 1.1).[7] Anatomical fugitive sheets were first produced in Germany around 1538.[8] Widely copied, this clever construction creating an animated image enables the viewer to investigate the anatomy himself (Moore 2015, 54). Rosemary Moore underlined the analogy between cutting into the body through the performance of anatomical acts and incising the plate during the creation of the print. This metaphor is extended by the viewer's physical interaction with the print: He repeats the cut by lifting the moveable paper flaps (Moore 2015, 54, 57). The representation of the heart and lungs was already conceived as a fugitive print in *De homine*. Two layers of paper corresponding to the right and left ventricles could be raised by the reader to reveal the

[5] The engravings are listed by (Vanpaemel 2011, 254). The list of engravings made by Michael Hayé was originally drawn by Esther van Gelder in her master's thesis. She suggests that the new sets of engravings were introduced between 1674 and 1685 (van Gelder 2005, 7). It is not known whether the entire set of images was available at the same time, nor for how long they were on the market (Vanpaemel 2011, 244).

[6] Carmelia Opsomer identified four sources used by the booksellers for the production of Cartesian images. Anatomical plates were taken from Florent Schuyl's *De homine* (1662), a Latin translation from René Descartes' *Traité de l'Homme*, and Clerselier's *L'homme de René Descartes* (1664). Illustrations of rainbows, light refraction, magnetic poles, mechanics, and hydrostatics are adapted from plates published in the *Fundamenta physices* by Henry Le Roy (1646). Courses on optics demonstrate the influence of Jacques Rohault's *Traité de physique* at Louvain (1671) (Opsomer 2000, 166–176).

[7] KULeuven: Ms. 211, f. 65r, Ms. 354, f. 113r, Ms. 355, f. 65r; Ms. 358, f. 175r; UCLouvain: Ms. C165, f. 48v; Royal Library of Belgium: Ms. II 106, f. 30v, Ms. II 3214, f. 101r, Ms. II 3703, f. 156r; Ms. II 4269, f. 145r, Ms. II 4765, f. 89v, Ms. II 4854, f. 221r, Ms. II 5444, f. 144r, Ms. II 5602, f. 126r; Liège University: Ms. 2058, f. 187, Ms. 2355, f. 106rv, Ms. W67, f. 173. Cleverly, Cox (Ms. 211) used two ink colors for the fugitive sheet: red for the general composition and black for the internal parts of the heart. This method facilitates the reading of the anatomical plate.

[8] The first anatomical fugitive sheet was produced by the printer and engraver Heinrich Vogtherr the Elder. A year later, Hans Guldenmundt executed a pair of fugitive sheets, depicting a male and a female figure. At least fifteen editions of these prints were made between 1538 and 1540 (Moore 2015, 54). About that topic, see also (Carlino 1999).

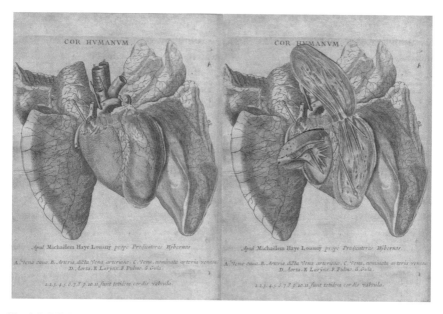

Fig. 1.1 Michael Hayé, "Cor humanum," in Albert Boone, *Physica, Metaphysica*, 1680–1681. Engraving. Louvain-la-Neuve, Archives de l'UCLouvain, inv. Be A 4006 CO 002–165, f. 48v (closed and open flaps)

heart valves (*cordis valvula*) indicated by numbers from one to eleven—while other elements such as the vena cava, aorta, and larynx are indicated by letters.

These scientific engravings were not made according to proposals of the academic institution, and "amazingly, many of them did not correspond to the actual topics or doctrine taught by the Faculty professors" (Vanpaemel 2011, 242). For instance, the letters added in some engravings, like *Cor humanum*, to indicate the different parts of an object are not explained in the handwritten text. The question remains as to the designer of the images, as Hayé and Blendeff were artists and probably had no education in natural philosophy, nor were they official representatives of the university.[9] But these visual representations certainly bear witness to the major changes introduced in the philosophy curriculum in the second half of the seventeenth century. The prints emerged following a progressive reform undertaken from 1658 in the Louvain education, and constituted an independent source of knowledge for the students (Vanpaemel 2011, 242, 245).

In the sixteenth century, the University of Louvain was favorable to the Copernican system, and as of 1650, several professors began propagating Cartesian ideas at the Faculty of Arts, despite the strong opposition of Louvain theologians. However, it

[9] Hayé was a member of the Guild of Saint Luke in Antwerp in 1661, and settled in Louvain shortly after that date, see (Delsaerdt 2001, 379–380). He was associated with the University of Louvain, as he matriculated in 1666 (Schillings 1963, 249, no. 48). Blendeff was a painter from Liège who moved around 1676 to Louvain, where he was appointed city painter and then "iconographer of the university" (Van Even 1868, col. 470–471).

is only toward the end of the seventeenth century that Cartesianism was clearly established in the teaching programs (Opsomer 2000, 156). Before that, Aristotelian and Cartesian doctrines were concurrently lectured by professors who could recommend one or the other to the students.[10] As the aim of the faculty was to provide a general philosophical background; emphasis was therefore put on the explanation of basic natural phenomena rather than on advanced metaphysical discussions (Vanpaemel 2011, 249).

The experimental philosophy of Isaac Newton (1643–1727) became predominant in Louvain in 1764. This corresponds to the popularity of two series of more descriptive engravings, made by Charles-Henri Becker (eighteenth century). Widely used in student notebooks from 1769 to 1797, they illustrate spheres, movement, and light, plus mechanics, electricity, gravity, perspective, hydrostatics, and astronomy. They likely depict the practices of the cabinet of physics of the University of Louvain which opened in 1755 (Opsomer 2000, 176–178). In this case, a close link can therefore be observed between the text and the plates.

This imagery had evident didactic purposes and testifies to the slow penetration of the new science. It is interesting to underline their concurrent use with emblematic representations in student notebooks. The first frontispieces and emblems appeared approximately at the same time as Cartesian representations, and were offered for sale by the same printers.

1.2 Learning Mechanisms

What were the aims of this manual activity, so widespread at university? Some images functioned in clear and direct support of grasping the subject matter. Diagrams and geometrical patterns were particularly useful in facilitating the understanding of the conveyed information. Contradiction and conversion of universal and particular propositions required conformity with the logical rules that diagrams could present more concretely than a text. A very common image inserted in philosophical notebooks was the *Porphyrius tree*, for which the same engraving was used from 1671 to 1792 (Opsomer 2000, 157).[11] This system of classification into genres and species was used for a long time by the students in logic, where they learned how to process the different sorts of logical propositions with their characteristics and reciprocal relations.

Moreover, the visual material was intended to embellish the notebook. In this sense, erudition was not only depicted, but also staged and celebrated. The presence of numerous illustrations can be explained by the desire to transform the manuscripts

[10] Open adherence to Cartesianism was nevertheless firmly condemned, as it was the case of Martin van Velden in 1691 (Vanpaemel 2011, note 24).

[11] The image of the *Porphyrius tree* was for instance used in Joannes Franciscus de Roemer, *Logica*, 1671. Liège, University Library, ms. W 65, f. 57. Other engravings of this diagrammatic tree circulated, such as a plate signed "I. Bonnart au coq," in Franciscus de Meulder, *Logica*, 1781–1782. KBr, Ms. 11,702, f. 10r.

into unique and personal memories of the study years, and even into luxury goods, in the manner of *alba amicorum* (D'Haenens 1994, 409). Such *ornare libros* activity provided a student with different forms of delectation: A way of relaxation (*otium*), a fight against boredom (*taedium*), or even the use of jokes (*iocus*) and mockeries (*risus*) (Van Vaeck 2012, 151). Humor and satirical language are indeed significant in university notebooks, as we can observe with the widespread engraving entitled *Pons Asinorum*, or "Donkeys Bridge," produced by Michael Hayé.[12] The composition presents the syllogistic figures under the form of a hexagon, which serves as a tool to find the premises of a syllogism.[13] It was already represented, but in a more schematic way, in the notebook dated 1481–1482 already mentioned above (Smeyers 1975, 277). In the lower part of Hayé's composition, the pond depicts the dangers of the distractions and excesses of student life: Games and sport, alcohol, tobacco, clothes expenditure, and music (Papy 2012, 117).

But above all, the images incorporated into college notebooks constituted a support to absorbing knowledge. They were intended to help visualizing a specific point in order to facilitate its retention. Representations embody abstract science in ways that can be assimilated more easily, and by consequence they leave the information in the memory more efficiently than an oral or written discourse (Dekoninck 2011, 113–114). This process of data retention was achieved through handiwork performed either during or after the lessons.

Sometimes, students cut and pasted prints they had found in existing books. This is the case of the notebook of *Physica* of Norbert Joseph Ligiers (1694–1695). Ligiers carefully cut ten engravings from emblem books and pasted them on blank pages across his volume (KULeuven, Ms. 354). The student wrote titles by hand under the images, conferring new meaning to them.[14] But most of the time, students bought engravings printed on individual leaves made to be added directly between hand-written pages; they could decide for themselves what to insert inside their *dictata*, and where. Students also copied and drew sketches after prints to improve their draftsmanship. *Halo*, an engraving conceived by Michael Hayé and often inserted in notebooks of physics,[15] is freely copied by Joannes van Alderweirelt in his *Tractatus de metheoris* ("Treatise on meteors") (UCLouvain, Ms. C72, f. 279r) (Fig. 1.2). The

[12] For humor and satirical language, see for instance: Georgius Jodoigne, Petrus de Molder, Joannes Van Esse, *Logica*, 1677–1678. KULeuven, Ms. 250, f. 132r. Adolphus Franciscus De Witte, *Dialectica*, 1698–1699. UCLouvain, Ms. C24, f. 131v.

[13] Today, the expression *Pons asinorum* means a simple technique to solve a problem, or a mnemonic support to remember something complex. But the Donkey's Bridge indicates also a danger. Pliny the Elder (23–79 AD) relates in his *Historia Naturalis* (8, 169) the story of donkeys that do not cross a bridge when they can see the water shine underneath. Only silly donkeys—that is to say, silly students—are scared by apparent obstacles when they take the explanation of a problem for the problem itself (Papy 2012, 117).

[14] For an in-depth analysis of this manuscript, see (de Mûelenaere 2022).

[15] Maximillianus Plischart, *Physica. Metaphysica*, 1738–1739. UCLouvain, Ms. C75, f. 305r. Engravings were sometimes colored by the student: Leo Joseph Daco, *Physica. Metaphysica*, 1678. KBr, ms. II 106, f. 323r. The *pictura* does not belong to Engelgrave's oeuvre, but the copperplate was perhaps made by Hayé to be added to the series of emblem engravings that the printer already had at his disposal (Van Vaeck 2012, 156–157).

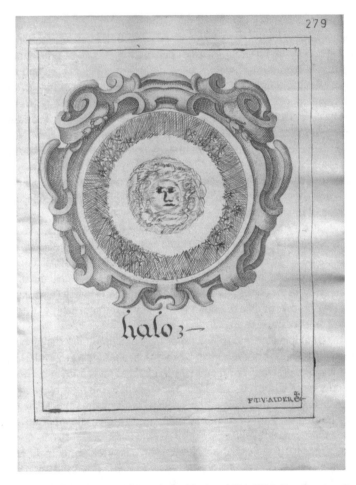

Fig. 1.2 "Halo," in Johannes van Alderweirelt, *Physica*, 1714–1715. Pen drawing. Louvain-la-Neuve, Archives de l'UCLouvain, inv. Be A 4006 CO 002, Ms. 072, f. 279r

student recuperated an engraved ornamental frame that he cut and pasted on a page, and then drew the representation of a galactic halo inside it. He added his name "F:I:V: Alder[weirelt]" in capital letters under the pen drawing, in the manner of a printed signature. This volume counts in total twenty-four pen drawings copied after engravings on sale in Louvain, some of them framed, titled, and signed in order to imitate the codes of printed materials.

A pen drawing of *Cor humanum*, the engraving by Blendeff, can be found in a volume dated from 1732,[16] and more interestingly, a drawn version of the composition with folding flaps was made with the superposition of two drawn sheets pasted

[16] Joannes Lambertus de Ponthier, *Physica*, 1732. KULeuven, Ms. 262, f. 286r.

thereon.[17] Here again, the student takes over codes and practices of prints (in this case, fugitive prints), and he adapts them to drawings that he executes himself.[18] All those examples show the importance of drawing in the process of assimilating knowledge. Raising the flaps in a fugitive engraving was a way for the students to imagine that they themselves conducted an anatomical dissection—in which they explored Descartes' account of the heart's structure. But patiently reproducing all the details of the representation by hand was certainly an excellent way to memorize the different components of a human heart. Furthermore, the addition of such visual material in notebooks allowed students to highlight the importance of the "new" philosophies in teaching during the second half of the seventeenth century (Berger 2017, 134).

While the same text can be found from one manuscript to the other, the images are unpredictably integrated in the booklets (Berger 2017, 125). These images thus attest to the freedom left to the student, who could give free rein to his imagination in arranging his manuscript, his effort to make it his own product through a manual exercise, and his active role in designing or collecting visual representations. Such activities kept students away from distractions and helped them to be involved in the study of philosophy (D'Haenens 1994, 406). As Susanna Berger demonstrated in her book *The Art of Philosophy*, those representations were used in lecture notebooks to manage information (Berger 2017, 116). They enabled the students to make textual subsets more visible (like sentences, paragraphs, chapters), to indicate a sequential relation between different concepts, to mark introductions and conclusions. The same engraved title page could be placed at the beginning of each section of a notebook to visually mark it, and the blanks were filled with information on the lecture, the professor *primarius* and *secondarius*, and the dates of the course.[19] Emblematic vignettes were usually added on the opposite page of a chapter or *quaestio* title. Regardless of their nature, the images therefore fulfilled a mnemonic purpose by visually structuring and framing the manuscript. The students would recall ideas through their association with specific imagery.

1.3 Emblematic Language: Recuperation and Adaptation

Investigating illustrated college notebooks requires one to grasp the visual culture in which they were compiled. Such production is not isolated but can be put in parallel with other kinds of works cleverly associating text and image and belonging to the same sphere of learning: Jesuit *affixiones*, devotional publications, scientific books,

[17] Michael van den Biesche, *Physica. Metaphysica*, 1675–1676. KULeuven, Ms. 261, f. 102r. This copy is based on Blendeff's print; it includes the title *Cor humanum*, absent in the original illustration in Schuyl's textbook (Berger 2017, 134).

[18] (Fowler 2016) studies the opposite practice, that is the pedagogy of draftsmanship illustrated in print, through an analysis of early modern printed drawing books.

[19] For instance, the same title page was inserted four times in Norbert Joseph Ligiers, *Physica*, 1694–1695. KULeuven, Ms. 354, f. 0r, 50r, 258r and 302r.

thesis booklets and broadsides, collections of emblems. This typically humanist genre, with its specific bimedial form, proved very popular in early modern Europe. Usually, the textual elements, an inscription or *motto*, a caption or *subscriptio*, and a commentary or *argumentum*, were combined with an engraving or *pictura*, in order to create a metaphorical or allegorical composition.

A characteristic of the *emblemata* practice is therefore the recuperation and adaptation of existing visual formulas in various fields: Profane love stories, moral and didactic lessons, or religious and meditative narratives (Van Vaeck 2012, 151). But emblems were also frequently applied in the teaching sphere, and they were by consequence vested with new meaning, as is the case for several emblems reused in handwritten *dictata*. In the 1660 s, the Antwerp printer Michiel Cnobbaert (1628–ca.1673) sold two series of copperplates designed for emblem books to Michael Hayé: Firstly, a series made for *Lux Evangelica sub velum Sacrorum Emblematum*, compiled by the Jesuit Hendrik Engelgrave (1610–1670) in 1648, and secondly, a set of oval engravings designed by Jan Thomas (1617–1678) for *Firmamentum symbolicum*, a book written by the Carmelite Father Sebastianus a Matre Dei in 1652.[20] *Lux Evangelica* was published by the widow and the heirs of Cnobbaert's father, Jan Cnobbaert (1590–1637) and gathers erudite sermons combined with emblems. The various editions of the book, often republished in Antwerp, Cologne, and Amsterdam until the eighteenth century, count up to 250 emblems inspired by profane and sacred history (Van Vaeck 2007, 535). The cartouches and some of the compositions are inspired by the *Imago Primi Saeculi*, a remarkable in-folio volume celebrating the first centenary of the Jesuit Order in 1640 (Daly and Dimler 2000, no. J.512, J.515; O'Malley 2015, 186). *Firmamentum symbolicum* is constructed in praise of the Mother of God and divided into fifty chapters associated with allegories or symbols. Hayé sold prints of those copperplates on loose leaflets to university students who interleaved these inside their handwritten volumes. As of 1677 (and probably earlier), the engraved emblems were accompanied by the title of a treaty or a chapter, and were therefore clearly related to the content of the course (Van Vaeck 2012, 161).

In a notebook written in 1671 by a student of logic, Nicolas Dereumont, a sundial is placed between the day and the night to illustrate contradictory propositions ("de contradictoriis").[21] In Emblem forty-two of Engelgrave's *Lux Evangelica*, the image of the gnomon situated between light and darkness is associated with a quotation from Matthew 6:24: "No one can serve two masters. [Either you will hate the one and love the other, or you will be devoted to the one and despise the other]" (*Matth. 6. Nemo potest duobus dominis servire*) (Fig. 1.3).[22] It insists thus on the fact that one

[20] At least eighty-seven of the 104 *picturae* published in Engelgrave's *Lux Evangelica* circulated as engravings for *dictata* (Van Vaeck 2012, 154, 243–261).

[21] Nicolas Dereumont, *Logica*, 1671. Liège, University Library, Ms. W65, f. 349v: "De contradictoriis."

[22] (Engelgrave 1652, 414, no. 42). The text under the *pictura* reads: "Uni soli. Dominica decimaquarta post Pentecosten. Uni & soli Deo serviendum esse, omnemque affectum ei soli exhibendum. § I. Nemo potest duobus Dominis servire. Mat. 6. § II. Gravis Daemonis fallacia persuadentis, posse aliquem duobus Dominis servire. § III. Uni soli Deo ac Domino serviendum."

Fig. 1.3 "Emblema XLII," in Hendrik Engelgrave, *Lux evangelica sub velum sacrorum emblematum recondita*, Antwerp, 1652, part. 2, 414. Antwerp, Ruusbroecgenootschap, inv. 3069 A 1

must be devoted to the one and only God. The religious connotation has disappeared in Dereumont's notebook, but the emblem still denotes the idea of contradiction.

However, the meaning of this emblem changes when the *pictura* is used by the same student for his notes in physics. In this case, the Latin caption refers to astronomy: "de ortu et occasu astrorum" ("On the rising and setting of stars").[23] In a later manuscript in *physica*, dated 1714–1715, the student Joannes van Alderweirelt cut and pasted the engraving on a page and added a pen drawing with the

[23] Nicolas Dereumont, *Physica, Metaphysica*, 1668. Liège, University Library, Ms. W64, f. 353v: "de ortu et occasu astrorum."

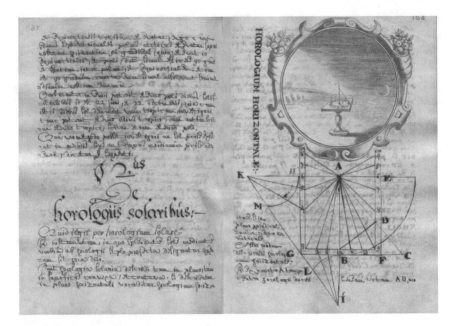

Fig. 1.4 "Horologium horizontale," in Johannes van Alderweirelt, *Physica*, 1714–1715. Pen drawing and engraving. Louvain-la-Neuve, Archives de l'UCLouvain, inv. Be A 4006 CO 002, Ms. 072, f. 163v–164r

caption "horologium horizontale" (Fig. 1.4).[24] The image is thus a direct illustration of the scientific content at hand, a sundial, which is the title of the sub-chapter: "De Horologiis solaribus." Following the same idea, the representation is inserted in yet another manuscript of *physica* (1694–1695), opening a chapter on the division of time.[25] There, the engraving bears the caption in logic added by the printer ("de contradictoriis") but the student, Norbert Joseph Ligiers, adapted the text to the appropriate subject by handwriting "De anno, die, et mense" ("on year, day, and month") over the printed letters.[26] On the facing page, the student wrote the title "Caput decimum quintum. De anno mense die nocte et hora" ("Chapter fifteen. On year, month, day, night, and hour").

The illustration inspired a pen drawing made by another student, Henricus Johannes van Cantelbeeck, to conclude a *quaestio* on double propositions in logic.[27] It depicts a solar table provided with the text *effluit hora diesque*, "hours and days pass by." This meaning conferred to the solar table as a sign of time passing is rather

[24] Joannes van Alderweirelt, *Physica*, 1714–1715. UCLouvain, Ms. C72, f. 164r (engraving pasted on folio and pen drawing).

[25] Norbert Joseph Ligiers, *Physica*, 1694–1695. KULeuven, Ms. 354, f. 346v–347r.

[26] The student probably reversed the logical order of month and year (well respected in the title) to more easily write over the word *contradictoriis* (*die* matching with the third syllable *-dic*).

[27] Henricus Joannes van Cantelbeke, *Logica*, 1669. KULeuven, Ms. 209, f. 63v ("Quaestio vigesima quarta Quid sint enuntiationes reduplicativae et quomodo exponantur").

common and can be found, for instance, in an engraving made by Boëtius a Bolswert (ca. 1585–1633) for Herman Hugo's (1588–1629) *Pia desideria* (Antwerp: Hendrick Aertssens, 1624).[28] Emblem thirteen quotes Job 10:20: "Are not my few days almost over? Turn away from me so I can have a moment's joy."[29] The human soul, held by sacred love, points at a sundial while wiping tears away.[30] Thus we can see that the same image added to university *dictata* can be vested with three different meanings, according to the subject matter concerned: The gnomon casting a shadow on a plate can convey the idea of contradiction when used in logic, while it is a measuring instrument when used in astronomy, and expresses time flying when placed at the end of a chapter, visually closing it.

A second example is provided by an emblem depicting a ray of light reflected by a mirror, the surface of which shows a symbol of the Eucharist (Fig. 1.5). In Engelgrave's book, the image illustrating the second Sunday after Pentecost (*Domenica secunda post Pentecosten*) is accompanied by a sentence from the Book of Wisdom 7:26: *Candor est [enim] lucis aeternae et speculum [sine macula Dei maiestatis et imago bonitatis illius]* ("For Wisdom is a reflection of eternal light, [a spotless mirror of God's activity, and an image of His goodness]")[31] and a quote from Ovid's (43–17 BCE) *Metamorphoses 3: Accendit et ardet* ("He inflames and burns") (Engelgrave 1652, 297, no. 30). The sermon developed in the following pages extends the metaphor of the burning mirror suggested by the *pictura* and the motto. This is clearly stated in the first paragraph: *Hostia Eucharistica quae mirificè facit ad illuminandos & inflammandos animos, speculo caustico comparatur* ("The Eucharistic host which prodigiously makes souls illuminated and inflamed, is compared to a burning mirror"). The title of the second paragraph is a quote from the Psalms: *Accedite ad eum, et illuminamini. Psal.33* ("Those who look to him are radiant; their faces are never covered with shame"). The fifth paragraph begins with the sentence *Speculum Eucharisticum, fidelium corda inflammat* ("The mirror of the Eucharist inflames the hearts of the faithful"). The other parts of the sermon develop similar ideas around the light, such as the fourth paragraph: *Umbram fugat veritas: Noctem lux eliminat* ("Truth chases shadow away, light eliminates the night").

The composition might be derived from *Speculum urens* ("Burning mirror"), an emblem conceived by Théodore Galle for *Duodecim Specula* (David 1610, 26, no. 3) (Fig. 1.6). This book on optics was written by the Jesuit father Jan David (1546–1613) and published by Jan Moretus (1543–1610) in 1610. A sequence of twelve annotated illustrations guides the viewer to the contemplation of spiritual

[28] *Pia desideria* was "the most popular religious emblem book of the seventeenth century," according to Peter Daly (Daly 2008, 106). It appeared in over forty-four Latin editions and many translations (i.e. the Dutch adaptation of Justus de Harduwijn, *Goddelycke wenschen* (Antwerp: Hendrick Aertssens, 1629)) until the eighteenth century.

[29] "Nunquid non paucitas dierum meorum finietur brevi? Dimitte ergo me ut plangam paullum dolorem meum!"

[30] A similar emblem shows a sundial under a cloudy sky in (De la Feuille 1691, 12, no. 14): *Mihi tollunt nubula solem* ("The clouds take my light from me").

[31] The quote is repeated in the introduction to the first paragraph, on the page facing the image.

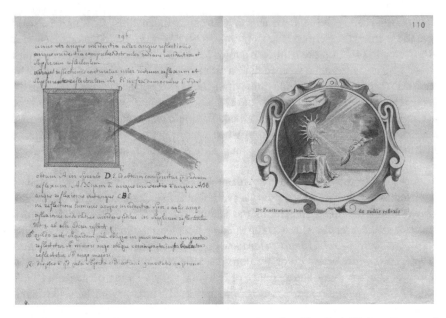

Fig. 1.5 A. Loemans after J. Thomas, "De penetratione. Item de radiis reflexis," in Jean-Emmanuel Van Parijs, *Physica*, 1760–1761. Engraving. Louvain-la-Neuve, Archives de l'UCLouvain, inv. Be A 4006 CO 002, Ms. 006, f. 109v–110r

scenes through consideration of the physical properties of the mirror (Bousquet-Bressolier 2002,158–159). Capital letters suggest a reading order in the image and are explained in the caption, which is printed in two columns. A is a concave mirror used by Archimedes (288–212 BCE) to set fire to an enemy ship in B; C is a lens which is able to concentrate rays of light to set a fire; the child D stung by nettles makes the image enter another dimension, the order of creatures; a basilisk E can cause death with a single glance; the eyes of the impudent woman F cause the worst burns and, along with devil's breath H, reduces the man's heart G to ashes.[32] The image helps to attract the viewer's curiosity, and it uses and flatters his knowledge to lead him through spiritual development. The facing page develops a dialog between desire (*Desiderius*) and soul (*Anima*).

This kind of motif circulated widely within the literature of the time—and was used in other emblem books, such as the *Amoris divini emblemata* by Otto Vaenius (1556–1629) in 1615,[33] the *Emblemata sacra* by Willem Van Hees (1601–1690) in

[32] The caption reads: "Flamma volat, micat aethra, fugam cape, conflagrat orbis: Plena adeò igni-uomis omnia sunt speculis. A. Vrens speculum concauum. B. Archimedes speculo naues hostiles incendit. C. Transparens speculum ustulans. D. Puer ab articis ictus et ustulatus. E. Basilicus visu necans. F. Impudicae mulieris oculi nequissima urentia specula. G.H. Cor viri, impudicae obtutu, et daemonis halite, concrematur."

[33] (Vaenius 1615, 41): "Crescit in Immensum" ("It grows to infinity"). The French *subscriptio* reads: "Le miroir accroist la lumiere Qu'il prend & reçoit du soleil, Nostre ame en la mesme maniere,

Fig. 1.6 Theodore Galle, "Speculum Urens," in Jan David, *Duodecim Specula Deum*, Antwerp, 1610, 26, no. 3. Engraving. Amsterdam, Rijksmuseum, inv. RP-P-OB-6754

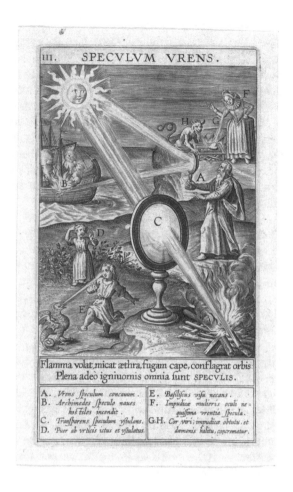

1636,[34] and the *Devises et emblèmes* by Daniel de la Feuille (1640–1709) in 1691.[35] In Vaenius' composition, the human soul, reflecting the divine sunlight with the help of a mirror, creates a fire to which sacred love points.

When included in the notebook of physics of the Louvain student Balthasar Cox in 1686–1687, the image is provided with the text *De Penetratione. Item de radiis reflexis*, "On penetration and on reflected rays" (Fig. 1.5).[36] It is joined to a *quaestio*

Et par vn effect tout pareil, Nourrit si sainctement les flammes, Que luy communique son Dieu; Qu'elle eschauffe des autres ames, Et les esprend au mesme feu."

[34] (Van Hees 1636, 307, no. 12): "Charitas non agit perperàm" (I Corinthians 13: 4: "Love does not act wrongly").

[35] (De la Feuille 1691, 17, no. 15): "Un Cœur allumé par la verberation du Soleil, par un miroir ardent, *Inflammatur*, …I burn but am not consumed".

[36] Balthasar Cox, *Metaphysica. Physica*, 1686–1687. KULeuven, Ms. 211, f. 87r. The engraving is also included in UCLouvain, Ms. C6, f. 110, with the same title.

discussing visible rays (*radius visualis*). The *quaestio* was a major principle in various liberal arts, or *Artes Liberales* (especially dialectic and rhetoric), and had been a cornerstone of education since antiquity. The *quaestio* or *thesis* was one of the most common pedagogical exercises in early modern Europe. Students learned to reason *in utrumque partes*, adopting both sides of the issue under discussion (Jonckheere 2018, 50). As the image of a ray of light reflected in a mirror takes place in a chapter of physics focusing on sensitive life (*De anima sensitiva*) and is associated with a title describing this optical process, it can be argued that the religious meaning attached to the representation has disappeared. The *pictura* is best understood literally and moves away from the metaphorical processes in play in the sermon book. The bimedial structure of emblematic devices is however still applied and creates a surprising effect (Van Vaeck 2012, 161).

Similarly, the first emblem of Engelgrave's book, depicting a comet and a divine hand lighting a cannon, was exploited by students to illustrate their handwritten *dictata* in *physica* (Fig. 1.7).[37] The composition was originally meant to insist on disastrous signs such as comets sent by God to scare men and divert them from sin. Diverse biblical and classical quotes in the title and subscription framing the image explain this idea: Luke 21:25: *Et erunt signa in sole et luna et stellis* ("There will be signs in the sun, moon, and stars"); Ovid, *Metamorphoses* 15:24: *Et, nisi paruerit, multa ac metuenda minatur* ("And he threatened him with many and fearful things if he did not obey"); "God threatens and scares through fatal signs, in order to take away from sin;" Acts 2:19: *Et dabo prodigia in caelo sursum et signa in terra deorsum sanguinem et ignem et vaporem fumi* ("I will cause wonders to occur in the heavens above and signs on the earth below, blood and fire and a cloud of smoke"); Psalms 59:6: *Dedisti timentibus te significationem, ut fugiant a facie arcus* ("To those who fear you, you gave the signal to make their escape before sentence falls").[38] Louvain students chose this emblem to ornate chapters on stars by type and their distance measurement (*De astris generatim et eorum paralaxi*).[39] Hayé simply added the title *De cometis* below the representation. Other students used this image for chapters on the physical phenomenon of condensation.[40] In any case, the idea of divine sign and threat of punishment suggested in *Lux Evangelica* has vanished.

Emblematic engravings borrowed from *Firmamentum Symbolicum* (1652) were included in college notebooks following the same process of adaptation to a new, scientific context. Page 180, the image of a cliff in the middle of a stormy sea, is associated with the caption *Rupes subveniens. Maria salutem procurans. Non pereo*

[37] See also Norbert Ligiers, *Physica*, 1694–1695. KULeuven, Ms. 354, f. 453r (title erased); Franciscus Gonzalez, *Physica*, 1739. KULeuven, Ms. 213, f. 212r; Joannes De Noefbourgh, *Physica*, 1705–1706. KBr, Ms. II 5422, f. 208r; *Physica*, 1761. UCLouvain, Ms. C209, f. 76r.

[38] (Engelgrave 1652, 1): "Emblema I. Erunt signa (Luc 21). Multa ac metuenda minatur (Ovid. 15 Met.). Funestus Deus signis minatur ac terret, ut à peccato deterreat. §I. Dabo prodigia in caelo sursum, & signa in terram deorsum (Act. 2). §II. Dedisti timentibus te significationem, ut fugiant à facie arcus (Psal. 59)."

[39] For instance, KULeuven, Ms. 213, f. 206v.

[40] Hermannus Veerdonck, *Physica*, 1669. Abdij van Berne Heeswijk, Ms. K6, f. 411v (without title) facing the chapter *De condensatione*.

Fig. 1.7 "De cometis," in Jacobus Steijart, *Physica*, 1709. Engraving. Louvain-la-Neuve, Archives de l'UCLouvain, inv. Be A 4006 CO 002–090, f. 207r

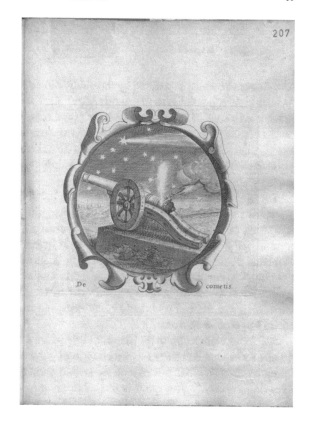

si pergo ("The rock helping. Maria providing salvation. I don't perish if I persist"). In university *dictata*, the composition illustrates a chapter on water (*De aqua*), in a treaty devoted to the study of the elements (*Tractatus de elementis*). This is incorporated in the lecture notes in *physica* written down by Henricus Johannes van Cantelbeeck.[41] There is no caption joined to the representation, but the title of the subchapter, about sea and salted water (*De mari et eius salsedine*), can be read on the page facing it. In the physics notebook of Balthasar Cox, the title *De ventis et de procella*, "On winds and on thunderstorm," has been added to the image by the printer.[42] In this case as well, the image is to be understood on a primary level. There is no more direct reference to the Virgin Mary presented as a rock, a source of salvation for the faithful who persisted in their devotion, as was the case in the original emblem devised by Sebastianus a Matre Dei.

[41] Henricus Johannes van Cantelbeeck, *Physica*, 1669–1670. KULeuven, Ms. 207, f. 18r.

[42] Balthasar Cox, *Metaphysica. Physica*, 1686–1687. KULeuven, Ms. 211, f. 122v.

1.4 *Affixiones*, Thesis Prints, and Emblem Books: The Jesuit Influence

The sixteenth century is marked by the publication of an important amount of works "whose common point is to give a privileged place to the image as well as to implement a principle of figurative meaning (symbolic, metaphorical, metonymic) by means of a combination of image and text" (Guiderdoni 2012, 422).[43] In the Southern Low Countries, this rich literature, cleverly associating textual and visual elements, persisted in the first half of the following century and saw publications such as the popular *Imago Primi Saeculi* (1640).

The emblematic tradition was particularly useful in education. Karel Porteman has shown the influence of emblematics in Jesuit teaching through the practice of *affixiones*, or exhibitions, conceived in the Jesuit college of Brussels in the seventeenth century (Porteman 1996). Pupils were trained to cleverly combine images, emblems, poems, chronograms, biblical or classical quotations, personifications, and mythological *topoi*, in order to improve their "intellectual dexterity" and their good command of symbolic language (Bousquet-Bressolier 2004, 166). This means of expression was shared by students, professors, and artists, who belonged to the same social and erudite sphere.

Affixiones were inspired by Hendrik Engelgrave's compositions as well. Emblem 46 of *Lux Evangelica* shows two men wringing a wet cloth from which drops flow into a basin. The *pictura* is associated with a quotation from Ovid's *Aeneid*, "into opposing parties."[44] The motif is reused in an *affixio* realized in 1648, the year of the publication of *Lux Evangelica*, by a Poesis pupil of the Brussels college, Frans Lemire (Fig. 1.8).[45] While the *affixio* was produced shortly after the proclamation of the Peace of Westphalia, the text makes no mention of it. Instead, it refers with sadness to the discord between the Southern Netherlands and the Dutch Republic: *Belgica, longa tuos discordia cives, Hinc lacrymae, toties quas tua terra bibit* ("Netherlands, a long conflict tortured your citizens. Thence the tears which your soil has so frequently drunk.") (Porteman 1996, 108). The image of torsion was relevant to connote the differences of economic situation and of religious and political opinions that divided the two countries. This evocation of tears and suffering caused by discord can be found in other *affixiones* series produced in the Brussels college in the following decades (Ems 2016, 89–93).[46] However, the representation takes on a literal meaning

[43] The importance of emblematic culture in the Plantinian circle has been widely demonstrated, Plantin having played an important role as a disseminator of this culture at a European level by (re)-publishing classics of the genre, including Alciato's emblems; see (Visser 2003).

[44] Engelgrave 1648, 412, no. 46. The full title reads: *[Et] ecce quidam de scribis [dixerunt intra se: Hic blasphemat]* (Matt. 9). *Studia in contrāria* (2. Aeneid). *Dominica decima-octava post Pentecosten* (Matthew 9:3: "And behold, some of the scribes [said to themselves, 'This man is blaspheming'];" *Aeneid* 2.39: "into opposing parties;" "Eighteenth Sunday after Pentecost").

[45] *Concordia—Discordia*, 1648. KBr, Ms. 20.307, f. 118v–119r.

[46] *Bellum—Pax*, 1659. KBr, Ms. 20.317, f. 51v. *Superbia—Humilitas*, 1662. KBr, Ms. 20.332, f. 61v: "Humili discordia dolori est".*Tristia—Laetitia*, 1665. KBr, Ms. 20.331, f. 83r: "Tristia civium discordia."

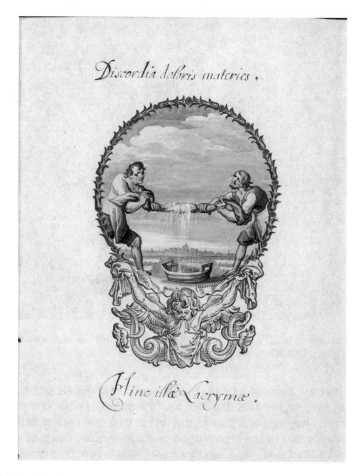

Fig. 1.8 Frans Lemire, "Discordia doloris materies," in *Emblemata de discordia affixa*, Jesuit college of Brussels, 1648. Gouache in ready-printed woodcut. Brussels, Royal Library of Belgium (KBr), inv. Ms. 20.307, f. 118v

when added to a lecture notebook in physics at the end of the seventeenth century, with the caption "De condensatione" (Fig. 1.9).[47] Following the same process of the recuperation of an existing motif, the emblematic engraving that had been devised for the specific circumstance of a Jesuit sermon book hence conveys a new interpretation directly related to the academic topic.

Focusing on secondary education—they formed the first teaching institution of modern Catholicism—Jesuits were also active in higher education.[48] Their influence is manifest in the abundant production of emblematic devotional or moral books at

[47] Norbert Joseph Ligiers, *Physica*, 1694–1695. KULeuven, Ms. 354, f. 477v–478r.

[48] The relationship between the University of Louvain and the Jesuit Order was conflictual; see (Roegiers 2012).

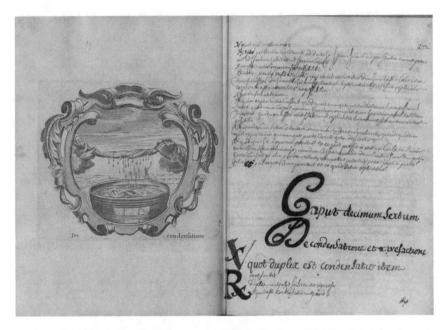

Fig. 1.9 "De condensatione," in Norbert Joseph Ligiers, *Physica*, 1694–1695. Engraving. Louvain, KULeuven, Special Collections, inv. Ms. 354, f. 477v–478r

the time. This explains the adoption of similar visual and textual structures in student practices, as encouraged by Jesuit professors, such as thesis prints. This genre made use of symbolic language as a pedagogical tool as well, and testifies to the natural and numerous exchanges and borrowings between science and emblematics.

The booklet *Disciplinae mathematicae traditae* was printed for a thesis defended at the Jesuit college of mathematics in Louvain in 1640 under the supervision of Jan Ciermans (1602–1648).[49] It takes the form of a textbook with thirty-five emblems engraved by Jacob Neeffs (1610–1660) after Philip Fruytiers (1610–1666) and Martin Mandekens (fl. 1631–1650) (Fig. 1.10). Each month is devoted to the teaching of a discipline (geometry, arithmetic, optic, statics, hydrostatics, military architecture, geography, astronomy, chronology) and is divided into three weeks.[50] The week ends with the practical applications of the course, the *problemata* (Bousquet-Bressolier 2004, 149–153; Dhombres and Radelet de Grave 2008, 161–166, 349–351). The month of December is dedicated to optics, and more specifically to perspective and optical projections (*De perspectiva, sive proiectionibus Opticis*), to beams reflected by the mirror (*De radiis reflexis ad specula*), and to rays refracted by the mirror (*De radiis refractis, eorumque angulis &c.*) (Bousquet-Bressolier 2002, 81–82). The representation accompanying this third subchapter recalls the image borrowed from

[49] The textbook was reprinted the following year under the title *Annus positionum mathematicarum* for the thesis of Wolffgang Philip I. Unverzagt (only the frontispiece is different).

[50] As an exception, September counts only two weeks.

Lux Evangelica and applied to college notebooks, as previously seen (Fig. 1.5). This program, representative of the Jesuit mode of education at the time, is therefore akin to the university curriculum. However, the Jesuit college of mathematics, targeting an aristocratic audience, developed an instruction that was primarily concerned with military applications—which can be explained by the permanent state of war in the Southern Low Countries (de Mûelenaere 2016, 443).

Emphasis is put on the individual learning and a proper assimilation of the subject through its concrete application. This work presents similarities with emblem books in the organization of the text (the name of the field, the *argumentum*, and the development) and the image that opens each week. A parallel can also be drawn between this pedagogical textbook and the structures adopted in contemporary books of meditation, divided into a prelude, a meditation, and a final prayer, including practical applications of the meditated subject (Dekoninck 2011, 111–112). The figure becomes a

Fig. 1.10 "Decembris. Hebdomas tertia," in Jan Ciermans, *Disciplinae mathematicae traditae,* 1640. Engraving. Brussels, Royal Library of Belgium (KBr), inv. VH 7.974 C (RP)

tool of scientific understanding, and testifies to the importance of observation and experimentation in mathematical fields.

This method of knowledge acquisition is visually translated into the use of an allegorical *mise en scène* of the students learning. In the engravings of *Disciplinae mathematicae traditae*, the arguments are illustrated by a composition staging a putto professor and a putto learner, a motif that appeared for the first time in the vignettes designed by Peter Paul Rubens (1577–1640) and engraved by Théodore Galle (1571–1633) for the *Opticorum libri sex* written by François de Aguilon (1567–1617) in 1613. The engravings of the *Opticorum* support the text and offer visual stimulation to the complex mathematical and geometrical demonstrations of the author (Held 1977, 18). The putti actively take part in the scientific scene: They help the old scholar to observe the results, draw geometrical figures, adjust optical instruments used by the magister, etc. The children seem therefore to adopt the paradoxical and ironic role of professor, despite their young age, while the adult is lost in view of the experiments he is supposed to be leading. After the publication of Aguilon's book, putti were often depicted in book or thesis illustrations, such as the *Positiones mathematicae* defended by Jean Ignace Brueghel at the Jesuit college of Antwerp in 1679.[51] These schoolboys denote the very act of learning, but they are not presented as those who know and teach anymore, as was the case in Rubens' images. They keep their juvenile and lively spirit dedicated to a better understanding of intricate reasoning. Putti can also be found in university notebooks, like Balthasar Cox's *Physica*.[52]

1.5 Framing Device, Representation of Science, and *Ars Memorativa*

The shape of the emblem reflects a particular practice, a symbolic mentality, or *mens symbolica*, that strives to transpose notional or conceptual content into figurative signs (Hayaert 2008, 6). The very principle of the functioning of an emblem is based on the possibility of combining an image with other texts, which alters its meaning (Russel 2009, 27–28). The emblematic image, by nature polysemous, drives the viewer to look for an interpretation through the text. Daniel Russel defined the emblematic image as a detachable rhetorical ornament: It adds nothing substantial to the discourse; its main function is to attract attention to the message being presented (Russel 2009, 34–35).[53] He identified five characteristics of the emblematic mode: "it is ornamental; it appears in margins and often functions as a frame; it is movable,

[51] Ghent University Library, inv. MA.000176. The etchings were executed by François Ertinger. The composition designed to ornament the title page to *Positiones mathematicae* is interesting as it presents a summary of the experiments led by putti in the twelve vignettes inaugurating the chapters of the booklet.

[52] Balthasar Cox, *Metaphysica. Physica*, 1686–1687. KULeuven, Ms. 211, f. 84v: "De speciebus visibilibus." See (Engelgrave 1652, 437, no. 46).

[53] Originating from a Greek verb meaning to throw, to put in, or to insert, the Latin word *emblema* referred to a detachable ornament, a graft, a mosaic, or other inlaid work (Russel 2009, 3).

and usually functions as some kind of quotation" (Russel 2009, 1). The circulation of images involved in this process made it a phenomenon of early modern print culture (Russel 2009, 28).

The images taken from existing books or copperplates and incorporated in college notebooks in Louvain also exemplify this process of *bricolage*, reuse, and appropriation typical of the emblematic mode, oscillating between imitation and variation. The verbal recontextualization of the *picturae*, a priori ornamental and marginal, can initiate a dialogue between the image and the student—who is both maker (when arranging his volume) and reader (when studying the content) of his own *dictata*. The representations he chooses to add lighten the manuscript. Such *parerga* constitute not only a marginal background but also a framing device, allowing for play between the interior and the exterior (Russel 2009, 6). The emblematic process can be seen as "a framing practice used for cutting fragments from traditional works or corpora and shaping them into new configurations of meaning as determined by the framing text" (Russel 2009, 6–7). Emblems themselves were enclosed in elaborate frames to remind the viewer that they were fragments that had been detached from an original context and applied to new situations and ideas.

Their presence in academic documents plays a role in the cognitive processes on the one hand, and in the transmission of knowledge on the other. At the turn of the sixteenth and seventeenth centuries, not only traditional doctrines but also new knowledge bases pertaining to the emerging observation sciences were expressed under a metaphorical or allegorical guise (Guiderdoni 2012, 421). The Jesuit father Nicolas Caussin (1583–1651) used an optical metaphor to demonstrate the efficiency of metaphorical images (Dekoninck 2011, 114):

> …Just as many bodies, seen through a piece of glass or amber, shine much more pleasantly, likewise the truth pleases much more when it shines through images and symbols. [Because] *je ne sais quoi* in the subtlety of the invention, and the expressiveness of the image, particularly pleasantly touches the senses, and, while pleasing, persuades more efficiently. (Caussin 1643, 132–133)

Emblematics, a product of human inventiveness, are indeed efficient and persuasive. This is why they were favored in the representation of sciences.[54] The early modern period saw the creation of "scientific imagery" that built knowledge *through* images. Emblematic thinking underlined a large number of scientific publishing undertakings in various fields: Botany, zoology, anatomy, geography, mathematics. This ancient mode of representation was gradually influenced and modified by the novelty brought by scientific experience (Guiderdoni 2012, 424). A new visual culture then emerged, freeing itself from literary authorities and placing the image at the heart of argumentation. The advent of these modern observational sciences thus marks a clear break from the medieval sphere of universal symbolism governed

[54] Conversely, rhetoric borrowed from science its descriptive or demonstrative images to emblematize them and thus put them at the service of a moralizing or religious message. This phenomenon can be observed for instance in a collection of sacred emblems published in Antwerp by Willem Van Hees (*Emblemata sacra de fide, spe, charitate*, 1636), whose images are inspired by mathematics: music, optics, and physics (Dekoninck 2011, 107–108).

by an analogical understanding of creation. But while the image occupied a central position in these encyclopedic and scientific works, it remained only a step on the path to essential knowledge (Dekoninck 2011, 100).

Can it be asserted that this creative *passe-temps* pertains to the *Ars memorativa*? Mnemonics, or the art of memory, can be defined as "the science or art of improving memory, a system devised for training memory, that is, artificial memory;" a distinction has to be made between the noun *mnemonics* and the adjective *mnemonic*, i.e. "anything intended to aid memory" (Daly 2014, 87). Frances Yates, in her seminal book on the subject, explains that the training used by Roman orators consisted of "impressing *loci*, or 'places' and *imagines*, or 'images,' on memory" (Yates 1969, xi). Mental places could be for instance a house and its rooms, or a theater, and an immaterial image could be the picture of a lion with a particularity. The aim was to attach notions to objects, personifications, or animals, and to determine a specific order in which to remember them. Aristotle, formulating ideas developed before him in ancient Greek philosophy, affirms that mental images are essential to memory and that recollection is facilitated by a fixed order (Berger 2017, 28).[55]

The images inserted in the philosophy notebooks produced at the University of Louvain are presumably related to these representational techniques, even though students adopted this practice in an experimental and personal manner. It cannot be assumed that they were well acquainted with the varied and complex theories of the art of memory developed in classical, medieval, and Renaissance treatises. But the students had at least a basic knowledge of the Roman works of reference on the subject, such as the *Ad Herennium* and Cicero's *De Oratore*. Memory systems, alongside four other cornerstones—*inventio* (invention), *dispositio* (arrangement), *elocutio* (style), and *pronuntiatio* (delivery)—were taught as a canon of rhetoric in Latin schools[56] and at university.[57]

An author such as Francis Bacon (1561–1626), who had a deep knowledge of the art of memory and himself used it, fully subscribed to the ancient view that the active image impresses itself best on memory, and to the Thomist view that intellectual things are best remembered through sensible things (Yates 1969, 371–372). He defines emblems in *De augmentis scientiarum* as follows:

[55] "Memory even of intellectual objects involves an image" (Aristotle 1984, 450a11–14, 715); "Things arranged in a fixed order, like the successive demonstrations in geometry, are easy to remember, while badly arranged subjects are remembered with difficulty" (Aristotle 1984, 452a1–4, 718).

[56] Cicero is cited as a reference for the construction of discourses in the *Ratio studiorum*, the organizing charter of Jesuit teaching; see (Demoustier et al. 1997, 165, 168, 174, 187, 191).

[57] The large number of preserved manuscripts of the *Ad Herennium* attests to its popularity in the middle ages. The first edition was issued in Venice in 1470. Furthermore, classical works on memory led to the publication of adapted versions and commentaries within educational institutions. For instance, Antoine Haneron, professor at the University of Louvain in the fifteenth century, published a number of writings on Latin language and style figures, and among them *Tractatus de coloribus verborum et sententiarum cum figuris grammaticalibus* (Utrecht, ca. 1475). It is a simplified adaptation of the fourth book of *Ad Herennium*. The book was used for more than fifty years by students not only in Louvain but also in Deventer, Leiden, and Vienna (Ijsewijn-Jacobs 1976, 187–188 (cat. no. 257)).

Emblems bring down intellectual conceits to sensible images; for what is sensible always strikes the memory stronger, and sooner impresses itself than the intellectual… And therefore it is easier to retain the image of a sportsman hunting the hare, of an apothecary ranging his boxes, an orator making a speech, a boy repeating verses, or a player acting his part, than the corresponding notions of invention, disposition, elocution, memory, action (Bacon 1858, V, 649).

The primacy of sight and the use of visual images to help fix more abstract notions were also highly valued by the Jesuits. The *ars memorativa* certainly played a role in their educational system during the early modern period. But there is little evidence of the impact of these artificial arts on the Jesuit creation of emblems (Daly 2014, 123, 121). Peter Daly argues that a central difference between the arts of artificial memory and emblems is that the first tradition insists on the importance of order, while in the second practice, individual emblems published in emblem books are complete in themselves, and are presented with little relationship to what appears before or after them (Daly 2014, 122). However, in college *dictata*, images recuperated from emblematic literature were precisely used to create an order intended to facilitate memory. Not only emblems but other types of images added to notebooks also functioned as mnemotechnic devices, in particular when a representation was systematically added near the title of a chapter or subchapter.[58] They constituted a visualization of the subject matter (a sundial for the measuring of time, mirrors reflecting (sacred) light for optical effects, (divine) comets for astronomical phenomena), and in doing so, they also helped students remembering the order in which the content was organized through a specific *mise en page* within the manuscript. Even if these images followed a general trend according to which illustrated and allegorical literature underwent a process of decodification and distancing from symbolic significance, they do not represent a mere complement to the text (Dolza 2003, 98). Remaining rooted in the allegorical and emblematic modes, the visual compositions applied to academic productions helped students to retain information by stimulating their imagination and by combining visual pleasure and utility.

1.6 Conclusion

The primacy of sight and its ability to activate the other senses is a persistent theme in humanism. Images therefore hold a privileged place in the transmission of knowledge (Bousquet-Bressolier 2002, 145, 147). The prints and drawings added in handwritten notebooks produced at the old University of Louvain testify to the high value attributed to images as pedagogical tools. The manuscripts often bring into play the ancient forms of allegorical, metaphorical, and symbolic images borrowed from emblematic literature. These result from the work of recycling, adapting, and interpreting extant patterns. They form an *assemblage* of representations of an ornamental

[58] On the relationships between the classical tradition of the artificial arts of memory and emblematic language, see (Bolzoni 2004; Daly 2014, 87–130; Freeman 1948, 198–203; Knape 1988; Yates 1969, 124).

and epistemic nature, a material and iconographic *bricolage* permitting inventiveness in the layout of the volume. Through a method of repeating recurrent and well-known motifs, such visual compositions were diverted from their primary spiritual, moral, or political meaning. As is the case in contemporary thesis prints or mathematical textbooks, the viewer must seek in the image the experience of reality that leads to a new understanding of material appearances (Guiderdoni 2012, 434).

There was no immediate transition from an allegorical universe to a realistic universe, or from a symbolic image to an illustrative, descriptive image, or from a rhetorical figure to an abstract, mathematical figure (Guiderdoni 2012, 434). Allegorical texts and images, open to multiple combinations and interpretations, "diffract as if they were reflected in different mirrors" (Bolzoni 2005, 11). Fragments taken from old corpora were reused and accommodated to a new context, which created a tension producing interest in the new interpretation. This was often specified by the addition of a title, either written by hand by the student, or printed by the bookseller. As we have seen, in the specific case of the emblems series recuperated by Michael Hayé for college notebooks, the role of the publisher, who added titles matching the topics of the university curriculum, must be taken into account. The intention of the creators of the original emblem or allegory (author, illustrator, printer) thus differs from the reception by the student/reader. The influence of the Jesuit Order has also been highlighted. In the practical pedagogy they developed, but also in the numerous publications of their members, the Jesuits promoted skillful combinations of "all forms of mental gymnastics, images, emblems, chronograms, versification" (Bousquet-Bressolier 2002, 87). In this way, students proved that they had mastered not only scientific topics, but also rhetoric, to be used "for the greater glory" (Bousquet-Bressolier 2002, 87) of the academic fields.

Allegorical forms and ways of thinking, particularly emblematics, often played a role in early modern education. In university notebooks, they were put at the service of cognitive processes. Using such images to depict scientific concepts, students created their own systems for training their memory and retaining the subject matter presented in class. Furthermore, through a form of celebration of knowledge, the embellishment of lecture notebooks also denotes symbolic and socio-political stakes. In addition to their framing, pedagogical, and mnemonic role, these marginal constructions could impress viewers as a display of wealth and luxury, when the college *dictata* functioned as memories of the study years after the graduation.

References

A Matre Dei, Sebastianus. 1652. *Firmamentum Symbolicum*. Lublin [= Antwerp]: Georg Forster.
Aristotle. 1984. The complete works of Aristotle: the revised Oxford translation. Jonathan Barnes (ed.), *On memory. Trans. J. Beare.* vol. 1. Princeton: Princeton University Press.
Bacon, Francis. 1858. De augmentis scientiarum. In *The works of Francis Bacon*, ed. James Spedding, et al., 413–414. London: Longmans.
Berger, Susanna. 2017. The art of philosophy. Visual thinking in Europe from the late Renaissance to the early Enlightenment. Princeton: Princeton University Press.

Bolzoni, Lina. 2004. Emblemi e arte della memoria: alcune note su invenzione e ricezione. In *Florilegio de estudios de Emblematica: A Florilegium of Studies on Emblematics,* ed. Sagrario Lopez Poza, 15–31. Coruna: Sociedad de Cultura Valle Inclan.

Bolzoni, Lina. 2005. *La chambre de la mémoire. Modèles littéraires et iconographiques à l'âge de l'imprimerie.* Geneva: Droz.

Bousquet-Bressolier, Catherine. 2002. Les mathématiques de l'honnête homme. Manuels pratiques à l'usage des officiers et ingénieurs au XVIIe siècle. *Revue Française D'histoire Du Livre* 114–115: 79–108.

Bousquet-Bressolier, Catherine. 2004. Pédagogie de l'image jésuite. De l'image emblématique spirituelle aux *Emblemata* mathématiques. In *François de Dainville S.J. (1909–1971). Pionnier de l'histoire de la cartographie et de l'éducation,* 143–166. Paris: École nationale des chartes.

Brueghel, Jean Ignace. 1679. Positiones mathematicae (under the supervision of Jean-Baptiste Billot). Antwerp: Michael Cnobbaert.

Carlino, Andrea. 1999. Paper Bodies: A catalogue of anatomical fugitive sheets 1538–1687. *Medical History,* Supplement no. 19.

Caussin, Nicolas. 1643. Eloquentiae sacrae et humanae parallela libri XVI. *Paris: Journal of Liberty.*

D'Haenens, Albert. 1994. Que faisaient les étudiants, à partir du XVe siècle, des textes qu'on leur imposait à l'université? Le non-textuel dans les manuels des étudiants de l'université de Louvain. In *Manuels, Programmes de Cours et Techniques d'enseignement dans les Universités Médiévales,* ed. Jacqueline Hamesse, 401–441. Louvain-la-Neuve: Fédération internationale des instituts d'études médiévales.

Daly, Peter, and G. Richard Dimler, eds. 2000. The Jesuit series, vol. 2. Toronto: University of Toronto Press.

Daly, Peter. 2008. *Companion to emblem studies.* New York: AMS Press.

Daly, Peter. 2014. *The emblem in early modern Europe. Contributions to the theory of the emblem.* Farnham: Ashgate.

David, Jan. 1610. *Duodecim specula Deum aliquando videre desideranti concinnata.* Antwerp: J. Plantin.

De la Feuille, Daniel. 1691. *Devises et emblèmes anciennes et modernes tirées des plus célèbres auteurs.* Amsterdam: [s.l.].

de Moreau, Edouard. 1918. *La bibliothèque de l'Université de Louvain 1636–1914.* Louvain: R. Fonteyn.

De Mûelenaere, Gwendoline. 2016. Double meaning of personification in early modern thesis prints of the southern low countries: Between noetic and encomiastic representation. In *Personification. Embodying Meaning and Emotion,* eds. Walter S. Melion and Bart Ramakers, 433–460. Leiden/Boston: Brill.

De Mûelenaere, Gwendoline. 2022. Academic print practices in the Southern Netherlands: Allegory and emblematics as epistemic tools. In *Reassessing Epistemic Images in the Early Modern World,* ed. Ruth Sargent Noyes. Amsterdam: Amsterdam University Press.

De Ridder-Symoens, Hilde. 2012. De praktijk van kennisoverdracht aan de Europese universiteiten voor 1800. In *Ex Cathedra. Leuvense Collegedictaten van de 16de tot de 18de eeuw,* eds. Geert Vanpaemel et al., 7–21. Louvain: Universiteitsbibliotheek.

Dekoninck, Ralph. 2011. Imaginer la science: la culture emblématique jésuite entre *Ars rhetorica* et *Scientia imaginum.* In *Transmigrations. Essays in honour of Alison Adams and Stephen Rawles,* eds. Laurence Glove and Alison Saunders, 99–114. Glasgow: Glasgow Emblem Studies.

Delsaerdt, Pierre. 2001. *Suam quisque bibliothecam. Boekhandel en particulier boekenbezit aan de oude Leuvense universiteit, 16e–18e eeuw.* Louvain: Universitaire Pers.

Demoustier, Adrien et al. 1997. *Ratio studiorum: plan raisonné et institution des études dans la Compagnie de Jésus.* Trans. Léone Albrieux and Dolorès Pralon-Julia. Paris: Belin.

Descartes, René. 1662. *De homine,* ed. F. Schuyl. Leiden: Peter Leffen & Franciscus Moyaerd.

Dhombres, Jean and Patricia Radelet de Grave. 2008. *Une mécanique donnée à voir: les thèses illustrées défendues à Louvain en juillet 1624 par Grégoire de Saint-Vincent.* Turnhout: Brepols.

Dolza, Luisa M. 2003. Reframing the language of inventions: The first theatre of machines. In *The Power of Images in Early Modern Science*, ed. Wolfgang Lefèvre, Jürgen. Renn, and Urs Schoepflin, 89–104. New York: Springer Science.

Ems, Grégory. 2016. *L'emblématique au service du pouvoir. La symbolique du prince chrétien dans les expositions emblématiques du collège des jésuites de Bruxelles sous le gouvernorat de Léopold-Guillaume (1647–1656)*. Louvain-la-Neuve: Presses universitaires de Louvain.

Engelgrave, Hendrik. 1648. *Lux Evangelica sub velum Sacrorum Emblematum Recondita in Anni Dominicas: Selecta Historia Et Morali Doctrina*. Antwerp: Jan Cnobbaert (new editions in 1652 and 1654).

Fowler, Caroline. 2016. *Drawing and the Senses. An Early Modern History*. Turnhout: Brepols.

Freeman, Rosemary. 1948. *English Emblem Books*. London: Chatto & Windus.

Guiderdoni, Agnès. 2012. Modes de penser allégoriques au service des sciences au début du XVIIe siècle: Dire et masquer la nouveauté. In *Allégorie et symbole: Voies de dissidence? De l'Antiquité à la Renaissance*, ed. Anne Rolet, 421–435. Rennes: Presses Universitaires de Rennes.

Hayaert, Valérie. 2008. *Mens emblematica et humanisme juridique: Le cas du Pegma de Pierre Coustau (1555)*. Geneva: Droz.

Held, Julius S. 1977. *Rubens and the book. Title pages by Peter Paul Rubens*. Williamstown: Williams College.

IJsewijn-Jacobs, J. 1976. Anthonius Haneron. In *550 jaar Universiteit Leuven 1425–1975*, 187–188. Louvain: Ceuterick.

Jonckheere, Koen. 2018. Aertsen, Rubens and the *questye* in early modern painting. *Nederlands Kunsthistorisch Jaarboek* 68: 49–77.

Knape, Joachim. 1988. Mnemonik, Bildbuch und Emblematik im Zeitalter Sebastian Brants (Brant, Scharzenberg, Alciati). In *Mnemosyne. Festschrift für Manfred Lurker zum 60. Geburtstag*, eds. Werner Bies and Hermann Jung, 133–178. Baden-Baden: Koerner.

Lamberts, Emiel, and Jan Roegiers. 1986. *De universiteit te Leuven 1425–1985*. Louvain: Universitaire Press.

Mirguet, Françoise, and Françoise Hiraux. 2003. *Collection de cours manuscrits de l'Université de Louvain. Catalogue analytique*. Louvain-la-Neuve: Bruylant-Academia.

Moore, Rosemary. 2015. Paper cuts. The early modern fugitive print. *Object* 17: 54–76.

O'Malley, John (ed.). 2015. *Art, controversy, and the Jesuits. The* Imago Primi Saeculi *(1640)*. Philadelphia: Saint Joseph's University Press.

Opsomer, Carmelia. 2000. Illustrated courses of natural philosophy in the southern low countries (1670–1797). In *Science and the visual image in the enlightenment*, ed. William Shea, 155–184. Canton, MA: Science History Publications.

Papy, Jan. 2017. Het leven aan het Drientalencollege. In *Het Leuvense Collegium Trilingue 1517–1797. Erasmus, humanistische onderwijspraktijk en het nieuwe taleninstituut Latijn-Grieks-Hebreeuws*, ed. Jan Papy. Louvain: Peeters.

Papy, Jan. 2012. Logicacursussen aan de Oude Leuvense Universiteit. Scholastieke traditie en innovatie? In *Ex Cathedra. Leuvense collegedictaten van de 16de tot de 18de eeuw*, eds. Geert Vanpaemel et al., 107–124. Louvain: Universiteitsbibliotheek.

Porteman, Karel. 1996. *Emblematic exhibitions* (affixiones*) at the Brussels Jesuit college (1630–1685). A study of the commemorative manuscripts*. Turnhout: Brepols.

Praz, Mario. 1975. *Studies in seventeenth-century imagery*. Rome: Storia e letteratura.

Roegiers, Jan. 2012. Awkward neighbours. The Leuven faculty of theology and the Jesuit college (1542–1773). In *The Jesuits of the low countries. Identity and impact (1540–1773)*, eds. Rob Faesen and Leo Kenis, 153–175. Louvain: Peeters.

Russell, Daniel. 2009. Emblems, frames, and other marginalia: Defining the emblematic. *Emblematica* 17: 1–40.

Salviucci Insolera, Lydia. 1996. *La spiritualité en images aux Pays-Bas méridionaux dans les livres imprimés des XVIe et XVIIe siècles conservés à la Bibliotheca Wittockiana*. Louvain: Peeters.

Schillings, A. 1963. *Matricule de l'Université de Louvain*, vol. 6. Brussels: Palais des Académies.

Schmutz, Jacob. 2008. Le petit scotisme du Grand Siècle. Etude doctrinale et documentaire sur la philosophie au Grand Couvent des Cordeliers de Paris, 1517–1771. *Quaestio* 8: 365–472.

Smets, An. 2014. De Leuvense hebben altijd wat'. 17de-eeuwse Leuvense collegedictaten bewaard in Leiden en Den Haag. *De Gulden Passer. Journal for book history* 92 (2): 195–214.

Smeyers, Maurits. 1975. Een collegeschrift van de oude Leuvense Universiteit (1481–1482). Een codicologisch en iconografisch onderzoek. Bijdrage tot de studie van het universitaire onderricht tijdens de middeleeuwen. *Arca Lovaniensis* 4: 243–303.

Steppe, J.K. 1968. Merkwaardige illustraties in oude Leuvense studentencursussen. *Academische Tijdingen* 6: 5–10.

Vaenius, Otto. 1615. *Amoris divini emblemata*. Antwerp: Jan Meursius.

Van de Vijver, Omer. 1980. L'école de mathématiques des Jésuites de la province flandro-belge au XVIIe siècle. *Archivum Historicum Societatis Iesu* 49: 265–271.

Van der Essen, Léon. 1921. *Une institution d'enseignement supérieur sous l'Ancien Régime. L'Université de Louvain (1425–1797)*. Brussels: Vromant.

Van Even, Edward. 1868. Blendeff (Lambert). In *Biographie nationale* 2, col. 470–471. Brussels: Thiry.

Van Gelder, Esther. 2005. *Echo's van een revolutie? Wetenschappelijke gravures in Leuvense fysicadictaten*. Master's thesis, KULeuven.

Van Hees, Willem. 1636. *Emblemata sacra de fide, spe, charitate*. Antwerp: Balthasar Moretus.

Van Vaeck, Marc. 2002. Printed emblem *picturae* in 17th- and 18th-Century Leuven university college notes. *Emblematica* 12: 285–326.

Van Vaeck, Marc. 2007. The use of the emblem as a rhetorical device in Engelgrave's emblematic sermon books. In *Emblemata Sacra. The rhetoric and hermeneutics of illustrated sacred discourse*, eds. Ralph Dekoninck and Agnès Guiderdoni-Bruslé, 535–552. Turnhout: Brepols.

Van Vaeck, Marc. 2012. Printjes…tot ciraet van de dictata reeksen van embleemgravures in de Leuvense collegedictaten. In *Ex Cathedra. Leuvense collegedictaten van de 16de tot de 18de eeuw*, eds. Geert Vanpaemel, Katharina Smeyers, An Smets, and Diewer Van der Meijden, 151–168. Louvain: Universiteitsbibliotheek.

Vanpaemel, Geert, Katharina Smeyers, An Smets, and Diewer Van der Meijden. 2012a. *Ex Cathedra. Leuvense collegedictaten van de 16de tot de 18de eeuw*. Louvain: Universiteitsbibliotheek.

Vanpaemel, Geert. 2003. Jesuit science in the Spanish Netherlands. In *Jesuit science and the Republic of Letters*, ed. Mordechai Feingold, 389–432. Cambridge (MA): MIT Press.

Vanpaemel, Geert. 2011. The Louvain printers and the establishment of the Cartesian curriculum. *Studium* 4 (4): 241–254.

Vanpaemel, Geert. 2012b. Jesuit mathematicians, military architecture and the transmission of technical knowledge. In *The Jesuits of the low countries: identity and impact (1540–1773)*, eds. Rob Faesen and Leo Kenis, 109–128. Louvain/Paris: Peeters.

Visser, Arnould. 2003. Why did Christopher Plantin publish emblem books? In *Emblems of the low countries: A book historical perspective*, eds. Alison Adams and Marleen van der Weij, 63–78. Glasgow: Glasgow Emblem Studies.

Yates, Frances. 1969. *The Art of Memory*. Harmondsworth: Penguin books.

Gwendoline de Mûelenaere is a postdoctoral fellow in history of art at Ghent University, in Belgium. Her current project focuses on illustrated lecture notebooks from the Old University of Louvain. She analyzes the features and the mode of operation of this visual production in order to assess their pedagogical role and to survey their socio-symbolic stakes from an art-historical perspective. Prior to that, she obtained a PhD at the Université catholique de Louvain. She carried out an iconological study of thesis prints produced in the Southern Low Countries in the seventeenth and eighteenth centuries. Her research interests include early modern prints, the history of education in the Southern Netherlands, the role of the Jesuits in the creation of images produced in academic frameworks, allegorical and emblematic languages, text/image relationships, frame and framing issues.

Chapter 2
The Illustrated Printed Page as a Tool for Thinking and for Transmitting Knowledge. The Case of the *Theoricae Planetarum*

Isabelle Pantin

Abstract During the early modern period, astronomy underwent a profound transformation in the way it was taught, as the response of an enlarged readership took on more and more importance. This change notably concerned the use of images and diagrams. The *Theoricae planetarum*, especially Peuerbach's *Theoricae novae planetarum*, are a privileged example in this respect, for they served a particularly large range of functions. They were mnemonic tools and visual glossaries, and an essential element in Peuerbach's pedagogical approach. They had a documentary role, as they gave plausible representations of the celestial spheres; they could be used as proofs of the soundness of a "theory," or could simply help to follow a geometrical demonstration. Some of them were small-scale models designed to serve as tools for the mind to better grasp the complex combination of movements in what was then called *machina mundi*. All these figures, and their power to exercise the mind, were well suited to a period when more and more astronomers were involved in imagining, drawing, and comparing hypothetical models of planetary movements.

Keywords *Theoricae planetarum* · Georg von Peuerbach · Knowledge transmission · Movements · Demonstration

2.1 Introduction

During the early modern period, astronomy underwent a profound transformation, not only in its methods, its aims, and its theoretical developments and prospects, but also in the way it was taught and even popularized as the response of an enlarged readership to the works of astronomers took more and more importance. All these changes were mirrored in (and sometimes accelerated by) the evolution of the layout of the books, notably concerning their use of images and geometrical diagrams.

I. Pantin (✉)
École Normale Supérieure (Paris)-PSL, IHMC (UMR 8066), Paris, France
e-mail: isabelle.pantin@ens.fr

I shall examine this evolution in a particular kind of astronomical book, the *Theoricae planetarum*, which gave images a role both prominent and multiple. In the *Theoricae*, especially in the *Theoricae novae planetarum*, written by Georg von Peuerbach (1423–1461) in the middle of the fifteenth century, the diagrams, in association with the text, were conceived as tools primarily for teaching a difficult mathematical discipline, but secondarily for helping the reader to understand that this discipline, astronomy, had various levels.

The first level was purely technical, as astronomy's main task was to calculate and predict the positions of the stars by conceiving geometrical models of celestial movement. But, on the other hand, astronomy was linked to philosophy in the sense that it was concerned with the organization of the cosmos. This is an old problem, posed by Pierre Duhem in terms of a perennial opposition between "instrumentalism" and "realism" (Duhem 1969). However, the contrast between these positions becomes blurred when the issue is approached through images and representations.

I shall thus try to place the diagrams of the *Theoricae* in their context, and to analyze their functions, while addressing the wider issue of the relationship between the subject of the treatise they belonged to (the science of planetary motions) and the extensive use of visual expression.

2.2 From the *Theorica Vetus* to Peuerbach's *Theoricae Novae*

If we go back to their probable origins, the *Theoricae* were a byproduct of higher astronomical theory, whose model was the *Almagest* of Ptolemy (ca. 100–ca. 170). They were meant to reduce the geometrical analysis of planetary motions—with its complete demonstrative apparatus—to pedagogical expositions that described models of kinematic motion in nearly the same manner that the construction of certain astronomical instruments can be described. This purpose was already present in Ptolemy's *Planetary hypotheses* (Goldstein 1967; Hartner 1968; Murschel 1995; Evans 2003; Hamm 2016). Although the treatise was not directly available to Latin-speaking astronomers,[1] it was translated into Arabic (and from Arabic into Hebrew). A tradition originated from it, whose paths of transmission are somewhat opaque. A crucial role was probably played by the twelfth-century translations of the *Elements of astronomy* of al-Farghānī (Alfraganus, ninth century) by Johannes Hispalensis (fl. 1118–1142) and Gerardus Cremonensis (ca. 1114–1187), and by the anonymous Spanish and Latin translations of the treatise *On the configuration of the world* of Ibn al-Haytham (Alhazen, 965–1040) in the thirteenth century (Langermann 1990; Mancha 1990; Samsó 1990; Hugonnard-Roche 1996; Sylla 2017). At any rate, from the second half of the thirteenth century the explanation of planetary motion through

[1] Only the first part of the first book of the *Planetary hypotheses* has survived in the original Greek text (in only two manuscripts); it was printed for the first time in 1620, with a Latin translation (Bainbridge 1620).

the description of geometrical models constituted the upper level of astronomical teaching at the university. It was known as *Theorica planetarum* (Pedersen 1962, 1975).

The most widely diffused *Theorica* was the *Theorica communis* (or *Theorica vetus* or *Theorica Gerardi*, as it was falsely attributed to Gerardus Cremonensis in some fourteenth- and fifteenth-century manuscripts and in the incunabula editions).[2]

Theorica communis probably owed its success to its relative simplicity; its main challenger, the *Theorica* of Campanus de Novara (1220–1296) was more complex and required higher technical and mathematical skills to penetrate (Benjamin and Toomer 1971). The *Theorica Gerardi*, which survives in more than 210 manuscripts (Pedersen 1981), follows a straightforward plan. It defines the principal astronomical terms; it describes the circles and lines of the Sun, the Moon (the explanation of the motion of the nodes included),[3] the superior planets (Mars, Jupiter, and Saturn), Venus, and Mercury; and it gives some instructions for computing these motions with the aid of astronomical tables.

In the Renaissance, the *Theorica communis* was totally supplanted by the *Theoricae novae* of Georg Peuerbach—originally a course taught in 1454 at the *Collegium civium* in Vienna. Peuerbach's more brilliant disciple, Johannes Regiomontanus (1436–1476), copied his master's manuscript, richly illustrated with twenty-nine large diagrams;[4] some twenty years later, between 1472 and 1474, he printed the work in Nuremberg[5] with thirty diagrams that faithfully reproduced (though with some slight improvements) those of the original manuscript.[6]

[2] Some Renaissance scholars, like Bernardino Baldi, preferred an attribution to Gerardus de Sabbionetta, a thirteenth-century astrologer (Baldi 1707, 91). Both attributions are based on little evidence, and even the date of the treatise is under discussion (Pedersen 1981; Federici-Vescovini 1996, 1998). The text is best identified by its *incipit* (a definition of the eccentric circle): "Circulus ecentricus vel egresse cuspidis vel egredientis centri dicitur [*or* "est"] qui non habet centrum suum cum centro mundi." See also (Gerardus 1942).

[3] The lunar nodes are the two opposite (and moving) points at which the eccentric circle of the Moon (that bears the epicycle with the Moon's body) intersects the path of the Sun (that is the ecliptic). One is the ascending node, or dragon's head (*caput draconis*), where the Moon "begins to turn to the north;" the other is the descending node, or dragon's tail (*cauda draconis*), where the Moon turns to the south (Gerardus 1974, §29–31). When the Moon is at a node, and either full or new, an eclipse may occur.

[4] Regiomontanus' autograph copy is now in Vienna (ÖNB, *Palatinus Latinus* 5203, 1r–26v). See (Peuerbach 1454; Grössing 1983, 101–102; Zinner 1990, 203; Malpangotto 2012, 344–346).

[5] In Regiomontanus' edition the last section, *De motu octavae sphaerae*, is more complete than in the early manuscripts, copied around 1454; we know that the addition was written by Peuerbach shortly before his death, for the manuscript of the *Theorica novae* he bequeathed to Bessarion in April 1461 (now in Rimini, Biblioteca civica) contains it. In this manuscript, the last two leaves are now missing, but what remains of the *De motu octavae sphaerae* in this last redaction corresponds exactly (notwithstanding insignificant variants) to the text in the *editio princeps* (Peuerbach 1461; Malpangotto, 2012, 379–380).

[6] The only diagram whose model is not in the known early manuscripts of the *Theoricae novae* concerns the eighth sphere and was probably drawn in the missing leaves of the Rimini manuscript.

Regiomontanus soon began a defamatory campaign against the *Theorica vetus* in order to impose his master's *Theoricae novae* as the only legitimate and reliable introduction to the knowledge of planetary motions. In 1476, he printed a dialogue that criticized many errors of "Gerardus" (Pedersen 1978; Shank 2012), later republished under the revealing title *Disputationes contra Cremonensia in planetarum theoricas deliramenta* (*Disputations against Gerardus Cremonensis' delirious ravings*).[7] Regiomontanus' purpose was not only to point out the old textbook's mistakes, some of which, by the way, had already been discussed and corrected by medieval commentators (Byrne 2011), but also to launch an attack against the traditional astronomy of eccentrics and epicycles, as, according to Shank (2012), the *Disputationes* are much indebted to Henry of Langenstein's *De reprobatione ecentricorum et epiciclorum* (1364) (Kren 1968). Regiomontanus probably carried copies of this pamphlet and of the *Theoricae novae* when he left Nuremberg for Venice, then Rome, where he was to die in July 1476.

At that time, the *Theorica Gerardi* had been printed twice in Venice and in Ferrara (Gerardus 1472a, b), together with the *Sphaera* of Johannes de Sacrobosco (died ca. 1256). Campanus' *Theorica* was never printed. Three subsequent editions, still paired with editions of the *Sphaera*, appeared in 1478 and 1480 (Gerardus 1478a, b, 1480), after which the *Theorica Gerardi* was no longer regarded as the standard textbook on the subject. The Venetian printers printed the *Theoricae novae* instead, introduced by Regiomontanus' attack on "Gerardus' delirious ravings."

The *Theorica Gerardi* was henceforth no longer of interest except as a document on medieval astronomy. In 1518, the Venetian bookseller Luca Antonio Giunta (1457–1538) published a large astronomical anthology, prepared by a Roman physician, Girolamo de Nuciarelli (fifteenth–sixteenth century), which was also published—probably some months afterward—by the heirs of Ottaviano Scoto (died ca. 1499) (Nuciarelli 1518, 1518/1519).[8] The main difference between the collections is that Giunta had the *Theorica Gerardi* appended to the beginning. This addition was mentioned and justified on the title page: "The *Theory of planets* of John [*sic*] of Cremona, most useful for [reading] Regiomontanus' *Disputationes*, that you cannot find in the other printed editions" (*Theorica planetarum Joannis [sic] Cremonensis plurimum faciens ad disputationem Joannis de Monte Regio, quam in aliis impressis non reperies*). The next collection, prepared by Luca Gaurico (1475–1558), still contained the *Theorica Gerardi*, but it was never printed again in the sixteenth century (Gaurico 1531).

[7] In the Nuremberg first edition, the dialogue *Disputationes contra Cremonensia in planetarum theoricas deliramenta* is untitled.

[8] The Scoto edition is dated January 19, 1518, the Giunta edition June 30, 1518. As these dates are probably expressed in "Venetian style" (*stile veneto, mos venetus*) with the beginning of the year fixed on the first of March (Cappelli 1983, 16), the Scoto edition must have appeared in January 1519, and Giunta was the first publisher of the collection. The addition of the old *Theorica* was probably determined at the last moment: the text is printed in the first quire (A3v–A6r), which was almost always printed last, and it is mentioned at the end of the list on the title page.

2.3 The Role of Illustration in the Rivalry Between the Old and New *Theories*

This complete victory of the new over the old treatise was certainly encouraged by the attack of Regiomontanus, launched at the very beginning of the printed career of the *Theorica planetarum*, when only a handful of printers (in northern Italy) published this kind of textbook. However, the decisive factor was likely that the intrinsic qualities of Peuerbach's treatise were imposed upon the viewer by the concerted use of images.

To begin with, the *Theoricae novae* are much more complete than the old *Theorica*. They are also more clearly written and organized, and every element of their descriptions is developed in a distinct subsection illustrated by a large diagram with a title (Fig. 2.1).

Each "chapter" on a particular planet (or group of planets in the case of the three "superior planets"[9] and Venus[10] that share the same diagrams) is illustrated with a series of specialized diagrams, always in the same order: first a global figure, discussed further below (*Theorica Solis* or *Theorica Lunae*, and so on) (Fig. 2.1), then a diagram of the axis and poles of the circles on which depend the planet's movements (*Theorica axium et polorum*) (Fig. 2.2), that of the different lines used for determining the planet's position and movement (*Theorica linearum et motuum*), and, if necessary, that of the "proportional minutes,"[11] which is necessary data for the calculations. In comparison, the old *Theorica* had, at best, one diagram to accompany the entire analysis.

The scope of the new treatise was also wider. Whereas the *Theorica vetus* was purely geometrical, the *Theoricae novae* more completely fulfilled the original purpose of Ptolemy's *Planetary hypotheses*: to construct virtually three-dimensional

[9] The three planets above the Sun, in the Ptolemaic system, Mars, Jupiter and Saturn, were traditionally dealt with together, for the mechanisms of their movements were similar.

[10] The *Theoricae novae* clearly link the superior planets with Venus, as the corresponding diagram is entitled "Theorica trium superiorum et Veneris," though the chapter "De tribus superioribus" is followed by the very short "De Venere," ending with these words: "the definitions of terms are here throughout just as for the superior planets" (Peuerbach 1987, 22). By contrast, the *Theorica Gerardi* has a section on the superior planets ("Sequitur de tribus planetis") followed by a section on Venus and Mercury ("Sequitur de Mercurio et Venere"), which, in fact, mainly deals with the complicated movement of Mercury, except in one passage that refers, for a series of definitions and descriptions, to the section on the superior planets ("Medius vero motus Mercurii et Veneris…omnia ista sic describuntur in Mercurio et Venere, sicut in tribus superioribus"). Then, at the end of the section, the similarity between Venus and the superior planets is stated: "Venus vero habet deferentem et aequantem dispositos sic sicut tres superiores…Omnia alia de Venere similia sunt in tribus superioribus."

[11] The "proportional minutes" ("minuta proportionalia") refer to the division into sixty parts, or minutes, of the distance between the apogee and the perigee of the eccentric deferent of the planet. This division plays a role in the calculation of the motions of all the planets with epicycles. The Moon, the superior planets, and Mercury each have a specific mode of calculation and a specific corresponding diagram. In the first incunabula editions of the *Theoricae novae*, hand coloring was used to improve the clarity of these diagrams.

Fig. 2.1 The orbs of Mercury. Munich, Bayerische Staatsbibliothek. Ink P-399, urn:nbn:de:bvb:12-bsb00030432-6. From (Peuerbach ca. 1473, 9r)

models of the planetary orbs, in order to demonstrate that the sophisticated geometry of eccentrics and epicycles—which, in the *Almagest*, accounts for the celestial motions—was both mechanically plausible (and potentially reproducible in actual instruments) and compatible with the Aristotelian cosmos composed of concentric celestial orbs (Lerner 1996, 74–81; Evans and Carman 2014; Hamm 2016). According to Peuerbach's nearly three-dimensional models, the "total orb" of each planet, itself perfectly concentric with the sphere of the universe, was divided into partial contiguous orbs, responsible for every component of the planet's complex movement. Some of these partial orbs were "deformed" (i.e., with one surface

ita ut auges fcilicet deferentium epicyclos fimiliter oppofita atq̃ centra & po/
li deferentium eccentricorum circumferentias fupficiei ecliptice uirtute mo/
tus octauę fp̃herę defcribant equidiftantes. unde &iam in illis fuperficies ec/
centricorum a fupficie ecliptice inęqualiter fecabuntur: atq̃ maiores porcio/
nes uerfus augem minores uerfus oppofitum reliquant̃. Motus aut̃ epi/
cyclum deferentis fuper centro & polis fuis difformis eft. Hęc tamen difformi
tas hanc regularitatis babet normam ut centrũ epicycli fuper quodam pun /
cto in linea augis tantum a centro bui? orbis quantum boc centrum a centro
mundi diftat elongato: regulariter moueatur. Vnde & punctuf ille centrum
ęquantis dicit̃. & circulus fup eo ad q̃ntitatem deferentis fecum in eadẽ fupfi
cie imaginatus eccentricus ęquans appellatur .Neceffario igit̃ oppofitum ei
q̃d i̅Luna fiebat accidit in iftis ut fcilicet centrũ epicycli q̃nto uicini? augi defe
rẽtis fuerit tanto tardi?: q̃nto uero ꝓpinqui? oppofito tãto uelociuf moueat̃.
⸿Epicyclus uero duos bab& mot? quoꝗ unus eft i̅ lõgitudinẽ: alt̃ i̅ latitudi
nẽ. De fecũdo dicẽdũ erit poftea. Mot? aũt ei? in lõgitudinẽ eft quo mouet̃
circa centrũ fui̅ corpus planetę fibi infixũ i̅ pte fupiori fecũdum fucceffionẽ:

⸿THEORICA AXIVM ET POLORVM.

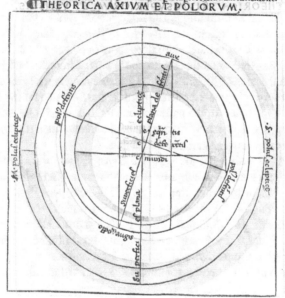

concentric with the universe and one surface eccentric); others were completely
eccentric (Aiton 1981; Lerner 1996, 115–126).

This was even highlighted by the illustration. In the first incunabula editions, the
diagram that, at the beginning of each "chapter" on a particular planet, shows the
general arrangement of its total and partial orbs, is hand colored, with some of the
partial orbs painted green or blackened with ink, to increase legibility and the realism

of the representation, and perhaps to suggest three-dimensionality (Fig. 2.1).[12] This was not an absolute innovation; in a few manuscripts of the *Theorica Gerardi*, color or ink blackening was used to clarify certain diagrams and to highlight that the orb which contains the planet and its epicycle (the "deferent" orb) is inserted between partial orbs.[13] But in the manuscripts of the old *Theorica* the function of the unique diagram that represents one planet (or group of planets), color or no color, is to show the geometrical lines and circles that account for the movement of the planet in question. This diagram corresponds mainly to the type of diagrams called *Theorica linearum et motuum* in the *Theoricae novae*. Whereas in the *Theoricae novae* the diagrams with parts blackened or colored in green are devoted only to showing the arrangement of the orbs. Thus, the effect is much more striking.

The diagrams of the *Theoricae novae* were certainly unusual and eye-catching, but they were linked to a tradition. The importance given to the illustration was a fundamental generic feature of the *Theories of planets*. Many manuscripts of the *Theorica Gerardi* were illustrated with a set, more or less complete, of five diagrams (Müller 2008, 253–266), sometimes with one or two additions. The five diagrams, as already mentioned, show lines and circles corresponding to the geometrical analysis of the movements of the planets: one diagram for the Sun, two for the Moon (one for the object itself, the other for the nodes of the Dragon), one for the superior planets, and one for Venus and Mercury.[14] An additional diagram often illustrates the causes of the stations and retrogradations of the planets.[15]

In the first 1472 editions of the *Theorica Gerardi*, there were large blank spaces that make room for hand-drawn figures, but no diagrams (Gerardus 1472a, b).[16] The 1478 edition, printed by Franz Renner (fl. 1471–1486) was illustrated with eight diagrams (Gerardus 1478a; Sander 1942, n° 6659), which were copied in the next 1478 and 1480 editions (Gerardus 1478b, 1480; Sander 1942, no. 3085, 6660). In the meantime, Peuerbach's *Theoricae novae* had been printed in Nuremberg with their thirty striking figures and circulated in Italy, and Renner's diagrams, which undoubtedly belong to the tradition of the old *Theorica*'s illustration, were marginally influenced by the diagrams of the new treatise.

In the four diagrams of the movements of the planets (Sun, Moon, superior planets, and Mercury) ink blackening makes visible the partial "deformed" orbs surrounding the eccentric orb (Gerardus 1478a, b, e2r, e4r, e9r, e10v). But this is not necessarily

[12] See, for instance, one of the copies of the *Theorica planetarum* in Munich, Bayerische Staats-Bibliothek (BSB Clm 27), digitized copy available at http://mdz-nbn-resolving.de/urn:nbn:de:bvb:12-bsb00030432-6. Accessed 9 May 2022.

[13] For instance, (Gerardus 14th/15th cent.); 8r (the Sun); 9r (the Moon); 9v (the Moon and the Dragon). This manuscript in digitized in the Gallica-Repository.

[14] For instance, Ms. Latin Add. 447 2°, 49r–56r (Copenhagen, Royal Library), dating from around 1300, has these five diagrams, reproduced in (Gerardus 1974, Figs. 1–5). For another diagram of Venus and Mercury (Cambridge University Library, MS Ii.III.3, 82r), see (Müller 2008, Abb. 83).

[15] For instance in Ms. Latin Add. 447 2° (Copenhagen, Royal Library), 54r, and in MS Ii.III.3 (Cambridge University Library), 84r. See (Müller 2008, Abb. 85, 86).

[16] In the Ferrara edition (Gerardus 1472a), two whole pages, two two-third pages, and five half pages are left blank; in the Venice edition (Gerardus 1472b), only three whole pages and a half.

significant—as we have seen, some manuscripts of the *Theorica Gerardi* used the same device. Much more important is the fact that the diagrams bear titles (like the diagrams of the *Theoricae novae*) that sometimes add clarity to the text itself. In particular, in the section on the superior planets, the diagram is entitled "Theorica trium superiorum *et Veneris*" (Gerardus 1478a, b, e9r) (emphasis by the author), as in Peuerbach's book, whereas, in the text of the *Theorica Gerardi* and often in its diagrams, Venus is awkwardly associated with Mercury; and the Mercury diagram is entitled "Theory of Mercury, the most difficult of all others" ("Theoria Mercurii inter alia difficilior," e10v), which emphasizes that Mercury poses highly specific problems—a fact somewhat blurred in the text.

Moreover, the 1478 editor and his printer added diagrams that were not in the original canonical set. These diagrams are not remarkable in themselves. They are simplified sketches of elements that enter in the analysis of the movements, unlettered and without captions. The first, "Theorica medii motus" (e2v) shows the construction of the line necessary to measure the mean motion of a planet on the ecliptic in the simplest case: that of the Sun.[17] The next one, "Figura capitis et caudae draconis lunae" (e6r), simply shows the intersection of two circles at two opposite points (the circles are the ecliptic and the eccentric of the Moon, and the opposite points are the nodes, as can be deduced from the text). The third, "Figura minutorum proportionalium" (e9v), though almost unintelligible, is supposed to clarify the definition of the proportional minutes, in the case of the superior planets. The last diagram of the same kind, the figure of the stations and retrogadations (f6r), belongs to the traditional illustration of the *Theorica Gerardi*.

The Renner edition thus displayed a set of eight diagrams, well balanced between two groups: that of the complex figures of the planets, meant to represent the movements of each of these planets in their globality, and that of much simpler geometrical sketches, which show only one feature or mechanism. Of course, both types of diagrams existed in the manuscripts, which had often rough and incomplete figures drawn in the margins. But the influence of the *Theoricae novae* probably prompted the editor of the 1478 edition to increase the number of canonical diagrams; perhaps it helped him to perceive the usefulness of a wider range of diagrams, devoted to different functions.

In any case, if the Renner edition initiated an evolution, it soon petered out. The *Theoricae novae* remained without rival and were printed and reprinted in a long series of editions, all illustrated with copies or new versions of the original set of figures, and also with new diagrams added by successive editors and commentators (Pantin 2012). Peuerbach's treatise thus made more evident the crucial role of illustration in this kind of textbook in helping students to visualize Ptolemy's work.

[17] The mean motion of the Sun ("medius motus Solis") is measured by the arc of the ecliptic between the first degree of Aries and the intersection of the ecliptic and the "line of the mean motion." This line begins at the center of the world and is parallel to the line that joins the center of the eccentric of the Sun to the center of the body of the Sun.

2.4 *Theorica*: The Meaning of a Term

The new treatise even modified—or rather clarified—the meaning of the word "theorica," and hence the meaning of its own title. Regiomontanus, who supervised the first printing, no longer used "theorica" (which we translate as "theory" for want of anything better) in the singular form, in the phrase "theorica planetarum" that could be understood as "science of the planetary motions," or in a collective sense, as "set of the theories of all the planets." Regiomontanus' edition, in all significant respects, is faithful to the manuscripts that can be traced directly to Peuerbach[18] (though Peuerbach's autograph is missing). However, its incipit differs from that of all five surviving manuscripts anterior to 1473. This incipit looks like a title: "Theoricae novae planetarum Georgii Purbachii astronomi celeberrimi," printed on two lines in capital letters. Regiomontanus reproduced this title with an advertisement-like addition ("with appropriate figures") on the first line of the trade list he published in 1474 or 1475: "Theoricae novae planetarum Georgii Purbachii astronomi celebratissimi: cum figurationibus oportunis" (Regiomontanus 1972, 533; Stromer 1980). By comparison, all the anterior manuscripts have incipits with the phrase "Theorica nova," obviously in the singular collective form, and in calculated opposition to the phrase "Theorica vetus."[19]

By modifying the phrase, and in the most conspicuous position, in the printed book, Regiomontanus probably wished to eliminate the vague and general use of the term "theorica." In medieval Latin, "theory" was most often termed "theoria." "Theorica," as a feminine noun, was also used to mean "speculative science," but it occurred more and more frequently in astronomical contexts and in the set phrase "theorica planetarum." Humanism increased this specialization of the word, for "theorica", as a feminine substantive, does not belong to classical Latin.

In the new plural use adopted in Peuerbach's title, as edited by Regiomontanus, "theoricae" clearly referred to the different geometrical models of the planets, and even, more precisely, to their diagrammatic representation. It thus reestablished a closer and more concrete relationship to its etymological root, *theôrein*: to observe.

We can even try to better determine to what extent Regiomontanus' use of the term was, in his time, purposefully innovative. In the three earliest manuscripts of Peuerbach's treatise, there is no indication of a possible shift in the meaning of the word "theorica." In particular, the diagrams have no titles, and the successive "chapters" are introduced by a brief formula written in red: "De Sole," "De Luna," "De Capite draconis Lune," and so on (Malpangotto 2012, 252–253, 256). By contrast, in the manuscript presented to János Vitéz (ca. 1408–1472), counsellor of Matthias Corvinus (1443–1490), and archbishop of Esztergom from 1465, there are no titles

[18] The most important manuscripts are Regiomontanus' autograph copy (Peuerbach 1454), and the copy bequeathed by Peuerbach to Bessarion in 1461 (Peuerbach 1461).

[19] On these five surviving manuscripts, see (Malpangotto 2012). On their incipits, see below. However, it must be noted that the explicits of the three earliest manuscripts, which are transcriptions of the 1454 lecture, use the plural, "Finiunt Theorice nove…" to refer to the whole set of "theories" devoted to different celestial objects (Malpangotto 2012, 352).

Table 2.1 Chapter titles of the Renner *Theorica Gerardi*, connected to the geometrical representations

Chapter title	Folio
Capitulum figurae Solis	e1r
Capitulum figurae Lunae	e2v
Capitulum figurae capitis et caudae draconis Lunae	e5v
Capitulum figurae trium superiorum scilicet Saturni Jovis et Martis	e6v
Capitulum figurae minutorum proportionalium	e9v
Capitulum figurae Mercurii et Veneris	e10r
Capitulum de retrogradatione, statione et directione planetarum	f4v
Capitulum de latitudine et declinatione planetarum	f6v

for the different "chapters," but five diagrams have a title, written in golden capitals: "Theorica solis," "Theorica lune," "Theorica trium superiorum," "Theorica Veneris," and "Theorica Mercurii." However, it must be noted that this manuscript (Peuerbach 1455–1468), probably edited by Martin Bylica de Olkusz (1433–1493), deviates notably from the tradition initiated by Peuerbach and followed by Regiomontanus, as concerns the diagrams.[20]

In the manuscript bequeathed to Bessarion (Peuerbach 1461), the first diagrams of the "chapters" on the planets are made with volvelles, and much differ from the corresponding diagrams in the 1454 manuscripts.[21] These 1461 diagrams have titles written in red capitals and inscribed in phylacteries: "Theorica solis," "Theorica lunae," "Theorica trium superiorvm et Veneris," and "Theorica Mercurii." Each marks the beginning of the "chapter" it belongs to (Malpangotto 2012, 375, Figs. 10–11).

Then the Regiomontanus edition proposes a different mode of titling, much more consistent, which was adopted in subsequent editions. In it, all thirty diagrams have titles with a similar wording ("Theorica Solis," "Theorica axium and polorum," and so on), which distinguish them clearly from the titles of the "chapters" ("De Sole," "De Luna," "De passionibus planetarum diversis," and so on).

Here again, the editor of the Renner edition of the *Theorica Gerardi* (Gerardus 1478a, b) was probably influenced by Regiomontanus' innovations. He added a division in chapters with titles that express the prominent role of the geometrical representations (Table 2.1).

[20] The images called "Theorica" are in 2r, 4v, 7r, 8v, 10r. The dates I give for the manuscript correspond to the first encounter of Vitéz with Peuerbach and Regiomontanus in Vienna (1455) and to the last year Bylica was in the service of Vitéz before being appointed as Matthias Corvinus' astrologer (1468). This manuscript was among the books and instruments bequeathed by Bylica to the university of Krakow. See also (Birkenmajer 1893, 41–42; Malpangotto 2012, 363, Fig. 5). On the illustration of this manuscript, see below, Sect. 2.7.

[21] On these volvelles, see Sect. 2.7 below.

Table 2.2 Diagram titles of
the Renner *Theorica Gerardi*

Diagram title	Folio
Theorica Solis	e2r
Theorica medii motus planetarum	e2v
Theorica Lunae	e4r
Figura capitis et caudae draconis lunae	e6r
Theorica trium superiorum et Veneris	e9r
Figura minutorum proportionalium	e9v
Theorica Mercurii inter alia difficilior	e10v
Figura retrogradationis, stationis et directionis planetarum	f6r

The eight diagrams of the Renner edition also had titles, and these titles marked the difference between the representation of a complete planetary model ("Theorica") and that of a particular element of such models ("Figura") (Table 2.2).

Thus, it seems possible to conclude that Regiomontanus made an effort to give "theorica" a clearer definition and a more specific function. By using the term so steadily and consistently to refer to all the diagrammatic representations in his edition of Peuerbach's treatise, he went as far as to propose the systematic replacement of "figura" by "theorica" in the case of the analysis of planetary motions.

This choice, though rather radical, had some roots in the habits of the language of astronomers. In the Middle Ages, "theorica" was already linked to the field of the geometrical analysis of planetary motions, as we have seen, as well as to the notion of "model." A few years after Peuerbach's momentous lectures at the Vienna *Collegium civium*, short treatises circulated at the universities of Erfurt, Leipzig, and Frankfurt. They described a new kind of "equatorium," a geometrical model of planetary motions, made in brass, in wood, or most often in parchment, cardboard, or paper, to serve as a calculating instrument: an "equatorium" helps to find the position of a given planet with the aid of threads and rotating wheels, much more easily than when using astronomical tables alone. The treatises were entitled *Theorice novelle*, or *Theorice nove* in the plural form, which suggests a close association between "theorica," as a term designating a specific object, and this kind of model, midway between a geometrical description and a material instrument.[22]

This established link explains why in the Vitéz and Bessarion manuscripts of the *Theoricae novae* (and in the Renner 1478 edition of the *Theorica Gerardi*) the main diagrams of the planets are labeled "Theorica Solis," and so on. It indicates an evolution that probably accelerated after 1450.[23] For, though no extensive survey

[22] According to Poulle (Poulle 1980, 377–393) these treatises, sometimes accompanied with paper instruments, are datable to between 1458 and the beginning of the 1470s. These "Theorice" were called "nove" to differentiate them from Campanus de Novara's *Theorica*, which combines a theory of planets and the construction of an "equatorium" (see Sect. 2.7 below).

[23] Poulle observed that the fifteenth century was "à coup sûr, par excellence, le siècle des équatoires," and that in the second half of this century, there even appeared "enthusiasm" for a certain type of "equatoria," which were then introduced in the syllabus of some German universities (under

has been made on this point, it seems that in the fourteenth- and fifteenth-century manuscripts of the *Theorica Gerardi*, the diagrams, when they were labeled at all, were labeled "figura"—most often in the set phrases "Figura motus solis," "Figura motus lunae," and so on.[24]

By giving a title to all the diagrams of Peuerbach's treatise, and by always using "theorica" in these titles, Regiomontanus initiated a new practice, which was imitated in subsequent editions of the *Theoricae novae* for about half a century.[25] Then the rule was loosened. In the Paris edition, supervised by Oronce Finé (1494–1555), no diagram has a title (Peuerbach 1525, 1534); the titles are replaced by legends. Finé has tried to impose his own layout on the book, in particular he boasted on the title page that he had considerably improved the illustration, as well as the text.

The editions prepared in Germany, first by Peter Apian (1495–1552), then by Jacob Milich (1501–1559) for a Wittenberg printer, are more faithful to the tradition initiated by Regiomontanus (Peuerbach 1528, 1535): the diagrams inherited from this tradition, or directly inspired by it, are, with a few exceptions, labeled "Theorica" in the "chapters" on the planets and in the last section, "De motu octavae sphaerae;" but all but one of the diagrams in the "chapters" "On the passions of the planets" ("De passionibus planetarum") and "On declination and latitude" ("De declinatione et latitudine"), as well as all the diagrams added in the "chapters" on the planets to clarify certain points of the description, are without titles. A partition is thus established between the "theoricae" proper, that is the diagrams that are essential to the modelization of the movements of the celestial orbs, and the other diagrams, which concern particular aspects or whose function is auxiliary.

In the Wittenberg editions with commentary by Erasmus Reinhold (1511–1553), this division of the diagrams into categories is carried further. The use of "theorica" in the diagrams' titles remains the same, or about the same, as it was in the Apian and Milich editions. But, though Reinhold has introduced many new diagrams in his commentaries (or "scholia"), the total number of diagrams without titles has decreased, for new categories have appeared. Two diagrams are called "instrumentum" (see Sect. 2.7 below) and Reinhold uses "typus" for the representations of the eclipses. This suggests that they are documentary images, for "typus," sometimes a synonym of "woodcut," is often found in the captions of the figures of books of natural history.

More importantly, a large number of diagrams are called "schema" ("form" or "figure" in Greek), a term sometimes spelled in Greek and associated with an other

the title "Theorice novelle") (Poulle 1980, 737). It is tempting to establish a link between this observation and the evolution in the use of the term "theorica."

[24] Manuscripts of the *Theorica Gerardi* are, for instance, in Copenhagen, Royal Library, Ms. Latin Add. 447 2°, and in Cambridge University Library, MS Ii.III.3, see (Müller 2008, Abb. 80, 82, 83); or in Paris (Gerardus 14th cent.; Gerardus 14th/15th cent.): both manuscripts are digitized in the Gallica-Repository.

[25] Using "theorica" in the titles of the diagram applies to the editions without commentaries: (Peuerbach 1482, 1485, 1488), and so on.

greek term, *apodeixis*.[26] *Apodeixis* (from *deiknein*, "to show") means "demonstration" in Aristotle's logic, as opposed to the dialectical reasoning that does not produce sure knowledge. The term is linked to the notion of evidence, and also of visuality. Reinhold's diagrams and their captions were faithfully copied in the Paris editions that gave them a wider audience (Peuerbach 1553a, 1556).

In Regiomontanus' edition, the uniform wording of the titles of the diagrams probably had a double purpose: to emphasize the importance of illustration in the *Theories of the planets*, and to draw attention to the singularity of the representation of the models of celestial movements among the variety of geometrical diagrams. By introducing some diversity in the diagram titles of his own editions (Peuerbach 1542, 1553b), Reinhold did not alter this original intent: the term "theorica" retained, and even refined, its specificity, and the diverse aspects of the relationship between visual representation and geometrical analysis, in the case of the theories of planets, were better clarified.

2.5 The "Theoricae" as "Pictures" of Heavens: The Elusive Relationship between Geometrical Abstraction, Modelization, and Concrete Reality

In Reinhold's editions, the "schemas" most often show methods for understanding an important feature of the mechanism of a celestial movement. A large portion of them are lettered and accompanied by detailed legends; they do not simply illustrate the text, but play the role of visual demonstrations. For instance, the "theoricae" (in Regiomontanus' edition) of the "proportional minutes" are called "schemas" in Reinhold's edition, and so are, among the added diagrams, the "schemas of the three points" (one for the Moon, one for the three superior planets). The "three points" are the mean and the true apogees of the epicycle, and a third point called "punctum cavitatis" ("point of the cavity" or "point of the concavity") by Peuerbach—a phrase that does not appear in the *Theorica Gerardi*, which runs quickly through the analysis of the motion of the epicycles.

In the case of the Moon (Fig. 2.3), the schema shows six successive positions (A, B, C, D, E, F) of the epicycle, which rotates in its eccentric deferent orb, represented by three white circles nested within two "deformed" orbs. The outermost circle, like in almost all diagrams of the *Theoricae planetarum*, is the ecliptic, whose center (T) is the center of the world. The small interior circle is the circle described by the center of the eccentric deferent (S), as it moves around the center of the world (T). The vertical line is the axis of the eccentric deferent of the moon that passes

[26] [in Greek:] "*schema kai apodeixis* longitudinum mediarum" (Peuerbach 1542, L4v): title of the diagram that shows the method for finding the mean longitudes of the three superior planets.

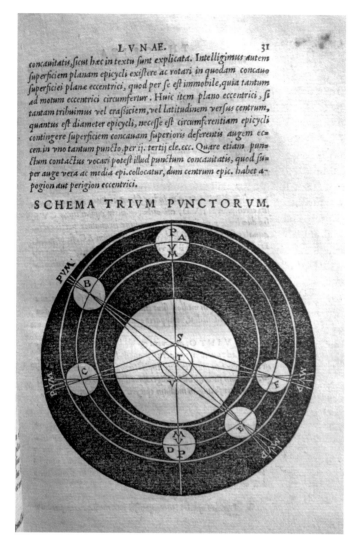

Fig. 2.3 The "three points" in the movement of the epicycle of the Moon. Cambridge, Trinity College, Wren Library. S.3.117. Reproduced by kind permission of the Master and Fellows of Trinity College, Cambridge. From (Peuerbach 1553a, 31r)

through the apogee and perigee of this deferent, the center of the eccentric deferent and the center of the world. This axis also passes through V, the "opposite point" ("punctum oppositum"),[27] situated on the little circle and diametrically opposed

[27] The "punctum oppositum," a term that belongs specifically to the theory of the Moon, plays a similar role as the equant point ("punctum aequans") in theories of other planets (the Sun excepted): with respect to this point, the center of the epicycle, carried by the eccentric deferent, is supposed to have a constant circular movement.

to S. The "three points" (M, P, V)[28] are marked on the epicycle by lines that all pass through the center of this epicycle but originate, respectively, at the center of the world, at the "opposite point," and in the center of the deferent. The first line (from T) encounters the epicycle in V, the "true apogee of the epicycle" ("aux vera epicycli"), the second line (from the "opposite point") ends in M, the "mean apogee of the epicycle" ("aux media epicycli"),[29] and a third line (from S), ends in P, the "point of the cavity of the epicycle." According to Peuerbach, the true and mean apogees of the epicycle are always "under" this last point ("sub quo") "when the center of the epicycle is in the apogee or perigee of the deferent" (Peuerbach 1987, 15), that is on the axis of this deferent. The schema, which did not exist before the Reinhold editions, effectively shows at first sight that when the center of the epicycle is on the axis, the three lines merge into one. In every other positions of the epicycle, the lines diverge, and V, the "true apogee," is always between the "mean apogee" M and the "point of the cavity" P (though M and P exchange their position after passing through the axis). To consider this "point of the cavity," which plays no role in the computation of the movement of the epicycle, gives a more concrete notion of this movement. This is probably why Reinhold has added the schema and written *scholia* to clarify the corresponding passage in the *Theoricae novae* "that is one of the most difficult" ("unus…ex difficilimis"). He begins by explaining the meaning of the unusual phrase "punctum cavitatis," as used by Peuerbach, and thus moves from pure geometry to a reflection on the mechanical problems of the construction of a model:

> We understand that the plane of the epicycle remains and rotates in some cavity of the plane of the eccentric;[30] [the cavity] is, by itself, immobile, as it is only carried by the movement of the eccentric. If we attribute to this plane of the eccentric as much thickness, or width in the direction of its center, as the diameter of the epicycle,[31] then the circumference of the epicycle will necessarily touch the concave surface of the upper deferent of the apogee of

[28] In sixteenth-century diagrams, it can occur that the same letter ("V" in this example) corresponds to two different points, as long as it does not cause inextricable ambiguity.

[29] The difference between the "true" (real and actual) movement or position of a celestial point or body, and its "mean" movement and position was an essential feature of the theories of planets. As the "true" celestial movements were irregular, due to diverse anomalies, mean motions, by which the celestial circles (and the bodies they carried) were supposed to rotate equably, had to be calculated. The difference between a "true" and a "mean" motion was called the "equation" ("equatio" or "aequatio").

[30] In Peuerbach's general description of the configuration of the sphere of the Moon, the epicycle is described not as a circle but as a "little sphere…immersed into the depth of the third orb [= the eccentric deferent], in which epicycle the body of the Moon is fixed:" "…sphaerulam…profunditati orbis tercii immersam in quo quidem epicyclo corpus lunare figitur" (Peuerbach ca 1473, 2v).

[31] It simply means that the thickness of the eccentric deferent orb exactly corresponds to the diameter of the epicycle, as shown in the diagram.

the eccentric[32] at only one point, according to Euclid, (*Elements*, III, 2, etc.).[33] That is also why this "point of the cavity" can be called the "point of contact," which is over (*super*) the true and mean apogees of the epicycle, when the center of the epicycle is at the apogee or perigee of the eccentric.[34]

According to pure geometry, M, V, and P merge at one unique point when the center of the epicycle is on the axis of the deferent, but Reinhold keeps Peuerbach's idea that P, the "point of the cavity," which belongs to the eccentric orb and touches the upper "deformed" orb, is "over" the other two, which belong to the epicycle nested inside the "cavity:" content and container must remain distinct. The phrase "point of contact," meaning the point where the true and mean apogees of the epicycle touch the concave border of the upper "deformed" orb, expresses this idea more clearly than "point of the cavity." The letters in the diagram are so disposed as to emphasize it—with some exaggeration.

Not all the diagrams in the *Theoricae novae* feature figures (with their legends and explanations) that could serve as bridges between abstract geometry and modelization efforts. But it was widely acknowledged that they were a support to the imagination, and that imagination played a crucial role in the theories of the planets.

One of the translators of the treatise *On the configuration of the world* had his patron, King Alfonso X of Castile (1221–1284), praise Ibn al-Haytham for having "imagined all that exist indeed universally in the celestial bodies, and in the heavens that are singularly imagined."[35] Some time later, Roger Bacon (ca. 1220–1294), in his *Opus tertium* and in his *De coelestibus*, used the depreciative "ymaginatio modernorum" to refer to the planetary models conceived in his time by some mathematicians (whose names he did not mention), under the probable influence of Ibn al-Haytham's treatise (Bacon 1909, 125; 1913, 438; Lerner 1996, 115–116).

But imagination has two sides: it is either a deceptive forger of illusions, or an indispensable tool for thinking and knowing. It has been theorized by the philosophers of the mind since antiquity (Bianchi and Fattori 1986; Lagerlund 2007; Panaccio

[32] The two "deferents of the apogee of the eccentric of the Moon" are the "deformed" orbs between which the eccentric orb is situated. They carry with them the apogee of the eccentric as they "move westward together, uniformly about the center of the world, by about eleven degrees and twelve minutes beyond the diurnal movement in a natural day" (Peuerbach 1987, 12). The "upper deferent of the apogee of the eccentric" is above the eccentric deferent.

[33] As the text concerns two circles (the epicycle and the concave surface of the upper deferent of the apogee) that meet at one point, the reference must be *Elements* III, def. 3 and prop. 6, 11, 13 (Euclid 1956, II, 1, 13, 24–25, 32–33).

[34] "Intelligimus autem superficiem planam epicycli existere ac rotari in quodam concavo superficiei planae eccentrici, quod per se est immobile, quia tantum ad motum eccentrici circumfertur. Huic item plano eccentrici, si tantam tribuimus vel crassitiem, vel latitudinem versus centrum, quantus est diameter epicycli, necesse est, circumferentiam epicycli contingere superficiem concavam superioris deferentis augem eccen <trici> in uno tantum puncto, per ii. tertii ele. etc. Quare etiam punctum contactus vocari potest illud punctum concavitatis, quod super auge vera ac media epi <cycli> collocatur, dum centrum epic <ycli> habet apogion aut perigion eccentrici (Peuerbach 1542, G8v–H1r, 1553a, 31r).

[35] "…est ymaginatus totum quod equidem est in corporibus celestibus universaliter et in celis singulariter imaginatis" (Mancha 1990, 143; Lerner 1996, 292–293).

2010; Schofield 1992; Spruit 1994–1995). The Renaissance editors and commentators of Peuerbach held a more positive view of the "imaginations" proposed in the *Theoricae novae*. They sometimes articulated the link between the non-demonstrative character of the textbook and its reliance on visual representation. At the beginning of his commentary on the *Theoricae novae*, Sylvester de Prierio (1456–1523) states that this compendium of the *Almagest* omits demonstrations in order to transmit knowledge "to the simple faith and to the *imagination*," in such a manner "that the disposition and movement of the celestial spheres, and the meaning of the terms employed in the tables, can be *seen*."[36]

According to Melanchthon, in the letter to Simon Grynaeus that introduces the new Wittenberg edition of the *Theoricae* (Peuerbach 1535), given that "elementary textbooks are needed in schools, no other manual is more necessary that these 'Theoricae,' as they are called, that is pictures of the celestial orbs."[37] This translation is repeated in Reinhold's dedication of his commentary to Albert of Brandenburg, duke of Prussia (1490–1568): "Theoricas, seu orbium picturas" (Peuerbach 1542, A6v).

This pictorial character of the "theoricae" had certain consequences, most of which were directly linked to the pedagogical function of the textbook—as if Peuerbach had been a precursor of Jan Comenius (1592–1670) and had conceived a kind of astronomical *Orbis pictus*. However, that did not exclude philosophical, and even religious implications. In the 1535 letter already quoted, Philipp Melanchthon refers to the Aristotelian distinction between "to hoti," knowledge that simply describes the facts as they are visible, and "to dioti" knowledge that explains them through in-depth inquiry into their causes,[38] it being understood that the former must be the first step toward the latter.

> Peuerbach did very wisely when he summarized in this summary Ptolemy's science of the motions of all the celestial orbs, in order to open the way for students to deal with the complete demonstrations…. Thus, when he sets up these pictures of the orbs, he delivers only [*Greek*] *to hoti*, so to speak. But he wishes that the causes why so many orbs are enumerated for each planet, and the observations by which so great a variety of movements has been noted, should be investigated in Ptolemy.[39]

This learning approach, aimed at acquiring a complete knowledge of celestial movements, was not an end in itself. Melanchthon and his Wittenberg disciples

[36] "… probationibus geometricis sic ommissis ut nude fidei *ymaginationique* tradantur: quo celorum situs, motusque nec non et tabularum vocabula *conspici* possint" (Prierias 1514, A1r). Author's emphasis.

[37] "Scis autem in scholis opus esse Elementis, Nec alius libellus magis necessarius est, quam theoricae ut vocant, seu *picturae orbium coelestium*" (Peuerbach 1535, A3r). Author's emphasis.

[38] In the *Praefatio* of his commentary, Reinhold explains the distinction and gives this definition of *to hoti* teaching: this is "when only nude and brief precepts, or maxims or rules are proposed, without the causes and demonstrations" ("cum videlicet nuda ac brevia quaedam praecepta, sive sententiae aut regulae proponuntur sine causis atque demonstrationibus…") (Peuerbach 1542, C4r–v).

[39] "Purbachius prudentissime in hanc epitomen contraxit Ptolemaei doctrinam de omnium orbium coelestium motibus, ut studiosis aditum ad integras disputationes patefaceret…Itaque dum hic *picturas* orbium instituit, tantum [*Greek*:] *to hoti* ut ita dicam tradit. Causas vero, cur tot cujusque planetae orbes numerentur, et quibus observationibus tanta varietas animadversa sit motuum, postea vult ex Ptolemaeo peti…" (Peuerbach 1535, A6v). Author's emphasis.

considered astronomy a deadly weapon against atheism because the beauty and complex regularity of heavenly revolutions, alongside their observable effects in this sublunary world, led to the recognition of divine Providence (Caroti 1986; Kusukawa 1995, 124–173; Brosseder 2004, 2005). The "theoricae" could thus be viewed not only as useful pedagogical images but also as a means for contemplating the geometrical order of the cosmos; and Melanchthon, in his prefatory letter, associates the praise of Peuerbach with an apology of Christian astronomy and astrology.

> Moreover, as Plato said, "God always does geometry,"[40] that is, he governs this our world by measuring everything according to a most certain movement, so that we could delight in that most beautiful geometry that shows us the divinity, by considering in our turn the lines drawn by this supreme Artist.[41]

However, the fact that Peuerbach's "pictures" led to an understanding of the beauty of cosmic geometry did not implicate that they represented the real "configuration of the world" (to borrow Ibn al-Haytham's title, as understood by its Western translators). All Peuerbach's readers did not share the same position on this point.

In the earliest manuscripts of the *Theoricae novae*, there is no ambiguity. With the notable exception of the manuscript bequeathed to Bessarion (Peuerbach 1461), they share the same incipit: "So begins the new theory that reveals the *real* disposition and motion of the spheres."[42] Thus, the contrast was signaled from the outset between the "New theory" and the old one that remained within the limits of a strictly geometrical exposition.

Diagrams played a key role in Peuerbach's project, not only because they revealed the originality of the treatise, as already mentioned in Sect. 2.3, but also because images can possess a certain degree of physical existence, at least as credible representations of physical things. They proved that the complex combinations of eccentrics and epicycles, conceived by Ptolemy, could be inserted into a system of contiguous orbs, both mechanically valid (as a well-regulated clock) and compatible with Aristotle's general description of the real cosmos. The figures of the *Theoricæ novae* that showed the main pieces of this clockwork thus possessed a cosmological value and hence some philosophical legitimacy.

However, in Regiomontanus' edition, the original incipit had disappeared, which left the book open to interpretation. Regiomontanus himself had an ambivalent stance on the issue. His published work makes him appear as an active rehabilitator of Ptolemaic astronomy and an admiring disciple of his master Peuerbach, but some of his letters and, above all, his unpublished *Defense of Theon against George of*

[40] *Theon aei geometrein.* This saying is attributed to Plato by Plutarch in one of his *Symposiacs*, "What was meant by saying God is always doing geometry" (718c–720c). In this passage, Melanchthon probably also refers to Plato's *Timaeus* where the necessary, harmonious, and regular motion of heaven is given as the model that men must contemplate to keep their souls in tune with it (*Timaeus*, 45b–46a, 47b).

[41] "Quin potius, ut Plato dixit, deum semper [in Greek:] *geômetrein*, hoc est certissimo motu omnia metientem, gubernare haec inferiora, ita nos vicissim hujus summi artificis lineas considerantes, hac pulcherrima geometria nos oblectemus, quae divinitatem nobis ostendit" (Peuerbach 1535, A4v).

[42] "Incipit Theorica nova *realem* sperarum habitudinem atque motum…declarans" (Malpangotto 2012, 352, 361). Author's emphasis.

Trebizond, studied by Michael Shank, reveal that he was critical of the astronomy of eccentrics and epicycles and tried to conceive a homocentrist astronomy that would possess the accuracy and predictive power of the models described in the *Almagest*—which the medieval homocentrists had failed to do. As Regiomontanus wished to find the real configuration of the world, he much preferred Peuerbach's *Theoricae novae*, with their nearly three-dimensional models, to the *Theorica Gerardi*, but all the same, he did not think that they showed the "*real* disposition…of the spheres," and he regarded them as second best (Shank 1998, 2002).

Regiomontanus' successors could therefore take varying positions on the matter, according to their philosophical stance. Two early commentators of the *Theoricae novae*, Francesco Capuano (fifteenth cent.) and Silvestro Mazzolini da Prierio, or Sylvester Prierias (ca. 1456–1523), used the treatise to defend opposite positions (Peuerbach 1495; Prierias 1514). The former affirmed the reality of the orbs described by Peuerbach to better defend Ptolemy against the "Averroist" attack of the homocentrist Alessandro Achillini (ca. 1463–1512), while the latter, who had "Averroist" sympathies,[43] dwelt on their fictitious nature (Lerner 1996, 129; Pantin 2012, 8–10). Further investigation would lead to the problem of the realism of hypotheses, which certainly touches on the question of the diagrams, but is much broader.

Some remarks from Reinhold show in any case that certain authors had a subtle perception of the different ways by which the "theoricae" allowed one to glimpse the truth of things. Like Melanchthon, Reinhold enlarges the Platonic theme of the contemplation of celestial geometry, but he enriches it by linking it with the construction of mechanical models—probably in full knowledge that he thus opposed Plato (ca. 428–348 BCE).[44]

> I hear that the Ancients made planetary automata. We ourselves, we have seen machines, made with wonderful art, which contained the daily motions of all the planets. But, certainly, to propose this brief summary of the movements has required more intelligence. I am sure that the craftsmen of that time, who made these machines, had taken thence their model. It was necessary to look at this *Idea* to make the courses of the stars sometimes slower and sometimes swifter, to show some stars move forward, others recede, some deviate southward, others northward. Having observed a kind of picture of such a variety in these *theoricae*, they built afterwards their machines according to this *Idea*.[45]

[43] Mazzolini de Prierio was a friend of the "Averroist" Agostino Nifo, see (Tavuzzi 1997, 97–104).

[44] In *Republic* VII (522c–530c), Plato insists that the mathematical sciences practiced by the philosopher must remain purely speculative, see also (*Philebus*, 56d–57b). In Plutarch's *What was meant by saying God is always doing geometry* (*Symposium*, VIII, 2, 718c–720c), one of the characters notes that Plato forbade to mix mathematics with any mechanical device (718e). Plutarch explains, in the *Life of Marcellus* (14: 4–6; 17: 4–5), that for that reason Archimedes considered his machines to be simple recreation and never consented to leave any treatise on them.

[45] "Audio fabrefacta esse a veteribus planetarum Automata. Vidimus et ipsi mira arte factas machinas, quae motus quotidianos omnium planetarum continebant. Sed profecto majoris ingenii fuit hanc tradere brevem motuum summam. Nec dubito, quin hujus aetatis artifices, qui machinas illas fabricarunt, hinc exemplum sumpserint. In hanc *Ideam* intueri necesse erat, cum itinera stellarum alias tardiora, alias celeriora facerent, cum alias progredi stellas, alias regredi, evagari alias in austrum, alias in arcton ostenderent. Hujus tantae varietatis, quasi *picturam* in his theoricis *spectantes*, postea machinas ad hanc *Ideam* accommodarunt" (Peuerbach 1542, A7v). Author's emphasis.

Idea, a Platonic term, originally refers to the essence of things that can be intuited by the mind but cannot be realized in matter except as an inferior copy. The spheres and planetaries made in antiquity and in modern times are a Ciceronian and humanist topos related to the praise of the excellence and divinity of the human mind (Pantin 1995, 86–98). Here, they are supposed to have been built after their makers contemplated the *Idea* provided by the *theoricae*. In hyperbole, the text conveys the notion that the *Theories of the planets* are truthful pictures of the heavens, whose genuineness is further attested by the wonderful craftsmanship of the planetaries. However, Reinhold goes on to deny any intention to comment on the physical organization of the world.

> For what is more absurd than to disturb the inventions of geometry with conjectures on physical matters? For disturbing geometrical demonstrations with the delusions of conjectures is not only vanity of the mind, as Plato said, but even hateful impudence.[46]

2.6 The Images as Pedagogical Summaries and Glossaries of Technical Terms

The *Theoricae novae planetarum*, as "pictures" of the celestial orbs and movements, thus had a philosophical background, but that did not interfere with their primary function: to provide a pedagogical summary of Ptolemy's geometrical analysis of the planetary motions, and to be a first introduction to astronomical practice. Ultimately, the reader of this manual was to become capable of computing celestial positions with the aid of astronomical tables; those referred to in the *Theoricae novae* belonged to the Alphonsine corpus,[47] which had progressively supplanted the *Toledan tables* from the fourteenth century (Poulle 1981; Pedersen 2002). The corpus contained numerous sets of tables that varied in number and in type (calendars, chronologies, tables of eclipses, tables of the prime mobile, planetary tables etc.), in their presentation, in their instructions for use, and in their reference meridian.[48]

The tables consisted of numerical series, laid out in columns, under cryptic headings whose understanding required the mastery of a specific vocabulary. They were accompanied by *Canones* that gave key information on how they had been made and the rules for using them, but the relationship between the numerical series

[46] "Quid est enim insulsius, quam inventa geometrica exagitare conjecturis physicorum? Non solum vanitas est ingenii, ut Plato dixit, sed etiam petulantia digna odio, conturbare geometricas demonstrationes praestigiis conjecturarum" (Peuerbach 1542, A8r).

[47] The origin of the *Alphonsine tables*, attributed to a group of astronomers working under the patronage of Alfonso X around 1270, is discussed because there is no surviving manuscript of their Castilian original (Poulle 1988; Chabás and Goldstein 2003; Swerdlow 2004). The *Tabulae alphonsinae* began to circulate in Latin from 1320, with canons prepared by Parisian astronomers Jean de Murs, Jean de Lignères, and Johannes de Saxonia.

[48] For a typology of the tables and indications on their organization and use, see (Poulle 1981, 1984; Chabás 2012; Chabás and Goldstein 2012); on the tables in the sixteenth century, see (Poulle and Savoie 1988).

and the actual mechanism of celestial motions was not explained. The latter task was performed by the *Theoricae*, which thus established a correspondence between the numerical and geometrical expressions of the celestial motions. Moreover, they provided definitions, both verbal and visual, of all the specific terms used in the tables.

The definitions of these technical terms were inserted in the text of the *Theorica communis* and occasionally gathered in separate glossaries (Pedersen 1973; Poulle 1987). The *Theoricae novae* modernized these definitions without drastically changing the technical vocabulary. Peuerbach even took care to quote and explain some obsolete formulas, so as not to confuse readers who were used to the old *Theory*. For instance, the first sentence of the *Theorica Gerardi* defines the eccentric circle as a circle "vel egresse cuspidis, vel egredientis centri:" "with a displaced cusp, or an outgoing center" (Gerard 1974, 452). In his opening paragraph, Peuerbach prefers a more usual definition, but later, when explaining that the Sun, on its eccentric, moves uniformly about the center of this eccentric, but nonuniformly about the center of the world, he adds that "for this reason" ("itaque") the eccentric circle is called "vel egresse cuspidis, vel egredientis centri circulus" (Peuerbach ca. 1473, 2r). The old formula, though useless, had to be clarified, given the importance of its terminological legacy.

The earliest manuscripts of the *Theoricae novae* make clear in their incipit that the explanation of technical vocabulary is a primary aim of the work: "Begins the new theorica…with the terms in the tables."[49] Reinhold accordingly adds complements to the definition given by Melanchthon: the *Theoricae* are not only "pictures of the orbs," they are, at the same time, "nomenclatures and summaries of the movements" ("et nomenclaturas, et motuum summas") (Peuerbach 1542, A6v).

The figures helped to perform this task. In astronomy, as in other disciplines like cartography (Woodward 1987) or medicine (Nutton 2001; Pantin 2013), the images were often used to facilitate the memorization of lists of names. In the manuscripts of the *Theorica Gerardi*, the diagrams often have at least some labeled lines, circles, or arcs (Müller 2008, Abb. 81–83; Gerard 1974, Figs. 2–5).

The thirty large diagrams of the *Theoricae novae*, which circulated in printed form, opened new possibilities as soon as technical difficulties were solved. For it was not easy to print a complex geometrical diagram and detailed labels, whatever the method chosen: be it cutting the text and the figure in relief on the same woodblock (like in xylographic books) or on a plate of metal—metalcut was a technique used in south Germany in the second half of the fifteenth century (Field 1965)—or inserting type in holes made in the woodcuts, or using metallic relief mirror-images of the diagrams with their letters, produced as when casting type fonts. Michael Shank has argued that the diagrams of the 1475 *Disputationes* were printed with this last technique (Shank 2012).

The *Theoricae novae* was the first illustrated astronomical book printed in the West, and its printing was a technological adventure that required solutions that had never been utilized before. Its figures are different from the relatively small

[49] "Incipit Theorica nova…cum terminis tabularum," the missing part of this incipit is quoted above.

geometrical diagrams of the *Disputationes*: drawn into square borders, they occupy about two-thirds of the page, and are situated either at the bottom or at the top of the pages instead of being embedded in the text. I will not hazard a guess on the method with which they were printed. Anyway, they often bore labels, very similar to those in the manuscript diagrams of the *Theorica Gerardi*. The centers were indicated ("c. mundi," "c. deferentis," "c. equantis"), as were the poles and the axes in the "theoricas" devoted to this matter; for instance in the case of the superior planets (Fig. 2.2):

M[eridionalis] polus ecliptice

S[eptentrionalis] polus ecliptice

polus deferentis

aux (= apogee) oppositum augis (= perigee)

superficies plana ecliptice

superficies plana deferentis

In other diagrams, other important points, lines, and circles were indicated, like "principium arietis" (the first degree of Aries), "linea medii motus" and "linea veri motus" (in the diagrams of the lines and motions), and the different ecliptics and their poles in the "De motu octavae sphaerae." However, these labels were limited to essential indications and were far from including the main technical vocabulary.

At the turn of the century, technical improvements almost allowed for a visual encyclopedia of astronomical knowledge. In 1503 in Freiburg im Breisgau, Gregor Reisch (d. 1525) published the *Margarita philosophia*, a compendium of university learning that contained (among many other matters) a summary of the *Theoricae novae planetarum*. At this date, after the Nuremberg princeps edition, Peuerbach's treatise had only been printed in Italy, and Reisch's *Margarita* initiated a tradition in Germany: its planetary diagrams influenced Peter Apian (Peuerbach 1528; Pantin 2012, 15–16) and through him the Wittenberg editors of Peuerbach.

In book VII of the *Margarita*, much information on planetary motions is condensed in three chapters that deal with the problem of terminology. The first one (Chap. 37), "On the meaning of the terms of astronomical tables" ("De significatione terminorum tabularum astronomicarum"), contains a series of definitions corresponding to the case of the Sun: "aux" (apogee), "oppositum augis" (perigee), "equatio," and so on. At the end, the reader is invited to look at a carefully labeled diagram: "you will be able to see all these things on the figure before your eyes" ("haec singula in subjecta oculis videre poteris descriptione"). The next chapters are similar and concern the Moon, then "the other planets" (the superior planets): "De terminis tabularibus in reliquis planetis" (Reisch 1503, o1r–o3v).

The diagram (Fig. 2.4) is loosely based on the "theorica of the lines and motions" of the superior planets in Regiomontanus' edition and in the subsequent Venetian editions. However, it adds elements taken from other diagrams (the "theorica of the orbs" and the "theorica of proportional minutes") to obtain a more synthetic figure— it thus somehow returns to the model of the diagrams of the *Theorica Gerardi*.

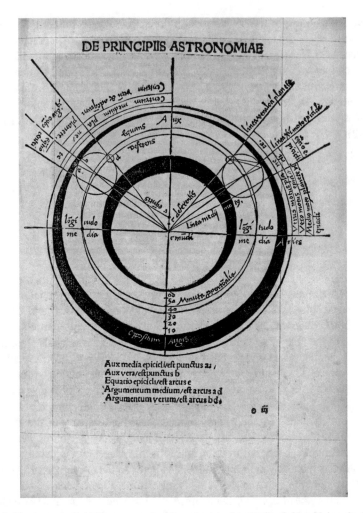

Fig. 2.4 The terms in the tables concerning the superior planets. Cambridge University Library. Norton.c.32. By permission of the Syndics of Cambridge University Library. From (Reisch 1503, o3r)

The *Margarita* diagram shows the system of three orbs, described by Peuerbach for the superior planets, with the "deformed" orbs blackened for better clarity and the eccentric deferent orb (that contains the epicycle) slightly enlarged to make the labels more legible. The outermost circle represents the ecliptic: the beginning of Aries is marked ("Aries"). The vertical line is the axis that passes through the apogee and perigee of the eccentric deferent of the planet ("Aux", "Oppositum Augis"), and the three aligned centers of the equant circle ("c. equantis"), of the eccentric deferent ("c. deferentis"), and of the world ("c. mundi"). The line that crosses it at right angles at the center of the world indicates the points of the eccentric deferent

that are at middle distance from the Earth (between the apogee and perigee). These points, marked "longitudo media" (mean longitudes) are also the intersection points of the equant circle ("Equans") and of the deferent circle ("Deferens"), the circle in the middle of the eccentric orb on which is fixed the center of the epicycle.

The terms concerning the epicycle are lettered on the diagram, and the corresponding labels are in the legend below. Point "a" is the mean apogee of the epicycle ("Aux media epicicli"), defined in the text as "the point of the epicycle marked by the line drawn from the center of the equant and passing through the center of the epicycle."[50] Point "b" is the true apogee of the epicycle ("Aux vera"), marked "by the line drawn from the center of the world and passing through the center of the epicycle."

Then come the specific terms used in the computation of the movements. The "line of the true motion of the epicycle" ("linea veri motus epicicli") is drawn from the center of the world to the ecliptic, passing through the center of the epicycle. The "line of the true place of the planet"("linea vera [sic] loci planete") is drawn from the center of the world and passes through the body of the planet.

The line of the mean motion of the epicycle and of the planet ("linea medii motus") is drawn from the center of the world to the ecliptic, parallel to the line from the center of the equant passing through the center of the epicycle. In the right part of the diagram (that with the label), this is not quite clear; the parallel line is incompletely drawn and does not meet the center of the equant, but in the left part both lines are correctly drawn.

All these lines mark on the ecliptic (the outward circle) the arcs that measure the different movements of the planet. The right part of the diagram shows the "true motion of the planet" ("Verus motus planete"), from "Aries" (first degree of the ecliptic) to the "linea vera loci planete;" the "true motion of the epicycle" ("Verus motus epicicli"), from "Aries" to the "linea veri motus epicicli;" and the "mean motion of the planet or the epicycle" ("Mediusmotus planetae vel epicycli"), from "Aries" to the "linea medii motus." The small arc between the "linea veri motus epicicli" and the "linea medii motus" is labeled "equatio [motus] epicicli."

Other arcs are shown in the left part of the diagram, whose lines and circles are symmetrical to those in the right part: the "mean center of the planet" ("centrum medium planetae"), measured eastward on the ecliptic from the apogee to the line of mean motion; the "true center of the planet" ("centrum verum et adequatum [sic] planetae"), from the apogee to the line of true motion; the "equation of the center" ("equatio centri"), which measures the difference between the mean and true "centers;" and the "equation of the argument" ("equatio argumenti"), between the line of the true place of the planet (that passes through the body of the planet) and the line of the true motion of the epicycle (which passes through the center of the epicycle).

The legend below adds the arcs measured on the epicycle, according to the direction of the movement of this epicycle: arc "e" (the letter is in white above arc "ab")

[50] "…punctum epicicli per lineam a centro equantis, per centrum epicicli ducta designatum" (Reisch 1503, o2v).

is the "equation in the epicycle" ("equatio epicicli [= in epicyclo]"), between the mean and true apogees of the epicycle; arc ad is the "mean argument" of the planet ("Argumentum medium"), from the mean apogee of the epicycle to the body of the planet; arc bd is the "true argument" of the planet ("Argumentum verum"), from the true apogee of the epicycle to the body of the planet.

Lastly, the "Minuta proportionalia" are represented by the graduation (10, 20, 30, 40, 50, 60) marked along the line of the apogee in the inferior part of the eccentric orb, between the interior limit of the exterior "deformed" orb and the exterior limit of the interior "deformed" orb. Here the diagram is faulty, as the graduation ought to be placed between the eccentric deferent circle (that bears the center of the epicycle) and a point slightly below the exterior limit of the eccentric orb.[51]

In spite of some inaccuracies, this *Margarita* diagram is an efficacious visual glossary. Later editors of Peuerbach were influenced by this model, though they found easier to replace the labels on the diagram itself with letters referring to detailed legends. The *Margarita* similar diagram of the lines and motions of the superior planets was imitated by Peter Apian (Peuerbach 1528, titlepage and 32).[52] Three years before, Oronce Finé, in Paris, had simplified the diagram and reorganized the legend (Peuerbach 1525, 17v), followed by a Wittenberg editor (Peuerbach 1535, D6v–D7r). In the Reinhold edition, this same diagram (in the Wittenberg version) is presented as a means not only for memorizing the technical terms and understanding their meaning, but also for recapitulating all that had been explained before. The figure is preceded by this title: "Theorica in which are shown all the lines and arcs hitherto described."[53] The legend is thus presented:

> Scholies of the preceding diagram.
>
> Now, in order that the terms hitherto explained should be more evident, it pleased us to expose simultaneously all their descriptions in one and the same figure.[54]

This is not an isolated example. Numerous of Reinhold's scholies are diagrams accompanied by detailed legends, sometimes headed by titles like "Declaratio praecedentium vocabulorum" (L3v) or "Declaratio textus et figurae praecedentis" (L6r).

2.7 The *Theoricae* as Instruments

The *Theoricae*, as a series of annotated diagrams, thus enabled students of astronomy to acquire a basic knowledge and understanding of planetary motions and to move

[51] For a correct representation, see (Peuerbach 1542, M3r).

[52] Page 32 is the last of squire B and the legend has been truncated, probably due to a mistaken casting off.

[53] "Theorica in qua omnes lineae et arcus hactenus descripti ostendentur" (Peuerbach 1542, D6r).

[54] "Scholia praecedentis schematis. Nunc, ut vocabula hactenus explicata, fiant magis perspicua, libuit eorum descriptiones simul in una eademque figura declarare" (Peuerbach 1542, D6v–D7r).

from this abstract knowledge to practice with the first keys for using astronomical tables. A further step would have been to use the book itself as an instrument for computing celestial movements. The idea is not absurd, given the close relationship between the *Theoricae* and the books on "equatoria": both aimed at making geometrical models of the movements of each planet, the former for teaching purposes, the latter for computational practice.

Nothing impeded the use of the geometrical diagrams of a *Theorica* as the basis of an "equatorium." Under this logic, Campanus de Novara wrote a *Theorica* (ca. 1260), coupled with instructions for constructing and using an "equatorium"—the earliest known such description in Latin Europe. He showed how graduated disks, corresponding to the various movements of a planet, could be assembled as the rotating parts of an instrument and used to find motions without difficult calculations of data from astronomical tables. For instance, a disk could be set to the "medius motus" of a planet for a chosen date (found in the tables), and then the planet's "verus motus" could be marked, on the ecliptic scale etched on the rim, by a string stretched from the center of the instrument and passing through the point marking the planet on the epicycle disk. The reverse operation was of course possible, as the proper function of the instrument was to "equate" planetary motions.[55]

There are more than sixty extant manuscripts of Campanus' *Theorica*, which shows that the treatise had a wide circulation and was probably used in universities— in twenty manuscripts, it is accompanied by the *Theorica Gerardi* (Benjamin and Toomer 1971, 58). However, it did not set an example followed by other authors of *Theoricae* or books on "equatoria." Both traditions remained distinct and unbalanced in number, as the books on "equatoria" (that of Campanus excepted) had very limited circulation (Poulle 1981, 738–741).

Peuerbach's treatise thoroughly transformed and enriched the iconographical corpus of the *Theoricae* without changing the terms of the problem. The needs of pedagogy and those of astronomical computation were divergent. The diagrams of the *Theorica Gerardi*, though often encircled by a graduated ecliptic, could not keep up with the level of accuracy required of an "equatorium" (except for the theory of the Sun, the simplest of all); for one thing, they dealt with the three superior planets collectively, without regard for their specificities. The *Theoricae novae* even regressed on this issue. No diagram of the 1473 edition has a graduated circle. Moreover, the diagrams showing the arrangements of the orbs are nothing like the diagrams of the books on "equatoria," which look like the drawings of an astronomical clock (Benjamin and Toomer 1971, plates 1–3).

In a sense, Peuerbach's treatise clearly distanced itself from the tradition of the books on "equatoria."[56] There were several printed books of this last category in the first half of the sixteenth century (Finé 1526; Sarzosus 1526; Schöner 1521,

[55] On "equatio," the difference between a "true" and a "mean" motion, see above, Sect. 2.6. The purpose of an "equatorium" is clearly explained by Campanus in the prologue of his treatise (Benjamin and Toomer 1971, 138–143).

[56] Peuerbach wrote at least one short treatise on an "equatorium:" "Quoniam experimentum sermonum verorum." A copy of it in Regiomontanus' hand is in the same manuscript (Wien, ÖNB 5203) that contains Regiomontanus' 1454 copy of the *Theoricae novae*.

1522, 1524; Apian 1540). None of them was connected with the *Theoricae novae*. Only later did James Bassantin (d. 1568), a Scottish mathematician then settled in Lyons, take up Campanus' idea and push it farther. He published the *Astronomique discours* in French and dedicated it to queen Caterina de' Medici (1519–1589). It was composed of two mathematical treatises (on the table of sines and on rectilinear and spherical triangles), a treatise of the *Sphere*, and a *Theory of planets* (*La Theoricque des cieux*), followed by a treatise on an "equatorium" entitled *Pratique des mouvemens celestes*, with fourteen volvelles made with thirty-six moving parts (Bassantin 1557).

Peuerbach himself had probably felt that at least some of his readers might prefer a different kind of illustration. In the last manuscript of the *Theoricae novae* copied under his direction, shortly before his death, which he bequeathed to Bessarion in April 1461, the four initial figures of the first section are volvelles with graduated rotating disks, devised like "equatoria."[57] The Vitéz manuscript also has an original illustration: the diagrams in the text are less numerous than in the earlier manuscripts (and in the printed editions) and more synthetic, like in the *Theorica Gerardi* manuscripts; there are also new diagrams and the text is followed by an appendix of thirteen additional figures on the latitude and declination of planets, on parallaxes, on the eclipses, and on the methods of domification (Peuerbach 1455–1468, 18r–21r; Malpangotto 2012, 362–368). However, the early history of this manuscript is not well known, and the originality of its illustration could be attributed to Regiomontanus, to Bylica, or to Vitéz himself, as well as to Peuerbach.

At any rate, the printed tradition of the *Theoricae novae* was founded on the Regiomontanus edition, whose diagrams differed from those in the *Theorica Gerardi* as from those in the books on "equatoria;" the commentaries were meant to clarify the difficulties in the text and refine the geometrical analysis of the movements, not to construct instruments. However, Reinhold's *scholia* contain two diagrams called "Instruments" that correspond to folded plates where the moving parts of volvelles are drawn. The volvelles can be mounted in the book, on the diagram that represents the underlying fixed part of the instrument (Fig. 2.5), but this underlying diagram is also printed on a folded plate and the reader can construct a paper instrument separate from the book. As a large majority of the remaining copies has neither the mounted volvelles nor the folded plates, it is probable that the readers preferred the second method.[58] The first instrument enables one "to perceive clearly this variety of the Lunar motion" ("Instrumentum ex quo haec motus lunae varietas perspici potest") (Peuerbach 1542, G2v); the second one concerns the "proportion of the mouvement

[57] (Peuerbach 1461): "Theorica Solis" (1v); "Theorica Lunae" (4r); "Theorica trium superiorum et Veneris" (9v); "Theorica Mercurii." See also (Malpangotto 2012, Figs. 10–11).

[58] The folded plates contained the diagrams for both volvelles and three large figures that were to be inserted at the proper place in the book: the proportional minutes for the Moon ("Theorica minutorum proportionalium et diversitatis diametri Lunae"), the oval shape of the movement of the Moon ("Typus figurae ovalis seu potius lenticularis in Luna"), and the movement of Mercury ("Theorica omnem fere varietatem motus centri epicycli et apogii eccentrici Mercurii ostendens").

of the Sun and of the superior planets" ("Instrumentum proportionis motuum solis et superiorum planetarum") (Peuerbach 1542, K8v).

Let's take as an example the first instrument. It is described in the text, and the mounting instructions are on the plate with the moving parts (Fig. 2.6). In the

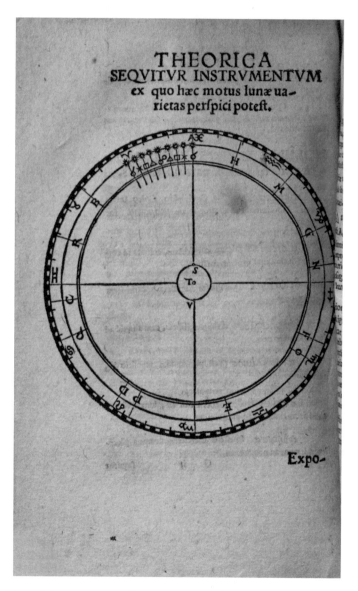

Fig. 2.5 The underlying diagram of the instrument for observing the relationship between the movement of the Sun and the movements of the Lunar orbs. Augsburg, Staats- und Stadtbibliothek. Math 745#. urn:nbn:de:bvb:12-bsb11267684-2. From (Peuerbach 1542, G2v)

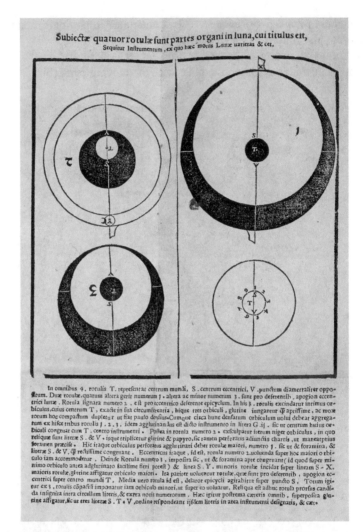

Fig. 2.6 The moving discs of the same instrument and the mounting instructions. Augsburg, Staats- und Stadtbibliothek. Math 745#. urn:nbn:de:bvb:12-bsb11267684-2. From (Peuerbach 1542, folded plate)

underlying diagram (Fig. 2.5) and on the four discs (*rotulae*) on the plate, T is the center of the world, S the center of the eccentric deferent, and V the "opposite point." Discs 1 and 3 represent the two "deformed" orbs, deferents of the apogee" that turn westward about the center of the world; disc 3 is the eccentric deferent between them, which turns eastward about its own center S.

First, the smaller circles at the center of discs 1, 2, and 3 must be carefully removed, glued together, and lined with paper or cardboard to increase the thickness. This thick small circle is glued at the center of the underlying diagram with exact superposition

of the letters, to serve as a pivot around which all the discs will rotate. Then the small black circle inside disc 2 is removed and "tripled" (*triplicetur*) with glued paper, while taking care that the hole inside it remains precisely defined. This last circle is glued to disc 1, with the interior holes and the letters S and V superimposed exactly. Thus disc 2 (the eccentric) will be able to rotate around this "larger small circle" (*major orbiculus*) as around a second pivot. Then disc 3 is adjusted above disc 2 and glued on the "larger small circle," while taking care that line SY on disc 3 is exactly superimposed to line SX on disc one. Thus, each disc will rotate around its proper center.

Lastly, the small white disc with the figures is glued at the center of the instrument, while taking care that the letters STV are superimposed to those on the instrument, in the same order.

The underlying diagram (Fig. 2.5) that supports all the discs has an outward circle, the ecliptic, "divided into 180 small spaces ("spaciola"), each corresponding to two degrees. Next is the "circle where the Sun is carried" ("in quo sol vehitur"). For simplicity's sake, its center is T, as the Sun's eccentricity does not matter in this example where only the mean motions of the Sun and Moon are taken into account. Nine small Suns are drawn on it, to represent nine successive positions of the Sun in Aries during a Lunar month. Under each Sun is the symbol of an aspect: conjunction (under letter A), sextile (60°), square (90°), trine (120°), opposition (180°), second trine, second square, and so on; in brief the series of the aspects between the Sun and the Moon, from one conjunction, or new Moon, to the next.

In the mounted instrument, line TX ends in X, the apogee of the Lunar eccentric, while TY is the line of the mean motion of the Moon, and Y the center of the epicycle of the Moon. If we suppose that the first conjunction of the Sun and the Moon occurs at point A, the beginning of Aries, then X and Y will also be in A. Peuerbach explains, some pages before, that

> in every mean conjunction of the Sun and Moon, the center of the epicycle of the Moon, the line of mean motion of the Sun, and the apogee of the eccentric of the Moon are in one point of the zodiac. (Peuerbach 1987, 14)[59]

As the center of the epicycle moves eastward, in the order of the signs ("in consequentia"), while the apogee of the Lunar eccentric moves westward ("in antecedentia"), on the fourth day Y will be in B, and X in M, and the Sun will be midway between B and M, where is the symbol of the sextile aspect. According to Peurbach,

> The line of mean motion of the Sun is always in the middle, between the center of the epicycle of the moon and the apogee of its eccentric, appearing either with them or in the opposite position when both of them are together. (Peuerbach 1987, 14)[60]

Then the Moon, at its waxing crescent, will be in one of its "longitudines mediae," midway between the apogee and perigee of its eccentric.

[59] (Peuerbach 1542, G1r): "… in omni media solis et lunae conjunctione, centrum epicycli lunae et linea medii motus solis et aux eccentrici lunae sint in uno puncto zodiaci."

[60] (Peuerbach 1542, G1r): "… semper linea medii motus solis sit in medio inter centrum epicycli lunae et augem eccentrici ejus, vel simul cum eis, vel in opposito amborum simul existentium."

Around the seventh day, Y is under C, and X is under N; the Moon, in dichotomy (in square aspect with the Sun) is at the perigee of its eccentric, and so on, until the end of the Lunar cycle. The reader, while rotating the discs according to the indications in the text (Peuerbach 1542, G3r–v), understands that the regularity of the phases masks a real "variety" in the Lunar movement that is composed of two contrary movements, made around two different centers, even in this simplest example that does not take into account the rotation of the Moon in its epicycle.

This instrument, like the second instrument, is nothing more than a pedagogical toy, but it fulfills several functions. It helps the reader to recapitulate and memorize what has been taught before, to acclimate to viewing particular celestial motions and phenomena in relation to other movements, and to acquire an aptitude for "mechanical thinking" (Shank 2007)—a necessity when dealing with as complex a moving object as the heavens.

2.8 Conclusion

The images of the *Theoricae novae planetarum* are probably a privileged example in the history of scientific illustration, for they served a particularly large range of functions. They were mnemonic tools and visual glossaries, and an essential element in Peuerbach's pedagogical approach, which consisted in constructing each "theory" step by step. They had a documentary role, as they offered plausible representations of the celestial spheres; they could be used as proofs of the soundness of a "theory," or simply as diagrams that help one follow a geometrical demonstration. Some of them were small-scale models not designed to reconstruct actual mechanisms, astronomical clocks, or computational instruments, but rather to serve as tools to help the mind better grasp the complex combination of movements in what was called *machina mundi*—not yet but soon to become *systema mundi* (Lerner 2005).

On the one hand, the *Theoricae novae* were the end of a long tradition begun with Ptolemy's *Planetary hypotheses*; they were not to survive the "new astronomy" of the next century. On the other hand, as an illustrated pedagogical and scientific book, they represented a pioneering experiment at the dawn of the age of printing. Their figures did not fit exactly in either of the main categories of scientific images: pictures of natural things (mineral, vegetal, animal, or human), geometrical diagrams, representations of artifacts or plans for machines; but they borrowed something from all. Above all, these figures, and their power to exercise the mind, were well suited to the period in which Peuerbach's treatise was composed, edited, and enriched by commentaries—a period of reform, transition, discussion, and hesitation in astronomical thought. It was a period when more and more astronomers were then involved in imagining, drawing, and comparing hypothetical (though not necessarily unreal) models of planetary movements.

References

Primary Sources

Apian, Petrus. 1540. *Astronomicum Caesareum*. Ingolstadt: Peter Apian.

Bacon, Roger. 1913. *Opera hactenus inedita Rogeri Baconi. IV*, ed. Robert Steele. Oxford: Clarendon Press.

Bacon, Roger. 1909. *Un fragment inédit de l'Opus tertium de Roger Bacon*, ed. Pierre Duhem. Quaracchi: Collegium S. Bonaventura.

Bainbridge, John. 1620. *Procli Sphaera. Ptolemaei De hypothesibus planetarum liber singularis, nunc primum in lucem editus. Cui accessit ejusdem Ptolemaei Canon regnorum*. London: William Jones.

Bassantin, James. 1557. *Astronomique discours*. Lyons: Jean de Tournes.

Euclid. 1956. *The thirteen books of the elements*, Trans. and comment. Thomas L. Heath. New York: Dover.

Finé, Oronce. 1526. *Aequatorium planetarum unico instrumento comprehensum omnium antehac excogitatorum, et intellectu et usu facillimum*. Paris: Nicolas Savetier.

Gaurico, Luca, ed. 1531. *Spherae tractatus Ioannis de Sacro Busto…Ioannis Baptistae Capuani Sipontini expositio in sphaera & theoricis. Ioannis de Monte Regio disputationes contra theoricas Gerardi…Gerardi Cremonensis theoricae planetarum ueteres. Georgii Purbachii theoricae planetarum nouae. Alpetragii Arabi theorica planetarum nuperrime Latinis mandata literis a Calo Calonymos Hebreo Neapolitano, ubi nititur saluare apparentias in motibus planetarum absq[ue] eccentricis & epicyclis*. Venice: Luca Antonio Giunta. https://hdl.handle.net/21.11103/ sphaera.100999.

Gerardus. 14th cent. *Theorica planetarum*, BNF, Ms Lat. 7413(1): 18v–25v.

Gerardus. 14th/15th cent. *Theorica planetarum*, BNF, Ms Lat. 7294: 7v–15r.

Gerardus. 1472a. *Theorica planetarum*. Ferrara: Andrea Belfortis. https://hdl.handle.net/21.11103/ sphaera.101681

Gerardus. 1472b. *Theorica planetarum*. Venice: Florentius de Argentina. https://hdl.handle.net/21. 11103/sphaera.101682

Gerardus. 1478a. *Theorica planetarum*. Venice: Franciscus Renner. https://hdl.handle.net/21.11103/ sphaera.100686

Gerardus. 1478b. *Theorica planetarum*. Venice: Adam von Rottweil. https://hdl.handle.net/21. 11103/sphaera.101683

Gerardus. 1480. *Theorica planetarum*. Bologna: Fuscus. https://hdl.handle.net/21.11103/sphaera. 100264

Gerardus. 1942. *Theorica planetarum Gerardi*, ed. Francis James Carmody. Berkeley: University of California.

Gerardus. 1974. *Theorica planetarum*. Trans. Olaf Pedersen. In *A source book in Medieval Science*, ed. Grant, Edward, 451–464. Cambridge: Harvard University Press.

Nuciarelli, Girolamo de, ed. 1518 (30 June). *Sphera mundi recognita, cum commentariis et authoribus in hoc volumine contentis, videlicet: Cichi Esculani cum textu…Theorica planetarum Joannis Cremonensis plurimum faciens ad disputationem Joannis de Monte Regio, quam in aliis impressis non reperies*. Venice: Luca Antonio Giunta. https://hdl.handle.net/21.11103/sphaera. 100047.

Nuciarelli, Girolamo de, ed. 1518/1519 (19 January 1518 Venetian style = 1519). *Sphera cum commentis in hoc volumine contentis, videlicet. Cichi Esculani cum textu…Disputatio Johannis de Monte Regio: Textus Theorice cum expositione Joannis Baptiste Capuani: Ptolomeus de Speculis*. Venice: B. Locatelli for the heirs of Ottaviano Scoto. https://hdl.handle.net/21.11103/sphaera. 101057.

Peuerbach, Georg von. 1454. *Incipit Theorica nova realem sperarum habitudinem atque motum cum terminis tabularum declarans*. Wien, Österreichische Nationalbibliothek, Cod. 5203, 2r–24r.

Peuerbach, Georg von. 1455–1468. *Incipit Theorica nova realem sperarum habitudinem atque motum cum terminis tabularum declarans.* Cracow, Biblioteka Jagiellońska, BJ 599.

Peuerbach, Georg von. 1461. *Theorica nova tabularum terminos motuumque habitudines explanans.* Rimini, Biblioteca Civica Gambalunga, Sc-Ms 27, 1–30.

Peuerbach, Georg von. ca. 1473. *Theoricae novae planetarum.* Nuremberg: Regiomontanus. https://hdl.handle.net/21.11103/sphaera.101610

Peuerbach, Georg von. 1482. *Theoricae novae planetarum.* [With Johannes de Sacro Bosco, *Sphaera mundi*; Regiomontanus: *Disputationes contra Cremonensia deliramenta*]. Venice: Erhard Ratdolt. https://hdl.handle.net/21.11103/sphaera.100692.

Peuerbach, Georg von. 1485. *Theoricae novae planetarum.* [With Johannes de Sacro Bosco, *Sphaera mundi*; Regiomontanus: *Disputationes contra Cremonensia deliramenta*]. Venice: Erhard Ratdolt. https://hdl.handle.net/21.11103/sphaera.101123.

Peuerbach, Georg von. 1488. *Theoricae novae planetarum.* [With Johannes de Sacro Bosco, *Sphaera mundi*; Regiomontanus: *Disputationes contra Cremonensia deliramenta*]. Venice: Johannes Lucilius Santritter. https://hdl.handle.net/21.11103/sphaera.100822.

Peuerbach, Georg von. 1495. *Theoricae novae planetarum*, comm. Franciscus Capuanus de Manfredonia. Venice: Simon Bevilaqua. https://hdl.handle.net/21.11103/sphaera.101636

Peuerbach, Georg von. 1525. *Theoricae novae planetarum*, ed. Oronce Finé. Paris: Regnault Chaudière. https://hdl.handle.net/21.11103/sphaera.101614

Peuerbach, Georg von. 1528. *Theoricae novae planetarum*, ed. Petrus Apianus. Ingoldstadt: Petrus Apianus. https://hdl.handle.net/21.11103/sphaera.101616

Peuerbach, Georg von. 1534. *Theoricae novae planetarum*, ed. Oronce Finé. Paris: Regnault Chaudière. https://hdl.handle.net/21.11103/sphaera.101615

Peuerbach, Georg von. 1535. *Theoricae novae planetarum*, ed. Jacob Milich. Wittenberg: Joseph Klug. https://hdl.handle.net/21.11103/sphaera.101618

Peuerbach, Georg von. 1542. *Theoricae novae planetarum*, comment. Erasmus Reinhold. Wittenberg: Johannes Lufft. https://hdl.handle.net/21.11103/sphaera.101637

Peuerbach, Georg von. 1553a. *Theoricae novae planetarum*, comment. Erasmus Reinhold. Paris: Charles Périer. https://hdl.handle.net/21.11103/sphaera.101638

Peuerbach, Georg von. 1553b. *Theoricae novae planetarum*, comment. Erasmus Reinhold (augmented). Wittenberg: Johannes Lufft. https://hdl.handle.net/21.11103/sphaera.101646

Peuerbach, Georg von. 1556. *Theoricae novae planetarum*, comment. Erasmus Reinhold (augmented). Paris: Charles Périer. https://hdl.handle.net/21.11103/sphaera.101649

Peuerbach, Georg von. 1987. *Theoricae novae planetarum*, trans. and comment. E.J. Aiton. *Osiris* 2nd ser. 3: 4–43.

Prierias, Sylvester, or Silvestro Mazzolini de Prierio. 1514. *In Spheram ac Theoricas preclarissima commentaria.* Milan: Gottardo da Ponte.

Regiomontanus, Johannes. 1972. *Joannis Regiomontani Opera collectanea* [a collection of facsimiles of early editions], ed. Felix Schmeidler. Osnabrück: Otto Zeller Verlag.

Reisch, Gregor. 1503. *Margarita philosophica.* Freiburg: Johann Schott.

Sarzosus, Franciscus. 1526. *In aequatorem planetarum libri duo.* Paris: Colines.

Schöner, Johann. 1521. *Aequatorium astronomicum.* Bamberg: Johann Schöner.

Schöner, Johann. 1522. *Equatorii astronomici omnium ferme uranicarum theorematum explanatorii canones.* Nuremberg: Friedrich Peypus.

Schöner, Johann. 1524. *Tabulae radicum extractarum ad fines annorum conscriptorum cum demonstrationibus exemplaribus pro motibus planetarum ex equatorio aucupandis.* Kirchehrenbach: Johann Schöner.

Secondary Literature

Aiton, E.J. 1981. Celestial spheres and circles. *History of Science* 19: 75–114.

Baldi, Bernardino. 1707. *Cronaca de Matematici.* Urbino: Angelo Antonio Monticelli.

Benjamin, Francis S., and G.J. Toomer. 1971. *Campanus of Novara and medieval planetary theory.* Madison: University of Wisconsin Press.

Bianchi, Massimo, and Marta Fattori. 1986. *Phantasia imaginatio: V Colloquio internazionale Roma 9–11 gennaio 1986.* Rome: Edizioni dell'Ateneo.

Birkenmajer, Ludwik Antoni. 1893. Marcin Bylica z Olkusza oraz narzędzia astronomiczne które zapisał Uniwersytetowi Jagiellońskiemu w roku 1493. *Rozprawy Akademii Umiejetnosci w Krakowie, Wydzial Matematyczno-Przyrodniczy, Ser.* 2 5: 1–164.

Brosseder, Claudia. 2004. *Im Bann der Sterne. Caspar Peucer, Philipp Melanchthon und andere Wittenbergen Astrologen.* Berlin: Akademie Verlag.

Brosseder, Claudia. 2005. The writing in the Wittenberg sky: Astrology in sixteenth-century Germany. *Journal of the History of Ideas* 66 (4): 557–576.

Byrne, James Steven. 2011. The mean distances of the sun and commentaries on the *Theorica planetarum. Journal for the History of Astronomy* 42: 205–221.

Cappelli, Adriano. 1983. *Cronologia, cronografia e calendario perpetuo.* Milan: Hoepli.

Caroti, Stefano. 1986. Melanchthon's astrology. In *'Astrologi hallucinati.' Stars and the end of the world in Luther's time*, ed. Paola Zambelli, 109–121. Berlin: Walter de Gruyter.

Chabás, José. 2012. Characteristics and typologies of medieval astronomical tables. *Journal for the History of Astronomy* 43: 269–286.

Chabás, José, and Bernard R. Goldstein. 2003. *The Alfonsine tables of Toledo.* Dordrecht: Springer.

Chabás, José and Bernard R. Goldstein. 2012. *A survey of European astronomical tables in the late Middle Ages.* Leiden: Brill.

Duhem, Pierre. 1969. *To save the phenomena. An essay on the idea of physical theory from Plato to Galileo*, Trans. Edmund Dolan and Chaminah Maschler. Chicago: University of Chicago Press.

Evans, James. 2003. The origins of Ptolemy's cosmos. In *Cosmology through time. Ancient and modern cosmologies in the Mediterranean area*, ed. Sergio Colafrancesco and Giuliana Giobbi, 123–132. Milan: Mimesis.

Evans, James, and Christian Carlos Carman. 2014. Mechanical astronomy: A route to the ancient discovery of epicycles and eccentrics. In *From Alexandria through Baghdad: Surveys and studies in the ancient Greek and medieval Islamic mathematical sciences in honor of J.L. Berggren*, ed. Nathan Sidoli and Glen Van Brummelen, 145–174. New York: Springer.

Federici-Vescovini, Graziella. 1996. Michel Scot et la *Theorica Planetarum Gerardi. Early Science and Medicine* 1 (2): 272–282.

Federici-Vescovini, Graziella. 1998. Autour de la *Theorica planetarum Gerardi.* In *Du copiste au collectionneur. Mélanges d'histoire des textes et des bibliothèques en l'honneur d'André Vernet*, ed. Anne-Marie Chagny-Sève and Geneviève Hasenohr, 169–174. Turhout: Brepols.

Field, Richard. 1965. *Fifteenth century woodcuts and metalcuts.* Washington: National Gallery of Art.

Goldstein, Bernard R. 1967. The Arabic version of Ptolemy's *Planetary hypotheses. Transactions of the American Philosophical Society* 57 (4): 3–55.

Grössing, Helmuth. 1983. *Humanistische Naturwissenschaft. Zur Geschichte der Wiener mathematischen Schulen des 15. und 16. Jahrhunderts.* Baden-Baden: Koerner.

Hamm, Elizabeth. 2016. Modeling the heavens: *Sphairopoiia* and Ptolemy's *Planetary Hypotheses. Perspectives on Science* 24: 416–424.

Hartner, Willy. 1968. Medieval views on cosmic dimensions and Ptolemy's Kitāb al-Manshūrāt. In *Oriens-Occidens. Ausgewählte Schriften zur Wissenschafts- und Kulturgeschichte. Festschrift zum 60. Geburtstag*, ed. W. Hartner, 319–348. Hildesheim: Olms.

Hugonnard-Roche, Henri. 1996. The influence of Arabic astronomy in the medieval West. In *Encyclopedia of the history of Arabic science*, vol. 1, ed. Roshdi Rashed and Régis. Morelon, 284–305. London and New York: Routledge.

Kren, Claudia. 1968. Homocentric astronomy in the Latin West. The *De reprobatione ecentricorum et epiciclorum* of Henry of Hesse. *Isis* 59: 269–281.

Kusukawa, Sachiko. 1995. *The transformation of natural philosophy: The case of Philip Melancthon.* Cambridge: Cambridge University Press.

Lagerlund, Henrik. 2007. *Representation and objects of thought in medieval philosophy*. Aldershot: Ashgate.

Langermann, Y. Tzvi. 1990. *Ibn al-Haytham's On the configuration of the world*. New York: Garland Publishing.

Lerner, Michel Pierre. 1996. *Le Monde des sphères I. Genèse et triomphe d'une représentation cosmique*. Paris: Les Belles Lettres.

Lerner, Michel Pierre. 2005. The origin and meaning of "world system." *Journal for the History of Astronomy* 36: 407–441.

Malpangotto, Michela. 2012. Les premiers manuscrits des *Theoricae novae planetarum* de Georg Peurbach: Présentation, description, évolution d'un ouvrage. *Revue d'histoire des sciences* 65 (2): 339–380.

Mancha, José Luis. 1990. La version alfonsi del 'Fi hay'aï al-ʿālam' (*De configuratione mundi*) de Ibn al-Haytam (Oxford, Canon misc. 45, ff. 1r–56r). In *Ochava espera y astrofísica: Textos y estudios sobre las fuentes Árabes de la astronomía de Alfonso X*, ed. Mercè Comes, Honorino Mielgo, and Julio Samsó, 133–207. Barcelona: Instituto Millás Vallicrosa.

Murschel, Andrea. 1995. The structure and function of Ptolemy's physical hypotheses of planetary motions. *Journal for the History of Astronomy* 26: 33–61.

Müller, Kathrin. 2008. *Visuelle Weltaneignung: astronomische und kosmologische Diagramme in Handschriften des Mittelalters*. Göttingen: Vandenhoeck & Ruprecht.

Nutton, Vivian. 2001. Representation and memory in Renaissance anatomical illustration. In *Immagini per conoscere dal Rinascimento alla rivoluzione scientifica*, ed. Fabrizio Meroi and Claudio Pogliano, 61–80. Florence: Olschki.

Panaccio, Claude. 2010. Mental representation. In *The Cambridge history of medieval philosophy*, ed. Robert Pasnau, 357–368. Cambridge: Cambridge University Press.

Pantin, Isabelle. 1995. *La poésie du ciel en France dans la seconde moitié du seizième siècle*. Geneva: Droz.

Pantin, Isabelle. 2012. The first phases of the *Theoricæ planetarum* printed tradition (1474–1535): The evolution of a genre observed through its images. *Journal for the History of Astronomy* 43: 3–26.

Pantin, Isabelle. 2013. Analogy and difference: A comparative study of medical and astronomical images in books, 1470–1550. *Early Science and Medicine* 18: 9–44.

Pedersen, Fritz Saaby. 2002. *The Toledan tables: A review of the manuscripts and the textual versions with an edition*. Copenhagen: Kongelige Danske Videnskabernes Selskab.

Pedersen, Olaf. 1962. The *Theorica planetarum* literature of the Middle Ages. *Classica et mediaevalia* 23: 225–232.

Pedersen, Olaf. 1973. A fifteenth century glossary of astronomical terms. *Classica et mediaevalia Dissertationes* IX: 584–594.

Pedersen, Olaf. 1975. The *corpus astronomicum* and the traditions of medieval Latin astronomy: a tentative interpretation. In *Colloquia Copernicana III, astronomy of Copernicus and its background, Wroclaw*, 57–96. Warszawa, Krakow, Gdansk: Ossolineum (*Studia Copernicana*, XIII).

Pedersen, Olaf. 1978. The decline and fall of the *Theorica planetarum* literature: Renaissance astronomy and the art of printing. *Studia Copernicana* 16: 157–185.

Pedersen, Olaf. 1981. The origins of the *Theorica planetarum*. *Journal for the History of Astronomy* 12: 113–123.

Poulle, Emmanuel. 1980. *Les instruments de la théorie des planètes selon Ptolémée: équatoires et horlogerie planétaire du XIIIe au XVIe siècle*. Geneva: Droz.

Poulle, Emmanuel. 1981. *Les sources astronomiques (textes, tables, instruments)*. Turnhout: Brepols.

Poulle, Emmanuel. 1984. *Les tables alphonsines avec les canons de Jean de Saxe*. Paris: CNRS.

Poulle, Emmanuel. 1987. Le vocabulaire de l'astronomie planétaire du XIIe au XIVe siècle. In *La diffusione delle scienze islamiche nel medio evo europeo*, 193–212. Rome: Accademia nazionale dei Lincei.

Poulle, Emmanuel. 1988. The Alfonsine tables and Alfonso X of Castile. *Journal for the History of Astronomy* 29: 97–113.

Poulle, Emmanuel, and Denis Savoie. 1988. La survie de l'astronomie alphonsine. *Journal for the History of Astronomy* 29: 201–207.

Samsó, Julio. 1990. El original arabe y la version alfonsi del *Kitab Fi hay'aï al-ʿālam* de Ibn al-Haytam. In *Ochava espera y astrofísica: Textos y estudios sobre las fuentes Árabes de la astronomía de Alfonso X*, ed. Mercè Comes, Honorino Mielgo, and Julio Samsó, 115–131. Barcelona: Instituto Millás Vallicrosa.

Sander, Max. 1942. *Le Livre à figures italien depuis 1467 jusqu'à 1530*, 6 vol. Milan: Hoepli.

Schofield, Malcolm. 1992. Aristotle on imagination. In *Essays on Aristotle's De Anima*, ed. Martha C. Nussbaum and Amélie Oksenberg Rorty, 249–278. Oxford: Clarendon Press.

Shank, Michael H. 1998. Regiomontanus and homocentric astronomy. *Journal for the History of Astronomy* 29: 157–166.

Shank, Michael H. 2002. Regiomontanus on Ptolemy, physical orbs, and astronomical fictionalism: Goldsteinian themes in *The Defense of Theon Against George of Trebizond*. *Perspectives on Science* 10: 179–207.

Shank, Michael H. 2007. Mechanical thinking in European astronomy (thirteenth to fifteenth centuries). In *Mechanics and cosmology in the medieval and early modern period*, ed. Massimo Bucciantini, Michele Camerota, and Sophie Roux, 3–27. Florence: Olschki.

Shank, Michael H. 2012. The geometrical diagrams in Regiomontanus' edition of his own *Disputationes* (ca 1475): Background, production, and diffusion. *Journal for the History of Astronomy* 43: 27–55.

Spruit, Leen. 1994–1995. *Species intelligibilis: From perception to knowledge*. Leiden: Brill.

Stromer, Wolfgang von. 1980. *Hæc opera fient in oppido Nuremberga Germanie ductu Joannis de Monteregio*. Regiomontanus und Nürnberg 1471–1475. In *Regiomontanus Studien*, ed. Günter Hamann, 267–290. Vienna: Akademie der Wissenschaften.

Swerdlow, Noel Mark. 2004. Alphonsine tables of Toledo and later Alphonsine tables. *Journal for the History of Astronomy* 35: 479–484.

Sylla, Edith Dudley. 2017. The status of astronomy as a science in fifteenth-century Cracow: Ibn al-Haytham, Peurbach, and Copernicus. In *Before Copernicus. The cultures and contexts of scientific learning in the Fifteenth century*, ed. E. Jamil Ragep and Rivka Feldhay, 45–78. Montreal: McGill-Queen's University Press.

Tavuzzi, Michael. 1997. *The life and work of Silvestro Mazzolini da Prierio 1456–1527*. Durham NC: Duke University Press.

Woodward, David. 1987. Medieval *mappaemundi*. In *The history of cartography*, vol. 1, ed. J.B. Harley and David Woodward, 286–370. Chicago: Chicago University Press.

Zinner, Ernst. 1990. *Regiomontanus. His life and work*, transl. Ezra Brown. Amsterdam: North-Holland.

Isabelle Pantin is Emerita Professor at the Ecole Normale Supérieure (PSL University Paris), and member of the Institut d'Histoire Moderne et Contemporaine (IHMC, UMR 8066). Her research interests concern notably the circulation of knowledge in printed books in the early modern period, and scientific illustration.

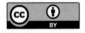

Chapter 3
Microscopy and Natural Philosophy: Robert Hooke, His *Micrographia*, and the Early Royal Society

Salvatore Ricciardo

Abstract This contribution focuses on the graphic project Robert Hooke developed for the Royal Society in the mid-1660s, which resulted in his celebrated *Micrographia*, the illustrated volume of his microscopical investigations published at London in 1665. Hooke's *Micrographia* stands out as the most notable example of the early Royal Society's reformist project, notably for the role played by visual demonstration in explaining and divulging the new world unveiled by the microscope. The book was seen as a model of the Society's experimentalism, and microscopical views of organic and inorganic bodies were presented as evidence of mechanisms operating at multiple levels in nature, though ultimately based on God's power and wisdom. Hooke's descriptions of his observations and the plates included in his *Micrographia* are relevant for understanding not only the cultural background in which the book was born and developed, but also the seventeenth-century debates over the theory of matter and the limits of purely mechanical explanations.

Keywords Microscopy · Seventeenth-century natural philosophy · Robert Hooke · Royal Society · Restoration England

3.1 Hooke and the Royal Society

Son of the Reverend John Hooke, minister of the parish, Robert Hooke (1635–1703) was born in Freshwater on the Isle of Wight on July 18, 1635. After his father's death in 1648, he received a modest inheritance of fifty pounds which allowed him to move to London and begin a period of apprenticeship with the celebrated painter Peter Lely (1618–1680). 1653 marked a turning point in Hooke's career. He moved to Oxford to study mathematics at Christ Church, and joined the group of experimental philosophers of Wadham College, the so-called "Oxford Experimental Club" which comprised, among others, John Wilkins (1614–1672), Seth Ward (1617–1689), Christopher Wren (1632–1723), Thomas Willis (1621–1675), and Robert

S. Ricciardo (✉)
Università degli Studi di Bergamo, Bergamo, Italy
e-mail: salvatore.ricciardo@unibg.it

Boyle (1627–1692) (Frank 1980, 51–57). Four years later, Hooke became Boyle's laboratory assistant on Willis's recommendation. Given his talent for mechanics, after the failure of the London instrument maker Ralph Greatorex (ca. 1625–1675) to carry out Boyle's design of the new air pump, Hooke built a working pneumatic engine (Waller 1705, iii; Boyle 1999–2000, 158–159). At this stage, Hooke became interested in the nature and mechanical properties of air. In 1661, he published a short essay devoted to the problem of capillarity, *An Attempt for the Explication of the Phaenomena Observable in an Experiment Published by the Honourable Robert Boyle* (Hooke 1661), later included in *Micrographia*. In 1662, his essay on the Cartesian and atomist interpretation of the phenomena of rarefaction and condensation was published anonymously as an appendix to Boyle's *Defence of the Doctrine Touching the Spring and Weight of the Air...Against the Objections of Franciscus Linus* (Boyle 1999–2000, vol. 3, 84–86; Clericuzio 1998; Ricciardo 2016, 243–245).

Hooke was of modest means, but his scientific talent soon earned him the respect and friendship of the chief members of the Oxford Experimental Club, especially Boyle's. According to John Aubrey, Hooke helped Boyle not only in building the first working air pump, but also in studying geometry and natural philosophy, reading to him Euclid's (ca. 3rd cent. BCE) *Elements*, and René Descartes's (1596–1650) philosophy (Aubrey 1898, 411; Davis 1994). Much has been written on Hooke's social status and his position in the Royal Society, especially with reference to his humble origins, which would have influenced his credibility as a natural philosopher (Shapin 1989). Nonetheless, as Mordechai Feingold has convincingly argued, Hooke's social status did not hinder him from being respected as a talented inventor and natural philosopher (Feingold 2006)—and anyway, in the early 1660s the Royal Society's operative needs intersected with Hooke's aspirations as a natural philosopher. In November 1662, Hooke was appointed the Society's first Curator of Experiments, with an expected remuneration of eighty pounds per year, and in 1663 was elected fellow. The following year, thanks to the support of John Wilkins, Hooke replaced Isaac Barrow (1630–1677) as professor of geometry at Gresham College (Cooper 2003, 9–29). It was precisely during this period that Hooke made the microscopical observations and the drawings included in *Micrographia*.

The Royal Society's inaugural meeting dates back to November 1660, the year of the restoration of the monarchy (known historically as the Restoration). The founding fellows comprised virtuosi, physicians, natural philosophers, and mathematicians who had been active in Oxford during the previous decade (Birch 1756–1757, 2–3; Feingold 2005). As Michel Hunter has pointed out (Hunter 1989b, 35–38) the Society's early scientific activity was closely linked to its aspirations to become a national institute of research. In the early 1660s, founding fellows like Sir Robert Moray exploited their courtly contacts to obtain a grant from the king and donations from the gentry and nobility. Institutionalization was regarded by the active nucleus of the Society as the most productive way of pursuing the reformation of natural knowledge they aspired to. Rules for elections, processes of decision, and subscription were laid down and ratified in the two royal charters granted in 1662 and 1663. One of the most significant signs of the Society's public role was the permission to license books. Between 1663 and 1664, the Council selected its official printers, John

Martyns (died 1680) and John Allestree of London, who published Hooke's *Micrographia*. The Society's council was aware of the importance of successful publication to reach a wider audience, to increase membership, and to raise funds. In the first half of the 1660s, when the project for a book on microscopical observations was planned and placed in Hooke's hands, the Society was fueled by a greater enthusiasm for the new science than it would ever have again (Hunter 1994, 35).

As far as the reform of natural knowledge was concerned, the Society promoted a Baconian program of systematic experimental investigation. Ambitious plans were made to scrutinize all previous knowledge in several fields, ranging from mechanics to mathematics, from life sciences to medicine, chemistry, and technology. Although its aspirations soon collided with its deficiencies as a corporate body (like shortages of funds and discontinuous levels of participation) this situation did not reduce the fellow's optimism, as attested by Henry Oldenburg's (1618–1677) letters as the secretary of the Royal Society (Hunter 1989b, 43–44; Boas Hall 1991). For example, on January 23, 1663, Oldenburg wrote to one of his foreign correspondents, Peter van Dam, that the Society's business was "in the first place, to scrutinize the whole of Nature and to investigate its activity and powers by means of observations and experiments; and then in course of time to hammer out a more solid philosophy and more ample amenities of civilization" (Oldenburg 1965–1986, 13–14). In addition, in March 1665 Oldenburg launched *Philosophical Transactions*, the world's first scientific journal, acting both as publisher and editor (Boas Hall 2002, 84–87). In the second edition of the journal, Oldenburg included a section devoted to book review. *Micrographia* was the first book reviewed. Oldenburg published an enthusiastic review that included a detailed summary of the objects examined by Hooke under the microscope, of his theories concerning light and capillarity, and of the instruments described in the book. The opening paragraph of the review gives us a sense of the close relationship between Hooke's graphic project and the Society's aims and ideals:

> The Ingenious and knowing Author of this *Treatise*, Mr. *Robert Hook*, considering with himself, of what importance a faithful *History of Nature* is to the establishing of a solid System of *Natural Philosophy*, and what advantage *Experimental and Mechanical* knowledge hath over the Philosophy of *discourse* and *disputation*, and making it, upon that account, his constant business to bring into that vast Treasury what portion he can, hath lately published a Specimen of his abilities in this kind of study, which certainly is very welcome to the Learned and Inquisitive world, both for the *New discoveries* in *Nature*, and the *New Inventions* of *Art*. (Oldenburg 1665, 27)

3.2 The *Micrographia* Project

In England, projects for books on microscopy went back to the mid-1650s, when Samuel Hartlib (ca. 1600–1662) recorded in his diary that the Oxford mathematician and astronomer Christopher Wren not only "hath brought a great perfection into Microscopes to make them multiply Exceedingly," but also planned "a Book…with Pictures of observations microscopical" (Greengrass et al. 2013, HP 29/5/46A). In

the late 1650s, Wren made a series of drawings of insects which were presented as a gift to Charles II (1630–1685) in early 1661. The king was so enthusiastic that he commanded the Royal Society to produce more drawings. The Society forwarded Wren the king's request in May 1661, but being engaged in other tasks—Wren was appointed Savilian Professor of Astronomy at Oxford the same month—he gave up the task (Wren 1750, 210). On August 13, 1661, the Royal Society decided to assign it to Hooke, as Hooke himself reported in the preface to *Micrographia*: "at last, being assured both by Dr. Wilkins, and Dr. Wren himself, that he had given over his intentions of prosecuting it, and not finding that there was any else design'd the pursuing of it, I set upon this undertaking, and was not a little incourag'd to proceed in it, by the Honour of the Royal Sociey was pleas'd to favour me with it, in approving of those draughts (which from time to time as I had an opportunity of describing) I presented to them" (Hooke 1665, sig. g1 *r*). Nonetheless, there are no references to Hooke's drawings in the minutes of the Society's meetings until March 1663, when the council decided that Hooke should complete his microscopical observations in order to publish them (Birch, vol. 1, 213; Neri 2011, 109–110; Harwood 1989, 124– 125). At this point, Hooke held the position of Curator of Experiments, an office of vital importance for the Society's mission for reforming knowledge primarily founded on experiments. The office of Curator was the first and for some time the only paid position in the Society, but due to the Society's financial problems—the royal grant did not include financial support—Hooke had a stable income only thanks to John Cutler's (1608–1693) patronage (Feingold 2006, 211–212; Purrington 2009, 87–89).

By April 1, 1663, Hooke had still not shown any images, so the Society pressed him to fulfill his duty: "Mr. Hooke was charged to bring it at every meeting one microscopical observation at least" (Birch 1756–1757, 215). Hooke showed his first drawing during the next meeting on April 6, when he presented to the fellows a microscopical image of a specimen of common moss, later published in *Micrographia* as plate thirteen: "Mr. Hooke shewed the company a scheme of the appearance of common moss in a microscope. He was desired to continue, and against next meeting to have ready, the microscopical appearance of the little fishes in vinegar" (Birch 1756–1757, 216). As it is apparent from this request, the Society's fellows suggested topics for investigation that were relevant to issues debated among natural philosophers, such as the generation of insects and the possibility of spontaneous generation in nature. As curator, Hooke was also expected to observe and draw objects at the Society's request. For example, in June he was ordered to observe sage leaves through the microscope to check the presence of cavities for little spiders to lodge in (Birch 1756–1757, 250, 255, 262, 270; Neri 2011, 110). Sometimes the fellows also provided Hooke with samples, and sometimes they exercised collective control on the accuracy of Hooke's drawings, as attested by the discussion of Hooke's illustration of a spider with six eyes that was judged "not perfectly drawn" during a meeting in April (Birch 1756–1757, vol. 1, 231; Harwood 1989, 128–129).

On July 6, 1663, the Society requested further images and observations: "Mr. Hooke was charged to shew his microscopical observations in a handsome book to be provided by him for that purpose" (Birch 1756–1757, vol. 1, 272). Two days later,

Hooke presented his microscopical observations of the edge of a razor, a piece of ribbon, and "of the millepedes," all included in *Micrographia* (Birch 1756–1757, 273). During the Society's meetings between April 1663 and March 1664, Hooke presented about forty microscopical observations on an almost weekly basis. Over this period, a book on microscopy evolved into a major publishing project on behalf of the Royal Society. It is worth noting that the council monitored not only the progress of the *Micrographia* project but also its textual content, in particular the lengthy preface Hooke started in early 1664. The Council repeatedly insisted on revisions in its wording, a circumstance that testifies, as Michael A. Dennis has pointed out, how "Hooke's 'draughts' and descriptions were the Society's as well as his own; his conjectures, although an important part of the book, were strictly his" (Dennis 1989, 311). In fact, the imprimatur was given on November 23, 1664, but under the condition that he would have given notice "in the dedication of that work to the society, that though they have licensed it, yet they own no theory, nor will be thought to do so: and that the several hypotheses and theories laid down by him therein, are not delivered as certainties, but as conjectures: and that he intends not at all to obtrude or expose them to the world as the opinion of the society" (Birch 1756–1757, vol. 1, 490–491).

Hooke obviously obeyed, as the preface attests, highlighting the provisional character of the theoretical assertions interspersed in the texts accompanying the images: "I have produced nothing here, with intent to bind his [the reader's] understanding to an implicit consent; I am so far from that, that I desire him, not absolutely to rely upon these Observations of my eyes, if he finds them contradicted the future Ocular Experiments of sober and impartial Discoverers" (Hooke 1665, sig. b *r*). Echoing Boyle's epistemological views contained in the "Pröemial Essay," which opens the collection of tracts entitled *Certain Physiological Essays* that Boyle published at Oxford in 1661 (Boyle 1999–2000, vol. 2, 20), Hooke presented himself as a humble contributor to the intellectual and philosophical reform advocated by Francis Bacon (1561–1626). As far as natural knowledge is concerned, the reform of natural history had to provide a sound basis for hypotheses about the causes of natural phenomena. "As for my part," Hooke declared,

> I have obtained my end…if I have contributed the meanest foundations whereon others may raise nobler Superstructures, I am abundantly satisfied…all my ambition is, that I may serve to the great Philosophers of this Age, as the makers of the grinders of my Glassed did to me; that I may prepare and furnish them some Materials, which they may afterwards order and manage with better skill, and to far greater advantage. (Hooke 1665, sig. b *r-v*)

This expression of moderate skepticism was linked to a shared distaste for what was labeled as "speculative philosophy," as contrasted with the "experimental philosophy" revived by Bacon and cultivated in London, Oxford, and Cambridge reformist circles active during the 1640s and 1650s (Dear 1985; Anstey 2005). However, the Society as a corporate body did not take positions on crucial philosophical issues— like the existence of void in nature—and distanced itself from any "sect" of natural philosophers. Nonetheless, its members had personal beliefs and preferences. The theoretical parts of *Micrographia* so attentively examined by the council reveal that

Hooke inclined to Cartesian explanations of natural phenomena, though he reinterpreted them in light of the experimental results he obtained in several fields, from optics to astronomy, geology, and pneumatics (Hooke 1661, 28–29; Frank 1980, 135).

3.3 Microscopy and Apologetics

Images played a crucial role in the investigations pursued by the members of the early Royal Society. Robert Hooke's *Micrographia* is widely regarded as a milestone in the history of scientific illustration, but to understand its content and scope it is important to explore its connection with the intellectual context of reformist projects that characterized the early years of the Society. For its descriptions and spectacular drawings of insects observed through the microscope, Robert Hooke's *Micrographia* undoubtedly represents a milestone in the history of scientific illustration. Published in London in 1665 by the Printers to the Royal Society, John Martyn and James Allestry, *Micrographia* is first and foremost the product of Hooke's labor, but, as recent studies have convincingly demonstrated, the book was also shaped by the Society's institutional and political needs. In this respect, the graphic project of *Micrographia* had a twofold aim. Firstly, the book and its plates were intended to provide a tangible and spectacular testimony of the achievements of the new experimental and mechanical philosophy embraced by most of the prominent fellows of the Society. Microscopical images, especially those of non-living things, were presented as evidence that nature operates like a mechanical device, though by much more complex and perfect processes than those occurring in the realm of human artifacts. Secondly, microscopy and Hooke's descriptions of the observed animate and inanimate beings supplied arguments against the Society's early critics who accused the institution of being useless or, even worse, an enemy of the restored church and monarchy (Wood 1980; Hunter 1989a; Dennis 1989, 311–316). Given this situation, as John Harwood has perceptively noted, during its early years the Royal Society simultaneously pursued scientific investigations and rhetorical strategies. It aimed at collecting and producing as much empirical evidence as possible on a range of natural phenomena in order to test previous assertions on the natural world and compile trustworthy natural histories as the basis for new hypotheses. On the other hand, the Society tried to establish and protect its public image. *Micrographia* was crucial to both aspects of the early Royal Society's activities (Harwood 1989, 131).

Published nearly two years after Hooke's masterpiece, Thomas Sprat's (1635–1713) *History of the Royal Society* (1666–1667) was shaped by the same needs of *Micrographia*, that is, persuading Restoration medical men, divines, and members of the educated class that the Royal Society as a corporate body fulfilled important social and intellectual functions. The founding fellows also felt the need to distance themselves and the Society from Epicureanism, religious skepticism, and more generally from the so-called "enthusiasm" (Heyd 1981, 272–280; Heyd 1995, 144–174). At the time of the publication of *Micrographia*, this criticism was mostly oral. It was

given in written form by Henry Stubbe (1632–1676) and Meric Casaubon (1599–1671) in the years following Sprat's *History* and Joseph Glanvill's (1636–1680) *Plus Ultra* (1668). Nonetheless, as attested by Sprat and Glanvill, there was substantial criticism of the Society's public role even in the early 1660s. Accusations ranged from disrespect for the authority of the ancients and Aristotle (385–323 BCE) to religious heterodoxy, as is apparent even from a cursory reading of Glanvill's *Plus Ultra*, a work especially devoted to answering those critics who sarcastically asked, "What have they done?" (Sprat 1667, 46–49; Glanvill 1668, 83–91, 116–122, 137–149). The sermons the Oxford public orator Robert South (1634–1716) delivered on several occasions provide us with a particularly powerful expression of the feelings of hostility dominating the scene. In a sermon preached in 1667 at Westminster, South portrayed the Royal Society as "a kind of *Diabolical Society*, for the finding out *new experiments* in Vice" whose members "allow no other measure of the Philosophy and Truth of things, but the sole *Judgement of sense*" (South 1697, vol. 2, 45–46). Criticism came not only from conservative quarters of the London and Oxford milieu, but also from Cambridge. For example, in 1669 the Lady Margaret Professor of Divinity Peter Gunning (1614–1684) vigorously opposed the publication of a poem by Peter du Moulin (1681–1756) in honor of the Royal Society, also reading against the virtuosi of the Society (Gascoigne 1989, 55–57).

As Hooke claimed in the preface and in many passages of *Micrographia*, microscopy revealed a perfectly ordered world, where everything has its own purpose in God's design. If Epicurus (341–270 BCE) had owned a microscope and observed a fly's eye, Hooke argued, instead of having recourse to chance he would have recognized the hand of God in nature:

> So infinitely wise and provident do we find all the Dispensations in Nature, that certainly Epicurus and his followers, must very little have consider'd them, who ascrib'd those things to the production of chance, that will to a more attentive considerer appear the products of the highest wisdom and providence. (Hooke 1665, 178)

According to Hooke, the manifestation of God's providence, wisdom, and omnipotence can be found in what he called "the geometrical mechanism of nature" (Hooke 1665, 91) observed in microscopical images of snowflakes, samples of frozen liquids, and in the kettering-stone (a stone dug out in Northamptonshire made up of small particles resembling little globes separated by small interstices):

> I have often with great pleasure, observ'd such an infinite variety of curiously figur'd Snow, that it would be as impossible to draw the Figure and shape of every one of them, as to imitate exactly the curious and Geometrical Mechanisme of Nature in any one…whatever were the cause of its [the kettering-stone's] curious texture, we may learn this information from it; that even in those things which we account vile, rude, and coorse, Nature has not been wanting to shew abundance of curiosity and excellent mechanism. (Hooke 1665, 95)

The mechanism behind natural operations is far from being the outcome of a "plastick nature" (an internal organizing principle which acted on matter as God's intermediary) but is the direct manifestation of God's wisdom and providence in the natural world. However, God's attributes are more conspicuous in living things

observed through the microscope, for instance in the structure of the fly's feet, or "the tufted, or brush horn'd gnat:"

> He that shall carefully and diligently observe the several methods of Nature therein, will have infinitely cause further to admire the wisdom and providence of the Creator.... To conclude, take this creature [the gnat] altogether, and for beauty and curious contrivances, it may be compared with the largest Animal upon Earth. Nor doth the Alwise Creator seem to have shewn less care and providence, in the fabric of it, then in those which seem most considerable. (Hooke 1665, 194–195)

The argument from design runs through the whole book. Microscopical observations were presented as evidence for the unbridgeable gap between art and nature, which emerges not only in living beings, but also in microscopical images of inanimate bodies like frozen urine and snowflakes (Fig. 3.1). What appears as a fine product of human art, like the edge of a razor or the point of a sharp needle (Fig. 3.2), observed through the microscope reveals an extremely irregular surface: "So inaccurate is it [Art], in all its productions, even in those which seem most neat, that if examin'd with an organ more acute then that by which they were made, the more we see of their shape, the less appearance will there be of their beauty: whereas in the works of Nature, the deepest Discoveries shew us the greatest Excellencies" (Hooke 1665, 2). "The Productions of art," Hooke concluded in the fifth "Observation" of a piece of watered silk,

> are such rude mis-shapen things, that when view'd with a microscope, there is little else observable, but their deformity.... So that my first Reason why I shall add but a few observations of them, is, their mis-shapen form; and the next, is their uselessness...whereas in natural forms there are some so small, and so curious, and their design'd business so far remov'd beyond the reach of our sight; that the more we magnify the object, the more excellencies and mysteries do appear; and the more we discover the imperfections our senses, and the Omnipotency and Infinite perfections of the great Creatour. (Hooke 1665, 8)

3.4 Interpreting Microscopical Images

Hooke placed himself and the work he had done in *Micrographia* between the world of practitioners, apothecaries, artisans, and instrument makers, and that of the "great philosophers," epitomizing the Society's aspiration to unite the disparate areas of mechanic or mathematical practitioners and the new natural philosophy, in which instruments were assuming unprecedented importance (Hooke 1665, sig. b *r-v*; Bennett 1986; Dennis 1989, 325–327).

The microscope used by Hooke is pictured in *Micrographia*'s second plate together with other instruments described in the preface: his lens-grinding engine, a device to demonstrate the law of refraction, and a barometer (Fig. 3.3). Hooke made his observations with different kinds of microscopes, including a reflecting microscope. This was a commercial product, one that could be purchased in the shop of Richard Reeve (fl. 1640–1680), perhaps the most renowned London optical

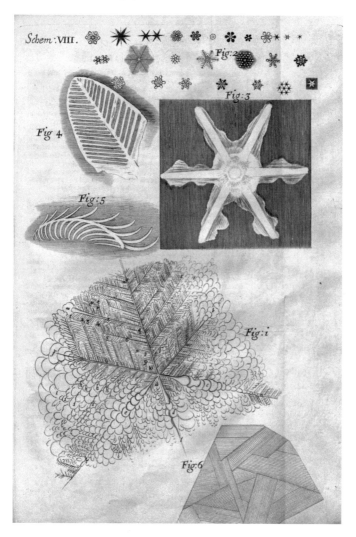

Fig. 3.1 Microscopical view of figures produced by freezing (I: six-branched figure on the surface of urine beginning to freeze; 2, 3: falling snow and a flake of snow magnified; 4, 5: ice on water and marble; 6: flakes of ice on the surface of water). From (Hooke 1665, Schem: VIII). Biodiversity Heritage Library / Public Domain Mark

instruments maker. Reeve had developed an improved compound microscope as early as 1652 (Simpson 1985). This instrument was used by Christopher Wren for his observations of insects reproduced in the plates presented to the king. Later on, Hooke made some contribution to the improvement of Reeve's microscope, but at the time of *Micrographia* the originality of his work mainly resided in introducing methods for illuminating objects. Hooke devised a glass globular flask to be filled with water (Fig. 3.3), capable of concentrating daylight or lamplight on the object

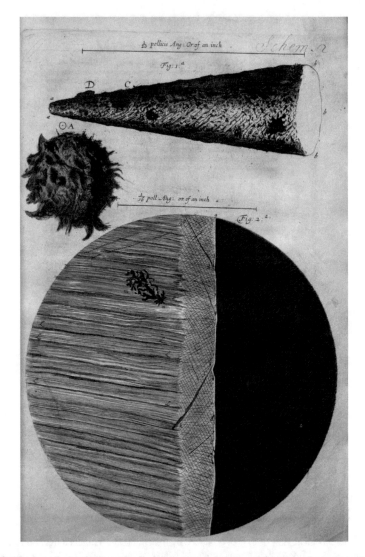

Fig. 3.2 The top of a small sharp needle (1); a printed dot (2) and the edge of a razor in the lower half of the image. From (Hooke 1665, Schem II). Biodiversity Heritage Library / Public Domain Mark

under examination. The advantages offered by increased illumination were significant, but following Descartes, Hooke tried to grind aspherical lenses—in his opinion the sole remedy for aberration (Bennett 2003, 93–94). Not only did it seem impossible to grind aspherical lenses, but it was so difficult to grind good spherical lenses that "there may be perhaps ten wrought before one be made tolerably good" (Hooke 1665, sig. d1 *v*). Contemporary microscopy also suffered the lack of a method for determining the magnifying power of optical instruments.

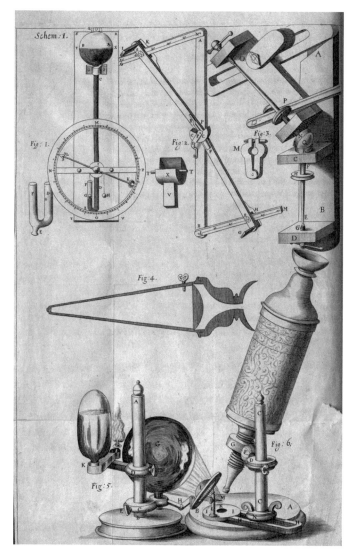

Fig. 3.3 Hooke's compound microscope (6) and the glass globe he devised to illuminate objects (5). In the middle his two-lens microscope using a cone filled with water (4). In the upper half the barometer driven by float (1), Hooke's device to measure light refraction by liquids (2) and his lens grinding machine (3). From (Hooke 1665, Schem I). Biodiversity Heritage Library / Public Domain Mark

Hooke tried to solve both problems by devising a lens-grinding engine, as Descartes had done, which never worked, and a method for measuring the degree of magnification. The latter involved looking at an object through the microscope with one eye while looking at the same object, unaided but at the same distance, with the other eye. Then the ratio of the magnified size to the original size was determined by using a ruler laid on a pedestal of the microscope. The accuracy of this method was founded on the law of refraction illustrated by "the most incomparable Descartes" (Hooke 1665 sig. e1 *v*-f *r*; Descartes 1897–1913, vol. VI, 100; Schuster 2000) that Hooke's readers would have been able to prove by another device described in *Micrographia*.

Hooke developed techniques of observation and instruments for regulating light, but his aim was to discover what he called "the true form" of natural bodies, that is, their true or natural appearance beyond the power of the naked eye. In making the draughts from which the engravers produced the illustrations of the book, Hooke explained that he endeavored.

> first to discover the true appearance, and next to make a plain representation of it. This I mention the rather, because of these kinds of Objects there is much more difficulty to discover the true shape, then of those visible to the naked eye, the same Object seeming quite differing, in one position to the Light, from what it really is, and may be discover'd in another. And therefore I never began to make any draughts before by many examinations in several lights, and in several positions to those lights, I had discover'd the true form. (Hooke 1665, sig f1 *v*)

"It is exceeding difficult in some Objects," Hooke continued, "to distinguish between a prominency and a depression, between a shadow and a black stain, or a reflection and a whiteness in the colour" (Hooke 1665, sig f1 *v*: Wilson 1995, 221–222). In other words, the new world Hooke observed through his microscope showed that things were often different from how they appear to the naked eye. Let us consider the celebrated image of the drone fly's head (Fig. 3.4). Hooke's illustration of the head of the *Eristalis tenax*, or the grey drone fly, is one of the most famous plates of *Micrographia*, a large-format image exceeding the size of the printed page, which needed to be folded into the book. The short essay related to this image is one of the most detailed and informative of the collection. It illustrates Hooke's observational procedure, gives us an insight into the act of drawing a microscopical image, and reveals the difference between Hooke's procedures and those of his microscopist colleague Henry Power (1623–1668).

3.5 The Graphic Transposition of the "True Form" and Its Functions

Henry Power was a Cambridge-educated physician who practiced in Halifax. He was a correspondent member of the Royal Society with interests ranging from natural philosophy to pneumatics and physiology, as attested by his *Experimental Philosophy, In Three Books* published in 1664 in London by the printers to the Royal

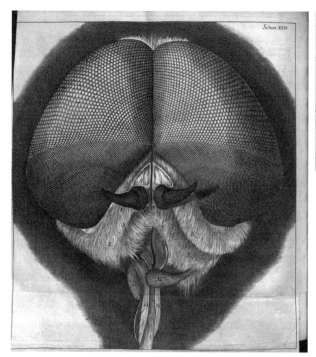

Fig. 3.4 View of the head of a grey drone-fly. On the right, portion of the eye magnified with windows reflecting on each globe of the fly's compound eye. From (Hooke 1665, Schem. XXIV). Biodiversity Heritage Library / Public Domain Mark

Society, James Allestry and John Martyn. It was the first book in English about microscopy and was soon superseded by Hooke's *Micrographia*. During a meeting of the Royal Society in 1663, Power presented some of the microscopical observations later discussed in *Experimental Philosophy*. As Hooke himself recorded in the preface, Power's book appeared just after Hooke had completed the drawings and descriptions contained in *Micrographia*: "After I had almost completed these Pictures and Observations (having divers of them ingraven, and was ready to send them to the Press) I was inform'd, that the Ingenious Physitian Dr. Henry Power had made several Microscopical Observations" (Hooke 1665, sig. g1 *v*). We also know that Hooke and Power exchanged the fruits of their labor, and that Hooke immediately realized the superiority of his work over Power's: "upon our interchangeably viewing each others Papers, I found that they were for the most part differing from mine, either in the Subject its self, or in the particulars taken notice of; and that his design was only to print Observations without Pictures" (Hooke 1665, sig. g1 *v*; Birch 1756–1757, vol. 1, 266; Neri 2011, 110–112).

In fact, though they were both published by the printers to the Society, Power's and Hooke's works differ significantly. *Micrographia* comprises thirty-eight plates

and sixty observations or short descriptions of the subject under examination, interspersed with digressions on light, colors, and air, whereas Power illustrated his fifty-one microscopical observations with just three small woodcuts of the eyes of a spider, a piece of ribbon, and poppy seeds. Most importantly, the small woodcuts did not convey a sense of depth and contrast. Power's images did not represent a three-dimensional object. Differences in depth and in light and dark are scarcely distinguishable. In contrast, Hooke's representations give a much stronger sense of the three-dimensionality of the microscopic world, as is evident even from a cursory comparison between two images of poppy seeds (Fig. 3.5).

The interpretation of the contrast of light and dark in microscopic images required a visual vocabulary that Hooke drew from graphic conventions adopted by engravers and painters, which helped him to translate the microscopic three-dimensional world into a two-dimensional representation of it, as Meghan Doherty has convincingly demonstrated (Doherty 2012, 223–227). The lack of this kind of visual vocabulary and expertise led Henry Power to erroneously conclude that the fly's eye was like a dotted lattice, thus missing its "true form," which could be observed only by concentrating light on the object (Power 1664, 49). Power did not try to define a protocol of observation as Hooke did, as attested by their different views of the fly's eye. Henry Power described the fly's eye as a single body with a hemispherical shape, "black and waved…all latticed or chequered, that is, having a pattern of squares of different colours" (Power 1664, 6–7).

Once the perceptual discovery was complete, picture making could begin. Drawing was intended to visualize the true form concealed by the deception of

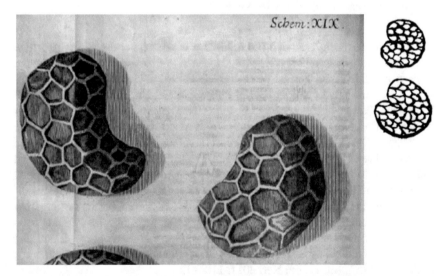

Fig. 3.5 On the left of the image, the image of poppy seeds in *Micrographia* (Hooke 1665, Schem XIX). On the right, the image of the same seeds published by Henry Power in the first edition of his *Experimental philosophy*. From (Power 1664, 49). Biodiversity Heritage Library / Public Domain Mark

the senses, and to illustrate in a powerful and concise image the results of experimental investigation. The demarcation between observation and graphic transposition implies that printed images embodied a series of diachronic visual acts, resulting in drawings by means of inferences from sensory perceptions. This is well illustrated by an image contained in *Micrographia*'s twenty-third plate (Fig. 3.4), which shows a cluster of nineteen little globes, each one showing the images of two illuminated windows distorted by their curvature. The windows reflected in the drone fly's eye led Hooke to infer their globular shape, that is, their true form (Hooke 1665, 176).

In conclusion, Hooke drew a clear distinction between the observational process of discovery of the true form and the act of drawing. "I endeavoured to discover the true appearance, and next to make a plain representation of it" (Hooke 1665, sig f 1 *v*). The rationale behind this demarcation becomes clear when we consider the influence of accidental factors like illumination and position of the object: "there is much more difficulty to discover the true shape…the same Object," Hooke argued, seems "quite differing in one position to the Light from what it really is….And therefore," he concluded, "I never began to make any draughts, before by many examinations in several lights…I had discover'd the true form" (Hooke 1665, sig. f1 *v*). As Matthew Hunter has perceptively argued, the inference from discrete visual acts implies that the true form represented by the engraver was not really seen at all, but it resulted from several factors involving quantitative considerations relating to dimensions and contingencies like the observation of images reflected by the objects seen through the microscope (Hunter 2013, 34–43).

3.6 Microscopy and Natural Philosophy

In the graphic project of *Micrographia* the discovery of the true form and the production were aimed not only at enriching natural history, but also at providing evidence to rule out alternative explanations of some of the most debated issues in contemporary experimental natural philosophy. The adoption of the principles of mechanical philosophy and Baconian experimentalism characterized much of English science during the second half of the seventeenth century. In this context, experiments raised questions about the mechanical interpretation of some natural phenomena. So-called mechanical philosophy found two main expressions in England: the atomistic or Epicurean, and the Cartesian, as Samuel Sorbière noted in a passage of his *Voyage en Angleterre*, written after his trip to England and his visit to the Royal Society in 1663–1664: "l'on ne remarque point qu'aucune authorité prevaille; & tandis que les simple Mathematiciens inclinent plus vers M. Descartes que vers M. Gassendi, d'autre costé les literateurs semblent plus portez vers cestuy-cy" (Sorbière 1664, 92; Lennon 1993, 101–103; Garber 2013).

In this respect, Hooke's *Micrographia* represents one of the first examples of the use of images in the debate over the explanatory power of the principles of Cartesian and Epicurean or atomistic mechanical philosophy. This is witnessed by several passages of description accompanying the images. In some cases, these descriptions

form short essays in which topics like the cause of combustion, the shape of the corpuscles or atoms, the generation of minerals, plants, and animals are discussed in light of the new experimental evidence offered by microscopy. One of Hooke's main criticisms of atomists was that the shape of atoms did not explain natural phenomena like cohesion, which Pierre Gassendi (1592–1655) (Gassendi 1649, 202–210) and his English disciple Walter Charleton (1619–1707) ascribed to little hooks sticking atoms together: "I am very apt to think, that the tenacity of bodies does not proceed from the hamous, or hooked particles, as the Epicureans, and some modern Philosophers have imagin'd; but from the more exact congruity of the constituent parts, which are contiguous to each other, and so bulky, as not to be easily separated, or shatter'd, by any small pulls or conclusion of heat" (Hooke 1665, 6; Clericuzio 2018, 15–19). As the quoted passage suggests, Hooke used microscopical evidence to support his theory of congruity and incongruity—properties attributed to the motion of particles endowed with geometrical and mechanical properties, which cause particles of unlike types to separate and particles of similar types to remain together (Ehrlich 1995). Hooke also used congruity and incongruity to explain the globular shape of the particles of the fiery sparks struck from a flint, in contrast with Descartes's explanation. In the fourth part of his *Principia Philosophiae* (1644), Descartes ascribed the production of fire to the particles of the second and first element. When flint is hit against steel or another hard body, the pores containing the particles of the second element become narrower to give them space. Those particles are expelled from the pores which contain only the particles of the first element. When the flint is no longer pressed, being a friable body, its particles are released surrounded by the first element, that is, fire (Descartes 1897–1913, vol. VIII, 251–252).

Hooke remembered having read Descartes' explanation "about eight years since," most likely when he was at Oxford with Boyle, and to have "great desire to be satisfied, what that substance was that gave such a shining and bright light" (Hooke 1665, 46). Having observed through the microscope the particles of the sparks, he realized that Descartes's explanation was purely speculative. His inclination to Cartesian and kinetic concepts in developing his theory of combustion yielded to the microscopical image of the residual combustion artifacts left on a piece of white paper. The globular form of these artifacts cannot be accounted for by Descartes' theory based on pores containing "atoms of fire" or the particles of the first element, since another experiment consisting in casting the filings of iron and steel through the flame of a candle produced residual combustion artifacts almost identical to those obtained by hitting flint and steel. Hooke had recourse to chemical properties, concluding that, "Iron does contain a very *combustile sulphureous* Body, which is, in all likelihood, one of the causes of this *Phenomenon*" (Hooke 1665, 46). As far as the globular shape is concerned, Hooke proposed a mechanical explanation based on his theory of congruity and incongruity. The little globes observed through the microscope (Fig. 3.6), Hooke concluded, owed their form to "a propriety which belongs to all kinds of fluid bodies more or less, and is caused by the incongruity of the ambient and included fluid, which so acts and modulates each other, that they acquire, as neer as is possible, a *spherical* or *globular* form" (Hooke 1665, 46–47).

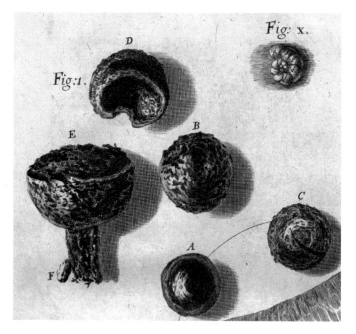

Fig. 3.6 Microscopical view of small pieces of flint and steel broken off by striking fire with them. From (Hooke 1665, Schem V, 1). Biodiversity Heritage Library / Public Domain Mark

Hooke's explanation was entirely consistent with his views on the role of air in combustion. According to him, combustion could be accounted for by the chemical properties of the air, the latter described as a "kind of *tincture* or *solution* of terrestrial and aqueous particles" perpetually agitated and dissolved in a kind of aether similar to Descartes,' which Hooke called the "*menstruum,* or universal dissolvent of all Sulphureous bodies" (Hooke 1665, 103). Consistent with the theory of nitrous substances dissolved in the air put forward by Boyle (Boyle 1999–2000, vol. 2, 93–96; Frank 1980, 138–139) and by the followers of the Helmontian and Paracelsian traditions (Newman and Principe 2002, 200ff.), Hooke surmised that air contained dissolving parts similar to the particles of the fixed part of nitre.

The microscopical view of the texture of cork Hooke discussed in the eighteenth observation led him to introduce the word *cells* to describe the "little boxes" observed in cork and plant tissues (Fig. 3.7).

Hooke claimed that the observation of cells was an absolute novelty in itself, since cells "were indeed the first *microscopical* pores I ever saw, and perhaps, that were ever seen" (Hooke 1665, 113), but its importance was mainly related to its explanatory power. Elasticity, weight, and other physical properties of cork are easily explained in terms of compression and expansion of the pores or "cells" full of air. Hooke also estimated the number of cells at one million in a square inch of cork tissue, concluding that in nature there were corpuscles smaller than Epicurus's atoms. The function of cells is to convey natural nutrients to plants like arteries and veins convey

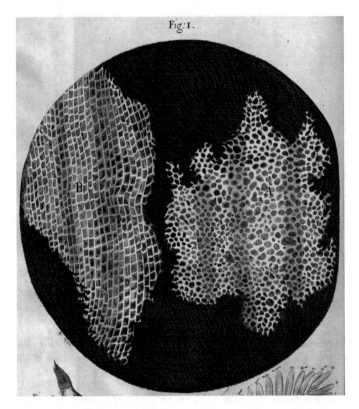

Fig. 3.7 The cells of cork. Two of the thin slices of cork Hooke observed through the microscope against a dark background. From (Hooke 1665, Schem XI, 1). Biodiversity Heritage Library / Public Domain Mark

blood in animal bodies, and their structure and dimension are perfectly adapted to perform it: "these pores I say, which seem to be the Vessels of nutrition to the vastest body in the World, are yet so exceeding small, that the *Atoms* which *Epicurus* fancy'd would go neer to prove too bigg to enter them, much more to constitute a fluid body in them" (Hooke 1665, 114).

Hooke explained the functions of cells in analogy with Harvey's discovery of the circulation of the blood. In addition, the cellular structure of animals and plants led him to consider the question of the boundaries between the animal realm and the plant kingdom, an issue discussed in the Royal Society. The sensitive plant (i.e. the *mimosa pudica*) was the subject of a committee of the Royal Society composed by Robert Moray (ca. 1608–1673), John Wilkins (1614–1672), the president William Brouncker (1620–1684), and the physician Timothy Clarke (died 1672). Clarke wrote an account of his observations of the plant made at St. James's Park on August 9, 1661, entitled *Observations on the Humble and Sensible Plants in Mr Chiffin's Garden in Saint James's Park*, later published in *Micrographia* as a supplement to

Hooke's observations. It is worth noting that the group did not use the microscope, but scissors, *aqua fortis* (nitric acid), and burning-glasses.

Nonetheless, in *Micrographia* Hooke presented Clarke's hypothesis "that the motion of this Plant upon touching, might be from this, that there being a constant *intercourse* betwixt every part of this Plant and its root, either by a *circulation* of this liquor, or a constant pressing of the subtiler parts of it to every extremity of the Plant" (Hooke 1665, 120) as entirely consistent with his own observations. However, the Royal Society committee drew only tentative conclusions, as Clarke himself admitted, since an exhaustive analysis of the anatomy of the sensitive plants was still a *desideratum* in 1661. Hooke himself openly confessed to having "not yet made so full and satisfactory Observation as I desire on this Plant." In the intervening years, Hooke had made microscopical observations on the sensitive plant which suggested him "the motion of it to proceed from causes very differing from those by which Gut-strings, or Lute-strings, the beard of a wilde *Oat*, or the beard of the Seeds of *Geranium*...move themselves" (Hooke 1665, 121). Hooke did not publish any image of the sensitive plant and let the question remain open, "designing much more accurate examinations and trials, both with my *Microscope*, and otherwise" (Hooke 1665, 121).

Hooke turned his attention to the Damask rose plant. Seen under the microscope, the yellow and red spots on its dry leaves revealed a microscopic world inhabited by strange bodies similar to little plants (Fig. 3.8). It is worth quoting in full Hooke's description of the "alien" world he observed through the lens of his microscope:

Examining these with a *Microscope*, I was able plainly to distinguish, up and down the surface, several small yellow knobs, of a kind of yellowish red gummy substance, out of which I perceiv'd there sprung multitudes of little cases of black bodies like Seed-cods, and those of them that were quite without the hillock of Gumm, disclos'd themselves to grow out of it with a small Straw-colour'd and transparent stem. (Hooke 1665, 121)

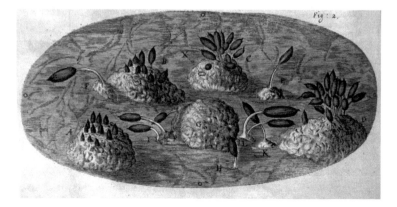

Fig. 3.8 Small curious plants growing on the leaves of rose trees. Hooke observed their reaction to liquids like vinegar to be very similar to that of the so called 'sensible plants.' From (Hooke 1665, Schem XII, 2). Biodiversity Heritage Library / Public Domain Mark

What surprised Hooke was the absence of seeds in the microscopic flowers growing on the surface of the leaves. This circumstance raised the question of the generation of the Damask rose, which Hooke ascribed to a process of decay or putrefaction that activated some seminal principles analogous to the generation of insects from vinegar (Hooke 1665, 122–123).

In the seventeenth century, many followers of atomism had recourse to the notion of seminal principles to explain chemical and biological phenomena, generation above all. Seminal principles were invoked to explain phenomena that could not be reduced to purely mechanical causes. In his *Syntagma philosophicum*, Gassendi had introduced the notion of seminal principles to explain generation in animals and plants, that is, a special kind of corpuscles endowed with a principle of activity, composed by "Atomos speciales" (Gassendi 1964–1994, vol. I, 493b). Seeds were created by God at the beginning, but their activation required suitable environmental conditions. The power of seeds to organize matter was derived directly from God. Despite Gassendi's description of seeds as little machines, their "soul" or active formative principle was implanted by God at the beginning. The notion of seminal principles allowed Gassendi and other corpuscular philosophers like Boyle and Charleton to maintain teleological views in their theories of matter (Clericuzio 2001; Hirai 2005, 463–490; Schaffer 1987).

Spontaneous generation was a subject hotly debated among natural philosophers during the seventeenth century. The belief in spontaneous generation of some vegetable substances was shared by philosophers like Sir Kenelm Digby (1603–1656), who claimed that saltpeter had the property of nourishing life, being the cause of the spontaneous generation of plants (Digby 1661, 64–71). Digby read his discourse on the "vegetation of plants" during one the first meetings of the Royal Society, but the phenomenon continued to attract the interest of the council. In 1661 a committee was appointed to investigate alleged cases of spontaneous generation during meetings held at Boyle's lodgings at Oxford. Over the first half of the 1660s, the members of the Royal Society devoted part of their efforts to study this controversial phenomenon, focusing on chemical experiments with May-Dew, the dew formed on May Day or in the month of May, popularly supposed to have medicinal properties linked to its power to regenerate and renew life (Birch 1756–1757, vol. 1, 23, 117; Taylor 1994, 167–168). However, natural philosophers like Boyle and Hooke were rather skeptical about the possibility of the generation of life without parents of the same species. The adoption of the notion of seminal principles implanted by God in nature allowed them not only to support the idea of a teleological order in nature, but also to avoid the hypothesis of spontaneous generation by chance. For instance, Boyle's aim in his unpublished *Essay on Spontaneous Generation* was to confute the Aristotelian and Epicurean theory of generation, and in particular to avoid the dangerous hypothesis of generation as the product of the purely mechanical and random aggregation of atoms (Boyle 1999–2000, vol. 13; Anstey 2002; Clericuzio 2018, 8).

Like Boyle and Charleton, Hooke adopted the doctrine of seminal principles to explain the generation of small worms and insects on the leaves of the Damask rose and other plants. The heat produced by putrefaction, the substance of air, and some

kind of corpuscles endowed with the power of organizing matter were the princi-
ples of Hooke's explanation of seemingly spontaneous generation. Some species
of insects (for instance those growing in water such as the water gnat represented
in *Micrographia*) may be generated by the joint action of some seminal principle
spawned by other insects and a putrefying or fermenting substance. The question of
spontaneous generation remained open in *Micrographia*.

Hooke did not deny the possibility of spontaneous generation but considered
it highly improbable in light of the results of his microscopical observations of
mites. These small creatures had attracted Aristotle's attention (Aristotle, *De historia
animalium* 557b), but it was only the development of microscopy that allowed
seventeenth-century natural philosophers to appreciate its complexity. Compared
to its smallness, the anatomical complexity of the mite aroused great interest.

Atomist and corpuscularian philosophers often cited Aristotle's description along-
side their own microscopical observations as evidence for the existence of atoms,
that is, indivisible particles. In discussing atoms' magnitude and figure, Gassendi put
forward an argument based on microscopical evidence, in particular on the observa-
tion of the mite. Seen through the lenses of microscopes, the mite showed a complete
set of vital organs which paralleled that of bigger creatures, a fact that could be
explained only assuming the atomic composition of its organs and fluids (Gassendi
1649, 221–222). This argument was taken up by the English philosophers who
admired Gassendi and who were engaged in elaborating their own corpuscular theory
of matter (Meinel 1988, 84–88). Such was the case of Robert Boyle, for example,
who brought up Gassendi's examination of the mite as empirical evidence of atoms
in his *Essays of Effluviums* (1673) and *Of the Atomical Philosophy* (1652–1654)
(Boyle 1999–2000, vol. 7, 233; vol. 13, 229).

In *Micrographia*, readers could find not only a detailed description of this small
creature, but also images showing the external features of the insect viewed from the
top and from the belly (Fig. 3.9). Hooke passed over the atomist argument and, in
his "Observation LV," dwelt upon the anatomical features of the mite, so small that
"there may be no less then a million of well grown Mites contain'd in a cubick inch,
and five hundred times as many Eggs" (Hooke 1665, 213).

Viewed through the microscope, mites showed differences in shape, color, and
hair that Hooke ascribed to the various substances in which mites were generated and
nourished. Mites appeared and proliferated in mold and putrefying substances, and
even more important, they seemed to be spontaneously generated therefrom. Hooke
openly declared that the issue of spontaneous generation could not be solved by the
available experimental evidence: "But whether indeed this Creature, or any other,
be such or not [spontaneous animals], I cannot positively, from any Experiment, or
Observation, I have yet made, determine" (Hooke 1665, 214). Nonetheless, Hooke
inclined toward a negative response. It is likely that mites were generated from parents
and seeds or eggs:

> It seems probable, that some kind of wandring Mite may sow, as 'twere, the first seeds, or
> lay the first eggs, in those places, which Nature has instructed them to know convenient the
> hatching and nourishing their young…I am very apt to think, the most sorts of Animals,
> generally accounted *spontaneous*, have their *origination*, and all the various sorts of Mites,

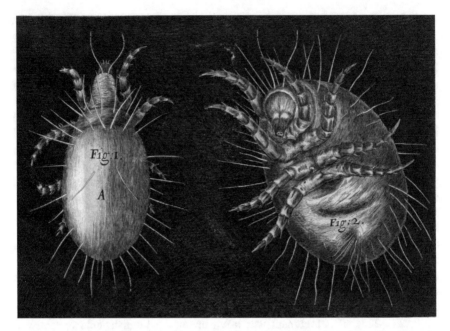

Fig. 3.9 A cheese mite viewed with its back (1) and another with its belly uppermost (2). From (Hooke 1665, Schem XXXVI). Biodiversity Heritage Library / Public Domain Mark

> that are to be met with up and down in divers putrifying substance, may perhaps be all of the same kind, and have sprung from one and the same sort of Mites first. (Hooke 1665, 215)

The same process occurs in the generation of gnats. The "Observation" devoted to this insect contains a full account of Hooke's views on spontaneous generation. Hooke believed that "the Almighty Creator has as well implanted in every creature a faculty of knowing what place is convenient for the hatching, nutrition, and preservations of their Eggs and of-springs, whereby they are stimulated and directed to convenient places, which becom, as'twere the wombs that perform those offices" (Hooke 1665, 189).

3.7 Conclusion

Hooke observed the mold growing on the leather of the cover of his notebook through the lens of his microscope, discovering that it consisted of different small vegetative bodies looking like small flowers with a cylindrical stalk, or mushrooms and sponges (Fig. 3.10). Microscopical observations of mold prompted Hooke to investigate the process of their generation and growth. Like mushrooms, mold "require no seminal property" but only putrefying vegetal or animal substances "kept moist and warm" (Hooke 1665, 127). In Hooke's eyes, their generation showed interesting analogies

with the formation of salts and minerals through crystallization. According to Hooke, the formation of mushrooms and mold was the manifestation of a "Primary kind of life and vegetation" that is "purely Mechanical, and that the effects or productions are as necessary upon the concurrence of those causes as that a Ship, when the Sails are hoist up, and the Rudder is set to such a position, when the Wind blows, be mov'd in such a way or course to that or to other place" (Hooke 1665, 130–131). Thus, the formation of this kind of living things is entirely different from the generation of plants and animals, which required seeds, "the Cabinet of Nature, wherein are laid up its Jewels" (Hooke 1665, 153).

The microscopical observation of seeds demonstrated "how curious and carefull Nature is in preserving the seminal principle of vegetable bodies, in what delicate, strong and most convenient Cabinets she lays them and closes them in a pulp for their safer protections from outward dangers and for the supply of convenient alimental juice" (Hooke 1665, 154). Microscopical images of seeds gave Hooke a strong sense of nature's "curiosity."

Curious and *curiosity* are terms which occur more than ninety times in *Micrographia*. Although Hooke employed them in different contexts, for the most part they

Fig. 3.10 Microscopical view of a spot of mould growing on a leather cover. From (Hooke 1665, Schem XII, 1). Biodiversity Heritage Library / Public Domain Mark

refer to microscopical images of the several non-living and living things. In some cases, Hooke tried to show that curious objects and creatures observed under the microscope were similar to those found in the macroworld. In the microworld there is nothing contrary to the natural order observed by the naked eye. According to Hooke, both the worlds are governed by mechanical principles, even though in some cases, like living things, mechanical causes are infinitely more complex, and require the concurrence of appropriate environmental conditions, plus God's creative act and providence. Except for the simple elements like air, water, and earth, whose micro-scopical images revealed no curiosity, almost all the objects and bodies described in *Micrographia* are "curious" in the extent to which they are arranged in a *scala naturae* or hierarchy ranging from the simplest bodies, in which nature "begin to geometrize," to more complex organisms like plants displaying "multitudes of curious Mechanick contrivances" or even "stupendious mechanisms and contrivances" in the case of insects (Hooke 1665, 154).

For example, in the flea legs Hooke observed the same adaptation of structure to function that characterized the organs of bigger animals. The flea was well known for its strength, and the microscope allowed Hooke to understand the reason: "the curious contrivance of its legs and joints, for the exerting that strength, is very plainly manifested…for the joints of it are so adapted, that he can, as'twere, fold them short one within another, and suddenly stretch, or spring them out to their whole length" (Hooke 1665, 210; Neri 2011, 97–99). The image of the "crab-like insect" (Fig. 3.11), one of the first of Hooke's microscopical drawings, revealed the general rule nature observed in her works:

> In all likelihood, Nature had crouded together into this very minute insect, as many, and as excellent contrivances, as into the body of a very large Crab, which exceeds it in bulk, perhaps, some millions of times…and 'tis very likely, that the internal curiosities are not less excellent: it being a general rule in Nature's proceedings, that where she begins to display any excellency, if the subject be further search'd into, it will manifest, that there is not less curiosity in those parts which our single eye cannot reach, then in those which are more obvious. (Hooke 1665, 208)

However, if nature seemed to operate like a "geometer" or "mechanician," the higher steps of the *scala naturae* revealed that mechanical philosophers had to have recourse to some kind of teleology or purpose to account for the order and regularity found both in the macro- and in the microworld:

> Nature does not only work mechanically, but by such excellent and most compendious, as well as stupendious contrivances, that it were impossible for all the reason in the world to find out any contrivance to do the same thing that should have more convenient properties. And can any be so fottish as to think all those things the productions of chance? Certainly, either their ratiocination must be extremely depraved, or they did never attentively consider and contemplate the Works of the Al-mighty. (Hooke 1665, 171)

Fig. 3.11 One of Hooke's first microscopical drawings, his 'crab-like' insect named so because of the shape of its legs and its claws. From (Hooke 1665, Schem XXXIII, 2). Biodiversity Heritage Library / Public Domain Mark

References

Anstey, Peter. 2002. Boyle on seminal principles. *Studies in History and Philosophy of Biological and Biomedical Sciences* 33: 597–630.

Anstey, Peter. 2005. Experimental versus speculative natural philosophy. In *The science of nature in the seventeenth century*, ed. Peter Anstey and John A. Schuster, 215–242. Dordrecht: Springer.

Aubrey, John. 1898. *Brief lives*, 2 vols., ed. Andrew Clark. Oxford: Clarendon Press.

Bennett, Jim. 1986. 'The mechanics' and the mechanical philosophy. *History of Science* 24: 1–28.

Bennett, Jim. 2003. Hooke's instruments. In *London's Leonardo. The life and work of Robert Hooke*, eds. Jim Bennet, Michael Cooper, Michael Hunter, and Lisa Jardine, 63–104. Oxford and New York: Oxford University Press.

Birch, Thomas. 1756–1757. *The history of the Royal Society of London for improving of natural knowledge…*, 4 vols. London: printed for A. Millar.

Boas Hall, Marie. 1991. *Promoting experimental learning. Experiment and the Royal Society (1660–1727)*. Cambridge/New York/Port Chester/Melbourne/Sydney: Cambridge University Press.

Boyle, Robert. 1999–2000. *The works of Robert Boyle*, 14 vols., eds. Michael Hunter and Edward B. Davis. London: Pickering & Chatto.

Charleton, Walter. 1654. *Epicuro-Gassendo-Charltoniana: or a fabrick of science natural, upon the hypothesis of atoms, founded by Epicurus, repaired by Petrus Gassendus, augmented by Walter Charleton*. London: printed by T. Newcomb, for Thomas Heath.

Clericuzio, Antonio. 1998. The mechanical philosophy and the spring of air. New light on Robert Boyle and Robert Hooke. *Nuncius* 13: 69–75.

Clericuzio, Antonio. 2001. Gassendi, Charleton and Boyle on matter and motion. In *Late medieval and early modern corpuscular matter theories*, eds. Christoph Lüthy, John E. Murdoch, and William R. Newman, 467–482. Leiden/Boston/Köln: Brill.

Clericuzio, Antonio. 2018. Gassendi and the English mechanical philosophers. Galilæana. *Studies in Renaissance and Early Modern Science* XV: 3–29.

Cooper, Michael. 2003. Hooke's career. In *London's Leonardo. The life and work of Robert Hooke*, eds. Jim Bennet, Michael Cooper, Michael Hunter, and Lisa Jardine, 1–62. Oxford/New York: Oxford University Press.

Davis, Edward B. 1994. *Parcere nominibus*: Boyle, Hooke and the rhetorical interpretation of Descartes. In *Robert Boyle reconsidered*, ed. Michael Hunter, 157–176. Cambridge: Cambridge University Press.

Dear, Peter. 1985. *Totius in verba*: Rethoric and authority in the early Royal Society. *Isis* 76: 145–161.

Dennis, Michael A. 1989. Graphic understanding: Instruments and interpretation in Robert Hooke's *Micrographia*. *Science in Context* 3: 309–364.

Descartes, René. 1897–1913. *Oeuvres de Descartes*, 13 vols., eds. Charles Adam and Paul Tannery. Paris: Cerf.

Digby, Kenelm. 1661. *A discourse concerning the vegetation of plants*…. London: printed by J.C.

Doherty, Meghan C. 2012. Discovering the "true form:" Hooke's *Micrographia* and the visual vocabulary of engraved portraits. *Notes and Records of the Royal Society* 66: 211–234.

Ehrlich, Mark E. 1995. Mechanism and activity in the scientific revolution: The case of Robert Hooke. *Annals of Science* 52: 127–151.

Feingold, Mordechai. 2005. The origins of the Royal Society revisited. In *The practice of reform in health, medicine and science, 1500–2000*, ed. Margaret Pelling, 167–183. Aldershot: Ashgate.

Feingold, Mordechai. 2006. Robert Hooke: Gentleman of science. In *Robert Hooke: Tercentennial studies*, ed. Michael Cooper and Michael Hunter, 203–217. Burlington: Ashgate.

Frank, Robert G. 1980. *Harvey and the Oxford physiologists. Scientific ideas and social interaction*. Berkeley/Los Angeles/London: University of California Press.

Garber, Daniel. 2013. Remarks on the pre-history of the mechanical philosophy. In *The mechanization of natural philosophy*, ed. Daniel Garber and Sophie Roux, 3–26. Dordrecht: Springer.

Gascoigne, John. 1989. *Cambridge in the age of enlightenment. Science, religion and politics from the restoration to the French Revolution*. Cambridge: Cambridge University Press.

Gassendi, Pierre. 1649. *Animadversiones in decimum librum Diogene Laertii*. Lyon: apud Guillelmum Barbier.

Gassendi, Pierre. 1964–1994. *Opera Omnia*, 6 vols., Faksimile-Neudruck der Ausgabe von Lyon 1658 in 6 Bänden, mit einer Einleitung von Tullio Gregory, F. Frommann (G. Holzboog): Stuttgart-Bad Cannstatt.

Glanvill, Joseph. 1668. *Plus ultra, or, the progress and advancement of knowledge since the days of Aristotle in an account of some of the most remarkable late improvements of practical, useful learning, to encourage philosophical endeavor*…. London: printed for James Collins.

Greengrass, Mark, Michael Leslie, and Michael Hannon. 2013. The Hartlib papers. Published by The Digital Humanities Institute, University of Sheffield. https://www.dhi.ac.uk/hartlib/view?docset=main&docname=29_05_43. Accessed 23 June 2020.

Harwood, John T. 1989. Rhetoric and graphics in *Micrographia*. In *Robert Hooke. New Studies*, eds. Michael Hunter, Simon Schaffer, 119–147. Woodbridge, Suffolk: The Boydell Press.

Heyd, Michael. 1981. The reaction to enthusiasm in the seventeenth century: Towards an integrative approach. *The Journal of Modern History* 53: 258–280.

Heyd, Michael. 1995. *Be sober and reasonable: the critique of enthusiasm in the seventeenth and early eighteenth centuries.* Leiden: Brill.

Hirai, Hirao. 2005. *Le concept de semence dans les théories de la matière à la Renaissance. De Marsile Ficin à Pierre Gassendi.* Thournout: Brepols.

Hooke, Robert. 1661. *An attempt for the explication of the phænomena observable in an experiment published by the honourable Robert Boyle, Esq.; In the xxxv experiment of his epistolical discourse touching the aire....* London: printed by J.H. for Sam. Thomson.

Hooke, Robert. 1665. *Micrographia, or some physiological descriptions of minute bodies made by magnifying glasses: with observations and inquiries thereupon.* London: Printed by Jo. Martyn and Ja. Allestry.

Hunter, Michael. 1989a. Latitudinarianism and the 'Ideology' of the Royal Society: Thomas Sprat's history of the Royal Society (1667) reconsidered. In *Establishing the new science: The experience of the early Royal Society*, ed. Michael Hunter, 45–71. Woodbridge, Suffolk: Boydell Press.

Hunter, Michael. 1989b. *Science and society in restoration England.* Cambridge: Cambridge University Press.

Hunter, Michael. 1994. *The Royal Society and its fellows (1660–1700), the morphology of an early scientific institutions*, 2nd ed. Oxford: Alden Press.

Hunter, Michael. 2007. Robert Boyle and the early Royal Society: A reciprocal exchange in the making of Baconian science. *British Journal for the History of Science* 20: 1–23.

Hunter, Matthew C. 2013. *Wicked intelligence: Visual art and the science of experiment in restoration London.* Chicago & London: The University of Chicago Press.

Lennon, Thomas M. 1993. *The battle of the gods and giants. The legacies of Descartes and Gassendi (1655–1715).* Princeton: Princeton University Press.

Meinel, Christoph. 1988. Early seventeenth-century atomism: Theory, epistemology and the insufficiency of experiment. *Isis* 79: 68–103.

Neri, Janice. 2011. *The insect and the image: Visualizing nature in early modern Europe, 1500–1700.* Minneapolis: University of Minnesota Press.

Newman, William R., and Lawrence M. Principe. 2002. *Alchemy tried in the fire: Starkey, Boyle and the fate of Helmontian chemistry.* Chicago: University of Chicago Press.

Oldenburg, Henry. 1665. An account of Mr. Hooks *Micrographia*, or the physiological descriptions of minute bodies, made by magnifying glasses. *Philosophical Transactions* 1: 27–32.

Oldenburg, Henry. 1965–1986. *The correspondence of Henry Oldenburg*, 13 vols., eds. Alfred R. Hall and Marie Boas Hall. Madison, Milwaukee: University of Wisconsin Press.

Power, Henry. 1664. *Experimental philosophy, in three books.* London: printed by T. Roycroft for John Martin and James Allestry.

Purrington, Robert D. 2009. *The first professional scientist: Robert Hooke and the Royal Society of London.* Basel/Boston/Berlin: Birkhäuser Verlag AG.

Ricciardo, Salvatore. 2016. *Robert Boyle. Un naturalista scettico.* Brescia: Morcelliana.

Schaffer, Simon. 1987. Godly man and mechanical philosophers: Souls and spirits in restoration natural philosophy. *Science in Context* 1: 53–85.

Schuster, John A. 2000. Descartes *opticien*: The construction of the law of refraction and the manufacture of its physical rationales, 1618–29. In *Descartes' natural philosophy*, ed. Stephen Gaukroger, John Schuster, and John Sutton, 258–312. London/New York: Routledge.

Shapin, Steven. 1989. Who was Robert Hooke? In *Robert Hooke. New studies*, eds. Michael Hunter and Simon Schaffer, 253–285. Woodbridge, Suffolk: The Boydell Press.

Simpson, A.D.C. 1985. Richard Reeve—the "English Campani"—and the origins of the London telescope-making tradition. *Vistas in Astronomy* 28: 357–365.

Sorbière, Samuel. 1664. *Relation d'un voyage en Angleterre, où sont touchées plusieurs choses, qui regardent l'estat des sciences, et de la religion....* Paris: Louis Billaine.

South, Robert. 1697. *Twelve sermons preached upon several occasions...The second edition*, 2 vols. London: S. D.

Sprat, Thomas. 1667. *The history of the Royal Society of London, for the improving of natural knowledge*. London: printed by T.R. for J. Martin.

Waller, Richard. 1705. The life of Dr. Robert Hooke. In *The posthumous works of Dr. Robert Hooke*, ed. Richard Waller. London: Smith and Walford.

Wilson, Catherine. 1995. *The invisible world: Early modern philosophy and the invention of the microscope*. Princeton: Princeton University Press.

Wood, Paul B. 1980. Methodology and apologetics: Thomas Sprat's "History of the Royal Society." *The British Journal for the History of Science* 13: 1–26.

Wren, Christopher. 1750. *Parentalia: or, memoirs of the family of the Wrens... chiefly of Sir Christopher Wren.... Compiled, by his Son Christopher, now published by his Grandson, Stephen Wren, Esq., With the Care of Joseph Ames*. London: T. Osborn and R. Dodsley.

Salvatore Ricciardo teaches History of Science at the University of Bergamo, Department of Human and Social Sciences. He published articles and books on early modern science and philosophy, and he is co-author (with M. Camerota and F. Giudice) of *The Reappearance of Galileo's Original Letter to Benedetto Castelli* (Notes and Records. The Royal Society Journal of the History of Science, 2018). His research interests include the relations between science and religion and the seventeenth-century debates concerned with theory of matter.

Chapter 4
Vision on Vision: Defining Similarities Among Early Modern Illustrations on Cosmology

Matteo Valleriani, Florian Kräutli, Daan Lockhorst, and Noga Shlomi

Abstract In the present work we show how many scientific illustrations of the early modern period can be used to track the evolution of visual knowledge and to detect historical communities involved in the production of the editions analyzed. In particular, we define three sorts of historically meaningful similarities among scientific illustrations, we show how such illustrations can be extracted from the sources and then clustered by means of fully computer-based methods, and finally we conclude with an example to show the potential of our approach.

Keywords Johannes de Sacrobosco · Scientific illustrations · Visualization · Similarity clusters · Machine learning

4.1 Introduction

In the present work we intend to show how to establish kinds of similarities among early modern scientific illustrations. The reason for such an investigation is related to the needs emerging in the frame of computational history, and specifically to our investigation "The Sphere: Knowledge System Evolution and the Shared Scientific Identity of Europe."

M. Valleriani (✉) · F. Kräutli · D. Lockhorst · N. Shlomi
Max Planck Institute for the History of Science, Berlin, Germany
e-mail: valleriani@mpiwg-berlin.mpg.de

F. Kräutli
e-mail: florian.kraeutli@uzh.ch

D. Lockhorst
e-mail: dlockhorst@mpiwg-berlin.mpg.de

N. Shlomi
e-mail: nshlomi@mpiwg-berlin.mpg.de

M. Valleriani
Technische Universität Berlin, Berlin, Germany

M. Valleriani · N. Shlomi
Tel Aviv University, Tel Aviv, Israel

© The Author(s) 2023
M. Valleriani et al. (eds.), *Scientific Visual Representations in History*,
https://doi.org/10.1007/978-3-031-11317-8_4

The general goal of our research is to reconstruct the transformation process a specific group of historical sources underwent. We refer to university textbooks used for the teaching of astronomy and cosmology all over Europe between the end of the fifteenth century and 1650. To accomplish this goal, we collected a batch of sources consisting of a corpus of early modern printed books that contain, in different forms, a specific treatise on cosmology: Johannes de Sacrobosco's (died ca. 1265) *Tractatus de sphaera*, a university textbook used for a qualitative introduction to geocentric cosmology, first compiled within the university of Paris during the thirteenth century. The corpus is also populated with 126 editions of university textbooks used for teaching the same subject that do not contain Sacrobosco's treatise, but rather an introduction to spherical astronomy that follows the same design of Sacrobosco's work, discusses the same subjects in the same order, and makes at least a partial use of the same visual apparatus. In total, 359 different editions were identified.[1]

To reconstruct the process of the transformation of knowledge taught in Europe we decided to extract a series of data that we conceive as highly representative for the scientific content of the textbooks at hand. For this reason, we called these data "knowledge atoms," purposely referring to the atomization of texts within the framework of commentary, a standard procedure to create new scientific knowledge from antiquity until the end of the early modern period (Grafton 2013).

Our knowledge atoms are texts (text parts), illustrations, and computational tables. We began with the text parts. By means of electronic copies of all sources, the texts were carefully atomized into "text parts." A text part is a textual passage that cannot be formally smaller than a paragraph and covers a well-defined subject with completeness. A text part in the corpus of Sacrobosco's *De sphaera*, for instance, might be the *Theoricae novae planetarum* of Georg von Peuerbach (1423–1461),[2] as this text began being printed together with the *Sphaera* as early as 1482 and had been reprinted together with the *Sphaera* seventeen times by 1537. If literary compositions—ordinarily printed in scientific books beginning in the sixteenth century—are considered, a text part can be much more modest in length. A representative example might be the short *carmen* written by Donato Villalta and dedicated to the scholar Pierio Valeriano (1477–1558),[3] printed for the first time in 1537[4] and then reprinted another

[1] The corpus has been collected for the project "The Sphere: Knowledge System Evolution and the Shared Scientific Identity of Europe." The collection is available online through the project website: https://sphaera.mpiwg-berlin.mpg.de (Last accessed 23 September 2022). For the function of this treatise and how it transformed over the centuries, see (Valleriani 2017). For a description of the corpus, concerning the places were the editions were printed, their book formats, their authors, printers, and publishers, as well as their language, see (Valleriani 2020).

[2] For Georg von Peuerbach's role in the frame of the corpus of *De sphaera*, see Valleriani, M., Kräutli, F. et al. 2019. Peuerbach, Georg von. In *Sphaera Database*. Available at: hdl.handle.net/21.11103/sphaera.100965. Accessed 21 February 2021.

[3] For Pierio Valeriano's role in the frame of the corpus of *De sphaera*, see Valleriani, M., Kräutli, F. et al. 2019. Valeriano, Pierio. In *Sphaera Database*. Available at: hdl.handle.net/21.11103/sphaera.100963. Accessed 21 February 2021.

[4] Donato Villalta's *carmen* was printed for the first time in Valleriani, M., Kräutli, F. et al. 2019. Compendium in sphaeram per Pierium Valerianum Bellunensem. In *Sphaera Database*. Available at: hdl.handle.net/21.11103/sphaera.101194. Accessed 21 February 2021.

thirty-two times. Another example of a text part—which can be seen as both a literary composition and a scientific contribution—is the famous letter to Simon Grynaeus (1493–1541) written by Philipp Melanchthon (1497–1560)[5] in defense of astrology as a teaching subject in the Reformed countries. The letter was printed, together with Sacrobosco's text, for the first time in 1531[6] and then another sixty-four times.

The advantage of such a textual "dissection" of the editions under investigation is evident when it becomes clear that many such text parts actually recur. On the basis of the recurrences of the text parts we were then able to analyze how the textbooks evolved.

Text-part analysis applied to the editions of the corpus resulted in the identification of a total of 563 text parts. Their identification is based on the principle of first appearance along the chronological line. Moreover, we considered only those text parts that were reprinted and re-published at least once, at least one year after their first appearance. By applying these criteria, 239 text parts remain, meaning that 324 text parts were published either only once or more than once but in the same year. Focusing on the remaining 239 text parts, their total number of recurrences (in the total timespan of 175 years considered here) is 1,653.

We first focused on the mechanisms of production of knowledge rather than on the content; therefore we created an ontology of text parts that allowed us to connect them and their recurrences on the basis of a taxonomy that includes the following categories: original text and text of reference, commentary, translation, and fragment. All the identified text parts were catalogued by making use of one or more of these categories. For instance, the quadrivial professor at the university of Leipzig active at the beginning of the sixteenth century, Konrad Tockler (1470–1530), authored a commentary on *De sphaera*. Such commentary is a text part in itself and was re-published twice, in 1503 and 1509.[7] The first time, the commentary was published together with one text part, namely a fragment of Thābit ibn Qurra's (836–901) *De imaginatione spere et circulorum*. The second time, however, it was published with three text parts: the fragment, Tockler's introduction, and finally his description on how to build an armillary sphere.[8] According to our ontology, therefore, Tockler's commentary allows us to connect not only these two editions because they contain the same commentary, but also all editions that contain the commentary on the same

[5] For Philipp Melanchthon's role in the frame of the corpus *De sphaera*, see Valleriani, M., Kräutli, F. et al. 2019. Melanchthon, Philipp. In *Sphaera Database*. Available at: hdl.handle.net/21.11103/sphaera.101002. Accessed 21 February 2021.

[6] Philipp Melanchthoin's letter to Grynaeus was printed for the first time in Valleriani, M., Kräutli, F. et al. 2019. Liber Iohannis de Sacro Busto, de Sphaera. In *Sphaera Database*. Available at: hdl.handle.net/21.11103/sphaera.100138. Accessed 21 February 2021.

[7] The 1503 edition is Valleriani, M., Kräutli, F. et al. 2019. Textus Spere materialis Joannis de Sacrobusto. In *Sphaera Database*. Available at: hdl.handle.net/21.11103/sphaera.100931 (Accessed 21 February 2021). The 1509 edition is Valleriani, M., Kräutli, F. et al. 2019. Textus Spere materialis Joannis de Sacrobusto. In *Sphaera Database*. Available at: hdl.handle.net/21.11103/sphaera.101042 (Accessed 21 February 2021).

[8] For an analysis of Konrad Tockler's scientific agenda and the positioning of his commentaries, see (Valleriani and Citron 2020).

Fig. 4.1 Representation of our complete multi-layer network representing how the edition of the corpus are connected to each other according to six different possibilities based on the taxonomy of the text parts. From (Zamani et al. 2020). Visualization realized by means of muxViz (De Domenico et al. 2015)

reference text, or all editions that contain one of the other text parts that were printed together with the commentary at hand.

To exploit all these possibilities and the high dimensionality of the dataset that we collected, we conceived a multi-layer network able to show us, in graphs, all possible connections along their temporal axis and, ultimately, to give as a formal system to be analyzed by means of methods typical of complex systems studies (Fig. 4.1).[9]

In previous studies based solely on the dynamics of the text parts, we were able for instance to identify editions that became dominant all over Europe, meaning that their content was "borrowed" from other printers and publishers. In particular, such dominance was executed by editions printed in recently reformed Wittenberg, illustrating how the Reformation produced scientific and pedagogic content able to influence the entire continent beyond confessional boundaries. Moreover, we were also able to show that a relatively small number of editions printed and published during the brief window between 1549 and 1562 acted as knowledge bridges ("great transmitters") by mixing old and traditional texts with innovations that emerged in the two decades before, and that such transmitters became the paradigms until long after the turn of the century.[10]

After the accomplishment of these studies, we decided to continue our research by approaching the second of the knowledge atoms listed above, namely the illustrations of the corpus. Our ultimate goal in this respect is not only to capture all the illustrations printed in the textbooks but also to conceive an ontology for the illustrations that allows us to enlarge our network by adding layers so that we can finally compare the dynamics of the scientific illustrations with that of the scientific texts and, in

[9] For the complete description of our ontology of text parts, see Sect. 3.1 of (Valleriani et al. 2019).

[10] The studies where we analyzed the dataset representing the dynamics of the dataset and which contain links to the data and the scripts to create the matrices are (Valleriani et al. 2019; Zamani et al. 2020).

the end, accomplish more comprehensive research concerned with the knowledge transformation process these sources underwent.

In the following therefore we will describe first the dataset of illustrations that we collected, including the method used to extract these data, and second the ontology we conceived in order to group the images according to historically meaningful principles that allow us to represent processes of the innovation, oblivion and diffusion of knowledge related to the scientific visual material. After this theoretical argument, we show how we technically realize clusters of illustrations in order to meet the requirements developed in the historical interpretative framework. Finally, we conclude with an example of the results we can achieve.

4.2 The Role of a Scientific Illustration

The illustrations have been manually annotated (captured) by a team of student assistants, using the *Mirador IIIF viewer* (Project Mirador 2014). The illustrations are stored as regions on the digitized pages. This means that for later analysis we are able to associate an illustration with the edition it originates from, its author, printer, publisher, the specific text part an image appears in, etc. The data is stored as RDF triples according to a CIDOC-CRM data model (Kräutli and Valleriani 2018).

The annotations have been classified as either Content Illustrations, Initials, Printer's Marks, and Decorations. We also distinguish whether these elements are printed on title pages or inside the book. As in the case of the text parts, this taxonomy describes the mechanisms of production of knowledge more than the content of the books themselves. Moreover, as we are interested in reconstructing the process of evolution of astronomic and cosmological knowledge represented by these textbooks, we ignore for the moment illustrations of initials and decorations. Given the relatively low number (maximally as many as the editions collected: 359) of printer's marks and title page illustrations, our method will focus on the largest of the groups of illustrations realized through the data extraction: the content illustrations. These amount to 21,407 images; all, in our corpus, are woodblock prints in the tradition of the early modern printing workshops (Reeves 2017; Werner 2019, 65–71).

Content illustrations are carriers of knowledge that we keep ontologically distinguished from the texts within which they are inserted. In the case of our textbooks, they can be scientific diagrams, flattened representations of the cosmos, geometric figures, or any kind of visual aid to describe, enrich, criticize, or explain what is expressed textually. But they can also constitute the central piece of information, which the text describes, enriches, explains, and criticizes.

To give an example, we could consider one of the oldest visual aids and that can be traced back in the manuscript material, inserted in the *Tractatus de sphaera* during the late medieval period. This image (Fig. 4.2), which is then taken over into the new medium of print, illustrates the sphericity of the element water around the element earth, in accord with the orthodox Aristotelian cosmological view.

Fig. 4.2 In the first chapter of the *Tractatus de sphaera*, Sacrobosco demonstrates the sphericity of the element water around the Earth by means of the empirical example of a ship leaving a shore. From (Sacrobosco et al. 1490, a-III-5). Courtesy of the Library of the Max Planck Institute for the History of Science

Since time immemorial, it was a well-known that when a ship is approaching the shore, an observer positioned at the top of the mast can see the shore earlier than another observer positioned on the hull of the ship. Since classical antiquity this phenomenon was used to explain the sphericity of our planet and, more precisely, that the element of water, according to the Aristotelian view, floats over the element of earth because it is less heavy.

For some time in the context of the historical sources collected in our corpus, the description of phenomena did not change. However, after the experiences of the journeys of exploration began entering the academic conversation, it became urgent to start claiming the obvious: that we do not inhabit a water globe dotted with a portion of emerged earth where life takes place; it is a terraqueous globe (Fig. 4.3).

The new illustration obviously represents a strong departure from the Aristotelian view, and an aspect of nature that cannot be explained on the basis of the Aristotelian worldview. Nevertheless, the new composition retains the previous meaning and function of the illustration and still represents a demonstration of the sphericity of the water globe. The text that accompanies the illustration, however, remained completely unaltered for a very long time, except in a few editions, implying that the illustration is commenting on the textual content by criticizing it.[11]

With our goal in mind of creating connections among editions based on the content illustrations in order to allow us to analyze how the scientific content of the treatises (or more precisely, how the method of production of scientific content) changed over time, we faced the task of identifying elements and characteristics of content-illustrations that express meaningful historical information.

In the same way that we used to connect editions on the basis of particular relations among text parts, we define three forms of similarity among illustrations, on whose basis we can create networks among the editions of the corpus that formally describe the process of transformation we want to reconstruct. Such similarities will

[11] For more information about the diffusion of the illustration representing the terraqueous globe, see (Pantin 2020).

Fig. 4.3 With the accumulation of experience from the journeys of exploration the planet starts being visually represented as a terraqueous globe. The content of the demonstration of the sphericity of the element water is not changed in the text, neither is the issue of the distribution of the element earth and the dissolution of the idea of an Oikumene. From (Sacrobosco and Melanchthon 1568, b-5-4). Courtesy of the Library of the Max Planck Institute for the History of Science

then allow us to group the content-illustrations on their basis; such groups, ordered chronologically by the dates of publication of the editions in which they were printed, will furnish us the data to finally create the graphs or layers of the network. In the present work we will describe these three forms of similarity and show how we grouped the illustrations. The analysis itself of the graphs will be accomplished in future works.

4.3 Three Historically Meaningful Forms of Similarity Among Early Modern Scientific Illustrations

The three forms of similarities that we have conceived allow us to group the content-illustrations following an operative hierarchal order, meaning that the formation of the first groups on the basis of the first form of similarity is a necessary condition for the formation of the second group, and so forth.

The first form is called "philological similarity," on whose basis we create "philological groups" of illustrations. Philological similarity implies that two illustrations are similar to each other if they are identical.

As we know from book historians (Nuovo 2013), the investment of a printer in producing a book was roughly subdivided into one-third for the costs of the paper and two-thirds for the preparation of the text, namely configuration of the page and the actual printing. However, the situation changed dramatically when an edition was supposed to include several or many illustrations. This change happened for two reasons related to the production process for printed books. The first concerns the fact that there was no way to print both text and illustrations in the same act. This means that each sheet that was supposed to display at least one image needed to be placed under the press twice, enormously lengthening the use of human resources (the press men) and influencing the consumption of the instruments and tools (the press). The second, eventually even more relevant from an economic point of view, was the need to first produce woodblocks. Such production was extremely costly because of the material and the human work. That said, the life of woodblocks could be extremely long; though they needed to be repaired or restyled every once in a while, they could eventually be reused, for longer than a century in certain cases.[12] Because of the high number of illustrations in the editions constituting our corpus (these are mathematical books) this factor matters for our study.

In fact, the combination of these two characteristics of the woodblocks—expensive but long-living objects—transformed the woodblocks into economic goods of exchange among printers, publishers, and booksellers (when they also acted as publishers): blocks were lent, borrowed, sold, and scrupulously inherited. For this reason, if illustrations are grouped because they are identical to each other, and assuming that this means that they have been produced by means of the same woodblock, we can create a graph of connections between editions of treatises of our corpus that, at the same time, identifies networks of printers and publishers in economic relationship among each other on the basis of the exchange of woodblocks.

Two limits concerning the applicability of our conception are related to the actual use of woodblocks. The first is due to the fact that, in principle, no illustration can be truly identical to another. In the course of a print run—and even for two subsequently printed sheets—the woodblock underwent a process of wear, plus new ink was added, and a different sheet, though probably extremely similar, was used. Secondly, the case is not infrequent that a woodblock was flipped upside down by accident or otherwise. As will be shown in the following, however, our method is able to cope with these inconsistencies.

There is finally a third limit, this time concerned with the actual practice of early modern printers' workshops: there were frequent cases in which printers replicated illustrations printed in other printers' editions by carving the woodblock while keeping a printed illustration on it; they copied it without "permissions," as we would express this practice nowadays. This was indeed a practice that reflected the

[12] For an interesting case of extremely long re-usage of a set of woodblocks in the context of different semantic scientific areas, see (Moran 2017).

period's conceptions of originality, invention, and especially reproduction, whose consequence was the lack of a normative framework in reference to engravers and their products (Pon 2004; Witcombe 2004, 10–20).

This particular case cannot be detected with our method but gave us the ability to design our second form of similarity, the one we defined as "same types of representation."

The case in which a printer reproduced an illustration in an identical or almost identical way by carving a new woodblock is a special, peripheral case in this second form of similarity. More generally, we speak about same types of representations when illustrations that express the same scientific meaning also "look similar." It is probably easier to express this form of similarity by means of a few examples.

To begin with, we could reuse the representation of the sphericity of the element water (Fig. 4.2) and compare it with another illustration, whose aim is to express the same scientific meaning but by means of a different form (Fig. 4.4).

The overall representation is very similar (it shows a ship leaving shore) and no further scientific meanings are transmitted thereby. On the other hand, it diverges because of some small differences in the representation. For instance, the second observer is not positioned on the hull but at the bow and there is small boat close to the ship, possibly representing an additional observer positioned at an even lower position.

According to the first form of similarity, Figs. 4.2 and 4.4 do not belong to the same group but they are indeed the same type of representation and, according to our categorization, belong to the same group as defined by the "same type of representation."

Another example will assist in understanding this type of similarity, especially its historical meaning. We will then discuss its limits of applicability and thence move to the next form of similarity. A subject that is always discussed in the textbooks constituting our corpus is the phenomenon of the lunar eclipse. This subject is always discussed toward the end of the *Tractatus de sphaera*, in its final chapter (Chap. 4). The illustration shows that the lunar eclipse takes place because of an alignment of

Fig. 4.4 Illustration describing the demonstration of the sphericity of the element water around the Earth. From (Sacrobosco and Nuñez 1537, a-IIII). Reprint. München: Obernetter, 1915

sun, Earth, and moon so that a shadow is cast over the moon, which then appears obscured to observers on the Earth (Fig. 4.5).

The type of representation of this illustration is very common in our corpus and many illustrations somehow reproduce it—as, for instance, in the next example (Fig. 4.6).

Once again, the two illustrations are clearly not identical, but they also clearly show the same type of visual representation.

From these two examples it is not difficult to understand the kind of historical meaning we can obtain by applying this category. By connecting the editions of our corpus on the basis of the illustrations contained therein—which belong to the groups defined by this second form of similarity and by ordering the editions chronologically—we are finally able to trace temporally and spatially the diffusion of specific scientific visual representations and, therefore, to trace their possible evolution. As we conceive of visual scientific illustrations as semantic carriers of scientific knowledge, then the evolution of the visual representation mirrors the evolution of scientific knowledge.

Fig. 4.5 Common illustration to explain how lunar eclipses take place. It shows the same type of representation as Fig. 4.6. From (Piccolomini 1553, 45r). Courtesy of the Library of the Max Planck Institute for the History of Science

Fig. 4.6 Common illustration to explain how lunar eclipses take place. It shows the same type of representation as Fig. 4.5. From (Piccolomini 1568, 122). Public domain: https://doi.org/10.3931/e-rara-19747

From an operative point of view, there is no need at this stage to compare all the illustrations again. What will be compared at this stage are single illustrations taken as representative of entire philological groups as defined above. In other words, groups of illustrations created on the basis of the identification of the same type of representation are constituted by philological groups, which in turn are constituted by illustrations. In this sense the two grouping methods are conceived as hierarchically ordered.

In the case of the types of representation, limits of applicability can also be easily detected. As the subject of the lunar eclipse is explained in nearly all the treatises of the corpus, there are obviously many different illustrations whose function is to explain it. A different example (Fig. 4.7) shows the same subject but with a clearly different, though not radically different, visual composition.

What this last example teaches us is that it is easy to imagine cases in which the question of whether two philological groups of illustrations belong to a group defined on the basis of the similarity of the type of representation becomes a matter of debate and cannot be unequivocally defined once and for all. In this respect, we will also refer to opinions based on the expertise developed in the frame of art history and the history of the book (Müller 2008, 2011).

Figures 4.5, 4.6 and 4.7, for instance, explain the same scientific subject in a similar way. However, the connection we made between Figs. 4.5 and 4.6 was much more obvious and bold than their connection with Fig. 4.7. The main apparent differences between Figs. 4.5, 4.6, and 4.7 are:

- Figures 4.5 and 4.6 include cartoon-like faces of the sun and moon;
- Figures 4.5 and 4.6 use the medieval T-shaped world map of the earth;
- Figures 4.5 and 4.6 use index letters, while in Fig. 4.7 the references are mentioned by the full words;
- diagonal versus perpendicular compositions;

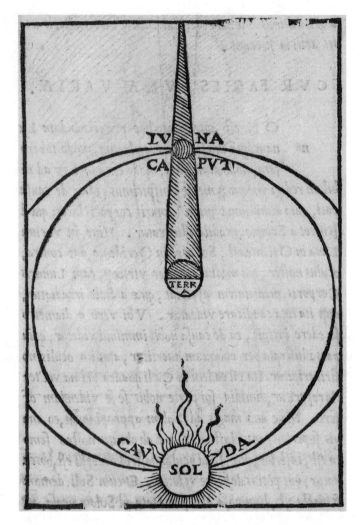

Fig. 4.7 Visual explanation of the phenomenon of the lunar eclipse. The lunar nodes are visualized. From (Valeriano 1537, eII). Courtesy of the Library of the Max Planck Institute for the History of Science

In spite of these differences, the images are not radically different. They use a similar visual language. However, the separation of both into two "type-of-representation" groups allows us to distinguish between different singular variations of the configuration. The hypothesis leading the research is that on the scale of the whole corpus, mapping different variations and visual formulations will exhibit specific paths of the evolution of the project's visual language in a way that is both specific and general.

The evolution of scientific visual language during the Renaissance is often discussed in relation to descriptive sciences like botany, anatomy, etc. In his canonical work, Erwin Panofsky characterized the Renaissance as taking a new approach to the visible world and prescribing a new definition of artistic representation. Panofsky writes that art during this period became more systematically based on scientific investigations. Another characteristic of the period is the process of bridging the gap between "professors and practitioners" (Panofsky 1962).

Panofsky's approach has been the subject of a large historical debate. Samuel Edgerton, for instance, has followed Panofsky and discussed the role of linear perspective in arts and its influence on the rise of experimental science. Other scholars have offered criticism of this approach—for example, considerations of the character of naturalistic representation (Givens 1999), the importance of decorations and aesthetic pleasure in scientific books (Kyle 2017), and the historically changing meaning of direct observation and its modes of documentation (Daston and Galison 1992; Daston 2015).

In this framework, astronomy is a unique case. Panofsky refers less to astronomy than to the descriptive sciences. According to Panofsky, before the Renaissance there was little contact between theoretical knowledge and practical observations and calculations. The bridging of practical and theoretical endeavors is expressed in astronomy by the theorization and systematization of practical endeavors, as well as in the theorization of practice (Panofsky 1962, 138–139). Concerning astronomical illustrations, however, an emphasis on observations that are documented and transmitted through art (as in the descriptive sciences) cannot be identified in the frame of astronomy because the subject of the illustration is not available at firsthand sight in the same manner, and cannot, in any circumstances, be drawn in its real dimensions. Accordingly, while abstraction is part of any process of drawing which translates three dimensional objects into two dimensions, it is even more prominent in astronomical illustrations. In contrast with medicine, revolutionary developments in astronomy were not accompanied by a shift in the style of the visual language. However, there were important changes in the ways illustrations were used in the context of each treatise (Kemp 1996; Pantin 2014).

As naturalism cannot be a prominent characteristic to evaluate the evolution of astronomical diagrams, we must search for different characteristics that allow us to distinguish among different types of astronomical representations. A fundamental distinction in this respect is between cartoon-like diagrams that express qualitative scientific knowledge and elements, such as diagrams, tables, and lists, that convey a knowledge of quantitative nature. Richard Oosterhoff, for example, in his discussion of the printed editions related to Jacques Lefèvre d'Étaples' (1450–1536) commentary on *De sphaera*, addresses the subject of the mathematization of the treatise. According to Oosterhoff, the transition of *De sphaera* toward a mathematical treatise is first expressed in its visual language. Oosterhoff connects the cartoon-like elements common to the illustrative tradition of *De sphaera*—including faces of suns and moons (as seen in Figs. 4.5 and 4.6) or disproportional figures and details—with the qualitative character of the treatise.

As the treatise is meant to teach students the basic principles of the discipline, the illustrations are not accurate, and are aimed to explain a single and simple principle. In contrast, the editions including the commentary by Jacques Lefèvre d'Étaples, for instance, are mathematically more advanced. This advancement is expressed visually. Oosterhoff writes that "the visual rhetoric of the diagrams facilitates quantitative readings." Mathematization is moreover also expressed in the replacement of full words in the images to index letters, which connect text and image, and in the priority given to geometrical lines over cartoon-like figures. The original *De sphaera* text now has a new subject and purpose. Instead of being a general and qualitative introduction, Lefevre's new edition became an exact and practically oriented text, based on calculations. The rising discipline of cosmography prioritized the practical benefits of astronomical knowledge over the rational understanding of the ancients' opinions (Oosterhoff 2018, 2020).

The transition of the visual rhetoric of the *De sphaera* tradition from qualitative and cartoon-like to accurate, quantitative, and geometrical, can supply an answer to the search for an evolution in the visual language of astronomical images, which reflects the beginning of modern scientific astronomical inquiry. Our example (Figs. 4.5, 4.6 and 4.7) does not display such a dichotomy. The two "type of representation" groups do not present such different modes of representation. The two groups (the group including Figs. 4.5 and 4.6 and the group including Fig. 4.7) indeed use a very similar visual language. However, recording the variations of uses of the different elements included in the illustrations throughout the full corpus can reveal patterns and mark the evolutionary path of the visual language in a continuous, less fragmented way.

The last comparison (Figs. 4.6 and 4.7) shows us how to enrich our taxonomy through a third form of similarity. If we reach the conclusion that the two last illustrations not only belong to two different philological groups but also that these two groups do not display the same type or representation, then we can nevertheless state that the two groups are related to each other because they express the same scientific meaning. In this way we build a new category of similarity that we call "content related" and we define "content-related" groups of illustrations.

From an operative point of view, however, there is no need to return to the philological groups, as content-related groups can easily be built by associating groups of the same type of representations. If we reconsider the first two illustrations of the sphericity of the element water (Figs. 4.2 and 4.3), for instance, they would belong to two different philological groups and, at the same time, to two different groups defined on the basis of the type of representation. At the level of content-related groups, however, they would be reunited, as they express the same scientific meaning at least partially, that being the demonstration of the sphericity of the element water. This also implies that content-related groups can unite groups based on the type of representation in multiple ways. Should we find, for instance, illustrations depicting the terraqueous globe with the intention of illustrating the different distribution of the two elements, but not demonstrating the sphericity of the element water, then these two groups would be united as different content-related groups. This last form

of similarity is the one that, more than the others, also requires focus on the textual apparatus and that therefore includes the consideration of text-image relations.

A special case can further help us to appreciate the analytical power of our taxonomy and, especially, the kind of historical results the content-related groups can bring us. This case is concerned with visual representations of the geocentric cosmos. Needless to say, this kind of illustration is the most common in the treatises we are investigating. But in spite of their great similitude among each other, such representations also convey very different aspects and scientific subjects.

According to the standard view, the view imparted in the original treatise of Johannes de Sacrobosco, the concentric planetary spheres are nine: the seven planets, the firmament, and the *primum mobile*. At its center, the four elements are organized according to their heaviness and lightness. In the middle there is the earth surrounded by the water. Over the water there is the air in turn surrounded by the element fire. A glance through the treatises reveals a myriad of variants to such a standard view. Many explanations are possible. For instance, it is possible that the illustration is not intended to convey a different meaning but that either for technical reasons or because of the curatorial design, the illustration depicting the cosmos misses the opportunity to convey all these pieces of information (Fig. 4.8). In frequent cases, for example, the cosmos is represented without great attention to its center and only the spheres are printed properly. In other cases, however, we do find a complete representation of the elements at the center and, in addition, a different number of spheres (Fig. 4.9); it is not uncommon to discern ten spheres instead of nine, for example. We know that the addition of one sphere was often due to the recognition of an additional motion in the cosmos (the precession of the equinoxes) that could not be satisfactorily explained by the standard model. Therefore, a sphere was introduced with the "mechanical" task of producing a movement to justify the mutations observed. Such slow movement was called *trepidatio* (Nothaft 2017; Axworthy 2020).

Both of the illustrations recur many times and therefore belong each to a different philological group. Moreover, they show the same type of representation mostly because both use concentric circles to represent the concentric spheres of the cosmos. However, they do not belong to the same content-related group because they convey different meanings—meanings that might have to be investigated case by case by reading the textual apparatus and/or commentary in which the illustration is inserted. For this reason, content-related groups express a historical meaning that can and will diverge from the meaning expressed by groupings based on the analysis of the type of representation only.

In the following we will show how we technically group and cluster this corpus of illustrations of exceptional dimensions, and we will show how the entire procedure is based on a visual analysis of the vision material: "vision on vision." Before describing such a method, however, we will first describe our dataset of illustrations.

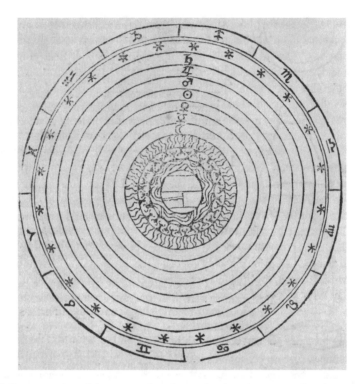

Fig. 4.8 Representation of the geocentric universe showing nine concentric spheres, a specific distribution of the elements in the center, and a T–O map of the planet. From (Sacrobosco et al. 1490, aIII-4). Courtesy of the Library of the Max Planck Institute for the History of Science

4.4 Statistics and Tools

For every edition in our corpus we obtained a digitized PDF copy. Through the database interface the PDF is accessible, along with its individual pages, which can be viewed through the *Mirador IIIIF Viewer* (Project Mirador 2014) that the student assistants worked with when capturing the illustrations. The process of analyzing a printed layout for the purpose of extracting illustrations could in principle also be automated. Many off-the-shelf *OCR* tools are capable of this for contemporary print material, and libraries such as *dhSegment* (Ares Oliveira et al. 2018) reproduce this functionality for historical documents.

We originally envisaged using *dhSegment* for automatically extracting the illustrations. However, the corpus was small enough to allow our student assistants to work through the material quicker than we managed to get the automated method functioning. The manual process also meant that the obtained dataset of illustrations was relatively clean from the start. An automatic extraction would need to undergo a manual cleaning process in order to weed out illustrations that had been misidentified (false positives) as well as illustrations that had not been captured (false negatives).

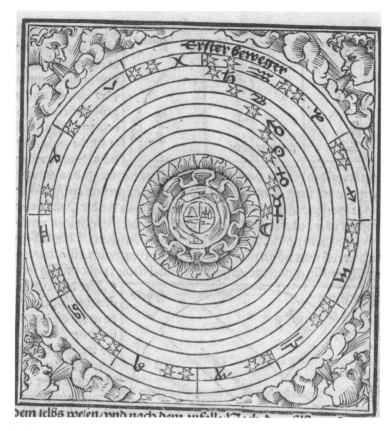

Fig. 4.9 Representation of the geocentric universe showing ten concentric spheres and a different distribution of the four elements in the center. From (Sacrobosco 1516, aIII). Public domain: https://doi.org/10.3931/e-rara-2230

While false positives can be identified quite quickly, recognizing false negatives is more time consuming. Every page would need to be inspected in order to spot illustrations that had not been identified. Due to the inevitable manual cleaning process, automated data extraction often saves less time than first hoped.

Before we go into the process of how we establish the aforementioned types of similarities between images, we want to take a brief look at the illustrations themselves and in relation to the metadata we have already gathered on the editions in our corpus. We recorded bibliographic data on the editions' printers and publishers, the place and date of publication, their language, size, etc. We begin by looking at the temporal distribution of the collected illustrations, in the first instance without taking into account the philological groups. We first plotted the total number of illustrations identified per decade in the observed timeframe (Fig. 4.10). The distribution of illustrations largely follows the overall distribution of printed editions (Fig. 4.11), including the lower number of illustrations in the years 1520–1529. Yet if we look

Fig. 4.10 The absolute number of content illustrations in our dataset is mapped against the date of publication of the book they appear in. The pattern largely corresponds to the overall temporal distribution of books in our dataset (Fig. 4.11)

at the number of illustrations in relation to the number of pages these books contain, we see a slightly negative correlation (Fig. 4.12).

Although the average number of pages an edition contains increases over time, those pages contain a decreasing proportion of illustrations. A possible explanation of this pattern can be found in the fact that a total of 11,365, or roughly half of all the collected illustrations have been printed in the text part identified with Sacrobosco's *Tractatus de Sphaera* and its commentaries. Additional text parts that have been added to later publications do overall contain fewer illustrations. An exception is the *Theorica novae planetarum* by Georg von Peuerbach, which contributes a total of 1,293 illustrations to the total collection. The total number of illustrations each (original) text part contributes to our collection can therefore be displayed. We can now also look at the number of illustrations each original part contains (Fig. 4.13). A 1611 edition printed by Reinhard Eltz in Mainz contains a richly illustrated text on astrolabes by Christoph Clavius (1538–1612), featuring 339 illustrations (Sacrobosco and Clavius 1611) (Fig. 4.14).

As may be expected, the physical format of a publication does relate to the number of illustrations included, with quartos and octavos containing about half as many illustrations per page as folios (Fig. 4.15).

In order to go beyond statistical insights and look at the visual imagery, we adapted two existing tools that are geared toward the visualization of large image datasets: *Coins*, a tool that was originally developed to visualize the numismatic collection of the Berlin Münzkabinett, and *VikusViewer*, a generic visualization tool for large image collections (Glinka et al. 2017; Gortana et al. 2017).

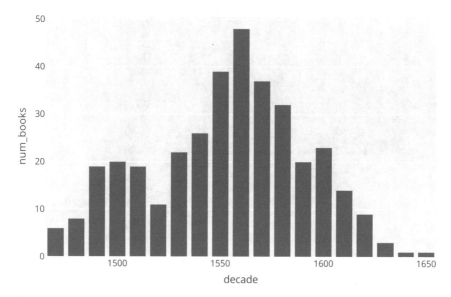

Fig. 4.11 The temporal distribution of the books in our corpus. Most books have been published around mid sixteenth century

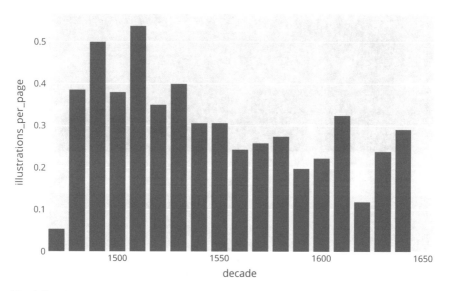

Fig. 4.12 The average number of content illustrations that a book contains in relation to its number of pages declines over time. While the later books in our corpus contain on average more texts, those texts are not as richly illustrated as the *Tractatus*, which contributes most of the illustrations in our collection

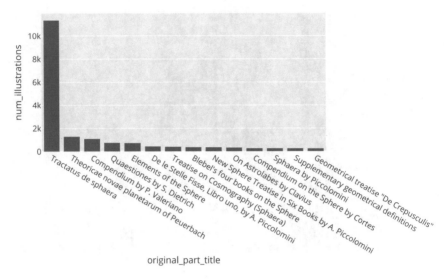

Fig. 4.13 In absolute numbers, most of the illustrations in our corpus originate from the *Tractatus de sphaera*. This comes as no surprise as the Tractatus forms the basis of our collection and is generally richly illustrated

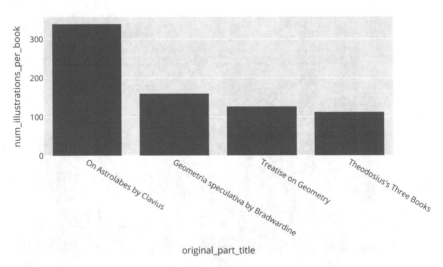

Fig. 4.14 Looking at how many illustrations an individual part contains on average, a text on astrolabes by the Jesuit mathematician Christoph Clavius stands out. It appears in only one edition in our collection, a 1611 work published in Mainz, where it is illustrated by a total of 339 illustrations

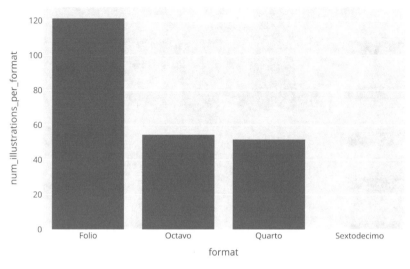

Fig. 4.15 Books that are printed in the large folio format contain on average 121 illustrations, more than twice as many as those produced in the smaller octavo and quarto formats

Using *Coins*, we are able to visualize the extracted content illustration in relation to other metadata that we gathered. Mapping the illustrations against the text parts they appear in and the dates of their publication, we see that the temporal distribution of our extracted illustration is uneven. The illustrations from the *Tractatus* appear throughout the timeframe of our corpus, while most other illustrations (along with the parts they appear in) were only introduced after about 1530 (Fig. 4.16). We can also spot some patterns when mapping the illustrations by their date and place of publication (Fig. 4.17).

A gap appears around 1530 among the images printed in Venice. The earliest images from Wittenberg appear at the same time. These patterns have nothing to do with the production of illustrations, but merely stem from the fact that our corpus does not contain any editions that were published in these places at these times. It is crucial to be aware, when analyzing data through visualization, that not all dimensions of our data are being visualized. Patterns that emerge through visualization may in fact stem from invisible dimensions.

VikusViewer's main view is a temporal histogram composed of the images themselves, with the ability to zoom in for close-up inspection (Fig. 4.18). Here we see the same patterns that we identified in our earlier analysis. In addition to the histogram, *VikusViewer* offers a *t-SNE* layout, which arranges the images by visual similarity (Fig. 4.19). The method works by classifying each image using a neural network trained for image recognition, in this case the *MobileNet* network. Instead of using the classification label, the entire output vector of the network is used as a "fingerprint" for the images. This 1,000-dimensional vector is then projected into a two-dimensional space using the *t-SNE* algorithm, which visually positions images in proximity proportional to their relationship in the high-dimensional space. We

Fig. 4.16 Content illustrations visualized using *Coins*. The content illustrations visualized on a horizontal time dimension and separated vertically by the text part they appear in. Most illustrations other than those originating from the *Tractatus* have been published only after around 1530

can already identify groups of recurring images and, most importantly, large enough groups to enable us to build a dense network of books based on image similarities (Fig. 4.20). The grouping established by the *t-SNE* algorithm is however purely visual. We need additional algorithms to organize the images into groups that we can then use to establish our network. We will discuss the necessary steps below.

As a final visual exploration of the dataset of content illustrations, we have trained a generative adversarial network to analyze and visualize the data using artificially generated recurring image patterns learned from the *Sphaera*-images dataset. We have used the "Progressive growing" of *GAN*'s training method because it suits our contextually and visually diverse data well (Karras et al. 2017).

Fig. 4.17 The patterns that appear when visualising content illustrations by time and place of publication corresponds to the periods of local book production as a whole and are not representative of the production of illustrations specifically

Fig. 4.18 All the content illustrations in our collection are visualized in a temporal histogram using *VikusViewer*

Fig. 4.19 The *t-SNE* view in *VikusViewer* groups the illustrations in our collection by visual similarity

A *GAN* creates a generative model to create new unique data from trained patterns, in our case from the *Sphaera*-image data. A generative adversarial network consists of a "Generator" and a "Discriminator." The Generator tries to make a new image, then the algorithm mixes generated images with real images to which the discriminator has to give a probability of reality. The goal of the Generator is to become a good forger and for the Discriminator to become a good curator. Through a feedback loop they keep improving each other until a good generative model is created.

To prepare our data for use with the algorithm, we had to gather a selection of images which could be made uniform in size. We decided to use all images from our set which had an aspect ratio of between 1:1.25 and 0.75:1 and contained at least 9 * 105 pixels. The images then were transformed to a 1:1 aspect ratio with 1024 × 1024 pixels. Most images already qualified unedited; all the others were transformed and interpolated to said size. A total 14,383 images qualified according to our preparation criteria.

The results gathered from the fully trained network were then cross analyzed by using the *t-SNE* method previously mentioned, to see if there were overarching groups

Fig. 4.20 A close-up of the *VikusViewer t-SNE* view (Fig. 4.19) with distinct groups of visually similar content illustrations

to be recognized and to find advantages and disadvantages to the various methods, as well as whether this method brought us similar groupings when compared to the other visual techniques.

We saw that the generated images performed similarly to the real images when analyzed by our image similarity algorithm, although images that were scaled too much fell short. It did create a good overview of the dataset and a good clear visual representation of the different image patterns found therein. It also pointed out that many images, although visually/contextually similar, were grouped or created in another place in the latent space.

As the different forms of similarity are all hierarchically based on the philological groups, it will suffice to show our methods in creating such a cluster. The last section will show one example.

4.5 Clustering of Philological Groups

With clustering we try to group illustrations together by using data points obtained from abstractions generated from the illustrations in our dataset. We judge a clustering methods effectiveness by how it detects increasing similarity among the created groups and then we score the group on how well it matches an initial philological group that we formed manually.

4.5.1 Methods to Cluster

For the clustering we have used two different methods to compare and utilize different approaches. They both follow the same steps:

- Create a value (usually a vector) from an abstraction of each image in a dataset;
- Map each vector to a space for the entire dataset;
- Calculate distance between the mapped points;
- Group images according to a distance-based grouping scheme.

We have analyzed prevalent methods of abstracting and comparing images to achieve a better understanding and to select the right method for this particular task (Fig. 4.21). These methods are convolutional neural networks, residual neural networks, and differential hashing (Kravetz 2013). There also are older techniques studied such as *ORB* (Rublee et al. 2011), histogram distance, pre-neural-network-template-matching, and *SIFT* (Lowe 2004). We have studied how well these performed on our set of images using a purpose-built application. These techniques however did not deliver results that were comparable in quality to those previously mentioned.

As mentioned, we use and compare two different methods to group illustrations while looking for identical ones. The first one is a conventional method that uses the Differential hashing (Kravetz 2013) of images and the Hamming distance between those hashes (Hamming 2013). We choose this method primarily for its transparency and explainability, as well as its efficiency and speed. The second grouping method uses a residual neural network, namely a *ResNet-50v2* (He 2015) for the abstractions and *k-means* for the mapping and grouping. We have selected this process based on its proven high accuracy in recent computer science literature. A residual neural network is a suitable process for training a very deep convolutional neural network that creates abstractions from the images in our dataset. These abstractions then get clustered with a vector quantization method, in our case *k-means*. *k-means*-clustering is a vector quantization method that clusters the abstractions into a predetermined number of clusters with the nearest mean. These processes together give us a more complete understanding and overview of the data analyzed.

Fig. 4.21 Example of calculation of the Hamming distance of two *dHash* abstractions. The Euclidean distance of the *ResNet* Abstractions is also shown. Abstraction Analyzer tool Max Planck Institute for the History of Science

Process A

a. Differential hashing

We use the difference hash—or *dHash*—algorithm, as this algorithm is both performant and, thanks to its relatively simple implementation, transparent in its operation. The steps for calculating the 8-byte *dHash* for a given image are as follows:

- Reduce the image size to 9×8 pixels;
- Convert the image to grayscale;
- For every pixel, calculate the difference to adjacent pixels;
- For every pixel, assign 1 when brighter, 0 when darker.

b. Hamming distance

The hamming distance is an error measurement which compares two strings or lists, in our case binary strings. It starts at 0 and increases by 1 for every difference found between the binary strings:

- Calculate the hamming distance between all images;
- Save the nearest neighboring (lowest hamming distance) image for every image;
- The output is a list with format (image original, image nearest neighbor, hamming distance).

c. Cutoff grouping

- Go over the list of nearest neighbors;
- If hamming distance is higher than the threshold (9 in 8 byte), remove from list.

Fig. 4.22 Visualization of two images being compared by using a *dHash* abstractions and hamming distance. Screenshot of Abstraction Analyser, a purpose-built application to evaluate different image comparison algorithms developed by Daan Lockhorst

This method gives us the final grouping by adding all the images that are linked to the same group (Fig. 4.22).

Process B

a. Residual neural network

Neural networks have the highest image classification scores measured today in some of the more popular image dataset classification competitions (Russakovski et al. 2015). We have taken updated versions of *xception* (Chollet 2017), *vgg19* (Simonyan and Zisserman 2014) and a *ResNet-50v2* (He 2015), all implemented in the framework *Keras* (Chollet 2015). The *ResNet-50v2* came out as the highest scoring after grouping it with *k-means* compared to our own philological group. We choose algorithms that have been part of scientific computing for some years but have recently been updated with newer technologies, over newer networks with a slightly higher possible score.

This process takes in an image scaled to 224×224 pixels with 3 color channels and returns a similar output vector to the *dHash*, though sized differently as a 128-byte string. All of the strings put together in a list can be represented as a high- (1,024) dimensional dataset and then reduced to a 2-dimensional dataset and mapped to a plane using a dimension reduction technique like *t-SNE* (Maaten and Hinton 2008) (Fig. 4.23).

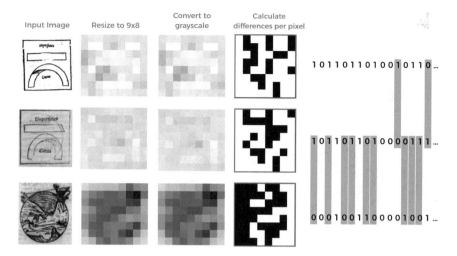

Fig. 4.23 Visualization in an adapted version of *VikusViewer*. In the top menu there all the *dHash* groups which can be selected to be highlighted. Distances between the images have been equalized

b. Clustering the network output

Although it is possible to group the images using *t-SNE* and a distance grouping scheme, this can easily go wrong (Wattenberg et al. 2016). *t-SNE* loses some information every time it removes a dimension. Therefore, we use it solely for visualization in a dimension we can understand, so we use it solely for its visualization abilities. We have decided to map the input to a plane and to use a distance scheme to group, as is typical among image datasets. A well-trained, specialized final network output would yield higher results than a means, but we would lose the process' general functionality and we would train and optimize for our own dataset alone. Replacing this last step with a neural network that is trained solely on a single grouping scheme can be an improvement if a higher score is needed.

For the clustering and grouping we use *k-means* (Lloyd 1982) implemented by *Scikit-Learn*, a tried and proven vector quantization method in which the amount of expected clusters has to be predefined. We had a good approximation of this information, but if it is not available or remains the subject of research, we recommend a different clustering scheme or that the number of groups found in the first round be utilized. This method finds a group for every image in the dataset. *k-means* clustering tries to minimize intra-cluster variances in an iterative manner by using their squared Euclidean distances as the vector to minimize. This process puts the data points in *voronoi* cells (Voronoï 1908), which indicate and visualize the border of each cluster (Fig. 4.24).

Fig. 4.24 *k-means* clustering of the *Sphaera*-image dataset visualized with *t-SNE*. The white dots are the clusters centroids (https://scikit-learn.org Last accessed June 17, 2020)

4.5.2 Results

The scores of the *dHash* method (Process A) finds 43% of images correctly and the residual neural network method (Process B) 72%. We expected some loss of accuracy compared to the *imagenet* benchmark (83%) mainly because of the generalized approach inherent in using the *k-means* method to group our output and differing dataset to *imagenet*. The *dHash* score is around its expected score for similar tasks (Fig. 4.25).

Fig. 4.25 Visualization in an adapted version of *VikusViewer*. Above there are the *dHash* groups which can now be compared: Group 0 is selected (all the images without a group)

4.5.3 Evaluation

We have learned that different approaches are advantageous in investigating a collection of images for their philological similarity. The various approaches can be used to yield false positives in one another's results by cross referencing and finding mistakes made in the general process.

The conventional method using the *dHash* algorithm is very fast, and the process is explainable. When investigating a dataset for irregularities, checking the quality of the data collected and the data preparation, it is a useful tool. If proof or explanation is needed, it is an advantage to have a clearly explainable algorithm. The neural network however boasts unprecedented accuracy in finding and mapping the groups of images into an easily visualizable space for analysis. In applying this method, we point our attention to one of the illustrations presented here: the representation of the terraqueous globe.

4.6 Diffusion, Communities, and Outlook

With our method, we were able to identify a group of 154 images representing the terraqueous globe as in (Fig. 4.3). The first advantage of such grouping becomes immediately evident when the illustrations are cross matched with standard metadata. By way of example, we show here the places of publication of the illustrations along a timeline (Fig. 4.26).

Fig. 4.26 Diffusion of the illustration representing the terraqueous globe from its first occurrence in Ingolstadt in 1526 toward other places of publication until ca. 1620. To improve visibility, we have deleted the instances for Rome (5 illustrations), Cologne (5 illustrations), Saint Gervais (2 illustrations), Geneva (1 illustration), and Padua (1 illustration)

This visualization shows that this illustration was first printed in Ingolstadt (Saco-bosco and Apian 1526) and then was rapidly adopted in Wittenberg, probably by re-carving the woodblock. Consistent with our results mentioned at the beginning of this work, the Wittenberg occurrence served as an amplifier all over Europe as shown by the adoption of the illustrations in the major early modern centers of book production: Venice, Paris, Antwerp, and Lyon.

In order to display the potential of our approach, we created a network to represent a community of book producers. In particular, we applied two conditions on the group of illustrations: we connected two book producers to each other when (a) at least one edition of each of them contains the illustration at hand, and (b) the two editions of each book producer were put on the market one after the other but within a time interval defined by the overlap of the two periods of work activity in the life of the two book producers. Moreover, as the scope of the present work is shy of a final encompassing historical interpretation (which would require work with all the clusters produced out of all the illustrations), we simplified the task by focusing only on the printers and ignoring the publishers, a choice that would prevent us from detecting the continuity of woodblock transmission. But that, at this stage, can nevertheless be neglected. Because of the fact that the group of illustrations at hand still requires a final round of clustering and cleaning, the resulting network displays possible commercial activities (due to travelling woodblocks) between places very distant from each other but in unrealistically short time intervals. To artificially avoid this problem—which will not appear when the analysis of the historical sources is completed at a deeper and more precise level—we decided to break down the entire network into as many network regions as there are regional areas represented in the data. These are regions that hold historical significance, such as those of Padua and Venice, or the great region of Paris, or the region that is delimited by Cologne, Frankfurt am Main, and Mainz. In this way we obtained a network constituted of seven discrete regions, each one chronologically oriented and representing a specific geographic area where treatises containing the illustration we are following were published. In this way, we can be more confident in defining communities of printers on the basis of woodblock circulation—at least more confident than we could be without any geographic or temporal limits. By way of example, we have zoomed in on the Venetian region (Fig. 4.27).

As mentioned, the network shown here cannot yet be seen as the final empirical network as extracted from the historical sources; some further clustering and cleaning are still needed and the role of the publishers (as distinguished from the one of the printers) must also be taken into consideration. However, it can already be observed that the great printer Girolamo Scoto (1505–1572), active on an international level, lies between the main sub-regions of the Venetian network. Moreover, the graph also displays the well-known economic vicinity of printers such as Domenico Basa (1500–1596) and Giovanni Battista Ciotti (1583–1635).

The empirical corroboration of all philological groups is not yet concluded. There-after, other groups, based on other forms of similarity, will be built according to the theoretical apparatus described in this essay. The community network, as well as the graphs that formalize the diffusion of visual knowledge in general, will finally

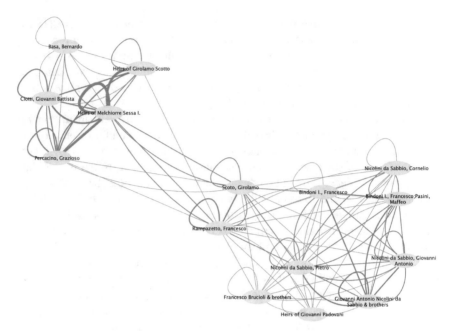

Fig. 4.27 Social network of Venetian early modern printers defined on the basis of the production of editions of the *Tractatus* that contain the illustration representing the terraqueous globe so to assume that those printers were using the same woodblock to print this specific illustration

become a mathematical matrix of the process of the evolution of visual knowledge in the cosmological textbooks of Europe in the early modern period. In general, we believe that this approach and this method will be transformed into a standard of the emerging field of computational history (Siebold et al. 2022).[13]

Acknowledgements The present work was also supported by the Berlin Institute for the Foundations of Learning and Data (BIFOLD-ref. 01IS18037A). We finally would like to express our gratitude to Beate Federau for her support in exploring the conceptual workflow for detecting communities among book producers through the identification of the circulation of woodblocks.

[13] The encompassing historical research is being accomplished in a PhD dissertation by one of the authors of the present work, Noga Shlomi. The title of the work is "The Evolution of Scientific Visual Language in Early Modern Science: A Machine-Learning Based Analysis," supported by the Cohn Institute for the History and Philosophy of Science and Ideas (Tel Aviv University), the Max Planck Institute for the History of Science (Berlin), and the Minerva Program of the Max Planck Society.

References

Ares Oliveira, S., B. Seguin, and F. Kaplan. 2018. *dhSegment: A generic deep-learning approach for document segmentation.* https://doi.org/10.1109/ICFHR-2018.2018.00011.

Axworthy, Angela. 2020. Oronce Fine and Sacrobosco: From the edition of the *Tractatus de sphaera* (1516) to the *Cosmographia* (1532). In *De sphaera of Johannes de Sacrobosco in the early modern period: The authors of the commentaries,* ed. Matteo Valleriani, 185–264. Cham: Springer Nature. https://doi.org/10.1007/978-3-030-30833-9_8.

Chollet, F. 2015. *keras.* https://github.com/keras-team/keras. Accessed 20 June 2020.

Chollet, F. 2017. Xception: Deep learning with depthwise separable convolutions. In *2017 IEEE Conference on computer vision and pattern recognition (CVPR),* 1800–1807. Honolulu, HI. https://doi.org/10.1109/CVPR.2017.195.

Daston, Lorraine. 2015. Epistemic images. In *Vision and its instruments: Art, science, and technology in early modern Europe,* ed. Alina Payne, 13–35. University Park, Pa.: The Pennsylvania State University Press.

Daston, Lorraine, and Peter Galison. 1992. The image of objectivity. *Representations* 40: 81–128.

De Domenico, Manlio, Mason A. Porter, and Alex Arenas. 2015. Multilayer analysis and visualization of networks. *Journal of Complex Networks* 3: 159–176.

Givens, Jean A. 1999. Observation and image-making in Gothic art. *Endeavour* 23 (4): 162–166.

Glinka, K., C. Pietsch, and M. Dörk. 2017. Past visions and reconciling views: Visualizing time, texture and themes in cultural collections. *Digital Humanities Quarterly* 11 (2).

Gortana, F., F. von Tenspolde, D. Guhlmann, and M. Dörk. 2017. *Coins.* https://uclab.fh-potsdam.de/projects/coins.

Grafton, Anthony T. 2013. Commentary. In *The classical tradition,* ed. Anthony T. Grafton, Glenn W. Most, and Salvatore Settis, 225–233. Harvard, Ma.: The Harvard University Press.

Hamming, R.W. 2013. Error detecting and error correcting codes. *The Bell System Technical Journal* 29 (2): 147–160. https://doi.org/10.1002/j.1538-7305.1950.tb00463.x.

He, R.W. 2015. *Deep residual learning for image recognition.* arXiv:1512.03385v03381.

Karras, Tero, Timo Aila, Samuli Laine, and Jaakko Lehtinen. 2017. *Progressive growing of GANs for improved quality, stability, and variation.* arXiv:1710.10196v10193.

Kemp, Martin. 1996. Temples of the body and temples of the Cosmos: Vision and visualization in the Vesalian and Copernican Revolutions. In *Picturing knowledge: Historical and philosophical problems concerning the use of art in science,* ed. Brian S. Baigrie, 40–85. Toronto: University of Toronto Press.

Kräutli, Florian, and Matteo Valleriani. 2018. Corpus*Tracer*: A CIDOC database for tracing knowledge networks. *Digital Scholarship in the Humanities* 33: 336–346. https://doi.org/10.1093/llc/fqx047.

Kravetz, N. 2013. *Kind of like that.* The Hacker Factor (blog). http://www.hackerfactor.com/blog/index.php?/archives/529-Kind-of-Like-That.html. Accessed 21 Jan 2013.

Kyle, Sarah Rozalja. 2017. *Medicine and humanism in late Medieval Italy: The Carrara Herbal, in Padua.* New York: Routledge.

Lloyd, S. 1982. Least squares quantization in PCM. *IEEE Transactions on Information Theory* 28 (2): 129–137. https://doi.org/10.1109/TIT.1982.1056489.

Lowe, David G. 2004. Distinctive image features from scale-invariant keypoints. *International Journal of Computer Vision.* https://doi.org/10.1023/B:VISI.0000029664.99615.94.

Maaten, Laurens van der, and Geoffrey Hinton. 2008. Visualizing data using t-SNE. *Journal of Machine Learning Research* 9: 2579–2605.

Moran, Bruce T. 2017. Preserving the cutting edge: Traveling woodblocks, material networks, and visualizing plants in early modern Europe. In *The structures of practical knowledge,* ed. Matteo Valleriani, 393–420. Cham: Springer Nature.

Müller, Kathrin. 2008. *Visuelle Weltaneignung. Astronomische und kosmologische Diagramme in Handschriften des Mittelalters.* Göttingen: Vandenhoeck & Ruprecht.

Müller, Kathrin. 2011. Gott ist (k)eine Sphäre. Visualisierungen des Göttlichen in geometrisch-abstrakten Diagrammen des Mittelalters. In *Handbuch der Bildtheologie: Zwischen Zeichen und Präsenz*, ed. Reinhard Hoeps, 311–355. Paderborn: F. Schöningh.

Nothaft, C. Philipp E. 2017. *Criticism of trepidation models and advocacy of uniform precession in Medieval Latin astronomy*. Berlin-Heidelberg: Springer.

Nuovo, Angela. 2013. *The book trade in the Italian Renaissance*. Leiden: Brill.

Oosterhoff, Richard J. 2018. *Making mathematical culture: University and print in the circle of Lefèvre d'Étaples*. Oxford: Oxford University Press.

Oosterhoff, Richard J. 2020. A lathe and the material sphaera: Astronomical technique at the origins of the cosmographical handbook. In *De sphaera of Johannes de Sacrobosco in the early modern period: The authors of the commentaries*, ed. Matteo Valleriani, 25–52. Cham: Springer Nature. https://doi.org/10.1007/978-3-030-30833-9_2.

Panofsky, Erwin. 1962. Artist, scientist, genius: Notes on the 'Renaissance-Dämmerung.' In *The Renaissance: Six essays*, ed. Ferguson K. Wallace, 121–184. New York: Harper & Row.

Pantin, Isabelle. 2014. Analogy and difference. A comparative study of medical and astronomical images in books, 1470–1550. In *Observing the world through images: Diagrams and figures in the early-modern art and sciences*, ed. Nicholas Jardine and Isla Fay, 9–43. Leiden: Brill.

Pantin, Isabelle. 2020. Borrowers and innovators in the printing history of Sacrobosco: The case of the "in-octavo" tradition. In *De sphaera of Johannes de Sacrobosco in the early modern period: The authors of the commentaries*, ed. Matteo Valleriani, 265–312. Cham: Springer Nature. https://doi.org/10.1007/978-3-030-30833-9_9.

Piccolomini, Alessandro. 1553. *Editione Tertia. Della Sfera del Mondo di M. Alisandro Piccolomini, divisa in libri quattro, i quali non per via di traduttione, ne à qual si voglia particolare scrittore obligati, ma parte da migliori raccogliendo, e parte di nuovo producendo, contengano in se tutto quel ch'intorno à tal materia si possa desiderare, ridotti a tanta agevolezza, et à cosi facil modo di dimostrare, che qual si voglia poco essercitato ne gli studij di Mathematica potrà agevolißimamente, et con prestezza incenderne il tutto. Di nuovo ricorretta, et ampliata. Delle Stelle Fisse. Libro uno con le sue figure et con le sue tavole, dove con maravigliosa agevolezza potrà ciascuno conoscere qualunque stella delle quarantaotto imagini del Cielo stellato, et le favole loro integramente, et sapere in ogni tempo del'anno, à qual si voglia hora di notte, in che parte del Cielo si truovino, non solo le dette imagini, ma qualunque stella di quelle*. Venice: Bartolomeo Cesano. https://hdl.handle.net/21.11103/sphaera.101047.

Piccolomini, Alessandro.1568. *Alexandri Picolhominei de sphaera libri quatuor, ex Italico in Latinum sermonem conversi. Eiusdem compendium de cognoscendis stellis fixis: & de magnitudine Terrae & Aquae liber unus, it idem Latinus factus. Ioan. Nicol. Stupano Rheto interprete*. Basel: Pietro Perna. https://hdl.handle.net/21.11103/sphaera.101113.

Pon, Lisa. 2004. *Raphael, Dürer, and Marcantonio Raimondi: Copying and the Italian Renaissance Print*. New Haven and London: Yale University Press.

Project Mirador. 2014. *Mirador IIIF image viewer*. http://projectmirador.org/.

Reeves, Eileen. 2017. The chiaroscuro woodcut in the early modern period. In *the structures of practical knowledge*, ed. Matteo Valleriani, 189–222. Cham: Springer Nature.

Rublee, E., V. Rabaud, K. Konolige, and G. Bradski. 2011. ORB: An efficient alternative to SIFT or SURF. In *2011 International conference on computer vision*. Barcelona. https://doi.org/10.1109/ICCV.2011.6126544.

Russakovski, Olga, Kia Deng, Hao Su, Jonathan Krause, Sanjeev Satheesh, Sean Ma, Zhiheng Muang, Andrej Karpathy, Aditya Khosla, Michael Bernstein, Alexander C. Berg, and Li Fei-Fei. 2015. ImageNet large scale visual recognition challenge. *International Journal of Computer Vision*. https://doi.org/10.1007/s11263-015-0816-y.

Sacobosco, Johannes de, and Petrus Apian. 1526. *Sphaera Iani de Sacrobusto astronomiae ac cosmographiae candidatis scitu apprime necessaria per Petrum Apianum accuratissima diligentia denuo recognita ac emendata*. Ingolstadt: Petrus Apianus. https://hdl.handle.net/21.11103/sphaera.100070.

Sacrobosco, Johannes de. 1516. *Sphera materialis*. Nuremberg: Jobst Gutknecht. https://hdl.han dle.net/21.11103/sphaera.100186.

Sacrobosco, Johannes de, and Christoph Clavius. 1611. *Christophori Clavii Bambergensis e Societate Iesu Operum Mathematicorum Tomus Tertius Complectens Commentarium in Sphaeram Ioannis de Sacro Bosco, & Astrolabium*. Mainz: Reinhard Eltz for Anton I Heirat. Reprint, Clavius, Christoph. In Sphaeram Ioannis de Sacro Bosco commentarius, ed. Eberhard Knobloch. Hildesheim: Olms-Weidmann, 1999. https://hdl.handle.net/21.11103/sphaera.100383.

Sacrobosco, Johannes de, and Philipp Melanchthon. 1568. *Iohannis de Sacro Busto Libellus de sphaera. Accessit eiusdem autoris computus ecclesiasticus, Et alia quaedam, in studiosorum gratiam edita. Cum praefatione Philippi Melanchthonis*. Wittenberg: Johann Krafft the Elder. https://hdl.handle.net/21.11103/sphaera.101112.

Sacrobosco, Johannes de, and Pedro Nuñez. 1537. *Tratado da sphera com a Theorica do Sol et da Lua. E ho primeiro livro da Geographia de Claudio Ptolomeo Alexandrino. Tirados novamente de Latim em lingoagem pello Doutor Pero Nunez Cosmographo del Rey Don João ho terceyro deste nome nosso Senhor. E acrecentatos de muitas annotaçiones et figuras per que mays facilmente se podem entender. Item dous tratados quo mesmo Doutor fez sobre a carta de marear. Em os quaes se decrarano todas as principaes du vidas da navegação. Con as tavoas do movimento do sol: et sua declinação. Eo regimento da altura assi ao meyo dia: como nos outros tempos. Com previlegio real*. Lisbon: Galharde. https://hdl.handle.net/21.11103/sphaera.101010.

Sacrobosco, Johannes de, Joannes Regiomontanus, and Georg von Peurbach. 1490. *Spaerae mundi compendium foeliciter inchoat. Noviciis adolescentibus: ad astronomicam rem publicam capessendam aditum impetrantibus: pro brevi rectoque tramite a vulgari vestigio semoto: Ioannis de Sacro busto sphaericum opusculum una cum additionibus nonnullis littera A sparsim ubi intersertae sint signatis: Contraque cremonensia in planetarum theoricas delyramenta Ioannis de monte regio disputationes tam acuratiss. atque utills. Nec non Georgii purbachii in erundem motus planetarum acuratiss. theoricae: dicatum opus: utili serie contextum: fausto sidere inchoat*. Venice: Ottaviano Scoto I. https://hdl.handle.net/21.11103/sphaera.100885.

Siebold, Anna and Matteo, Valleriani. 2022. Digital Perspectives in History. *Histories* 2(2): 170–177. https://doi.org/10.3390/histories2020013

Simonyan, Karen, and Andrew Zisserman. 2014. *Very deep convolutional networks for large-scale image recognition*. https://arxiv.org/abs/1409.1556.

Valeriano, Pierio. 1537. *Compendium in sphaeram per Pierium Valerianum Bellunensem*. Rome: Antonio Blado. https://hdl.handle.net/21.11103/sphaera.101194.

Valleriani, Matteo. 2017. The tracts on the sphere. Knowledge restructured over a network. In *Structures of practical knowledge*, ed. Matteo Valleriani, 421–473. Dordrecht: Springer.

Valleriani, Matteo. 2020. Prolegomena to the study of early modern commentators on Johannes de Sacrobosco's *Tractatus de sphaera*. In *De sphaera of Johannes de Sacrobosco in the early modern period: The authors of the commentaries*, ed. Matteo Valleriani, 1–23. Cham: Springer Nature. https://doi.org/10.1007/978-3-030-30833-9_1.

Valleriani, Matteo, and Nana Citron. 2020. Conrad Tockler's research agenda. In *De sphaera of Johannes de Sacrobosco in the early modern period: The authors of the commentaries*, ed. Matteo Valleriani, 111–136. Cham: Sringer Nature. https://doi.org/10.1007/978-3-030-30833-9_5.

Valleriani, Matteo, Florian Kräutli, Maryam Zamani, Alejandro Tejedor, Christoph Sander, Malte Vogl, Sabine Bertram, Gesa Funke, and Holger Kantz. 2019. The emergence of epistemic communities in the Sphaera Corpus: Mechanisms of knowledge evolution. *Journal of Historical Network Research* 3: 50–91. https://doi.org/10.25517/jhnr.v3i1.63.

Voronoï, Georges. 1908. Nouvelles applications des paramètres continus à la théorie des formes quadratiques. Deuxième mémoire. Recherches sur les parallélloèdres primitifs. *Journal Für Die Reine Und Angewandte Mathematik* 134: 198–287.

Wattenberg, Martin, Fernanda Viégas, and Ian Johnson. 2016. How to use t-SNE effectively. *Distill*. https://doi.org/10.23915/distill.00002.

Werner, Sarah. 2019. *Studying early printed books. 1450–1800. A practical guide*. Hoboken, NJ: Wiley Blackwell.

Witcombe, Christopher L.C.E. 2004. *Copyright in the renaissance: Prints and the privilegio in sixteenth-century Venice and Rome.* Leiden: Brill.

Zamani, Maryam, Alejandro Tejedor, Malte Vogl, Florian Kräutli, Matteo Valleriani, and Holger Kantz. 2020. Evolution and transformation of early modern cosmological knowledge: A network study. *Scientific Reports—Nature* 10: 19822. https://doi.org/10.1038/s41598-020-76916-3.

Matteo Valleriani is research group leader at the Department I at the Max Planck Institute for the History of Science in Berlin, honorary professor at the Technische Universität of Berlin, and professor by Special Appointment at the University of Tel Aviv. He investigates the relation between diffusion processes of scientific, practical, and technological knowledge and their economic and political preconditions. His research focuses on the Hellenistic period, the late Middle Ages, and the early modern period. Among his principal research endeavors, he leads the project "The Sphere: Knowledge System Evolution and the Shared Scientific Identity of Europe" (https://sphaera.mpiwg-berlin.mpg.de), which investigates the formation and evolution of a shared scientific identity in Europe between the thirteenth and seventeenth centuries. Among his publications, he has authored the book *Galileo Engineer* (Springer 2010), is editor of *The Structures of Practical Knowledge* (Springer Nature 2017), and published *De sphaera of Johannes de Sacrobosco in the Early Modern Period. The Authors of the Commentaries* (Springer Nature 2020). Together with Andrea Ottone, he also published Publishing Sacrobosco's *De sphaera in Early Modern Europe. Modes of Material and Scientific Exchange* (Springer Nature 2022)

Florian Kräutli is Knowledge Graph Engineer and Digital Humanities Specialist at the Swiss Art Research Infrastructure (SARI), University of Zurich. Before joining SARI, he led the Digital Humanities activities at the Max Planck Institute for the History of Science in Berlin (2016–2020). His research focusses on digital methods for knowledge production in the humanities, specializing in knowledge representation and visualization. He obtained a Ph.D. in this area at the Royal College of Art, London (2016). Previously he completed an MSc in Cognitive Computing at Goldsmiths, University of London (2012), focussing on philosophy of perception and artificial intelligence, and trained as a designer at the Design Academy Eindhoven (2009).

Daan Lockhorst studies visual computing at the HTW berlin. He currently is a research assistant for projects "The Sphere: Knowledge System Evolution and the Shared Scientific Identity of Europe" at the Max Planck Institute for the History of Science, Berlin.

Noga Shlomi is a doctoral student at the Cohn Institute for the History and Philosophy of Science and Ideas at the Tel Aviv University since 2019. She is writing her PhD dissertation on the evolution of visual language in Early Modern Cosmology under the supervision of professor Matteo Valleriani and professor Yossef Schwartz, as part of the project "The Sphere: Knowledge System Evolution and the Shared Scientific Identity of Europe" (https://sphaera.mpiwg-berlin.mpg.de) at the Max Planck Institute for the History of Science, Berlin. She has completed her master's degree in the Cohn Institute and holds a BFA from the Bezalel Academy of Art and Design, Jerusalem.

Part II
Transformation

Chapter 5
Theorizing Technology: *Theōria*, Diagram, and Artifact in Hero of Alexandria

Courtney Ann Roby

Abstract Hero of Alexandria, who probably dates to the first or second century CE, produced treatises on a wide range of scientific and technical topics: geometry, surveying, catapult design, elaborate pneumatic devices, and more. The term *theōria* and its cognates appear throughout Hero's works to reflect a set of disciplined observational activities that interrogate the links between text and artifact, the boundaries between nature and the artificial structures (including texts) that mediate our experience of it, and the limits of our ability to observe and describe the world around us. The objects observed include natural phenomena and artificial devices, as well as the diagrams in Hero's own texts and the logical structures that underlie the systematic frameworks of his books. This paper will examine the interplay in Hero's *Dioptra*, *Belopoeica*, and *Pneumatica* between "diagrammatic" and "theoretical" ways of subjecting technological artifacts to forms of visual discipline. Though Hero's *theōria* certainly embraces a wide range of ways of seeing, they cluster semantically around their ability to link domains—the abstract and the concrete, the mathematical and the material, objects in the world and diagrams in the text—while preserving the truth value of observations as they move between domains.

Keywords Greco-Roman science · Mechanics · Diagrams · Thought experiments · Proof

5.1 Introduction: Theorizing Hero

The Greek "theoretical" always carries with it the semantic traces of its roots in vision, though the range of types of visual experience it can summon up is very broad. Andrea Nightingale identifies Plato's (428–348 BCE) contemplative *theōria* as an extension of a longstanding Greek social institution (also called *theōria*) where a citizen of one city would travel to another to observe a civic festival, and then return

C. A. Roby (✉)
Cornell University, Ithaca, USA
e-mail: croby@cornell.edu

© The Author(s), under exclusive license to Springer Nature Switzerland AG 2023
M. Valleriani et al. (eds.), *Scientific Visual Representations in History*,
https://doi.org/10.1007/978-3-031-11317-8_5

to his own city to relate his experience to his fellow citizens. For Plato, philosophical *theōria* likewise involves a round-trip journey to another domain, from which the philosopher brings back "divine and true" knowledge for others to partake in (Nightingale 2004, 187). Nightingale finds that while Aristotle's account of *theōria* involves a similar mechanic of dispatching one's vision to another domain, he abandons the metaphor of the return journey, rendering *theōria* "an activity that is radically cut off from social life" (Nightingale 2004, 189). The Aristotelian idea of *theōria* as a solitary activity confined to a domain of contemplation rather than action came to dominate much later interpretation of the term. As Nightingale notes, however, this interpretation is reductive even for Aristotle, as it ignores the fragment of the *Protrepticus* where Aristotle now indicates that the philosophical theorist is a craftsman who performs "demiourgic" tasks in the practical sphere. As he claims, "this knowledge is theoretical, but it enables us to fashion (*dēmiourgein*) all things in accordance with it" (Nightingale 2004, 197).

A return or a one-way journey, operating between worldly or purely contemplative domains, resulting in shared or hoarded knowledge that might apply to material, social, or purely contemplated objects: clearly *theōria* can engage an extraordinarily varied set of modes of seeing. In what follows I will examine how these modes play out the dynamics of *theōria* in the works of Hero of Alexandria, an ancient author on mechanics who (like Aristotle's philosophical demiurge) gives his reader tools for visualizing targets that range from objects in the book itself, to objects in the real world, to abstract objects never instantiated anywhere physically.[1]

Like many scientific and technical authors in antiquity, Hero adapts the proof-and-diagram structures characteristic of Greek geometrical texts in order to make claims of his own. These diagrams, a visual tool enmeshed in a verbal argument, suggest a host of epistemological and ontological questions. Just what is a diagram, and how does it work to mediate seeing? What kind of relationship connects the diagram instantiated on the page with the mathematical objects it represents, and the mental images upon which the geometer may work alongside the object on the page? Why do we allow ourselves to transfer the mechanisms of proof between these domains?

In moving from the territory of Greek mathematics to that of Greek technical disciplines that drew some of their methods from mathematics and others from craft practices, we are confronted with a new set of questions. Under what circumstances do we allow ourselves to perform comparable truth-transferring operations that not only span the diagrammatic and geometrical domains, but extend as well to material objects beyond the diagram? To what extent can a mechanical construction be said to resemble a geometrical construction, and how can diagrams serve to mediate between the mathematical and material domains? Certain attributes of an artifact under construction, like the materials of which it is composed, the names and sizes

[1] Hero most likely lived during the first or second century CE, though his dates are controversial and scholars have suggested alternatives ranging from the third century BCE to the third century CE (Keyser 1988; Asper 2001; Hero 2003, 8–30; Sidoli 2011).

of its components, claims and proofs about how its components function, are typically expressed verbally rather than visually in ancient texts. Other attributes, like the combination of multiple components into a complex structure or a geometrical analogue for a precisely-shaped component, are very often adumbrated with the aid of a diagram. The diagram provides a site where those attributes can be experienced with the immediacy of a visual encounter, which can reinforce, supplement, or even challenge the verbal text.

Hero of Alexandria's corpus is a particularly rich field for exploring these questions, as he composed a broad spectrum of texts including works on pure geometry, surveying, theoretical mechanics, and applications of mechanics from building catapults to designing elaborate theatrical automata. He presents his readers with both verbal and visual descriptions of a vast range of objects: the *Definitiones* and *Metrica* present readers with geometrical objects like cylinders and pyramids as well as their real-world analogues like bathtubs and vaulted roofs; the *Belopoeica* and *Cheiroballistra* describe ballistic machines in respectively lower and higher degrees of detail; the *Automata* presents two types of elaborate theatrical automaton, and so on. Throughout his corpus of texts, Hero emphasizes that he means to open up the various subdisciplines of mechanics to a broad audience, making material that had for too long remained the purview of specialists accessible even to beginners. His strategies included careful organization of information from simpler to more complex designs, engagement with contemporary philosophical questions about the best way to acquire knowledge or secure happiness, and vivid descriptions of mechanical constructions at work.

Perhaps the most powerful tools in Hero's accessibility arsenal, however, were the diagrams he used to illustrate everything from geometrical problems to machine designs to observations of the celestial sphere. Every surviving text is filled with elaborately letter-labelled diagrams, signalling that the verbal text is always meant to be contemplated alongside its companion images. Furthermore, Hero couples the immediately available visual elements of the books with additional stipulations for how to carry the kind of orderly viewing his letter-labelled diagrams enable out into the real world. His reader learns how to conduct careful observations of terrestrial and celestial territories alike with a precision surveying instrument, how to create pneumatic devices that amplify minute physical phenomena to make them visible through artificial means, and how to build conceptual connections between the natural world and the mechanic's artifice. Diagrams in the text become a kind of overlay in the world as Hero's reader learns to see through the text and activate its visual elements for himself.

Hero uses *theōria* and its cognates to encompass a variety of acts of observation and cognition disciplined by tools ranging from external instruments to the text itself. The objects observed include natural phenomena and artificial devices, as well as the spatial and logical structures that underlie the systems he studies. In its breadth of application, the term seems in Hero's works to defy narrow definitions that would enclose it on one side or the other of the divides between the natural and the artificial, the concrete and the abstract, the text and the world. Yet this is not to say the term's use in the corpus is indefinably broad. The term and its cognates, along with a

small group of other recurring terms, instead reflect a set of structured observational activities that interrogate the links between disciplines and their methodologies, the boundaries between nature and the artificial structures (including texts) that mediate our experience of it, and the limits of our abilities to observe and describe the world around us. Hero's cultural context of course means that the tools his reader had for bridging between the book and the world, and between nature and artifice, were quite different from those available to readers and practitioners of early modern science or contemporary technoscience. Nevertheless, the way Hero engages visual aspects of his texts to build those conceptual bridges reveal some striking common ground.

5.2 Ways of Seeing in Early Greek Science

Ancient Mediterranean practices of securing and propagating knowledge about the natural world of course took some very different forms from those more familiar from early modern Europe. The complete absence of any kind of standardized scientific training, certification, or institutions (public or private) which might have supported their development created a very different world for patrons, authors, and consumers of scientific and technical texts. As Markus Asper has observed, no public institutions analogous to the competitive Athenian festivals of comedy and drama supported the competitive refinement of genres of scientific writing (Asper 2007, 48–51). The only close analogue might have been the competitive medical displays of bandaging, surgery, and other skills attested from the classical period onward. We know little about education in scientific or technical disciplines, but at least in the case of medicine, knowledge was transmitted through a system of apprenticeship. A doctor might have one teacher or many in the course of his career, but in the absence of any formal educational institutions, teaching was a small-scale affair.

Likewise, the propagation of scientific and technical knowledge was a slow trickle of information communicated gradually to other experts, to patrons, or to the broader reading public. Crowds of viewers might gather around one of the physician Galen's (born 129 CE) public animal vivisections (Gleason 2009), or gaze astonished at Archimedes' (288–212 BCE) display of the power of a multiple-pulley system to single-handedly launch a giant ship (Athenaeus *Deipnosophistai* 206D–207E). Yet there was no mechanism to capture these events for viewers who could not be on the scene, like the photographs of life aboard the HMS Challenger Stephanie Hood discusses in this volume (Chap. 9). The absence of printing technology meant that any images had to be copied by hand, a process whose vulnerability to accidental alteration provoked Galen to warn students of medicine away from relying on books as sources of information on anatomical structures, and Pliny the Elder (died 79 CE) to criticize attempts to represent plant species visually (Galen *De anatomicis administrationibus*, 2.220–221 K; Pliny *Natural History* 25.4.8). Marcello Malpighi's (1628–1694) precise observations of chicks at different growth stages could not have been propagated in antiquity, since before long the copies' precision would have deteriorated so far.

Hence autopsy—seeing for oneself—took on a particularly privileged role in antiquity, and not only for experts. Galen tells his students to dissect animals of all kinds early and often, Pliny tells his reader to get out of the lecture hall and into the fields to directly experience the characteristics of different types of plants, and Aristotle (who might be seen as an early analogue of Malpighi) reports his own observations of chicken eggs at different phases of development in a way that encourages the reader to try observing for himself. So, for many scientific disciplines in antiquity, the epistemologically valid visual was something found in the world, not in books. Yet there were a few exceptions, mostly drawing on mathematics as a foundation: astronomy, mechanics, and associated technical disciplines like surveying. These disciplines found techniques of visualization and information transmission that lent themselves well to the textual technologies available in antiquity, and Hero's work falls squarely within this territory.

Techniques for exploring and explaining the world, with a strong emphasis on the visual, had been under development in Greece since at least the sixth century BCE. The so-called "Presocratic" philosophers including Thales (624–548 BCE), Empedocles (born 494 BCE), and Heraclitus (520–460 BCE) had developed a diverse array of physical theories involving elemental matter and ordering principles, like Empedocles' four elements under the constant shifting influence of Love and Strife (White 2008). The elemental theories of the Presocratics strongly influenced the development of Hippocratic medicine, where they were coupled with an emphasis on autopsy, creating a newly strengthened role for the visual in structuring scientific theory (van der Eijk 2008). Over the next few centuries, the ideal balance between explanatory theory and direct evidence in medicine would be hotly contested in the battle between the "rationalist" and "empiricist" sects (Galen 1985; Berrey 2014).

During the Hellenistic period, developments like these in the larger context of Greek science were mirrored in specifically textual technologies for engaging vision in the exploration of the world. There were of course many complex reasons for these developments, including Hellenistic court cultures and the institutions of learning and discourse they sponsored, including of course the Library of Alexandria. The Library's structure, functions, and relationship with the surrounding court and citizens (to say nothing of its destruction) are less well understood than some cut-and-dried accounts might suggest (Hatzimichali 2013). Whatever resources and personnel the Library and Museum actually comprised, it is clear that literary and scientific enterprises at Alexandria centered on the court and its sponsored institutions created a host of new practices both for encoding knowledge in text and for transforming it into spectacles that could be appreciated by an audience of lay patrons.

Apollonius of Citium exemplified the Hellenistic-era transformation of specialist scientific knowledge into textual spectacles which might appeal to experts and laymen alike. He dedicated his commentary to the Hippocratic treatise *On Joints* (*In Hippocratis de articulis commentarius*) to a "king Ptolemy," most likely to be identified as Ptolemy Auletes, who ruled at Alexandria in the first century BCE (Flemming 2007, 455). His book, which as Asper points out is the earliest surviving medical commentary, is devoted more to highlighting and explicating what Apollonius deems the most important passages of the Hippocratic work than to critical engagement

(Asper 2013, 44). Apollonius' innovation comes rather from blending his textual explanations with images (*hypodeigmata*), versions of which still survive in a tenth-century manuscript copy (Berrey 2017, 140–45; Stückelberger 1994, Figs. 30–31). Apollonius frequently refers to his images as explanatory tools that will help the reader understand just how a certain arrangement of limbs and traction systems works (e.g. *On joints* 10.4, 20.10, 20.38, 31.2), which ought to be particularly useful when the method is unfamiliar (18.12–17).

He promises to teach his material to the reader "with naturalistic scene-paintings furnishing an image of each part of the dislocation and the limbs in a way clear to the eye."[2] Berrey contextualizes Apollonius' choice of "naturalistic" images rather than sparse diagrams as part of an effort to appeal to his royal patron through a contribution (*eranos*) that a relative layman will not find intimidating; these "images are presented in a manner easily accessible to a lay viewer, who needs no imagination or technical clarification to understand the image on the page" (Berrey 2017, 127, 142).

Apollonius' joint-setting machine already suggests the blending of the scientific and technical which would produce what Berrey calls "hybridization," which is to say "the breaking down of traditional generic and ontological distinctions, such as that between Greek and Egyptian customs or between different sciences" (Berrey 2017, 28). Eratosthenes of Cyrene (276–194 BCE), who succeeded Apollonius of Rhodes (born 295 BCE) as head of the Library around the middle of the third century BCE (P. Oxy. 1241), perhaps exemplified Hellenistic generic hybridity most fully. The very breadth of his work earned him the nickname "Beta," at best a rather backhanded compliment. In another backhanded move, Strabo calls him a "mathematician among geographers, a geographer among mathematicians," and elsewhere straightforwardly criticizes him as a dilettante philosopher and desultory fun-seeker (Strabo *Geography* 2.1.41, 1.2.2).

Though Eratosthenes composed philological, historical, and poetic works, he is better known for his technical works. These include a geography (partly preserved in Strabo), a work on calculating the circumference of the earth, and a text on the duplication of the cube (that is, how to find the edge length of a cube with double the volume of a given cube) (Eratosthenes et al. 2010; Taub 2008; Berrey 2017, 147, 164–178). The latter treatise takes the form of a letter likely addressed to Ptolemy III of Egypt (Taub 2017, 55), preserved in Eutocius' commentary to Archimedes' *Sphere and Cylinder* alongside solutions to the problem from other authors, including Hero. Liba Taub calls the letter a "mosaic," an apt characterization of its heterogeneous contents (Taub 2008). Eratosthenes sets a fable-like history of the problem alongside a geometrical solution, gives a description of the "mesolabe," an instrument for solving the problem mechanically, and an account of a stele surmounted by a real mesolabe, and even closes with an epigram celebrating the mesolabe's many practical applications. The text is a remarkable display of the author's command of cultural

[2] τοὺς δὲ ἑξῆς τρόπους τῶν ἐμβολέων δι' ὑπομνημάτων, ζωγραφικῆς δὲ σκιαγραφίας τῶν κατὰ μέρος ἐξαρθρήσεων παραγωγῆς τε τῶν ἄρθρων ὀφθαλμοφανῶς τὴν θέαν αὐτῶν παρασχησόμεθά σοι (*On joints* 2.30–33).

domains including mathematics, mechanics, and poetic composition, as well as the device's utility for solving practical problems including the construction of wells, grain-pits, and cattle enclosures. Each transition Eratosthenes performs between the mathematical and material domains imposes a regime of viewing all its own on the reader, from the diagram in the proof, to the movable calculating machine, to the real-world constructions the calculator makes possible.

The graphical "hybridity" exhibited by Hellenistic technical projects like those of Apollonius and Eratosthenes link them to the developing discipline of mathematics. Greek geometrical texts exhibit a remarkable stability from the earliest examples, through their Hellenistic heyday, and beyond into late antiquity. Since Hero adopts (and adapts) many of their characteristics, a brief overview is perhaps in order here. Geometrical proofs proceed formally through a series of stages, including *protasis* (enunciation), *kataskeuē* (construction), and *apodeixis* (proof) (Netz 1999, 10–11). Some later mathematicians, notably Archimedes, take a looser approach to proof construction, leaving it to the reader to infer some of the stages, but most authors follow the formula with reasonable fidelity.

The action of the proof nearly always plays out in an impersonal voice, usually distinctive third-person passive imperatives like "*estō*" ("let there be"), which (as one might imagine) rarely appear in other genres of Greek text. Under this regime, the proof is carried out not by authorial claims to direct action, nor by direct orders to the reader to take action, but by a mysterious force denoted by Taisbak and Fowler as the "Helping Hand,"

> a well-known factotum in Greek geometry who takes care that lines are drawn, circles are described, points are taken, perpendiculars are dropped, etc. The perfect imperative passive is its verbal mask: "Let a circle have been described (γεγράφθω) with center A and radius AB." (Fowler and Taisbak 1999, 362)

The impersonal tone the "Helping Hand" affords is violated much less often than the strict order of proof stages, save the formulaic "*legō*" ("I say") that signals mathematical claims being made. The impersonal commands, presented as carried out by the "Helping Hand," contribute to what Asper describes as "presence without cause" that suggests objectivity (Asper 2007, 126). The convention of structuring mathematical discourse impersonally might have emerged from a Platonist conviction that mathematical objects belong properly to the domain of Forms, but this is far from certain (Fowler and Taisbak 1999, 362). What is certain is that the diction of geometrical texts is merely a convention (albeit one that has survived into modern mathematical texts), as mathematical texts of other kinds, like the Babylonian calculation texts and their Greek analogues (even including some in the Heronian corpus), use direct imperatives to a "you" addressee (Asper 2007, 198–199). Geometrical texts could have been written this way too, but their generic conventions dictated otherwise. When Hero adopts this language in his mechanical works, he is making a marked statement linking his work to the high-status works of the geometers.

Diagrams are a universal feature of Greek geometrical texts. Geometrical diagrams consist of assemblages of lines and circular arcs, labelled with letters that provide reference back to the text of the proof (usually one letter for a point, two for a

line segment, three for a circle). The diagram is not an optional accessory to make the text more visually enticing, but is epistemologically *essential* to the proof, as Netz has shown (Netz 1999). Almost all surviving diagrams from ancient texts are preserved in manuscripts written centuries later than the texts themselves. A few mathematical and astronomical diagrams survive in papyri, but those that survive are, unsurprisingly, later copies of earlier texts. For example, the so-called "Eudoxus papyrus" (P. Par. 1), a quite early example of an illustrated papyrus, probably dates to the second century BCE (Weitzmann 1947, 49–50; Jones 2009, 345). This papyrus in fact contains not a text of Eudoxus but an astronomical miscellany citing him among others, so-called from an iambic acrostic on the *verso* which spells out his name. Its line drawings, in red and black ink, depict the zodiacal constellations, as well as interactions between cosmic bodies such as eclipses. Surviving mathematical papyri with tables and other images include a set of division tables (P. Cair. [inv.] 10,758), a collection of stereometric problems with diagrams (P. Vindob. [inv.] 19,996), and four papyri of Euclid's *Elements* (P. Herc. 1061, P. Oxy. I 29, P. Fay. 9, P. Berol [inv.] 17,469) (Worp et al. 1977; Fowler 1999, 204–217, 229–278, 1995; Jones 2009). "Technical" texts (except for medicine) are even more sparsely represented among the surviving papyri than mathematical and astronomical texts.

The earliest surviving generations of codex manuscripts are bereft of images. Not until the sixth century CE do we find surviving technical illustrations like those in the surveying texts of the *Corpus Agrimensorum* or Dioscorides' pharmacological *De materia medica* (Buberl 1936; Riddle 1985, 180–217; Orofino 1991; Stückelberger 1994, Figs. 17–22, 37–38; Mauch 2006; Hudler 2008).[3] Yet those works are very richly illustrated, and at least in the case of the *Corpus Agrimensorum* the graphical "language" of the images resembles that of surviving surveying documents from antiquity like the monumental marble cadastral plan of Orange, suggesting that at least some technical visual traditions remained in continuous use from antiquity, even if their media do not now survive.

The earliest surviving manuscripts of Hero's works are from the tenth century CE, and the earliest manuscript of the *Pneumatica* dates to the thirteenth century CE. The images in more "mathematical" works like the *Definitiones* tend to closely resemble those in surviving manuscripts of Euclid (and indeed the Euclid papyri): sparse diagrams of geometrical objects drawn with compass and straightedge. Those in works like the *Pneumatica* and *Automata* combine neat renderings of the internal hydraulic machinery of pipes and valves with the imaginative designs of animals, trumpeters, and other features that adorned the exterior of those pneumatic wonders (Fig. 5.1). The works on catapult design feature schematic diagrams of the catapults' mechanisms, sometimes separated into a kind of "exploded diagram" (Fig. 5.2). Unlike manuscripts of Apollodorus's (born 180 BCE) work on siege warfare (likely

[3] Carder analyzes the images in the Wolfenbüttel "Arcerianus A," one of the oldest manuscripts of the *Corpus Agrimensorum*, and Dilke discusses the images in the corpus more broadly (Carder 1978; Dilke 1967). André Piganiol provides the most comprehensive guide to the Orange cadastral map (Piganiol 1962). Sachiko Kusukawa discusses the reception of Dioscorides in early modern botanical and pharmacological works (Kusukawa 2011, 125–136).

Fig. 5.1 Hydraulic automaton featuring owl and singing birds from Hero's Pneumatica. Codex Marcianus 516 Gr. Z 516, fol. 172v. Biblioteca Marciana. Su concessione del Ministero della Cultura—Biblioteca Nazionale Marciana. Divieto di riproduzione

written just a few decades after Hero's work), Hero's *Belopoeica* and *Cheirobal-listra* do not show images of complete machines in the act of besieging an enemy (Stückelberger 1994, Fig. 35; Apollodorus 1999).

What faith can we place in the surviving images in Hero's corpus, which postdate him by several centuries? After all, images can change drastically from one copy of a manuscript to another, or even be left out entirely (Lefèvre 2002). The scribe who writes the words of a manuscript was not usually the same person who drew its images, and the two tasks could be completed in either order (though usually the words came first). But the images in the surviving manuscripts of Hero's texts, from the tenth to the seventeenth century, are remarkably stable. In texts like the *Pneu-matica*, the specific appearance of a decorative element like a steam-hissing dragon may change from one diagram to another, but the hydraulic "guts" of the machine are depicted in the same way. Hero uses letter labels as liberally as a mathematical author, creating a mechanism for checking the correspondence between text and image. Other authors, like Apollodorus for example, do not use letter labels in the text, and the resulting images (which contain only word labels denoting machines

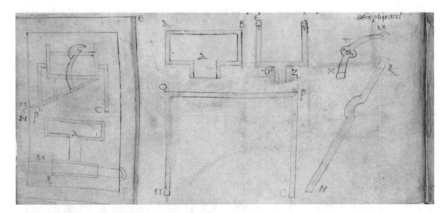

Fig. 5.2 Trigger assembly components from Hero's *Cheiroballistra*. Codex Parisinus suppl. gr. 607, fol. 56v. Bibliothèque Nationale de France

or their components, or none at all) change a great deal from one manuscript to the next. Hero also makes frequent in-text references to his images, stipulating whether they are found before or after the corresponding text, and in some cases pointing out important features of the diagram. Between his generous use of letter labels, other references to the diagram, and the fact that the diagrams are largely intended to show schematic, mechanical elements rather than depict specific elements of decoration or scenes of catapults besieging cities, Hero's diagrams are among the most stable of surviving technical images. But all the same there are still variations between manuscripts, and claims about "original" images must always be approached with a great deal of caution.

5.3 Theorem and Diagram in Hero

Hero knits together the objects he describes from the two quite different subsets of information presented by the text's verbal and visual components in such a way that the reader can shift easily between them. He often relies on techniques of reference adapted closely from the geometers' language, like connecting the object in the world and its diagram with a simple "let [a component of the machine] be (*estō*) [a component of the diagram]." The presence of the "Helping Hand" can readily be seen in the way he presents mechanical components, for all that they are definitively the product of human work rather than Platonically ideal structures. The tight connection Hero establishes between the diagram and the machine blurs the distinction between them, whereas other mechanical authors draw attention to that distinction by using more cumbersome references like "let the arm be where the letters AB are" and so forth (Roby 2016b, 166–181). Diagrams in the Heronian corpus are not always mentioned explicitly in the text even when they are clearly intended to be present (based on the

inclusion in the text of letter labels or references to geometrical manipulations), but the interactions of verbal and visual elements can be more precisely guided when they are referenced directly by terms like *schēma* (*form*) or *theōrēma*, or by various forms of *graphein* (*write/draw*).

Hero sometimes references marking up artifacts in such a way that the diagram might be viewed as participating in the artifact itself. For example, he recommends using a template for constructing the washer of a catapult (which connects the skeins of twisted sinew spring-cord that give the catapult its ballistic power to the machine's frame) in the *Belopoeica*:

> The washer is made in this way. It is necessary to construct a template similar to the below-drawn ABΓΔEZ, which [i.e. the diagram] has circumferences AE and BZ, and lines EΓ and ZΔ, AB equal to the diameter of the bore-hole, and to miter out the washer against this. If it [i.e. the washer] is going to be bronze, it is necessary to mold it while ductile in a circle from beaten bronze, making its width sufficient for the power of the weapon.[4]

The form of the washer thus evolves through three stages: the diagram in the text serves as a model for the template diagram, which is sized according to the user's specific needs and constructed on a separate object (perhaps papyrus or light wood) before being cut out and used to size the washer, thus becoming a permanent part of the machine.

In the *Belopoeica*, the form of the "hole-carrier" into which the spring is packed is first defined using a geometrical diagram which serves as a model for the hole-carrier's proportions, though not its dimensions (Fig. 5.3). It is particularly important that the hole-carrier be accurately sized and shaped, because the catapult's firing capacity is proportionally linked to the cube of its diameter. Hero describes its construction as follows:

> The oblique walls are called "hole-carriers," and they are made in the following way. It is necessary for a right-angled parallelogram ABΓΔ to be placed in it, having AB double BΓ; when AΓ has been joined, it is necessary to draw a parallel ΔE to this through Δ, and this will be the form of the hole-carrier AΓEΔ.
>
> Once AE has been joined, it is necessary to draw a circle around the center Z equal to the hole receiving the spring, and through this circle to drive in the aforementioned borehole. Drawing HΘ and KΛ parallel to AΔ and ΓE, which cut off at AΔ and ΓE the same widths as the depths of the side-support and opposite-support, [it is necessary] to drive the bore-holes into the tenon joined to the side-support and opposite-support, M, N, Ξ, and O, not through the whole depth of the hole-carrier, but leaving off for the tenons about a third of the depth for the sake of the framework and appearance.[5]

[4] (*Belopoeica* 20.1–13): Ἡ δὲ χοινικὶς γίνεται τόνδε τὸν τρόπον· ἐμβολέα δεῖ κατασκευάσαι ὅμοιον τῷ ABΓΔEZ ὑπογεγραμμένῳ, ἔχοντι τὰς μὲν AE, BZ περιφερείας, τὰς δὲ EΓ, ZΔ εὐθείας, τὴν δὲ AB ἴσην τῇ τοῦ τρήματος διαμέτρῳ, καὶ πρὸς τοῦτον ἐκτορνεύσασθαι τὴν χοινικίδα· ἐὰν μὲν χαλκῆ μέλλῃ ὑπάρχειν, διαπλάσαντα κύκλῳ χυτὴν ποιῆσαι ἀπὸ ἐλατοῦ χαλκοῦ, πάχος ποιοῦντα τὸ αὔταρκες πρὸς τὴν τοῦ ὀργάνου βίαν.

[5] (*Belopoeica* 18.1–29): Οἱ δὲ πλάγιοι τοῖχοι καλοῦνται μὲν περίτρητα, γίνονται δὲ τὸν τρόπον τοῦτον· ἐγκεῖσθαι δεῖ παραλληλόγραμμον ὀρθογώνιον τὸ ABΓΔ, διπλῆν ἔχον τὴν AB τῆς BΓ, καὶ ἐπιζευχθείσης τῆς AΓ, παράλληλον ἀγαγεῖν δεῖ ταύτῃ διὰ τοῦ Δ τὴν ΔE, καὶ ἔσται τὸ σχῆμα τοῦ περιτρήτου τὸ AΓEΔ· ἐπιζευχθείσης δὲ καὶ τῆς AE, περὶ κέντρον τὸ Z

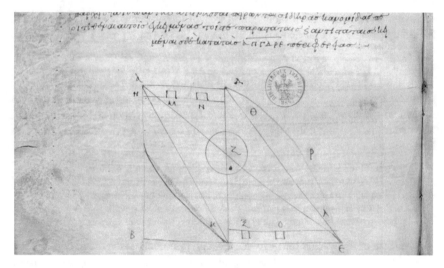

Fig. 5.3 Template for catapult's "hole-carrier" in Hero's *Belopoeica*. Cod. Parisinus Suppl. grec 607, fol. 50v. Bibliothèque Nationale de France

Hero narrates this diagram's construction in a way that elides the difference between the diagram and the wooden artifact based on it. The work of constructing the diagram is assimilated to the work of constructing the hole-carrier through a gradual process: first the parallelogram ΑΒΓΔ is constructed, then the figure ΑΓΕΔ, which is identified as "the form (*schēma*) of the hole-carrier." The circle inscribed in that figure is at first just "equal" (*ison*) to the hole in which the spring will be packed, but from this point on the diagram undergoes the same actions as the hole-carrier itself. When the borehole is made in the hole-carrier, it is made in the diagram; when the form on the diagram is further delineated by the construction of ΗΘ and ΚΛ, so is the hole-carrier, and so forth.

Even where Hero departs from the simple equivalence of "let it be (*estō*)" he emphasizes the similarity between object and diagram. His *Cheiroballistra* (which does not survive in its entirety) describes how to construct a single type of relatively small catapult in much greater detail than the *Belopoeica*'s overview. Each mechanical element in the surviving text receives detailed attention, both verbal and visual. So, for example, the diagrams included in the *Cheiroballistra* interact with the accompanying verbal description in the instructions for building the "mini-arch (*kamarion*)" and "mini-ladder (*klimakion*):"

κύκλον γράψαι ἴσον τῷ τρήματι τῷ τὸν τόνον δεχομένῳ, καὶ διὰ τούτου τοῦ κύκλου ἐκκόψαι τὸ εἰρημένον τρῆμα· ἀγαγόντα δὴ ταῖς ΑΔ ΓΕ παραλλήλους τὰς ΗΘ ΚΛ ἀπολαμβανούσας πρὸς τὰς ΑΔ ΓΕ πλάτη τὰ αὐτὰ τοῖς πάχεσιν τοῦ παραστάτου καὶ ἀντιστάτου, ἐκκόψαι τὰ τρήματα τοῖς τόρμοις ἀραρότα τοῦ τε παραστάτου καὶ τοῦ ἀντιστάτου τὰ Μ, Ν, Ξ, Ο, μὴ δι' ὅλου δὲ τοῦ πάχους τοῦ περιτρήτου, ἀλλὰ καταλείποντα τοῖς τορμικοῖς ὡς τὸ τρίτον μέρος τοῦ πάχους στερεώματος καὶ εὐπρεπείας ἕνεκα.

And let there have been made the so-called *kamarion*, in form such as is drawn below: ABΓΔEZH, having the line ΓE of one foot and 7.5 dactyls, and the interval of the *kamarion*, ΘK, of 5 dactyls.[6]

The linkage between the diagram and the text here is quite explicit; the reader is instructed to construct the *kamarion* by hewing so closely to the lines of the reference diagram that they appear as a single object in the text. Hero follows the same pattern for the *klimakion*:

> Let the so-called *klimakion* be ΛMNΞ OΠPΣ, consisting of two boards (*kanones*) in form such as is drawn below, the *kanōn* OΠPΣ having a length of one foot and 10 dactyls, and ΛMNΞ of one foot and 8 dactyls, and width 2 dactyls against the parts ΥT, and against [ΛM and NΞ] OΠ and PΣ one and one-fourth dactyls. And let the width of each of the boreholes Λ, B N, Γ O, Δ P, E, be 2 dactyls.[7]

The boards into which the cross-pieces are to be inserted are likewise identified with their diagram when they are first introduced:

> And let the *kanones* ΛMNΞ and OPΠΣ be jointed in three equal [parts], ΦTΨXΥΩ. And let TΥ be drilled along its length with parallelogram boreholes, and ΦXΨΩ with round boreholes.[8]

The acts of mechanical construction then carried out on them, such as drilling TΥ, are invoked with a new imperative, suggesting that the boards are first produced so as to be indistinguishable from their diagram, but further operations such as drilling, which would not be possible on the diagram, are carried out in a separate act.

An earlier passage of the text, explaining the structure of the frame for the *Cheiroballistra*, hints at a comparably dynamic relationship between the objects represented by the diagram and the objects of material construction:

> Having made four steel rods, having length 10½ dactyls apiece, breadth a little more than 2/3 of a dactyl, and width so as not to be easily bent, let there be AB ΓΔ EZ HΘ, such as are drawn in the diagram, having eyelets KΛ MN ΞO ΠP, having breadth 2 dactyls, width 1 dactyl, and depth the same as the little rods.[9]

[6] (*Cheiroballistra* 4.1): Γεγονέτω δὲ καὶ τὸ καλούμενον Καμάριον, τῷ σχήματι οἷον ὑπογέγραπται τὸ ABΓΔEZH, ἔχον τὴν μὲν ΓE ποδὸς ἑνὸς καὶ δακτύλων ZΣ, τὸ δὲ διάστημα τοῦ Καμαρίου τὸ ΘK δακτύλων E.

[7] (*Cheiroballistra* 4.3): Τὸ δὲ καλούμενον Κλιμάκιον ἔστω τὸ ΛMNΞ OΠPΣ, ἐκ δύο κανόνων τῷ σχήματι οἷον ὑπογέγραπται, μῆκος ἔχων ὁ μὲν OΠPΣ κανὼν ποδὸς ἑνὸς καὶ δακτύλων I, ὁ δὲ ΛMNΞ ποδὸς ἑνὸς καὶ δακτύλων H, πλάτος δὲ πρὸς τοῖς ΥT μέρεσι δακτύλους B, πρὸς δὲ τοῖς [ΛM NΞ] OΠ PΣ δάκτυλον ἕνα τέταρτον· πάχος δὲ ἑκάστου τῶν Λ, B N, Γ O, Δ P, E τόρμων ἔστω δακτύλων B.

[8] (*Cheiroballistra* 4.4): Καὶ διῃρήσθωσαν οἱ ΛMNΞ OPΠΣ κανόνες εἰς τρία ἴσα, τὰ ΦTΨXΥΩ. καὶ τετρήσθω τὰ μὲν TΥ κατὰ τὸ μῆκος τρήμασι παραλληλογράμμοις, τὰ δὲ ΦXΨΩ τρήμασι στρογγύλοις.

[9] (*Cheiroballistra* 3.2–3): Ποιήσαντες γὰρ σιδηροῦς κανόνας τέσσαρας, μῆκος ἔχοντας ἑκάτερον δακτύλους IΣ, πλάτος δὲ δακτύλου διμοίρου μικρῷ πλεῖον, πάχος δὲ ὥστε μὴ εὐχερῶς κάμπτεσθαι. Ἔστωσαν δὲ οἱ AB ΓΔ EZ HΘ, οἷοί εἰσι τῷ σχήματι καταγεγραμμένοι, ἔχοντες συμφυεῖς κρίκους τοὺς KΛ MN ΞO ΠP, τὸ εὖρος ἔχοντας δακτύλους δύο, τὸ δὲ πλάτος δάκτυλον ἕνα, τὸ δὲ πάχος τὸ αὐτὸ τοῖς κανονίοις. Marsden notes that while Wescher

Here the verb "let there be (*estōsan*)" serves to connect the previously introduced steel objects to the objects drawn in the diagram, superimposing the regularity of the diagram upon objects given not only a material substrate, but also an absolute size. Markers of scale and other dimensional measures are regularly introduced into diagrams only many centuries later. In Hero's works and other ancient technical texts, that information is available only through the verbal text, to serve as an optional "overlay" that can supplement the information about spatial form the diagram gives.

The letter labels serve as anchor points that pin the verbal and visual descriptions together, suggesting paths for the eye to traverse back and forth between the two. When he describes the trigger assembly, he gradually introduces the parts and then tells the reader how to imagine them coming together:

> Let there be made from steel a handle ABΓΔ, in form as drawn below, having a two-pronged part EZ; and let there be a square pivot ZΘ, a claw KΛM, a trigger NΞ, and and a plate ΟΠΡΣ. And let the handle ABΓΔ be drilled at Δ. As for the *kanōn* BΔ, which is in the first diagram, let it have been drilled at MNΞ, and pierced at MN with a rounded borehole, and at Ξ with a parallelogram-shaped one. And let the handle be joined on so that the pivot is driven through and connected with the handle through the borehole Δ.[10]

The reader is invited to consider this component of the *Cheiroballistra* as a concrete object (which perhaps has yet to be constructed) that comes together gradually from different materials subjected to different mechanical operations. Some of those operations might have geometrical analogues, others not, but throughout the construction (real or imagined) the reader has to negotiate between two imagined domains, one concrete and one embodied in the diagram. The diagram (Fig. 5.2), just as in a mathematical text, presents the full suite of components of the artifact, which the reader must mentally dismantle in order to follow along with the text's instructions to imagine the construction process. Throughout the process, the reader is encouraged to shift fluidly back and forth between the concrete and diagrammatic domains rather than regarding them as distinct entities.

Indeed, it can often be difficult to say without ambiguity whether the object or its diagram is referred to. The term *schēma* can refer to the "form" of an object as well as a depiction of it, and Hero at least once uses *theōrēma* in a way that suggests a similar ambiguity. In the *Cheiroballistra* the word appears twice, linked by letter labels to what definitely appears to be a diagram (Fig. 5.2):

preferred M's reading (ΙΣ, 10½), the alternative K (20), easily confused in manuscripts, gives a form factor closer to that of the standard catapult of this type (*palintone*) (Marsden 1971, 222–223, n. 17).

[10] (*Cheiroballistra* 2.2–3): Γεγονέτω ἐξ ὕλης σιδηρᾶς χειρολάβη ἡ ABΓΔ, τῷ σχήματι οἵα ὑπογέγραπται, δίχηλον δὲ τὸ EZ μέρος ἔχον· τὸ δὲ ZΘ τόρμος ἔστω τετράγωνος, σχαστηρία δὲ KΛM, δρακόντιον δὲ τὸ NΞ, πιττάριον δὲ τὸ ΟΠΡΣ. Καὶ τετρήσθω ἡ ABΓΔ χειρολάβη κατὰ τὸ Δ· ὁ δὲ ΓΔ κανὼν, ὁ ἐν τῷ πρώτῳ θεωρήματι, τετρήσθω κατὰ MNΞ, καὶ κατὰ μὲν τὰ MN στρογγύλῳ τρήματι διαμπερές, κατὰ δὲ τὸ Ξ παραλληλογράμμῳ· καὶ οὕτως ἐνηρμόσθω ἡ χειρολάβη, ὥστε περόνην διὰ τῆς MN διωσθῆναι καὶ διὰ τοῦ Δ τρήματος τῆς χειρολάβης κοινωθῆναι.

Then, drilling the trigger NΞ at N, and the *kanōn* ΓΔ at Π (the one in the first *theōrēma*) separated from M by 4 dactyls, and letting down the pivot through the borehole of the screw and Π, we attach it so that the trigger NΞ is easily moved around it.[11]

And again separating ΞP from the handle ABΓΔ, we pierce it at P, and again measuring 45 dactyls from it, as PΣ, we pierce it at Σ, and thus we let down the *pittarion* on the *kanōn* ΓΔ, which is in the first *theōrēma*.[12]

In the *Belopoeica*, *theōrēma* is used in a related but semantically shifted sense:

Once the force of the arms has become strong, it is necessary for the mechanism for winding them back to be made strong because of the need for equal force for drawing back the arms. Therefore in place of what was called the winding mechanism in the *theōrēma* above, they added to the barrel on its upper end a transverse, easily-turning axle.[13]

Here the term seems to mean something more like "design" than "diagram;" though the manuscript tradition of the *Belopoeica* does feature word labels in diagrams, Hero does not elsewhere use word rather than letter labels to link the diagram to his text. Moreover, the act of replacement referred to here has to happen in the domain of the machine rather than its diagram; there is never any reference, for example, to a second diagram with this mechanism swapped out. So in this instance the term seems to demonstrate a second shade of meaning, referring to a particular catapult type's *theōrēma* either as an artifact or as a design rather than the diagram that instantiates the artifact in the text. The reader thus has to shift his mental vision back and forth from the diagram on the page to the object in the world. This use of *theōrēma* recalls Peuerbach's novel of the term *theorica* in his adaptation of Ptolemy's *Planetary Hypotheses*, discussed in this volume by Isabelle Pantin (Chap. 2). There, as in this case, the term seems to denote a fusion of form and operating principle, whether the design in question is a catapult or a cosmos.

Even in the limited "theoretical" territory with which we are concerned here, we have already discovered a broad semantic range for the kinds of objects *theōria* and its cognates allow one to see, including material objects, their geometrical analogues, and their underlying principles of design or operation, as well as the ways diagrams can be engaged to mediate the transitions between these domains. What authorizes the transitions between these multiform operations of seeing—what renders the knowledge obtained in one domain applicable to another?

[11] (*Cheiroballistra* 2.6.1–11): Ἔπειτα τρήσαντες τὸ ΝΞ δρακόντιον κατὰ τὸ Ν, καὶ τὸν ΓΔ κανόνα κατὰ τὸ Π (τὸν ἐν τῷ πρώτῳ θεωρήματι) ἄπεχον τοῦ Μ δακτύλους Δ, καὶ καθέντες διά τε τοῦ τρήματος τοῦ δρακοντίου καὶ τοῦ Π περόνην, κοινοῦμεν ὥστε εὐχερῶς κινεῖσθαι τὸ ΝΞ δρακόντιον περὶ αὐτήν.

[12] (*Cheiroballistra* 2.7.1–11): Καὶ πάλιν ἀποστήσαντες ἀπὸ τῆς χειρολάβης τῆς [AB]ΓΔ τὴν ΞP, τιτρῶμεν κατὰ τὸ P, καὶ πάλιν ἀπ' αὐτοῦ μετρήσαντες δακτύλους ΔΣ, ὡς τὴν PΣ, τιτρῶμεν κατὰ τὸ Σ, καὶ οὕτω καθίεμεν [τὸ πιττάριον] ἐν τῷ ΓΔ κανόνι, ὅστις ἐστὶν ἐν τῷ πρώτῳ θεωρήματι.

[13] (*Belopoeica* 10.1–12): Τῆς οὖν τῶν ἀγκώνων βίας ἰσχυρᾶς γενομένης, δεῖ καὶ τὴν καταγωγὴν ἰσχυρὰν γενέσθαι διὰ τὸ ἴσης δεῖσθαι βίας πρὸς τὸ τοὺς ἀγκῶνας κατάγεσθαι. διὸ ἀντὶ τῆς καλουμένης ἐπὶ τοῦ ἐπάνω θεωρήματος καταγωγίδος ἄξονα προσέθηκαν τῇ σύριγγι ἐπὶ τοῦ ὀπίσω αὐτῆς ἄκρου πλάγιον στρεφόμενον εὐλύτως.

5.4 Learning to See in Hero's World

"Learning to see the world" here means developing an educated eye for the physical properties of materials, learning techniques for analyzing objects mathematically, and setting them within a broader context of natural phenomena and artificial interventions. Although Hero's works usually tend more toward the "technical" than the "scientific," the interweaving of disciplines and techniques that characterizes the texts of the Heronian corpus allows them to participate alongside more clearly "scientific" works in a shared discourse about exploring the world. The treatment of theoretical mechanics in the *Mechanica*, for example, is clearly in dialogue with the Peripatetic *Mechanica* and Archimedes' mechanical approaches to mathematical problems, while the detailed discussion of how to use the precision surveying instrument known as the "dioptra" for conducting celestial as well as terrestrial observations recalls Ptolemy's close attention to protocols of observation in the *Almagest* and *Harmonica*.

Here I will focus on some of the observational activities Hero describes using *theōria* and its cognates—note that he does not set them in opposition to a domain of praxis. Hero does not conceive of geometry as unsuitable for practical operations in the world, nor is *theōria* itself somehow limited to a separate domain from the practical; indeed, it serves as a guide to help navigate these disparate domains. The world of the surveyor, whose task it is to impose geometrical order upon a wild landscape, is a productive place to watch these disciplined domain transitions at work. In the preface to the third book of his *Metrica* (a text on techniques for measuring both geometrical and material shapes), Hero makes a rhetorical connection between geometrically proportional (κατὰ τὴν ἀναλογίαν) land division, which he argues is the most just, and a methodological approach that privileges mathematical rigor (Feke 2014, 267–272; Netz 2017). At the beginning of the preface, Hero has already identified *theōria* as the act that certifies the value and justice of proportional division:

> We do not think that the divisions of areas [of land] differ greatly from the measurements that occur in areas. And the apportionment of an equal area to equals, and more to those who are worthy, is observed to be very useful and necessary.[14]

In this passage Hero thus shifts a well-known philosophical trope with mathematical trappings (Plato *Laws* 757a-e, Aristotle *Politics* 1301b26–39) into more firmly mathematical territory, and then uses *theōria* to shift the problem again into the context of observations made in the real world. The cognates of *theōria* have, as we shall see, a very strong connection in Hero with marshalling observable phenomena into arguments that are often quite rigorous. It is not only the logic of *apodeixis* (*proof*) that strengthens the surveyor's claim on justice, but the fact that the demonstration is rooted in a phenomenon that can be directly observed (*theōreitai*) to be both useful and necessary. Land division is identified with land measurement, a

[14] (*Metrica* 3. pr. 1–5): Οὐ πολὺ ἀπᾴδειν νομίζομεν τὰς τῶν χωρίων διαιρέσεις τῶν γιγνομένων ἐν τοῖς χωρίοις μετρήσεων· καὶ γὰρ τὸ ἀπονεῖμαι χωρίον τοῖς ἴσοις ἴσον καὶ τὸ πλέον τοῖς ἀξίοις κατὰ τὴν ἀναλογίαν πάνυ εὔχρηστον καὶ ἀναγκαῖον θεωρεῖται.

rhetorical move framed here as taking sides in a debate, which serves the additional purpose of relocating the debate over justice from the philosophical realm onto *terra firma*. Direct and scrupulous observation of the admirable philosophical ramifications of such a system of division is connected to the direct and scrupulous observation performed in the field by the surveyor as he makes the actual measurements.

Those observations are quite visible in the *Dioptra*, where they continue to occupy the semantic territory of the "theoretical." The instrument that enables the surveyor to make the most precise and reliable observations is the dioptra, which comprises a sighting tube oriented using glass-walled water levels adjusted precisely in both horizontal and vertical planes with geared drums moved by screws. The dioptra disciplines the surveyor's sightings of terrestrial objects as well as the astronomer's observations of celestial ones:

> It will be possible quickly to make clear that the practice [of using the dioptra] presents great utility for life. For in addition to paths for water and designs of walls and harbors and what is most useful for every home-construction, it greatly benefits the observation of celestial objects, measuring the intervals between the stars, as well as those concerning the sizes and distances and eclipses of the sun and moon.[15]

Theōria through the dioptra links together earth, sky, and sea in service of human needs; even astronomical observations that could be called "scientific" fall under the rubric of utility. Clearly, *theōria* here is in no way defined by opposition to the practical; instead, it is defined by certain acts of instrumentally and textually disciplined seeing, which will be spelled out in more detail as the *Dioptra* goes on.

The dioptra's ability to mediate between the material and the mathematical owes much to its careful design as a measuring instrument. Hero begins the treatise by specifying the features that enhance the precision of its measurements: the glass cylinders that serve as water levels on the dioptra itself, and the markings that accompany the measuring rods. The glass cylinders appear early in the text, just after Hero has described the installation of the drum assembly (*Dioptra* 4.1–17). A bronze pipe of a certain length is to be fitted into a channel excised for it in the upper surface of the rod on top of the dioptra, and on its end two short perpendicular pipes are attached so that the pipe appears to be bent upwards at its ends. The whole thing is covered over with a rectangular case "for the sake of a neat appearance." Then the glass cylinders are attached to the upturned ends of the pipe, and capped off with wax so that the water will not leak out of them. The water levels are an important part of the dioptra's precision and its ability to reduce many three-dimensional surveying problems, viewed from in front of the instrument, to two-dimensional geometry problems, framed by Hero as viewed from above or in a cutaway side. The glass cylinders provide a compact and stable way of ensuring that the instrument is evenly positioned. They offer the dioptra considerable observational advantages compared

[15] (*Dioptra* 2.1–10): Ὅτι δὲ πολλὰς παρέχεται τῷ βίῳ χρείας ἡ πραγματεία, δι' ὀλίγων ἐστὶν ἐμφανίσαι. πρός τε γὰρ ὑδάτων ἀγωγὰς καὶ τειχῶν κατασκευὰς καὶ λιμένων καὶ παντὸς οἰκοδομήματος εὔχρηστος τυγχάνει, πολλὰ δὲ ὤνησεν καὶ τὴν περὶ τὰ οὐράνια θεωρίαν, ἀναμετροῦσα τά [τε] μεταξὺ τῶν ἀστέρων διαστήματα, καὶ τὰ περὶ μεγεθῶν καὶ ἀποστημάτων καὶ ἐκλείψεων ἡλίου καὶ σελήνης.

to the plumb bobs that hang from the relatively simple *asteriskos* (also known as a *ferramentum* or *groma*), a simple cross mounted on a staff. The surveyor must sight across the lines they weigh down, which as Hero complains have an annoying tendency to blow around in the wind.

The cylinders' position at roughly the same height as the sighting-tube of the dioptra also allows the surveyor to keep an eye on the levels all the while he is using the next precision-enhancing feature of the dioptra, which is actually situated not on the instrument itself but on the sighting-rods. Right after describing the glass cylinders, Hero moves on to describe the sighting-rods and the painted disks used with them (Hero, *Dioptra* 5.1–50). Whereas the Roman *agrimensores* simply describe their rods as rods, without mentioning any inscriptions, Hero's are more complex. Each rod is incised with the socket of a dovetail running along its length, into which a tailpiece is fitted so that it can run up and down the length of the rod without falling out. Onto this tailpiece a circular disk painted half white and half black is mounted with the division line perpendicular to the length of the rod. Then the rod is inscribed with markings dividing it into cubits, palms, and dactyls, and a pointer is mounted on the disk pointing to the markings. The surveyor holding the rod moves the disk up and down on the rod until the operator of the dioptra sees the division between white and black through the sighting-tube, and then records the measurement off the rod.

The work of seeing according to the *Dioptra*'s prescriptions involves some quite complex and delicate manual operations predicated on careful visual observation, alongside simpler physical activities like setting up the sighting-rods which the surveyor sights backwards and forwards across to line up his observations. First, the sighting line is given a physical length, not merely by placing a letter label on a point, but by placing a rod on the earth. The length is itself ergonomically constrained by both the surveyor's physiognomy and the local topography (Roby 2016a, 223–229): the dioptra must be placed at such a distance that the sighting-rod remains visible. The surveyor's eyes are then engaged in another way, aligning the height of the dioptra's stand, and then the height of the sighting-targets with the water-level on the dioptra. Only at this point is the surveyor ready to engage in the linked acts of "sighting" (*diopteuein*) and "viewing" (*theōrein*) that will yield his measurements (*Dioptra* 6.21–6.30). The text of the *Dioptra* becomes a guide for the sequence of highly disciplined actions—placing the surveying equipment on the earth, peering through the sighting-tube, and tabulating data—that certify acts of seeing as acts of measurement.

The dioptra's precision as an instrument is matched by precise instructions for the inscriptions that commemorate the surveyor's observations. Hero specifies the columnar format appropriate for the measurements of the surveyor's forward and reverse sightings, and instructs that the measurements should be recorded "on papyrus or a tablet" (*Dioptra* 6.41–6.86, 7.22). Hero gives these instructions for recording the results of the measurement in the first two surveying problems of the text; despite being situated in the context of a specific surveying problem, the instructions represent a general protocol the reader will be expected to follow throughout the text.

The surveyor's "theorizing" brings us back to the relationship between Hero's diagrams and the objects they represent. The text of the *Dioptra* includes its fair share of geometrical diagrams, which serve as a kind of idealized gloss over the unpredictable details of the terrain in which the surveyor works, and with which he must contend on an ad hoc basis. Besides their idealization and abstraction, many of the text's diagrams present a bird's-eye view of the landscape, enacting a quite different regime of viewing than the surveyor experiences at ground level. However, in *Dioptra* 17 Hero gives the diagram a newly concrete life, instantiated in the physical world as a template. The problem at hand is, at first, to create a harbor bounded by any given section of a circle. In order to do this the dioptra is set up with its (circular) drum horizontal, and the sighting rods are used to identify a path with the same proportions as the circular segment desired for the harbor, but at a smaller scale. The rays from the dioptra to these points are then further extended to generate the harbor's actual outline (*Dioptra* 17.13–17.17). The grammar of the construction is telling: a geometrical construction, made using third-person imperatives, serves as a kind of lemma that helps to produce the actual desired result of a construction on the ground, which is itself described using active first-person verbs (Roby 2018, 80–85).

In the next passage, Hero proceeds beyond the circular outline that can be made with materials conveniently at hand using the circular drum of the dioptra. Here he promises that the harbor can in fact be bounded by any conic section or indeed any other line, by constructing a template in the desired shape and using the same ray-extension method as before. Since the object similar to the harbor's desired form is not immediately available like the dioptra's circular drum, "we" must make it. As in the case of a chart of sighting distances mentioned earlier in the text and the template we saw used in the *Belopoeica*, Hero identifies its raw material; in this case it is to be made from a plank of wood. "We" then affix the plank to the dioptra and carry out the same sighting exercise as before, but this time the whole procedure is presented through active verbs rather than the third-person imperatives as in the initial circular case. It is as though the template, when first invoked as a material object crafted by a first-person figure, shifts the whole problem into the domain of hands-on, active engagement. The template changes from a geometrical construction to another piece of equipment for the surveyor to pick up and manually engage with.

The surveyor's disciplined *theōria* is what gives him license to make that domain shift, to act upon the world as he would on a diagram. From the dioptra's precision as an observational instrument, to the techniques that allow Hero to reduce many surveying problems to geometry problems, to the normalized protocols for recording the observations, the *Dioptra* offers a disciplined method for turning the undulating landscape into neat columns of data. The surveyor's journey of *theōria* takes him through the landscape, via the instrument, to the diagram and the chart of measurements: from one visual regime to another.

5.5 Seeing Invisible Things: The *Pneumatica*

Hero's *Pneumatica* introduces an array of artifacts range from building-blocks like various kinds of siphons to complex performance installations, like a branch full of birds which burble merrily as water and air are pushed through their hidden pipeworks, until a nearby owl rotates to face them, at which point they hush in apparent fear. When the owl rotates away again, they resume their song (Fig. 5.1). The latter kind of device in particular would certainly qualify as *theōrēmata* in the sense of "spectacle," like those he describes in his later work on automata. But those installations, taken along with the rest of the devices in the book, simultaneously create the opportunity for another kind of *theōria* entirely: physical processes too minute to see under natural conditions are amplified and made visible by the artifacts of the *Pneumatica*. Hero explicitly arranges those artifacts in a Euclidean order graduating from simple siphons to more complex assemblies, to help the reader see their functional principles clearly. By reading the text as an ordered whole, the reader is enabled to participate in a special kind of observation that might well be likened to experiment: a disciplined way of seeing physical principles in action through material artifacts.

While the text is often viewed simply as a collection of pneumatic wonders, the preface indicates Hero has a more disciplined kind of investigation in mind for them. Much of the lengthy preface is spent excoriating philosophers who debate endlessly about invisible particles without ever reaching a rigorous apodeictic conclusion (*Pneumatica* 1. pr. 190–3). Hero promises the devices he describes in the text will put a stop to those debates, producing a kind of *apodeixis* accessible to the senses (*Pneumatica* 1. pr. 329–332). Here he effects a remarkable shift in the objects that might yield *apodeixis*, moving from a symbolic mathematical-verbal domain to one that includes material objects and embodied actors. The physical assertions made in the *Pneumatica* are predicated on a manual operation, carried out on a well-defined material artifact and yielding a result that is perceptible to the senses. The work of shifting one's vision between the philosophical-explanatory and material-demonstrative domains is once again mediated through diagrams, which (as so often in Hero's works) are equated to the objects they represent with a simple *estō*.

Generating demonstrations of the requisite precision and reliability will be possible thanks to some kind of "*theōrēmata* about the interweaving of the elements mentioned" (*Pneumatica* 1. pr. 343–347). What are the *theōrēmata* here? They are something subject to inscription (*graphein*), pertaining to how elemental particles move and interact, through which it will be possible to discover a full spectrum of elemental-level physical principles. It might be tempting to assume that Hero here refers simply to a set of philosophical arguments about physical principles, but this cannot be the case, given his strong objections to purely verbal debate about these matters (*Pneumatica* 1. pr. 190–193). In fact, the *theōrēmata* of the *Pneumatica* appear to be complex overlays of design, diagram, and constructed artifact, which collectively create opportunities to "see" physical phenomena which are not perceptible under natural circumstances.

One must begin, he says, by taking a stand on the controversy over whether there is any such thing as a naturally occurring void. Hero will stand with those who argue that void is "scattered" (*paresparmenon*) throughout all kinds of bulk matter, drawing his argument not from philosophical rhetoric but from the evidence of the senses (*Pneumatica* 1. pr. 18–25). As Karin Tybjerg points out, Hero places philosophical arguments under suspicion by identifying them with rhetoric, suggesting that their authors will seek any "loophole" (*pareisdusis*) in their desperation to convince a listener (*Pneumatica* 1. pr. 197; Tybjerg 2003, 453). Hero instead identifies "perceptible proof" (αἰσθητικῆς ἀπόδειξις) as the gold standard for making convincing arguments about the physics of matter: if the structure and behavior of matter can be made accessible to the senses, there will be no more need for such fungible philosophical arguments. But of course evidence for the invisible "microvoid" is not immediately available, or there would not be a controversy; instead it has to be created, under the right circumstances, out of thin air. There is a marked theatricality to Hero's argumentation in the proem of the *Pneumatica*: as he reveals his physics he creates moments of suspense, revelation, and sudden reversal that remind one of the spectacles executed by Hero's own automatic theaters.

After setting the scene of the ongoing battle over the microvoid, he reminds the reader that vessels that look empty to the unschooled are really full of air (*Pneumatica* 1. pr. 25–27). Air is not empty space to "those practiced in physics," but rather a substance made up of "small and tiny-particled bodies, for the most part invisible to us." Hero's task is to create the special circumstances that will make its physics visible. He begins with something to prove: "so indeed if someone (*tis*) should pour water into a vessel that appeared empty, to the degree that the mass of water is poured into the vessel, to that degree the mass of air is displaced." His use of the indefinite pronoun suggests a universality of experimental results—anyone could expect the same outcome. The initial hypothetical might suggest an impending thought experiment based on the hypothesis, but instead Hero introduces another layer of dramatic action:

> Someone might grasp what was said from something like this: for if you upturn a vessel that seemed empty into water, and press on its underside, making sure it remains straight, the water will not be permitted into it, even if you cover the whole thing.[16]

Another "someone" (*tis*) can be enlightened about air's true nature if *you* turn the vessel upside down—the specificity of the second-person singular here connects the experimental work more directly to the reader, while maintaining the universalizing intelligibility of the results. While both a vessel being filled up with water as the air inside escapes and a vessel refusing to fill with water while the air is trapped inside are cases of air behaving according to its nature, only the latter case *shows* you that nature, since the air escapes invisibly in the former. Hero's project in the *Pneumatica* is to create this kind of spectacle: the text and instrument alike are privileged, specialized spaces where a viewer can see physics in action.

[16] (*Pneumatica* 1. pr. 32–37): κατανοήσειε δ' ἄν τις τὸ λεγόμενον ἐκ τοῦ τοιούτου· ἐὰν γὰρ εἰς ὕδωρ καταστρέψας ἀγγεῖον τὸ δοκοῦν εἶναι κενὸν πιέζῃς εἰς τὸ κάτω ἀκλινὲς διαφυλάσσων, οὐκ εἰσελεύσεται τὸ ὕδωρ εἰς αὐτό, κἂν ὅλον αὐτὸ κρύψῃς·.

The instructive spectacle of the vessel has further acts to unfold, after Hero reviews the lesson of the second act. In the third, "someone" (*tis*) produces a drill and makes a hole in the inverted bottom of the vessel, at which point the water rushes in as the air rushes out. But now Hero creates a narrative surprise by rewinding the third act so that the reader can appreciate a bit of evidence from the second they might not have noted at the time:

> Then again, if someone raises the vessel straight up out of the water before the drilling, when once it has been overturned it will be observed that all the internal surface of the vessel is free from water, just as it was before it was placed.[17]

The quick "then again" (*palin*) undoes the drill's destructive work and draws the reader's viewpoint inside the vessel to survey its dryness. Is Hero's account here a thought experiment? Nothing prevents the reader from executing the steps described, turning the vessel's inversion, perforation, and immersion from a hypothesis to a reality. At the same time, the process of discovery cannot proceed in the real world in the same way that it does in the narrative, punctuated by the surprise of the "rewind." So Hero's text offers the reader a kind of heightened drama, not just for its own sake but because the interruption in the experiment's flow creates a strong focus for the moment when the mind's eye enters the unperforated vessel to find the interior bone dry.

Hero then fast-forwards back to the point where the vessel has been drilled, and invites the hand into the drama:

> So indeed, when the vessel has been drilled and dunked into the water, if someone places their hand over the borehole, the wind will be felt escaping from the vessel. This is nothing other than the air being forced out by the water.[18]

Hero's description of the vivid sensory experience of feeling the escaping air rush over the hand recalls Tamar Gendler's appeal to the important role imagined sensory experiences play in thought experiments:

> in the case of imaginary scenarios that evoke certain sorts of quasi-sensory intuitions, their contemplation may bring us to new beliefs about contingent features of the natural world that are produced not inferentially, but quasi-observationally; the presence of a mental image may play a crucial cognitive role in the formation of the belief in question. (Gendler 2004, 1154)

This experiment could easily be carried out in the real world, but at the same time the focalizing features of the account in the text give the reader a carefully directed spectacle that transcends the purely visual to include a proprioceptive imaginary as well: better, perhaps, than the real thing.

[17] (*Pneumatica* 1. pr. 43–46): πάλιν δὲ πρὸ τοῦ τρυπῆσαι τὸν πυθμένα ἐάν τις ὀρθὸν ἐκ τοῦ ὕδατος τὸ ἀγγεῖον ἐπάρῃ, ἀνατρέψας ὄψεται πᾶσαν τὴν ἐντὸς τοῦ ἀγγείου ἐπιφάνειαν καθαρὰν ἀπὸ τοῦ ὑγροῦ, καθάπερ ἦν καὶ πρὸ τοῦ τεθῆναι.

[18] (*Pneumatica* 1. pr. 49–53): ἐὰν γοῦν τετρυπημένου τοῦ ἀγγείου κατὰ τὸν πυθμένα καὶ εἰσπίπτοντος τοῦ ὕδατος παραθῇ τις τῷ τρυπήματι τὴν χεῖρα, αἰσθήσεται τὸ πνεῦμα ἐκπῖπτον ἐκ τοῦ ἀγγείου· τοῦτο δὲ οὐκ ἄλλο τί ἐστιν ἢ ὁ ἐκκρουόμενος ὑπὸ τοῦ ὕδατος ἀήρ.

Other simple experiments can be carried out through simple vessels whose form is more important than the unspecified vessel with which he began:

> Then if someone takes a vessel, as light as possible and with a narrow neck, and holding it by the mouth he sucks out the air and gets rid of it, he hangs the vessel from his lips, with the void attracting the flesh to refill the emptied-out space. Thus it becomes clear from this that a continuous void is present in the vessel.[19]

But Hero does not insist that only this single type of apparatus can make this experiment work; he immediately opens up alternative theaters for seeing the continuous void in action. The cupping-glasses commonly used in medical practice for drawing blood and other humors to a particular place on the skin will work as well, both the narrow-necked "egg" (*ōon*) vessels and the ones called "gourd-shaped" (*sikya*). The former work by having the air sucked out of them, the physician preserving the semi-vacuum thus created by placing a finger over it before applying it to the skin, where they attract the humor through an artificial (παρὰ φύσιν) upward force. The latter are heated, reducing the density of the air within and so drawing the humor upward as the air cools by a mechanism "no different in sense than what has been described above" (*Pneumatica* 1. pr. 98–100).

Other maneuvers will require somewhat more specialized equipment. Recall Hero's self-defense against philosophers, where he promises that even though it is possible to make any number of purely verbal arguments against the void's existence, a demonstration before the senses will leave them no loophole. For this task he introduces a new apparatus, more elaborate than the everyday vessels used previously:

> For a sphere is constructed having some thickness of beaten metal, so that it will not be easily collapsed, having a capacity around eight *kotylae*. When it has been sealed up everywhere, it is necessary to drill into it and insert a bronze siphon, that is a narrow tube, not touching the part diametrically opposite the drilled point, so that there is established a passage for water, while its other portion projects outside the sphere, about three dactyls. Then it is necessary to seal up the circumference of the drilled part, where the siphon enters, with tin, integrating the siphon and the surface outside the sphere, so that whenever we wish to blow through the siphon with the mouth, the breath will not at all escape the sphere. Let us watch what happens....[20]

[19] (*Pneumatica* 1. pr. 86–91): ἐὰν οὖν ἀγγεῖον λαβών τις κουφότατον καὶ σύστομον, προσθεὶς τῷ στόματι ἐκμυζήσῃ τὸν ἀέρα καὶ ἀφῇ, ἐκκρεμασθήσεται ἐκ τῶν χειλέων τὸ ἀγγεῖον, ἐπισπωμένου τοῦ κενοῦ τὴν σάρκα πρὸς τὸ ἀναπληρωθῆναι τὸν κενωθέντα τόπον· ὥστε ἐκ τούτου φανερὸν γενέσθαι, ὅτι ἄθρους κενὸς ὑπῆρξεν ἐν τῷ ἀγγείῳ τόπος.

[20] (*Pneumatica* pr. 200–213): κατασκευάζεται γὰρ σφαῖρα πάχος ἔχουσα τοῦ ἐλάσματος, ὥστε μὴ εὔθλαστος εἶναι, χωροῦσα ὅσον κοτύλας η. στεγνῆς δὲ οὔσης αὐτῆς πάντοθεν τρυπήσαντα δεῖ σίφωνα καθεῖναι χαλκοῦν, τουτέστι σωλῆνα λεπτόν, μὴ ψαύοντα τοῦ κατὰ διάμετρον τόπου τοῦ τετρυπημένου σημείου, ὅπως ὕδατι διάρρυσις ὑπάρχῃ, τὸ δὲ ἄλλο μέρος αὐτοῦ ἐκτὸς ὑπερέχειν τῆς σφαίρας ὅσον δακτύλους τρεῖς· τὴν δὲ τοῦ τρυπήματος περιοχήν, δι᾽ οὗ καθίεται ὁ σίφων, στεγνοῦν δεῖ κασσιτέρῳ προσλαμβάνοντα πρός τε τὸν σίφωνα καὶ τὴν ἐκτὸς τῆς σφαίρας ἐπιφάνειαν, ὥστε ὅταν βουλώμεθα τῷ στόματι διὰ τοῦ σίφωνος ἐμφυσᾶν, κατὰ μηδένα τρόπον τὸ πνεῦμα τῆς σφαίρας διεκπίπτειν. σκοπῶμεν δὴ τὰ συμβαίνοντα....

The solidly built and tightly sealed sphere allows one to create internal air pressure that compresses the air within "artificially" (*para physin*); that is, this apparatus is marked as an environment where one can see things happen that go beyond what one witnesses in nature (*Pneumatica*, pr. 241).[21] By specifying the terms of its materials and construction even down to the approximate size of the components, Hero can make a stronger argument about the existence of the void than he could based on the uncontrolled apparatus of the previous experiments. Those vessels were contingent on what the reader had to hand, whereas here the apparatus is specified as uncollapsible, soldered against leaks, permitting fluids to flow only through its siphon. Once again the results are presented as an inclusive spectacle, this time with a showman like invitation: "let us watch what happens."

Hero offers a gentle reminder that just like all other vessels called "empty," this one is filled with air, and tightly sealed so that even if one were by brute force to introduce more air into the vessel, it would break under the pressure—unless, that is, there were a way for the air to yield. *They*, the opponents of the theory that there is void in matter, think it is now impossible to introduce more air into the vessel. Time to prove them wrong:

> Yet if someone wishes to put the siphon to his mouth and blow into the sphere, he will introduce a lot of extra air, without the air that was already in there making its way out. Since this always happens, it is clearly demonstrated that there is some compression of the particles already present in the sphere into the interstitial void.[22]

"This always happens" is a strong experimental claim. On the other hand, it is not yet quite clear from the text how to verify this claim through observation. In order to help the reader understand what the observable effects of the compression might be, Hero then "replays" the experiment, with a little poetic license:

> Then if someone blows in, places his hand at the mouth, and immediately covers the siphon with a finger, the air will remain trapped in the sphere. If anyone uncovers it, the aggregated air will rush outside again with a blast and a roar in the expulsion, as we established before, because of the expansion of the air that was previously there, and this happens on account of its tension.[23]

Of course the air probably does not produce "a blast and a roar" on its escape if it was only compressed as much as a normal set of lungs can manage, but Hero is

[21] Note that *para physin* should not be taken as meaning "against nature" in the strong sense of being "unnatural," as Sylvia Berryman has shown (Berryman 2009, 44–46).

[22] (*Pneumatica* pr. 235–242): καὶ μὴν ἐάν τις ἐθέλῃ τὸν σίφωνα βαλὼν εἰς τὸ στόμα ἐμφυσᾶν εἰς τὴν σφαῖραν, πολὺ προσεισκρινεῖ πνεῦμα, μὴ ὑποχωρήσαν τος τοῦ προ῁υπάρχοντος ἐν αὐτῇ ἀέρος· τούτου δὲ ἀεὶ συμβαίνοντος, σαφῶς δείκνυται συστολὴ γινομένη τῶν ὑπαρχόντων ἐν τῇ σφαίρᾳ σωμάτων εἰς τὰ παρεμπεπλεγμένα κενά. παρὰ φύσιν δὲ ἡ συστολὴ γίνεται διὰ τὴν τῆς εἰσκρίσεως βίαν.

[23] (*Pneumatica* pr. 242–249): ἐάν τις οὖν ἐμφυσήσας καὶ παρ' αὐτὸ τὸ στόμα προσαγαγὼν τὴν χεῖρα συντόμως ἐπιπωμάσῃ τῷ δακτύλῳ τὸν σίφωνα, μενεῖ πάντα τὸν χρόνον συνεσφιγμένος ὁ ἀὴρ ἐν τῇ σφαίρᾳ· ἐὰν δέ τις ἀναπωμάσῃ, πάλιν ἐκτὸς ὁρμήσει μετά τε ψόφου καὶ βοῆς πολλῆς ὁ προσεισκριθεὶς ἀὴρ διὰ τὸ ἐκκρούεσθαι, καθάπερ προεθέμεθα, κατὰ τὴν τοῦ προ῁υπάρχοντος ἀέρος διαστολὴν τὴν κατὰ τὴν εὐτονίαν γινομένην.

here prefiguring the sound effects produced by some of the devices described later in the text. The preface to the *Pneumatica* tempts the reader to press further into the text and see these physical effects unfold in many different ways. A particularly conscientious reader will be spurred to solve a mystery not yet addressed: how *do* we know that "this always happens," and thus that compression occurs inside the vessel, given that Hero's report on the results of the experiment are so clearly narratively amplified beyond what can actually be observed?

The devices in the main text will amplify those effects mechanically, forcing air into greater degrees of compression and using it to create highly visible effects like ejecting pressurized air or steam. The casual "experiments" of the preface, with their dramatic presentation of elementally simple processes, create a hunger in the reader to see how they might play out on the more advanced stage of Hero's siphons, steam-powered systems, and singing figurines. The main text also introduces new visual elements: while the preface offers some vivid sensory narratives of pneumatic experiments in action, no surviving copy of the manuscript includes diagrams for the preface, nor are there any in-text references to images that might have been lost. The visual aspect of the preface has thus been borne out completely in the reader's mind if the experiments are left as "thought experiments," or in the world if they have carried them out for themselves.

All this changes in the main text, where we find elaborate letter-labelled diagrams associated with each device. In fact, the main text becomes a theater for visualizing phenomena explored purely verbally in the preface, since several of the devices in the text mirror natural phenomena Hero referenced there as part of his larger pneumatic argument. For example, in the preface, Hero follows up his description of the cupping-glass, burning coals, and a steaming kettle with a sudden transition to the cosmic stage, inviting the reader to imagine the process of dew's production from the earth:

> [The exhalation] occurs by means of some fiery substance, when the sun is beneath the earth and heating up the place underneath [the water], especially whatever is sulfurous and bituminous, which when heated creates the greatest exhalation. And the warm waters found in the earth result from the same cause. So the more refined parts of the dew are changed into air; the denser parts which accompanied them for a while because of the force of this exhalation are borne back to the place below once [the exhalation is] cooled off by the turning of the sun.[24]

The macroscopic operation of sun's heat on the earth's internal waters described in the preface plays out later in the *Pneumatica* on a miniature scale. The device called the "spring" (*Pneumatica* 2.8) is designed to emit a trickle of water when the sun shines on it (Fig. 5.4). A sphere and a funnel mounted on a hollow base are

[24] (*Pneumatica* 1. pr. 127–137): αὕτη δὲ ὑπὸ πυρώδους τινὸς οὐσίας γίνεται, τοῦ ἡλίου ὑπὸ γῆν ὄντος καὶ θερμαίνοντος τὸν κατ᾽ ἐκεῖνο τόπον, καὶ μᾶλλον ἤτοι θειώδη ἢ ἀσφαλτώδη ὄντα, ὃς θερμαινόμενος ἐπὶ πλεῖον τὴν ἀναθυμίασιν ποιεῖ· καὶ τὰ θερμὰ δὲ τῶν ὑδάτων τὰ ἐν τῇ γῇ εὑρισκόμενα ἐκ τῆς αὐτῆς αἰτίας γίνεται. τῶν οὖν δρόσων τὰ μὲν λεπτότερα εἰς ἀέρα μεταβάλλει, τὰ δὲ παχύτερα ἐπὶ ποσὸν συνανενεχθέντα διὰ τὴν τῆς ἀναθυμιάσεως βίας, ταύτης ἀποψυχείσης κατὰ τὴν τοῦ ἡλίου μετατροπὴν πάλιν εἰς τὸν κάτω φέρεται τόπον.

Fig. 5.4 "Spring" device
from Hero's *Pneumatica*.
Codex Marcianus gr. Z 516,
fol. 186v. Biblioteca
Marciana. Su concessione
del Ministero della
Cultura—Biblioteca
Nazionale Marciana. Divieto
di riproduzione

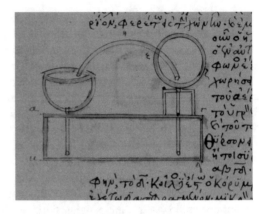

connected by a siphon. Water is introduced into the sphere, enough that when the air inside is heated by the sun, water percolates through the connecting siphon into the funnel, and from there into the base. When the device is placed in the shade to cool down, the condensing air in the sphere causes the siphon to draw the water back up.

Hero notes the spring's cycle of discharging and re-absorbing water "will happen whenever the sun falls on it," recalling the diurnal cycle of solar heating that causes water to percolate through the earth itself. While the "spring" is not explicitly described as a model of the earth, the reader has been primed to think in these terms by the previous device, a sphere suspended in a sphere half filled with air and half with water, which is itself described as a model of the earth suspended in the center of the cosmos. Moreover, the action of the sun shining on a vessel of water was previously connected to the hydrological cycle in the preface, in an argument that the evaporation of water involves the transformation of matter rather than its destruction. The argument takes the form of a thought experiment on a quantity of water "put into some vessel, whether glass or bronze or some other solid stuff" and left in the sun.

The hydrological cycle is familiar through the appearance of dew, yet its mechanism remains essentially invisible because of the vast scale on which it occurs. By re-enacting the cycle in the smaller, simpler form of the "spring" device, Hero creates a "concrete model" to serve his larger physical argument. Many of the devices in the *Pneumatica* can be viewed as concrete models, which in Michael Weisberg's formulation are "physical objects whose physical properties can potentially stand in representational relationships with real-world phenomena" (Weisberg 2015, 7). In the clash between philosophical discourse and experimental demonstration Hero invokes in the preface to the *Pneumatica*, his devices take the place of deductive argumentation, which they can only do by virtue of the representational work they themselves do as "concrete models." In this sense they recall "material embodiments of knowledge." The imaginative leaps Hero encourages his reader to make, the blend of real and conceptual amplifications of normally invisible physical effects he suggests, become sites of the "generative ambiguity" which lends creative power to external representations.

Hero's pneumatic *theōrēmata* thus turn out to be a complex blend of physical principles and their enaction in systems both natural and artificial, as well as the conceptual connections that allow the reader to "see" those principles in action. The work of seeing happens through a variety of modes, including thought experiment, hands-on experience, diagrammatic representations, and analogical image-building. The "concrete models" he enables his reader to construct follow up on the concepts from the preface in many different ways. We have already seen how the "spring" device mirrors the hydrological cycle; in addition to this Hero presents devices that turn the everyday experiences of heat and pressure mentioned in his preface—burning coals, boiling kettles, oil lamps consuming their fuel—into spectacular artificial amplifications. In this way his pneumatic "spectacles" (one sense of the term *theōrēmata*) become a launching pad for conceptual expeditions (something closer to Nightingale's philosophical *theōria*) that train the reader to see the artificial processes through the natural ones, and the natural through the artificial.

5.6 Conclusion

We might say that *theōria* in the context of Hero's work is a special kind of seeing that licenses one to move one's gaze between domains in confidence that what was seen in one domain may be carried back to another with its truth value intact. Nightingale's "spectacles of truth" suggest an analogy between (on the one hand) the transformation of civic spectacles into the viewer's report about them to the people back home, and (on the other) the transition from the philosopher's work of viewing in a domain of contemplation to his verbal articulation of his vision in verbal form. Likewise, though *theōria* in the Heronian corpus certainly embraces a wide range of ways of seeing, they cluster semantically around their ability to link domains—the abstract and the concrete, the mathematical and the material, objects in the world and diagrams in the text—while preserving the truth value of observations as they move between domains. We might call the resulting acts of seeing "scientific spectacles:" observations disciplined in a certain way (which might vary from one field to another) so as to allow the viewer to see the layers of material, mathematical, and explanatory structures that constitute a model of an object in the world.

As Tarja Knuutila has observed, models are media in their own right, and.

> Learning is thus made possible through the material dimension of models, which provides scientists a working object. The material dimension, which is actually required of models if they are to be 'independent' in the sense that they can be transferred to other tasks and contexts, is also critical for their productivity. (Knuutila 2005, 1267)

The "media" of Hero's models are various: concrete models like his mechanical amplifiers of heat and pressure, his diagrams that connect verbal explanations to a reader's mental image of a device, the verbal explanations themselves, and so on. Knuutila goes on to argue that models can thus provide knowledge "in many other ways than simply by virtue of some kind of pre-established abstract representative

function" (Knuuttila 2005, 1269). Likewise, Mauricio Suárez has argued that in thinking about scientific representations we should not ask merely, for example, "how does the graph manage to represent the bridge truthfully and completely?" but "in virtue of what is the graph a representation (however incomplete or inaccurate) of the bridge?" (Suárez 2004, 767–768). Hero's ostentatiously artificial devices represent the natural behaviors of heat by amplifying them so that they become available to the senses in ways never found in nature, and by holding up a focusing mirror to the structures and mechanisms of heat's activity in the natural world.

The focus, the amplification, are of course types of distortion. Hero's pneumatic creations are incomplete representations insofar as each device highlights one or two phenomena, in isolation from the rest of the natural world, and inaccurate insofar as they serve as a kind of representational hothouse, where the physical phenomena associated with heat as described in the preface, which are often too weak to perceive in nature, are amped up into multisensory experiences. Yet their epistemic value arises precisely from the complexity of the representational work they do—and we might be able to inquire along these lines into other approaches to accessing the connections between the physical realities of heat and human experiences of it. These experimental narratives induct the reader into a new regime of seeing, where natural phenomena like steam and dew are reflected and amplified by artificial devices.

The *Dioptra*'s methods for transferring knowledge between the mathematical and material domains likewise require the reader (and surveyor) to shift back and forth between visual regimes—from the bird's-eye view of a surveying problem abstracted to a geometrical diagram to the surveyor's ground-level sightings through the dioptra's tube and water levels. Abstract as the diagram may be, it goes from an "external representation" to a conceptual representation the surveyor can summon up in his mind as he carries out his observations. Perhaps he works in a rugged space that requires some modifications to the geometrical model, or a hilly landscape that must be modeled in "cutaway" side view as well as from above (for which Hero provides instructions elsewhere in the *Dioptra*). From the generalized diagram to the specifics of a particular situation in a landscape, and then to new external representations in the form of the tables of measurements, Hero teaches the surveyor to shift fluidly between different regimes of viewing. The *Belopoeica* and *Cheiroballistra* demand shifts of their own. Once again the diagram performs some work of abstraction, and as in the surveyor's case the reader of the *Belopoeica* must move from the diagram's scale-free geometrical world to meet the specific needs of his situation. The *Cheiroballistra* specifies most of the device's measurements, but in both cases the catapult engineer will have to translate between the clean realm of the diagram and the messier assemblage of wood, bronze, and sinew he has in his hands. Here the flexibility of Hero's *theōria* can help smooth the transition between design and diagram, particularly where he offers templates that fuse the two concretely.

How do Hero's "scientific spectacles" compare to the experimental regimes of visualization that play out in the later scientific contexts explored elsewhere in this volume? The efforts by the members of the Accademia del Cimento to render the properties of heat and cold visible, described here by Giulia Giannini (Chap. 7),

resonate particularly strongly with Hero's pneumatic experiments in heat and pressure, and with the earlier Hellenistic context of theory and experiment upon which he drew. The direct involvement of Prince Leopoldo in the experimental activities of the Accademia suggests a very different set of protocols for courtly science than those which dominated the Ptolemaic court of Alexandria. There, the royal patron enjoyed the status of a social superior to whom scientific knowledge was conveyed as a kind of gift, as part of a reciprocal arrangement in which the scientist gained the social prestige of "ritualized friendship" with the patron (Berrey 2017, 25). The mechanisms of institutionalizing trust in Ptolemaic Alexandria (not to mention the Romanized Alexandria of a few centuries later) and seventeenth-century Florence clearly relied on quite different assumptions about how patron and expert might engage in the work of "making visible" scientific principles and technological possibilities.

At the same time, other features of the Accademia's experimental processes find more familiar analogues in Hero. Leopoldo's experiment was carried out on a simple (if specialized) vessel, and proceeded through various forms of visualization, from the unillustrated diaries of the Accademia at the moment to the minimal images published later in the *Saggi*. His simple yet vivid performance of freezing expansion in the long-necked vessel seems to have served as a heuristic springboard for the later experiments by the Accademia, which were accompanied by new visual elements including diagrams as well as data tables, which survive both in manuscript and printed form. The multimodal experience of seeing and feeling heat and cold in action (as well as perhaps hearing the cracking vessels) is reminiscent of the experiences of seeing and feeling the effects of compression and expansion in the preface to the *Pneumatica*. The richly letter-labeled diagrams of experimental apparatus designed by Rinaldini and Viviani, including the metal ring which could make expansion and contraction visible, enable some of the same pathways to making natural principles artificially visible as Hero's letter-labelled diagrams of his pneumatic devices.

The "horizons of possibilities" for exploring and representing scientific and technical knowledge which would have been available to Hero's reader, or mechanical engineer, or indeed Hero himself were of course very different from those available to the figures described elsewhere in this volume. In a world populated only by manuscripts, whose text and images needed to be laboriously hand-copied each time a new book was made, the kinds of images that could be faithfully reproduced were worlds away from the sleek MRI visualizations Silvia Casini (Chap. 10) describes, and even from the ready reproducibility enjoyed by the pools of early printed images Matteo Valleriani, Florian Kräutli, Daan Lockhorst and Noga Shlomi (Chap. 4) are working to navigate. Even the medieval manuscript copies of mechanical diagrams from antiquity are sparse. At the same time, the aims of ancient scientific and technical practitioners were in some sense the same as their colleagues from later centuries—to see the world more clearly, to explain it to others, to craft new experiences with creative artifice. The varying visual regimes Hero engages in service of these goals of course represent just one small part of those aims—and a rather technical one at that. He makes varied use of the technologies of visualization available to him, which include not only the letter-labeled diagram itself but the ways he sets it against verbal explanations of various kinds to lead his reader toward new conceptual connections.

Through these technologies, he takes his reader on structured journeys of *theōria*, from which they return enabled not only to see the world in new ways, but to engage with it actively and creatively.

References

Apollodorus. 1999. *L'arte dell'assedio di Apollodoro di Damasco.* Edited by Adriano La Regina. Milan: Electa.

Asper, Markus. 2001. Dionysios (Heron, Def. 14. 3) und die Datierung Herons von Alexandria. *Hermes* 129 (1): 135–137.

Asper, Markus. 2007. *Griechische Wissenschaftstexte: Formen, Funktionen, Differenzierungsgeschichten.* Stuttgart: Steiner.

Asper, Markus. 2013. Explanation between nature and text: Ancient Greek commentators on science. *Studies in History and Philosophy of Science Part A* 44 (1): 43–50. https://doi.org/10.1016/j.shpsa.2012.10.002.

Berrey, Marquis. 2014. Early empiricism, therapeutic motivation, and the asymmetrical dispute between the hellenistic medical sects. *Apeiron* 47 (2). https://doi.org/10.1515/apeiron-2013-0002.

Berrey, Marquis. 2017. *Hellenistic science at court.* Berlin: De Gruyter.

Berryman, Sylvia. 2009. *The mechanical hypothesis in ancient Greek natural philosophy.* Cambridge/New York: Cambridge University Press.

Buberl, P. 1936. Die antiken Grundlagen der Miniaturen des Wiener Dioskuridescodex. *Jahrbuch des Deutschen Archäologischen Instituts* 51.

Carder, James Nelson. 1978. *Art historical problems of a roman land surveying manuscript, the Codex Arcerianus A, Wolfenbüttel.* New York: Garland Pub.

Dilke, O.A.W. 1967. Illustrations from roman surveyors' manuals. *Imago Mundi* 21: 9–29.

Eratosthenes, Duane W Roller, and Strabo. 2010. *Eratosthenes' geography.* Princeton/ N.J.: Princeton University Press.

Feke, Jacqueline. 2014. Meta-mathematical rhetoric: Hero and Ptolemy against the philosophers. *Historia Mathematica* 41 (3): 261–276. https://doi.org/10.1016/j.hm.2014.02.002.

Flemming, Rebecca. 2007. Empires of knowledge: medicine and health in the hellenistic world. In *A companion to the hellenistic world*, ed. Andre Erskine, 449–463. Oxford: Wiley-Blackwell. https://doi.org/10.1002/9780470996584.ch26.

Fowler, David. 1995. Further arithmetical tables. *Zeitschrift für Papyrologie und Epigraphik* 105 (January): 225–228.

Fowler, David. 1999. *The mathematics of Plato's academy: A new reconstruction,* 2nd ed. Oxford/New York: Clarendon Press.

Fowler, David, and Christian Taisbak. 1999. Did Euclid's circles have two kinds of radius? *Historia Mathematica* 26 (4): 361–364. https://doi.org/10.1006/hmat.1999.2254.

Galen. 1985. *Three treatises on the nature of science.* Trans. Richard Walzer and Michael Frede. Indianapolis, Ind.: Hackett Pub. Co.

Gendler, Tamar Szabó. 2004. Thought experiments rethought—and reperceived. *Philosophy of Science* 71 (5): 1152–1163. https://doi.org/10.1086/425239.

Gleason, Maud. 2009. Shock and awe: The performance dimension of Galen's anatomy demonstrations. In *Galen and the world of knowledge*, ed. Christopher Gill, Tim Whitmarsh, and John Wilkins, 85–114. Cambridge, UK/New York: Cambridge University Press.

Hatzimichali, Myrto. 2013. Ashes to ashes? the library of Alexandria after 48 BC. In *Ancient libraries*, ed. Jason König, Aikaterini Oikonomopoulou, and Greg Woolf, 167–182. Cambridge: Cambridge University Press.

Hero. 2003. *Erone di Alessandria: le radici filosofico-matematiche della tecnologia applicata: Definitiones: testo, traduzione e commento.* Ed. Giovanna R. Giardina. Catania: CUECM.

Hudler, Petra. 2008. Die Pflanzenbilder in den Codices 187 und 2277 der Österreichischen Nation-albibliothek in Beziehung zu ihren Vorbildern in den bebilderten Dioskurides-Ausgaben. *Codices Manuscripti* 66: 1–54.

Jones, Alexander. 2009. Mathematics, science, and medicine in the papyri. In *The Oxford handbook of papyrology*, ed. Roger S. Bagnall, 338–357. Oxford Handbooks. Oxford/New York: Oxford University Press.

Keyser, Paul. 1988. *Suetonius Nero* 41.2 and the date of Heron mechanicus of Alexandria. *Classical Philology* 83: 218–220.

Knuuttila, Tarja. 2005. Models, representation, and mediation. *Philosophy of Science* 72 (5): 1260–1271.

Kusukawa, Sachiko. 2011. *Picturing the book of nature: Image, text, and argument in sixteenth-century human anatomy and medical botany*. Chicago/London: University of Chicago Press.

Lefèvre, Wolfgang. 2002. Drawings in ancient treatises on mechanics. In *Homo faber: Studies on nature, technology, and science at the time of Pompeii*, ed. Giuseppe Castagnetti, 109–120. Rome: L'Erma di Bretschneider.

Marsden, Eric William. 1971. *Greek and roman artillery: Technical treatises*. Oxford: Clarendon Press.

Mauch, Ute. 2006. Pflanzenabbildungen des Wiener Dioskurides und das Habituskonzept: Ein Beitrag zur botanischen Charakterisierung von antiken Pflanzen durch den Habitus. In *Antike Naturwissenschaft und ihre Rezeption 16*, eds. Jochen Althoff, Bernhard Herzhoff, and Georg Wöhrl, 125–138. Trier: Wissenschaftlicher Verl. Trier.

Netz, Reviel. 1999. *The shaping of deduction in Greek mathematics: A study in cognitive history*. New York: Cambridge University Press.

Netz, Reviel. 2017. Mathematical expertise and ancient writing *more geometrico*. In *Authority and expertise in ancient scientific culture*, ed. Jason König and Greg Woolf, 374–408. Cambridge: Cambridge University Press.

Nightingale, Andrea Wilson. 2004. *Spectacles of truth in classical Greek philosophy: Theoria in its cultural context*. West Nyack, NY: Cambridge University Press.

Orofino, Giulia. 1991. Dioskurides war gegen Pflanzenbilder: Die Illustration der Heilmittellehre des Dioskurides zwischen Spätantike und dem Hochmittelalter. *Die Waage* 30: 144–149.

Piganiol, André. 1962. *Les documents cadastraux de la colonie romaine d'Orange*. Paris: Centre national de la recherche scientifique; renseignements et vente au Comité technique de la recherche archéologique en France.

Riddle, John M. 1985. *Dioscorides on pharmacy and medicine*. 1st ed. History of Science Series, no. 3. Austin: University of Texas Press.

Roby, Courtney. 2016a. Embodiment in Latin technical texts. In *Embodiment in Latin semantics*, ed. William Michael Short, 211–238. Studies in Language Companion Series 374. John Benjamins.

Roby, Courtney. 2016b. *Technical Ekphrasis in Greek and Roman science and literature: The written machine between Alexandria and Rome*. New York/London: Cambridge University Press.

Roby, Courtney. 2018. Geometer, in a landscape: embodied mathematics in Hero's *Dioptra*. In *Revolutions and continuity in Greek mathematics*, ed. Michalis Sialaros, 67–88. Berlin/Boston: De Gruyter. https://doi.org/10.1515/9783110565959.

Sidoli, Nathan. 2011. Heron of Alexandria's date. *Centaurus* 53 (1): 55–61. https://doi.org/10.1111/j.1600-0498.2010.00203.x.

Stückelberger, Alfred. 1994. *Bild und Wort: Das Illustrierte Fachbuch in der antiken Naturwissenschaft, Medizin und Technik*. Mainz am Rhein: P. von Zabern.

Suárez, Mauricio. 2004. An inferential conception of scientific representation. *Philosophy of Science* 71 (5): 767–779. https://doi.org/10.1086/421415.

Taub, Liba Chaia. 2008. Eratosthenes sends greetings to King Ptolemy. In *Mathematics celestial and terrestrial: Festschrift für Menso Folkerts zum 65. Geburtstag*, ed. Joseph Warren Dauben, 285–302. Halle (Saale)/Stuttgart: Deutsche Akademie der Naturforscher Leopoldina; Wissenschaftliche Verlagsgesellschaft.

Taub, Liba Chaia. 2017. *Science writing in Greco-Roman antiquity*. Cambridge: Cambridge University Press.

Tybjerg, Karin. 2003. Wonder-making and philosophical wonder in Hero of Alexandria. *Studies in the History and Philosophy of Science* 34: 443–466.

van der Eijk, Philip. 2008. The role of medicine in the formation of early Greek thought. *The Oxford Handbook of Presocratic Philosophy*, October 2008. https://doi.org/10.1093/oxfordhb/9780195146875.003.0015.

Weisberg, Michael. 2015. *Simulation and similarity: Using models to understand the world*. New York: Oxford University Press.

Weitzmann, Kurt. 1947. *Illustrations in roll and codex: A study of the origin and method of text illustration*. Princeton: Princeton University Press.

White, Stephen A. 2008. Milesian measures: Time, space, and matter. In: *The oxford handbook of presocratic philosophy*, Oct. https://doi.org/10.1093/oxfordhb/9780195146875.003.0004.

Worp, K.A., E.M. Bruins, and P.J. Sijpesteijn. 1977. Fragments of mathematics on papyrus. *Chronique D'égypte* 52: 105–111.

Courtney Ann Roby is Associate Professor in the Department of Classics at Cornell University. Her work on scientific and technical texts from Greco-Roman antiquity focuses on the interplay between their verbal and visual components, the use of scientific models in antiquity, and cognitive aspects of ancient scientific and technical work. Her first book, *Technical Ekphrasis in Greek and Roman Science and Literature: The Written Machine between Alexandria and Rome*, was published by Cambridge University Press in 2016, and her new monograph on Hero of Alexandria is forthcoming from Cambridge University Press.

Chapter 6
Internal and External Images: Sixteenth-Century Herbals and the *Vis Imaginativa*

Magdalena Bushart

Abstract In no other area of the natural sciences have images been so controversial over such a long period as in botany. After all, the appearance of plants varies according to the season and from specimen to specimen. Nevertheless, in 1542 the physician Leonhard Fuchs set out to show "true" pictures in his famous herbal *De historia stirpium*. But did this mean that epistemic qualities were attributed to the pictures? This essay explores this question by comparing the pictorial strategies in sixteenth century herbals, also taking into account vernacular editions. In addition to the Latin and German versions of *De historia stirpium*, the focus is on the published *Herbarum vivae eicones* by Otto Brunfels and its German counterpart, the *Contrafayt Kreüterbuch*. Like most of their colleagues, Fuchs and Brunfels were convinced that knowledge could only be acquired through sensual perception. They therefore aimed at stimulating the imagination through pictures. The depiction of plants in text, in illustrative woodcuts or in a combination of both media was intended to call up memories of sensual experiences and help readers to generate their own mental images. As will be shown, this had consequences not only for the design of the pictures but also for the layout of the books.

Keywords Woodcut · Herbals · Otto Brunfels · Leonhard Fuchs · True Images

6.1 Introduction

In no other area of the natural sciences have images been as contentious over such a long period as in botany. As late as the nineteenth century, representatives in the field still dismissed illustrated handbooks as unscientific (Endersby 2008, 118–124). This skepticism toward images was due on the one hand to an object of study whose morphological variation could not be adequately grasped in a single representation. On the other, and closely related to this, was the belief that textual description permitted a more precise morphological characterization than pictures,

M. Bushart (✉)
Technische Universität Berlin, Berlin, Germany
e-mail: magdalena.bushart@tu-berlin.de

which were necessarily confined to external appearance. Finally, plant representations were suspected of being beholden to aesthetics rather than to knowledge. In 1869, the renowned botanical illustrator Walter Hood Fitch (1817–1892) noted with frustration:

> Botanical artists require to possess a certain amount of equanimity to enable them to endure criticism, for as no two flowers are exactly alike, it is hardly to be expected that a drawing should keep pace with their variations in size and color. (Fitch 1869, 499)

Despite this reservation, Fitch did not doubt that botanical drawings contributed to a better understanding of plant morphology. However, in order to satisfy the requirements of science, he believed they should adhere to certain compositional rules. These rules were set out by Fitch in a series of articles he wrote for the periodical *The Gardeners' Chronicle*. In his view, morphological characteristics should be rendered with a sharp outline and well-defined internal detail. Overlapping should be avoided (Fitch 1869, 7) and leaves were best arranged parallel to the picture plane, placed slightly askew along the stem—while foreshortening was allowed "for the sake of variety" (Fitch 1869, 51). Flowers should be shown in multiple views (Fitch 1869, 165), with details and sections magnified (Fitch 1869, 389). Shading should be executed with the utmost caution ("faintly put in"), and not in an artistic way but according to a principle of "theoretical shading" with parallel hatching or dots (Fitch 1869, 499).

Fitch's guidelines are interesting in a number of ways. First, they show that botanical drawings are distinguished not by their naturalism but by a high degree of abstraction, sometimes even based on modified plants. At the same time, they demonstrate that the information provided by the pictures is limited to the form, however much it may have been manipulated beforehand. Whether or not the result can be said to have an epistemic value depends on one's perspective. It certainly does not correspond to Lorraine Daston's definition, whereby epistemic pictures are made with the intention "not only of depicting the object of scientific inquiry but also of replacing it" (Daston 2015, 18). Ultimately a line drawing cannot convey information about color, smell, or taste. And even if that were the case a certain prior knowledge is required in order to correlate visual and textual information.

The same applies to sixteenth-century plant woodcuts, a tradition in which Fitch's drawing guide should also be placed. The prototype of botanic representation was largely developed in the illustrations of two printed herbals: the three-volume *Herbarum vivae eicones* by the theologian and physician Otto Brunfels (1488–1534), the first volume of which appeared in 1530,[1] and *De historia stirpium* by the Tübingen botanist and physician Leonhart Fuchs (1501–1566), published in 1542. Both authors also submitted vernacular versions of their books: the first volume of Brunfels's *Contrafayt Kreüterbuch* was published in 1532, the second in 1537; Leonhart Fuchs's *New Kreüterbuch* appeared in 1543. The works of both authors have been prominently and intensively researched, as they are generally seen to mark the

[1] Volume 1 of the *Herbarum vivae eicones* was published in 1530, volume 2 (*Novi herbarii tomus II*) in 1531, and volume 3 (*Tomus herbarii Othonis Brunfelsii III*) posthumously in 1536. All three volumes were republished in 1539 as *Brunfelsii herbarium*.

beginning of modern botany. Their illustrations, however, have been judged very differently. While those of the *Historia stirpium* are seen as the first attempt at a scientific depiction of plants, the woodcuts in the *Herbarum vivae eicones* are principally understood as works of art whose creators—without prior consultation with the author and without regard for the requirements of a herbal—simply followed their own agenda (Sprague 1928, 82–86; Rytz 1936, 25–29; Zucchi 2004; Touwaide 2008, 43–44; Ogilvie 2006, 169; Kusukawa 2012, 19). Whereas Fuchs regarded himself as the co-author of the plant representations, Brunfels complained of the independent decision making of his artists. Through a closer consideration not only of the Latin but also of the vernacular editions, however, it becomes apparent that in terms of both the composition and the status of the pictures there is a gradual rather than a categorical difference between the two works. Brunfels's publication not only developed a model for printed botanic pictures that would still be referred to by Fitch, it also constituted the first attempt to correlate text and plant illustrations.

Moreover, the two scientists had the same objective. Both assumed that the acquisition of knowledge must take the *sensibilia* as the point of departure and that human knowledge could only be acquired via images (Coleman 1992, 438). This conviction, which in the final analysis can be traced back to Aristotle (385–323 BCE)—but in the scholastic tradition to Thomas Aquinas (1225–1274)—linked them with most empirically working naturalists and theologians of the period. Thus the herbals set out to stimulate the imagination (Swan 2006). The representation of the plants in the text, in the illustrating woodcuts, or in a combination of both was intended to invoke memories of the reader's own sensory experiences and, with the help of the *imagination*, to generate mental images that could then be compared with the object itself. In this sense, "recognition" took precedence over "cognition." To this end artists and authors developed modes of representation and pictorial construction that made form the starting point of reflection.

6.2 *Descriptio versus depictio*

The conviction that pictures could not convey reliable information about plants was a commonplace in medieval botany. It can be traced back to Pliny the Elder (died 79 CE), who (in book twenty-four of his *Naturalis historia*) condemned the attempts of Greek authors to combine text and image as misguided:

> Crateuas, Dionysius, and Metrodorus…painted likenesses of the plants and then wrote under them their properties…. But not only is a picture misleading when the colors are so many, particularly as the aim is to copy nature, but besides this, much imperfection arises from the manifold hazards in the accuracy of copyists. Furthermore, one cannot just paint them at individual stages of their life, since they change their appearance according to the fourfold changes of the year.[2]

[2] "Praeter hos Graeci auctores prodidere, quos suis locis diximus, ex his Crateuas, Dionysius, Metrodorus ratione blandissima, sed qua nihil paene aliud quam difficultas rei intellegatur. pinxere namque effigies herbarum atque ita subscripsere effectus. verum et pictura fallax est coloribus

Pliny's warning concerning pictures—particularly their colors—and the reference to the mutability of nature survived in Germany throughout the Middle Ages and into the early modern period. At the time, herbalism was a purely textual science and herbals drew exclusively on the writings of classical and Arabic authors, who were treated as infallible sources of information. Personal observation had as little place in this system as the visualization of knowledge through images. The fact that, from the late fifteenth century onwards, most printed herbals included woodcut illustrations was primarily due to the initiative of the publisher, who expected them to increase the books' profits.[3] Nevertheless, the schematic representations placed before the plant descriptions lay no claim to the discernable representation of the various species: form was rendered without embellishment by a highly simplified outline drawing, flowers and leaves were arranged regularly, roots were shown hanging freely. The woodcuts were mostly oriented toward the representations of earlier illustrated manuscripts or were copies of woodcuts in precursor works, leading to a further loss of precision.[4] If no model was available the same image was used for several plants. The pictures may have been understood as memory aids (Kusukawa 2012, 17–19) or thought to have magical properties (Isphording 2008, 41) or seen as a compromise between a book culture that craved woodcut illustrations and a tradition of skepticism toward images that can be traced back to Pliny; they did not, however, serve as conveyors of information, nor were they considered as such. This was even the case when, as in the *Gart der Gesundheit* (1485), they claimed to be the product of direct observation (Fig. 6.1).[5]

Authors were fully aware of the problem of negligent and unsystematic illustration. In the afterword to his *Destillierbuch* published in 1500, Hieronymus Brunschwig (1450–1512) apologized for the fact that the printer had unwittingly ascribed a number of woodcuts to the wrong plant descriptions. He went on to remark, however, that the pictures were inadequate in any case because, unlike words, they could capture neither the appearance nor the properties of herbs. He advised his readers "not to look at the figures only, but to focus on the written text and to learn about the plants by *gesicht* instead, "as figures are nothing more than a feast for the eyes and

tam numerosis, praesertim in aemulationem naturae, multumque degenerat transcribentium fors varia. praeterea parum est singulas earum aetates pingi, cum quadripertitis varietatibus anni faciem mutent" (Pliny, *Naturalis historia* 24, 4, trans. Meyer et al. 1999, vol. 1, 3) with slight alterations.

[3] On early printed herbals, see recently (Baumann and Baumann 2010; Isphording 2008, 107–123). On herbals in general, see (Nissen 1951; Arber 1990).

[4] On the reuses and filiations of herbals, see (Klebs 2007).

[5] The initiator of the book project, the canon of Mainz Cathedral Bernhard von Breydenbach, claimed that he specifically engaged a good artist ("von vernunft und hant subtiel und behende") to copy the herbs "in their proper colors and forms" ("in ihren rechten farben und gestalt…kunterfeyen und entwerfen") (Wonnecke von Kaub 1485, fol. 2v). However, the majority of illustrations followed earlier manuscript illustrations, were freely invented, or were based on descriptions (Baumann and Baumann 2010, 122–140).

Fig. 6.1 Johannes Wonnecke von Kaub, Gart der Gesundheit, Mainz 1485: Borago/Porrich. Woodcut. Private collection

a supply for those who cannot write nor read."[6] With the term "gesicht" he is probably referring in this context to the imagination, which engenders "internal images" when prompted by description or calls these up from the memory.[7] It is contrasted with the idea of bodily vision, which according to Brunschwig only serves to please the senses. The belief that mental images should be valued more highly than the *depictio*—the pictorial rendering of an object—was familiar to his contemporaries. In particular, theological debates on spiritual meditation reflected on the respective merits of external and internal vision (Carruthers 1998, 116–135). Brunschwig was referring directly to these discussions when he remarked that pictures were of use principally to the illiterate. This famous topos can ultimately be traced back to Gregory the Great (died 604) and was the subject of manifold efforts to legitimate the status of religious images during pre-Reformation disputes over their role (Duggan 1989, 227–251).[8]

Significantly, Brunschwig's skepticism regarding the epistemic potential of images only related to plant representations, and furthermore to representations that were copies of copies.[9] When it comes to the presentation of the distillation apparatuses a reverse relation between text and image can be observed. Vessels and ovens are described rather cursorily; for further information the reader is referred to the highly simplified illustrations placed directly beneath the text. Hence the instruction: "Then you need rounded glassware…of the following form" ("Darnach müßtu haben krumme gleser… / deren form also ist") is followed by a woodcut showing the corresponding flask (Brunschwig 1500, fol. 20r), and the chapter on ovens begins with the sentence: "Now I wish to speak about the distillation oven, whose illustration is here" ("Nun will ich fürbaß begynnen zu leren von den destillier offen / deren figur hier stott") (Brunschwig 1500, fol. 23v). It is clear therefore that for the author the information value of pictures depended on the complexity of the object of study. While the form of apparatuses could be defined clearly, the mutability of natural objects eluded the static *depictio*. In such cases the *vis imaginativa* was needed to engender mental images of the absent object. These shifting phantasmata were able to incorporate not only recollections of visual sense data but also sensations of touch, smell, and taste (Dewender 2003, 150–155). Presumably they also made it possible to grasp the variety of appearances, the phases of growth, and various habitats.

[6] "Darum ist nit zu achten allein uff die figuren / sundern uff die geschrifft vnd dz erkennen durch die gesicht / und nit durch die figuren / wan die figuren nit anders synd dann ein ougenweid vnd ein anzeigung geben ist die weder schriben noch lesen kündent…" (Brunschwig 1500, fol. 228v).

[7] On the layers of meaning found in the term *Gesicht*, see the lemma "Gesicht" in the *Frühneuhochdeutsches Wörterbuch*: https://fwb-online.de/lemma/gesicht.s.2n?q=gesicht&page=1 (accessed 5 August 2020). For the discussion of this point I thank Hans Jürgen Scheuer, Humboldt University Berlin.

[8] On the reception of this topos in early modern literature in Germany, see (Heinrichs 2007, 23–43).

[9] The woodcuts are based on copies that the publisher Johannes Grüninger had made for his reprint of the *Hortus Saniatis / Gart der Gesundheit* by Wonnecke von Kaub (1485) after the woodcuts of the first edition. See (Isphording 2008, 123f). On the copying industry, see (Klebs 2007; Leitch 2017; Mar and Ryff 2014).

6.3 *Ante oculos ponere*

In the third decade of the sixteenth century the approach to herbalism changed. The knowledge handed down in literary form was now supplemented and verified by individual observation (Ogilvie 2006, 126–208; Touwaide 2008, 38–42). A natural history based on empiricism could no longer be content with the old schematic representations passed on from generation to generation or from book to book. For Hieronymus Bock (1498–1554) (alias Hieronymus Tragus) this would lead to a renunciation of images. In his foreword to Bock's *Kreütter Buch* (1539), a work dedicated exclusively to native plants, the book's publisher, Wendel Rihel, listed three reasons as pivotal for this decision: First, the commissioning of new lifelike illustrations would raise production costs and thus the price of the book—an argument that may well have been based on experience, as illustrated books only made a profit by working with pirated copies or by reusing blocks from earlier publications. Second, it was difficult to find suitable artists who would be able to adequately render subtle differences—a variation of Pliny's complaint about the incompetence of draughtsmen and copyists. Third, Rihel (as Brunschwig before him) invoked the limited epistemic value of visual information. Only description, he argued, could capture the characteristics of a plant and provide a proper idea of its morphology,[10] for knowledge about nature arises "from the right use of the understanding rather than from uncertain appearance" ("auß rechtem verstand dann nach ungewissem augenschein") (Bock 1539, 1v). While economic considerations were of obvious interest to the publisher, this last point corresponded to the convictions of the author. As Bock writes, he placed "each herb with its species, sex, form, name, smell, and taste, how, where and when it grew…clearly before the eyes [of the reader]" ("eyn yedes [Kraut] mit seiner art / geschlecht / gestalt / namen / geruch / geschmack / wie / wo / und wann es wachst…klerich für die Augen gestelt") (Bock 1539, 5v). Here Bock is arguing in the tradition of ancient rhetoric, whereby the quality of a speech was measured by its vividness; the description of an event or an object should give the audience the impression that it was being acted out, or placed, before their eyes.[11] Ultimately the *ante oculos ponere* of rhetoric also aimed at the *vis imaginativa*. "Placed before the eyes" in the text was of course not only the visible form but also impressions of taste and smell, as well as information about habitat and flowering times—all of which were combined to form a mental image of the plant.

For Rihel and Bock the fact that only a small circle of a "learned" or at least "receptive" audience with sufficient prior knowledge felt addressed by this concept was not perceived as problematic (Bock 1539, fol. 2r). Indeed the decision not to include woodcuts may have been an attempt at safeguarding the exclusivity of pharmacological knowledge. From the point of view of specialists, the vernacular editions, by

[10] "…wo nun der fleissig leser sein beschreibungen wol bedenke unnd sie recht in die augen fasse / so habe er leicht zusehen / welches Kraut solcher beschreibung zu sage oder nit." Wendel Rihel, foreword, in (Bock 1539, 1v).

[11] In the *Rhetorica ad Herennium* we read: "Demonstratio est, cum ita verbis res exprimitur, ut geri negotium est et res ante oculos videatur" (Nüsslein 1994, 314).

making herbalism accessible to the laity, already presented a danger (Habermann 2002, 200–206). The addition of pictures, it was feared, would attract a readership that would be unable to understand the material in its complexity. For this reason the botanist Euricius Cordus (1486–1535) emphatically warned against illustrated vernacular herbals:

> The herbals translated into German that are so lavishly and handsomely illustrated and colored are worthless. They also cause notable damage in the hands of ignorant people who without basis consider themselves doctors, and thereby frequently become murderers.[12]

Reactions to the *Kreütter Buch* confirmed the book's success—at least in the world of scholarship. When Leonhart Fuchs for instance noted that his colleague "painted" (*pingit*) with words what he had previously seen with his own eyes, he was praising not only Bock's empirical approach but also the image-like quality of his descriptions.[13] Nevertheless, the absence of pictures probably did not help sales—which may have led Rihel to furnish the second edition, published in 1546, with "handsome and pleasing illustrations" ("hüpschen artigen Figuren") partly based on copies pirated from Brunfels and Fuchs (Bock 1546).[14]

Euricius Cordus's *Botanologicon*, a treatise in the form of a dialogue that can be understood as a call for an empirical natural history, also did without illustrations. Cordus advocated excursions to the immediate and wider surroundings to study plants in their original habitat. However, his investigations continued to be guided by text, in particular by the descriptions in *De materia medica* by the Greek pharmacologist Dioscorides (died ca. 90), which for Cordus was *the* foundational work of herbalism and which he took along with him on his trips (Dilg 1969, 139).[15] To identify plants, he drew on knowledge acquired through reading as well as images gathered in his memory, which were then supplemented with the accounts of knowledgeable laypeople. According to this model, material images were superfluous, since the comparison of information took place next to the living plant:

> I take great pleasure in going into the countryside and comparing all sorts of herbs and plants that grow in various locales and about which I have read at home, with the images stored in my memory and observing them. And sometimes I am able to ask their properties or their names from the old wives I meet along the way. On this basis—after comparing all of them

[12] "[Die] vertheutschten Kreuterbucher / die doch allesampt wie kostlich und hubsch sie vermalet unnd außgestrichen nicht eins pfifferling werd seynt / Thun auch mircklichen schaden unter den unverstendigen leuten / welche so sich daraus an all fundament zu arzten unterstehen zum meren mal morder werden." From Euricius Cordus, *Theriakbüchlein* (1532), quoted in (Dilg 1969, 110).

[13] "Et quidem hunc non esse imperitum herbarum, earundem descriptiones quas affert palàm testantur. Eiusmodi enim magna ex parte suntut oculis suis inspexisse hunc herbas quas pingit abundè demonstrent" (Fuchs 1542, fol. A5v).

[14] Rihel's foreword in this edition clearly addresses economic considerations: (Fuchs 1542, fol. Br). The studies for the woodcuts were by the Strasbourg artist David Kandel, who in approximately half of the pictures drew on models from the herbals of Brunfels and Fuchs while also contributing seventy-eight representations of his own, which in part were developed into mythological or allegorical scenes (Isphording 2008, 148).

[15] On the sixteenth-century reception of Dioscorides, see (Stannard 1999).

with their descriptions—I am the better able to judge them clearly and come to as accurate a conclusion as possible about them.[16]

6.4 Living Images

Another strategy was agreed on by Otto Brunfels and his publisher Johann Schott (1477–1548). The three volumes of the *Herbarum vivae eicones ad naturae imitationem, summa cum diligentia et artificio effigiate…*and the *Contrafayt Kreüterbuch* represent the first attempts to convey information about the appearance of the plants presented not only via the text but also via pictures. The title in both its Latin and German versions can be understood programmatically. As Peter Parshall has shown, the terms *eikon, abcontrafehung*, and *effigies* described a relation between representation and represented—whether an object, a person, or a work of art—which aimed primarily at external similarity. Hence they were distinguished (if not always clearly) from the terms *eidos, bildnuß*, and *imago*, which could also imply an essential correspondence with the object (Parshall 1993, 554–579, 561).[17] Albrecht Dürer (1471–1528) for instance designated his portrait engraving of Erasmus of Rotterdam (1466–1536) as an "imago…ad vivam effigiem delineata" and thus as an essential image or *Wesensbild* (Rudolf Preimesberger) transcribed in the medium of the life-like *effigies*, which in the rendering of physical appearance also makes visible what is non-representable in the sitter—his spirit (Preimesberger 1999, 234). To the extent that Brunfels and Schott considered this conceptual distinction, the "vivae eicones ad naturae imitationem…effigiatae" could be understood as indicative of the fact that the woodcuts only captured one facet of the complex entity "plant," namely that of its mutable external appearance. A *Wesensbild* going beyond this was not thereby implied.

While the initiative for the illustrations probably came from Schott, Brunfels wrote a vigorous defense of their use in the *Contrafayt Kreüterbuch* two years after the publication of the first volume of the *Herbarum vivae eicones*. Here he adopted two lines of argument: first he referred to a classical tradition dating back to *before* Pliny, one that was entirely familiar with plant illustrations; then he countered the argument that the mutability of natural objects could not be captured in a single picture with the possibility of the latter's multiplication. As he remarked, it would be desirable ("ein köstlich ding") if one could record the stages of development from a plant's "childhood" and youth to its maturity and old age and depict each herb several

[16] "Maxime enim ruri delector, ubi coram vivas illas, de quibus domi legeram, herbas ad commendatas memoriae effigies confero et contemplor, ipsasque tum nomenclaturas, tum etiam vires ab obviis vetulis exploro, dehinc collatis ad earum historias omnibus maturo et quam sagace possum iudicio vel decero vel opinor" (Cordus 1534, 26–27); the translation follows (Swan 2011, 188). While Brunfels's *Herbarum vivae eicones* is brought along by a participant in the excursion described in Cordus's text, the pictures do not play a role in the identification, especially since Cordus is at the same time critical regarding the scientific benefit of the book.

[17] See also the lemma "Bildnis" in the *Frühneuhochdeutsches Wörterbuch*: http://fwb-online.de/go/bildnis.s.1fn_1604924559 (Accessed 5 August 2020).

times.[18] He went on to note, however, that this task would have to be left unrealized if one did not wish, as had other authors, to make do with inadequate representations.[19] That meant by implication that, as the possibility of presenting the development of the plants in sequences was ruled out for reasons of cost, single pictures were to be favored that remained recognizable despite their limitations. Through his reference to the different ages of a plant, Brunfels suggests that this limitation is also true of portraits—but without portraiture ever becoming obsolete.

At the same time, Brunfels understood the vividness of the *Contrafayt* or the *eicones* in a double sense. With the terms εἰκών and *Contrafractur* he designated not only the pictorial representation of plants but also (his own or another's) textual descriptions.[20] Moreover it is not always clear which medium is being characterized; even the verb *abmalen* (to paint) is used in a double sense.[21] In any case, the point of reference for these various forms of "image" remained the engagement with the

[18] "Dieweil aber solichs mügsam gesein / die kreüter mit iren fyer alteren zu beschreiben / unnd dazumal der Truck noch nit gesein / hat solichs kein bestandt mogen haben. Dann gleich wie die menschen ire glidmass / ire eygenen complexionen / ire eygene alter habent / also die kyndheit / yugent / mannschafft / und alter / also auch die kreüter / welche sich auch der mass von eyner zeyt in die andere verwandelen / unnd ynen selb gar nicht gleich noch ähnlich seind / bringt desshalb grossz yrrthymb / das wir vil kreüter in irer jugent kennen / die uns im alter entwachsen / und unbekannt / und so auch widerumb. Die kindkeyt nenne ich / wann sye erstlich uffgan in den Meyen. Die jugent / wann sye blüen. Mannheyt / wann sye anfhane sich besomen. Alter / wann sye im abnemen seind. Unnd diese dinge verlauffen sich alle in fyer monaten. Solchich alter der kreuter war zu nennen / wer wol ein kostlich ding / ist aber mügsam und müsst man yedes kraut wol fyermal contrafeyen / möcht mit der zeyt sich mit unserm kreüterbuch sich zutragen....." (Brunfels 1532, fol. Bv). Here Brunfels responds to the reservation expressed by Janus Cornarius in 1529 in his edition of the Greek text of Dioscorides's *De materia medica* that pictures cannot show how plants change over time. See (Touwaide 2008, 43).

[19] In this Brunfels made a distinction between painted herbals, which an exclusive clientele had recently made after classical models, and printed works: "Diese furnemen der Alten / habe ynnerthalb fünffzig jaren auch wider angefangen / ein Theil bey ynen selber / etlich großmächtige / reiche / gewaltige / welche sich kein kosten haben dauren lassen / unnd ynen eygene besondere bücher lassen malen / welche sye für ein grossen schatz gehebt / und noch haben / deren ich auch zum Theyl bey etlichen gesehen / bey etlichen aber hab hoeren ruemen.... Die anderen aber haben solichen dem Truck under standen / wie wir der selbigen vilfaltig / vnd mancherley gattung gesehen / aber dieweil sye den kosten gespart / und villeicht auch der waren kunst nicht bericht / alle verhympelt / unnd nichts rechtschaffens worden / so der figuren halb die blößlich gefyßiert / so der beschreibung / welche deß merentheyl falsch / unnd auß nochgütlichen / verachtlichen Bücheren gezogen" (Brunfels 1532, fol. Bv). Here the designation "gefüßiert" does not seem to describe a "construction" acquired from observation but one following a description.

[20] For the Greek εἰκών, see (Brunfels 1530, 31, 38). In the German edition, Brunfels speaks for example in the descriptions of the *Grosse Wallwurz* (Brunfels 1532, XIII) and the *Spitzwegerich* (Brunfels 1532, LVIII) of "Contrafactur." Here and there one also finds the terms *Picturatio* (Brunfels 1530, 121), *Pictura* (Brunfels 1530, 160), and *Abmalung* (Brunfels 1532, CLXXXVI).

[21] The concept of "Contrafractur" is already unclear in the introduction to the German edition when Brunfels explains: "dieweil wir unser fürnemen dahyn gesetzt / der kreuter kunst wider herfür zu helfe / und uff die ban bringen / haben wir solichs nicht künnen zu wegen bringen / dann durch die contrafactur, und die rechten warhafften beschreybungen Dioscorides / Plinii und der Alten" (Brunfels 1532, fol. C4v/C5r). On the lack of conceptual distinction between textual and pictorial representation, see (De Angelis 2011, 225–226).

plant itself. This had already been suggested by the depiction of Dioscorides facing Apollo, the god of medicine, on the title page of the Latin edition (Fig. 6.2). In one hand the scholar is holding an impressive plant along with its root system, in the other a book. In this way a connection is made between the information conveyed by the book and the information presented by the object itself.

As is known, Brunfels himself failed regarding the programmatic claim formulated by the title woodcut. In the *Herbarum vivae eicones* the external appearance of the plants is only marginally addressed and largely through the descriptions of others. The core of the entries is formed by the opinions of the all-too-familiar authorities regarding the *temperamentum* and *vires et iuvamenta* (properties and use) of the plants. Because Brunfels attempted to apply the taxonomy of the classical authors to native plant species and trusted too little his own observation—as was already noted by his contemporaries—this repeatedly led to inconsistencies between nomenclature, descriptions, and illustrations. While the author acknowledged that errors had been made, he put the blame on the artists, whom he claimed had completed the woodcuts without prior consultation and in an unsystematic order.[22] His shortcomings were particularly manifest in his treatment of herbs that the artists had represented on their own initiative and for which he knew neither the scientific name nor the possible use. While in the Latin edition he attempted to identify the plants and to add their common name (although he did not always manage even this—in the case of the illustration of the *Anemone nemorosa* he noted succinctly: "forest herb, name unknown"),[23] on the whole, plants that were not included in the classical canon of knowledge were described as "herbae nudae."[24] However, it is precisely the absence of commentary that made these "herbae nudae" a novelty in the history of printed herbals. Where details on nomenclature, properties, and use were lacking it was the images themselves that had to be interrogated for epistemic content.

Nevertheless, the *Herbarum vivae eicones* was innovative in other respects too. As in earlier herbals the woodcuts are placed before their respective descriptions. In the first two volumes of the Latin edition, the names of the plants are occasionally only revealed in the subsequent listing of the *nomenclaturae*; occasionally, however, they are treated as part of the illustration. Here a number of possible variations are tested: at times only the Latin, at times only the German name is given, occasionally both. At the

[22] In the vernacular edition one reads: "Es ist auch mein meynung nit / alle kreüter zu beschreiben (dann mir solichs nicht möglich), sonder etliche / die dann auff dißmal von den meystern und contrafactyeren uns haben zu handen mögen ston / welchen wir in dißem werck / wie hernachmals offt bezeüget / vil haben müsszen zu / unnd nach geben / dieweil die wilkür bey den selbigen gestanden / zureissen was sye gewölt / oder auch vermöcht / unser fürnemen und beschreibungen zerrüttet / und zerstöret worden / das wir nit satte ordnung mögen halten" (Brunfels 1532, fol. A3v). In the Latin edition one finds a reference to the complications of the production process in the entries on the *Pulsatilla vulgaris* (Brunfels 1530, 217) and the *Weiß Fleyschblum* (Brunfels 1531, 55).

[23] "Herba sylvestris, ignota nominis" (Brunfels 1531, 80). The vernacular edition still notes briefly: "Ein unbekant waldtkraut" (Brunfels 1532, CXI).

[24] "Nam cum formarium delineatores & sculptores, vehementer nos remorarentur, ne interim ociose agerent prela, coacti sumus, quamlibet proxime obviam arripere, statuimus igitur nudas herbas, quarum tantum nomina germanica nobis cognita sunt, praeterea nihil" (Brunfels 1530, 217).

Fig. 6.2 Otto Brunfels, *Herbarum Vivae Eicones*, vol. 1: Straßburg, 1530: Title Woodcut. Universitätsbibliothek Münster, urn:nbn:de:hbz:6:1-67044

same time their respective position also varies: names are placed above and below the picture or on both sides of the plant. In the German edition the captions were adapted in a more systematic way. The German names were now added throughout (although still in changing positions).[25] The combination of pictures and names bound the identification more tightly. Euricius Cordus remarked (not without malice) that the "plant representations made after mother nature" ("genetricem naturam expressae herbarum icones") added further to the problem of false attribution: "The more accurately each [plant] is represented in its external appearance, the more serious is the error when one does not give it its proper name."[26]

Slightly different was the problem arising from the picture sequences—another innovation of the *Herbarum vivae eicones*. Here the woodcuts of plants, which Brunfels assigned first to a family or species, then to different "sexes" (he speaks of "männlin" and "weiblin"), are placed in a series one after the other and the (often merely presumed) affiliation is discussed in the subsequent text. Thus, even *before* we read the text, the representations of the various *Plantago*, *Nymphaea*, *Orchis*, and *Ranunculus* species already invite a comparative study that enables us to discern differences and similarities in the external form. However, pictures do not only serve to indicate taxonomies; they are also used to delegate decisions. Accordingly, Brunfels shifted the famous dispute enflaming the passion of scholars in the third decade of the sixteenth century, as to whether the ancient *Buglossum* was to be identified with the contemporary *Borago* (borage), through a sequence of pictures (Kusukawa 1997, 417–419) (Figs. 6.3, 6.4 and 6.5). He arranged the woodcuts of an *Anchusa officinalis*, a *Borago officinalis*, and a plant wrongly designated as a *Buglossa silvestris / Wild Ochsenzung* (it is actually an *Echium vulgare* belonging to the Boraginaceae family) in a series, then reported on the different positions in the controversy, and finally invited the reader to form his or her own judgment on the basis of the pictures and descriptions: "On both sides we have added illustrations of both the *Buglossum* and the *Borago*. In addition we have placed beneath the judgments of scholars and the words of Dioscorides. To me at least it seems probable that they agree in flowers and leaves as well as in their possible uses [*iuvamenta*]."[27]

6.5 Pictures as a Basis of Discussion

In the vernacular edition, which was addressed to a wider, less exclusive audience, the pictures play a more important role. Furthermore, scientific discussions and scholarly

[25] Pictures and names were set separately, however, as is shown by the entry on the *Melissa*. Here the caption is given without the corresponding picture (Brunfels 1532, CCCI).

[26] "Quo similius sua quaeque facie pingitur, eo peius errantur, si non & verum eidem nomen tribuitur" (Cordus 1534, 14; Fuchs 1542, fol. A5v). On the critique of modern botany, see (Baumann and Baumann 2010, 175).

[27] "Nos utramque tibi adpinximus & Buglosson & Boraginem. Habes praeterea doctorum hominum iudicia, & Dioscoridis verba tibi subscripta; verisimilieque mihi videtur, ut in floribus & herbis conveniunt, ita quoque in iuvamentis" (Brunfels 1530, 117).

Fig. 6.3 Otto Brunfels, *Herbarum Vivae Eicones*, vol. 1, Straßburg, 1530: Borago/Burretsch. Woodcut. Universitätsbibliothek Münster, urn:nbn:de:hbz:6:1-67044

corum, T O M V S Primus. 111
Buglossa fylueftris.

Wild Ochfen zung.

Fig. 6.4 Otto Brunfels, *Herbarum Vivae Eicones*, vol. 1, Straßburg, 1530: Buglossa Sylvestris/Wild Ochsenzung. Woodcut, Universitätsbibliothek Münster, urn:nbn:de:hbz:6:1-67044

corum, TOMVS Primus. 113
Borago.

Burretsch.

Fig. 6.5 Otto Brunfels, *Herbarum Vivae Eicones*, vol. 1, Straßburg, 1530: Borago/Boretsch. Woodcut. Universitätsbibliothek Münster, urn:nbn:de:hbz:6:1-67044

references give way to more detailed descriptions, which increasingly draw on the oral accounts of herbalists.[28] For Brunfels the "nakedness" of the unknown herbs was evidence of the limited validity of classical herbal medicine; it provided him with the opportunity to take a stand against his critics. He comments on the woodcut of the *Campanula ranunculus*, for example, with the words: "I offer these *rapüntzelin* to scholars as a salad in order that they tell me what they are called in Dioscorides and Pliny. If they [the plants] were as familiar to me in Latin and Greek as they are in German on the printing block I would happily write about them."[29] The author repeatedly refers to the illustrations to support his own attribution. On the *Blitum bonus-henricus*, which he wrongly ascribed to the Araceae family, he remarks: "There is in addition another herb that is called *Gutheynrich*. The old wives want to make me believe it is a *Natterwurz*. It has leaves [like those of the] *Aron* that resemble a forked beard, but stouter and rougher, and pollinates itself, as you can see here"[30] (Fig. 6.6).

Brunfels compares the *Vincetoxicum hirundinaria*—a plant that was familiar to him, as he explains, not from literature but only from "augenschein" (i.e. from what he has seen with his own eyes)—with the genus *Valeriana*, from whose species it was only distinguished by its stronger root formation. However, this only applied to older plants, not to the specimen represented, "since the young [*Schwalbenwurze*] have delicate roots like a young *Valeriana*, as you can see represented here."[31] Furthermore he demonstrates the difference between *Lilium martagon* and *Lilium bilbuferum*, which are both given the common name *Goldgilge* or *Goldwurtz*, not in the text but with the help of pictures: "I have represented [*contra fayet*] both so that the difference becomes visible [*augenscheinlich*]."[32] Finally, he discusses the depiction of an *Iris pseudacorus* in relation to Dioscorides' description of a plant named *Acorus* to come

[28] As we read in the vernacular edition on the *Anemone pulsatilla* (*Küchenschelle*): "Kuchschell / nennen etlich alte Kraeuterlin Hackerkraut / unnd sagen dabey / das es gewaltige Krafft hab wunden zu heylen. Weiters ist mir nit zu wissen / wie sein nam im Dioscoride sey" (Brunfels 1532, CXLIII). In fact, the woodcut is considered the first attestation of the *Anemone pulsatilla*. See (Sprague 1928, 113).

[29] "Diße rapüntzelin will ich den geleerten zu einem sallat schencken / das sye mir sagen wie soliche beym Dioscoride unnd Plinio genennet werden. Welche / wann sye mir so wol bekannt weren zu Latin unn kryechisch / als uff teütsch in der platten / wolt ich auch gern etwas darvon schreiben" (Brunfels 1532, CLXXIII). In the Latin version the plant was left without commentary (Brunfels 1531, 84). Similar commentaries are found on the *Maiglöckchen* (Brunfels 1531, CLXV).

[30] "Noch ist ein Kraut Gutheynrich genannt / wöllen mich alte weiber bereden / es sey auch einer Naterwurtz / hatt Aronbletter gleich eim gespaltenen bart / aber kurtzgestossener und rauher / besamet sich allent halben / wie du es hye zu gegen syhest" (Brunfels 1532, LXXV). In the Latin version, there is a much briefer remark on how he included the plant at the suggestion of laywomen: "Praetera et eam adpinximus quae vulgo Gut Heinrich vocatur, vel Schwerbel. Ita enim vetulae nos persuasserunt." For another picture-based argument cf. the entry on the *Agrimonia eupatoria* (Brunfels 1532, LXXXVI).

[31] "Dann die jungen [Schwalbenwurze] haben zarte würtzelin / wie ein junger Baldrian / wie du auch hye abgemalet sychst" (Brunfels 1532, CLIX).

[32] "Welchs nun die recht Goltwurtz sey under dißen zweyen / oder ob es ein ander sey / beger ich gelert zu werden / ich hab beyde contra fayet / damit man augenscheinlich den underscheyt sehe" (Brunfels 1532, CVII).

Fig. 6.6 Otto Brunfels, *Contrafayt Kreüterbuch*, Straßburg 1532: Gut Heynrich. Woodcut with hand-colouring. Bayerische Staatsbibliothek München, VD16 B 8503, urn:nbn:de:bvb:12-bsb000 54201-5

to the conclusion that the *Schwertel* (*Iris pseudacorus*) shown in the woodcut could hardly be considered identical with the ancient *Acorus*.[33]

The *Contrafayt Kreüterbuch* also shows that the complaint about insufficient consultation from the artists need not imply that Brunfels had no part at all in the illustration of the herbal (Arber 1990, 55). The author repeatedly indicates that the pictures or the selection of plants were the result of his initiative. In the case of the *Wylden Knoblauch* (wild garlic, *Allium ursinum*) he notes that the depicted herb ("dißes gegenwertig Kraut") was brought to him from the Swiss mountains (Brunfels 1537, XXXV).[34] In the case of the *Natterwurz* (*Bistorta officinalis*) on the other hand he apologizes for the absence of an illustration; the specimen he received from Brabant through the intercession of Johann Schott had unfortunately died and therefore could not be *contrafayt*—here again both picture and word are surely meant (Brunfels 1532, LXXIII). In the *Contrafayt Kreüterbuch* too, however, it is impossible to discern a consistent system in Brunfels's treatment of the woodcuts. On the whole, text and image simply run parallel to each other with no apparent connection; links are made only occasionally. Even when several species are discussed in the text, we rarely learn which of these species is to be seen in the woodcut.[35]

There were surely a number of reasons for the inadequate correlation between pictures and descriptions: First the production process, which allowed Brunfels to see a portion of the pictures only after the completion of the text.[36] Second, the author concealed his incomplete botanic knowledge beneath a deliberate vagueness in his judgments; he often considered it sufficient to simply report on the discussion among experts over an interpretation of the classical authors.[37] Above all, however, he believed that for widely known, uncontroversially identified species no *contrafayt* was necessary, since the name alone would invoke a mental image. Hence he justifies the brief description of *Salvia* with the following words: "Because sage is a very well-known herb and has also been described clearly in Dioscorides…, its name and use need not be discussed further. And we wish to treat the other common herbs in the same way and not trouble to paint with words those that are also known by children, since we have them before our eyes even without [descriptions]."[38] Accordingly,

[33] "Aus welcher beschreibung auch ein kindt wol möcht abnemen / das unser gelb Schwertel nicht der recht Acorus ist / sonder des selbigen ein geschlecht" (Brunfels 1532, CX).

[34] Similar remarks are found in the third volume of the Latin edition (Sprague 1928, 108, no. 210).

[35] In the case of the *Storchenschnabel*, Brunfels makes clear which of the four species of Geraniaceae is shown in the picture: "Das fyerd gar klein / kreücher uff der erden / nicht über ein spannen hoch / hat lange schnäbelin, und das selbig haben wir gesetzt" (Brunfels 1532, CXCVII). In the case of the *Nachtschatt* on the other hand, there is uncertainty about the "Geschlecht" of the specimen represented (Brunfels 1532, CXCIIII).

[36] On the woodcut of a plant summarily designated as an *Einblatt* he remarks with frustration: "Ist mir nicht weyter bekannt / dann dem augenschein nach / hab auch sonst von nyemants anders mögen bericht werden / was es für andere nammen hab. Ist aber ein Waldkraut / unnd ausser der gwültnis uns zu hand gestanden" (Brunfels 1532, CCXXXV).

[37] On this T. A. Sprague has noted: "Brunfels seems to have regarded the choice of names almost as a matter of indifference" (Sprague 1928, 85).

[38] "Dieweil Salbey gar ein bekannt kraut / und auch bey dem Dioscoride klar außgesprochen/… ist nicht not des namens und der gestalt halb hoch zu disputieren. Und solichs woellen wir auch in

images are always involved in the reading of the book. They can emerge through the description and the name, but in problematic cases acquire necessary precision only through the woodcuts. In this way uncertain attributions (as with the *Blitum bonus-henricus*) can be discussed and confusion in the event of identical names (as with the *Goldgilge*) can be avoided. In this sense Brunfels certainly attributed an epistemic quality to the pictures—even when, as in the case of the "herbae nudae," the knowledge acquired was only that of one's own or others' ignorance. That he did not always voluntarily submit himself to this epistemic process is another matter.

6.6 The Artist as Naturalist

The woodcuts were based on watercolors by the Strasbourg artist Hans Weiditz (1500–1536) and his assistants; Laurentius Schenckbecher, the dean of Saint Thomas Church in Strasbourg, has been linked to the block cutting (Rytz 1936, 19; Isphording 2008, 55).[39] In the foreword to the Latin edition the poet Johannes Sapidus (1490–1561) mentions Weiditz by name and praises him as a "second Apelles:" "Also that Painter Johannes Weiditz, no less ingenious than Apelles, who gave figures in a manner so masterly that nobody could say they were not real."[40]

Around 1500 the reference to eye-deceiving artistry that is always heard in the comparison with Apelles was a widespread topos chiefly applied to trompe l'oeil painting and portraits, but also to the mimetic qualities of prints.[41] Applied to plant representations it acquired a particular meaning, namely the exact correlation between the represented and the representation. Indeed, at first glance one is tempted to speak here of "plant portraits," since Weiditz's illustrations provide information not only about the appearance of the species but also about the occasionally pitiful state of the models: a few specimens are partially withered, others suffer from insect damage or leaf blight and have broken stems or torn-off shoots (Fig. 6.6). While the withered and damaged leaves appear to bear witness to the realism that Sapidus's verses claim for Weiditz's art, their appearance owes nothing to chance, as has often been supposed (Rytz 1936, 26; Arber 1990, 55; Kusukawa 2012, 15–19),

anderen gemyenen kreüteren halten / und die jhenige so auch den kinderen bekannt / sonderlich nit höch bekümmeren mit worten abzumalen / so mans on das wol vor den augen sycht." The same is said of *Bellis perennis*: "Ich acht / es bedörff nit vil abmalens" (Brunfels 1532, CXLV). Nevertheless, Brunfels (as later also Fuchs) complains in the introduction that knowledge was lost in antiquity because it was considered banal to treat again what was already known by everybody: "Es haben auch die Alten etlich kreütter für so gewiss / unnd meniglich bekantlich geacht / das sye soliche gar nicht ebgemalet / sondern allein ire krefften anzeygt haben / vermeynt / sye seyen in ander landen / oder yederman so bekant als ynen" (Brunfels 1532, B3r).

[39] In both cases it was probably a matter of teamwork, as Brunfels speaks of "delineatores et sculptores."

[40] "Nunc & Johannes pictor Gudictius ille/Clarus Apellaeo non minus ingenio/Reddidit ad fabras acri sic arte figuras / Ut nemo Herbas dixerit esse meras!" (Brunfels 1530, 6r9).

[41] On the topos of "alter Apelles" in prints, see (Panofsky 1969; Körner 2013).

but follows a clear concept. The plants, along with their root systems, are spread out horizontally; as Luca Zucchi has pointed out, their presentation resembles that of dried plants (Zucchi 2004, 439). This reduces overlapping and avoids the creation of deep shadows. The damage too seems to be deliberate. In many cases the torn-off or cut-off shoots reveal the plant's structure and direct the eye to the main shoot.[42] The limp leaves are presented at times with their underside, at times with their upper side visible in order to show the differing structure on both sides (Brunfels 1530, 36, 41). Flowers are shown in different views, and frequently also in different stages of development. The purpose of the damage was to ensure maximum legibility. At times it also served to aid the visual comparison between species. That is shown for instance in the abovementioned series of the Boraginaceae genera. The clipped shoots make the kinship between the *Anchusa officinalis*, the branched *Borago officinalis*, and the *Echium vulgare* plausible (Figs. 6.4, 6.5 and 6.6). Finally, the broken or cropped stems allow a near-life-size rendering despite the restriction of the paper format (Fig. 6.7).[43] It has not yet been established who was responsible for this concept; it probably goes back to directives established by Brunfels. That does not change the fact that it was Weiditz who put these directives into practice.

This can be observed as early as the surviving studies for the woodcuts. While the watercolors have been cut out and remounted by their later owner (the naturalist Felix Platter)[44] even the fragments that have come down to us show that the artist attempted to clarify proportions, to characterize the growth of the plants, and to study the root systems and the details of the flower forms (Fig. 6.8a, b). It also becomes clear that he did this in anticipation of their transferal to woodcut: important information is conveyed not by the color but by the pen, and thus by lines that can subsequently be cut into wood. On the back of the watercolors one still finds fragments of text that clearly record the time of collection and the names of the plants, as well as their size and form. Thus on the back of the *Symphytum officinale* one can make out the words "on the 11th day…of June…2" as well as: "the leaves very hairy, …grows as high as….".[45] If these notes are by Weiditz himself (which is to be assumed) (Rytz 1936, 8–9), that means that the artist anticipated what the naturalists Pietro Andrea Mattioli (1501–1577), Andrés de Laguna (1499–1559), and Conrad Gessner (1516–1565) would shortly afterward elevate to a principle: the documentation of empirically gathered data in text *and* image (Touwaide 2008, 45–52). What distinguished Weiditz's watercolors from the plant representations of his colleagues—which were either intended as

[42] As in the case of the plant designated by Brunfels as *Heischkraut* (*Solanum dulcamara*) (Brunfels 1530, 28), of borage (*Borago officinalis*; "Burretsch") (Brunfels 1530, 113), and greater celandine (*Chelidonium majus*; "Schölkraut" (Brunfels 1530, 236).

[43] As in the case of the *Symphytum* (in Brunfels "Walwurtz") (Brunfels 1530, 75, 76), rampion bellflower (*Campanula rapunculus*), creeping cinquefoil (*Potentilla erecta*; in Brunfels "Tormentill") (Brunfels 1530, 85).

[44] A number of these fragments were mounted in a herbal and are currently found in the Burgerbibliothek of Berne (Inv. no. Es71).

[45] "uf den 11. …des brachmonats…2;" "ode di [blätt]lin [g]ans harig…wachst als hoch als…" (Rytz 1936, 12, no. 45).

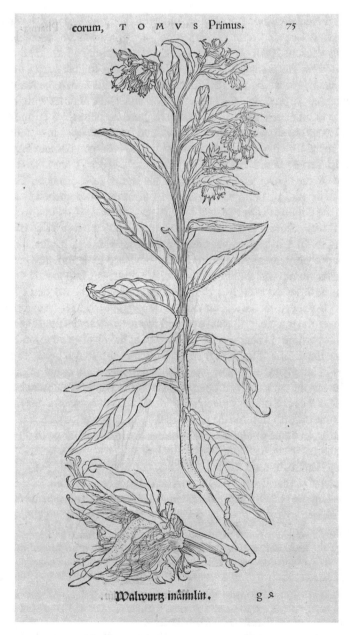

Fig. 6.7 Otto Brunfels, *Herbarum Vivae Eicones*, vol. 1, Straßburg, 1530: Walwurtz männlin. Woodcut. Universitätsbibliothek Münster, urn:nbn:de:hbz:6:1-67044

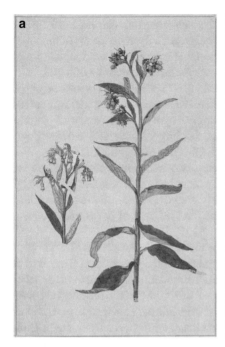

Fig. 6.8 Hans Weiditz, *Symphytum officinale* (plant and root). Pen, watercolour on paper. Platter-Herbar, Burgerbibliothek Bern, ES 71 (9), (**a**) and ES 71(9) (**b**)

virtuoso pieces or as studies for paintings—was less the precision of observation than the awareness of their function (Koreny 1985, 228–230; Smith 2008, 18–21).

Neither the artist's comments nor (with a few exceptions) the detail studies are incorporated into the woodcuts;[46] the majority of the partial representations are assembled to form a "whole" picture cropped to the size of the page, the format slightly reduced compared with the watercolor.[47] The curve of the plant stems familiar from the tradition of ornamental prints and the artful celebration of the curling leaves should probably be seen as a tribute to the woodcut as decoration, but touches on the general problem of reproduced and transregionally distributed "portraits:" they did not merely master likeness in order to address different audiences, they also needed to conform to representational conventions. The "rhetoric of portraiture" that Adrian W. B. Randolph sees as characterizing printed likenesses (Randolph 2003, 2) clearly pertained not only to the rendering of people but also to that of plants.

While Weiditz and/or the block cutter appear to fall short of the precision of the watercolors on this point, in other respects they push it further by turning the descriptive function of the line into a ruling principle. While the woodcuts convey

[46] The exceptions are the *Arum maculatum* (Brunfels 1530, 56), the *Narcissus luteus* (Brunfels 1530, 129) and the *Ranunculus nemorosus* (Brunfels 1530, 143). Added to this is the *Potentilla reptans* of which only one detail—a single leaf—is depicted (Brunfels 1530, 233).

[47] The watercolors measure 390 × 260 mm, the woodcuts 260 × 160 mm (Rytz 1936, 5).

a rich internal drawing, they do without all visual elements that relate to surface qualities or hue. Hatching is deployed extremely sparingly. As a means of modeling it is only found in the first half of the first volume of the Latin edition, and in the subsequent woodcuts only when it appears unavoidable for reasons of legibility. In those cases it is applied in a uniformly thin, evenly spaced line that does not belong to the form. This is notable because after the turn of the fifteenth to the sixteenth century, parallel and cross-hatching became increasingly important as a means of pictorial representation in woodcuts. It was used to indicate brightness values, to define three-dimensionality, and to characterize surfaces—in short to suggest lifelikeness. With the *Gart der Gesundheit* hatching also found its way into plant woodcuts, albeit at a rather modest level (Fig. 6.1). Weiditz on the other hand was familiar with the high standards set by Albrecht Dürer. That he had mastered the descriptive use of hatching is demonstrated not least in the woodcuts on the title page of the *Herbarum vivae eicones* (Fig. 6.2).[48]

Hence, there must have been a reason for the focus on the outline. The simplest explanation is that this volume like so many books of the period was intended to be colored and that color would assume the task of modeling the plants (Arber 1940, 803).[49] Elsewhere, however, the fact that a book was to be colored did not prevent the artists from working with hatching.[50] Moreover, the title pages of the *Herbarum vivae eicones* were also often colored. It seems rather that the artist wanted as far as possible to make each line significant for the definition either of the total form or the internal structure. The "naturalism" of the *vivae eicones* was not an attempt at mimesis—in their uncolored state the woodcuts make considerable demands on the imagination of the viewer—but at a correspondence between the artistic and the natural. If one searches for models of this mode of representation, one will not find them in the schematic outline drawings of earlier plant representations but in a work that was very much of its time: Dürer's illustrated treatise *Von menschlicher Proportion*, published posthumously in Nuremberg in 1528. In this work, Dürer attempted to establish geometric-arithmetic proportional schemes for different types of human physique. He did this by translating not only the figures but also complex movement motifs into pure line systems (Dürer 2004, 324) (Fig. 6.9). The text suggests that the representations are based on Dürer's own measurements; they were understood by contemporaries as being the result of empirically gathered data.[51] At the same time the artist made clear that his investigation only concerned the human exterior: "With this teaching I only wish to write about the external lines of the form and pictures and how these should

[48] For Weiditz's prints, see (Röttinger 1937).

[49] On the coloring of herbals, see (Kusukawa 2012, 69–81). On the coloring of prints in the early modern period in general, see (Dackerman 2002).

[50] Even the richly detailed engravings of the *Hortus Eystettensis* were colored in the luxury editions (Roth 2017, 89–97).

[51] Thus, Dürer recommended that his readers take measurements of many living people ("vil lebendiger menschen") (Dürer 1528, T3r). On the contemporary reception, see (Dürer 2004, 323). It can be assumed, however, that the representations were based primarily on aesthetic decisions. See (Dürer 2004, 367).

be drawn from point to point and not at all about internal things."[52] Both the supposed empiricism and the focus on form made Dürer's line drawings a suitable model for representations that would provide information about the external appearance of the herbs.

For Dürer as for Weiditz, the focus on the outline can be linked to Aristotle's definition of the process of perception. For Aristotle the first stage of perception is "what can receive the perceptible forms without the matter, as wax receives the seal of the signet-ring without the iron or the gold—it takes on a golden or brazen seal, but not insofar as the seal is gold or bronze" (Aristotle 2017, 17–22, 43–44). In a second stage, size, figure, and movement were added, which in a third stage were synthesized into a total impression (Busche 2003, 26–30). All steps going beyond this involved the support of the *phantasia*. In this sense the woodcuts could be read as an invitation to make active use of one's imagination to fill in the missing information. The title page serves another purpose, however, and is therefore beholden to another compositional model: the mythological representations place the book in a tradition of herbalism that can be traced back to antiquity.

6.7 Visual Didactics

For contemporaries, the idea of a plant representation that had been reduced solely to its outline must have seemed unusual, perhaps even anachronistic. This is shown by the pirated copies that the publisher Christian Egenolff (1501–1555) produced shortly afterward for his illustrated book *Herbarum imagines vivae: Der kreuter lebliche Conterfeytunge* (Egenolff 1533; Röttinger 1937, 9–22; Isphording 2008, 134). Here the block cutter who made the copies followed the representational conventions of the time and reintroduced hatching to characterize the upper and under sides of the leaf and to suggest three-dimensionality—with the result that the already shrunken and simplified representations lost the last vestiges of precision. Leonhart Fuchs on the other hand astutely recognized in the woodcuts of the *Herbarum vivae eicones* "the right method to draw plants,"[53] and hence the model for the style and arrangement of the pictures that would form the basis of his own publication.

[52] "Ich will auch mir diser meiner underricht allein von den eusseren linien der form und pilder / und wie die von punckt zu punckt gezogen sollen werden / schreibenn / aber von den innerlichen dingen gar nit" (Dürer 1528, A2v).

[53] The praise is combined with strong criticism of Brunfels's botanic mistakes and therefore appears all the more significant: "Quamvis autem multa in illius scriptis desiderentur...: nihilominus tamen ut hunc omnes certatim laudibus efferant vel unica hac de causa meritus est, quod ipse primus omnium rectam pingendearum stirpium rationem denuò in Germaniam nostram invexerit, aliis hanc imitandi occasionem praebuerit" (Fuchs 1542, 6v). ("True, there are many shortcomings in his writings.... Nonetheless, he deserves that all should vie in praise of him for this reason alone, that he was the first to bring back the correct method of illustrating plants into our Germany, giving others something to imitate" (Meyer et al. 1999, 208).

Fig. 6.9 Albrecht Dürer, *Hierin sind begriffen vier bücher von menschlicher Proportion…*. Nürnberg 1528, fol. V5v and V5r: *Ein bewrischer man von siben haupt lengen.* Woodcuts. Beinecke Rare Book and Manuscript Library, Yale University, https://brbl-dl.library

Fuchs, like Bock, Cordus, and Brunfels, put his faith in *autopsia* as the basis of a modern herbalism that, following the example of the ancients, made direct engagement with the plants the leading instrument of research (Kusukawa 2012, 107–135).[54] An unusual author's portrait on the frontispiece emblematizes his scientific approach. It shows the author standing in an open, indeterminate space; in his hand he is holding the object of his investigation: a flower that has been identified as a *Veronica chamaedrys* (Baumann and Baumann 2001, 42–44) (Fig. 6.10). This representation refers indirectly to the figure of Dioscorides in the title woodcut of the *Herbarum vivae eicones*. At the same time it operates as an argument against the supremacy of the classical authorities on which Brunfels foundered in the *Herbarum vivae eicones*. This time it is not the Greek scholar but the sixteenth-century author who represents the model of *autopsia*, and it is not traditional book learning that forms the basis of judgment but engagement with the plant itself. As a common and unspectacular plant, the *Veronica chamaedrys* was also to be understood as a statement. It illustrates the universal claim made by the *Historia stirpium*: Fuchs wanted to place "before the eyes" (*sub oculos*) of his contemporaries—again in a double sense—the full range of native and foreign plants.[55] As mentioned, the author himself complained that valuable knowledge had been lost because Dioscorides had been ashamed to record common herbs in his medical treatise (Fuchs 1542, fol. A6r).

Fuchs explicitly did not reduce the value of sensory perception to the *autopsia*. While he was still convinced that the forms of herbs could be better expressed by words than by images in 1536 (*longe melius est ut verbis herbarum formas, quam pictura exprimamus*) (Kusukawa 1997, 420), he notes in the preface to *De historia stirpium* that it is not pictures that are deficient but descriptions:

> What sane person, I ask, would despise a picture, which certainly expresses objects much more clearly than they can be delineated by any words, even the most eloquent? Indeed, it has been thus arranged by nature, that we are all captivated by a painting; and those things that are set forth and pictured on panel [*tabulae*] and paper [*charta*] are fixed more deeply in our minds than those described in bare words. Hence it is certain that there are many plants that, although they cannot be described in words so that they are recognized, are placed before our eyes in a painting so that they are grasped at first glance.[56]

Sachiko Kusukawa has traced this change of attitude back to the influence of Brunfels's *Herbarum vivae eicones*, but also to Philipp Melanchthon's (1407–1516) concept of substance (Kusukawa 1997, 421–423). Nevertheless it is still surprising

[54] Fuchs, however, attached greater importance to Galen than to Dioscorides.

[55] "Ut tanquam diversos copiis iunctis nobis contra varios morborum insultus aciem istruere liceret, tam nostratium quam exterarum stirpium tum historias tum imagines studiosorum oculis subiicere placuit" (Fuchs 1542, A6r).

[56] "[Q]uis quaeso sanae mentis picturam contemneret, quam constat res multo clarius exprimere, quam verbis ullis, etiam eloquentissimorum deliniari queant. Et quidem natura sic comparatum est, ut pictura omnes capiamur: adeoque altius animo insident quae in tabulis aut charta oculis exposita sunt & depicta, quam quae nudis verbis describuntur. Hinc multas esse stirpes constat, quae cum nullis verbis ita describi possint ut cognoscantur, pictura tamen sic ob oculos ponuntur, ut primo statim aspectu deprehendatur" (Fuchs 1542, B1r); the slightly altered translation is quoted in (Meyer et al. 1999, 209).

Fig. 6.10 Heinrich Füllmaurer, *Albrecht Meyer and Veit Speckle*, Portrait Leonhart Fuchs from New Kreüterbuch, 1543. Woodcut with hand-colouring. Berlin, Staatliche Museen zu Berlin, Kupferstichkabinett, Inv. Nr. 377–10

how easily Fuchs was able to jettison the established hierarchy between image and text. For the author pictures saved time and left a more lasting impression: things can be immediately (*ut primo statim aspectu*) perceived and better imprinted on the memory via the external image than via the *descriptio*. The reference to the internal bodily process of imprinting on the mind shows that Fuchs continued to see his task as the generation of mental images.[57] The condition for this, however, was a secure knowledge of plant morphology, which as Fuchs made clear in his remarks on the classical *autopsia* could only be acquired through repeated observation (Fuchs 1542, fol. A4r). Based on this assumption the woodcut functions as a didactic instrument that facilitates the comparative study of a species' appearance. Like the plant itself, it is addressed to a bodily vision; but unlike the plant it is available at any time for renewed consultation. In other words it facilitates the storage of sense data in the memory. According to Fuchs it was precisely this mnemonic role that material images had already assumed in the education of young noblemen in ancient Greece:

> And it is known that all over Greece freeborn boys receiving a liberal education were taught drawing before all else, or at least along with their letters, because they all agreed it was this skill that not only expressed the nature of individual things but also preserved their memory.[58]

6.8 Artistic *libido* and Scientific Truth

In order to avoid the loss of control that Brunfels had experienced with the *Herbarum vivae eicones* Fuchs took charge of the illustration of his herbal himself. The painters Albrecht Meyer and Heinrich Füllmaurer (1526–1546), who produced the pictures in accordance with Fuchs's instructions, were not engaged by the publisher, as would usually be the case, but by the author in person. Transferal to woodblocks was carried out by the Strasbourg block cutter Veit Specklin (1505–1550). Work had probably begun in 1535; up to the publication of the *Historia stirpium* in 1542, 515 woodcuts had been completed. Fuchs organized the financing, delivered the fresh specimens that he found in his garden and in the vicinity of his hometown of Tübingen, and oversaw the execution, whereby he also intervened in the work of the artists (Baumann and Baumann 2001, 25–29). He proudly proclaimed the illustrations to be a triumph of "truth" over the rules of art:

> As for the pictures themselves, every single one of them portrays the lines [*lineamenta*] and appearance [*effigies*] of the living plant. We were especially careful that they should be absolutely correct [*absolutissima*], and we have devoted the greatest diligence to secure that every plant should be depicted with its own roots, stalks, leaves, flowers, seeds, and fruits.

[57] Simone De Angelis has already drawn attention to this aspect (De Angelis 2011, 227).

[58] "Et in universa Graecia hunc morem fuisse notum est, ut ingenui et libere educati pueri ante omnia, aut saltem una cum literis picturam docerentur, quod illis constaret, hanc ipsam esse quae singularum rerum non solum naturam exprimeret, sed memoriam conservaret" (Fuchs 1542, B1r; Meyer et al. 1999, 213–214). Bock also refers to the didactic dimension of the use of images in the foreword of the (now illustrated) third edition of his *Kreütter Buch* (Bock 1551, 16b).

Over and over again, we have purposely and deliberately avoided the obliteration of the natural form of the plants lest they be obscured by shading and other artifices that painters sometimes employ to win artistic glory. And we have not allowed the craftsmen so to indulge their whims as to cause the drawing not to correspond accurately to the truth.[59]

The aspects that Fuchs here named as specific to "his" pictures—the full rendering of the plants, the emphasis on the outline and the avoidance of shading—had essentially been present in the woodcuts of the *Herbarum vivae eicones*. Again the line is deployed exclusively as a form-describing element; hatching has been reduced still further. The captioning of the pictures was also inspired by Brunfels, but was now standardized: in the *Historia stirpium* the Latin and German plant names are given throughout (Fig. 6.11).[60] In many cases, names are added to the left and right of the stem; in this way, to some extent, they frame the representation while also making unmistakably clear that the woodcuts are not decoration but an integral part of the scientific classification system.[61] An additional advantage of continuous labeling was that the pictures no longer needed to be placed at the beginning of their respective chapters—therefore the text need not be interrupted. Finally, Fuchs also borrowed Weiditz and/or Brunfels's idea of reducing the number of stems and spreading the plants out horizontally for increased legibility. This time, however, there is no question who was responsible for the decision. To the extent that Meyer and Füllmaurer were downgraded to mere functionaries of his observations, Fuchs could claim absolute agreement between his observations and their pictorial realization, thereby marginalizing the interpretive freedom of art without eliminating it entirely (Daston and Galison 2007, 84–98).

Nevertheless there are a number of differences between the "living" images of the *Herbarum vivae eicones* and the "true" images of the *Historia stirpium*. While Weiditz gave his illustrations the character of a moment caught in time in order to confirm the lifelikeness of a single picture, the task of the "true" image was to convey a universally valid idea of the *species*. Thus, in the case of Fuchs, flowers and leaves are systematized, stems straightened. Decorative curves are principally found where—as with ivy or pumpkins—they characterize the plant's growth. Otherwise only the decoratively draped root systems recall the tradition of botanical ornament. References to the condition of the specimen are largely omitted: missing stems are no longer staged as damaged, the spreading out of the plant no longer seems like a sign

[59] "Quod ad picturas ipsas attinet, quae certe singulae ad vivarum stirpium lineamenta et effigies expressae sunt, unive curavimus ut essent absolutissimas, atque adeo ut quaevis stirps suis pingeretur dacicibus, caulibus, foliis, floribuns, seminibus ac fructibus, summam adhibuimus diligentiam. De industria vero et data opera cavimus ne umbris, alijsque minus necessarjs, quibus interdum artis gloriam affectant pictores, nativa herbarum forma obliteraretur; neque passi sumus ut sic libidini suae indulgerent artifices, ut minus subinde veritati pictura respondet" (Fuchs 1542, A6v; Meyer et al. 1999, 212).

[60] The double naming is abandoned in the *New Kreüterbuch*. Here the German designation has assumed the place on the right of the stem; on the left are the chapter numbers, which create a reliable link between image and textual description.

[61] Added to the categories *nomina, forma, locus, tempus,* and *temperamentum* are, as the case arises, *genera* and *appendices*.

Fig. 6.11 Leonhart Fuchs, *De historis stirpium*, Basel 1542: Buglossum/Borragen. Woodcut. Bayerische Staatsbibliothek München, http://mdz-nbn-resolving.de/urn:nbn:de:bvb:12-bsb112002 59-3

of decay. Instead, the manipulations are clearly identified as a means of representation. Even plants that could only have been available to the draughtsmen as dried specimens generally look fresh and intact—an act of interpretation that Fitch still considered an important criterion for a good botanical drawing (Fitch 1869, 499).[62]

[62] In Fuchs, however, there are specimens with hanging leaves or flower heads (Fuchs 1542, 203, 274, 457).

Also new was the way in which different stages of development were frequently (but far from always!) overlaid to form composites showing up to three plants—species and varieties—on a single stem (Meyer et al. 1999, 116–119, 122). They supplement the picture sequences that, following the model of Brunfels's herbals, represented the different *genera* of a plant. The further development of this pictorial concept emerges particularly clearly in cases in which Fuchs and his artists aligned themselves directly with the woodcuts of the *Herbarum vivae eicones*.[63] Thus their *Consolida* is unmistakably beholden to Brunfels's herbal (Figs. 6.12 and 6.13). While in the latter the plant is spread out on the sheet with hanging leaves, its pendant looks as if it has just been plucked from the earth and is standing by its own effort in an open space. And while in Brunfels the flowers are concentrated on a single stem, in Fuchs they are distributed evenly over all the shoots.

In light of such changes it is only logical that Fuchs avoided the term *eikon*. Instead, he designated the pictures in the title as *imagines*—"in imitation of nature artfully depicted and expressed" (*ad naturae imitationem artificiosius effectis et expressis*)— and in the text as *picturae*—in which the plants' "outline and form are expressed" (*lineamenta et effigies expressae sunt*) (Fuchs 1542, A6v).[64] It is not by chance that these formulations recall the famous expression "imago…ad vivam effigiem delineata" that Dürer used to characterize his Erasmus portrait; they substantiate the claim that what is being referred to here are not *Abbilder* (depictions) but *Wesensbilder* (essence images). Nonetheless, the information offered remained limited to the external form. For color, smell, and taste (in the majority of cases for the stages of development) one still needed to have recourse to the text and to draw on one's own sensory experiences.

Depictio and *descriptio*, which in the *Herbarum vivae eicones* frequently run parallel to one another without connection, now became more closely linked. Both were based on the author's *autopsia* and thus bore witness to a prior act of observation. What the description "shows" is also "shown" by the image—even when they do not explicitly refer to one another. Both served the comparison with the observations of classical authorities. As a rule it was the text that augmented the image. It indicated which genera of a plant were depicted and which not (*De Philyra*) (Fuchs 1542, 863), elucidated the meaning of composite representations (*De Lamio*) (Fuchs 1542, 468), or briefly stated that a description did not have much to add to its attendant picture.[65] Due to the common starting point, however, it could also be the woodcuts that supplemented or confirmed the description. This was often reduced to a simple *ut pictura ostendit* or *ut pictura demonstrat*. For the similarity between the leaves of the *Lilium bulbiferum* and those of the *Lilium candidum*, for example, Fuchs referred to the *picturae* just as he did for the difference between the *Garten Benedictenwurtz* and

[63] On the borrowings of the woodcuts from the *Herbarum vivae eicones*, see Meyer et al. (1999, 119), Kusukawa (2012, 68–69).

[64] In the *New Kreüterbuch* the concepts are handled less scrupulously. Here one reads of "der wahrhafftigen und lebendigen abbildung und figuren der Kreüter" (Fuchs 1543, 2r).

[65] On the *Ricinus communis* Fuchs remarks that nothing can be added to the picture of the plant: "Quae ita descriptio picturae quadrat, ut nihil magis" (Fuchs 1542, 339).

Fig. 6.12 Leonhart Fuchs: *New Kreüterbuch*, Basel 1543: Rittersporn. Woodcut with hand-colouring. Bbiblotèques de l'Université de Strasbourg, https://docnum.unistra.fr/digital/collection/coll13/id/2265

Fig. 6.13 Otto Brunfels, *Contrafayt Kreütterbuch*, Straßburg 1532. Woodcut with hand-colouring. Bayerische Staatsbibliothek München VD16 B 8499, urn:nbn:de:bvb:12-bsb00076311-5

the *Wild Benedictenwurtz* (treated in one sentence in the text).[66] With the question of

[66] On the lilies one reads "Folia quoque eius angustiora sunt quam prioris, alias simile, ut pictura luculenter ostendit" (Fuchs 1542, 366); on the *Centaurea benedicta*: "Differentiam tamen nemo rectius quam ipsa pictura demonstrabit" (Fuchs 1542, 383).

whether cypresses should be included among the *chamaephytes*, on the other hand, the pictures acted as an argumentation aid: according to Fuchs this could not be the case because the tree did not creep along the ground but grew upwards, as could be seen in the image.[67] Also the discussion about which plant the ancient descriptions of the *Apium* referred to was initially resolved through the description of the *forma* but was sealed by the *pictura*: "Therefore the herb whose picture we show is the right *Apium*."[68]

That Fuchs also used pictures to convince the observer step-by-step of the rightness of his judgment has been shown by Sachiko Kusukawa in relation to the *Petasites* (Kusukawa 1997, 413–415). However, neither the woodcuts nor the descriptions were considered a surrogate for the *res ipsa*; rather, they were components of a triangular system of reference and functioned only collectively and in relation to the plant.[69] Where the *autopsia* reached its limits, the picture also remained incomplete. The same was true of the text. Of the seven species of the *Euphorbiaceae* of which Dioscorides and other "witnesses" report, Fuchs could only present a few, since he had not (yet) seen all of them himself.[70] In the case of the *Nerium oleander* as well, he remained short on information for his readers: "We cannot know the month in which the *Nerion* flowers and bears fruit because we have seen neither its flowers nor its leaves. Therefore the picture that we are showing has nothing of this either."[71]

There can be no doubt that Fuchs was better informed about botany than Brunfels, that his scientific findings were better supported, and that his argumentation was more clearly structured. In comparison with the *Historia stirpium*, the *Herbarum vivae eicones* resembles a random collection of opinions. Nonetheless, with the mode of representation of the woodcuts, the (still unsystematic) link between image and nomenclature, the equal treatment of description and image, and the partial outsourcing of the argumentation to the image, a pattern quickly becomes evident—a pattern that Fuchs would later turn into a principle in his own publication. Both publications aimed at the development of mental images in which all the senses are included. For Brunfels, these synthesizing internal images could arise through the *descriptio* alone, and occasionally through the simple mentioning of the name. For Fuchs on the other hand, they were to be secured with the help of material images. Admittedly, the difference was probably not so great in practice. Hieronymus Bock, who as we have seen had initially insisted on the power of the word, was still prepared to accept illustrated herbals as reference books in 1551. In his view, it was acceptable

[67] "Errant qui Chamaepityn esse arbitrantur: neque enim illa humi serpit, sed altius a terra, ut pictura monstrat, consurgit" (Fuchs 1542, 873).

[68] "Haec itaque herba, cuius picturam damus, est verum Apium" (Fuchs 1542, 743).

[69] That is shown for instance by Fuchs's assessment as to whether one should follow Pliny or Dioscorides in the description of the properties of the *Hortense serpyllum* when he notes: "res enim ipsa et vivae herbarum imagines satis testantur, Discoridis sententiam esse veriorem" (Fuchs 1542, 250).

[70] "Nos ex iiis generibus tria tantum depicta damus, quod reliqua videre nondum nobis licuerit.... Nos ea tantum genera quorum picturas exhibemus, omisis aliis, describemus" (Fuchs 1542, 734).

[71] "Quod mense floribus et fructus praegnat sit Nerion, non satis constat. Hinc est quod etiam pictura quam exhibemus iisdem careat" (Fuchs 1542, 543).

to have recourse to pictures when one did not have fresh herbs at hand, or if one was interested in exotic species that could not be cultivated in Germany.[72] In principle, however, the observation of the object itself was to be preferred: "Whoever has their own garden can plant and grow many different plants...and tends not to need illustrated [*gemalten*] books."[73]

Nevertheless, as an example of a successful reference book, Bock invoked neither the *Historia stirpium* nor the *Herbarum vivae eicones* but two publications that managed (almost) entirely without accompanying text: Christian Egenolff's *Herbarum imagines vivae*, whose woodcuts were largely based on those of the *Herbarum vivae eicones*, and the *Läbliche abbildung vnd contrafaytung aller kreüter*, conceived as a *vademecum*, in which Michael Isingrin had gathered shrunken *Historia* woodcuts in an octavo format (Isingrin 1545).[74] Accordingly, the cautious praise was probably addressed to the entrepreneurial spirit of the publishers rather than to his colleagues' attempts to bring together word and image. Bock's uneasiness regarding the existing "gemalten" books, however, is shown by the hope he placed in a work that had yet to be written: Conrad Gessner's *Historia Plantarum* project.[75]

6.9 Deceitful Colors

With all due care there was still one factor that Fuchs had just as little control over as Brunfels, and that was color. Like most books of the period, plant books were frequently colored. However, while information about form was specified by the printing block, coloring remained an individual matter. As a rule it was commissioned by the buyers from independent colorists; in the case of the *Historia stirpium* we know that Isingrin offered exemplars that had already been colored by the publisher (Kusukawa 2012, 114–119). Here there is no evidence that the watercolors might have acted as a model (Meyer et al. 1999, 120). Hence the user of the books could only expect reliable information in the woodcuts from the outline. For information about color, one depended exclusively on the texts, which admittedly allowed considerable latitude for interpretation. That is shown for instance by the coloring

[72] "So dienen aber die gemalt Kreütter bücher endlich dahin / wann man die natürliche Gewächs nit alle mal wo sie auffwachsen / bei handt hat / oder die selben nicht allemal frisch bekommen kan / als dann dienen uns die Rechte Contrafeite gemalte bücher der gewächst vast wohl / daraus mag man sich wol in vilem erkundigen. [...] Es werden dann gar frembde gewächs / so man nit allenthalben frisch grün haben köndt / oder die sich in unsern landen lufft haben nit wollen zemen und gewehnen lassen / als dan werden aber mal die rechte gemalte Bücher vast nutz und dienstlich" (Bock 1551, fol. 16b).

[73] "Wer aber eigen Garten und Gärtner hat / der mag vil und mancherlei gewächs und pflantzen und auffbringen...als dann bedarff man der gemalten Bücher nit so hoch" (Bock 1551, fol. 16b).

[74] The title page is addressed to the "deambulantes" and the "peregrinantes," http://mdz-nbn-resolv ing.de/urn:nbn:de:bvb:12-bsb00034002-0 (Last accessed February 16, 2021); on later editions, see Meyer et al. (1999, 134).

[75] The importance Bock attached to Gessner's undertaking is shown by the well-wishes he addressed to his colleague: "Gott wölle im seligen beistandt und gnade dazu verleihen" (Bock 1551, 17a).

of the *Rittersporn* (delphinium), which in some copies of the *New Kreüterbuch* is colored blue,[76] in others red.[77] Following the description both are possible, since here one reads of a purple flower ("purpurfab blumen"), which is to say, of a color whose spectrum ranges from red to blue (Fuchs 1543, B5r). It is also shown where a colorist of the *Contrafayt Kreüterbuch* mistook cotyledons for petals, invented a red-blue variety of bluebell, and gave a narcissus a green calyx.[78] The authors and their readers were clearly prepared to suffer this kind of uncertainty. They were used to the fact that colors could be misleading, since there was no fixed terminology. In Brunfels, for example, the delphinium was not purple but "gay blue" ("lustig blau") (Brunfels 1532, 19); in Bock one finds purple-violet ("schön purpur viol") (Bock 1539, 203r; Seidensticker 2010, 49–81) as a color designation. In the case of colors, not only the *descriptio* but also *depictio* needed to be regulated by the *vis imaginativa*.

References

Arber, Agnes. 1990. *Herbals. Their origin and evolution: A chapter in the history of botany 1470–1670.* Cambridge: Cambridge University Press.

Arber, Agnes. 1940. The coloring of sixteenth-century herbals. *Nature* 145: 803–804.

Aristotle. 2017. *De Anima* (trans: Reeve, C.D.C.). Indianapolis/Cambridge: Hackett Publishing Company.

Baumann, Brigitte, and Helmuth Baumann. 2001. *Die Kräuterbuchhandschrift des Leonhard Fuchs.* Stuttgart: Verlag Eugen Ulmer.

Baumann, Brigitte and Helmuth Baumann. 2010. *Die Mainzer Kräuterbuch-Inkunabeln "Herbaius Moguntinus" (1484), "Gart der Gesundheit" (1485), "Hortus Sanitatis" (1491). Wissenschaftshistorische Untersuchung der drei Prototypen botanisch-medizinischer Literatur des Spätmittelalters.* Stuttgart: Hiersemann.

Bock, Hieronymus. 1539. *New Kreütter Buch von underscheydt/ würckung und Namen der Kreütter so in Teütschen Landen wachsen. Auch der selbigen eygentlichem vnd wolgegründtem gebrauch in der Artznei zu behalten und zu fürdern Leibs Gesuntheyt fast nutz und tröslichen, vorab gemeynem Verstand.* Strasbourg: Wendel Rihel. Bayerische Staatsbibliothek München. http://mdz-nbn-res olving.de/urn:nbn:de:bvb:12-bsb11069345-9.

Bock, Hieronymus. 1546. *Kreüter Buch, Von newem fleissig übersehen/gebessert/vnd gemehret/Dazu mit hüpschen artigen Figuren allenthalben gezieret.* Strasbourg: Wendel Rihel. Staats- und Stadtbibliothek Augsburg. http://mdz-nbn-resolving.de/urn:nbn:de:bvb:12-bsb112 00232-0.

Bock, Hieronymus. 1551. *Kreüter Buch: Darinn Underscheidt, Namen vnnd Würckung der Kreutter, Stauden, Hecken vnnd Beumen, sampt jhren Früchten, so inn Deütschen Landen wachsen.* Strasbourg: Wendel Rihel. Universitätsbibliothek Freiburg. http://dl.ub.uni-freiburg.de/diglit/boc k1551/0036?sid=a9f908d6077255bee36cbfbbe0594ef3.

Brunfels, Otto. 1530. *Herbarum Vivae Eicones, ad natur[a]e imitationem, sum[m]a cum diligentia et artificio effigiat[a]e, una cum Effectibus earundem, in gratiam veteris illius, & iamiam*

[76] As in the copy found in the University of Strasbourg library: http://docnum.u-strasbg.fr/cdm/ref/collection/coll13/id/3096 (accessed 5 August 2020).

[77] As in the author's personal copy in the Stadtbibliothek Ulm (Fuchs 2001, fig. XV).

[78] As in the copy in the Bayerische Staatsbibliothek: http://mdz-nbn-resolving.de/urn:nbn:de:bvb: 12-bsb00054201-5 (accessed February 16, 2021).

renascentis Herbariae Medicinae, Bd. 1. Strasbourg: Johannes Schott. Universitätsbibliothek Münster. https://sammlungen.ulb.uni-muenster.de/urn/urn:nbn:de:hbz:6:1-67044.

Brunfels, Otto. 1531. *Herbarum Vivae Eicones Bd. 2 (Novi herbarii tomus II).* Strasbourg: Johannes Schott.

Brunfels, Otto. 1532. *Contrafayt Kreüterbuch: nach rechter vollkommener Art, unnd Beschreibungen der alten, besstberümpten Ärtzt, vormals in teütscher Sprach, der masßen nye gesehen, noch im Truck außgangen; sampt einer gemeynen Inleytung der Kreüter Urhab, Erkantnüsß, Brauch, Lob, und Herrlicheit.* Strasbourg: Johann Schott. Bayerische Staatsbibliothek München. http://mdz-nbn-resolving.de/urn:nbn:de:bvb:12-bsb00054201-5.

Brunschwig, Hieronymus. 1500. *Liber de arte distillandi de simplcibus/Das buch der rechten kunst zu distilieren die eintzigen ding (Kleines Destillierbuch).* Strasbourg: Johann Grüninger. Bayerische Staatsbibliothek München. http://mdz-nbn-resolving.de/urn:nbn:de:bvb:12-bsb000 31146-3.

Busche, Hubertus. 2003. Die Aufgaben der phantasia nach Aristoteles. In *Imagination—Fiktion—Kreation. Das kulturschaffende Vermögen der Phantasie,* ed. Thomas Dewender and Thomas Welt, 23–42. Leipzig: Saur.

Carruthers, Mary. 1998. *The craft oft thought. Meditation, rhetoric, and the making of images, 400–1200.* Cambridge: Cambridge University Press.

Coleman, Janet. 1992. *Ancient and medieval memories. Studies in the reconstruction of the past.* Cambridge: Cambridge University Press.

Cordus, Euricius. 1534. *Botanologicon.* Cologne: Johann Gymnich. Bayerische Staatsbibliothek München. http://mdz-nbn-resolving.de/urn:nbn:de:bvb:12-bsb10192665-6.

Dackerman, Susan. 2002. *Painted prints: The revelation of color in northern Renaissance & Baroque engravings, etchings & woodcuts. Exh. Cat. The Baltimore Museum of Art/Saint Louis Museum of Art.* University Park: Pennsylvania State University Press.

Daston, Lorraine. 2015. Epistemic images. In *Vision and its instruments. Art, science, and technology in early modern Europe,* ed. Alina Payne, 13–48. University Park: The Pennsylvania State University.

Daston, Lorraine, and Peter Galison. 2007. *Objectivity.* New York: Zone Books.

De Angelis, Simone. 2011. Sehen mit dem physischen und dem geistigen Auge. Formen des Wissens, Vertrauens und Zeigens in Texten der frühneuzeitlichen Medizin. In *Diskurse der Gelehrtenkultur in der Frühen Neuzeit. Ein Handbuch,* ed. Herbert Jaumann, 211–253. Berlin/New York: de Gruyter.

Dewender, Thomas. 2003. Zur Rezeption der Aristotelischen Phantasialehre in der lateinischen Philosophie des Mittelalters. In *Imagination—Fiktion—Kreation. Das kulturschaffende Vermögen der Phantasie,* ed. Thomas Dewender and Thomas Welt, 141–160. Leipzig: Saur.

Dilg, Peter. 1969. *Das Botanologicon des Euricius Cordus: ein Beitrag zur botanischen Literatur des Humanismus.* Dissertation Universität Marburg.

Dürer, Albrecht. 1528. *Hierin sind begriffen vier bücher von menschlicher Proportion....* Nuremberg: Hiernoymus [Andreae] für Agnes Dürer.

Dürer, Albrecht. 2004. *Albrecht Dürer. Das druckgraphische Werk, Bd. 3: Buchillustrationen,* ed. Rainer Schoch, Matthias Mende and Anna Scherbaum. Munich: Prestel.

Duggan, Lawrence. 1989. Was art really the, book of the illiterate? *Word & Image* 5: 227–251.

Endersby, Jim. 2008. *Imperial nature: Joseph Hooker and the practices of Victorian science.* Chicago: University of Chicago Press.

Habermann, Mechthild. 2002. *Deutsche Fachtexte der frühen Neuzeit: Naturkundlich-medizinische Wissensvermittlung im Spannungsfeld von Latein und Volkssprache.* Berlin: de Gruyter.

Heinrichs, Ulrike. 2007. *Martin Schongauer - Maler und Kupferstecher. Kunst und Wissenschaft unter dem Primat des Sehens.* München/Berlin: Deutscher Kunstverlag.

Fitch, William Hood. 1869. Botanical drawing I-VIII. *The Gardener´s Chronicle and Agricultural Gazette,* 2 January, 16 January, 30 January, 13 February, 27 February, 20 March, 10 April, 8 May 1869: 7, 51, 116, 163, 221, 305, 389, 499.

Fuchs, Leonhart. 1542. *De historia stirpivm commentarii insignes, maximis impensis et vigiliis elaborati, adiectis earvndem vivis plvsqvam quingentis imaginibus, nunquam antea ad naturae imitationem artificiosius effictis & expressis, Leonharto Fvchsio....* Basel: Michael Isingrin. Bayerische Staatsbibliothek München. http://mdz-nbn-resolving.de/urn:nbn:de:bvb:12-bsb11200259-3.

Fuchs, Leonhart. 1543. *New Kreüterbuch.* Basel: Michael Isingrin. Collection Bnu en dépôt à l'Université de Strasbourg. https://docnum.unistra.fr/digital/collection/coll13/id/3096.

Fuchs, Leonhart. 2001. *Das Käuterbuch von 1543.* Cologne: Taschen.

Egenolff, Christian. 1533. *Herbarum imagines vivae. Der kreuter lebliche Conterfeytunge,* vol. 1. Frankfurt: Christian Egenolff. Universitätsbibliothek Kiel. http://dibiki.ub.uni-kiel.de/viewer/resolver?urn=urn:nbn:de:gbv:8:2-22573.

Isingrin, Michael. 1545. *Läbliche abbildung vnd contrafaytung aller kreüter so der hochglert herr Leonhart Fuchs der artzney Doctor/ inn dem ersten theyl seins neüwen Kreüterbuochs hat begriffen/ in ein kleinere form auff das aller artlichest gezogen....* Basel: Michael Isingrin.

Isphording, Eduard. 2008. *Kräuter und Blumen. Kommentiertes Bestandsverzeichnis der botanischen Bücher bis 1850 in der Bibliothek des Germanischen Nationalmuseums Nürnberg.* Nuremberg: Verlag des Germanischen Nationalmuseums.

Klebs, Arnold C. 2007. *A catalogue of early herbals, mostly form the well know library of Dr. Karl Becher, Karlsbad. With an Introduction by Arnold C. Klebs.* Lugano: Mansfield Center.

Körner, Hans. 2013. Albrecht Dürer, der Apelles der schwarzen Linien. In *Dürer. Kunst–Künstler– Kontext. Exh. Cat. Städel Museum Frankfurt/Main,* ed. Jochen Sander, 74–79. Munich: Prestel.

Koreny, Fritz. 1985. *Albrecht Dürer und die Tier- und Pflanzenstudien der Renaissance.* Munich: Prestel.

Kusukawa, Sachiko. 1997. Leonhart Fuchs on the importance of pictures. *Journal of the History of Ideas* 58 (3): 403–426.

Kusukawa, Sachiko. 2012. *Picturing the book of nature. Image, text, and argument in sixteenth century human anatomy and medical botany.* Chicago/London: University of Chicago Press.

Leitch, Stephanie. 2017. Dürer's Rhinoceros Underway: The Epistemology of copy in the Early Modern Print. In *The primacy of the image, 1400–1700,* ed. Debra Taylor Cashion, Henry Luttikhuizen, and Ashley D. West, 241–255. Boston/Leiden: Brill.

Marr, Alexander, and Walter Ryff. 2014. Plagiarism and imitation in sixteenth century Germany. *Print Quarterly* 31 (4): 131–143.

Meyer, Frederick G., Emily Emmart Trueblood, and John L. Heller. 1999. *The Great Herbal of Leonhart Fuchs "De Historia Stirpium Commentarii Insignes", 1542.* Stanford: Stanford University Press.

Nissen, Claus. 1951. *Die botanische Buchillustration: Ihre Geschichte und Bibliographie.* Stuttgart: Hiersemann.

Nüsslein, Theodor. 1994. *Rhetorica ad Herennium.* Munich: Artemis & Winkler.

Ogilvie, Brian W. 2006. *The science of describing. Natural history in Renaissance Europe.* Chicago: University of Chicago Press.

Panofsky, Erwin. 1969. Erasmus and the visual arts. *Journal of the Warburg and Courtauld Institutes* 32 (1969): 200–228.

Parshall, Peter. 1993. Imago Contrafacta: Images and facts in the northern Renaissance. *Art History* 16 (4): 554–579.

Preimesberger, Rudolf. 1999. Albrecht Dürer: Imago und effigies (1526). In *Porträt,* ed. Rudolf Preimesberger, et al., 228–238. Berlin: Reimer.

Randolph, Adrian W.B.. 2003. Introduction: The authority of likeness. *Word & Image* 19 (1–2): 1–5.

Röttinger, Heinrich. 1937. *Hans Weiditz, der Strassburger Holzschnittzeichner.* Frankfurt a. M.: Diesterweg.

Roth, Michael. 2017. Vom "Hortus Eystettensis" zum "Hortus Berolinus." In *Maria Sibylla Merian und die Tradition des Blumenbildes von der Renaissance bis zur Romantik, Exh. Cat. Kupferstichkabinett–Staatliches Museen zu Berlin/Städel Museum Frankfurt a.M.,* ed. Michael Roth, Magdalena Bushart, and Martin Sonnabend, 89–99. Munich: Hirmer.

Rytz, Walther. 1936. *Pflanzenaquarelle des Hans Weiditz aus dem Jahre 1529. Die Originale zu den Holzschnitten im Brunfels'schen Kräuterbuch von Prof. Walther Rytz Bern.* Bern: Verlag Paul Haupt.

Seidensticker, Peter. 2010. *Aisthesis. Wahrnehmung der Farben in den Pflanzenbeschreibungen der frühen deutschen Kräuterbücher.* Stuttgart: Steiner.

Smith, Pamela O. 2008. Artisanal knowledge and the representation of nature in sixteenth-century Germany. In *The art of natural history. Illustrated treatises and botanical paintings, 1400–1850,* ed. Therese O'Malley and Amy R.W. Meyers, 15–31. New Haven, CT: Yale University Press.

Sprague, Thomas A. 1928. The herbal of Otto Brunfels. *Journal of Botanists* 49: 70–124.

Stannard, Jerry. 1999. Dioscorides and Renaissance Materia Medica. In *Herbs and herbalism in the middle ages and Renaissance,* ed. Katherine E. Stannard and Richard Kay. Aldershot: Ashgate.

Swan, Claudia. 2006. The uses of realism in early modern illustrated botany. In *Visualizing medieval medicine and natural history, 1200–1550,* ed. Jean A. Givens, Karem M. Reeds, and Alain Touwaide, 239–249. Aldershot: Ashgate.

Swan, Claudia. 2011. Illustrated natural history. In *Prints and the pursuit of knowledge in early modern Europe. Ausst. Kat. Harvard Art Museums/Block Museum of Art,* ed. Susan Dackerman, 186–192. Cambridge, MA: Harvard Art Museums.

Touwaide, Alain. 2008. Botany and humanism in the Renaissance: Background, interaction, contradictions. In *The art of natural history. Illustrated treatises and botanical paintings, 1400–1850,* ed. Therese O'Malley and Amy R.W. Meyers, 33–61. New Haven, Conn.: Yale University Press.

Wonnecke von Kaub, Johannes. 1485. *Gart der Gesundheit.* Mainz: Peter Schoeffer.

Zucchi, Luca. 2004. *Brunfels e Fuchs: L'illustrazione botanica quale ritratto della singola pianta o immagine della spezie.* Florence: Leo S. Olschki Editore.

Magdalena Bushart is a Professor and Chair of the department of Art History at the Institute for Art History and Historical Urban Studies at Technische Universität Berlin. She is currently heading the DFG-research group *Dimensions of Techne in den Künsten.* She earned her Ph.D. from the Freie Universiät Berlin (*Der Geist der Gotik und die expressionistische Kunst. Kunstgeschichte und Kunsttheorie 1911–1925,* München 1990) and her 'Habilitation' from the Technische Universität München (*Sehen und Erkennen. Albrecht Altdorfers religiöse Bilder* München 2004). She has published works on art criticism, early modern German art and on artistic techniques. Furthermore, she (together with Henrike Haug) is the editor of the book series *Interdependenzen. Die Künste und ihre Techniken.*

Chapter 7
Capturing, Modeling, Overseeing, and Making Credible: The Functions of Vision and Visual Material at the *Accademia del Cimento*

Giulia Giannini

Abstract The *Accademia del Cimento* (Florence) is the first European academy to be supported by a public power and to put experimentation at the core of scientific activity. During its activity (1657–1667), the Cimento carried out hundreds of experiments. A minor part of them is collected in the only printed work produced by the Accademia, the *Saggi di Naturali Esperienze* (1667). Almost one hundred illustrations accompany the twelve groups of experiments presented in the *Saggi*. They are mainly drawings of instruments and experimental apparatus. In spite of the sumptuousness of the edition, these drawings are characterized by a functional simplicity. Tables, diagrams and illustrations also punctuate diaries, handwritten notes and correspondence. A study of the unpublished documents shows the role of visual images in experimental design and allows to explore the wider problem of the relationship between thought and vision. This contribution analyses the epistemic function of vision in the Cimento's experiments and debates around the issue of natural freezing and the properties of heat and cold. Discussions on the topic include geometrical demonstrations and mathematical representations, punctually excluded from the *Saggi* but occasionally resumed by individual members in later works.

Keywords Accademia del Cimento · Institutions · Experiments · Heat/cold · Geometrical demonstrations

7.1 An Institutional Context: The Florentine *Accademia del Cimento* (1657–1667)

This contribution examines an institutional context; specifically, it explores the use of vision and visual material within the activities of the Florentine *Accademia del Cimento*.

G. Giannini (✉)
Università degli Studi di Milano, Milan, Italy
e-mail: giulia.giannini1@unimi.it

M. Valleriani et al. (eds.), *Scientific Visual Representations in History*,
https://doi.org/10.1007/978-3-031-11317-8_7

The *Accademia del Cimento* was one of the first scientific academies in Europe to be supported by a public power, and to pay increased and exclusive attention to the study of natural phenomena through the systematic use of experiments.

It lasted only ten years (1657–1667)—the same years that saw the establishment of societies of greater fame and longevity, such as the *Royal Society* and the *Académie Royale des Sciences*—and its research was based not only on experimental practice, but also on collegial activity. Experiments were proposed by the members of the Cimento or its patron, Prince Leopoldo de Medici (1617–1665), and then collectively carried out within academic sessions. As will be seen, the collegial and public nature of the Accademia is also reflected in the role that images took on within the group's work and its dissemination.

During the ten years of its activity, the Cimento carried out hundreds of experiments: The diaries, compiled by the members, list more than six hundred academic sessions, and at least one or more experiments was carried out during each meeting. The objects of such experiments were varied. The question of air pressure and the void was one of the most debated within the Cimento. Besides replicating Evangelista Torricelli's (1608–1647) experiment, famously described in a letter to Michelangelo Ricci (1619–1682) in June 1644, with many variations, the academicians also observed various objects placed in the "void:" from the shape taken by water drops to the attraction of a magnet, from the swelling of bladders to the unique motion of smoke. They did not hesitate to create a vacuum and trap birds, butterflies, flies, crickets, lizards, and fish therein to observe their reactions. The academicians also carried out a large number of experiments on the nature of heat and cold, and on the process of natural freezing. Whereas pneumatics and thermology where undoubtedly the predominant research strands in the Cimento, various experiments were also performed in other areas of physics. To name a few examples, the Cimento academicians studied falling bodies, projectile motion, and pendulum motion; they analyzed the weight and incompressibility of liquids; they conducted experiments on distillation and combustion, and studied changes of color in liquid mixtures; they investigated the "electric virtue" of various substances and carried out experiments involving magnets; building up on Pierre Gassendi's (1592–1655) experiments, they attempted to measure the speed of sound. Moreover, the members of the Cimento took an interest in astronomical questions and demonstrated an inclination—though perhaps never too deep—toward the study of the nature of life, the structure and forms of living bodies, and the sensibility and physiological complexity of the various parts of an organism.

7.2 The Function of Visual Material in the Only Work Published by the Cimento: The *Saggi di Naturali Esperienze* (1667)

A small part of the experiments carried out between 1657 and 1667 is collected in the only printed work produced by the Cimento, the *Saggi di Naturali Esperienze* (1667).

The book was intended to revive the glory of the Medici family, whose extraordinary patronage of science had been celebrated all over Europe. It was published in a sumptuous folio edition with ornate chapter initials and section headings featuring floral and figural decorations and images. A full-page portrait of Grand Duke Ferdinand II (1610–1670), to whom the book was dedicated, followed the title page printed in red and black.

Curiously, one of the first pieces of information circulating about the book (at that time still unpublished) concerned an image, and the precise description of the Cimento's device (*impresa*) that should have been printed on the frontispiece. At the beginning of 1666, Lorenzo Magalotti (1637–1717) wrote to Alessandro Segni (1633–1697), his predecessor as secretary of the Cimento, at that moment in Paris:

> …I send you the title decided upon by the Academicians, that shall serve to correct the one you wrote to me: *Saggi di naturali esperienze fatte nell'Accademia del Cimento sotto la protezione del Serenissimo Principe Leopoldo di Toscana descritte dal Segretario di essa Accademia. A Ferdinando Secondo Gran Duca di Toscana.* Below this is set the figure with the following: A jug that they use for the royal cementation of gold, with a mass of gold at the bottom that dissolves in aquafort; it is recognizable to the experienced from the shape of the container and from the smoke coming out, even if it has no fire under it. The motto is taken from Dante: "Provando e riprovando" ["By testing and testing again"]. At the foot of the figure there is written "Cimento," which is the name.[1]

Actually, in its final form, the *impresa* depicted a furnace with three crucibles filled with molten metals to be tested (Fig. 7.1). On the top of the picture, a fluttering decorative ribbon set out the Dante motto: "Provando e riprovando:" "trying and trying again" or "testing and retesting"). There are no records disclosing what led to the choice of the image and we do not possess (or cannot exactly identify) the preparatory drawings of the illustration described by Magalotti to Segni. At any rate, both images emphasized the experimental nature of the Accademia. The *impresa* was a fundamental totem for many Renaissance and Early Modern academies (Quondam

[1] "…le mando il titolo fermato e stabilito da' Signori Accademici, che intanto servirà a corregger quello che V.S.Ill.ᵐᵃ mi ha scritto darsele costà: *Saggi di naturali esperienze fatte nell'Accademia del Cimento sotto la protezione del Ser.ᵐᵒ P.ᵖᵉ Leopoldo di Toscana descritte dal Segretario di essa Accademia. A Ferdinando Secondo Gran Duca di Toscana.* Sotto a questo va la cartella con la seguente impresa: Una caraffa di quelle che s'adoprano al cimento regio dell'oro, con una massa d'oro nel fondo che si solve in acqua forte, il che si riconosce da' periti dalla figura della stessa boccia e dal fumar ch'ella fa, quantunque non abbia sotto il fuoco. Il motto preso da Dante: "Provando e riprovando." In piè della cartella v'è scritto: "Cimento, ch'è nome." Lorenzo Magalotti to Alessandro Segni, January 15th, 1666, ACF, Stanza 5, *Carteggio Segni*, 130r–131v, published in (Mirto 2016, 140–141). English translation in (Mirto 2009, 144).

Fig. 7.1 The impresa printed in the *Saggi*. From (Magalotti 1667, frontispiece). Smithsonian Libraries / Public Domain

1982).[2] It was a deep, communicative intertwining of pictures and words, between the visual image and the motto that accompanied it. In keeping with this Renaissance academic tradition, the *Accademia del Cimento* displayed its *impresa*: a visible mark, a figurative expression of its identity.

Almost one hundred illustrations accompany the twelve groups of experiments presented in the *Saggi*. They are mainly drawings of instruments and experimental apparatus. In spite of the sumptuousness of the edition, these drawings have a functional simplicity and an absence of decorations and embellishments. They often are simplified abstractions of the experimental apparatus showing the apparatus' internal workings.

The publication was anonymous. By omitting the names of the authors, a maximum emphasis was given to the Accademia and its patron. As a result, the Cimento was presented as a cohesive institution working on behalf of the Medici family. Lorenzo Magalotti, the secretary of the Accademia, became the Cimento's voice on paper. Prince Leopoldo de Medici assigned him to select the experiments to be published and to draft the text. The manuscript of the *Saggi* was substantially ready in 1664 (Mirto 2009), but the volume was only published in 1667. The rough copies went through various changes and edits from the other members of the Cimento. Among the notes and corrections to Magalotti's draft of the *Saggi*, one can also find remarks on the figures (Figs. 7.2 and 7.3).

[2] According to Maylander's classification, forty-three percent of sixteenth-century academies and 50% of seventeenth-century academies used an *impresa*. For many such academies, the *impresa* is the only surviving artifact aside from their name (Maylender 1926–1930).

Fig. 7.2 The "void in the void" experiment in the *Saggi*'s draft. From (BNCF, Gal. 270, c. 18r). Su concessione del Ministero della cultura / Biblioteca Nazionale Centrale. Firenze. Divieto di riproduzione

The main criticisms, primarily made by Carlo Rinaldini (1615–1698)[3] and then summarized by Magalotti, concerned the general style of the proposed illustrations

[3] "Quanto alle figure. -Non mi piace la prima, si perché il quadrante deve aver per costa tutta l'altezza del cannello A B, come anche perché il vaso bisogna tingerlo trasparente, onde si vegga la parte immersa del cannello tanto eretto perpendicolare quanto inclinato. Inoltre, il vaso sole esser messo in prospettiva, e che sia liscio e pulito senza lavori, perché meglio si distingua la parte immersa sotto il livello dell'argento vivo stagnante. La figura vorrebbe esser disegnata in prospettiva da chi intende queste materie, e così disegnata darla all'intagliatore perché l'intagli per l'appunto. Le figure non vogliono aver tanta scarsità di lettere, onde quel vaso avrebbe a essere chiamato con lettere proprie, la parte immersa del cannello, tanto perpendicolare quanto inclinata, con lettera propria, così anche

Fig. 7.3 The "void in the
void" experiment in the
Saggi. From (Magalotti
1667, 69). Smithsonian
Libraries / Public Domain

l'argento vivo stagnante con lettere proprie, così anche la parte del cannello fuori dell'argento, così
il quadrante etc. Quanto alla seconda figura. -La seconda figura non mi piace. Prima, perché non è
in prospettiva, non mostrandosi bene il fondo del vaso, che pure si puol mostrare esquisitamente;
secondo perché ci sono dei sostegni con lavori e cose puerili; terzo perché quel vaso deve mostrare
trasparenza perché si vegga l'effetto dell'immersione del cannello; quarto perché il vaso deve essere
liscio e pulito; quinto perché la parte immersa del cannello non è chiamata con lettere; sei perché il
bicchier quadro non mostra la sua trasparenza, onde non si scopre il suo fondo; settimo, perché il
coperchio non è disegnato bene, mentre non si scorge in che maniera si commetta, e si confondono
i vivi del vaso principale con i vivi del coperchio; ottavo, perché presa tutta la macchina insieme
è mal disegnata in prospettiva, onde l'estremo H del cannello non risponde con l'altre partu sino
all'estremo del catino. In oltre la lettera G dovrebbe essere all'estremo inferiore del cannello, tanto
più che la lettera G sola è posta per significare il bicchiere, quale piuttosto chiamarei con più lettere;
e mi parrebbe che dentro il vaso A si dovesse accennare la vescica. La terza figura patisce al solito la

and focused on their function; in short, the pictures should have been designed to be practical and useful, rather than attractive. In particular, (1) the figures should have been in perspective and the vases drawn smooth and clean, so as to allow the reader to better see the inside; (2) letters indicating the different parts of the figure were too scarce—each element of the figure should have been marked with its own letter to make the narrative more understandable and clear; and (3) it was necessary to remove ornaments and childish decorations ("cose puerili").

The other two figures (relating to the "void in the void" experiment) (Figs. 7.2 and 7.3) exemplify the changes that the illustrations underwent during the publication process of the work.

The volume collected the experiments to be presented to the outside world, and the illustrations therein were primarily intended to support the description and explanation of such experiments. This is why, if we just look at the *Saggi*, we can attribute to the images a transmission function and little more.

As in many other experimental reports of the time (suffice it to mention Boyle's work), the textual and visual descriptions of the instruments functioned here to establish the credibility of the experiment; by means of visual and textual material, the reader could reproduce and repeat the experiment or virtually witness it as described in the book.

7.3 Other Sources: The Unpublished Documents

But in order to fully understand the role and the functions that visual material played within the Cimento, it is necessary to go beyond the *Saggi*, through the large amount of manuscripts the members left behind.

The Galileo collection at the Biblioteca Nazionale Centrale in Florence (BNCF) preserves an extensive corpus of manuscripts of various kinds showing the concrete activity of the Cimento behind the exhibited neutrality of the *Saggi*. In terms of their purpose, the documents connected with the activities of the Cimento are mainly of three types: (1) the *Saggi*, which were to present the work of the Medici's academy to the outside world; (2) the diaries, mainly complied with the aim of collecting experiments for the *Saggi*; (3) the correspondence, which served for communication abroad and between the members of the group before and after the academic sessions.

Because of its collegial nature, the work of the Cimento was carried out through a constant dialogue, a dialogue that took place above all between the walls of the Pitti palace—the residence of the Gran Duke—where the academicians gathered to

prospettiva; levarei quei trabiccoli, fingerei il vaso liscio e trasparente, e mostrarrei l'immersione del cannello. Nella quarta sono gli stessi difetti, come nella quinta, sesta e settima, in tutte le quali parmi ancora che ci sia scarsezza di lettere delle quali parerebbe che dovessi esser maggior abondanza. L'ottava figura parmi difettosa; prima, per mancanza della prospettiva; secondo, perché il vaso deve essere liscio e trasparente; terzo perché è scarsa di lettere onde la narrazione si rende confusa." Rinaldini's notes to draft A of the *Saggi* (BNCF, Gal. 267, cc. 39r–40r); published in (Abetti and Pagnini 1942, 345).

design and carry out the experiments. The large majority of the experiments were the result of discussion and exchange between the members. Traces of these debates can be found in the correspondence, which also report academicians' discussions on experiments proposed and performed.

Moreover, tables, diagrams, and illustrations punctuate diaries, handwritten notes, and letters. The presence of visual material in these "unofficial" reports cannot be merely attributed to the desire to make the experiments more credible.

It is thus through the study of the unpublished documents that it is possible to clarify the role of visual material not only in the dissemination of the Cimento's activity but especially in the design of its experiments, and to explore the wider problem of the relationship between thought and vision.

This contribution will analyze the epistemic functions of visual material in the Cimento's experiments and debates around the issue of natural freezing and the properties of heat and cold. Indeed, the group's activity on thermology provides a key example of the various uses of visual material within the Accademia. Through some of the experiments carried out on this topic, the various phases in which visualizations enter the Cimento's reasoning and procedures will be considered.

7.4 The Experiments on the Nature of Heat and Cold

The academicians performed a multitude of experiments on the nature of heat and cold, on the existence of "frigorific" atoms, and on hypotheses advanced to explain the process of natural freezing. This is one of the subjects that reveal more clearly the diversity of principles held by the academicians, and that produced the most violent internal clashes on interpretive matters, in spite of the neutral tone that characterized the *Saggi*.

7.4.1 *Leopoldo's Trial: Explaining Nature's Mechanisms by Making Them Visible*

Within the Cimento, the scholastic idea of heat and cold as "qualities" and the atomistic interpretation of heat and cold as "bodies" coexisted. The academicians' work on this topic was animated by contrasting natural philosophical beliefs.

The expansion of volume that takes place when water turns into ice questioned the theory that cold is the mere absence of heat. Gassendi and his followers claimed that the ice was produced by atoms of cold that, by insinuating themselves into the water, made its bulk grow and hardened it by welding its particles.

In order to justify this phenomenon and salvage the idea of cold as deprivation, many experiments and hypothesis were put forward. From at least October 4, 1657, the members of the Cimento were engaged in a series of experiments on

the freezing process.[4] Prince Leopoldo—the Accademia's patron and sponsor—was very involved in this debate; not only did he urge his fellow academicians to work on this problem, but he himself designed and carried out experiments.

For example, he chilled an empty carafe with a long, fragile neck by putting it in ice, and then he turned it upside down into a bowl filled with water.[5] After breaking the neck of the carafe he observed that the water entered the carafe without encountering any oppositions. On the other hand, by heating up a similar carafe and repeating the same experiment, not only did the water not enter the carafe, but one could visibly observe something resembling a waft coming out from the mouth of the carafe. This experiment seemed to visually demonstrate the corporeity of heat and the privative nature of cold.

Actually, many of the experiments carried out by the academicians—from those performed in Torricelli's void to those on the effects of heat and cold—aimed at explaining nature's mechanisms by making them visible. In this sense, the entire operation of the Cimento could be read as an attempt to explore nature by means of visualizations. By focusing on their effects, invisible entities such as cold and heat could be perceived through the sense of sight.

In the diaries, the experiment proposed by Prince Leopoldo was not accompanied by any visual material. The experiment did not require particular instruments and the internal report, drafted by the academicians, only contains a textual description of the experimental procedure and its outcomes. As for the *Saggi*, in which a later version of the experiment was included, only a couple of images were printed to support the description of the apparatus (Fig. 7.4): "A glass bulb (Fig. XI) about one-eighth of an ell [7.3 cm] in diameter with a thin neck about an ell and a half [88 cm] long, closely divided in degrees." And a "smaller one (Fig. XII)" made "so that the cold might insinuate itself into all the water more easily and quickly" (Magalotti 1667, 147, 150; Middleton 1971, 181, 183). Figure XIII in (Fig. 7.4) shows the container of crushed ice in which the bulb of the instrument and a thermometer were immersed in order to analyze the movement of the water in the freezing process.

[4] "Posta l'acqua a diacciare, s'è osservato che da principio scema il livello, e poi nel diacciarsi va tuttavia rarefacendosi, infino a che riman congelata; e fu veduto in conformità di quello che scrive il Padre Zucchi, nell'agghiacciarsi l'acqua, salire dal fondo del vaso alcune gallozzine minutissime di figura sferica, di differenti grandezze, le maggiori delle quali ascendono più velocemente dell'altre" (BNCF, Gal. 262, 36r–v). The reference is to the second edition of the work *Nova de machinis philosophia* (Rome, 1649) of Father Zucchi, included in the list of books "on the subject of experimental things" sent by Rinaldini to Prince Leopold in November 1656: "Anno 1647 per aestatem exhibitum spectaculum infrigidationis aquae, amphora vitrea inclusae, per immissionem, & agitationem convenientem intra praeparatam glaciem contusam. In quo primò aqua visa est ad minus spatium restringi, relicta parte colli, quam, ante inchoatam frigoris actionem, occupabar; tum progrediente ab ambiente frigido alteratione, coepit dilatari; ut non solum spatium relictum repleret; sed exundaret, aliquot eius partibus ex amphora defluentibus: cum assurgerent interim intra aquam maiores bullae, quae ad superficiem accurrentes, postqua, supernatassent, rumpebantur; crebrescebant verò minutiores multae, quarum extimae, adhaerentes passim vitro amphorae, spectabantur" (Zucchi 1649, 61).

[5] A description of the experiment can be found in (BNCF, Gal. 263, 50r–51r). The document indicates that these phenomena were first noted by Prince Leopold.

Fig. 7.4 Illustration of the apparatus used in the experiments on the progress of artificial freezing. From (Magalotti 1667, 151). Smithsonian Libraries / Public Domain

This example depicts the main use of images in the *Saggi*, where visual material basically fulfills the role of enriching textual descriptions of the instruments and the experimental apparatus.

7.4.2 The Use of Tables: Exploring by Creating a Synthetic Image of the Data

The experiment designed by Leopoldo was only the starting point for deeper research into the behavior of various liquids in the freezing process. Through Leopoldo's experiment, the academicians came to identify six different phases in the process of artificial freezing: a "natural state" (namely the degrees the liquid reaches when simply poured in the vessel), a "jump upon immersion" (the degrees the liquid reaches rising in the tube once the instrument is inserted in a container with crushed ice), a "fall" (the degrees the liquid reaches descending slowly because of the cold, after the initial jump), a "point of rest" (the degrees the liquid maintains in the tube for some time, with no apparent sign of motion, once the descent in the tube ends), a "rise" (the degrees the liquid reaches slowly rising in the tube after the point of rest), and a "jump upon freezing" (the degrees the liquid speedily reaches at the moment of freezing before breaking the tube and bursting the bulb once transformed into ice).

From then on, the academicians tried to study the process in different liquids, noting the variations in temperature in the transition from one state to the other and, by means of a pendulum, the particular timing of every change occurring in the fluid.

It is at this stage that another kind of visual representation enters the *Saggi*: the results are gathered in tables (Fig. 7.5).

Each table shows the degrees a specific fluid reaches in each phase, the temperature of the liquid in that phase, and the time needed by the fluid for attaining it. For each of these data, the academicians also added a column displaying the difference in respect to the previous phase.

This was not merely a means of presenting the results in a simpler and more immediate way. Since the beginning of the experiments, the members of the group started to compile tables (Fig. 7.6). The aim was to visualize the phases of the freezing process at one glance in order to easily relate the results. The creation of synthetic images from the collection of data could in fact provide new insight into the process of artificial freezing. Tables did not only allow for the rapid comparison of the results of different trials with the same liquid, they could also show analogies or differences in time or temperature variations from one state to another.

In this sense, they became a means for exploring possible causes and effects in the process of artificial freezing.

7.4.3 Exploring Physical Effects Through Geometrical Demonstrations

The rise of the liquid after the insertion of the instrument in the ice was not caused by its increase in volume but from the contraction of the apparatus because of the cold. Cold and heat would cause a contraction or a dilatation, respectively, of the glass tube and bulb, causing the rise or the fall of the liquid inside them. Giovanni

PRIMO AGGHIACCIAMENTO

Dell' acqua di fonte.

Gradi del vaso. Differenze. Gradi del term. Differ. Vibraz. Differ.

Agghiacciamento dell'acqua di fonte. Primo.	Gradi del vaso	Differenze	Gradi del term.	Differ.	Vibraz.	Differ.
Stato naturale	142	1 ½	139	6	—	23
Salto dell' immers.	143 ½		133	64	23	232
Abbaslamento	120	23 ½	69	20	255	75
Quiete	120	10	49	16	330	132
Solleuamento	130	36	33	—	462	
Salto dell' agghiac.	166		33		—	

SECONDO AGGHIACCIAMENTO

Della stess' acqua.

Gradi del vaso. Differenze. Gradi del term. Differ. Vibraz. Differ.

	Gradi del vaso	Differenze	Gradi del term.	Differ.	Vibraz.	Differ.
Stato naturale	144	2 ½	141 ½	23 ½	—	25 *Secondo.*
Salto dell' immers.	146 ½		118	80	25	255
Abbaffamento	119 ½	27	38	10	280	135
Quiete	119 ½	11 ½	28	11	415	467
Solleuamento	131	39	17	—	882	
Salto dell'agghiac.	170		17		—	

TERZO AGGHIACCIAMENTO

Della medesima.

Gradi del vaso. Differenze. Gradi del term. Differ. Vibraz. Differ.

	Gradi del vaso	Differenze	Gradi del term.	Differ.	Vibraz.	Differ.
Stato naturale	143	2	141 ½	16 ½	—	23 *Terzo.*
Salto dell' immers.	145		125	74	23	346
Abbaffamento	119 ½	25 ½	51	7	369	196
Quiete	119 ½	10	44	6	565	368
Solleuamento	129 ½	39 ½	38	—	933	
Salto dell'agghiac.	169		38		—	

Fig. 7.5 Tables gathering the experimental results in the *Saggi*. From (Magalotti 1667, 156–157). Smithsonian Libraries / Public Domain

Alfonso Borelli (1608–1679)—one of the staunchest followers of Galileo Galilei (1564–1642) in the Cimento and a key figure in the scientific and experimental activity gravitating around Prince Leopoldo de Medici—was convinced of this, but not all the members of the group agreed with him. To disprove the hypothesis, Carlo

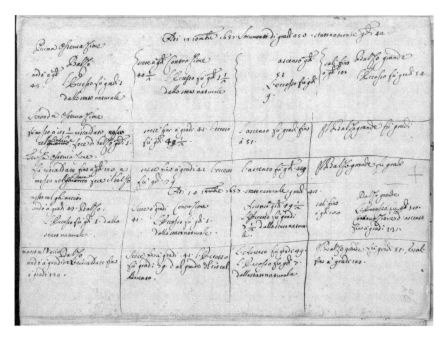

Fig. 7.6 One of the tables gathering the experimental results in the diaries. From (BNCF, Gal. 260, c. 26r). Su concessione del Ministero della cultura / Biblioteca Nazionale Centrale. Firenze. Divieto di riproduzione

Fig. 7.7 The heated ring experiment in the diaries. From (BNCF, Gal. 262, c. 47r). Su concessione del Ministero della cultura / Biblioteca Nazionale Centrale. Firenze. Divieto di riproduzione

Rinaldini—promoter of an innovation of the classical framework of Aristotelian tradition through experimentation—put forward another experiment (Fig. 7.7).

In October/November of 1657—while he was teaching in Pisa—Rinaldini suggested to Borelli[6] that they take a metal ring made for fitting perfectly on a plug. He proposed to observe how it would react once heated or frozen. Rinaldini's

[6] Either the proposal was made in person or Rinaldini's letter to Borelli is lost. Evidence of the fact that the experiment was proposed by Rinaldini to Borelli is preserved however in some subsequent

proposal is an important step toward a geometrical abstraction of the problem: the ring represented a section of the tube and allowed him to reduce the problem to its essential form. The inner and outer circumferences of the ring corresponded to the inner and outer surfaces of the container.

The experiment is recorded in the diaries on the dates of December 3, 4, and 5 of 1657,[7] but it was probably performed a few weeks earlier.[8] In the records, it is presented as a test of Borelli's hypothesis, according to which the "jump upon immersion" was caused by a contraction of the container. Similarly—according to Borelli—in the heating experiments carried out in the weeks before, the water in the instrument went down due to an expansion of the glass container caused by the intrusion of igneous atoms following its immersion in hot water. Since "someone had challenged the hypothesis, in order to confirm this enlargement of the container's surface due to the heating, it was observed that a brass ring, which put on a plug fit perfectly, once heated, widened so much that when tightened on one side against the plug, the maximum eccentricity would have contained the size of a Giulio. The opposite happened by chilling it."

In confirmation of Borelli's opinion and of what was observed with the ring, the following day the academicians noted that horn rims were heated in order to let glass into them; then they were cooled to make the rims shrink around the glass.[9]

Like the others, Rinaldini too believed that the dilatation due to the heat would have caused an expansion of the ring in all the directions. But in his opinion, once the ring was heated, its inner circumference would have to decrease and fit more tightly on the plug. Even if the trials revealed the contrary, Rinaldini was hard to convince.

In order to explain the failure of the experiment he proposed in relation to his predictions, Rinaldini started looking for alternative explanations. For instance, he appealed to the "effect of the latch" ("effetto del chiavistello"), that is, to the fact that the air surrounding the ring could become more rarefied and therefore offer less resistance.[10]

letters. See for example: Rinaldini to Viviani, November 11, 1657 (BNCF, Gal. 283, 12r–13v); Rinaldini to Prince Leopold, November 11, 1657 (BNCF, Gal. 275, 82r–83v).

[7] "Perché era stata assegnata dal Sig. Borelli per cagion principalissima del calare l'acqua dell'Instrumento da diacciare nella prima immersione di quello nell'acqua calda, la dilatazione del corpo della palla fatta per l'intrusione degli atomi ignei nelle particelle del vetro, et era tale opinione da qualcuno stata impugnata, per confermare questa ampliazione di superfice pel riscaldamento, si vedde che un anello d'ottone, che messo nel mascolo combagiava ottimamente riscaldato poi allargava tanto che stretto da una parte addosso al mascolo, la massima eccentricità avrebbe capito la grossezza di un Giulio. Il contrario succede diacciandola." (BNCF, Gal. 262, 47r; BNCF, Gal. 260, 280r).

[8] "Si sono fatte l'esperienze dell'anello di metallo, e di legno come propose V.S...." Viviani to Rinaldini, November 15, 1667 (BNCF, Gal. 252, 40r).

[9] "A dì 4 Dicembre 1657. In Conferma dell'oppinione suddetta del Sig. Borelli, si vedde, che i vetri degli occhiali si cavano dalle loro casse di corno, col riscaldarle, e si ristringono in esse col freddo" (BNCF, Gal. 262, 47v).

[10] "Il Signor Borelli mi ha participato una di V.A.S. nella quale significa la sperienza dell'anello riscaldato et cetera. Ci sento qualche difficultà et è che quanto si pone riscaldato nel mascolo mentre giuochi più di quello faceva postovi freddo, o pure ch'all'ora vi fosse quasi calzante. Io temo che

The problem could not therefore be considered solved. By then, Rinaldini and Borelli were in Pisa to hold their courses at the university. The discussions that followed mainly involved, in addition, Vincenzo Viviani (1622–1703) and Prince Leopoldo, still in Florence. Traces of the discussion is preserved in the letters exchanged between Pisa and Florence in November/December 1657.

The main sense employed in Rinaldini's experiment was the sense of touch; the effect of heating the ring was tested by "touching" the play between the ring and the plug. For convincing their colleague(s), Viviani and Borelli proposed a number of other physical and theoretic demonstrations. In particular, Viviani tried to persuade Rinaldini by shifting the focus from the sense of touch to the senses of hearing and sight:

> Your doubt, based on the effect of the latch, really comes as a surprise to me. I believed that in order to demonstrate the enlargement and contraction of the vase through heat and cold, you could not do more than find a way to touch it with your hand, as His Most Serene Highness has recently pointed out to us by means of that metal core applied inside the metal ring, which is once hot, once cold. So, if the sense of touch does not seem to you to be that reliable a guide to making judgments (since you attribute the effect of the greater play of the Male in the heated ring to the attenuation of the air enclosed between them caused by heating the ring), consider whether some other of our senses, such as hearing or sight, seem more reliable to you.[11]

The visual demonstration consisted of several steps. Viviani started with an easily viewable example, namely the lengthening of a heated copper rope in a pendulum.

As he explained in his letters to Rinaldini, Viviani took a copper rope about an ell in length and attached a lead ball to the bottom end of the rope. Then he placed a glass plate under the ball, leaving about three cm of space between the ball and the plate. By heating the rope with the flame of a candle, the ball came to touch the glass plate. Once the flame was removed, the ball returned to the same height as before. Viviani added to the description of the experiment an illustration of the apparatus (Fig. 7.8).

The fact that a heated body increase its sizes (and in all directions) was not questioned by Rinaldini, who could not raise objections to this experiment. The problem laid in determining what it meant that the body increases its sizes in all

quel calore non attenui l'aria, di modo che possi quell'anello meglio giuocare ch'essendo l'aria non tenue. Sappiamo che quando l'aria è più crassa i chiavistelli delle porte giuocono meno ne' loro sostegni che quando l'aria sia pura e ben tenue." Rinaldini to Prince Leopoldo, November 11th, 1657 (BNCF, Gal. 275, cc. 82r–83v).

[11] "Il dubbio di V.S. Eccellentissima fondato su l'effetto del Chiavistello veramente mi giugne nuovo, perché mi credevo che per dimostrar l'allargamento e strignimento del vaso mediante il caldo et il freddo, non si potesse far più che trovar modo di toccarlo con mano come ultimamente c'ha fatto osservare S.A.S. per mezzo di quell'anima di metallo applicata dentro l'anello pur di metallo ora caldo, et ora freddo. Se dunque il senso del tatto non gli par questo giudice (già che ella attribuisce l'effetto del meglio giocar del Maschio nell'anello riscaldato all'attenuazione dell'aria racchiusa tra l'uno, e l'altro cagionata dal calor dell'anello) consideri in grazie V.S. se gli par di dover prestare più fede ad alcun altro de nostri sensi come a quel dell'udito o più della vista." Viviani to Rinaldini, November 17, 1657 (BNCF, Gal. 252, 31r–34v).

Fig. 7.8 Viviani's rope experiment in the correspondence. From (BNCF, Gal. 252, 32r). Su concessione del Ministero della cultura / Biblioteca Nazionale Centrale. Firenze. Divieto di riproduzione

directions, and in particular in determining if this dilatation in all directions resulted in an increase or in a reduction of the inner circumference of a ring.

The pendulum example was only the first step of the demonstration. It allowed the conversation to begin from common ground. The following steps aimed to mentally visualize, and thus in a sense foresee, what would happen in the case of the ring.

Viviani's physico-mathematical hypothesis was that dilatation occurred proportionally to the body's dimensions. For this reason, according to him a heated ring would necessarily increase its inner circumference. Viviani thus sharpened the pendulum example until he came to the desired result.

In particular, he invoked a rope whose length is "a hundred and a thousand times greater than its thickness"[12] and folded it into a ring; the lengthening and enlargement or the shortening and thinning of the rope would be the same in the wrapped and folded one as in the extended one. This change of measure would occur with the same proportions. One cannot lengthen the circle of a ring and proportionally enlarge its width if the inner circle does not widen, nor can one shorten its circle and proportionally shrink its thickness or width if the inner circle does not become smaller.[13]

[12] "…et essendo la lunghezza della corda cento e mille volte maggior della grossezza della medesima" Viviani to Rinaldini, November 17, 1657 (BNCF, Gal. 252, 33r).

[13] "…se dunque tali esperienze son vere come V.S pure le troverà verissime, dicami di grazia per qual ragione non mi concederà ella che l'istessa variazione di misure, che segue per il caldo o per il freddo nel suddetto filo disteso non habbi da seguire per appunto nel medesimo filo ma piegato in anello: son certo che V.S. affermerà che giustamente altrettanto sarà l'allungamento e ingrossamento o l'accorciamento et assottigliamento nel filo avvolto e piegato in giro che nel disteso, data la parità del caldo e del freddo etc. e che tal mutazione di misura si farà pure come prima con la proporzione delle medesime dimensioni, ma non si può mai allungare il giro d'un anello e proporzionalmente ingrossare la larghezza di esso, se non si fa maggiore il cerchio interno, nemmeno si può accorciare il suo giro e ristringer proporzionalmente la grossezza o larghezza se il cerchio interiore non si fa minore come il tutto si può geometricamente dimostrare adunque parmi che a bastanza resti

On the same day, Viviani sent to Borelli a geometrical demonstration with an invitation to share it with Rinaldini too. However, Rinaldini never received the letter from Borelli.[14] The rope experiment did not convince him and he proposed varying the experimental conditions—using rings of different thicknesses, shape, and materials—in order to see if the experiment would lead to the same result (Fig. 7.9).[15]

Rinaldini learned of the geometrical demonstration in a later letter from Viviani—dated November 21, 1657—which contains the only surviving version of the demonstration.[16]

Through the geometrical demonstration, Viviani determined that the lengthening and proportional widening of the rope give rise to an increase in the ring's circumference (both internal and external).

As the length of the ring is determined by two circumferences (an external and an internal) that, a priori, could act independently (one could for instance increase while the other decreased), Viviani took the average circumference as a point of reference. In Viviani's demonstration, the increase of the average circumference resulted in an increase of both the external and internal circumference of the heated ring.

He first presupposed the expansion of the ring, and thus that the average circumference EI grew to another circumference FH (greater than the previous one and corresponding to the average circumference of the heated ring).

His demonstration was substantially based on the fact that the ratio of two concentric circumferences is equal to the ratio of their radii. The circumference EI should thus be to the increased circumference FH as the width AD to the increased width

provato che la capacità dell'anello e del vaso deva necessariamente farsi maggiore e minore per la introduzione o partita dei calidi dalla sua solidità." Viviani to Rinaldini, November 17, 1657 (BNCF, Gal. 252, 33r–v).

[14] See: Borelli to Viviani, November 21, 1657 (BNCF, Gal. 283, 19r–20v) and Viviani to Borelli, November 24, 1657 (BNCF, Gal. 283, 21r).

[15] "Ma parlo dell'esperienza fatta da S.A.S. dell'anello di metallo posto nel mascolo pur di metallo, che se non è notabile l'effetto del giuocolare in esso doppo riscaldato, non credo basti per conchiudere l'a[lla]rgamento, potendo venire da quel aria attenuata che meno impedisce, e ciò perché nelle sperienze da registrarsi deve haversi riguardo a più e più cose. Né V.S. mi haverà mai sentito dire che l'ingresso de' corpuscoli caldi non facci crescere le dimensioni del corpo riscaldato, ma dico bene che la fa crescere per tutti i versi e, se quell'anello è di figura circolare, non fa per ciò che non possi far alargamento per il largo, di modo che si stringhi il concavo di esso. Confesso però potersi dire che sarà più il crescimento per l'altro verso che per questo, di ciò ne miango [sic] capace. Qual sia poi il mio parere circa gli effetti dell'acqua nella boccia col collo lungo, non mi vo' dichiarar per ora, se prima non ho combinato esperienze diverse. Per tanto V.S. mi facci grazia dir a S.A.S. che facci far l'esperienza dell'anello su detto in questi modi: si facci l'anello grosso per un verso nella sua orbita tre diti in circa, per l'altro un mezzo dito. Un altro largo per ogni verso mezzo dito, et ambidue si misurino con le seste per di dentro senza adoprar mascolo. Poi si riscaldino che scottino un poco e si torni a misurar i diametri, havendo segnato con linee l'estremità di essi nell'orbita per poter subito ritrouvar il diametro. Poi si faccino riscaldar da vantaggio e si misurino. Poi si infuochino, sì che rimanghino rossi ferventi e si misurino. Il simile si facci di due quadrati e mi facci grazia darmi aviso di quanto occorre perché all'ora potrò dir qualche cosa." Rinaldini to [Viviani], November 19 (BNCF, Gal. 283, 16r–18r).

[16] Viviani to Rinaldini, November 26, 1657 (BNCF, Gal. 252, 35r–39v).

Fig. 7.9 Figures of the rings to be made in wood and metal. From (BNCF, Gal. 268, 108r). Su concessione del Ministero della cultura / Biblioteca Nazionale Centrale. Firenze. Divieto di riproduzione

BG, and the circumference radius EC to the increased circumference radius FC as the internal width of the ring ED to the internal width of the heated ring FG.

Consequently, he demonstrated that it was impossible to increase the circumference of a ring (and proportionally its width) without increasing its inner circle. The images he suggested provided convincing evidence. In his letter, Viviani also provided two mathematical representations (Fig. 7.10).

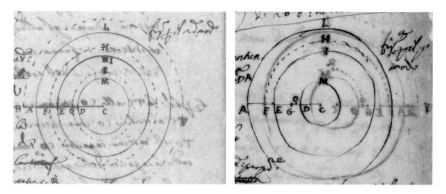

Fig. 7.10 Viviani's geometrical demonstration. From (BNCF, Gal. 252, 36r, 37v). Su concessione del Ministero della cultura / Biblioteca Nazionale Centrale. Firenze. Divieto di riproduzione

Even the geometrical demonstration did not immediately persuade Rinaldini. In his reply to Viviani of December 3, 1657,[17] Rinaldini asked him not to be surprised if he posed several problems—he was the one who proposed the experiment to Prince Leopoldo and wanted to obtain the maximum knowledge from it.[18] Actually, his doubts did not concern the geometrical proof in itself. Assuming that the increase must take place in every direction, and that it occurs proportionally, the demonstration is very clear and effective. He had already demonstrated this himself—Rinaldini wrote—with a parallelepiped, proceeding in the same way.[19] But the geometrical explication did not correspond to what happens in practice; in practice, things could be more complicated.

> Nonetheless, while experiments are being carried out, I would like them to be done to remove any scruple; and although geometry does not lie, nothing less, it conflicts with matter, its whiteness can be stained by it; so that, speaking of an orbit abstracted from matter, and I of my parallelepiped, I have no doubts that we conclude, but when we move to the work of nature, we pass the boundaries of geometry; therefore, in my opinion, it is advisable to try again to make up for the discrepancies that could arise from matter.[20]

[17] Rinaldini to Viviani, December 21, 1657 (BNCF, Gal. 283, 24r–25v).

[18] "In risposta le dico che per sua informazione quest'esperienza dell'anello fu proposta da me al Serenissimo Leopoldo, come S.A.S. gli puol attestare, onde V.S. non se maravigli s'io ciò ho fatto qualche difficultà, perché pretendo poterne cavar molte notizie," Rinaldini to Viviani, December 21, 1657 (BNCF, Gal. 283, 24r).

[19] "Non negando ch'il crescimento possa esser più per un verso che per l'altro, anzi concedendo che debba farsi proporzionalmente, la cosa è chiarissima e quello che V.S. dimostra nell'anello io di già avevo dimostrato in un parallelepipedo, a punto procedendo nella maniera medesima." Rinaldini to Viviani, December 21, 1657 (BNCF, Gal. 283, 24v).

[20] "Con tutto cio, mentre si fa esperienze io le vorei fatte per levar ogni scrupolo e ben che la geometria non mentisca, nulla di meno, contratta alla materia, puol da questa ricever qualche macchia il suo candore, sì che parlando d'un'orbita astratta dalla materia, et io del mio parallelepipedo, non ha dubbio che conchiudiamo, ma quando si vien all'operar della natura, passiamo in confini della geometria, che per ciò, per mio credere, convien far riprove per supplire al mancamento che dalla materia potesse accadere." Rinaldini to Viviani, December 21, 1657 (BNCF, Gal. 283, 24v).

Fig. 7.11 The ring
experiment. From (Magalotti
1667). Smithsonian
Libraries / Public Domain

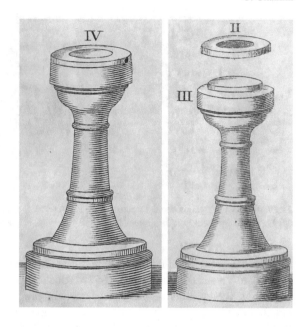

7.4.4 The Publication of the Heated Ring Experiment

There were no further developments on the issue and the experiment was published
in the *Saggi* in its original form, with an illustration of the experimental apparatus
(Fig. 7.11) and without any reference to Viviani's demonstration.

Rinaldini's notes to Draft A of the *Saggi* contain no relevant objections to the
description of the experiment and its effects (Abetti and Pagnini 1942, 344). This
leads us to believe that, at least from 1664, he was convinced of the enlargement of
the inner circumference of the ring (and therefore of the container) due to the effect
of heat. It is not clear whether it was the reduction of the problem to an image that
eventually persuaded Rinaldini. Nevertheless, like Borelli, Rinaldini too, once he
left Florence, published a series of works in which he reported—though not without
claims—part of the work previously carried out in the Cimento.

In particular, in his *De resolutione et compositione mathematica* (1668), Rinaldini
came back to the ring experiments. The experiment described by Rinaldini was a more
elaborate version in which the plug was a conical frustum and the ring's dilatation
was deduced from the fact that it descended further down the plug (Fig. 7.12).[21] The
main sense employed in the experiment was no longer the sense of touch; the effect
of heating the ring was not tested by "touching" the play between the ring and the
plug but by "seeing" the ring's descent.

[21] A similar version is also published in the essays. However, in this case the ring is not heated but
is immersed in water to investigate the effect of humidity (Magalotti Magalotti, 1667, 210–211;
Middleton 1971, 210–211).

Fig. 7.12 The heated ring experiment described by Rinaldini. From (Rinaldini 1668, 169). Bayerische Staatsbibliothek, München, 2 Math.p. 53; urn:nbn:de:bvb:12-bsb10942366-1

As in the *Saggi*, Rinaldini's account begins with an observation of the "jump of the immersion." Then he explains that he conceived the ring experiment, silencing any doubts regarding his perplexities about the interpretation of the observed effects: "…from which I deduced the dilation of the ring itself."[22]

Rinaldini clearly no longer doubted that the internal circumference of the ring increases in the heating process. Interestingly, in order to prove it, he employed a series of geometrical demonstrations. He started from the dilation of a rectangle[23] to arrive at the example of the ring.

Although the demonstration did not follow Viviani's procedure, the figure proposed by Rinaldini was very similar to that drawn by his colleague and, curiously, it used exactly the same letters (Fig. 7.13).

It is not clear how Rinaldini became convinced of the ring's increasing internal circumference, but Viviani's reduction of the problem to an image appears to have played a significant role. Through this representation, Viviani not only transmitted his

[22] "Quinimo, ut impensius rem ipsam nostra contemplation persequeremur, anulum eneum fieri curavi, ut in tertia figura ABC, quem aptabam masculo DFGE, in quo descendere usque ad H advertebam: erat autem mascvulum etiam aeneum, mox in ignem anmulo iniecto, donec fere candesceret, eidem iterum aptabam masculo observans quousque descenderet; et adverti pervenisse ad I punctum infra H, existente anulo, tam prius, quam postea, parallel horizonti: unde eiusdem annuli dilatationem conieci" (Rinaldini 1668, 169).

[23] This is probably the demonstration of the parallelepiped he described to Viviani in his letter of December 21, 1657. Rinaldini to Viviani, December 21, 1657 (BNCF, Gal. 283, 24r–25v).

Fig. 7.13 Rinaldini's
geometrical demonstration.
From (Rinaldini 1668, 172).
Bayerische Staatsbibliothek,
München, 2 Math.p. 53;
urn:nbn:de:bvb:12-
bsb10942366-1

idea about the process of heating dilatation but, in a sense, transformed the problem by shifting the focus from experimental observation to geometrical explication.

In spite of this, the *Saggi* is devoid of any reference to geometric demonstrations. The visual grammar does not include diagrams or mathematical representations. As mentioned, the large number of images contained in it focuses on the representation of the experimental apparatus and, at most, on the visual synthesis of the results through their collection in tables.

The absence of geometric diagrams in the Cimento's only printed work certainly cannot be attributed to a lack of interest in geometry on the part of its members. During his life, Viviani worked on the restoration of a number of ancient Greek mathematical works, from the Book V of the *Conics* of Apollonius of Perga (b. 262 BCE), through Euclid's (third century BCE) fifth book, to Aristeo's five last books (Viviani 1659, 1674, 1701). In 1658, Borelli published a compendium of Euclid's *Elements* (Borelli 1658) and from 1658 to 1661—with the help of Abraham Ecchellensis (1605–1664)—he prepared an edited Latin translation of an Arabic manuscript of Books V–VII of the *Conics* in Florence (Borelli 1661).

The suppression of geometrical reasoning and diagrams in the *Saggi* rather falls in line with its emphasis on pure empiricism and the exclusion of larger theoretical speculations. Even the preface to the work seems to suggest a sort of retraction from the mathematization of nature, too close to what had brought the case of Galilei:

> Now this is exactly what the soul is trying to do in the investigation of natural things. Here it must be confessed that nothing is better for this than geometry, which at once opens the way to truth and frees us in a moment from every other more uncertain and fatiguing investigation. The fact is that geometry leads us a little way along the road of philosophical speculation, but then abandons us when we least expect it. This is not because it does not cover infinite spaces and traverse all the universal works of nature in the sense that they all obey the mathematical laws by which the eternal Understanding governs and direct them; but because we ourselves have not as yet taken more than our faith in experiments. (Magalotti 1667, 36–37; Middleton 1971, 90)

These words, written by Lorenzo Magalotti, recall the objections raised by Rinaldini to Viviani after receiving his geometrical demonstration. However, the *De resolutione et compositione mathematica* does not show the same caution. The nature of the two works was profoundly different. In the first place, while relating some of the experiments performed in the Cimento, Rinaldini's book was primarily a work of pure mathematics. The inclusion in it of an experimental physics section may have mainly been due to Rinaldini's desire to claim his contribution within the Cimento (Baldini 2011, 197). Second, it is the work of a single author, and it was published when Rinaldini had already left the Medici court for Padua.

7.5 Conclusive Remarks

The use of images within the work of the Cimento reflects the institutional nature of the group. On the one hand, the collective character of the Accademia's work gave it a dialogic character. The need to devise experiments together and to offer a shared interpretation led different styles of reasoning to intertwine and influence each other. Sketches of experimental apparatus, drawings of experiments, tables and geometric representations—aiming to explain the experimental results—populate the unofficial papers of the Academy. These images aim to capture, model, explain and provide an overview of the various experiments conducted within the Cimento. Their purpose is to contribute to the design and interpretation of the experimental work.

On the other hand, the group worked and published on behalf of the Medici family, who had to manage and balance the difficult Galilean heritage in Tuscany. The images included in the only official publication must conform to the general style of the text, they have to provide credibility to the experiments and an image as "neutral" as possible of the academic work.

Acknowledgement This work is part of a project that has received funding from the European Research Council (ERC) as part of the European Union's Horizon 2020 research and innovation program (TACITROOTS, PI: Giulia Giannini, Grant agreement No. 818098).

References

Abetti, Giorgio and Pietro Pagnini. 1942. *Le opere dei discepoli di Galileo Galilei, L'Accademia del Cimento*. Florence: Giunti-Barbéra.

Baldini, Ugo. 2011. Tra due paradigmi? La *Naturalis Philosophia* di Carlo Rinaldini. In *Galileo e la scuola galileiana nelle Università del Seicento*, ed. Luigi Pepe, 189–222. Bologna: CLUEB.

Borelli, Giovanni Alfonso. 1658. *Euclides restitutus, siue, Prisca geometriae elementa breuiùs & faciliùs contexta: in quibus praecipuè proportionum theoria noua firmiorique methodo promuntur*. Pisa: ex Officina Francisci Honophri.

Borelli, Giovanni Alfonso. 1661. *Apolloni Pergaei conicorum libri V, VI et VII paraphraste Abalphato Asphahanensi nuncprimum editi*. Florence: ex Typographia Iosephi Cocchini.

Magalotti, Lorenzo. 1667. *Saggi di naturali esperienze fatte nell'Accademia del Cimento*. Florence: ex Typographia Iosephi Cocchini.

Maylender, Michele. 1926–1930. *Storia delle accademie d'Italia*, vol. 5. Bologna: Cappelli.

Middleton, W. E. Knowles. 1971. *The experimenters: Study of the Accademia del Cimento*. Baltimore: The John Hopkins Press.

Mirto, Alfonso. 2016. *Alessandro Segni e gli accademici della Crusca*. Florence, Accademia della Crusca.

Mirto, Alfonso. 2009. Genesis of the *Saggi* and its publishing success. In *The Accademia del Cimento and its European context*, ed. Marco Beretta, Antonio Clericuzio, and Lawrence M. Principe, 135–149. Sagamore Beach: Watson Publishing International llc.

Quondam, Amedeo. 1982. L'Accademia. In *Letteratura italiana* vol. I (Il letterato e le istituzioni), ed. Alberto Asor Rosa, 823–894. Turin: Einaudi.

Rinaldini, Carlo. 1668. *De resolutione atque compositione mathematica libri duo*. Padua: typis ac impensis heredum Pauli Frambotti.

Viviani, Vincenzo. 1659. *De Maximis et Minimis Geometrica Divinatio in Quintum Conicorum Apollonii Pergaei*. Florence: ex Typographia Iosephi Cocchini.

Viviani, Vincenzo. 1674. *Quinto libro degli elementi d'Euclide ovvero scienza universale delle proporzioni spiegata colla dottrina del Galileo, con nuov'ordine distesa*. Florence: Alla Condotta.

Viviani, Vincenzo. 1701. *De locis solidis secunda divinatio geometrica in quinque libros iniuria temporum amissos Aristaei Senioris Geometrae*. Florence: Typis Regiae Celsitudinis, apud Petrum Antonium Brigonci.

Giulia Giannini is Associate Professor of History of Science at the University of Milan (Italy). She is the principal investigator of the ERC Consolidator research project TACITROOTS—The *Accademia del Cimento in Florence: tracing the roots of the European scientific enterprise* (2019–2024). She worked at the Centre Koyré in Paris and at the Max Planck Institute for the History of Science in Berlin. Her research interests focus on the history of experimentation, and on cultural, political and social studies of science in Early Modern Europe.

Chapter 8
The Transformations of Physico-mathematical Visual Thinking: From Descartes to Quantum Physics

Enrico Giannetto

Abstract After the Copernican revolution, it was clear that the experience of vision could no longer be considered a completely reliable source of knowledge due to the optical relativity of motion. Furthermore, new optical instruments (telescope, microscope) pointed out the epistemological problem of the limits of human vision. However, the spatial-visual representation of physical phenomena by geometry remained a stalwart scientific practice and the source of certain conclusions. But, as is known, the algebraization of geometry by Descartes's analytic geometry broke the correspondence between arithmetic or algebra and its intuitive geometric meaning. In mathematical semiotics, we passed from iconic symbols to arbitrary signs. The change led to a reduction of geometry to algebraic calculus and the abandonment of visual geometric thought. The analytical geometry of Descartes, on the other hand, involved a new geometric visualization of physico-mathematical relations. The birth of non-Euclidean geometries, the special and general relativity theories, and the four-dimensional representation of space–time inspired a new chrono-geometric graphic representation. Quantum physics and quantization of space–time required a completely new mathematical creative imagination to understand Nature.

Keywords Visual thinking · Ancient geometry · Modern science · Descartes's analytic geometry · Relativity · Quantum physics

8.1 Introduction: Visual Thinking

Understanding the epistemic functions of vision in science involves an understanding of what is scientific thinking and what is merely thinking. Observations of Nature were already present within early human mythical thinking as observation of the sky

The original version of this chapter was revised: The affiliation of Enrico Giannetto has been changed. The correction to this chapter is available at https://doi.org/10.1007/978-3-031-11317-8_13

E. Giannetto (✉)
Dipartimento di Lettere, Filosofia, Comunicazione, Università di Bergamo, Bergamo, Italy
e-mail: enrico.giannetto@unibg.it

M. Valleriani et al. (eds.), *Scientific Visual Representations in History*,
https://doi.org/10.1007/978-3-031-11317-8_8

and of the motions of stars, which were considered divine. The first mathematical, geometrical, and arithmetical, symbols were born to describe the motions of stars (de Santillana 1968, 82–119; Giannetto 2005, 19–22). Geometrical thinking was a kind of visual thinking and imagination. Points were points of light seen on the vault of heaven. Straight lines were beams of light. Geometric figures were derived from real and imaginary connections of stars with straight lines of light, from configurations of stars in constellations, not from abstract concepts. The first mode of thought was a visual one; mathematical thought belonged to this mode. Thus, if we assign a fundamental role to mathematics in characterizing scientific thought, like in the modern physical sciences, scientific mathematical thought indeed differs from philosophical thought. At least partially, scientific thought is related to visualization.

What does it actually mean to think? A new understanding of human thinking is needed. There are at least two human ways of thinking: thinking through images and thinking through words—visual thinking and verbal reasoning. These two ways of thinking correspond respectively to what Aristotle defined as noetic thought and dianoetic thought (Calogero 1968). All the ancient Greek philosophies, as a matter of fact, can be understood in terms of the relationship between visual thinking and verbal reasoning (Calogero 2012).

Mythical thinking is "essentially" visual thinking, whereas Western philosophical thinking is essentially verbal reasoning. This can be related to the transition from an iconic symbolism of ideograms and *mythograms* to an alphabetic, phonetic, linear form of writing (Leroi-Gourhan 1964–1965).

Visual thinking is indeed a more complex way of thinking, a non-linear, non-sequential, three-dimensional way of thinking; it is the most ancient way of thinking, but also the form of future "parallel" (computer) thinking (Bailey 1996). However, even if verbal reasoning is dominant in logic-linguistic thought, when one has to think in the fastest way, one returns to visual thinking by simply visualizing the situation (Calogero 1960, 12–24). Dreaming is a kind of visual and, in general, "sensual" thinking. However, visual thinking is not simply a form of automatic or unconscious thought.

Pure (ancient) geometrical thinking is a kind of visual thinking; in this respect, mathematical thinking, as far as it is related to a non-alphabetic, non-phonetic, non-linear form of writing, is a different way of thinking than a philosophical one. This contradicts the notion that thinking through images is less certain than is verbal reasoning. The definiteness of a figure like a circle has exact properties, which cannot be confused with those of a square. Poetic imagery and visual arts as well, as the painter René Magritte has shown, are kinds of visual thinking.

Thus, thinking cannot be reduced to verbal reasoning. This has many implications. The human presumption that we are the unique being with the ability to think has always been related to our definition of thinking in terms of verbal reasoning. Thus, the most important implication is that, although they are not capable of verbal reasoning, non-human animals who have a nervous system related to vision have a visual way of thinking. Only by this consciousness of the primary visual character of thinking is it possible to understand that thought does not manifest itself in

human beings alone and to overcome the foundation on which anthropocentrism and speciesism have been erected (Giannetto 2013, 75–89).

In philosophical terms, non-human animal thinking is noetic thinking, related to vision and intuition through images, as opposed to dianoetic thinking, which constitutes itself on human language. The specific character of human thinking is a synthesis of visual thinking and verbal language into verbal reasoning—embedded visual thinking transformed into a dialogical praxis, and successively into written texts allowing for abstractions from life.

8.2 Scientific Visual Thinking, Descartes, and Modern Science

Images are central to the process of knowledge and to the construction of scientific theories. Wolfgang Pauli (1900–1958), in his paper on Johannes Kepler's (1571–1630) imagination, has shown how images have a fundamental function to archetypes of collective unconscious (Pauli 1952, 119–190; Giannetto 2001, 103–115, 2005, 403–437). The most usual mathematical, geometrical figures (points, straight lines, circles, spheres) must be considered archetypic, that is primeval, even pre-historical images that have continued to influence our historical way of thinking.

After the so-called Copernican revolution, it was clear that the experience of vision, due to the optical relativity of motion, could no longer be considered a completely reliable source of knowledge. Furthermore, new optical instruments (telescope, microscope) pointed out the epistemological problem of the limits of human vision. However, the spatial-visual representation of physical phenomena by geometry remained a stalwart scientific practice and the source of certain conclusions. The relativization of the geometric figures made by the projective geometry of Gérard Desargues (1591–1661) and Blaise Pascal (1623–1662) (Giannetto 2018, 95–110) was relevant but had no accepted consequences until the work of Gottfried Wilhelm Leibniz (1646–1716) and then, almost two centuries later, in relativity theory.

As it is known, however, the algebrization of geometry by René Descartes's (1596–1650) analytic geometry broke the correspondence between arithmetic or algebra and its intuitive geometric meaning (Descartes 1897–1913).

In 1619, in the city of Ulm (where, coincidentally, Albert Einstein would be born 260 yearslater), Descartes had what would be his decisive inspiration not only for science but for the whole of modernity. In truth, Descartes—within this *mathesis*—had invented a new form of mathematics on an abstract base, the so-called analytic geometry, aimed at reducing mathematics to a means of calculation with a subjectivist and humanist perspective; he had established a conventional correspondence between geometrical figures and algebraic equations. According to the ancient symbolic relationship, a number raised to the first power corresponded to a one-dimensional geometric line, a number raised to the second power (that is, squared) corresponded to a two-dimensional surface (a square), and a number raised to the

third power (that is, cubed) corresponded to a three-dimensional volume (a cube); this symbolic relationship ensured that the numbers had a geometrical significance and, thereby, recalled their optical-astronomical temporal reality. Descartes destroyed this symbolism, and the relationship between algebraic powers and geometric figures became arbitrary. In mathematical semiotics, we had passed from iconic symbols to arbitrary signs.

Geometric figuration had been linked to visual mathematical thought and the geometric representation of physical phenomena up to Galileo Galilei (1564–1642); even Isaac Newton (1642–1727) based his work on this visual mathematical thought. The change introduced by Descartes led to a reduction of geometry to algebraic calculus for the resolution of equations and the abandonment of visual geometric thought.

The analytical geometry of Descartes, on the other hand, involved a new graphic representation with respect to originally straight-line axes (not necessarily orthogonal) and thus a new geometric visualization of physico-mathematical "functions."

Descartes attained this correspondence between geometric figures and algebraic equations through the introduction of a "mathematical subjectivity," that is, by introducing a *rectilinear* system of coordinates onto which all figures were projected. In practice, this was a *rectification* of curves through projection, which had the effect, among other things, of making a circular curve more complicated in its algebraic representation—a second-degree algebraic equation—than a straight line—a first-degree algebraic equation. The primacy of *rectilinear* motion over the circular motion of Descartes encompassed analytic geometry. Introducing a system of coordinates into geometry corresponded to complete calculatory and algebraic control over geometrical forms, which Pythagoreanism had been lacking due to the incommensurability of the diagonal of the square with physical space (Giannetto 2010, 157–202).

Descartes's geometrization of physical space, which Alexandre Koyré called characteristic of modern science (Koyré 1957), and, in particular, Descartes's "analytic geometrization" of physical space was the scientific equivalent of European colonization and dominion in terrestrial space following the conquest of America—an enterprise that had required flat maps with coordinates, thus leveling the terrestrial curve and bringing it under mathematical control. In ancient Greece and the middle ages, there were problems of incommensurability that prevented geometric forms from being reduced to arithmetical and algebraic calculations, plus the fact that Euclidean geometric forms could refer only to figures of light from the celestial world. Without doubt, the (flat) Euclidean geometrization of physical space in terrestrial matter came about not only as a consequence of the Copernican astronomical revolution, but also because of the need for practical dominion over terrestrial space, just as the motion of projectiles from war machines led to the geometrization of physical space and motion.

Unlike a rectilinear system of coordinates, which constituted a sort of mathematical subjectivity, these geometric entities were reduced to their "subjective"

representation, and the symbolism was replaced in turn by a surreptitious and conventional iconism in Cartesian rectilinear coordinates (not necessarily orthogonal). With Descartes, mathematics and the science based upon it was no longer symbolic, no longer an iconic script; geometric symbols were reduced to arbitrary algebraic signs and geometry itself to pure calculation. This was a semiotic revolution, one which transformed the whole of science and which has its roots in the global cultural effects of Protestant iconoclasm—linked to a literal interpretation of the Bible—against idolatrous images (which effected all semiotics, not just the mathematical). Descartes reduced mathematical symbols to instruments of computation, the mathematics of thinking in images to a computational technique. Thus, the "pagan" archetypic image of the circle was replaced by the Christian symbol of the cross constituted by orthogonal coordinates (Nicholson 1960).

With analytic geometry, one first calculates, then one gives a graphic representation of algebraic equations. That is, images are not completely excluded, but they come after calculus; images are no more the guides of our scientific thinking, they are reconstructed by calculus, like rhetorical figures within language.

For Descartes, the notion that geometry could reveal the being of the world is guaranteed by the fact that the essence of the corporeal material world is spatial extension itself, the only reality plausibly susceptible to a determination of form. The matter of the world must, therefore, be considered *res extensa*. Spatial extension is no more a property of matter, as in Galileo; in Descartes, matter is defined by spatial extension. Thus, mathematics comes first, is a priori assumed, and experimental physics only verifies a given mathematical structure later. Spatial extension is that which can change, according to the divisibility, the shape, and the motion, and is that which, in all these changes, remains. Being in the world is conceived of in terms of the "simple geometric presence" that remains constant, as the immutable creation of an immutable Mathematician: God. Matter, which Descartes identified with spatial extension, is no longer an abstract metaphysical substratum of time and becoming—as in Aristotle (385–323 BCE) and Plato (428–348 BCE)—but is the substratum of the immutable being of the various geometrical figures, the geometric shapeless substratum of which the geometric forms are mere determinations. Being has been reduced to a geometricized spatial extension, material bodies have been reduced to geometric figures, general change has been reduced to the local motion of their points, and the local motion to a simple change in position of a geometric point.

The mathematical essence of a world that can now explain "matter" is the reason why Descartes, as well as many contemporary physicists, think that modern science should adopt the mathematical method in order to explain nature. As long as geometric figures can be replaced by numbers and their algebraic powers and relations, material phenomena are constituted by and can be calculated in numerical terms.

Numbers no longer have a geometric meaning, but geometric figures are numerical relations; figures and with them visual thinking no longer have direct ontological and gnoseological relevance. Visual thinking, as far as it is related to perception, is replaced by a completely rational representation as given by calculation.

According to Martin Heidegger (1889–1976), at least as far as Descartes is concerned, behind the mathematical ontology there lies the presupposed mathematical gnoseology of the reducibility of things, of temporal entities to *mathemata*, namely to timeless, unchanging, ideal, and universal essences, therefore knowable a priori with certainty, independent of existence, of concrete being (Heidegger 1962). Descartes attempted to trace back the history of mathematics to an essence of mathematics, using his method of *mathesis universalis*. Mathematics, according to Descartes, is this science of the essences, one of necessarily-deducible pure connections and formal relations of order and measure; numbers and geometric forms are the best examples of ideal essences and, for this reason, arithmetic and geometry are part of "mathematics" as a science of things in that they are knowable a priori. Descartes's analytical geometry itself was founded on the idea of a common essence in arithmetic and geometry, on the reduction of spatial relations and numbers to a formal grid of points and coordinates.

If being and time are considered as inside the *essentia* of entities, as in Suárez (Heidegger 1975, 108–139), then clearly what was, what is, and what will be are all to be found, in some way, deployed within this concept, and the *essentia* can be thought of as mathematical, since it is given a priori, and only mathematical representation can effectively open out *existentia* into its various articulations. The being of entities, the being of Nature, is mathematical. For this reason, a mathematical science of Nature explains phenomena by attributing them to implicit universal laws that are mathematical and timeless (for Descartes, bodies are reduced to universal figures of geometric points); it determines them through a geometric method that is axiomatic and deductive or via arithmetical and algebraic calculation, and predicts them—modern science is explanatory and predictive because it is mathematical. Without doubt, this concept of mathematics as an abstract science of ideal-formal essences is the most widespread, and Descartes's seventeenth-century interpretation has become the dominant, but it reduces the complexity of historical changes in mathematics, and particularly those connected with the revolutions in physics in the twentieth century, as we shall see later.

Here, we need to understand that from the ancient Greeks up to the Renaissance, above and beyond the question of ideality, mathematics was considered symbolic and mathematical symbols were either considered the expression of a celestial-divine *logos* of the star-gods, of Nature, as the Pythagoreans held, or they had an astronomical and non-abstract sense. The numbers and geometric forms identified with the gods or their expressions were considered active principles (de Santillana 1968). The essence of mathematics needs to be reconsidered along these lines. As with language, the essence of mathematics, of the mathematical *logos*, is not technical, instrumental, and human, but is a sort of *revelation* of being in certain aspects; only in this way can we follow Heidegger and rethink the essence of technology as a sort of revelation of being, strictly correlated to the mathematical *logos*.

According to classical and Pythagorean geometry, the "theo-rem" (from *theòs* and *rema*) is literally and really the word of God, and the theory (from *theòs* and *orao*) is the vision of God—in the sense of a genitive subject—is that which God sees; geometry is the divine science and its *logos* is, therefore, revelation.

For the moderns, after Descartes, mathematics linked to mechanics is an instrument of calculus and a human and technical *logos*, with the purpose of quantifying and measuring. Numbers and geometric forms (like the Aristotelian and medieval forms) are no longer active principles, but are incorporated into inert and passive matter. Aristotelian *forms* have been replaced by *formulas* (de Santillana 1956). The modern *mathesis universalis*, which, for Descartes, characterized modern science, was very different from the Pythagorean *mathesis*, and was based on reducing the mathematical essence of things to that which could be quantified, calculated, and measured technically, mechanically, and experimentally. That which was knowable a priori was identified with what could be calculated and verified a posteriori by a technical subject-instrument, by a subject-machine, namely by a "subject-ity" (a term introduced by Heidegger to distinguish it from human subjectivity) (Heidegger 1961, 2003).

In truth, Galileo had overcome the theoretical impossibility of reducing Nature to an ontological image-representation of the supposedly true, ideal-mathematical world of Plato, by means of an active process of "mathematization," on a practical level, coupled with the replacement of experience with the ideal mechanical experimentation of Archimedes (287–212 BCE) and the replacement of abstract mathematics with Archimedes's mechanical geometry (Giannetto 2010, 141–202, 2012, 137–151, 2017a, 423–424, 2017b, 21–38).

Descartes, on the contrary, sought to reformulate the new practical learning—mathematical and technical, or geometrical and mechanical—of modern Galilean science, presenting it as new theoretical learning and establishing laws of Nature from which to proceed by means of an axiomatic-deductive method, clarifying gnoseology and ontology, regardless of the implicit differences with Galileo. According to Descartes, it is not the calculatory or technical and operational praxis that founds itself and then founds the certainty of *ratio*, but it is the theoretical and philosophical calculatory *ratio* of the *mathesis universalis* that constitutes the possibility of this praxis. From this point of view, modern science was grafted onto a gnoseological metaphysics of the subject, like a "mathematical I-think," which, after Descartes, would be further elaborated by Immanuel Kant (1724–1804) (Giannetto 2010, 141–202). This subjectivist metaphysics is nothing more than the counterpart of objectivist metaphysics—followed by most modern scientists—which, unknowingly, shares the same assumptions. In Heidegger's view, it was Descartes who revealed the metaphysical basis implicit in modern science as a reduction of the being in Nature within a pre-set mathematical determination; at the same time, though, Heidegger revealed the practical-technical knowledge of the dominion over Nature, typical of modern science, modern metaphysics, and the modern era—the modern mathematical concept of Nature and the mechanistic concept of practical-technical knowledge are strictly connected and inseparable. In Descartes' view, the truth was no longer the truth of being which revealed itself (as in Galileo, where mathematical writing is the divine language) but was reduced to the certainty of human rational representation.

Thus, visual thinking was not replaced by calculating mathematical thinking, but Descartes transformed visual (geometric) mathematical thinking into calculatory

thought. Descartes's subordination of visual thinking to calculatory thought was needed to affirm a mechanist ontology and metaphysics of Nature.

8.3 From Descartes to Relativity and Quantum Physics

The transformation of science, of mathematics and physics, instigated by Descartes was lasting. However, visual thinking remained within science, in mathematics and physics, but at the subordinated level of graphic representation. More important is the role that visual thinking had in the creation of new theories, which were often related to new experiments but also to a new form of visual thinking.

The birth of non-Euclidean geometries led to a relativization of Descartes's analytic geometric representations, but more profoundly introduced a new form of visual spatial representation, which was related to a new understanding of physical phenomena (Poincaré 1902/1907).

In a paper presented at the *Circolo matematico di Palermo* on July 23, 1905 and then published on 1906, Poincaré introduced a quadridimensional (pseudo-)euclidean chrono-geometry, or a space–time for an electromagnetic mechanics. Poincaré developed mathematically the new relativistic dynamics published on June 5, 1905 (Poincaré 1905), based on electrodynamics and thus invariant by Lorentz transformations, which Poincaré himself corrected (Poincaré 1904–1905; Miller 1981, 80–81) and described as a rotation in four-dimensional space–time. He defined also the space–time interval as an invariant quantity:

> Regardons $x, y, z, t(-1)^{1/2}$... comme le cordonnées de trois points P, P', P'', dans l'espace à quatre dimensions. Nous voyons que la trasformation de Lorentz n'est qu'une rotation de cet espace autour de l'origine, regardée comme fixe. Nous n'aurons donc pas d'autres invariants distincts que les six distances.... $x^2 + y^2 + z^2 - t^2$ (Poincaré 1906, § 9, 168–169).

It was not a pure, formal, mathematical change of geometry. Space–time was needed to describe physical reality in terms of the electromagnetic field of light, which was constituted by waves as functions of space and time $f(x, y, z, t)$ that cannot exist at rest in a pure space: a fourth dimension was required by an electromagnetic conception of Nature (the electron was considered in terms of the electromagnetic field), where the electromagnetic field is the fundamental, immaterial, physical reality. Light's velocity as a unity expresses the identity of the space of light and time: time is the space of light, and the space of light is time.

Poincaré's new visual thinking transformed the representation of physical phenomena, replacing geometry with a four-dimensional chrono-geometry (Poincaré 1906, 129–175; Giannetto 1995, 365–433). This new visual thinking allowed for an understanding of physical reality as an electromagnetic field, and electromagnetic waves as functions of space and the time necessary for their representation because they never exist at rest.

This new visual thinking was related to the ontology of the electromagnetic conception of Nature, which was in some ways continued by Hermann Minkowski (1864–1909).

In a lecture delivered on 5 November 1907, Hermann Minkowski declared that he took up Poincaré's ideas on four-dimensional space–time, but unfortunately the text was published only in 1915, and this important source of Minkowski's work on space–time was not recognized, scholars instead considering the 1908 paper on *Raum und Zeit* as his first published work on the subject. But here Minkowski further clarified, mathematically and conceptually, Poincaré's vision of a world of light that was eternal and absolute in time and space (Minkowski 1907/1915; 1908/1909).

Albert Einstein (1879–1955) also continued this new visual thinking after 1907, following Minkowski's elaboration on Poincaré and creating general relativity on a four-dimensional pseudo-Riemannian chrono-geometry (Einstein 1905, 1915, 1916; Giannetto 2006, 107–137). Here, space–time itself is also constituted by an invisible sea of gravitational waves or by the cosmic microwave background radiation (CMB) which can never be at rest.

Thus, visual thinking, subordinated within a given mechanist physical theory, constituted the way to a new physical theory and to a new non-mechanist physical (field) ontology. With the special and general relativity theories and the four-dimensional representation of space–time came the externalization of the internal dimension of time into a new graphic representation, which led not only to a new temporal ontology of physical reality but also to a new temporal understanding of human self-consciousness (Whitehead 1920; Giannetto 2005, 2010). Henry Poincaré's work on non-Euclidean geometries and on the fourth dimension opened a new way to visual arts (Darlymple Henderson 2014).

When experiments led to exploration of the microscopic world of atoms and subatomic particles and to quantum physics, there was need for a new kind of imagination to make visible the invisible world (Giannetto 2018a, b, 2019, 179–197).

Heisenberg's mechanics (Heisenberg 1925) originated with the ascertainment of what is effectively observable and, therefore, can only be considered real: Heisenberg had noticed that in atomic and microphysical phenomena it was possible to observe only the frequency and intensity of the electromagnetic radiation emitted or absorbed by an electron when changing its atomic energy state. Consequently, all mechanical quantities at the atomic level are unobservable and have no physical sense; only electromagnetic quantities are observable and have a physical sense. As a result, kinematics and mechanics must not be considered fundamental physical disciplines, but rather should be re-founded, based on the theory of electromagnetism. Likewise, all mechanical quantities would become problematic for what concerns their effective operative definitions; physical reality is just the electromagnetic field in some of its observable properties. This radical perspective marked the end of the mechanistic concept of Nature and the emergence, following Poincaré's relativity, of the electromagnetic conception of Nature which begins at a microphysical atomic level and at experimental gnoseology/ontology level.

As is well known, there was a discretization of space and time (and of other physical variables) until to the more recent quantization of space–time turned physics and

science upside down. The "matrix mechanics" of Heisenberg, Born and Jordan (Born and Jordan 1925; Born et al. 1926) represented an even more extreme "epistemological fracture" with previous physical theories in its discrete mathematical language, its radical concept of physical theory regarding practical experimentation, and with what appeared—even in 1927—as its intrinsic indeterministic scope (Heisenberg 1927).

Instead, Schrödinger's "wave mechanics" (Schrödinger 1926) was meant to restore the easily intuitable, visualizable nature of a continuous physical reality, describable in space–time terms, albeit in terms of particles—"atoms," to be considered as material waves. However, Schrödinger's wave mechanics lead to a new kind of visualizable configuration space.

Pauli's interpretation of Schrödinger (Pauli 1952) is instead based on very particular assumptions, linked to the ancient and medieval theory of the "correspondentia" between microcosm and macrocosm, to the idea of the unconscious and mythical roots of the creative imagination of scientific theories, in short to a cultural perspective—elaborated especially through dialogue with Carl Gustav Jung (Jung and Pauli 1952)—which identifies quantum mechanics as a "new alchemy," a new language that, in a unified way, allows us to overcome the division between "natural sciences" and "spiritual sciences."

Furthermore, suddenly a new quantum mathematics and a new quantum logic were needed (Finkelstein 1969, 199–215; Giannetto 2018a, b, 443–469). John Archibald Wheeler introduced a new kind of graphic representation of what he called super-geometro-dynamics (Wheeler 1957, 604–614, 1968, 242–307). Even in this case, the new visual thinking was not subordinated to calculatory thought. Wheeler's work constituted the path toward a new understanding of things. It led to a completely new mathematical creative imagination for understanding Nature, to a new cosmology with a new gnoseology (implying a super-logo-dynamics), and to a new ontology of physical reality and of mankind (Giannetto 1990, 404–405, 2010).

References

Bailey, James. 1996. *After thought*. New York: Harper Collins.
Born, Max & Jordan, Pascual. 1925. Zür Quantenmechanik I. *Zeitschrift für Physik* 34: 858.
Born, Max, Heisenberg, Werner & Jordan, Pascual. 1926. Zür Quantenmechanik II. *Zeitschrift für Physik* 35: 557–615.
Calogero, Guido. 1960. *Lezioni di Filosofia I-II-III: Logica-Etica-Estetica. Vol. I, Logica*. Torino: Einaudi.
Calogero, Guido. 1968. *I fondamenti della logica aristotelica* (Firenze: Le Monnier, 1927, second edition, Firenze: La Nuova Italia 1968).
Calogero, Guido. 2012. *Storia della logica antica*. Pisa: ETS.
Darlymple Henderson, Linda. 2014. *The fourth dimension and non-Euclidean geometry in modern art*. Princeton: Princeton University Press.
de Santillana, Giorgio. 1956. *The age of adventure. The Renaissance philosophers*. New York: The New American Library.

de Santillana, Giorgio. 1968. Prologue to Parmenides, lectures in memory of Luise Taft Semple. In *Reflections on men and ideas*, ed. Giorgio de Santillana, 82–119. Cambridge, Mass.: MIT Press.

Descartes, René. 1897–1913. *Discours de la méthode pour bien conduire sa raison et chercher la vérité dans les sciences. Plus la Dioptrique, les Météores et la Géométrie, qui sont des essais de cette Méthode*. In *Oeuvres de Descartes I-XIII*, ed. C. Adam and P. Tannery. Paris: Adam.

Einstein, Albert. 1905. Zur Elektrodynamik bewegter Körper. *Annalen der Physik* 17: 891–921.

Einstein, Albert. 1915. Die Feldgleichungen der Gravitation. *Königlich Preussische Akademie der Wissenschaften (Berlin), Sitzungsberichte, 25 November 1915*: 844–847.

Einstein, Albert. 1916. Die Grundlagen der allgemeinen Relativitätstheorie. *Annalen der Physik*, Leipzig: Barth, ser. 4, 49 n. 7: 769–822.

Finkelstein, David. 1969. Matter space and logic. In *Boston studies in the philosophy of science*, ed. David Finkelstein, 99–215. New York: Humanities Press.

Giannetto, Enrico. 1990. Toward a physical superlogodynamics. Logic Colloquium '88. Padova: *Journal of Symbolic Logic* 55, 404–405.

Giannetto, Enrico. 1995. Henri Poincaré and the rise of special relativity. *Hadronic Journal Supplement* 10: 365–433.

Giannetto, Enrico. 2001. Pauli, Jung and quantum unconscious. *Teorie e Modelli VI*: 103–115.

Giannetto, Enrico. 2005. *Saggi di storie del pensiero scientifico*. Bergamo: Bergamo University Press.

Giannetto, Enrico. 2006. Da Bruno ad Einstein. *Nuova Civiltà delle Macchine* 24 (3): 107–137.

Giannetto, Enrico. 2010. *Un fisico delle origini. Heidegger, la scienza e la Natura*. Roma: Donzelli.

Giannetto, Enrico. 2012. Galileo, modern science and the principle of inertia. *Galilaeana* IX: 137–151.

Giannetto, Enrico. 2013. Notes for a metamorphosis. *Society and Animals* 21 (1): 75–89.

Giannetto, Enrico. 2017a. Maurice Clavelin, Galilée, cosmologie et science du mouvement. *Isis* 108 (2): 423–424.

Giannetto, Enrico. 2017b. Some remarks on Galileo and atomism. *Galilaeana* XIV: 21–38.

Giannetto, Enrico. 2018a. Pascal's physics, mathematics and cosmology. *Physis* 53: 95–110.

Giannetto, Enrico. 2018b. *Sguardi sul pensiero contemporaneo. Filosofia e scienze per cambiare il mondo*. Limena (PD): libreriauniversitaria.it.

Giannetto, Enrico. 2019. Something is rotten in the state of Denmark: Søren Kierkegaard, Niels Bohr e la nascita della fisica quantistica. *Altre Modernità* 22 (9): 179–197. https://riviste.unimi.it/index.php/AMonline/article/view/12152/11361. Accessed 21 July 2020.

Heisenberg, Werner. 1925. Über quantentheoretische Umdeutung kinematischer und mechanischer Beziehungen. *Zeitschrift für Physik* 33: 879–893.

Heisenberg, Werner. 1927. Über den anschaulichen Inhalt der quantentheoretischen Kinematik und Mechanik. *Zeitschrift für Physik* 43: 172–198.

Heidegger, Martin. 1961. *Nietzsche*. Pfullingen: Neske.

Heidegger, Martin. 1962. *Die Frage nach dem Ding. Zu Kants Lehre von den transzendentalen Grundsätzen*. Tübingen: Niemeyer.

Heidegger, Martin. 1975. Die Grundprobleme der Phänomenologie. In *Gesamtausgabe*, vol. 24, 108–139. Frankfurt am Main: Klostermann.

Heidegger, Martin. 2003. Die Zeit des Weltbildes. In *Holzwege*, ed. Friedrich-Wilhelm von Hermann. Frankfurt am Main: Klostermann.

Jung, Carl Gustav, Pauli, Wolfgang.1952. *Naturerklärung und Psyche*. Zurich: Rascher Verlag.

Koyré, Alexandre. 1957. *From the closed world to the infinite universe*. Baltimore: The John Hopkins Press.

Leroi-Gourhan, André. 1964–1965. *Le geste et la parole: I. Technique et langage; II. La mémoire et les rythmes*. Paris: A. Michel.

Minkowski, Hermann. 1909. Lecture delivered before the Versammlung Deutscher Naturforscher und Ärzte, Cologne, September 21, 1908. *Raum und Zeit, Physikalische Zeitschrift*, 10: 104–111.

Minkowski, Hermann. 1915. Das Relativitätsprinzip. Lecture delivered on 5 November 1907. *Annalen Der Physik* IV (47): 927–938.

Miller, Arthur I. 1981. *Albert Einstein's special theory of relativity: emergence (1905) and early interpretation (1905–1911)*. Reading, Mass.: Addison-Wesley.

Nicholson, Marjorie Hope. 1960. *The breaking of the circle: Studies in the effect of the "new science" upon seventeenth-century poetry*. New York: Columbia University Press.

Pauli, Wolfgang. 1952. Der Einfluss archetypischer Vorstellungen auf die Bildung naturwissenschaftlicher Theorien bei Kepler. In *Naturerklärung und Psyche*, ed. C.G. Jung and Wolfgang Pauli, 119–190. Zürich: Rascher Verlag.

Poincaré, Henry. 1906. Sur la dynamique de l'électron. *Rendiconti del Circolo Matematico di Palermo* 21: 129–175.

Poincaré, Henry. 1902, 1907. *La science et l'hypothèse*. Paris: Flammarion.

Poincaré, Henry. 1904–1905. Letter of Poincaré to Lorentz. In Arthur I. Miller. (1981). *Albert Einstein's special theory of relativity: emergence (1905) and early interpretation (1905–1911)* (Vol. 4679). Reading, MA: Addison-Wesley. 80–81.

Poincaré, Henry. 1905. Sur la dynamique de l'électron. *Comptes Rendus de l'Académie des Sciences*, 5 June 140:1504–1508.

Schrödinger, Erwin. 1926. Quantisierung als Eigenwertproblem, I, II, III, IV. *Annalen der Physik* 79: 361–376, 489–527, 80: 437–490, 81: 109–139.

Schrödinger, Erwin. 1926. Der stetige Übergang von der Micro- zur Macromechanik. *Naturwissenschaften* 14: 664–666.

Wheeler, John Archibald. 1957. On the nature of quantum geometrodynamics. *Annals of Physics* 2: 604–614.

Wheeler, John Archibald. 1968. Superspace and the nature of quantum geometrodynamics. In *Battelle rencontres: 1967 lectures in mathematics and physics*, ed. B.S. De Witt and J.A. Wheeler, 242–307. New York: Benjamin.

Whitehead, Alfred North. 1920. *The concept of nature*. Cambridge: Cambridge University Press.

Enrico Giannetto graduated at the University of Padova in elementary particle theoretical physics, and then he studied early universe cosmology at the ISAS of Trieste. He studied history of science at the *Domus Galilaeana* in Pisa, and obtained his doctorate in theoretical physics of condensed matter at the University of Messina. He has been working as researcher for ten years at the University of Pavia within the History of Science & Science Education Group. There, he taught in particular 'General Physics.' Since 2001 he is full professor of History of Physics and History of Science at the University of Bergamo, Italy. Here, he has been teaching many disciplines from 'History of Scientific Thinking' to 'Theoretical Philosophy,' 'Epistemology of Complexity,' and 'Physics.' His researches are focused on a perspective of a wide history of cultures where mythology, history of religions, anthropology, philosophy, human and natural science are entangled. In particular, he worked on the following disciplines: quantum chromodynamics, quantum electrodynamics, early universe quantum cosmology, phase transitions in cosmology and condensed matter, special and general relativity, foundations of quantum mechanics, quantum logic; history of quantum physics, of relativity, of chaos physics, of elementary particle physics, of mediaeval physics, of romantic natural philosophy, of the scientific revolution and of theoretical physics, history of psychology versus physics, science education, hermeneutics, philosophy of dialogue, anthropology of scientific thinking, and history of primeval Christianity. He has published more than 200 scientific papers and four major books: Saggi di Storie del Pensiero Scientifico, Bergamo University Press, Bergamo 2005; *Il vangelo di Giuda— traduzione dal copto e commento*, Medusa, Milano 2006; *Un fisico delle origini. Heidegger, la scienza e la Natura*, Donzelli, Roma 2010; *Sguardi sul pensiero contemporaneo. Filosofia e scienze per cambiare il mondo*, libreriauniversitaria.it, Limena (PD) 2018.

Part III
Exploration

Chapter 9
Science, Photography, and Objectivity? Exploring Nineteenth-Century Visual Cultures through the HMS *Challenger* Expedition (1872–1876)

Stephanie L. Hood

Abstract Preparing to set off from England in 1872 on an oceanographic expedition around the globe, the officers and crew of HMS *Challenger* gathered on board the ship for a photographic portrait. It was one of the first photographs of crew on a scientific voyage of exploration ever taken. Over eight hundred photographs were taken or acquired on the *Challenger* in addition to drawings and paintings. This chapter uses these photographs to reexamine Daston and Galison's theory that photography was successful in nineteenth-century science on account of its perceived "objectivity" as an epistemic ideal. The chapter first outlines the history and historiography of photography and of the *Challenger* expedition, proceeding to outline photographic practices on the voyage, and evaluating the photographs' place within longer aesthetic traditions. It then examines the *Challenger* photographs' circulation and use in its official scientific report, and in wider scientific contexts. The chapter finally analyzes the photographs' personal, and then broader public, economic, and political circulation and uses. It concludes by arguing that drawing and painting were the preferred scientific visual strategies on the *Challenger*, indicating that photography was not preferred on account of its perceived "objectivity" for science. Instead, photographs afforded other benefits such as speed of capture, replicability, and adaptability—for economic, social, and political use as well as scientific. Photography was therefore an effective visual strategy not on account of its perceived scientific "objectivity" but due to its *flexibility*, which corresponded to the expedition's scientific aims as well as its broader economic, social, and political context.

Keywords Objectivity · Visual culture · Photography · Global exploration · Nineteenth-century science

S. L. Hood (✉)
Max Planck Institute for the History of Science, Berlin, Germany
e-mail: shood@mpiwg-berlin.mpg.de

© The Author(s) 2023
M. Valleriani et al. (eds.), *Scientific Visual Representations in History*,
https://doi.org/10.1007/978-3-031-11317-8_9

9.1 A Short History of the *Challenger* Expedition, Photography, and Their Historiographies

9.1.1 History and Historiography of the Challenger Expedition

As the first ship known to be specifically adapted for global oceanographic investigation, the HMS *Challenger* undertook her 69,000-nautical mile circumnavigation of the globe between December 1872 and May 1876. Commissioned and sponsored by the British government and the Royal Society (Britain's organization for scientific research), the ship carried both naval and civil scientific crew, including Royal Navy Officer and explorer Captain George Strong Nares (1831–1915) and a Director of Scientific Staff, the natural historian and marine zoologist Charles Wyville Thomson (1830–1882). The expedition's scientific objectives, as outlined by the Royal Society, were clear: to research the biological, physical, and chemical constitutions of the ocean. The ship was equipped especially for purpose, comprising the chemical and zoological laboratories, workrooms, libraries, archival resources, and measuring devices requisite for oceanographic research (Brunton 2004, 1–15). It is therefore unsurprising that the historiography of the *Challenger* voyage has focused upon its scientific purposes and achievements. Accounts by historians Richard Corfield, Erika Jones, Eric Linklater, Helen Rozwadowski, and Maurice Yonge have outlined the importance of the expedition for scientific research, with Rozwadowski in particular emphasizing how the *Challenger* signified a shift from the "romantic" voyages reminiscent of those of James Cook to "business-like" scientific exploration (Linklater 1972; Yonge 1972; Corfield 2003; Rozwadowski 2009, 27–61, 106–216; Jones 2019). Although voyages of exploration were common in the nineteenth century, the *Challenger* generated significant interest: regular updates were published in both scientific circles and public press during the expedition, and afterwards in the official scientific *Report,* receiving considerable public and scientific attention (Tizard et al. 1885, 47–48; Linklater 1972, 12; Corfield 2003, 4–5; Kennedy 2007).

9.1.2 Visual Culture on the Challenger Expedition

Visual depiction had long been a common practice on such voyages of exploration, with drawing and painting serving for scientific, artistic, and other documentary purposes (Jacobs 1995; Smith 1992, 1985; Quilley 2011). Drawing and painting was likewise an integral practice on the *Challenger* expedition—but in addition over eight hundred photographs were accumulated, including the first known to exist of Antarctic icebergs (Headland 1989, 107). Other photographs in the expedition's unique collection depict the voyagers aboard the ship with indigenous peoples and

in vast landscapes, as individual portraits and amongst groups of people; vegetation, modes of transport, various forms of architecture, geology, tombstones, and copies of graphs and drawings also featured. Historian Eileen Brunton made significant progress in cataloguing the photographs, identifying the names of the photographers and inferring their purpose to have been as anthropological evidence and as economic commodities (Brunton 2004, 1–20). Rosamunde Codling has claimed photographs of icebergs made on the *Challenger* expedition were seen as an "accurate reproduction" of their subjects, while James Ryan has described the photographs' "unique appeal" in comparison to other forms of visual depiction to "serve the sciences of anthropology, geography, geology, and botany," nevertheless noting that many of them are more comparable to tourist souvenirs than scientific evidence (Codling 1997, 206; Ryan 2013, 33–35, 116–117). Aside from these historiographies, the visual culture of the *Challenger*, and in particular its photographs and photographic practices, have evaded in-depth historical research until now.

9.1.3 Objectivity? The Historiography of Nineteenth-Century Photography and Science

Photography was a popular visual strategy in scientific research in the latter half of the nineteenth century, and photographic practices in science more generally during this time period have received greater historiographical attention. Photography was fundamentally perceived as an empirical, objective means of recording the world in the years of the *Challenger* voyage: a photographic manual published during the expedition claimed that "a painting or watercolor can never have such rigorous precision" in comparison (Tissandier 1876, 302). A common historiographical theme is therefore that of photography's perceived "objectivity" in science, supposedly achieved through its ability to overcome the subjectivity of human observation, and that represented a shift from the preceding aesthetic and representational traditions seen in drawing and painting. One example of such historiography is that of Lorraine Daston and Peter Galison, who argue—using atlases as a case study—that photography was applied in nineteenth-century science owing to this supposed ability to combat "the subjectivity of scientific and aesthetic judgment" (Daston and Galison 2007, 82). Photography, Daston and Galison argue, was perceived as a tool that enabled one to achieve "mechanical objectivity" in scientific image-making that, when undertaken by a trained "ideal character," would "move nature to the page through a strict protocol, if not automatically" (Daston and Galison 2007, 121). This mechanical objectivity stood in contrast with the earlier visual "ideal" or "truth-to-nature" illustrations produced by drawing and painting—which aimed to extract universal truths and depended upon the subjective judgment of its artist—and made photography particularly appealing as a visual strategy in nineteenth-century science (Daston and Galison 1992, 98).

Likewise, historians Kelley Wilder, Christopher Pinney, and Joan Schwartz have emphasized a nineteenth-century preference for photography in science owing to its perceived "objectivity." Schwartz, for example, has claimed that "photographs were embraced as a scientific and objective way of capturing the world" during the time period (Schwartz 2000, 7–23, 26, 33–34; Wilder 2009, 7; Pinney 2011, 15). Similarly, the visual and historical anthropologist Elizabeth Edwards has shown that photography was preferred over drawings as a means of obtaining objective images for racial "typing" of people in nineteenth-century anthropological science (Edwards 1990, 235–258). This historiographical trend gives additional weight to the idea that photography was successful on account of its reputation as an "objective" means of data collection and visual observation for science in the nineteenth century, which was preferred over "subjective" written accounts, drawings, and paintings (Davenport 1991, 59–75, 106–107; Schwartz 2000, 7–23, 33–34; Kennedy 2007; Wilder 2009, 7; Pinney 2011, 15).

9.1.4 Historiographical Divergence and Complexity

This historiographical norm has nevertheless not gone entirely undisputed. Some historians such as Jennifer Tucker argue that the idea is too simplistic, and that nineteenth-century scientists "did not…accept photographic evidence as unconditionally true" but viewed and interpreted photographs just as they did other scientific images (Tucker 1997, 378–381; 2005, 2–4). More closely connected to this chapter's theme, Ryan has also revealed the complexity of photography on voyages of exploration and argued that photographs were "essential to visualizing the romance as well as the science" of expeditions during this period (Ryan 2013, 19–21, 117, 170–171). Despite claiming that photography was successful in science on account of its supposed objectivity, Wilder too has emphasized how even photographs made as scientific evidence could also be used as art, consequently taking on different, subjective meanings and uses (Wilder 2009, 53). It is this complexity that this chapter seeks to further investigate in relation to the *Challenger* expedition: from here it therefore begins by evaluating the expedition's photographic collection and practices, and how it connects to this historiography.

9.2 Complexity: The *Challenger's* Photographic Practices and Collections

From the 1850s—not long after photography's invention by Louis Daguerre (1787–1851) and William Henry Fox Talbot (1800–1877) in 1839—photographic equipment became a standard tool for visual documentation on voyages of exploration (Wamsley and Barr 1996; Hannavy 2007; Ryan 2013, 8–13). The *Challenger* expedition was

no exception to this development: the ship adopted photography as a visual strategy in addition to carrying an official artist, John James Wild (1824–1900), and benefited from its own on-board darkroom that was installed especially for the voyage (Brunton 2004, 16). It is not clear whether the *Challenger* expedition's photography followed a formal procedure—a discernible official protocol has not been found—but the need for "objectivity" in photography was not mentioned in any of the available reports by the crew. The expedition's photographic practices therefore demand further analysis.

9.2.1 Ideal Characters? The Several Photographers of the Challenger Expedition

At least three official photographers were employed on the *Challenger* voyage. The first, Caleb Newbold, joined at the start of the expedition in December 1872. A letter from his instructor in the *British Journal of Photography* stated that he had taken his photographic training with the Royal Engineers—a corps of the colonial-era British Armed Forces providing military engineering and technical support—for "some two-and-a-half years" (Abney 1873, 57). This indicates that some consideration had gone into placing the *Challenger* photography into trained hands.[1] Since photographers of the Royal Engineers were employed to generate a "collective record" of exploration rather than being independent creators of their work, the information on Newbold is unfortunately limited (Ryan 1997, 81). However, as a Royal Engineer, we *can* know that Newbold would have been trained for military and topographic surveying rather than necessarily for producing objective scientific evidence (Haworth-Booth 1984, 114). After Newbold deserted the ship in late 1873, Frederick Hodgeson replaced him until June 1874, from when there exists a gap—possibly occupied by an unnamed photographer—until Jesse Lay, another Royal Engineer photographer trained for military purposes, joined the expedition in 1875 and stayed for remainder of the voyage (Brunton 2004, 1–21).[2] The multiple photographers and the fact that

[1] See also (Haworth-Booth 1984, 114) regarding the training of photographers from 1855 by the Royal Engineers for the purpose of surveying; (Brunton 2004, 16–18) and the Quarterly ledger of HMS *Challenger*, 15 Nov. 1872–1831 Dec. 1873, Records of the Admiralty, Naval Forces, Royal Marines, Coastguard, and related bodies, National Archives, London, ADM 117/196, n.p.

[2] See also Captain Nares' log books regarding the names of photographers (George Nares' ship's log, 1873–1876, Records of the Admiralty, Naval Forces, Royal Marines, Coastguard, and related bodies, National Archives, London, ADM 53/10536, n.p.). In his journal, Lieutenant Pelham Aldrich wrote about the presence of a new photographer, Hodgeson, on board in December 1873 in accordance with these dates (Journal of Pelham Aldrich on HMS *Challenger*, 1873–1874, Foyle Reading Room, Royal Geographical Society, London, ar PEA/2, f.47r). The supposed existence of only one photographer at a time is however complicated by Aldrich and Balfour's journal descriptions of the presence of more than one on board in January and November 1873, whilst the official artist, Wild, himself inferred some involvement with the photographic process (Journal of Andrew Balfour from HMS *Challenger*, 1873–1874, Foyle Reading Room, Royal Geographical Society, London, mg ABA/1, n.p.; Diary of JJ Wild, 1872–1876, Natural History Museum Library and Archives, London, Murray Col. Section 1.7 (Volume 2), f. 74r.).

they were primarily trained for military purposes indicates that the scientific "ideal character" was not a priority in the photography of the expedition.

9.2.2 The Challenger's Diverse Photographic Methods

The various methods by which the *Challenger* photographs were made also uncover their limitations as "objective" scientific evidence. Its photographic practice was certainly taken seriously: as well as having its own darkroom, a notice in *The British Journal of Photography* claimed "a very complete photographic equipment" to have been purchased for the expedition (Abney 1873, 57). It has not been possible to confirm the camera type used by the official photographers, but a whole plate Dallmeyer wide-angle rectilinear lens was purchased eighteen months into the voyage.[3] This lens was popular for landscape photography, so it is likely that the official photographer chose lenses for certain purposes, using more than one lens type to suit the subject and conditions (Dallmeyer 1874, 59–62; Kingslake 1989). Both whole plates (6½" × 8½") and the more customary half plates (4½" × 5½") were used, enabling the production of different sized photographs.[4] Inventories from England, Hong Kong, and Japan also reveal the purchase of collodion filters that, together with the listing of a dark tent for portable developing, indicates that photographs were made using the wet collodion method standard for professional and amateur photographers from the mid-1850s onwards.[5] Wet collodion was also the most common photographic technique on voyages of exploration until the mid-1870s owing to its sharpness, durability, and speed in comparison to earlier daguerreotype and calotype photography, and due to the wider availability of its equipment compared to the newer dry plate method (Davenport 1991, 22; McGabe 1991, 41–45).

The *Challenger* expedition photography therefore represents a continuation of the photographic practices common on other voyages of exploration in the mid-nineteenth century (Davenport 1991, 22). The wet collodion method enabled a near-universal representation of a range of subjects and was popular in scientific imaging on account of its fine detail (Davenport 1991, 22; Ryan 1997, 25). But even this method required long exposure times and could be unreliable in the development process, often resulting in a rippling effect in the final photograph. On the *Challenger*

[3] Purchased from Hopkin and Williams on September 30, 1874 (Detailed account of scientific apparatus, chemicals, philosophical & mathl. instruments, drawing materials, stationery etc. etc. on board H.M.S. "Challenger" for the service of the scientific staff of the circum navigation expedition, 1872, Natural History Museum Library and Archives, London, Murray Col. Section 1, No. 49, n.p.).

[4] The negative size is evident in the glass negatives—which are whole plates—and in the purchase of half plates in the inventory, in addition to the original photographs which would have been developed in the same size as the plates and are of both half and full size (Detailed account of scientific apparatus 1872, n.p.; also through discussion and with thanks to Dr Michael Pritchard of the Royal Photographic Society). Photographs as measured in the Carpenter album (Photograph album of Alfred Carpenter 1872–1876, n.p.).

[5] Detailed account of scientific apparatus 1872, n.p.; (Brunton 2004, 19–20).

expedition this problem was even more severe than usual, as highlighted by Assistant Paymaster John Hynes' complaint in his journal that photographs taken of icebergs between Samboangan and Humboldt Bay were "not very good in consequence of the motion of the ship."[6] The naval crew members were not the only people on the *Challenger* to lament at the poor quality of its photography: on attempts to produce photographs as scientific evidence, Director of Scientific Staff Thomson complained that we were very anxious to carry away a permanent record of the present condition of…stalagmite, and we twice tried to photograph it with the magnesium light. On the first occasion the picture came out fairly, but, most unfortunately, in the darkness the difficulty of conducting such operations it was spoiled. When we tried it again, there was something wrong with the bath, and it was a complete failure (Thomson 1878, 34).

We can see ourselves that this was the case: a number of the *Challenger* photographs were blurred, smudged, and lacking lucidity.[7] Although Charles Wyville Thomson's statement indicates that the photographs were indeed *intended* for scientific use, the photographic process on the *Challenger* was clearly complex and prone to error, limiting its status as an objective visual strategy.

The story of photography on the *Challenger* is complicated further upon examination of two of the glass negatives from Lay's time on the voyage, which indicate that a second technique, the dry collodion method, was also used.[8] Dry plate technology was uncommon on voyages of exploration until the later 1870s owing to the lack of availability of apparatus as an early form of photographic technology (Wamsley and Barr 1996, 311–314; Ryan 2013, 13). However, it was more convenient for photographs taken at a distance from the ship compared to the wet collodion process, as it did not require developing immediately. Dry collodion photography also avoided the major disadvantage of wet collodion's requirement of a cumbersome traveling laboratory for instant developing, a constraint that greatly inconvenienced

[6] Journal of John Hynes on HMS *Challenger*, Dec. 1873–Mar. 1874, Caird Library, National Maritime Museum, London, JOD/15/1, f. 104r; Album two of Assistant Paymaster John Hynes 1872–1876, n.p.

[7] This poor quality can be seen in several photographs, such as the photo depicting "Natives in canoe" in Humboldt Bay, New Guinea (ship no. 344, in Journal two of Richard Routley Adams Richards on Board HMS *Challenger,* 1872–1876, Foyle Reading Room, Royal Geographical Society, London, RRR/2, n.p.). Photograph ship no. 390 also depicts people within a blurred landscape (in Photograph Album of Thomas Henry Tizard, 1873–1876, Historic Photographs and Ships Plans Collection, National Maritime Museum, London, ALB0859, n.p.). Wild was employed as both artist and private secretary to the Director of Scientific Staff, Dr. Charles Wyville Thomson, a dual role that was common of expedition artists (Codling 1997, 193; Rice and Bellamy 2000, 293).

[8] The glass negative for ship no. 436a, of Fuegian people, shows evidence of have been produced by the wet collodion method, including patterns of solution running down the plate, silvering around its edges, and grains fixed to the viscous wet collodion. Although it cannot be confirmed without detailed chemical analysis, the negative for photograph ship no. 439, a landscape of the Falkland Islands taken on the next stop of the voyage, lacks these features, suggesting it to have been produced using a dry plate process. Glass negatives from Natural History Museum Library and Archives, London, Murray Col., reference codes as per ship no. Established using McCabe, "Preservation of 19th-Century Negatives." With thanks to Dr Michael Pritchard of the Royal Photographic Society for advice.

the photographer when travelling long distances, in bad weather, or across awkward terrain (Davenport 1991, 22). The dry collodion method was certainly in use on the expedition: the renowned photographic supplier Henry Stuart-Wortley claimed in *Nature* and *The British Journal of Photography* to have supplied the photographers with apparatus for the dry plate method, and Lay claimed in a letter to Stuart-Wortley that he had "travelled up 2,500 feet (where the wet process seemed impossible) and obtained perfect negatives" using the dry plates (Stuart-Wortley 1875a, 25–26, b, 550–551). But while this method offered the benefit of convenience over wet collodion, it had the disadvantage of an average exposure time three times longer, leading it to produce even poorer quality and inaccurate images (Wamsley and Barr 1996, 309).[9] If "objectivity" required a "strict protocol" then these mixed practices indicate that photography was not being used on the expedition on account of such a benefit for its scientific research alone (Daston and Galison 1992, 118).

9.2.3 The Multiple Mediators and Sources of the Challenger Photographs

The *Challenger* photographs' multiple mediators and sources provide further evidence that their "objectivity" for scientific use was not a priority (Daston and Galison 2007, 121). Several people whom the crew encountered on land throughout the voyage requested photographs to be taken by the official photographer—for example, *Challenger* engineer William Spry declared in his book that the King and Queen of Tonga "expressed a wish during our stay to have their portraits taken. This was attended to, and for the occasion their Majesties were got up in regal attire" (Spry 1877, 184–185; Daston and Galison 1992, 103). The photographs that were taken appear to have been considered just as valuable as the others, as they were retained in the official expedition collection.[10] Around a quarter of the catalogued photographs were also purchased or received as gifts by the crew at several stages of the voyage, as opposed to having been taken by the on-board photographers. According to the letters of *Challenger* naturalist Rudolf von Willemoes-Suhm (1847–1875) some photographs were received in Hong Kong, and self-portraits were obtained from the Japanese Mikado and Mikadesse.[11] Spry also noted in his popular account of the expedition that a single photograph of a Buddha[12] was bought from a "priest in

[9] For further information about the wet collodion and dry plate processes, see (Davenport 1991, 22).

[10] The photographs can be attributed to ship nos. 247–248, originals in Album two of Assistant Paymaster John Hynes 1872–1876, n.p.

[11] Photographs' origins described by Rudolf von Willemoes-Suhm, *Challenger-Briefe* (Leipzig: Verlag von Wilhelm Engelmann, 1877, 172). These photographs are attributable to ship nos. 353 and 355 (originals in Album two of Assistant Paymaster John Hynes 1872–1876, n.p.).

[12] Brunton, *The Challenger Expedition,* photo no. 726 (original in Photograph album of Alfred Carpenter, 1872–1876, Natural History Museum Library and Archives, London, Murray Col. MSS CAR, n.p.).

attendance" at a temple in Japan, while Sub-lieutenant Andrew Francis Balfour, also onboard the ship, wrote in his journal that he had received photographs as gifts in Sydney, Australia from a local family and had bought others in Manila (Spry 1877, 294).[13] Other photographs in the collection were purchased from photographers in New Zealand, at least one of which can be attributed to William Thomas Locke Travers (1819–1903)—a local lawyer, politician, explorer, photographer, and naturalist.[14] Considering the multiplicity of the photographs—made by different people, in various ways, and collected from various sources—leads one to consider if they were even considered to be "scientific" images. How, for example, did they fit into wider aesthetic traditions?

9.3 Art or Science? Placing the *Challenger* Photographs within Longer Aesthetic Traditions

The nineteenth-century status of photography as an objective visual strategy has been taken to separate it from longer aesthetic traditions, such as the ideal, "truth-to-nature" representations achieved by drawing and painting (Daston and Galison 1992, 2007). Yet the *Challenger* photographs can be seen to represent such an "ideal," on account of the aesthetic selectivity as to what was chosen for inclusion, and as is evident in the photographs' broad range of content as described at the start of this chapter. Looking at how they fit within longer artistic conventions can therefore reveal more to us about the reasoning behind photography on the *Challenger.*

9.3.1 Aesthetic Selectivity and Naturalistic Visual Ordering

While Daston and Galison have claimed that the "objectivity" of photography was seen to *remove* artistry, arguing that the strategy was used for scientific evidence because those using it believed it "could and would triumph over art," the *Challenger* photographs display many traditions in art on voyages of exploration (Daston and Galison 1992, 98–100). Such images were able to gain authority not through their supposed "objectivity" but by *appealing* to artistic convention: the *Challenger* photographs continued the naturalistic visual ordering of the world that is commonly seen in the history of art on eighteenth and nineteenth-century voyages of exploration. Take, for example, the painting of eighteenth-century natural history artist Sydney Parkinson, *Portrait of a New Zealand Man* (1769), which has been credited

[13] Named 'the Alloways' (Journal of Andrew Balfour from HMS *Challenger* 1873–1874, n.p.).

[14] See also (Brunton 2004, ship nos. 243a, 313–315), which labels the photographers as a Mr Travers and Mr D.L. Mundy, respectively. For details relating to Travers see (Shepherd 2007; Willemoes-Suhm 1877, 108–109), specifically describing their acquisition from Mr Travers (originals in Album two of Assistant Paymaster John Hynes 1872–1876, n.p.).

with recording people with the "detachment of an anthropologist" as part of natural-
istic ethnographic conventions (Jacobs 1995, 84; Smith 1992, 83–85). Art historian
Michael Jacobs asserts that this painting portrayed people with little evidence of
displaying emotion—a tradition evoked in many of the front and profile portrait
Challenger photographs of indigenous peoples in the Pacific.[15] In this way the
photographs appealed to science through *following* naturalistic artistic conventions
rather than by evading them.

9.3.2 The Depiction of Character, Romanticism, and Adventure in Artistic Traditions

While much art from voyages of exploration had developed this naturalistic style of
depiction by the nineteenth century, it was inevitably influenced by the wider artistic
conventions of the era, and particularly by the Romantic movement (Jacobs 1995,
9–14). The eighteenth-century painter William Hodges, who traveled on expeditions
with James Cook, has been credited with sketching indigenous people not as detached
ethnographic "types," but showing pronounced expression and a sense of character
(Jacobs 1995, 88). This aesthetic theme can also be seen in a *Challenger* photo-
graph of a Moro Indian, which is set up to include props that hint at the personality
of the individual being represented (Fig. 9.1). In addition, by portraying extended
topographical scenes across several photographs, the *Challenger* also continued the
artistic tradition of the landscape panorama style that art historian Bernard Smith
claims emerged in the late eighteenth century (Smith 1985, 218).[16]

A considerable number of artworks made on voyages of exploration in the late
eighteenth and nineteenth-century were also influenced by a Romantic sense of
adventure, and were often produced to appeal to increasing British public interest in
travel (Jacobs 1995, 9–14, 80–90). Artists had long played important roles in famil-
iarizing the public with unknown places, none more so than in the Pacific (Jacobs
1995, 80). This theme is also apparent in many of the *Challenger* photographs: one
of the Pacific Island of Tonga depicts palm trees and people along a vast beach that
disappears into the distance (Fig. 9.2), evoking a William Hodges' 1773 painting
of the South Pacific, *View from Point Venus*. Although photographs were unable to
capture color, perspective, or depict light to enhance the romance of the scene—and
as a result *View from Point Venus* evokes the warm, tropical climate in a way that
the photograph arguably does not—the Romantic aesthetic is evident in both. In this
sense the *Challenger* photographs fit Ryan's assertion that photography was used to
capture the romantic as well as scientific features of exploration (Ryan 2013, 19–21).

[15] For example ship no. 435a in Album three of Assistant Paymaster John Hynes, 1872–1876,
Historic Photographs and Ships Plans Collection, National Maritime Museum, London, ALB0176,
n.p.

[16] Photographs in (Smith 1985) include ship nos. 267, 267a, 267b, 267c (originals in Album two
of Assistant Paymaster John Hynes 1872–1876, n.p.).

Fig. 9.1 Photograph of a Moro Indian (ship no. 339, original in Album three of Assistant Paymaster John Hynes 1872–1876, Historic Photographs and Ships Plans Collection, National Maritime Museum, London, ALB0176, n.p.)

This likelihood is raised further when comparing the photographs to Thomas Baines' watercolor *Herd of Buffaloes* at the Victoria Falls (1862), which depicts an unusual landscape and scenes of human interaction.[17] Such representation of both people and place is evident in a *Challenger* photograph of a village in the Admiralty Islands, in which a group of indigenous people dwells amongst palm

[17] *Herd of Buffaloes,* at The Victoria Falls, Zambezi River (1862) by John Thomas Baines (Foyle Reading Room, Royal Geographical Society, London, S0012338). See also analysis in (Butlin 2005, 19).

Fig. 9.2 Photograph of Beach, Tonga (ship no. 254, original in Album two of Assistant Paymaster John Hynes 1872–1876, Historic Photographs and Ships Plans collection, National Maritime Museum, London, ALB0175, n.p.)

trees outside their "exotic" home.[18] Also outside of the newly-experienced South Pacific, drawings and paintings often portrayed nature, according to Jacobs, "at her most strikingly unusual…with an overlay of metaphor, poetry and adventure" (Jacobs 1995, 153).[19] As the first known photographs of Antarctic icebergs, the *Challenger* therefore likewise captured visual scenes to create an impression of the unusual with a sense of romance, adventure, and excitement typical of aesthetic traditions on voyages of exploration (Fig. 9.3).[20]

[18] See e.g., Photograph of a Village, Admiralty Islands (ship no. 351, in Journal two of Richard Routley Adams Richards 1872–1876, n.p.).

[19] Specifically on icebergs see (Potter 2007, 3–13; Mifflin 2011).

[20] Photographs of icebergs include ship no. 179, the original of which can be found in Album two of Assistant Paymaster John Hynes 1872–1876 (Historic Photographs and Ships Plans Collection, National Maritime Museum, London, ALB0175, n.p).

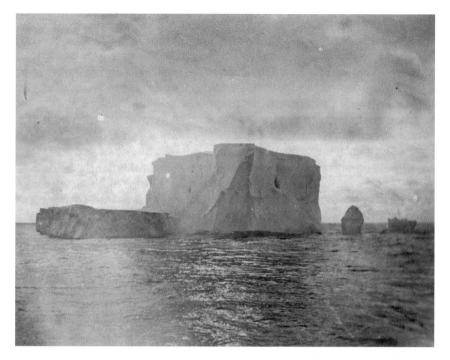

Fig. 9.3 Antarctic Icebergs (ship no. 178 in Album two of Assistant Paymaster John Hynes 1872–1876, Historic Photographs and Ships Plans Collection, National Maritime Museum, London, ALB0175, n.p.)

9.3.3 Aesthetics of Empire

In the context of nineteenth-century British imperialism, themes of Empire and trade were another common aesthetic in art in the eighteenth and nineteenth century (Barringer et al. 2007, 1–19; Quilley 2011). Such themes are also evident in the *Challenger* photographs: one of them, for example, shows indigenous peoples crossing the ocean in a canoe to trade with the inhabitants of a nearby island, inkeeping with a common aesthetic theme of exchange (Barringer et al. 2007, 1; Quilley 2011, 10). Other photographs appear to seek to express a sense of British imperial superiority, attempting to construct an image of a "civilized" crew amongst "primitive" indigenous people, which is another theme commonly seen in nineteenth-century expedition art in the context of Empire (Quilley 2011, 60).[21] The *Challenger* photographs furthermore represent such nineteenth–century themes as colonial possession by their depiction of churches and government buildings in the imperial Kingdom of Hawaii: the portrayal of colonial architecture was a particular theme in the paintings

[21] For example ship no. 349 in Album two of Assistant Paymaster John Hynes 1872–1876, n.p.

of eighteenth-century artist Edward Dayes (Quilley 2011, 10; McLean 2007).[22] In addition, and further complicating the story of these images, one *Challenger* photograph in Lieutenant Alfred Carpenter's album not only portrayed a fort in Tahiti but was also annotated with a description of the "wall defending mountain pass," suggesting this fact to be of some importance and perhaps connecting it to art or even Imperial military survey rather than objective scientific evidence.[23]

This is not to argue that every *Challenger* photograph represented subjects or scenes in a way that connects them to the wider history of art on voyages of exploration, nor is every aesthetic tradition manifest in the photographs. Despite following themes in the history of art, the lack of color, comparable quality of light, and patterns of brushstrokes in photographs separates them from longer aesthetics traditions, while some photographs—particularly face and profile portraits—do nevertheless appear more inkeeping with photography used as "objective" scientific evidence.[24] Yet for many of the photographs their status as evidence depended upon a debt to existing artistic conventions, inferring an epistemic authority as art rather than as "objective" visual scientific evidence. Such a paradox leads this chapter to ask: Were the photographs circulated and used scientifically, and if so, how? Can this reveal more about photography as a visual strategy on the *Challenger* expedition?

9.4 Scientific Circulation and Use: Photographs in the Official *Report of Scientific Results*

This chapter has already shown that the *Challenger* photographs were limited in their intention and ability to serve as "objective" scientific evidence, but it is nevertheless clear that a number of them were anticipated for scientific use from the outset. Minutes from a meeting of the Royal Society in the weeks before the expedition stated that "photographs or careful drawings of tropical vegetation often contain very interesting information, and should contain some reference to a scale of dimensions,"[25] while instructions added to the oceanographic objectives of the expedition stated that "Every opportunity should be taken of obtaining photographs of native races to one scale" for anthropological use (Brunton 2004, 15). These clear scientific intentions therefore warrant a further look at how the photographs were used in the

[22] Government buildings in Honolulu were taken as per ship no. 392 in Album three of Assistant Paymaster John Hynes 1872–1876, n.p. Churches are depicted in photo no. 842 in Photograph album of Alfred Carpenter 1872–1876, n.p.

[23] Ship no. 410 in Photograph album of Alfred Carpenter 1872–1876, n.p.

[24] For example, ship nos. 382 and 383 in Album three of Assistant Paymaster John Hynes 1872–1876, n.p.

[25] Unconfirmed minutes of the Royal Society, November 14, 1872. Library, Art and Archives, Royal Botanic Gardens Kew, London, JDH1/14/1, f. 5r.

Fig. 9.4 Front page of the *Narrative* to the *Official Report of Scientific Results* (Tizard et al. 1885. Narrative of the Cruise of H.M.S *Challenger* with a General Account of the Scientific Results of the Expedition. In *Report on the scientific results of the voyage of HMS 'Challenger' during the years 1873–1876*. London: Longmans and Co.)

official fifty-volume *Report of Scientific Results*, which was issued in the decades following the voyage, alongside its other visual strategies (Fig. 9.4).[26]

[26] The *Narrative* (1885) was written by *Challenger* Staff Commander Thomas Tizard and its scientific crew members Henry Nottidge Moseley, J.Y. Buchanan, and John Murray.

9.4.1 Photographic Plates and Woodcut Reproductions

As intended, some of *the Challenger* photographs went on to find scientific uses in the official *Report*. Thirty-five of them appeared as plates in its first volume, the *Narrative*: one of them, labeled as "Wood Scenery, Tonga," was used as a means of illustrating "plain evidence of the reduction of the population" of vegetation in the landscape on the Polynesian island (Tizard et al. 1885, 484, ship no. 257a). Others were used to exhibit the patterns of the *Pringlea antiscorbutica* (Kerguelen cabbage) and *Azorella selago* plant species on the Kerguelen Islands of Antarctica, a prominent site of scientific enquiry in the 1870s (Tizard et al. 1885, 299, 300, ship nos. 228a, 220).[27]

 In addition to these thirty-five plates, several of the *Challenger* photographs were also published in the *Narrative* as woodcut reproductions, such as those of *Carica papaya* trees (Fig. 9.5). There is no discernible reason as to why certain photographs were printed as plates and others as reproductions, but it might have been a result of the practical limitations posed by printing several plates, or more likely an issue of cost, since photographic plates were significantly more expensive to print than wood-cuts. In any case, once transformed into woodcut reproductions, *less* authority was afforded to photographs over drawings or paintings as scientific evidence (Daston and Galison 1992, 101). Rather than photography serving as "objective" visual evidence, therefore, this serves as further indication that it must have been used as a visual strategy for the expedition's scientific purposes owing to *other* advantages it had over drawing and painting.

9.4.2 Maintenance of Drawing Practices for Illustrating Scientific Specimens

This assertion is further supported by the fact that drawing, rather than photography, was maintained as a means of accurately illustrating specimens in the *Narrative*. Few of the *Challenger* photographs depicted individual flora or fauna, a preference for the authentic depiction of which was maintained through these drawings made by the on-board artist Wild and the scientific crew Willemoes-Suhm, Moseley, and Wyville Thomson. Many of these illustrations published in the *Narrative* were produced using a camera lucida in order to draw to scale and with accurate perspective, such as that of the crustacean *Polycheles crucifera*.[28] The camera lucida was listed separately from Wild's drawing and painting materials, suggesting that it was perceived as a scientific instrument for the crew to be able to draw in perspective rather than as

[27] See (Mills 2003, 345–346) regarding the importance of Kerguelen.

[28] Drawing by Willemoes-Suhm of "*Polycheles crucifera*…twice the natural size. From 450 fathoms, off Sombrero, West Indies" (Tizard et al. 1885, 523). The camera lucida was used as a means of creating traceable images of objects to achieve accurate perspective (Davenport 1991, xiii). See also *Detailed account of scientific apparatus* 1872, n.p.

Fig. 9.5 "Papaw trees (Carica papaya), in the Governor's garden at Clarence Hill." Reproduced from ship no. 69 of trees in Bermuda (Tizard et al., "Narrative of the Cruise," 147; original photograph in Photograph Album of Thomas Henry Tizard 1873–1876, Historic Photographs and Ships Plans Collection, National Maritime Museum, London, ALB0859, n.p.)

a purely artistic tool.[29] Wild also asserted the importance of his own drawings and paintings in "representing…accurately…the natural scenery," indicating that these images were intended for use as accurate scientific evidence (Wild 1878, 4). This theory that drawing was preferred as a scientific visual tool on the *Challenger* is supported further by letters written by Captain Thomson during the voyage, where he claimed that certain species were to be "described and illustrated under my direction," praising Wild to be "most expert in drawing animals."[30]

9.4.3 Depicting Color

A further, and perhaps more clearly discernible reason that drawings and paintings were prioritized over photographs as visual strategies for the scientific *Narrative* was that photography was unable to depict color in the mid-nineteenth century.

[29] *Detailed account of scientific apparatus* 1872, n.p.; (Brunton 2004, 16; Codling 1997, 193).

[30] Letter from C. Wyville Thomson to Ctn Evans, 8 Jan. 1875, Library, Art and Archives, Royal Botanic Gardens Kew, London, JDH1/14/2, ff.169–170r–v.

The volume contained color lithographs, including drawings of icebergs by Wild, accompanied by detailed descriptions such as "the colouring of the southern bergs is magnificent…with a slight bluish tint…On this ground color there are parallel streaks of cobalt blue, of various intensities," and "the colouring of the crevasses, caves, and hollows is of the deepest and purest azure possible," clearly written with the aim of invoking the richness of color in the landscapes (Tizard et al. 1885, 433; Codling 1997, 193). The *Challenger* photographs can therefore be argued to have possessed little to no epistemological authority over drawing and painting as visual strategies, which had the advantage of depicting color.

The ability to illustrate color was also important for the anthropological sections of the *Narrative* as well as those parts that described fauna and flora. This is evident foremost in the inclusion of Wild's colorful sketches of people in Tonga "to show the color of race" and of spears from the Admiralty Islands drawn to depict their "highly decorated" patterns.[31] Despite the rise of photography in nineteenth-century anthropology and "race science" (scientific racism) the omission of photographs appears not to have limited the scientific value that was attributed to the anthropological parts of the publication: a review of the *Narrative* in the prestigious journal *Science* claimed that "the ethnologist will find himself well rewarded for his study of its pages" (Anon 1885, 15–16). This further suggests that drawings were seen by those on the expedition, and by scientific authorities outside of it, to be just as valuable for science as photography.

9.4.4 The (In)accessibility of Landscapes

Drawings and paintings not only provided the benefit over photography of depicting color in the *Narrative:* a further advantage was that certain scenes and objects were more accessible to the artist than to the photographer. Paintings and drawings printed in the volume depicted flora, fauna, and sediments taken from under the ocean as part of the expedition—not only were these printed in color, but they depicted samples that were underwater and therefore could not have been photographed in their natural habitat (Tizard et al. 1885, 926). Such specimens would have required artistic agency to depict them as accurately as possible, as their appearance and context would have changed upon their removal from the sea. Photography was unable to capture the sediments *as if* they were in the ocean, while the creative agency employed in drawing and painting enabled such depiction. This provides a further argument as to why drawing and painting were maintained as a scientific visual strategy on the *Challenger*.

From their use as plates and woodcuts in the *Narrative* it is clear that the *Challenger's* photographs held a function as scientific evidence. But that many of them

[31] See "Various Dancing Costumes worn at Nakello, Fiji; a Tongan to show the color of the race" (Tizard et al. 1885, 503) and "Admiralty Islands. Unusually large and highly decorated obsidian bladed spears" (Tizard et al. 1885, 710).

were printed as reproductions tells us that objectivity was not a significant factor in their use—traditional visual strategies such as drawing and painting were retained for this purpose in order to depict scale and color, and to illustrate specimens that photography was unable to due to inaccessibility. Looking instead at the photographs' circulation and uses in the wider scientific community points to other reasons that photography was used on the expedition.

9.5 The Reproduction and Circulation of the *Challenger* Photographs within Wider Scientific Circles

As well as being published in the *Narrative,* the *Challenger* photographs reached other scientific publications in the 1870s as engravings and woodcut reproductions. Focusing upon their reproduction and circulation in these contexts reveals more about why photography was a successful visual strategy on the expedition.

9.5.1 Speedy Capture and Replication

The photographs' use in these wider scientific contexts firstly serves as further evidence that photography served to speedily capture and reproduce visuals for their circulation as scientific evidence both during and after the expedition.[32] In 1876, the journal *Nature* included woodcut reproductions of photographs from the *Challenger* of the botany of the Bermudas, in illustration of the gardens rich with tropical vegetation such as *Carica papaya* trees.[33] A number of the photographs were also reproduced as woodcuts in *Nature* to illustrate geological structures including a "Sand-glacier" in Bermuda and indigenous people amongst various landscapes and vegetation types.[34] This functional benefit of replicability is also evident in Charles Wyville Thomson's scientific publication *The Voyage of the Challenger,* which included reproductions of the same photograph of sand glaciers in Bermuda shortly after the expedition. Drawing and painting would not have enabled the quick and simple reproduction of an image for dissemination to more than one scientific publication: in this case, therefore, photography possessed a distinct advantage over other visual strategies.[35]

[32] See (Hamber 1990) regarding the common printing in newspapers of photographs as reproductions, since it was not possible to print them directly due to the technological limitations of the mid-nineteenth century.

[33] Reproduction of ship no. 64 in (Anon 1876, 97–99), original in Album two of Assistant Paymaster John Hynes 1872–1876, n.p.

[34] Ship no. 80 in (Anon 1876, 97–100); original in Photograph Album of Thomas Henry Tizard 1873–1876, n.p.

[35] Ship nos. 61, 80 in (Thomson 1878, 290–291); originals in Album one of Assistant Paymaster John Hynes, 1872–1876, Historic Photographs and Ships Plans Collection, National Maritime

This appeal of photography in reproducing visual scientific evidence was not limited only to their use in scientific publications, but in the ability to circulate such images amongst those in the wider scientific community during the expedition. Naturalist Willemoes-Suhm, for example, posted photographs from the expedition to zoologists in Europe for their scientific use, having acquired copies of them on board the ship (Willemoes-Suhm 1877, 27). Likewise naturalist Moseley, in a letter sent to fellow naturalist Joseph D. Hooker early on in the expedition, claimed "I will send you some [photographs] when I get them...Prof Thomson promised to give me a set for that purpose."[36] Moseley kept his word: the *Proceedings of the Linnean Society* stated that its President Joseph Hooker had in a lecture of 1875 "exhibited an extensive series of drawings and photographs taken during the 'Challenger' Expedition" whilst a "Professor Dyer, in illustration of Mr. Moseley's 'Notes on the Insects and Plants of Kerguelen,' called attention to a photograph showing the Kerguelen Cabbage (*Pringba antiscorbutica, Br.*) in different stages of growth" (Anon 1875b, v). No rationale was given for the use of both photographs and drawings, and it is not known if the drawings were those of Wild or one of the amateur artists or scientists on board the *Challenger*. But their use further demonstrates that photography was utilized due to its ability to quickly capture and reproduce scenes, which drawing was unable to do. This replicative capacity also enabled Willemoes-Suhm to post photographs home of indigenous people of the Philippines and Tonga on the account of their being "very anthropologically important" and thus to be kept for his later scientific study.[37]

9.5.2 Saving for Later: Photographs as Templates for Drawing and Painting

The *Challenger* expedition's photography also served as a speedy means of capturing and reproducing images for scientific use as *templates* from which to draw at a later date. One of Moseley's scientific publications on the inhabitants of the Admiralty Islands used a *Challenger* photograph from which to sketch people as anthropological illustrations (Moseley 1877). Yet another pencil-sketch drawing of a single person was unmistakably copied directly from a group portrait photograph taken on the voyage.[38] Whilst this drawing could have been made alongside the photographer

Museum, London, ALB0174, n.p., and in Photograph Album of Thomas Henry Tizard 1873–1876, n.p., respectively.

[36] Letter from Henry Moseley to Joseph Hooker, August 3 1873, Library, Art and Archives, Royal Botanic Gardens Kew, London, JDH1/14/1, f. 82r–v.

[37] Translated from German, "sind anthropologisch sehr wichtig" (Willemoes-Suhm, *Challenger-Briefe*, 111, 146–148: p. 146).

[38] Photograph of Admiralty Islanders in Photograph ship no. 348, original in Album two of Assistant Paymaster John Hynes 1872–1876, n.p. For the corresponding drawing see (Moseley 1877, pl. XIII).

taking the picture, the identical appearance of the drawing to the photograph—including the angle—and the obvious convenience of being able to capture scenes quickly to use as a template for producing scientific illustrations serves as further indication that the photograph was used for the artist to work with later, at a more convenient time or location. On this basis the appeal of photography for science on the expedition, over drawing and painting, can again be seen as its speed of capture and its replicability.

9.5.3 Photography as a Printing-Press-in-the-Field

Photography on the *Challenger* also functioned as a strategy for capturing, replicating, and disseminating drawings for various scientific publications, operating as what Ryan has defined as a "printing-press-in-the-field" (Ryan 1997, 79). This was a deliberate and regular practice on the *Challenger*: Willemoes-Suhm claimed in a letter to his mother "The artist Mr Wild has drawn the laboratory, which was then photographed, but I do not send it to you because it will soon be displayed in Thomson's letter to 'Nature.'"[39] Wild's drawing of *Euplectella subarea,* which was printed as a reproduction in *Nature* (Fig. 9.6), is identical to one of the *Challenger* photographs, further revealing the use of photography as a "printing-press" to be a functional benefit that was deliberately utilized on the voyage for replicating and circulating visual evidence for wider scientific use both during and after the expedition.

Although traditional means of visual depiction including drawing and painting were utilized for depiction of scale, perspective, color, and inaccessible specimens, by functioning as a speedy method of capturing and reproducing scenes for circulation, and as a "printing-press-in-the-field" for drawings, photography offered additional flexibility for the purposes of scientific evidence during and after the expedition. This leads this chapter to its next question: Did the purpose and success of photography on the *Challenger* even extend past both the "artistic" and "scientific"?

9.6 Personal Circulation and Use of the *Challenger* Photographs

The quick and simple replicability of photographs, as highlighted earlier in this chapter, provided not only scientific benefits: it also enabled multiple individual copies to be printed on board the *Challenger*. The photographs were distributed to crew members during the voyage for their personal use, as single copies at sixpence

[39] Translated from German: "Das Laboratorium hat der Artist Mr. Wild gezeichnet, und dasselbe ist dann photographiert worden; ich sende es Euch nicht, weil es demnächst in einem Briefe Thomsons in»Nature« abgebildet wird" (Willemoes-Suhm 1877, 21). Author's translation.

Fig. 9.6 A drawing by Wild of "Euplectella subarea" (Drawing in Anon, "The Cruise of the Challenger" 1876, 93–94. Corresponding to photograph ship no. 28, original in Album one of Assistant Paymaster John Hynes 1872–1876, Historic Photographs and Ships Plans Collection, National Maritime Museum, London, ALB0174, n.p.)

Fig. 9.7 Photograph of Captain Thomson with people from the Admiralty Islands (ship no. 349, original in Album two of Assistant Paymaster John Hynes 1872–1876, Historic Photographs and Ships Plans Collection, National Maritime Museum, London, ALB0175, n.p.)

each, or one shilling for a second copy.[40] Schwartz has detailed how photographs were used in the nineteenth-century as a means of narration, personal memory, and for sharing experiences with friends and family, which is also something that we see in these photos collected on the *Challenger* expedition (Schwartz 2000, 19–21). Narrative accounts in the crew's journals correlate with much of the photographic content, the range of subjects of the photographs revealing a chronological visual representation of the expedition. A photograph of Captain Thomson with people of the Admiralty Islands (Fig. 9.7) can be viewed in this way since its composition provides limited basis for comparative anthropological analysis, instead appearing more to be a narrative or novelty photograph. That Willemoes-Suhm sent home photographs of Malaysian huts and people to narrate his experiences to his family also demonstrates their wider subjective interpretation and function as personal souvenirs from the expedition, in addition to highlighting their advantage of replicability for wider circulation.[41]

[40] Letter from Henry Moseley to Joseph Hooker 3 Aug. 1873, f. 82rv. See (Brunton 2004, 15).

[41] For example on staying with indigenous people in the Malaysian Archipelago, describing staying in a 'camp' in the forest, at the foot of a small hill, where mats were spread out among huge palm leaves (Willemoes-Suhm 1877, 108–177).

9.6.1 Personal Albums and Journals

A number of the *Challenger* photographs were used in the personal albums and jour-
nals of several of both the naval and civilian scientific staff, including those of botanist
Moseley, naturalist Willemoes-Suhm, chemist Buchanan, assistant paymaster John
Hynes, Navigating Lieutenant Tizard, ship carpenter Robert Higham, and Lieutenant
Carpenter. Many of the photographs also appear in more than one of the albums, again
demonstrating the advantage of replicability that made photography such a successful
visual strategy on the *Challenger* expedition. In these albums the photographs were
also flexible enough to take on a multitude of meanings and uses: the personal use of
the *Challenger* photographs was varied in these albums and journals, and included
those purchased or received as gifts as well as those taken by the official expedition
photographers.[42] Some front-and-profile portraits were used specifically to describe
"types" of male and female indigenous people from and anthropological perspec-
tive, as can be seen in the album of Lieutenant Carpenter (Willemoes-Suhm 1877,
146–148).[43] In others they were used more decoratively, as in the album of Hynes,
which combined front and profile portraits of Hawaiian and Japanese people at right
angles to each other with no clear intention of anthropological comparison.[44] The
photographs therefore took on a range of subjective meanings and interpretations
once circulating for the personal use of those on board the expedition.

These case studies tell us that the *Challenger* photographs were manifestly valued
as flexible material objects that were capable of multiple uses and interpretations. A
recently-discovered photograph album and seven journals incorporating photographs
belonging to expedition Paymaster Richard Routley Adams Richards—including
new photographs not yet incorporated into the Brunton catalogue—reveal yet more
about their use.[45] In Richards' album and journals the *Challenger* photographs did
not necessarily replace other forms of visualization when it came to creating personal
narratives of the expedition, but were used alongside drawings, paintings, and other
visual items such as train timetables and tickets. The photographs were enclosed
alongside annotations and written accounts as a means of illustrating a narrative of
the expedition, and spanned a range of themes including people, landscapes and
vegetation, Chinese architecture, and hieroglyphics on wood—indicating how the

[42] (Brunton 2004) has catalogued the albums, and further details can be found on pages 1–23. The
photographs in these personal albums and journals do not display the government copyright stamp
added after the expedition, indicating them to have been acquired during the voyage.

[43] Photograph album of Alfred Carpenter 1872–1876, n.p.

[44] Album three of Assistant Paymaster John Hynes 1872–1876, n.p.

[45] A photograph album belonging Bromley is also omitted from the Brunton catalogue, but its
content and whereabouts are unknown (Logbooks, photographs and microscope slides kept by
Bromley during Challenger's voyage, 1872–1876, Natural History Museum Library and Archives,
London, Murray Col. MSS Bro 1, n.p.). For Richards photographs, see Journals 1–7 of Richard
Routley Adams Richards on Board HMS *Challenger,* 1872–1876, Foyle Reading Room, Royal
Geographical Society, London, RRR/1–7 and Photograph Album of Richard Routley Adams
Richards, 1872–1876, Foyle Reading Room, Royal Geographical Society, London, RRR/8.

photographs could be used in varied ways depending on the person's preferences, memories, and creative agency.

Richards also included in his album a photograph of one of Wild's drawings of icebergs.[46] Other photographs of artist Wild's drawings, such as that of *Euplectella subarea* (discussed earlier in this chapter) were included too in Hynes' personal album.[47] For personal albums too the function of the *Challenger's* photography as a "printing-press-in-the-field" is evident as a benefit over drawing and painting that made it a worthwhile and successful visual strategy on the expedition. Looking at these personal albums and correspondences therefore shows us how the success of the *Challenger's* photographic practice can be attributed to the flexibility of photography and of the photographs themselves. Considering the even wider scientific, social, political, and economic context of the expedition in the next and final part of this chapter provides further insights into photographic strategies on the *Challenger* as well as their connections to each other.

9.7 Complex Interplays: The *Challenger*, Science, and Society

The photographs from the *Challenger* found themselves circulating even more widely than these personal and scientific circles, both during and after the voyage. This should come as no surprise: the use of photographs for public communication, education, and entertainment—in newspaper articles, popular accounts, public lantern shows, and museum exhibitions—was a common practice in Britain at the time of the voyage. Correspondingly, looking closely at photographic practices on the *Challenger* expedition begins to uncover a complex interplay between science, economy, imperial politics, and public communication—also revealing how science itself was embedded in its wider social contexts in the nineteenth century, and that "objectivity" was not necessarily the sole aim even of its scientific photography (Corbey 1993; Schwartz 1996, 33; Maxwell 2000, 27; Ryan 2013, 12–13).

9.7.1 Photography as a Printing Press for Public Communication

During the expedition, photography served as a "printing press" with which to replicate and disseminate drawings and paintings not only for private and scientific use but also into the British public sphere. The *Illustrated London News* is an example of

[46] *New Photograph of a Drawing of Antarctic Icebergs*, with the Signature of J.J. Wild (in Photograph Album of Richard Routley Adams Richards 1872–1876, n.p.).

[47] For example ship no. 28 in Album one of Assistant Paymaster John Hynes 1872–1876, n.p.

Fig. 9.8 "The Challenger at St. Paul's Rocks," in the *Illustrated London News* (ship no. 136, original in Album one of Assistant Paymaster John Hynes 1872–1876, Historic Photographs and Ships Plans Collection, National Maritime Museum, London, ALB0174, n.p.)

a national news outlet that published drawings accompanying accounts of the *Challenger* expedition throughout its voyage. One of these drawings was produced from a photograph taken of a sketch by Wild that depicted the ship at St. Paul's Rocks—part of the Atlantic's Saint Peter and Saint Paul Archipelago—in 1873 (Anon 1873, 412–414) (Fig. 9.8).[48] Another woodcut image of the ship amongst rocks at Christmas Island, Kerguelen harbor in 1874 was also printed in the newspaper, having been replicated through photography on the voyage—these are only two examples of the photographs' multiple uses and formats (Anon 1874, 505). The image of St Paul's Rocks was deliberately composed to illustrate the experience of boats being "sent off with a lot of whale line" for a loop "to be passed round one of the rocks" for landing (Anon 1873, 414).The drawing also illustrated the description of the "strong current" and "heavy surf…of from 5 ft. to 7ft." experienced by the ship's crew (Anon 1873, 414). These examples provide further reason to believe that drawing was useful as a visual strategy on the *Challenger* because the ship could not be depicted at sea through photography. What photography instead made possible was that both of these sketches would be *replicated* in order for Wild to disseminate them to newspapers to be published: the *Illustrated London News* claimed in its print to be "indebted to [Wild] for the photographs" and accompanying accounts (Anon 1875a, 590–591).[49]

[48] Photograph corresponds to ship no. 136, original in Album one of Assistant Paymaster John Hynes 1872–1876, n.p.

[49] Ship nos. 136 and 228c, original in Album one of Assistant Paymaster John Hynes 1872–1876, n.p.

Some of the photographs also reached the wider public sphere during the voyage as reproductions in Thomson's *Letters from H.M.S. Challenger* (1874), which appeared in the popular monthly anthology *Good Words*—a magazine directed at Britain's lower middle classes that included religious material, fiction, and science articles. This case can be seen as connected to the phenomenon of "armchair travel" that was popular in the nineteenth century, and of the increasing communication of science to a wider public (Schwartz 1996, 33). Reproductions of the photographs used in the publication ranged from scenes of vegetation, such as Kerguelen cabbages to depict botanical specimens, and of Thomson himself on Kerguelen Island.[50] The Bermudas, Azores, and other destinations were also featured to illustrate Thomson's narrative of the voyage, including anecdotes of indigenous people, findings of botanical specimens, and his own particular ventures during the expedition.[51] Photography on the *Challenger* thus functioned as a means of *reproducing* and *disseminating* illustrations for the public communication of the voyage to the British public during the expedition—not coincidentally at a time when its government also sought to communicate its exploration and colonial empire-building activities more widely.

9.7.2 Use in Popular Accounts of the Challenger Expedition

Such practices of dissemination continued after the *Challenger* expedition, when the photographs were used more extensively in popular accounts of the voyage. Once again photography functioned as a speedy method of capturing scenes to be used as templates for later artistic depiction: artist Wild's popular account of the voyage *At Anchor* (1878) included drawings of King George and Queen Charlotte of the Friendly Islands, which were unmistakably copied in pencil from the *Challenger* photographs (Wild 1878, 90) (Fig. 9.9). Since Wild had other responsibilities as the *Challenger* secretary, and as he seems to have utilized very little of his artistic skill or agency in these drawings, it can be assumed that some photographs were intentionally taken for his later use as a template, so as to prevent distortion of the view from his memory. This speedy capture and replicability further enabled other popular accounts to include reproductions of the *Challenger* photographs after the expedition, including Spry's *The Cruise of Her Majesty's Ship Challenger* (1877), which depicted the ship's workrooms, town architecture, and the people of the Polynesian island of Tongatabu.[52]

[50] Ship 220–221 and 223, 228a respectively in (Thomson 1874c, 744–745).

[51] See for example reproductions in (Thomson 1874a, 94–102; b, 381–387).

[52] Ship nos. 1, 33, 30, 91, 253 in (Spry 1877, 9, 25, 59, 61, 178) respectively. Originals in Album two of Assistant Paymaster John Hynes 1872–1876, n.p.

Fig. 9.9 Photographs of King George and Queen Charlotte (ship no. 247 and 248, original in Album two of Assistant Paymaster John Hynes 1872–1876, Historic Photographs and Ships Plans Collection, National Maritime Museum, London, ALB0175, n.p.)

9.7.3 Adding Popular Appeal to the Official Narrative

As well as using the *Challenger* photographs for its scientific purposes, the official Report's *Narrative* also printed them as plates, seemingly to convey a sense of adventure in the expedition that might have been intended to appeal to a more general audience. One photograph taken from on board the ship depicted indigenous peoples on a canoe, who had brought a gift of a green turtle to Captain Nares, whilst another was used to depict a "wide flat expanse of hardened lava" at the Kilauae volcano, Mauna Loa (Tizard et al. 1885, 506–507, 767).[53] The description of being "struck with the strange appearance of the wonderful termite hills" on approach to Albany Pass, Somerset, Cape York was also illustrated with a photograph, and another of Bisayan Houses, Samboangan was used to demonstrate the "condition" and "impossibility" of their architecture (Tizard et al. 1885, 532, 660).[54] The "unusual" Ki Doulan Mohammedan Mosque was similarly illustrated as an example of architecture through a *Challenger* photograph that was accompanied in the *Narrative* by the description of "a curious development of the high-peaked Malay roof into a sort of half tower, half spire" in Ki Doulan.[55] Further flexibility in the photographs' use can be seen in those of icebergs, which accompanied descriptions of the navigational

[53] Photograph ship nos. 269 and 400 on pages 508, 767, respectively.

[54] Ship nos. 270 and 337 respectively.

[55] Building in a Village in Ki Doulan; ship no. 279a (Tizard et al. 1885, 555).

problems that the captain experienced trying to get around them rather than communicating scientific information (Tizard et al. 1885, 396–405).[56] This ability to use the photographs to communicate the "wonder" of a scientific expedition to a wider audience was a particular benefit of the visual strategy on the voyage that further demonstrates the connection between the scientific value of the photographs with their popular use.

9.7.4 The Photographs as Commodities

Adding a further dimension of complexity to the story of visual culture on the *Challenger* is that the photographs from the expedition also functioned as saleable "commodities" to be used for economic benefit. During the voyage, 479 of the photographs were circulated as part of an Official Album, which was used to impress visiting dignitaries and circulated individually as gifts to onshore hosts, such as in New Zealand (Brunton 2004, 17–19). Following the voyage they continued to circulate as commodities through the Edinburgh photographic company J. Horsburgh and Sons by Her Majesty's Stationery Office (Ryan 1997, 33).[57] This circulation began in 1885—strategically in the same year as the publication of the *Narrative*, indicating a specific intention to capitalize on the photographs as the story of the *Challenger* reached a wider public audience.[58] Such "saleable" features included those of indigenous people in groups and as front and profile portraits, crew on board the ship, volcanoes, and icebergs, and local and colonial architecture including homes, temples, and churches.[59] The photographs adopted a range of formats: they could be purchased from the Horsburgh catalogue as single 8" × 6" unmounted copies, a set of "any 50" unmounted copies, and a complete set of 350 either unmounted, mounted on linen with alphabetical index bound in French morocco, or bound in Turkey morocco with "extra finish."[60] Purchasers also had the option of buying "outside size" copies of 15" × 11" and any photograph in platinotype for twenty-five per cent extra, in carbon for 33½ per cent extra, as enlarged or reduced copies, "or any special fancy" requested.[61] Individual photographs came at a cost of £0.1.0, or one could pay up to £18.18.0 for the complete set; they could also be purchased as transparencies "for Lantern Exhibitions" at an unspecified cost.[62] In being sold for economic means in such a wide variety of formats the *Challenger* photographs fit the earlier tradition of sketches and

[56] Ship no. 177a on page 404.

[57] Horsburgh catalogue of the photographic negatives taken during the challenger expedition, 1885, Natural History Museum Library and Archives, London, Murray Col. Section 5, No. 47, ff. 1–12.

[58] Horsburgh catalogue 1885, ff. 1–12.

[59] Horsburgh catalogue of the photographic negatives taken during the challenger expedition, 1885, Natural History Museum Library and Archives, London, Murray Col. Section 5, No. 47, ff. 1–12.

[60] Horsburgh catalogue 1885, ff. 1–12.

[61] Horsburgh catalogue 1885, f. 12.

[62] Horsburgh catalogue 1885, f. 12.

paintings being sold as prints to accompany scientific works and illustrated books of travel, whilst also being valuable themselves as commodities and making them adaptable to wider public and scientific use (Jacobs 1995, 16).

9.7.5 Subjective Interpretations: The Commodified Photographs Return to Science and the Public

Intriguingly, through their commercial circulation through the Horsburgh catalogue the *Challenger* photographs found themselves additional scientific uses—where the scientific meaning attributed to them became further relative to the perspective of the observers in the different contexts in which they were used. A number of photographs purchased from the catalogue were published as plates in Alfred Russel Wallace's *Studies Scientific and Social* (1900) in which they were used to illustrate racial "types" of people at a time when "race science" (scientific racism) was being established as a discipline (Wallace 1900, 457).[63] Wallace acquired the photographs of indigenous Api, Hawaiian, and Tahitian men and women specifically for his study.[64] Despite taking them from a commercial catalogue, Wallace's use of the photographs for "scientific" purposes, which he utilized alongside photographs taken by the Anthropological Institute, indicates that he deemed them equally appropriate as scientific evidence: he declared alongside two of the *Challenger* of the photographs in the book their capacity to "sufficiently show the general character" of his subjects (Wallace 1900, 406). Owing to developments in printing technology by the date that *Studies Scientific and Social* was published, the photographs could be printed as plates rather than reproductions, which also arguably increased their value as evidence for racialized "scientific" thinking.[65] Here we see a multifaceted connection between the economic use of the *Challenger* photographs with their value as scientific evidence, which could be used to further investigate the use of science and visual culture to both rationalize and sensationalize British science, exploration, colonialism, and racism in the nineteenth century.

[63] Including front and profile portraits of men and women on Tahiti, and a man from Api, New Hebrides corresponding to ship nos. 380, 383, 405, 403, 295 respectively. The photographs are likely to have been purchased from the Horsburgh catalogue since they were found stored in Wallace's personal archives with a translucent envelope printed "J. Horsburgh & Son." See Alfred Russel Wallace's papers re. Studies Scientific and Social, 1852–1905, Natural History Museum Library and Archives, London WP6/6/6, ff. 1–12; Alfred Russel Wallace's papers re. Studies Scientific and Social, 1852–1905, Natural History Museum Library and Archives, London, WP6/6/7, ff. 9–14.

[64] Russel Wallace stated this specifically in a letter to his daughter regarding the photographs he had collected for the book. In Letter from Alfred Russel Wallace to Violet Wallace, 18 Nov. 1899, Natural History Museum Library and Archives, London, WP/1/2/124, n.p.

[65] See (Hamber 1990) regarding the printing of photographs as reproductions. See also (Codling 1997, 205–206) relating to the improvements in printing technology.

9.7.6 Public Communication of Scientific Racism

Revealing further intricate connections between photographs as commodity, scientific evidence, and wider public communication in the nineteenth century, the *Challenger* photographs also reached the British Museum's (Natural History) exhibition "Races of Mankind" in the early twentieth century through the commercial route of the Horsburgh catalogue.[66] Used to legitimize scientific racism to the public, several front and profile portrait photographs of Polynesian, Fuegian, Melanesian, and Japanese men and women were displayed as framed exhibits, while others appeared in the exhibition guidebook to illustrate racial "types."[67] Their use in this way also placed the photographs in an "ethnographic showcase" context that was typical of the "edutainment" popular amongst the British public in the latter nineteenth and early twentieth centuries.[68] The exhibition received mixed responses: the *Museums Journal* praised the exhibition and guidebook's entertainment value on the basis of its "excellent" photographs on public display. On the other hand, *Man: A Monthly Record of Anthropological Science* criticized both the exhibition and guidebook for their scientific inaccuracy and irrelevance to anthropologists, nevertheless claiming "the plates are of considerable interest, and are worth preserving" (Anon 1909a, 1–2, b, 59). This suggests that the photographs themselves were considered valuable for use as scientific evidence, but that their interpretation and use in this context of public education and entertainment that *Man* considered to not be sufficiently scientifically rigorous. Again we see here how the *Challenger* photographs were able to take on different subjective meanings and uses following their circulation.

Through their distribution through the Horsburgh catalogue the *Challenger* photographs undoubtedly reached other destinations—homes, "scientific" research, public display—and will have been used and interpreted in a multiplicity of ways. In addition to the various visual strategies and scientific and personal uses, this further reflects the multiple functions of the *Challenger* photography and its complex interplay between science, society, and visual culture in the nineteenth century that extends past photographic "objectivity."

[66] Some of the exhibition photographs attributed to the *Challenger* are not in the Brunton catalogue, and may be further additions to the photographic collection. The photograph exhibits are labeled 'Challenger Expedition,' therefore linking them to the collection. It might be that the photographs were mislabeled as such, and their identification should be an area of further research.

[67] Ship nos. 354, 377, 382, 404, 435, 436, 436a, and photo no. 769 in Photographic Collection, Undated, Natural History Museum Library and Archives, London, DF PAL/143, ff. 112–115, 121, 123–124, 151, 162–163r; Ship no. 435 and 435a in Richard Lydekker's guide to the specimens illustrating the 'Races of mankind,' 1908, Natural History Museum, London, DF PUB/516/1/1, n.p.

[68] The government copyright stamp is not visible on the photographs, which have been cropped, but on account of the increased size and format for display they were likely to have been purchased through the Horsburgh catalogue for this purpose (Photographic Collection, Undated, ff. 112–115, 121, 123–124, 151, 162–163r).

9.8 Flexibility: *Challenger* Photographs, Science, and Society in the Nineteenth Century

This chapter has highlighted how a historiographical theory that nineteenth-century photography became important for science due to its perceived potential as "objective" visual evidence is not strictly supported by the *Challenger*'s maritime experience, nor is it evident in the expedition's extensive written and published record. The background to the expedition demonstrates that photographic practice on the voyage was not conducive to "objective" scientific image-making: the *Challenger* utilized several official photographers, none of whom were known to be trained for scientific purposes (but some who were trained by the military), and photographs acquired as gifts and purchases were also incorporated into the collection. In fact it was incredibly difficult to make objective photos on the *Challenger* due to the conditions of the voyage. Traditions in art also shaped the *Challenger*'s photographic aesthetics, giving them an epistemic authority that extended outside of the "scientific." This builds upon arguments as to the undue simplicity of defining photography's success in nineteenth-century science to have been on account of its perceived "objectivity."

The case of the *Challenger* expedition therefore shows that, for photography to be used in this context, it must have been valuable for other reasons. Photography was indeed a successful method of visual depiction as scientific evidence on the expedition, despite the fact that drawings and paintings were used to serve a multitude of scientific functions including depicting scale, color, patterns, and objects in difficult-to-reach places such as specimens from under the sea, which photography was unable to achieve. The functional benefits of photography instead included speed of capture, reproducibility, and as a "printing-press-in-the-field" for drawings and paintings. All of these functions were advantageous in the creation and circulation of the *Challenger*'s visual scientific evidence.

These functional benefits of photography also applied to non-scientific contexts—including their personal uses and in popular written accounts, and for public entertainment and education. In some cases the photographs themselves were used, but they also served as visual templates for drawing and painting. Utilized too for economic benefit, upon their commercial circulation they went on to find multiple additional uses and interpretations, as scientific books, public entertainment, and exhibitions. Photography on the *Challenger* therefore achieved success not only on account of its supposed "objectivity," but owing to its *flexibility* as a visual strategy, also revealing a multiplicity of connections between visual culture, science, economy, imperial politics, and British society in the nineteenth century.

The *Challenger* expedition therefore serves as an excellent case study towards a deeper understanding of visual culture in science, exploration, and society in the nineteenth century. Additional research should be directed towards the many other photographs from the *Challenger* not referenced in this chapter, and incorporating the new photographs found through this study into the catalogue. Other questions include: How does the *Challenger*'s visual strategies compare to those of other voyages of exploration, in the nineteenth century and during other time periods? Did

changing technology alter the possible uses and interpretations of the expedition's photographs? How were the photographs further used for legitimizing and communicating scientific ideas to the public and within research communities—and how were they then interpreted? Taking a broader perspective: What more can photographic practices, including those on the *Challenger*, tell us about the complex relationships between visual culture, science, exploration, economy, politics, and society in the nineteenth-century?

Acknowledgments With thanks to the reviewers and editors of this volume; to staff of the library and archives at the National Archives, National Maritime Museum, Natural History Museum, Royal Botanic Gardens Kew, and Royal Geographical Society in London for assistance in finding sources; to Dr. Michael Pritchard of the Royal Photographic Society for providing invaluable expertise; to Simon Werrett in the Science and Technology Studies (STS) department at University College London (UCL) for your support and advice during my MSc; to friends and colleagues at the Rachel Carson Center and the Max Planck Institute for the History of Science, in particular the library team; and to my family, without whom this project wouldn't have been realized.

References

Archival Sources

Caird Library, National Maritime Museum, London.
Foyle Reading Room, Royal Geographical Society, London.
Historic Photographs and Ships Plans Collection, National Maritime Museum, London.
Library and Archives, Natural History Museum, London.
Library, Art and Archives, Royal Botanic Gardens Kew, London.
Records of the Admiralty, Naval Forces, Royal Marines, Coastguard, and related bodies, National Archives, London.

Published Primary Sources

Abney, W. 1873. Photography in the Arctic Seas. *The British Journal of Photography*, 57.
Anon. 1873. The Challenger at St. Paul's Rocks. *Illustrated London News*, 412–414.
Anon. 1874. H.M.S. Challenger's scientific ocean surveying expedition. *Illustrated London News*, 505.
Anon. 1875a. The Challenger's visit to New Guinea. *Illustrated London News*, 590–591.
Anon. 1875b. Session 1874–1875b. *Proceedings of the Linnean Society of London*, v.
Anon. 1876. The cruise of the Challenger. *Nature*, 93–105.
Anon. 1885. Work of the Challenger expedition I. General and physical. *Science* 6 (126): 15–16.
Anon. 1909a. Guide to the specimens illustrating the races of mankind (Anthropology), exhibited in the Department of Zoology, British Museum (Natural History), 1908. *The Museums Journal* 8 (7): 1–2.
Anon. 1909b. Reviews: Anthropology, British Museum. Guide to the specimens illustrating the races of mankind. *MAN: A Monthly Record of Anthropological Science* 9: 58–59.

Dallmeyer, John Henry. 1874. *On the choice and use of photographic lenses.* New York: E & HT Anthony & Co.

Moseley, Henry Nottidge. 1877. On the inhabitants of the Admiralty Islands, & c. *The Journal of the Anthropological Institute of Great Britain and Ireland* 6: 379–429.

Spry, W.J.J. 1877. *The cruise of her majesty's ship 'Challenger': Voyages over many seas, scenes in many lands.* New York: Harper and Brothers.

Stuart-Wortley, Henry. 1875a. Photography in the 'Challenger.' *Nature* 13: 25–26.

Stuart-Wortley, Henry. 1875b. Rapidity in dry plates. *The British Journal of Photography*, 550–551.

Thomson, Charles Wyville. 1874a. Letters from HMS *Challenger.* II. Bermudas. In *Good words,* ed. Donald McLeod, 94–102. Philadelphia: J.B. Lippincott & Co.

Thomson, Charles Wyville. 1874b. Letters from HMS *Challenger.* IV. Azores. In *Good Words,* ed. Donald McLeod, 381–387. Philadelphia: J.B. Lippincott & Co.

Thomson, Charles Wyville. 1874c. Letters from HMS *Challenger.* IX. Kerguelen Island. In *Good words,* ed. Donald McLeod, 743–751. Philadelphia: J.B. Lippincott & Co.

Thomson, Charles Wyville 1878. *The voyage of the "Challenger:" The Atlantic: A preliminary account of the general results of the exploring voyage of H.M.S. "Challenger" during the year 1873 and the early part of the year 1876,* vol. 1. New York: Harper.

Tissandier, Gaston. 1876. *A history and handbook of photography.* London: John Thomson.

Tizard, Thomas Henry, Henry Nottidge Moseley, J.Y. Buchanan, and John Murray. 1885. Narrative of the Cruise of H.M.S Challenger with a general account of the scientific results of the expedition. In *Report on the scientific results of the voyage of HMS 'Challenger' during the years 1873–1876.* London: Longmans and Co.

Wallace, Alfred Russel. 1900. *Studies scientific and social,* vol. 1. London: Macmillan and Co., Ltd.

von Willemoes-Suhm, Rudolf. 1877. *Challenger-Briefe.* Leipzig: Verlag von Wilhelm Engelmann.

Wild, John James. 1878. *At Anchor: A narrative of experiences afloat and ashore during the voyage of HMS 'Challenger.'* London: Marcus Ward and Co.

Secondary Literature

Barringer, Tim, Geoff Quilley, and Douglas Fordham. 2007. Introduction. In *Art and the British Empire,* ed. Tim Barringer, Geoff Quilley, and Douglas Fordham, 1–19. Manchester: Manchester University Press.

Butlin, Robin. 2005. Changing visions: The RGS in the 19th Century. In *To the ends of the earth: Visions of a changing world: 175 years of exploration and photography,* ed. Anon, 14–18. London: Bloomsbury.

Brunton, Eileen V. 2004. *The Challenger expedition, 1872–1876: A visual index.* London: Natural History Museum.

Codling, Rosamunde. 1997. HMS Challenger in the Antarctic: Pictures and photographs from 1874. *Landscape Research* 22 (2): 191–208.

Corbey, Raymond. 1993. Ethnographic showcases, 1870–1930. *Cultural Anthropology* 8 (3): 338–369.

Corfield, Richard. 2003. *Silent landscape: The scientific voyage of HMS Challenger.* Washington DC: The Joseph Henry Press.

Daston, Lorraine, and Peter Galison. 1992. The image of objectivity. *Representations* 40: 81–128.

Daston, Lorraine, and Peter Galison. 2007. *Objectivity.* New York: Zone Books.

Davenport, Alma. 1991. *The history of photography: An overview.* Boston: Focal Press.

Edwards, Elizabeth. 1990. Photographic 'types': The pursuit of method. *Visual Anthropology* 3 (2–3): 235–258.

Hamber, Anthony. 1990. The use of photography by nineteenth century art historians. *Visual Resources* 7 (2–3): 135–161.

Hannavy, John. 2007. *Encyclopedia of nineteenth-century photography*. London: CRC Press.

Haworth-Booth, M. 1984. *The golden age of British photography 1839–1900*. London: Aperture.

Headland, Robert. 1989. *Chronological list of Antarctic expeditions and related historical events*. Cambridge: Cambridge University Press.

Jacobs, M. 1995. *The painted voyage: Art, travel and exploration 1564–1875*. London: Trustees of the British Museum.

Jones, Erika Lynn. 2019. *Making the ocean visible: science and mobility on the* Challenger *expedition, 1872–1895*. Doctoral thesis (PhD), UCL (University College London).

Kennedy, Dane. 2007. British exploration in the nineteenth century: A historiographical survey. *History Compass* 6: 1879–1900.

Kingslake, Rudolph. 1989. *A history of the photographic lens*. London: Academic Press.

Linklater, Eric. 1972. *The voyage of the Challenger*. London: John Murray Publishers.

Maxwell, Anne. 2000. *Colonial photography and exhibitions: Representations of the native and the making of European identities*. London: Burns & Oates.

McCabe, Constance. 1991. Preservation of 19th-century negatives in the National Archives. *Journal of the American Institute for Conservation* 30 (1): 41–73.

McLean, Ian. 2007. The expanded field of the picturesque: Contested identities and empire in *Sydney-Cove 1794*. In *Art and the British Empire*, ed. Tim Barringer, Geoff Quilley, and Douglas Fordham, 23–37. Manchester: Manchester University Press.

Mifflin, Jeffrey. 2011. Arctic spectacles: The frozen North in visual culture, 1818–1875. *Early Popular Visual Culture* 9 (4): 363–365.

Mills, William J. 2003. *Exploring polar frontiers: A historical encyclopedia*, vol. 1. ABC-CLIO.

Pinney, Christopher. 2011. *Photography and anthropology*. London: Reaktion.

Potter, Russell A. 2007. *Arctic spectacles: The frozen North in visual culture, 1818–1875*. Seattle: University of Washington Press.

Quilley, Geoff. 2011. *Empire to nation: Art, history and the visualization of maritime Britain, 1768–1829*. New Haven/London: Yale University Press.

Rice, Tony, and David Bellamy. 2000. *Voyages of discovery: Three centuries of natural history exploration*. London: Scriptum Editions in Association with the Natural History Museum.

Rozwadowski, Helen M. 2009. *Fathoming the ocean: The discovery and exploration of the deep sea*. Cambridge, MA: Harvard University Press.

Ryan, James R. 1997. *Picturing empire: Photography and the visualization of the British Empire*. Chicago: University of Chicago Press.

Ryan, James R. 2013. *Photography and exploration*. London: Reaktion.

Schwartz, Joan M. 1996. The geography lesson: Photographs and the construction of imaginative geographies. *Journal of Historical Geography* 22 (1): 16–45.

Schwartz, Joan M. 2000. Records of simple truth and precision: Photography, archives, and the illusion of control. *Archivaria* 1 (50): 1–50.

Shepherd, R. Winsome. 2007. Travers, William Thomas Locke 1819–1903. *Dictionary of New Zealand Biography*. Accessed 10 Aug 2013.

Smith, Bernard. 1985. *European vision and the South Pacific*. New Haven: Yale University Press.

Smith, Bernard. 1992. *Imagining the Pacific: In the wake of the Cook voyages*. New Haven: Yale University Press.

Tucker, Jennifer. 2005. *Nature exposed: Photography as eyewitness in Victorian science*. Baltimore: Johns Hopkins University Press.

Tucker, Jennifer. 1997. Photography as witness, detective, and impostor: Visual representation in Victorian science. In *Victorian science in context*, ed. Bernard Lightman, 378–408. Chicago: The University of Chicago Press.

Wamsley, Douglas, and William Barr. 1996. Early photographers of the Arctic. *Polar Record* 32 (183): 295–316.

Wilder, Kelley. 2009. *Photography and science*. London: Reaktion.

Yonge, Maurice. 1972. The inception and significance of the *Challenger* expedition. *Proceedings of the Royal Society of Edinburgh (B)* 72: 1–13.

Stephanie Hood is based at the Max Planck Institute for the History of Science in Berlin, Germany. She has a BSc (Hons) in Biology from the University of York, UK (2009), and an MSc (with Distinction) in History of Science awarded by the Department of Science and Technology Studies at University College London (UCL) jointly with Imperial College London (2013). Her interests span public science communication and engagement, with a focus on environmental humanities and the history and sociology of science and medicine. Before joining the MPIWG, Stephanie was an Editor at the Rachel Carson Center for Environment and Society in Munich. She has also worked as an English-language editor of tourist information at UNESCO heritage sites in China, supported and evaluated environmental and cultural heritage education projects for the Chinese Society for Education (CSE).

Chapter 10
Images, Data-Visualization and the Narratives They Create: The Narrative Function of Images in Fostering MRI Innovation

Silvia Casini

Abstract Magnetic Resonance Imaging (MRI) is one of the twentieth century's key diagnostic imaging technologies used in biomedicine and the neurosciences. Narratives around MRI invention and development are multiple and make use of a variety of approaches, from the historical-sociological to the semiotic. However, none of these accounts has considered the narratives that accompany and shape a technology in its earliest developmental stage. These emerging narratives, mediated or circulated by images, are fundamental for grasping the social construction of a technology as an ever-changing set of processes. Informed by literature and methods in image science, historical epistemology, and science and technology studies, this chapter demonstrates that the narrative function of images enriches our understanding of their epistemic roles in the exploration, transformation, and transmission of knowledge within scientific practice. Images and data-visualization can create myths, narratives, and counter-narratives to the official story that usually accompanies the invention and development of a technology. To illustrate this point, the chapter focuses on MRI early development as a clinical tool carried out within the medical physics laboratory in the 1970s at the University of Aberdeen, a trajectory considered peripheral by historical accounts of MRI innovation, which tend to privilege theory creation over practical making.

Keywords MRI development history · Centre-periphery · Narrative function of images · Data-visualisation

10.1 Introduction

Magnetic Resonance Imaging (MRI) is one of the key diagnostic imaging technologies of the twentieth century. It is used in biomedicine and the neurosciences, sometimes in combination with other non-imaging techniques. It is a non-invasive scanning technique using strong magnetic fields, radio waves, and field gradients to

S. Casini (✉)
University of Aberdeen, Aberdeen, Scotland
e-mail: silvia.casini@abdn.ac.uk

© The Author(s), under exclusive license to Springer Nature Switzerland AG 2023
M. Valleriani et al. (eds.), *Scientific Visual Representations in History*,
https://doi.org/10.1007/978-3-031-11317-8_10

visualize the anatomy and the physiological processes of the body in both health and disease (McRobbie et al. 2003). MRI is carried out on many millions of patients every year all over the world.

Like the majority of scientific breakthroughs and discoveries, the development of MRI, involving different scientific laboratories and research teams across the world and in the UK, in particular, has not been a linear one.[1] Comparable to the discovery of X-rays in 1895, multiple steps led toward the scientific, technological, and diagnostic breakthrough of MRI. Sociological and cultural studies accounts of MRI demonstrate that this technology does not have a single origin, be it one inventor or a single point of development that can be located geographically and temporally (Joyce 2006). In his transnational history of MRI, sociologist Amit Prasad, for example, dismantles the myth of a single "origin" of MRI: "[T]he 'invention' of MRI was not a singular event, or a set of events, frozen in time (the early 1970s), but, rather, the result of entangled activities of a number of actors that extended over decades" (Prasad 2014, 13).

An invention never happens in the way in which it is later publicized. MRI was not the result of a singular event or discovery, but the result of the entangled activities of laboratory teams across the world that extended over decades, as will be discussed in what follows. The medical physics department at the University of Aberdeen occupies a peripheral place within the historiographical accounts of MRI invention, which tend to privilege theory-creation over practical-making.

Innovation scholar Nathan Rosenberg argues that subsequent improvements in an invention after its first introduction may be vastly more important, economically, than the initial availability of the invention in its original form (Rosenberg 2010, vii). Innovation is a combination of material things and conceptual leaps from different locations and temporalities, brought together and put into a new place. Scientific practice moves through a topography made of research centers, institutions, and academic journals, with expertise from physics, design, clinical practice, and engineering, but also memories, affective investment, and hands-on labor. These nodes make up the cartography that embodies the dynamics of the center-periphery relationship in the history of MRI innovation. Things perceived as peripheral to the science (for example, aesthetic choices and craftsmanship) are in fact central to it. This is the case, for example, of aesthetic choices and craftsmanship that images and data visualization make visible.

The center-periphery pair provides the conceptual background to this chapter, which examines the way images and data visualization contribute to construct a certain narrative around the University of Aberdeen's contribution to the development of MRI as a clinical technique. Narratives around MRI technology are multiple and make use of a variety of approaches, from the historical-sociological to the semiotic.[2] However, none of these accounts has considered the narratives that accompany and

[1] Some of the controversies related to the different trajectories of the invention of MRI are recounted in (Dawson 2013).

[2] For a broader historical-sociological perspective on medical imaging in the twentieth century (Kevles 1998). The three most recent and comprehensive studies focusing on MRI are (Casini 2021), (Prasad 2014) and (Joyce 2008). For a semiotic study on how scientists working with functional

shape a technology in its early developmental stage. These emerging narratives, often mediated or circulated by images, are fundamental for grasping the social construction of a technology as an ever-changing set of processes. This chapter focuses on one aspect and period in the history of MRI: its development as a tool for clinical purposes within the medical physics laboratory in the 1970s at the University of Aberdeen.

10.2 The Narrative Function of Images and Data-Visualization in the Innovation Trajectory of MRI Development

Informed by image science, history of technology, and science and technology studies, the focus of this analysis is primarily on the material form and iconology of technical images rather than on the social construction of images, as would be the case for a strictly visual-culture approach (Bredekamp et al. 2015). Technical images and other types of data visualization are at the center of contemporary science, encompassing a wide range of subjects such as chemistry, economics, psychology, engineering, biomedicine, etc. Technical images and data visualization, however, are not simply the result of imaging procedures; they come into being as ways of thinking through, presenting, and mediating constellations of material artifacts, bodies, and data by image-making scientists.

The use of images in scientific practice has raised the interest of historians, philosophers, and sociologists of science, particularly since Martin Rudwick's seminal paper on the emergence of a "visual language" for geologists in the eighteenth and nineteenth centuries (Rudwick 1976). As the history of science and technology has shown, scientific practice has always been about creating new worlds and new objects (so that they become visible) or about throwing new light onto familiar things (so that the way we look at them changes). Well-known examples include Leonardo da Vinci's (1452–1519) anatomical drawings, Galileo Galilei's (1564–ca. 1641) observations of the lunar surface made visible by his telescope, and Santiago Ramón y Cajal's (1852–1934) drawings of neurons and neural functions visualized and lit up in colorful brain scans. All these visualizations enable us to interrogate, rather than simply represent, the object made visible. Visualization in science, therefore, works as a "question-generating machine" (Rheinberger 1997, 32).

Data visualization in biomedical science cannot be discussed without attention to its sociocultural and historical specificities: the process of turning data into visual output is profoundly historical, locally constructed, and co-evolving with the specific circumstances in which it is situated (Harding 2008, 75–97). As Sabina Leonelli argues in her study on data-intensive science, scientific practice should be studied by

MRI make sense of digital brain scans, see the multi-modal semiotic analysis conducted in (Alač 2011).

looking at the "situation," which is defined as "the dynamic entanglement of conceptual, material, social, and institutional factors involved in developing knowledge and clearly positions research efforts in relation to the publics for whom such knowledge is expected to be of value" (Leonelli 2016, 8). Scientific data visualization emerges from highly specific situations and processes that are, in themselves, fragmented and recursive (Rheinberger 2010, xvii).

The historian of science and technology Peter Galison offers a conceptual framework to describe two traditions present in the field of twentieth-century microphysics. The first, called the image tradition, describes images as natural, illusionary, or mimetic. The second, the logic tradition, substitutes images with the notion of statistical projection of data and digital information (Galison 1997). These two traditions employ different forms of experimental arguments: the first seeks to base its demonstrations not on statistics but on single "golden" events, such as those proving the forms of the subatomic world. A single picture can provide the onlooker with evidence about an entity or a phenomenon. The second tradition uses statistical demonstrations and is based on the aggregation of data. The images belonging to this second tradition tend to be pixelated or statistical rather than mimetic. This is evident in graphs representing curves, which are averages, as opposed to direct visualizations. Galison argues that these two traditions have recently merged into a hybrid characterized by the co-presence of numbers (data) and pictorial values (images). Being able to move between these two traditions and to produce high-quality imaged-data is paramount to enabling physicists to reach out to different communities—radiologists, clinicians, patients, and the lay public.

Galison's description of the two-image traditions in physics is the platform from which the epistemic function of images can be investigated. Images that belong to either of the traditions mentioned above enable the exploration, transformation, and transmission of knowledge. These three epistemic functions, as the authors of this volume suggest, are at the center of the use of images, diagrammatic maps, photographs, and other types of data visualization in science. The argument presented in this chapter, however, is that images also perform another epistemic function: narrative.

The narrative function is an example of a peripheral epistemic function of images within scientific practice. A narrative requires the intentional or arbitrary arrangement of elements (imaginary or real) in a certain way (chronological or not, syntagmatic or paradigmatic, etc.) using a wide range of materials including maps, prose, diagrams, and photographs. The ordering of data and information, the arrangement of materials and tools at the laboratory bench, for example, can become part of the narrative of a certain scientific practice or theory. The narrative (not necessarily chronological) ordering and organizing of different kinds of materials and instruments can become visible through laboratory ethnography and the analysis of laboratory notebooks and images.[3] Every scientific argument and practice contains narrative elements. Images can facilitate the construction and/or transmission of these narratives. An image can play a role in the construction of narrative related to the history of a technology and/or

[3] On the narrative function of images, see, for example, (Morgan and Norton Wise 2017).

of a certain laboratory. An image, a photograph, or a map can enable the onlooker to reconstruct a sense of time and duration that is otherwise unavailable. Scrutinizing the use of scientific narratives, for example by studying the visual elements that contribute to them, can reveal the rationales and motives for which the narratives are put at work.

The goal in what follows is not to use the University of Aberdeen's contribution to MRI development as a platform to move to an encompassing theory on the use of images in contemporary biomedical physics. Rather, it is to show how understanding the narrative function of images can enrich our analysis of their epistemic roles. Scientific arguments can contain narrative elements, even at a simply paratextual level, in the guise of images accompanying the text rather than offering an argument. Images can create myths, narratives, and counter-narratives to the official story that usually accompanies the invention and development of a technology. The historian and philosopher of science Dominic J. Berry defines "narrative positioning" as an epistemic activity undertaken by individual researchers in their local laboratories and research teams (Berry 2019, 2). Narrative is key to explaining why some kinds of evidence are better at provoking dissemination and inspiring assent to new knowledge than others.

To position the narrative function of images and visualization at the center of scientific practice can contribute to a more nuanced understanding of the function of images within science and of how scientists work with images. Moreover, if this enriched understanding is shared with scientists, it might encourage them to become more self-reflexive about how their imaging technologies and their ways of seeing are part of wider socio-cultural practices and histories. Analyzing the narrative function of images means engaging with the ability of images to embody the histories of a technology or of a laboratory as well as fictional scenarios (the "what if") or the fictive allegiances between past, ongoing, and future technologies/techniques. Furthermore, the narrative function of images points to the limits of an analysis that focuses exclusively on images and other forms of visualization but is detached from the hands, eyes, and brains of those who made, used, and circulated these images.[4]

This analysis does not aim to be exhaustive, as it is circumscribed by two images of different kinds. The first is the image of an engraving used by a scientist as a prop to reconstruct the narrative around the milestones of MRI development carried out in his laboratory; the second is a data-visualization map created by scientists. Interestingly, the two images appear published in the same journal article. The first one is a picture of an early modern engraving depicting, in the interpretation of the physicist using it, a sort of MRI scanner *ante litteram*. The image, in this case, is not produced by scientists but is circulated by the team leader as a kind of *divertissement* within a historical-driven paper aiming at tracing the history of MRI development at the University of Aberdeen's biomedical physics laboratory. The image serves the purpose of illustrating the technological innovation trajectory undertaken by a specific laboratory within the broader transnational history of MRI invention. This artistic image, however, contributes to the rhetorical construction of the MRI's

[4] On the relationship between visualization and embodied cognition, see (Latour 1986).

development for clinical purposes—the transformation of a theoretical principle into a diagnostic technique.

The second image, which was published in the same historically driven paper containing the picture of the early modern "scanner," should be more correctly defined as a map enabling the visualization of data. It was created by the team working on the development of *Mark-1*, the world's first full-body scanner for clinical purposes, built by the University of Aberdeen biomedical physics laboratory. The data visualization map embodies all three epistemic functions of images and the importance of craftsmanship and aesthetic choice in the production of data visualization at a time when computer technologies were not advanced. Both images, albeit in a different way, function as ways of "anticipating" the full-body clinical scanner to come.

Peter Galison's distinction between the image and the logic tradition in microphysics is the backdrop to grasping the concept of data visualization. The work of the philosopher of social sciences Sabina Leonelli on data production in biology and data journeys across laboratories is a good starting point for understanding the epistemological implications of data-driven science. Leonelli points out that data are either objects treated as evidence for making claims about phenomena or handled in such a way as to facilitate their circulation for further analysis among researchers and research groups (Leonelli 2016).

She tracks data practices and their journeys from the sites in which data are created (laboratories, clinical studies, etc.) to the sites of data mobilization (databases, archives, data banks, publications, etc.) and of data interpretation (laboratories, journalism, etc.). Data, Leonelli argues, are not "given," in the sense that they are context-dependent rather than expressing incontrovertible facts on a given entity or process. How are data generated? How do they circulate and contribute to knowledge? According to Leonelli, data are objects that "are treated as potential evidence for one or more claims about phenomena and are formatted and handled in ways that enable their circulation among individuals or groups for analysis" (Leonelli 2016, 78). The second part of this definition highlights how a crucial component of data is their portability. Namely, rather than having "intrinsic representational powers," data "acquire evidential value through mobilization" (Leonelli 2016, 198). Any product of research activities which is collected, stored, and disseminated for use can be data. The same object can function or not as a datum depending on the situation. Any object can be a datum if it is a claim about a phenomenon and as long as it can circulate. Data are mutable in form and medium. Data are produced by human interactions with the world, mediated or not by technology. Therefore, data are relational entities rather than a straightforward representation of the phenomenon under investigation.

Data do not simply exist; they must be generated. Who is responsible for the construction, interpretation, and display of data within the laboratory? This question cannot escape the role played by the act of visualizing data, regardless of whether this act is a product of a human, machinic, or mixed collaboration. The act of visualizing reinforces and expands further the relational view of data, requiring us to pay attention to its use. Visualization is a crucial component of how data are produced, interpreted, displayed, and even contested inside the laboratory.

The term *visualization* varies across knowledge domains. It can be defined as any message presented in a format suitable for display, which provides evidence or explanation to the viewer. Visualizations can have descriptive, aesthetic, instructive, explanatory, interpretative, evaluative, and persuasive intents (Tufte 2001; Polman and Gebre 2015; Hegarty 2011). They can also function as bridges between communities of users from different backgrounds (for example, scientists and artists) and their ways of seeing (Wise 2006). In this sense, visualization favors a common understanding despite users' disparate views.[5]

Whether in the form of a photograph, a diagram, or a graph, data visualization in science is both a discursive tool with which to share experimental outcomes with colleagues without reproducing the experiment, and a rhetorical way to convince audiences beyond the strict scientific circle of those who are already part of the experimental setting. Visualization plays a key role in how data travel across laboratories and from the laboratory to the wider cultural arena—popular magazines, scientific journals, exhibitions, and public engagement initiatives are means through which data travel and solidify into knowledge. Visualization is a crucial component of how data are formed inside the laboratory.

We return to Leonelli's claim that scientific practice should be studied by looking at the "situation." Like data, visualization does not speak for itself but always embodies a specific voice—usually from the dominant group among various stakeholders (for example, a certain research group). The choices made by scientists with respect to data emerge from intellectual, technical, political, or economic struggles, all of which entail power imbalances. These choices remain hidden in the final published output.

Historian of science and biologist Hans-Jörg Rheinberger argues that the foundational gesture of science is to make things visible in the broader context of laboratory experimentation. An experimental system is set up by two drives, one toward analysis, which is about the examination of the constitutive elements of the phenomenon under study (molecules, chemical elements, physical forces, etc.). The other drive is toward synthesis and consists of the effort to create new things (Rheinberger 2011, 340). Analysis, however, always involves synthesis. For example, the elements composing the experimental system part of any MRI system (the signal, the magnetic field, the coils, the couch, the console, the mathematical equations, the K-space matrix, etc.) are reassembled constantly, then taken apart and put together mathematically in new configurations in order to create new things.

For doing so, science can choose to put different strategies to work, depending on whether the thing that is *made visible* (experimented upon) is a structure or a process. Rheinberger argues that compression and dilatation are two methods of experimenting with structures; speeding up and slowing down methods of experimentation on processes. The other two strategies are enhancement and schematization. To give an example, the hardware and software components of an MRI scanner need to be set up so that the process of acquiring the signal and then turning data into a visual output can be accelerated. Swifter signal acquisition enables the patient to spend less

[5] On the concept of the boundary object, see (Star and Griesemer 1989). For a more recent reassessment of the concept of boundary by Star, see (Star 2010).

time lying still inside the scanner. The schematization strategy is present in diagrammatic images of anatomical structures. These diagrams assist the radiologist with the reading of the image and the correct localization of a certain pathology within the MRI image. Acts of compression, dilatation, enhancement, or schematization make certain phenomena visible whilst others fade into the background.

The laboratory is a space of experimentation in which the intersections between scientific "objects," instruments, apparatuses, and experimenters quiver with uncertainty—where the liveliness of experimentation has not yet been stilled by epistemological resolution. A living experimental system, Rheinberger argues, has *"more stories* to tell than the experimenter at a given moment is trying to tell with it" (Rheinberger 1994, 77–78). Because such a system still holds "excess" within itself, it "contain[s] remnants of older narratives as well as fragments of narratives that have not yet been told" (Rheinberger 1994, 78). The experimentation of a technology like MRI is characterized by the assemblage of instruments, visualization protocols, materials, different professionals, data, and bodies. The narratives related to this space of experimentation can be circulated to the circle of experts and to the wider public by means of images and other forms of data visualization.

10.3 The Invention and Development of Magnetic Resonance Imaging

The history of MRI can be visualized as a cartographic map with multiple centers across continents (the US, Europe, Asia) and multiple temporalities. To single out the inventor(s), the first one who discovered the principle of magnetism, the first one to develop the clinical application of MRI or the first image ever obtained, gives the illusion of a linearity in this historical trajectory.

The phenomenon behind magnetic resonance (MR) was first observed by Isidor Rabi in 1938 in the context of atomic beam experiments in Chicago. A focused stream of heated atoms escaping through a small opening in an oven was directed through a magnetic field and their electromagnetic radiation recorded. As the historian of technology and physicist Klaus Hentschel argues, the initial context in which nuclear magnetic resonance (NMR) first appeared "was limited to high precision measurements of magnetic moments in atomic and nuclear physics. It was not yet a visual culture, but primarily an experimental culture yielding as final results a few numerical values for atomic and subatomic quantities" (Hentschel 2014, 188–189).[6]

In 1946, with a background in radar research and a familiarity with electromagnetic technology, Bloch and Purcell, who would earn the Nobel Prize in Physics in 1952, made the NMR technique applicable to experiments with liquids and solids. Bloch performed the first biological experiment with NMR when he placed his finger in the test coil and obtained a strong proton NMR signal. However, there was yet no

[6] (Hentschel 2014) is particularly relevant for understanding the context in which nuclear magnetic resonance first appeared, including in relation to other image-generating technologies.

way to transform nuclear magnetic resonance into any particularly visual field, the focus being on atomic and nuclear precision measurements. Purcell argued that it took twenty years to realize clinically useful NMR images. This delay, in his view, was aggravated by two main factors, the first technical and the second motivational. First, there was no sufficient computing capacity to process the signal; second, there was no appetite to obtain images of the interior of objects with NMR, perhaps because the realm of NMR was that of physicists and chemists rather than clinicians (Hentschel 2014, 190).

Trained as a physician, Raymond Damadian noticed in 1970 that samples from diseased tissues had more prolonged relaxation times than normal tissues. He realized that this would open NMR to medical diagnostics. In 1971, Lauterbur—who was already known for his NMR studies in the field of chemistry and was aware of Damadian's claim that NMR could be used to distinguish cancerous tissues from normal ones—was persuaded that pictures could be made using a technique called zeugmatography.[7] Being a physician, Damadian looked at NMR as a phenomenon that might be used to probe the body and diagnose human disease. He demonstrated that cancer cells had longer T1 and T2 values than normal cells, an achievement crucial to the clinical development of MRI in Aberdeen. In 1972, he filed a US patent application for an apparatus and method to detect cancer in tissue. By mid-summer of 1977, thanks to a device called *Indomitable*, the first ever scan of a whole, live human body was produced. Damadian called his imaging method "field-focused NMR" or FONAR. This became the name of his company, the first to manufacture clinical MR scanners commercially.

Images played a role in the successive development of MRI as a diagnostic device. The attempt to produce a visual output resulted from the will to transform the technology into a diagnostic tool. The transfer from physics and chemistry into medicine took twenty years, but in the 1970s medical imaging technologies were enhanced by what was later renamed MRI. The historical details of this transfer are still somewhat controversial.[8]

As Hentschel points out, the first cross-section NMR "image" of a human chest, which was obtained on July 3, 1977, was a matrix of columns and rows filled with numbers that stand in for measurements of the relaxation time. Rather than being a passive recording of numbers, this pictorial diagram was carefully constructed following conventions related to gray or color values assigned to an NMR parameter range, as the laboratory sketch of the measurements data demonstrates (Hentschel 2014, 195–196). Damadian's experiments had been conducted in the manner of a physicist rather than with attention to the image component—as mere recording of relaxation times and diffusion coefficients, using only the oscilloscope graphs of the NMR signals.

[7] John R. Mallard recalls the dispute around the name to be given to the new technique. 'Zeugmatography' was dropped in favor of 'Nuclear Magnetic Resonance.' On the phases that lead to the name Magnetic Resonance Imaging, see (Joyce 2006).

[8] Hentschel attributes to Damadian, who was not given the Nobel Prize granted to Lauterbur and Mansfield, a greater role in the development of MRI; see (Hentschel 2014, 191).

To obtain some sort of two-dimensional image, Damadian developed the field focusing technique. However, it was soon recognized that Damadian's field-focused method was far too slow and clumsy for routine clinical imaging, and so it was abandoned in favor of the methods of Lauterbur and Mansfield in subsequent versions of the scanner. The problem Damadian and Lauterbur had to face was whether one could tell exactly which location an NMR signal was coming from within a complex object. Lauterbur was the first to provide an accurate and practical technique to collect data not only from the relaxation time of tissues, but also from a variety of other parameters, such as proton density.

Lauterbur used the language of cartography to describe the visual output produced by NMR. For him, the scan was similar to a mathematical map or graphical representation of spatial information: "an image of an object may be defined as a graphical representation of the spatial distribution of one or more of its properties" (Lauterbur 1973, 190; Joyce 2006, 9). The beginning of the medical application of NMR imaging is dated to 1973. However, there was no straightforward translation from an idea to a machine and then to a machine that could be used for diagnosis: "the first MRI for clinical use were developed in the first half of the 1980s after a decade of complex socio-technical tuning" (Prasad 2005, 465). The Aberdonian case study witnesses this complexity.

The development of MRI was carried out at the University of Aberdeen between the late 1960s and the early 1980s thanks to the work of a visionary team of medical physicists (Hutchison et al. 1980). The research group, comprising physicists John R. Mallard, James Hutchison (named Jim), and William A. Edelstein (named Bill), constructed *Mark-I* (Fig. 10.1), the world's first full-body MRI clinical scanner, and invented the spin-warp method, which became the *global standard* for data–image conversion. Building a full-body scanner meant capturing the body in all its aliveness—the heart beating, the blood pumping, vessels and lungs moving, and the patient inadvertently moving inside the machine. This aliveness, however, means artifacts are possible in the image. Without the spin-warp method, *Mark-I* would have been a silent piece of technology, unable to produce a clinically useful visual output (Edelstein et al. 1980). Thanks to this method, images of good quality and clinical usefulness could be obtained from data, and problems related to movement artifacts could be solved in the post-processing of the image after data collection. Research carried out by the Aberdonian group was "at the forefront of MRI development until 1981" (Prasad 2014, 5), being superseded by research centers that could count on cutting-edge scanners manufactured by big companies.

The Aberdonian innovation trajectory of MRI development is characterized by in-house *know-how* about building scanners without relying upon manufacturers; a focus on data visualization challenges; and the motivation to develop a biomedical technology to improve patients' health.

Challenging the classical narrative in innovation studies, which presumes that within an emerging global economy innovation only occurs within advanced Western metropolitan centers, the focus on the development of MRI at the University of Aberdeen serves to re-orient how researchers and practitioners theorize and foster innovation. In his ethnographic account of the polymerase chain reaction technique

Fig. 10.1 Professor Jim Hutchison with *Mark-1*. Courtesy of Special Collections, Sir Duncan Rice Library, University of Aberdeen

(PCR), anthropologist Paul Rabinow asks one simple question: Who invented PRC? If conception, development, and application are all scientific issues, the question around invention engages historians, anthropologists, Nobel Prize committees, patent lawyers, and even journalists. Rabinow highlights how the simplest thing in the presence of a new technique is to name an individual as the inventor of its concept (Rabinow 1997, 4). As he points out, naming the Nobel Prize recipient(s) is not enough because other scientists and technicians were instrumental in making the PCR work. Another argument goes on to say that a concept (like that of PCR) is not enough until it can be put into practice within an experimental system. The very same reflections are valid for MRI.

The University of Aberdeen "case study" is worthwhile, for it means re-centering the history of MRI invention and development, shifting it from the supposed "center" (the US and UK research centers where the principles of MR were first discovered) to the "periphery" (where MRI was transformed into a viable clinical technique). Peripheral knowledge is, clearly, not only related to geography but also to the role played by manual labor, affectivity, and memory, dimensions that can be brought to the foreground by highlighting the narrative dimension of images and data visualization.

The archival material explored in this chapter comes from the materials held in the Special Collection of the University of Aberdeen, which is the official repository of published articles, manuscripts, slides, and photographs relating to MRI and other technologies developed by the team of physicists and engineers at Aberdeen, a team led by John R. Mallard and including the physicists James Hutchison and William Edelstein. This team developed and tested the MRI body scanning machine and brought its widespread use to the medical profession. Spanning the development and clinical use of MRI, positron emission tomography (PET) and other significant biomedical imaging technologies from 1965 (the year Professor Mallard was appointed to the purposefully created chair in biomedical physics at the university) to the early 1980s, the selection of materials represent key moments in the development of such technologies in Aberdeen.

The archive, in particular, becomes the repository of sociotechnical and affective imaginaries rather than of dead documents and objects waiting to be brought back to life. The analysis of archival material can bring to the foreground aesthetic, broader socio-cultural, and affective tropes embedded in images and data visualization. Affectivity is connected to materiality, with reference not just to bodily processes, but also to the material world as a site of affective exchange between human and non-human agents (including machines and their components). Design sketches, photographs, lab notes, and newspaper clippings that might seem marginal at first glance—the "cursed" part of scientific research—can turn out to be the driving forces and narratives behind the development of a certain technology or of a certain scientific theory. These "things" are repositories of memory, aesthetic choices, and affective labor (Turkle 2007).

For example, the manual labor involved in the creation of each component of a new technology such as MRI (from the design and assemblage of the hardware, to writing the code, to the methods for turning data into images) is not simply taking care of the technological object but much more of patients, who are the end users of this technology. Highlighting the narrative dimension of images in scientific practice can bring to the foreground this highly unstable, affective immersion in the spectacle of data-driven science.

10.4 The Patient as a Driving Force in the Aberdonian Development of MRI

As discussed in the Introduction to this chapter, images can perform functions complementary to the epistemic functions of creation, transmission, and transformation of knowledge, such as the function of narrating a history or multiple histories, fictional or otherwise. For example, certain images can contribute to the construction of a mythological origin of a technology. In the case of the picture which will be discussed in this section, what is at stake are not notions of scientific visible evidence, but rather rhetorical strategies used to persuade of the historical necessity of MRI as *the* diagnostic device. This picture is peripheral to the other images and data visualization maps used by Mallard and his laboratory group. It is peripheral in so far as it does not serve any immediate epistemic role related to the construction of knowledge within the laboratory.

This image, used by Mallard without quoting its source, without engaging with its content, insists on the margins of the paper's text and its main argument. As an image it exercises a rhetorical/persuasive function, though not related to any scientific argument or proof, but rather to the place of that particular laboratory and its ways of working toward clinical application rather than theory development, within the broader early history of MRI. This image functions almost as a *divertissement*; it is used arbitrarily for its vague metaphorical resemblance to the contemporary procedure of undergoing a scan. To say that the image of the scanner *ante-litteram* partakes in the construction of the myth related to MRI development acknowledges the need for creating a myth around the historical necessity of turning the principles and properties of magnetization into a clinical device that can be used to diagnose patients. This engraving plays the function of narrating one of the key red threads underlying MRI development at the University of Aberdeen: the centrality of the patient. The specific function remains, regardless of the fact that, ironically, the iconology of the engraving is an explicit criticism of the promises offered and the procedures undertaken by a healing apparatus consisting of both humans and machinery.

Namely, it was the close connection between the research laboratory and the clinic—between physics, biology, and medicine—that made the biomedical physics laboratory at Aberdeen University different from other places. Although it is not possible to summarize the changes that medicine underwent in the early twentieth century into a single narrative, the term "biomedicine," coined between the two World Wars, was shorthand for identifying the work of scientists and doctors. The rise of biomedicine corresponds to the molecularization of biology and medicine and to the sharing of methods and techniques applied to study life processes and diseases (De Chadarevian and Harmke 1998; Löwy 2011, 177).

There was no institutional drive to bridge the gap between physics and medicine in the UK in the 1970s. The creation of the chair in medical physics at the University of Aberdeen in 1965—the first in its field in Scotland—gave Mallard and his team the opportunity to establish a tighter connection between research, technological innovation, clinical practice, and patients. The process was anything but smooth, at

least initially, and required access to technologies developed elsewhere. This was the case with the cyclotron, the UK's first radionuclide imaging device, which could be used for producing radioactive isotopes for nuclear medicine. Mallard built it at Hammersmith Hospital in London thanks to a grant from the Medical Research Council; he then struggled hard to relocate it to Aberdeen. He ultimately managed to get the army to move the machine.

Bringing medicine, biology, physics, and the clinic closer together was the driving force behind the success of the specific research program implemented in Aberdeen as Mallard recalls: "a biological program to understand the resonance signals went hand-in-hand with the physics and technological development of the imager" (Mallard et al. 1979; Mallard 2006, 49). The department of Medical Physics and Bioengineering pioneered the clinical use of full-body computed tomography (CT) scanners and gamma-cameras for nuclear medicine. Not only were there excellent mechanical, electronic, and computing facilities, but highly skilled staff (academics, clinicians, and technicians) were also working together to develop in-house equipment for clinical use. In Aberdeen, building close ties between research and innovation in physics and biology was what enabled the creation of scanners that could be used for clinical purposes.

The patient, albeit not present flesh and blood in the laboratory during the first phase of the technological development of *Mark-1*, was in the mind and writings of the physicists working in the biomedical physics laboratory. References to the possible future community of patients are not always explicit in the scientific papers published by the Aberdonian research team on the development of biomedical imaging technologies. This is not surprising, given that the clinical application of an emerging technology is not necessarily clear in the early stages of research, before clinical trials can occur. Rather, any references to the patient can take the form of pictures or words that are paratextual to the main technical argument advanced in a scientific article.

The proximity between the visualized data and the patient plays a major role in the development of biomedical imaging techniques. First, data visualization is not just about creating pictures that embellish the experimental results. The picture itself is a number, a way of measuring bodily parameters. Second, imaging is deeply connected to the patient's body and its condition of health and illness. Any results obtained after imaging are hard to read because the human body is extremely complex and the image itself is complex, as it shows both pathology and normality on the same surface at the same time.

The relationship between the biomedical apparatus (in this case, the MRI scanner) and the patient is closer than one might expect and influences the final visual output. For example, the comfort of the patient inside the claustrophobic scanner tube is crucial for ensuring that the patient does not make any voluntary or involuntary movements that might cause artifacts to appear in the final scan. Great attention is given to the design of the bed on which the patient slides into the scanner. The mirror placed on top of the scanner roof offers a gateway to the outside, reducing the feeling of claustrophobia. Headphones and a buzzer may be provided to allow the patient to

listen to music or attract attention, to further minimize any discomfort caused by the experience of undergoing the biomedical scan.

It is not surprising, therefore, that the relationship between scanners and patients was in the minds of the physicists working on the development of a clinically useful MRI scanner. In one of his articles published in a history-oriented journal of medical biology, Mallard briefly discusses a line engraving by M. Greuter, ca. 1600, depicting a procedure where all phantasies and follies are purged and good qualities are prescribed (Fig. 10.2).[9] In this article, at the end of his own historical account of MRI development at the University of Aberdeen, Mallard recalls the centuries-old fascination for the phenomenon of magnetism, already known by the Chinese in the Middle Ages and then systematized centuries later when William Gilbert (1544–1603), physician to Queen Elizabeth I (1533–1603), published his text *De Magnete* (1600). Although Mallard's paper does not cite the source of the image, the cultural and literary historian Sander Gilman discusses this picture in his book on the cultural history of madness and art in the Western world (Gilman 1982, 42) and identifies the original picture as an early-modern German sixteenth-century broadside by the etcher and engraver Matthias Greuter (1564–1638). The broadside is a satirical depiction of "Dr. Wurmbrandt" (literally: worm distilled) and his cure for folly.

The picture, which is full of alchemic symbols, is a complex composition of two different scenes showing the patient first diagnosed (in the background) and then cured (in the foreground). The scene that captures Mallard's eyes is the latter, in which a physician is sliding a patient, lying on a portable bed, into a furnace-like structure. The head of the patient is inside the furnace, the rest of the body outside. The top of the structure has an opening from which smoke billows out in a cloud. These are the "phantasies" (illnesses) being distilled or burned out from the patient's head.[10] The French version has the following text: "The physician exhibits fantasy, in addition to cleansing the drug of madness."[11] In Mallard's own words, the scene and this furnace-like structure bear a striking resemblance to the MRI scanner:

> At the beginning, it could not have been expected that the work of physicists in nuclear medicine—and later MRI—would lead to a step forward in the battle against mental disorders; a fulfilment of a medieval dream....All those years ago, the conceptual relationship was predicted between the patient and modern imagers or scanners! (Mallard 2006, 47–49)

Without referring to any sources to support his idea, Mallard argues that the drive toward the technological development of biomedical imaging scanners was present long before the technology was available. The picture allows the technology to take on the mantle of historical necessity. Not only does Mallard avoid specifying what the "conceptual relationship" between scanners and patients actually means, but he also

[9] The picture is reproduced in (Mallard 2006, 49). In another article, Mallard recounts the history of MRI development in Aberdeen (Mallard 2003).

[10] In the Middle Ages, the term *phantasia* (which is the Greek word for imagination) was charged with negative connotations having little to do with intellectual cognition and being closer to optical deceit and illusion. For a philosophical and cultural appraisal of the term, see (Karnes 2011).

[11] The original French: "Le médecin guarillant phantasie, purgeant aussi par drogues la folie."

Fig. 10.2 *A surgery where all fantasy and follies are purged and good qualities are prescribed.*
Line engraving by M. Greuter, c. 1600. Courtesy of Wellcome Collection. CC BY

overlooks any close reading of the image, despite being accustomed to reading other
types of images—those that belong to physics and medicine. A close reading would
have helped to better interpret, and to challenge, this image as a straightforward
pictorial representation of the doctor-patient relationship mediated by a scanner *ante
litteram*, a machine for vision.

There are several overlooked cues on how to appreciate the cultural-historical
significance of this image. Besides Gilman, Jacqueline Vons (a philologist and histo-
rian of medicine) conducts a close reading and historical analysis of the French
version of the broadside in light of Renaissance medical discourse and practice.
The iconology of this picture is not straightforward. The image, far from being the
original creation of an artist, is inspired by a cluster of similar copies and variants
that were in widespread circulation in Europe during the sixteenth and seventeenth
centuries. Both the background and foreground of the image show rather terrifying
and ambiguous procedures that seem to have little to do with medical practice and
more to do with metaphorical cures and motifs around the idea of purging sins and
folly (Vons 2010). The first procedure, in the background, takes place before a row
of shelved bottles labeled "humilite," "obeisance," "honnestete," and other "good"
qualities. A man, sitting on a chair, is forced to swallow a liquid (labeled "sagesse,"
the French word for wisdom) from an alembic held by a practitioner. The man defe-
cates demons. Vons interprets the procedure as a purge unfolding in front of our

eyes. Elements that belong to medicine and imagination are juxtaposed and mixed together to enhance the sense of a nightmarish world rather than one of objective reality.

The second, the "familiar" MRI-like scene, offers a representation of madness as being physically located in the head of the patient. This image represents the physical source of insanity by reference to one of Galen's theories in physiology, which posits that cranial sutures ("cracks" in the skull) are chimneys from which the humoral superfluities of the brain are evacuated (Vons 2010, 124).[12] If this function is impaired, the moods accumulate and cause disease. Another practitioner holds a patient (the same or another one) on a wooden stretcher while his head is placed in a furnace from which vices and phantasies are being expelled. By placing the patient's skull in the furnace, the doctor dries the moods and allows the vapors to escape.

Fire plays an important role in the procedure. Alchemists' fire was a viscous liquid that, upon contact with air, would burst into flames and burn until it was consumed. It was non-magical and could be created by an alchemist. In early modernity, Robert Boyle (1627–1691), the experimental philosopher of the seventeenth century and one of the fathers of the experimental method, conducted a series of experiments by fire analysis, in which he subjected samples to intense heat and subsequent distillation to reveal their elemental principles.[13]

Art historian Leclerc de la Verpillière argues that the only techniques the print clearly refers to (always in a metaphorical way) are the processes of distillation or sublimation, which were used in early modernity not only in alchemy but also in artisans' workshops (Leclerc de la Verpillière 2019). Distillation is the process of separating the components or substances from a liquid mixture by using selective boiling and condensation. In the engraving, the physician is depicted as someone capable of pointing out to the patient the material substance of her illnesses. Sublimation is the phase transition of a substance from solid into gas without passing through its intermediate liquid phase. In early modernity the human body was often represented as an alchemical vessel which could take the form of a crucible, a still, or a retort. The techniques of distillation and sublimation hint, albeit in a simplified manner, at the process of alchemic transformation that was a prerogative of the human body as alchemical vessel.

The physiological process is accompanied by a more allegorical and moralizing memento, following Vons's interpretation: the released images (phantasies and illnesses, as Mallard correctly calls them) are dangerous for the social order as they

[12] Galen created a detailed anatomical and physiological description of the brain, the cranial nerves, and the spinal cord (Frampton 2008).

[13] Boyle championed both the corpuscularian doctrine and the Baconian method (Boyle 1661). In his book (Boyle 1661), Boyle attacked Aristotle's and Paracelsus' theories. He proposed that elements are composed of "corpuscles" capable of organizing themselves into groups, and that each group constitutes a chemical substance. He distinguished between mixtures and compounds and showed that a compound can have very different properties from those of its constituents. This prefigured the atomic theory of matter. He would report the results of his experiments, whether successful or not, arguing for the importance of keeping track of the "histories" (collections of experimental results and accurate observations) in doing science.

evoke the arts, gallantry and love, and war games. To visualize something that lies in the depths of the skull means detaching the illness from the body in order to free the patient from the hidden source of their illness. This interpretation is further supported by looking at the original German version of the engraving, which is accompanied by a long text under the image. Sander Gilman translates this as follows:

> You sick men and women: If you wish to entrust yourself to a doctor, then entrust yourself to me. I am the best healer of the human race….If my medicine is to refresh you then you must have faith in it.…But come! We will test it in my chemical laboratory. There I have set up my Brennhelm [a dome used for distilling]. Come. Present your head and do not be afraid. We will in a short while see the mist go up in full current with the thousand-fold contents of a fool's mind—contents which I noticed so well in you! Oho! They already come up. What distilling! What things fly out! What trash was stuck in your head!…If I make you free of this illness then proclaim that I am a master. (Gilman 1982, 42)

The medicine becomes more than a simple aid in the hands of the healer. It becomes an agent, able to release what is entrapped deep in the psyche. Illnesses and phantasies, the psyche and the brain, are all conflated in the images puffed from the top of the furnace. The so-called predecessor of the MRI scanner has a moralizing function implicitly at work. The comparison between this medieval "scanner" and contemporary ones becomes plausible at a metaphorical level, insofar as contemporary brain imaging techniques attempt to discipline the body via the images they produce. Recent appropriations of this image have taken it as an illustration of either broad concepts related to the mind and folly or of medical instruments and procedures.[14] The narrative function of this picture brings to the foreground ways in which MRI development as a clinical technique becomes a myth created and made to circulate inside and outside the circle of scientific expertise.

10.5 Scaling Up: From the Hand-Painted Image of a Dead Mouse to a Full-Body MRI Scan

In 1971 Lauterbur, who was already known for his nuclear magnetic resonance (NMR) studies in the field of chemistry and was familiar with Damadian's studies on the utility of NMR in distinguishing cancerous tissues from normal ones in vivo, became persuaded that pictures could be made: "If we applied a field gradient of a known shape, we could back-extrapolate against the shape of the field gradient. We can make pictures with this thing!"[15] Just a few years later, inspired by Lauterbur's

[14] For example, Benjamin Breen's post on his blog *Res Obscura* describes this picture as an early brain scan (Breen 2015). See https://resobscura.blogspot.com/2015/12/the-alchemy-of-madness.html. Accessed 5 October 2020.

[15] Klaus Hentschel argues in (Hentschel 2014) that the initial context of MRI was limited to producing numerical values rather than images, thus being closer to an experimental than visual culture. Nuclear magnetic resonance research was a scientific area of inquiry developed in the first half of the twentieth century after the physicist Pauli theorized in 1924 that the nucleus of an atom spins around on its axis (Joyce 2006, 5). The negative associations between the name of this

Fig. 10.3 Map of mouse produced in 1974 and presented at a conference in Nottingham. Courtesy of Special Collections, Sir Duncan Rice Library, University of Aberdeen

remarks, Mallard and his team put together a permanent magnet and magnetic field gradient system to try it out. This led to the first ever NMR map of a whole mouse (Casini 2021, 38) (Fig. 10.3).

The colorful, pop-art-like hand-painted map of the mouse with a broken neck was produced in late March 1974 and presented in April at an annual academic physics conference held at the University of Nottingham (Hutchison et al. 1974; Mallard 2006). The image acquisition time was around one hour, during which the experimental subject had to remain completely still (and, therefore, had to be killed). This map, offering a dorsal view of the mouse, was acquired using twenty-five projections. The diagram accompanying the image shows the anatomical features of the mouse. The map is an example of convolution and back-projection techniques, which were deemed to be the most appropriate for NMR. The outline of the mouse is shown by NMR intensity signals related to the concentrations of protons in each pixel of the image. The colors represent average relaxation time (T1)—the time it takes the tissue to return to a state of equilibrium after magnetization. The liver and brain are localized by the yellow and blue regions (longer T1) throughout the thickness of the animal.

But the image also revealed something unforeseen: the long T1 values around the neck fracture. Mallard commented, "To our astonishment, we saw also on the image

emerging research area and nuclear weapons prompted physicists to drop the nuclear from the name magnetic resonance imaging in the early 1980s (Kevles 1998, 184).

the long T1 values of the inflammation surrounding the fracture. The very first image had shown a sort of pathology!" (Mallard 2006, 50). The long T1 of the edema around the broken neck is rendered as the very black area. The light area, which represents the shortest T1, coincides with the expected position of the liver. The two dark areas exhibiting a long relaxation time coincide with the expected positions of the brain and the lower neck. The white corresponds to noise regions. The two main difficulties encountered were, first, the problem of carrying out a full 3-D reconstruction from 2-D projections, particularly if one had to work with living samples; and second, the difficulty of guaranteeing a uniform magnetic field and gradients throughout the experiment (Hutchison 1979).[16]

With its striking colors and series of numbers, the hand-painted image of the mouse was the world's first NMR quantitative T1 image to show an abnormality. The image worked as a proof-of-concept visualization of biological data in terms of function rather than structure alone, and it was quickly believed that NMR would soon be in wide commercial clinical use (Hutchison 1979, 92). The use of colors in the image of the mouse is in concert with the image generated by the mechanized automated scanner built by Mallard in 1957. What is striking in the image of the mouse is the co-presence of numbers and pictorial elements that, in the form of a diagram, refer to anatomical features. Before biomedical imaging technologies such as MRI could be permanently placed within radiological units, the standard procedure followed by physicists was to print out both the numbers and the anatomical pictures (Joyce 2006). As Mallard remembers,

> Our very first mouse image, we did actually publish it with all of the numbers and then we showed a color version of it, converting those numbers into the different bands of color that we decided to use. You could see an abnormality in the mouse from the color change. You could see it in the numbers as well, but radiologists don't think that way....Radiologists just weren't interested in the numbers. They never have been. (Mallard in a personal interview 2017)

The mouse map sits between mimesis and convention. It is realistic and artificial at the same time—pictorial yet based on measurements. The dichotomy between numbers and pictures is a thread running through the history of data visualization in biomedical physics. Brain scans, for example, are considered by physicists as "data" rather than images. Visual displays in science tend to render the object under study (be it a mouse, a cell, a brain) measurable and, therefore, quantifiable and mathematized (Lynch 1990). This process of the mathematization and transformation of a visualized object into numerical data is explicit in the mouse picture that was produced at a time when powerful computers were not yet available. Nowadays, this process is inbuilt and, therefore, black-boxed in computerized software.

The use of hand-painted strong colors (green, red, yellow) to represent the bodily interior reveals that physicists were not used to collaborating with radiologists on

[16] The mouse image was obtained before the image created by Damadian with an NMR scanner on July 3, 1977.

anatomical images.[17] Physicists did not have to look at images to produce a diagnosis. Images, however, were useful to radiologists and clinicians who ultimately could decide whether a new technology was going to be useful in clinical diagnosis. The power to attract funding so that a new technology, still in its infancy, could be transformed into a fully functioning prototype to be used for clinical trials and, ultimately, commercialized, was in the hands of clinicians and radiologists.

Nuclear imaging involves encoding color or gray shade from gamma ray counts or density. If count density modulates in shades of gray, it is very difficult to immediately recognize the absolute level. The co-existence of numbers and colors—anatomical details and functional measurements—was motivated by the need to appeal to diverse audiences. Physicists read the T1 values, whereas clinicians and radiologists could look at the gray scale variations in the different anatomical regions of the mouse and "read" any abnormalities. But when bright colors were used, the stark contrast between them and the clear contours of the mouse meant even lay audiences, including potential funders, could grasp, at a glance, the internal structure of the body of the mouse.

The color code used for displaying information in this image does not mirror in a straightforward manner the color conventions used at that time in visualization in the field of biomedical physics, or even in previous images produced by Mallard and his team using a variety of techniques. Notably, the color scale does not normally include pink. This color was chosen to allow certain pixels to represent the experimental subject as an organic body rather than an ensemble of measurements and parameters. Usually associated with some human skin, pink seems to be used here to convey the impression of an object (the mouse) in its wholeness. The gradation has a degree of arbitrariness: it is organized by grouping yellow and orange for the liver, darker and lighter pinks for the body parts of the mouse not at the center of the physicists' and radiologists' attention (that is, the body parts that are not reproduced in the anatomical diagram), green and black for the area of the neck directly affected by the fracture, and blue and purple for both the brain of the mouse and the injured area.

The mouse is made visible and invisible, simultaneously, in the diagrammatic map. The numerical data transposed into colorful pixels, paired with the sketchy anatomical diagram, convey a visual schematization that embodies yet eschews a realistic representation of the mouse. This visualization is a map that portrays hierarchical and power relations between the types of matter composing it (the body of the mouse, the colors, the T1 values, etc.). Although flattened onto a two-dimensional surface, the physiological vitality of the mouse is captured in this map both in its realism and abstraction.

Diagrams explain, illustrate, provide a concise overview, and correlate information. They are often preceded by series of measurements or collections of data

[17] Joyce explains how scientists such as Damadian, Mallard, and Lauterbur, who were "free to tinker with the representational form, chose vibrant, rainbow colors, such as green, yellow, and red, to represent the inner body" (Joyce 2006, 11). Joyce argues that the bright and often primary color choices mirrored the aesthetics of popular art and television in the 1970s.

which are visualized using graphical methods.[18] Diagrams can also visualize abstract concepts and ideas. The philosopher of information Luciano Floridi highlights the relational character of data. He uses the example of a black dot on white paper. There are two things: the black dot and the white paper; the lack of uniformity between the two produces the datum. The relationship is fundamental to the existence of the datum; in Floridi's words, "A datum is a relational entity" (Floridi 2011). The white paper is not just the background to the dot—it is a constitutive part of it. The datum is the differential relationship between the two. The mouse map brings to the fore-ground this relational aspect of data. By means of color, physicists were here creating an aesthetics that matched numbers connected to measurements, equations, and the mouse.

In his ethnomethodological study on the moral and epistemic relations between diagrams and photographs, science and technology studies scholar Michael Lynch examines photograph-diagram pairs in scientific texts, claiming that when the diagram is superimposed over the photograph, the authority of the document is undermined. He observes that the manually produced diagram exercises a disci-plinary function upon the photograph it accompanies, taming the surplus of reality that the photograph embodies (Lynch 1985). In the case of the diagrammatic map of the mouse, the diagram offers a crude schematization of the anatomy of the mouse with the purpose of guiding the reading of the image without overwhelming the viewer with colors and numbers. In this manually-painted diagrammatic map, the realistic quality of the mouse exists only in the form of the outline of the diagram. The diagrammatic image of the mouse and its broken neck demonstrates how data are aesthetic-laden even before they leave the laboratory.

Both forms of display—the array of numbers and the anatomical picture of the mouse—reveal the location of abnormalities. It was radiologists' preferences that shaped the visual turn toward representing data as images, dropping not only the numbers but eventually also color in favor of adopting a gray scale. Radiologists, in fact, had been reading and interpreting the body in black-and-white images since the advent of X-rays. Scientists continued to publish nuclear medicine data as both an array of numbers and an anatomical image until nuclear medicine technology was firmly ensconced in radiology units.[19] Since then, the data have been presented solely in image form. The decision to drop the numerical values from the image meant that the supposed immediate access to the body of the patient was masked, and additional knowledge about a patient's health would not be available (Joyce 2006, 1–22). By the end of the 1970s, features of MRI technologies were stabilized. Research teams around the world arrived at a working consensus about the name of the technology (from zeugmatography to nuclear magnetic resonance to magnetic resonance), the representation of the data, and the machine design.

[18] On the distinction between *pictures* and *diagrams*, and their common property of being iconic signs, see (Giardino and Greenberg 2015).

[19] To contextualize historically the dichotomy between images and numbers at the time of nuclear medicine, see (Mallard et al 1979; Mansfield and Maudsley 1977; Lauterbur 1986).

The passage from the image of the mouse to a full-body scanner could not have occurred without other major achievements obtained by different research groups. Two were the prerequisites for building a human-sized scanner able to image patients: Damadian's work on samples of human tissues, and (in the early 1970s) Lauterbur's recommendations on how to build an imager and his suggestion to put a field gradient across the patient so that the full spectrum of magnetization would become detectable (Hentschel 2014, 192–194). There was a third contributing factor: by the time the mouse image had been created, the Aberdonian research team already had considerable experience in building scanners for nuclear medicine. They were also familiar with the difficulty of persuading clinicians of the usefulness of a new image-generating technique. Clinicians always want to make sure that whatever technology is developed will be clinically viable.

The picture of the mouse with the broken neck functioned as an interface between the two communities of physicists and clinicians. It was with this picture in his hands that Mallard gained support from clinicians and radiologists for scaling up research to build a full-body MRI scanner for clinical purposes. To reiterate a point made above, data visualization in science—whether in the form of a photograph, a diagram, or a graph—is both a discursive tool with which to share experimental outcomes to colleagues without the need to reproduce the experiment, and a rhetorical way to convince audiences reaching out beyond the strict scientific circle of those who are already part of the experimental setting.

One cannot understand the development of MRI without taking into consideration the other epistemic contributors besides physicists: the communities of radiologists and clinicians. The close connection between these research and clinical communities in Aberdeen provided the biomedical physics team with fertile ground on which they dared move from the mouse to a full-body clinical MRI scanner:

> Now all the other teams were pure physicists working in pure physics departments so to them it was the physics problem that was important; to us it was the clinical problem that was important. We wanted to get it going on patients, they wanted to get it going as a physics experiment. So they all worked up from little fingers, I'm serious, little fingers to wrists, to arms to heads. Whereas we wanted to jump in at the deep end because we knew it was no good showing an image of a wrist to a Consultant Neurosurgeon and saying, "Look, this is going to help you find brain tumors" and so on.[20]

The visual persuasiveness of the mouse image was critical in the construction of the narrative required to convince both clinicians and potential sponsors, first, of the diagnostic value of the MRI image of the mouse with the broken neck and, second, of the feasibility of scaling up the research project from imaging a mouse to building a full-body MRI scanner. The colors increased the visual appeal of the image and conveyed its information more clearly and directly. At a time when computers were not yet that powerful, the manual labor put into the image creation and display of

[20] Interview with John R. Mallard, 15 November 2004, GB 0231 University of Aberdeen, Special Collections, MS 3620/1/183.

the mouse image was part of its visual performance.[21] The mouse map embodies all three epistemic functions of images. It enables to explore, to transform (from the small tissues to full body human, from theory to diagnosis) and to transmit knowledge to both radiologists and potential sponsors. The diagrammatic map is not simply a schematic representation of an entity that exists but is rather a performative visualization that both creates and organizes relations among data coming from an animal, a technology, and human intervention. The diagram makes dynamic relations visible. It is an act of creation rather than an act of translation.

The mouse is an engendered reality—a fact that has been made, not something already given. A scientific fact is what we make real with our undertakings, not in the sense that scientific endeavor does not deal with reality but in the sense that it transforms reality (Rheinberger 2011). The mouse was killed or "sacrificed" (this is the terminology used by the team in describing the setting up of the experiment) because of the long exposure needed to build up an image. The mouse with a broken neck was turned into a fact and, because of that, became easy to control and was transformed into a docile 2-D diagrammatic picture that could be made available for scrutiny and analysis (Lynch 1985, 58). The picture of the dead mouse became the visual evidence for the feasibility and usefulness of scaling up from imaging a mouse to imaging a full human body—a leap in scale and imagination. After the mouse image, the laboratory team turned their attention to building *Mark-I*.

10.6 Conclusion

To conclude, the passage from the hand-painted image of the dead mouse with a broken neck to a full-body scan of a living human signified the passage from a 2-D image with diagnostic potential to a full human body scanner that, thanks to the spin-warp method, was clinically useful. Through the use of laboratory-created data visualization (such as the mouse map) and images that performed a narrative function (such as the engraving by Greuter), the history of biomedical imaging development in Aberdeen became a long story of heroic steps and milestones that brought magnetism and medicine together for "the benefit of humankind" (Mallard 2003, 367).

On the one hand, the argument against a certain vision of technicized medicine that the engraving suggests becomes, in the narrative created by Mallard, an endorsement of the dream of constructing diagnostic imaging technologies for the healing of human beings. On the other, the use of literary and visual sources (for example the engraving) within the more historically oriented papers written by Mallard and his team, hints at the role played by broader cultural and aesthetic elements within scientific practice and innovation trajectories. Although Mallard might have lacked the references and cultural background to articulate this intuition in a more sustained

[21] Burri's tripartite model of visual logic (visual value, visual performance, and visual persuasive-ness) is present in the image of the mouse. Burri elaborates her model within an ethnographic study related to medical images (Burri 2012).

manner, the recourse to images, poems, and personal memories opens up the way to an investigation of the role played by aesthetics, affectivity, and craftsmanship in science.

The narrative created in Mallard's historical article on MRI development in Aberdeen offers historians and image science scholars the opportunity to think about the epistemic role played by images and other forms of data visualization in scientific practice. In the article, arguments expressed in prose are accompanied by both technical images (the mouse map) and non-technical ones (the early modern engraving of a doctor-patient relationship, to use Mallard's interpretation of the picture).

It is not only the juxtaposition in the same article of scientific phenomena (be it the property of magnetism or the T1 parameter) with experiments, historical-cultural sources, and personal memories that challenges any linear storytelling of the endeavors and research activities carried out by the biomedical physics laboratory. It is also that through the narrative function performed by images such as that of Greuter's engraving that a straightforward chronological history of MRI development in Aberdeen becomes untenable. The epistemic power of images used as a narrative device relies more on their ability to create a constellation of practices, instruments, and concepts not connected by temporality but rather by metaphorical resonances. Even when the historical connection between a particular image (for example, the engraving) and a particular practice (the modern-day MRI scanner) is tenuous or unsupported by evidence, the narrative function of such an image encourages a form of self-reflexivity within the scientific community. Images can, through their narrative epistemic function, enable scientists to situate their own theory and practice within a broader historical and socio-cultural framework.

References

Alač, Morana. 2011. *Handling digital brains. A laboratory study of multimodal semiotic interaction in the age of computers.* Cambridge, MA: MIT Press.

Berry, Dominic J. 2019. Narrative positioning. *Economic History Working Papers Narrative Science Series* 1: 1–21.

Boyle, Robert. 1661. *The sceptical chymist.* London: Cadwell.

Bredekamp, Horst, Vera Dünkel, and Birgit Schneider, eds. 2015. *The technical image. A history of styles in scientific imagery.* Chicago, London: The University of Chicago Press.

Breen, Benjamin. 2015. The alchemy of madness: Understanding a seventeenth century brain scan. *Research Obscura.* https://resobscura.blogspot.com/2015/12/the-alchemy-of-madness.html. Accessed 20 June 2020.

Burri, Regula Valérie. 2012. Visual rationalities: Towards a sociology of images. *Current Sociology* 60 (1): 45–60.

Casini, Silvia. 2021. *Giving bodies back to data. Image makers, bricolage, and reinvention in magnetic resonance technology.* Cambridge, MA: MIT Press.

Dawson, Mary Joan. 2013. *Paul Lauterbur and the Invention of MRI.* Cambridge, MA: MIT Press.

De Chadarevian, Soraya and Kamminga Harmke (eds). 1998. *Molecularizing biology and medicine: New practices and alliances, 1910s–1970s.* Amsterdam: Harwood

De la Verpillière, Leclerc L. 2019. *Visceral creativity: Digestion, earthly melancholy, and materiality in the graphic arts of early modern France and the German-speaking lands* (c. 1530–1675). (Doctoral thesis).

Edelstein, Bill, James M.S. Hutchison, Glyn Johnson, and Thomas Redpath. 1980. Spin warp NMR imaging and applications to human whole-body imaging. *Physics in Medicine & Biology* 25 (4): 751–756.

Floridi, Luciano. 2011. *The philosophy of information.* Oxford: Oxford University Press.

Frampton, Michael. 2008. *Embodiments of will. Anatomical and physiological theories of voluntary animal motion from Greek antiquity to the Latin middle ages, 400 D.C.–A.D. 1300.* Berlin, US: VDM Verlag.

Galison, Peter. 1997. *Image and logic. A material culture of microphysics.* Chicago: The University of Chicago Press.

Giardino, Valeria, and Gabriel Greenberg. 2015. Introduction: Varieties of Iconicity. *Review of Philosophy and Psychology* 6: 1–25.

Gilman, Sander. 1982. *Seeing the insane. A visual and cultural history of our attitudes toward the mentally ill.* Vermont: Echo Point Books and Media.

Harding, Sandra. 2008. *Sciences from below. Feminisms, postcolonialities, and modernities.* Durham/London: Duke University Press.

Hegarty, Mary. 2011. The cognitive science of visual-spatial displays: Implications for design. *Topics in Cognitive Science* 3: 446–474.

Hentschel, Klaus. 2014. *Visual cultures in science and technology: A comparative history.* Oxford: Oxford University Press.

Hutchison, Jim, Bill Edelstein, Glyn Johnson, and Thomas Redpath. 1980. A whole-body NMR imaging machine. *Journal of Physics E: Scientific Instruments* 13 (9): 947.

Hutchison, James M.S. 1979. Imaging by nuclear magnetic resonance. In *Medical imaging techniques,* ed. B.W. Watson, 79–93. Institution of Engineering and Technology.

Hutchison, James M. S., John R. Mallard, and C. C. Goll. 1974. In-vivo imaging of body structures using proton resonance. In *Magnetic resonance and related phenomena: Proceedings of the 18th ampere congress, Nottingham, 9–14 September 1974,* eds. Peter S. Allen, E. Raymond Andrew, and Colin Arthur Bates, 283–284. Nottingham: University of Nottingham.

Joyce, Kelly. 2008. *Magnetic appeal: MRI and the myth of transparency.* Ithaca, NY: Cornell University Press.

Joyce, Kelly. 2006. From numbers to pictures: The development of magnetic resonance imaging and the visual turn in medicine. *Science as Culture* 15 (1): 1–22.

Karnes, Michelle. 2011. *Imagination, meditation, and cognition in the middle ages.* Chicago/London: The University of Chicago Press.

Kevles, Bettyann H. 1998. *Naked to the bone: Medical imaging in the twentieth century.* Cambridge: Perseus Publishing.

Latour, Bruno. 1986. Visualization and cognition: Thinking with eyes and hands. *Knowledge and Society: Studies in the Sociology of Culture past and Present* 6: 1–40.

Lauterbur, Paul. 1986. Cancer detection by nuclear magnetic resonance zeugmatographic imaging. *Cancer* 57: 1899–1904.

Lauterbur, Paul. 1973. Image formation by induced local interactions: Examples employing nuclear magnetic resonance. *Nature* 242: 190–191.

Leclerc de la Verpillière, Lorraine. 2019. *Visceral creativity: Digestion, earthly melancholy, and materiality in the graphic arts of early modern France and the German-speaking lands (c. 1530–1675).* Doctoral thesis. https://doi.org/10.17863/CAM.35715.

Leonelli, Sabina. 2016. *Data-centric biology: A philosophical study.* Chicago: The University of Chicago Press.

Löwy, Ilana. 2011. Historiography of biomedicine "bio", "medicine", and in between. *Isis* 102 (1): 116–122.

Lynch, Michael. 1985. Discipline and the material form of images: An analysis of scientific visibility. *Social Studies of Science* 15 (1): 37–66.

Lynch, Michael. 1990. The externalized retina: Selection and mathematization in the visual documentation of objects in the life sciences. In *Representation in scientific practice*, ed. M. Lynch and S. Woolgar, 153–186. Cambridge, MA: MIT Press.

Mallard, John R. 2006. Magnetic resonance imaging—The Aberdeen perspective on developments in the early years. *History of Medical Biology* 51: 45–60.

Mallard, John R. 2003. The evolution of medical imaging: From Geiger counters to MRI—A personal saga. *Perspectives in Biology and Medicine* 46 (3): 349–370.

Mallard, John R., Jim M.S. Hutchison, Bill Edelstein, Richard Ling, and Margaret Foster. 1979. Imaging by nuclear magnetic resonance and its bio-medical implications. *Journal of Biomedical Engineering* 1 (3): 153–160.

Mansfield, Peter, and Andrew Maudsley. 1977. A medical imaging by NMR. *British Journal of Radiology* 50 (591): 188–194.

McRobbie, Donald W., Elizabeth A. Moore, Martin J. Graves, and Martin R. Prince. 2003. *MRI: From picture to proton*. Cambridge: Cambridge University Press.

Morgan, Mary S., and M. Norton Wise. 2017. Narrative science and narrative knowing. Introduction to special issue on narrative science. *Studies in History and Philosophy of Science Part A* 62: 1–5.

Polman, Joseph L., and Engida H. Gebre. 2015. Towards critical appraisal of infographics as scientific inscriptions. *Journal of Research in Science Teaching* 52 (6): 868–893.

Prasad, Amit. 2014. *Imperial technoscience: Transnational histories of MRI in the United States, Britain, and India*. Cambridge, MA: MIT Press.

Prasad, Amit. 2005. Making images/making bodies: Visibilizing and disciplining through magnetic resonance imaging (MRI). *Science, Technology, & Human Values* 30 (2): 291–316.

Rabinow, Paul. 1997. *Making PCR: A story of biotechnology*. Chicago: The University of Chicago Press.

Rheinberger, Hans-Jörg. 2011. Infra-experimentality: From traces to data, from data to patterning facts. *History of Science* 49 (3): 337–348.

Rheinberger, Hans-Jörg. 2010. *An epistemology of the concrete. Twentieth-century histories of life*. Durham/London: Duke University Press.

Rheinberger, Hans-Jörg. 1997. *Toward a history of epistemic things. Synthesizing proteins in the test tube*. Stanford: Stanford University Press.

Rheinberger, Hans-Jörg. 1994. Experimental systems: Historiality, narration, and deconstruction. *Science in Context* 7 (1): 65–81.

Rosenberg, Nathan. 2010. *Studies on science and the innovation process*. London/New Jersey: World Scientific.

Rudwick, Martin J. S. 1976. The emergence of a visual language for geological science 1760–1840. *History of Science* 14 (3): 149–195.

Star, Susan L. 2010. This is not a boundary object: Reflections of the origin of a concept. *Science, Technology, & Human Values* 35: 601–617.

Star, Susan L., and James R. Griesemer. 1989. Institutional ecology, 'translations' and boundary objects: Amateurs and professionals in Berkeley's museum of vertebrate zoology, 1907–1939. *Social Studies of Science* 19 (3): 387–420.

Tufte, Edward. 2001. *The visual display of quantitative information*. Connecticut: Graphics Press.

Turkle, Sherry. 2007. *Evocative objects. Things we think with*. Cambridge, MA: MIT Press.

Vons, Jacqueline. 2010. Le medecin guarissant phantasie: Purgeant aussi par drogues la folie. *Histoire Des Sciences Médicales* 44 (2): 121–129.

Wise, M. Norton. 2006. Making visible. *Isis* 97 (1): 75–82.

Silvia Casini is lecturer in visual culture and cinema at the University of Aberdeen (United Kingdom). She studies the aesthetic, epistemological and societal implications of scientific visualization with attention to emerging technologies. Her work has been published in international journals including *Configurations, Leonardo, Contemporary Aesthetics, Nuncius, The Senses and Society, Forum for Modern Language Studies*. Her first monograph, *Il Ritratto Scansione* was

published by Mimesis in 2016. Thanks to a Leverhulme Trust Research Fellowship she completed her second monograph entitled *Giving Bodies back to Data. Image-makers, Bricolage and Re-invention in Magnetic Resonance Technologies* (MIT Press Spring 2021).

Chapter 11
Arguing from Appearance: The Numerical Reconstruction of Galactic Tails and Bridges

Matthias Schemmel

Abstract A large part of the information we obtain from astronomical objects such as galaxies is contained in the spatial structures they display in two-dimensional projection in various frequency ranges. One of the tasks of astrophysics is to find physical explanations for the spatial features of these images. From the mid-twentieth century on, new approaches to finding such explanations became possible through the advancement of computer technology: simulations of multi-particle objects could be used to construct artificial images, which could then be compared to the observational ones. This essay discusses historical examples of the computational reconstruction of encounters between galaxies. Features of computationally generated images have been used to argue about physical processes. Images have thus provided a pivotal link between empirical appearance and theoretical construction. It is argued here that images can serve such a purpose only because they are part of conceptions far beyond what is visible, conceptions based in astronomical and physical knowledge, which itself is the result of a long historical process of interaction between astronomical observation and physical explanation. In fact, this knowledge base is not only employed to render the described use of images convincing, but also to assess the limits of the images' explanatory power.

Keywords Images · Numerical modelling · Galaxy encounters · Analog computer · Scientific reasoning

11.1 Images of Very Large (But Very Distant) Objects

Astronomical objects such as galaxies are known to us from the various kinds of radiation we receive from them.[1] A large amount of information about them is contained in the spatial structures they display in their projection onto our two-dimensional

M. Schemmel (✉)
Universität Hamburg, Hamburg, Germany
e-mail: matthias.schemmel@uni-hamburg.de

[1] This is first and foremost electromagnetic radiation, ranging from the long-wave radio band via visible light to highly energetic gamma radiation. More recently the detection of gravitational waves has opened a new window into the cosmos (Abbott et al. 2016). Cosmic neutrinos may provide us

field of vision. Galaxies have been observed and depicted (which before the rise of photography means drawn) long before it was known for sure that they were extragalactic, i.e., that they lie at vastly greater distances than the stars of our Milky Way. While the Milky Way could be resolved into single stars with the earliest telescopes, as Galileo Galilei (1564–1642) used them in 1609/1610,[2] the resolution into stars of the nearby Andromeda Nebula became possible only after three hundred years of telescopic evolution and had to await the construction of the 100-in. telescope of Mt. Wilson Observatory with which Edwin Hubble (1889–1953) worked in the 1920s. Only then did it become clear that these objects were "island universes," star systems comparable to ours.[3]

Another important development in the observation, depiction, and analysis of astronomical objects was what John North refers to as the "photographic revolution" of the nineteenth and early twentieth centuries (North 1994, 441) and the subsequent development of photoelectric instruments, which have gradually replaced photography over recent decades. These techniques blur the distinction between observation and depiction, which could easily be made in the case of drawing. Observation, depiction, and indeed measurement, have become merely different aspects of one and the same set of procedures and practices.

The growing number of observed and depicted galaxies are categorized according to their appearance, using a morphological classification scheme.[4] But there are many that show peculiarities such as long, thin filaments extending into intergalactic space ("tails") or seemingly connecting two galaxies ("bridges"). Halton Arp's (1927–2013) *Atlas of Peculiar Galaxies* from 1966 catalogues 338 such objects with negative print images photographed with high sensitivity in the blue-visual using the 200-in. telescope at the Mt. Wilson Observatory (Arp 1966). A small excerpt of this atlas is reproduced in Fig. 11.1.

Today we possess high-quality visual images of many of these objects taken with the help of the Hubble Space Telescope. An example is given in Fig. 11.2, which shows M51, a large spiral galaxy (NGC 4194) discovered by Charles Messier (1730–1817) in 1773, with a smaller companion (NGC 4195) and an apparent bridge linking the two.[5] The objects are about twenty-seven million light-years away from us. The

with further information about extragalactic objects; see for instance (The IceCube Collaboration et al. 2018).

[2] The resolution of the Milky Way into single stars was first described in print by Galileo in his *Sidereal Messenger* in 1610 (Galilei 2015).

[3] Hubble was able to resolve the outer regions of the Andromeda Nebula M31 and the Triangulum Nebula M33 into single stars. The observation in these nearby systems of novae and cepheid variables, which may be used to determine distance, further helped establish the nebulae's extragalactic status. Hubble's *The Realm of the Nebulae* of 1936 gives a lucid account of these early distance determinations and the historical discussions surrounding them (Hubble 1958, 83–101).

[4] This scheme, which distinguishes regular from irregular systems and divides the regular ones into *ellipticals* of different degrees of ellipticity and *spirals* with arms of varying degrees of tightness, further distinguishing between normal spirals and spirals with a bar, also goes back to Hubble (Hubble 1926).

[5] The name *M51* derives from the Messier catalogue of Nebulae, in which the object figures as no. 51. Messier devised it as a catalogue of objects that one should disregard when searching for

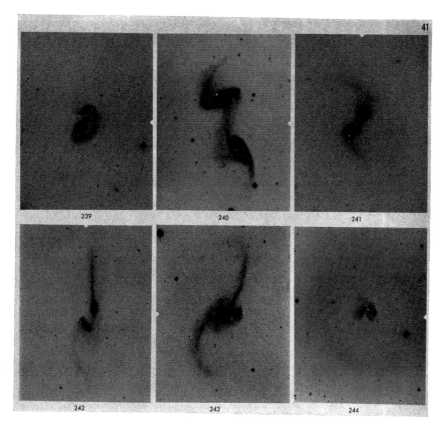

Fig. 11.1 Excerpt from *Arp's Atlas of Peculiar Galaxies* (Arp 1966, 41). https://doi.org/10.1086/190147. © AAS. Reproduced with permission

spiral galaxy has a diameter of around ninety thousand light-years and is thus a little smaller than the Milky Way. Another example is given in Fig. 11.3, which shows peculiar galaxies NGC 4038/9 (Arp 244), discovered by William Herschel (1738–1822) in 1785. They are sometimes called the Antennae Galaxies, owing to their two long tails extending several hundred thousand light-years into intergalactic space and resembling an insect's antennae.

One of the obvious constitutive tasks of astrophysics is to find physical explanations for the shapes and spatial features of the observed two-dimensional images. Thus, Arp in 1966 opens his *Atlas* with the words:

> Forty years after the discovery that galaxies were independent stellar systems, we still have not penetrated very far into the mystery of how they maintain themselves or what physical forces are responsible for shaping their observed forms. (Arp 1966, 1)

comets. For a modern atlas, see (Stoyan et al. 2008). The NGC-numbers refer to the *New General Catalogue* of 1888.

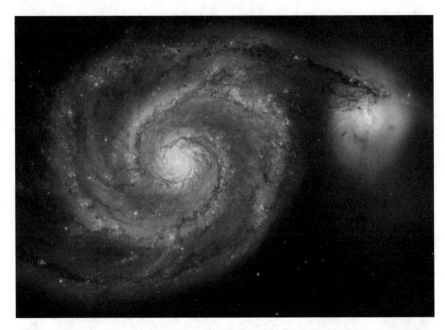

Fig. 11.2 M51, a large spiral galaxy (NGC 4194) and a smaller companion (NGC 4195) apparently connected by a "bridge." The image is composed from Hubble Space Telescope pictures taken at four different wavelengths. Courtesy of NASA, ESA, S. Beckwith (STScI), and The Hubble Heritage Team (STScI/AURA)

For galaxies with bridges and tails, the fact that they mostly come as two (or more) galaxies close to each other—all examples in Figs. 11.1, 11.2 and 11.3 are of this kind—Arp suggested that they exist in mutual interaction, possibly even capturing one another. But what are the forces relevant to shaping the objects in their encounter? Can gravity alone explain the phenomena or must electromagnetic forces be invoked? How do parameters such as the ratio of the masses of the two galaxies, their states of rotation, their material composition, and the trajectory and speed of their encounter influence the resulting shapes?

Answers to these questions are difficult to find for at least two reasons: First, developments cannot be observed directly, because the large sizes of the objects involved imply enormous time scales. We can only see a snapshot of each process, even if we were able to observe it for the entire existence of humankind—the timescales necessary for the development of the prominent features observed are typically of the magnitude of several hundred million, or even a billion years.[6] Second, theoretical attempts to get from a standing image given by observation to a "film" of evolutionary dynamics through calculation appear hopeless, owing to the huge number of

[6] Using the Doppler shift of spectral lines we are able to know—in addition to the spatial arrangement projected on the visual plane—radial velocities, i.e., velocities orthogonal to the visual plane. We are thus faced with the curious situation of knowing position but not velocity in the two dimensions of the visual plane, and velocity but not position in the one orthogonal to the visual plane.

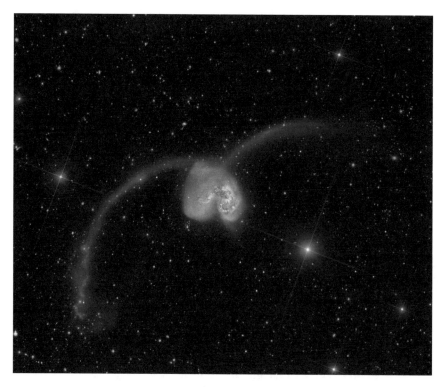

Fig. 11.3 "Antennae Galaxies" NGC 4038/9, an encounter of two large spiral galaxies. Composite Image from three Data Sources. Courtesy of NASA, ESA, Hubble Legacy Archive (STScI, ST-ECF, CADC/NRC/CSA), image assembly and processing: Robert Gendler

interacting particles involved: a typical, normal-sized galaxy consists of roughly a hundred billion stars and, in addition, contains interstellar gas, dark matter, and other matter components, all in mutual interaction.

The only possible pathway to address these questions then appears to be the application of computers to calculate dynamic encounters between simplified model galaxies. Images from certain stages of the development shown in computer simulations can then be compared to images of real galaxies in order to mount a physical argument about their evolution. This is exactly what has been done. In the following I will briefly discuss two examples of such work.

11.2 Images of Model Encounters

It appears to be coincidental that computer technology developed exactly at, or only shortly after, the time when questions concerning galactic encounters could sensibly be formulated by astronomers. At first glance, one may suspect the questions were

raised only because the means to address them were gradually becoming available. But my first example shows that astronomers were pushing their means of addressing such questions even before the availability of digital computers.

In 1941, Erik Holmberg (1908–2000) investigated model encounters between galaxies at the observatory of Lund University (Holmberg 1941). His central idea was to simulate gravitational pull by means of light intensity. In doing this he made use of the fact that a star (or any body with mass) exerts a gravitational pull on other massive bodies that diminishes as the inverse square of their mutual distance, and that the measured intensity of a light source also diminishes as the inverse square of the distance of the light source from the place of measurement.

Holmberg thus set up two "galaxies," each consisting of thirty-seven light bulbs arranged in concentric circles on a plane of three by four meters. The "galaxies" had diameters of eighty centimeters. Since thirty-seven is a very small number compared to one hundred billion, the light-bulbs should not be viewed as representing individual stars, but larger conglomerations of matter within a galaxy. By assigning different candle powers to different light bulbs, corresponding to different mass densities, Holmberg could even model different mass distributions within the galactic discs.

To measure the gravitational pull on a particle, Holmberg replaced the corresponding light bulb with a photocell and measured the light intensity in four orthogonal directions, from which he could deduce the particle's acceleration in the given unit of time. The computing is thus done by the photocell and the galvanometer, which is why we may think of this experimental setup as an analogue computer. In fact, Holmberg calibrated his galvanometer in such a way that it immediately indicated the acceleration in millimeters per square unit of time.

Holmberg tracked the motion of each particle, one by one, in a given unit of time, and recorded the resulting particle positions on paper. Then the light bulbs were placed accordingly and the procedure was repeated for the next unit of time. The shifting of the light bulbs had to be done by hand, just as the tracing of their orbits on paper, using graph paper and a set of French curves.

Holmberg presents his results primarily by means of a drawing that shows two of the several model cases he realized (Fig. 11.4). Holmberg's original caption reads:

> Fig. 4a.—Tidal deformations corresponding to parabolic motions, clockwise rotations, and a distance of closest approach equal to the diameters of the nebulae. The spiral arms point in the direction of the rotation.

> Fig. 4b.—Same as above, with the exception of counterclockwise rotations. The spiral arms point in the direction opposite to the rotation. (Holmberg 1941, 391)

The two galaxies are thought to have no initial velocity at infinite distance from each other ("parabolic motions"), to pass each other with the closest distance of one diameter center to center, and to rotate either in the direction of their translatory motion on their near sides ("clockwise rotations," left image) or in the opposite direction ("counterclockwise rotations," right image). He shows the moment of closest approach (upper images) and a later stage with clearly visible tidal deformations (lower images). He points out that in his model spiral arms, a significant visual feature of many galaxies, come about as a consequence of the encounter, and that

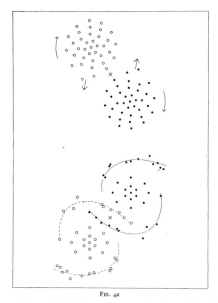 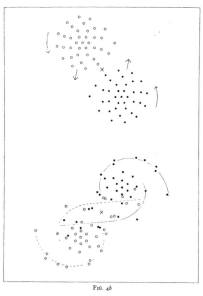

Fɪɢ. 4a

Fɪɢ. 4b

Fɪɢ. 4a.—Tidal deformations corresponding to parabolic motions, clockwise rotations, and a distance of closest approach equal to the diameters of the nebulae. The spiral arms point in the direction of the rotation.

Fɪɢ. 4b.—Same as above, with the exception of counterclockwise rotations. The spiral arms point in the direction opposite to the rotation.

Fig. 11.4 Reproduction of Figs. 4a and 4b with original captions from (Holmberg 1941, 391), which present major results of his simulations of the encounter of two galactic discs by means of an experimental set-up in which all gravitational interactions between particles are accounted for through analogue computation. DOI: https://doi.org/10.1086/144344. © AAS. Reproduced with permission

their orientation with respect to the direction of rotation depends on the encounter's initial conditions.

My second example is the work of Alar and Juri Toomre from about thirty years later. They follow Holmberg in modeling galaxies by means of mass particles arranged concentrically around a center (Toomre and Toomre 1972). They make the discussion more realistic and more involved by considering three dimensions— for instance, a companion revolving about a disc galaxy on an orbit greatly inclined with respect to the plane of the disc. But in contrast to Holmberg they do not take into account mutual interactions among the disc particles. Their discs consist of "test particles" that move in the gravitational field of only two massive cores (masses at the center of each galaxy). What they then need to calculate are the trajectories of the two cores and those of the test particles in their gravitational field, a so-called restricted three body problem, which they solve numerically using iterative methods. Instead of thirty-seven, their discs now consist of one hundred and twenty particles. The authors note that "numerical accuracy was not difficult to achieve" (Toomre and

Toomre 1972, 625) and that it clearly exceeded the accuracy of graphical representation. How the figures were produced in detail remains unclear from this publication, but the authors state that "much in our figures has been traced directly from computer-drawn diagrams" (Toomre and Toomre 1972, 625).

Using this framework, Toomre and Toomre discuss various test cases. In one, they vary the inclination i of the orbital plane of a smaller mass that disturbs a larger disc; they present the results in images such as those given in Fig. 11.5. A further parameter varied in that figure is the *argument* ω of the orbit. It describes the angle between a node (the point at which the orbit crosses the plane of rotation of the disc) and the point of closest approach to the center of the disc (Toomre and Toomre 1972, 632).

They furthermore try to construct models mimicking known observed objects. Thus, they produce a model of M51 by specifying the parameters of the orbit of a small companion around the center of a galactic disc, assuming their mass ratio to be 1:3, and plotting the various particles' positions at a certain point in time during the encounter from different perspectives. Figure 11.6 shows the "onto sky" perspective of the modulation next to the observational image of M51 for purposes of comparison.

Toomre and Toomre further produce an idealized model of the Antennae, for which they specified the orbital parameters of an encounter between two identical discs. Figure 11.7 shows a snapshot image of the model encounter from two perspectives: normal and edge-on to the orbit plane. In Fig. 11.8 the edge-on view is put on top of the observational image of the Antennae for purposes of comparison.

11.3 The Image and the Argument

In the examples discussed, images provide an important link between empirical appearance and theoretical construction. Features of the images generated by means of analogue or numerical simulations are used to argue physical explanations of features displayed in the images observed. Thus, Holmberg points out the ways that spiral arms develop in his model and links these insights to contemporary discussions about the direction of observed spiral arms with respect to the direction of rotation:

> This result is very interesting in the light of past and present discussions about the direction of spiral arms. Arguments, theoretical and observational, have been put forth for arms pointing in both directions. (Holmberg 1941, 390)

From their constructed images, Toomre and Toomre conclude (among many other things) that gravity and its tidal effects alone are enough to produce thin and extended tails and bridges, arguing against the notion that electromagnetic forces have to be invoked to explain the corresponding shapes observed in the sky:

> Taken together with the pioneering work of Pfleiderer and Siedentopf—plus the recent efforts of Tashpulatov, Yabushita, and Wright—the present demonstrations should suffice as antidotes to such often-voiced sentiments as "a tidal perturbation of a galaxy can alter its shape, but cannot draw out a long narrow filament" (Gold and Hoyle 1959) or that "the

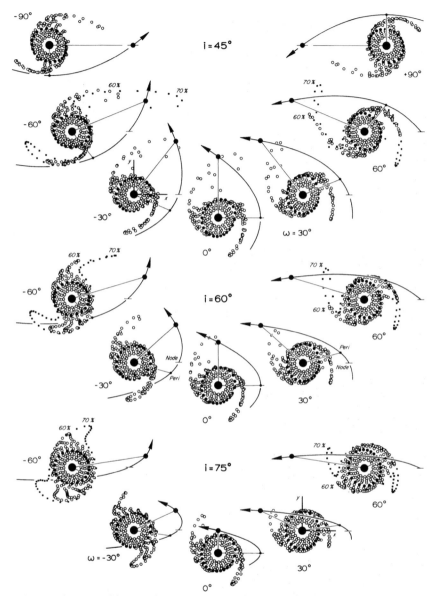

FIG. 9.—A survey of face-on views of disks perturbed during passages of inclination $i = 45°$, 60°, and 75°, and a range of values of ω. (Note that the line of nodes has been drawn in the same direction in all 17 of these views.)

Fig. 11.5 Reproduction of Fig. 9 with original caption from (Toomre and Toomre 1972, 635), which shows images of model encounters between a galactic disc and a small companion for different values of inclination i of the orbital plane and of the argument ω of the pericenter, which is defined as the angle, measured in the orbital plane, between a node of the orbit and the point of closest approach center to center. DOI: https://doi.org/10.1086/151823. © AAS. Reproduced with permission

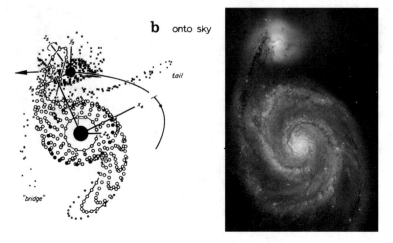

Fig. 11.6 Left: Snap shot image of the model encounter simulating the appearance of M51 from (Toomre and Toomre 1972, 653) (excerpt of their Fig. 21); right: observational image of M51—see description of Fig. 11.2 above. Courtesy of NASA, ESA, S. Beckwith (STScI), and The Hubble Heritage Team (STScI/AURA)

> bridges and tails of interacting galaxies…can hardly exist without a regular magnetic field."
> (Pikel'ner 1968; Toomre and Toomre 1972, 660–661)

They even use their images to make arguments about the concrete physical situation of particular observed objects. Thus, by referring to images they produced (Fig. 11.5), they argue about the inclination of the orbital plane of the small companion in M51:

> On the tentative hypothesis that the relative mass of [NGC] 5195 is roughly one-quarter, and the orbit roughly parabolic, figure 9 [here Fig. 11.5] suggests at once that the orbital *inclination* i_4 relative to [NGC] 5194 is *fairly high*, probably between $-60°$ and $-75°$. (Toomre and Toomre 1972, 654)

The images, both obtained by observation and numerically generated, thus play a pivotal role in the physical argument. It is the matching of visual features between these two types of images that establishes the connection between observation and physical explanation. This is what, in the title of this contribution, I refer to as "arguing from appearance."[7] But what enables the images to carry this argumentative weight? How can their appearance become a plausible criterion?

From the way the images are used in the arguments it becomes clear that they are able to function as strong argumentative links only because they are part of a broader argument. A mere coincidence of shapes between arbitrarily constructed images and

[7] The method of comparing computer simulations with observations is, of course, not restricted to the analysis of galactic encounters and has, for instance, played a crucial role in the interpretation of the visual material recently obtained through the Event Horizon Telescope of the supermassive black hole at the center of M87.

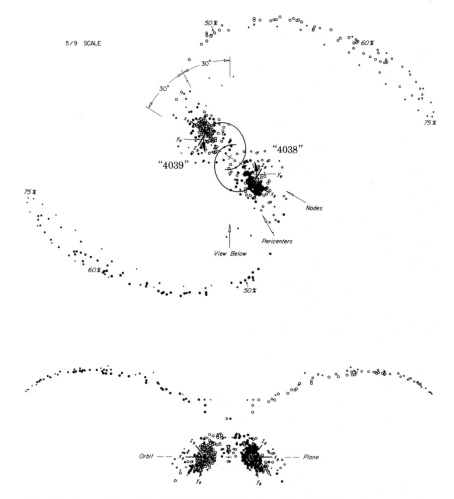

FIG. 23.—Symmetric model of NGC 4038/9. Here two identical disks of radius $0.75R_{min}$ suffered an $e \approx 0.5$ encounter with orbit angles $i_8 = i_9 = 60°$ and $\omega_8 = \omega_9 = -30°$ that appeared the same to both. The above all-inclusive views of the debris and remnants of these disks have been drawn exactly normal and edge-on to the orbit plane; the latter viewing direction is itself $30°$ from the line connecting the two pericenters. The viewing time is $t = 15$, or slightly past apocenter. The filled and open symbols again disclose the original loyalties of the various test particles.

Fig. 11.7 Snapshot image of the model encounter simulating the appearance of NGC 4038/9 (the "Antennae") from (Toomre and Toomre 1972, 659), with original caption (their Fig. 23); above normal and below edge-on to the orbit plane. DOI: https://doi.org/10.1086/151823. © AAS. Reproduced with permission

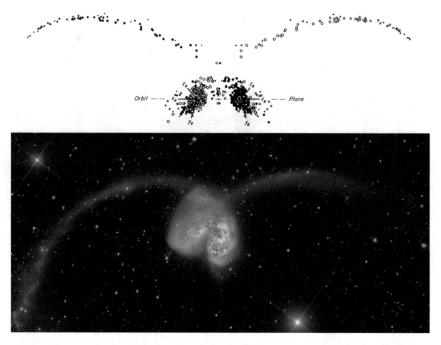

Fig. 11.8 Comparison of the edge-on view of the "Antennae" modeled by (Toomre and Toomre 1972, 659) (top) and an observational image (bottom—see description of Fig. 11.3). https://doi.org/10.1086/151823. © AAS. Reproduced with permission

their observed counterparts would provide no physical explanation and would therefore be wholly unconvincing. In fact, it would be as unconvincing as deriving $E = mc^2$ by discarding $E = ma^2$ and $E = mb^2$, as a comic Einstein does in a famous cartoon. The overall argument, in which the images serve as a pivotal link, by contrast, goes far beyond what is visible in the images alone. It is rooted in a large corpus of shared physical and astronomical knowledge, which itself is the result of a long historical process of interaction between astronomical observation and physical explanation. Consider, for example, the fact that all simulations start out with the assumption that gravitation is the most relevant force on galactic scales. Given all the empirical knowledge about gravitational forces, this fundamental assumption severely restricts freedom in model building. In fact, in Holmberg's case, knowledge of similarities between gravitational forces and light made the experimental setup possible in the first place. Consider, as another example, knowledge about mass distribution in disc-shaped galaxies, which all authors took into account when constructing their models. This broad base of shared knowledge is not only responsible for rendering the use of images plausible in the first place, it is also relied on when assessing the limits of those images' explanatory power. Thus Toomre and Toomre state:

> [Our model image] is at best only a caricature of the real M51: in outer shape it certainly resembles its subject, but the simulated counterarm, for instance, does not curve quite

enough… we must caution that the neglected self-gravity probably renders untrustworthy all departures of the reported particle speeds from purely circular motion… . (Toomre and Toomre 1972, 655)

The images, which are snapshots of computer-generated "films" of the dynamical evolution of model systems, thus appear as nothing more or less than a novel medium in the long-term interaction between astronomical observation and physical explanation. Their own evolution through the history of astrophysics depends not only on the accumulation of observational data obtained by means of ever-improving and expanding technology, as well as on the advancement of the physical knowledge available for understanding the observations, but also on the availability of ever more powerful computing capacity and on novel techniques that make good use of that capacity.[8] Thus, while Toomre and Toomre worked with a few hundred non-interacting particles, less than twenty years later, even when the mutual interactions of the particles were taken into account, it was possible to consider several thousand mass-units representing stars in the discs and bulges of galaxies, a halo of dark matter,[9] and, in addition, a gaseous component of galactic matter.[10]

Recent simulations such as that of the Antennae galaxies presented in (Lahén et al. 2018) use several million mutually interacting particles and take into account astrophysical processes such as the cooling of the gas and star formation. The comparison of simulated and observed images has also become increasingly refined. The days are long gone when such comparisons were simply concerned with the positions of particles in three-dimensional space projected onto the two-dimensional field of vision. With the increasing richness of astrophysical processes taken into account (such as star formation), the relevance of the wealth of spectral information contained in astrophysical images has increased as well. In this context, the "argument from appearance," as it is called here, is pushed a decisive step further: to make simulation-generated images comparable to the observational ones, procedures of image processing are applied with an aim to mimic secondary factors that influence the way astronomical objects look to us. In particular, the radiation leaving an astrophysical system, such as a galaxy has, as a rule, been multiply transformed by galactic dust. (Lahén et al. 2018) use SKIRT—an "open source code for simulating continuum radiation transfer in dusty astrophysical systems, such as spiral galaxies and accretion disks" (Camps and Baes 2015, 20)—to model such transformations of radiation spectra. It is the resulting "mock observations" (Lahén et al. 2018, 3938) or "mock images" (Lahén et al. 2018, 3940), which are then compared to the observed ones, as exemplified in Fig. 11.9.

[8] A particularly useful technique is the grouping of particles within spatial cubes that can be recursively subdivided into further cubes (a "hierarchical tree"). Each particle can then interact with different levels of this hierarchy of cells. In this way the calculation cost of a self-consistent gravitational potential can be reduced from the order of n^2, where n is the number of particles, to the order of $n \cdot \log n$.

[9] Such models were, for instance, presented by (Barnes 1988), who also produced "look-alike" images of the Antennae.

[10] Such models were, for instance, presented by (Hernquist 1989).

328 M. Schemmel

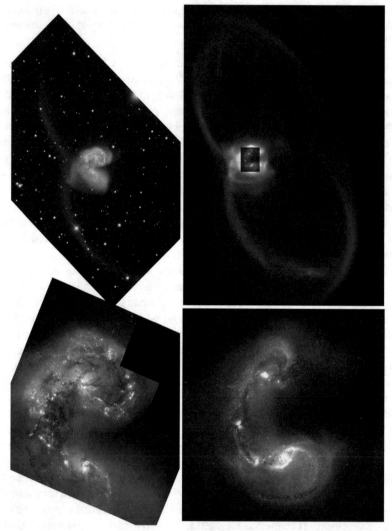

Figure 4. Left column: a colour composite from the Hubble Legacy Archive in ACS/WFC F435W (blue), F550M (green), F658N (H α+[N ii]) (pink) and F814W (red) filters (top), and an *HST* composite of the inner region converted to Johnson–Cousins $U + B$ (blue), V (green), and I (red) bands from Whitmore et al. (1999) (bottom). Right column: simulated colour composite images of the entire Antennae system and its inner region obtained through the same respective filters (omitting the H α band). The resolution of the mock image is 1.03 arcsec pix^{-1} for the large-scale image (top) and a WFPC2 equivalent resolution of 0.1 arcsec pix^{-1} for the inner region (bottom). The tails have been highlighted using a logarithmic stretch, whereas the inlet and the zoomed image have a square root stretch. The intricate details in the simulated images are best viewed on a computer screen.

Fig. 11.9 Reproduction of Fig. 4 of (Lahén et al. 2018, 3942), comparing color composite images of observations using the Hubble Space Telescope (left-hand side) with "mock images," color-composite images of the numerical simulation (right-hand side) of the entire Antennae system (top) and its inner region (bottom). https://doi.org/10.1093/mnras/sty060. © OUP. Reproduced with permission

References

Abbott, B.P., et al. 2016. Observation of gravitational waves from a binary black hole merger. *Physical Review Letters* 116: 061102. https://doi.org/10.1103/PhysRevLett.116.061102.

Arp, Halton. 1966. Atlas of peculiar galaxies. *The Astrophysical Journal Supplement Series*, Supplement 123 (14): 1–20 (20+57 pages).

Barnes, Joshua E. 1988. Encounters of disk/halo galaxies. *The Astrophysical Journal* 331: 699–717.

Camps, Peter, and Maarten Baes. 2015. SKIRT: An advanced dust radiative transfer code with a user-friendly architecture. *Astronomy and Computing* 9: 20–33.

Galilei, Galileo. [1610] 2015. *Sidereus nuncius or, the sidereal messenger*. Chicago: The University of Chicago Press.

Gold, T., and Hoyle, F. 1959. Cosmic rays and radio waves as manifestations of a hot universe. In *Paris Symposium on Radio Astronomy* (I.A.U. Symp. No. 9), ed. R. N. Bracewell, 583. Palo Alto: Stanford University Press.

Hernquist, Lars. 1989. Tidal triggering of starbursts and nuclear activity in galaxies. *Nature* 340: 687–691.

Holmberg, Erik. 1941. On the clustering tendencies among the nebulae: II. A study of encounters between laboratory models of stellar systems by a new integration procedure. *The Astrophysical Journal* 94: 385–395.

Hubble, Edwin. 1926. Extra-galactic nebulae. *The Astrophysical Journal* 64: 321–369.

Hubble, Edwin. [1936] 1958. *The realm of the nebulae*. New York: Dover.

Lahén, Natalia, Peter H. Johansson, Antti Rantala, Thorsten Naab, and Matteo Frigo. 2018. The fate of the Antennae galaxies. *Monthly Notices of the Royal Astronomical Society* 475: 3934–3958.

North, John. 1994. *The Fontana history of astronomy and cosmology*. London: Fontana Press.

Pikel'ner, S. B. 1968. Structure and dynamics of the interstellar medium. *Annual Review of Astronomy and Astrophysics* 6: 165–194

Stoyan, Ronald, et al. 2008. *Atlas of the Messier objects: Highlights of the deep sky*. Cambridge: Cambridge University Press.

The IceCube Collaboration et al. 2018. Multimessenger observations of a flaring blazar coincident with high-energy neutrino IceCube-170922A. *Science* 361 (6398). https://doi.org/10.1126/science.aat1378

Toomre, Alar, and Juri Toomre. 1972. Galactic bridges and tails. *The Astrophysical Journal* 178: 623–666.

Matthias Schemmel is professor of historical epistemology at the University of Hamburg. He studies the historical development of structures of knowledge connected to the exact sciences in their cognitive, material, and social dimensions, both from a long-term and a global perspective. He has worked on the emergence of theoretical science in ancient China; on transformations within the medieval and early modern European knowledge systems; on the transfer of knowledge between Europe and China; and on the reorganization of the knowledge of physics, astronomy, and their neighboring disciplines in the twentieth century. Current research and teaching activities further pertain to the political dimension of science and the role of science in the Anthropocene. Among his publications are the books *The English Galileo: Thomas Harriot's Work on Motion as an Example of Preclassical Mechanics* (Springer 2008) and *Historical Epistemology of Space: From Primate Cognition to Spacetime Physics* (Springer 2016).

Chapter 12
Ethnoscience and Spatial Representations of Changing Environments

Elena Bougleux

Abstract Strategies of adaptation and resilience to climate change challenge the perdurable distinction between natural and cultural. Natural and cultural environments are coupled concepts, but they become fully interdependent in situations of environmental change, when traditional representations become unsuitable to describe the transformed spaces. New representations become necessary particularly during environmental crises connected to climate change as they unfold as accelerated processes, caused by both predictable and unpredictable human-driven factors. Enhanced mapping strategies re/developed at the local level need to include former imaginaries superposed with new sets of information. This paper discusses the cases of changing spatial representations developed by Aboriginal communities that live in strict coupling with their natural environment. The paper focuses on the case of the Northern Territory in Australia, which faces enduring conditions of low tides and land degradation mainly due to extensive fires. As the fundamental orientation of Aboriginal communities to land and water is modified by the introduction of GIS technologies, a techno-visual hybrid language is being developed to represent their spaces and themselves at the same time through visual negotiations and technical compromises. A discussion follows on the efficacy of participatory mapping processes in contexts of a manifested imbalance of power, and on the epistemic role played by vision in creating the ground for a constructive negotiation at the cross section between technology, narration, experience, and traditional knowledge.

Keywords Ethnoscience · Spatial representations · Climate change · Aboriginal communities · Australia

E. Bougleux (✉)
Università degli Studi di Bergamo, Bergamo, Italy
e-mail: elena.bougleux@unibg.it

331

12.1 Layout

In the framework of environmental change, the traditional distinction between the concepts of natural and cultural is challenged by emerging strategies of adaptation and resilience enacted by endangered communities. The natural and the cultural have been often considered coupled concepts (Bateson 1972; Ingold 1993), but they become fully interdependent in situations of environmental change, when fixed and stable representations of space become unsuitable to describe swift spatial transformations. In the context of environmental change, multiple actors participate in the redefinition of spaces in a process aimed at bridging this broad and historically rooted epistemological gap, a process that appears incomplete, and still requiring profound methodological revisions in order to avoid practical failures.

I want to discuss the production of maps depicting rapidly changing spaces as a negotiated and open process between natural and cultural contributions, in a coupled dynamic that has become of primary relevance in contemporary environmental studies.

Traditional representations of space have emerged in human populations as a form of cultural artifact firstly rooted in experience and developed at a local level (Dove and Barnes 2015), then developed and gradually complexified by integrating layers of new scientific information.

Spatial representations unfold when the outcomes of technical surveys, environmental data, and quantitative data are superposed over preexisting images and imaginaries. The superposition of traditional images, which incorporate long-term knowledge repositories, and sets of visuals produced through scientific processing—with the mediation of visual technologies—helps to shape new imaginaries and qualitative visions in a recursive process of reciprocal determination. Every step of visual production needs to be considered likewise as culturally produced. Present representations of space have become mixed and enmeshed artifacts.

The ongoing entanglement between natural and cultural visions on space emerges more clearly today during extreme climate change events, since they unfold through an accelerated environmental crisis. The environmental crisis situation—mostly induced by human driven causes, as is known—generates both predictable and unpredictable spatial changes in coastline profiles, in the courses of rivers, in vegetation distribution, all of them continuously requiring new mapping efforts. The map is processual and open.

This paper discusses some cases of changing spatial representation developed by local communities that live in strict coupling with their natural environment. I focus on the case study of Aboriginal communities historically located in the Northern Territory of Australia, who face a condition of enduring coexistence with unstable tidal patterns, low tides in particular, and intense land degradation mostly due to inland wildfires occurring in the extremely dry seasons. As the visual techniques of spatial surveys improve, so do the everyday interrelations between communities and their land and waters, which are strongly impacted by climate change. Quick adaptation skills become more and more necessary. The oral transmission of territorial

knowledge is no longer sufficient; but the introduction of GIS technologies cannot supply the required detail in a useful timeframe (Sect. 12.2). What emerges after multiple negotiations is a techno-visual hybrid language capable of simultaneously representing the space and the people: space as it is now, as it was before, and in its development. The Aboriginal people are active in the mapping process, as holders of the competencies necessary to track, follow, pursue morphing features, and fold the notions of (individual) perception, risk, possibility, and prohibition, into visual negotiations and technical compromises.

12.2 Some Questions About Cartography

This section is dedicated to the epistemological function of cartography in a specific geographical set referred to as the Australian Outback—despite the fact that this widely used definition is vague and neglects precise boundaries, including part of the north end of the Northern Territory—which has precise administrative borders, drawn on the Australian map in straight lines (the southern, eastern, and western borders of the Northern Territory).

I will discuss the role of cartography as an intellectual enterprise requiring a variety of skills and competencies, as the final or, more often, the provisional convergence of multiple knowledge patterns: adaptive, intuitive, oral, systemic, transformative, and of course visual. Cartography is never a neutral epistemological tool—assuming that any tool employed to develop knowledge can actually be neutral at all. More effective than ancient armies and early modern global trading companies, cartography has been an efficient tool in the hands of ruling powers across the centuries, a fundamental means to draw empires on land, to cut borders, define properties, and maintain enduring control over them.

Neither nations nor empires have emerged as natural features of a landscape, rather they are entirely human constructs that have been carved out of a territory and have then *acted on* the land through the imposition of maps. Mapping used to be the strategy of converting large tracts of the world's surface into properties. Maps were accurately developed during the age of great explorations: indeed, the galleries of historical maps preserved in national libraries and museums not only display the evolution of geographic knowledge, but also show the spatial setting where political programs unfolded, displaying visually the extent of powers for the rulers, and casting visual threats for all the others.

Through the spread of modern cartography, the qualities attributed to space have become naturalized as space itself. Processes of knowledge (of space) and power (on spaces) have been charted in terms of divisions among nations and realms, along imaginary lines cutting the seas into legitimate and illegitimate zones, all such constructions gaining their physical materiality through the domain of vision. If modern cartography acquires the function of naturalizing the projection of human constructs over land, its production also unfolds with the goal of creating accurate copies of real space, growing more and more perfect, almost interchangeable copies:

exactly drawn maps as natural as spatial objects, but tacitly inscribed with history and economy. A modern map is therefore an advanced knowledge tool, generated from and rooted in a natural entity, then evolved into a complex socio-cultural product. Cartography has rightly been dubbed "the science of princes," used by governments and élites to map valuable land and locate the existence of resources precisely. Indigenous peoples have hardly ever been involved in the process of mapping their own lands. They have been the most common victims of cartography (Chapin et al. 2005). This analysis doesn't refer to Aboriginal Australians in particular, rather it is a statement meaning to address colonial history at large; indeed, the exclusion of Aboriginal contributions fits perfectly with the historical development of the maps of Australia, despite the fact that Australia has been the last continent to be charted with modern techniques, after the second half of the nineteenth century, when the process of *knowing by seeing* (on the maps) was already a consolidated practice (Livingstone 1993; Martin 2005).

To complete this introductory theoretical framework, it is useful to emphasize the relevant role of materiality and action required in the process of map production: maps derive(d) from first-hand experiential involvement. The rich collection of continental maps describing Australia from the 1870s to the 1920s shows how the enhancement of detail drawn along the Australian coasts was slowly gained through the decades, one exploration after the other. The notion of *Terra Australis* being a separated land from a hypothetical Fifth Continent was firstly reached after Matthew Flinder's (1774–1814) expedition in 1801–1802, when with his multi-competent crew including botanists, landscape painters, and unofficial astronomers, he mapped the West and North-West for the first time.[1] Here "mapping" stands for "navigating about"—a slow, unpredictable, imperfect, and personal direct experience. Flinder's map became publicly available over a decade later, when the full Australian coastline appeared for the first time on paper in 1814, after his troubled return to Britain (Fig. 12.1).

Each bay and cove were drawn after direct and careful interrelation with the places over time. The permanence of spatial features separating the lands from the seas allowed the development of a cumulative knowledge eventually brought to the charting of coastal details at any scale. A completely different situation stands for the mapping of the inland—mostly covered by deserts or held to be so—where difficulties arose from the scarcity of fixed and stable landmarks.

12.3 Tides and Wildfires. Mapping Problems

The Northern Territory is the least populated Australian state, with less than 240,000 inhabitants, half of which live in the capital Darwin. The state covers 1.4 million km^2, being therefore almost *empty* in terms of human population. The over 120 Aboriginal tribes of the Northern Territory live separated and sparse, mainly on the cost and along

[1] For Matthew Flinder's journal on his expedition in 1801–1802, see (King 1801–1802).

Fig. 12.1 Left: Complete map of the Southern Continent/survey'd by Capt. Abel Tasman & depicted by order of the East India Company in Holland in the Stadt House at Amsterdam. From Bowen, Emanuel & Harris, John & Tasman, Abel Janszoon & Thévenot, M & Nederlandsche Oost-Indische Compagnie. 1744. *A Complete map of the Southern Continent.* East India Company. http://nla.gov.au/nla.obj-163902730 (Last accessed February 25, 2021); Right: General chart of Terra Australis or Australia by Matthew Flinders, circumnavigating it in 1801–1802. The first map of Australia depicted as a single continent was published in 1814. From W. Bulmer, London & G. and W. Nicol & Captain Matthew Flinders. 1814. *Terra Australis or Australia, the Parts Explored Between 1798 and 1803 by Matthew Flinders.* http://collectionsearch.nma.gov.au?object=73880 (Last accessed October 30, 2022)

the single principal road that crosses the state from north to south. Satellite mapping of the desert zones clearly reveals the uneven population distribution: the survey of very large areas is processed with the satellite techniques adopted for urban and peri-urban areas, with the substantial difference that the resolution is coarsely grained. On the Earth Observation Science Division website managed by the Australian government, it is possible to access the map of each zone regularly surveyed by satellites flyovers to check the frequency and width of the scanned area (a "strip" of land, several hundred kilometers across) (Fig. 12.2). An accuracy disclaimer pops up during the online consultation of the interactive maps, warning the website user to take into consideration the provisional validity of the data, "which are not to be used for life saving decisions." This refers for example to the location of wildfires, due to their rapid dynamics compared to the frequency of data collection.

The representation of the spatial features of the desert inland regions thus emerges as the result of two complex measuring processes at the intersection of two critical-ities: on the one hand, the data is provided by standard GIS surveys, characterized by low resolution in most scarcely populated and desert areas; and on the other is the difficulty in keeping track of the brisk shifts in morphology occurring on a large scale due to unforeseen and adverse events throughout the continent (Harvey and Hill 2001). Such morphological land changes include the modification of coastal profiles induced by unstable tidal patterns, the diffusion of extended wildfires with the consequent destruction of vegetation, and land reshaping and degradation, as well as geologically driven processes. As reported in the accurately updated documents included in the Cadasters Register Update, "an assumption that earth deformation

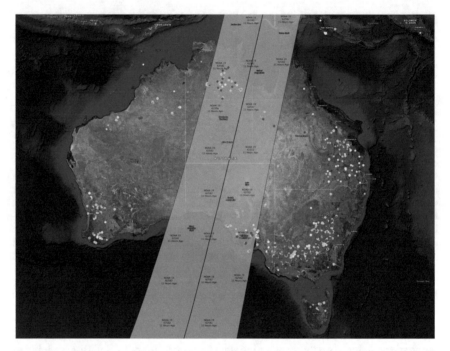

Fig. 12.2 Satellite scan of NOAA-12 in 24 h. https://www.ga.gov.au/scientific-topics/earth-obs (Last acecssed May 23, 2022)

will continue to have no impact on boundaries in Australia may not be correct—particularly if relying on coordinates defined in a continental scale geodetic datum" (Grant et al. 2018, 9).

12.3.1 Tides

This section of the study focuses on the interrelation between the land and the people belonging to the Aboriginal community living in the small peninsula of Hotham, northeast of the city of Darwin, by the delta of the river Adelaide. The region crossed by the river is flat and swampy; the area of the delta is characterized by the slow flowing of the river toward the Timor Sea northbound and by a strong tidal regime in the opposite direction, with an average of four meters difference between the high and low tides. Such relevant sea level variation with respect to the freshwater level in the swamps, occurring mostly on the left bank of the river, creates a peculiar, humid ecosystem with hybrid salinity. The wetland area is subjected to recurrent seawater floods and deep withdrawals; the river delta is environmentally protected, in particular the area known as Melacca Swamp Conservation Area, located between fifteen and twenty kilometers from the coast toward the inland. A network of thematic

satellites (Sentinel 1, Sentinel 2, AQUA, NOAA-12)[2] try to plot the course of the river as it crosses the swampy area, revealing all the aforementioned criticalities. In this landscape the definition of a clear land/water orientation appears dubious and complex, due to the total lack of fixed references, landmarks, or watermarks. Wooden signs inside the sandy levees disappear and decay as the tides flow, leaving confusing partial trails and modified paths. At the same time sea streams and sand trails on the seabed are quickly erased by the wild flowing of waters, leaving an ever-changing and hardly recognizable pattern of heights and depressions, and creating waterbeds through which the sea can easily rise toward the inland. Here the superposition of multiple satellite surveys collected at different times does not provide a better resolution; on the contrary, it produces blurred bordering zones that are difficult to interpret. Despite the relevant distance from the coast, in the Melacca Conservation Area an increasing risk of intrusion from saline waters has been repeatedly detected by park authorities, that have put the vegetation needed for the nesting of birds and crocodiles at risk (Northern Territory Government, Parks and Wildlife Commission 2014). The seawater intrusion can be attributed by direct observations to a semi-permanent rise in the ocean level, which still has not been mapped. Once again, the cognitive role played by practical experience appears decisive, and direct access on land to the critical issues supplies otherwise elusive data. The picture remains highly dynamic and influenced by multiple causes, thus creating intrinsic obstacles to the generation of a reliable and stable representation of space, at least from a distance.

12.3.2 Fires

Australia is responsible for 1.3 percent of global CO_2 emissions[3] but it contributes 90% to the greenhouse gas emission on the equatorial plane, which is the Earth zone where it is most likely to be triggered the so-called super greenhouse effect (SGS), a positive feedback effect of the joint influences of heat, high humidity, and greenhouse gas concentration. When these elements are coupled, they can recursively increase each other until a point of no return, which is why the emissions on the equatorial plane are more dangerous than in temperate or cold regions (Schmidt 2018). Australia is also the third global CO_2 producer per capita, after Saudi Arabia and

[2] For the research data of the satellites, see http://pid.geoscience.gov.au/dataset/ga/122229 for Sentinel-2; https://sentinel.esa.int/web/sentinel/missions/sentinel-1/data-products https://sentinel.esa.int/web/sentinel/missions/sentinel-1/data-products for Sentinel-1; https://www.nesdis.noaa.gov/content/dual-cyclones-swirl-above-australia%E2%80%99s-northern-coast for NOAA-12; and https://modis.gsfc.nasa.gov/gallery/individual.php?db_date=2020-02-26 for AQUA. Accessed 21 February 2021.

[3] To access the World Bank Data, see https://data.worldbank.org/indicator/EN.ATM.CO2E.PC. Accessed 19 October 2020.

Fig. 12.3 Kurun Warun
"Firesticks Sunset". https://
kurunwarun.com/artwork/
pakup-yallandar-fire-stick-
sunset/. Courtesy of the artist

Kazakhstan, which is amazing considering its small population.[4] The main contributors to Australian CO_2 emissions are the standard entries for an industrialized economy—energy and electricity production (over fifty-two percent) and transportation (over eighteen percent)—but also the so-called local uses, land use changes and forestry contribute over ten percent of the total (Quarterly Update of Australia's National Greenhouse Gas Inventory 2019). This last entry in CO_2 emissions sources can be also associated with traditional forms of land usage, mainly carried out by the Aboriginal traditional owners. Aboriginal Australians have actually always used fires to cut through the vegetation; indeed the representation of fires and lands on fire is a recurring theme in traditional rock-art and paintings (Fig. 12.3).

But traditional, small and patchy fires are not detected by satellite surveys—a cloudy sky can blur their observation, and small fires may last so briefly as to be missed completely by a large-scale survey repeated on a weekly basis. As such, there is surely a contribution from unmapped fires that escapes control and prevention measures. In an era of carbon quota trading, the reduction of the ten percent CO_2 emissions associated with Aboriginal land uses acquires an economic relevance (Russel-Smith et al. 2003). On the other hand, massive, recurring, and devastating wildfires characterize the era of climate change in the Australian regions, with disquieting durations and long-lasting impacts on land, vegetation, and animals (CSIRO and Bureau of Meteorology 2015). The dynamic geography of large scale wildfires is studied through multiple-scale mapping by the Northern Territory government, through its Department of Environment and Natural Resources, which provides a digital citizen service for the prevention and management of bushfires: Bushfires NT. Here explanations and appropriate behavioral norms in major fire events are provided in detail, the first of which is abandoning the house and properties instead of trying to defend

[4] To gain an overview about the CO_2 emissions of different countries, see https://www.ucsusa.org/resources/each-countrys-share-co2-emissions. Accessed 19 October 2020.

them from the fire. The service maintains an up-to-date map of the fires classified by source and type.[5]

These two diverse categories of fire events, the first type connected to traditional, functional, and symbolic land usage, and the second type devastating climate-change-driven wildfires, converge to generate the total CO_2 emissions in the national report, under the label of LULUCF, Land Use and Land Use Change and Forestry. Despite their obvious differences in relevance and impact, both kinds of fires require a deepening of specific knowledge; they require additional qualitative and quantitative data to be understood, precisely charted, usefully followed, and managed.

Large wildfires leave "fire scars" on the land, which can be observed via ground observations for a long time afterward; animals' trails change after the fires are extinguished, leaving networks of landmarks behind and drawing new trails to reach the water wells. An attentive campaign of on-land observations comes back as a necessary source of information, as much as on-land observation allows the small and patchy fires escaping from surveys to be precisely located on maps. The active role of acknowledged observers is raised here again in its crucial relevance, making clear its direct and practical presence on the field the qualitative element needed for the enhancement and completion of technical data. The acknowledged observers are expected not just to *know* the land, but also to be able to *recognize* the land through the signs of moving fires, to spot the differences in hills' morphology, to identify the old passages of animals once they are no longer used, and to recognize their modified trails. Therefore a memory-rich observer and an active scout is the skilled actor required, capable of transferring practical and visual knowledge as well as longstanding memory into geographic surveys: this is the acknowledged role of the Aboriginal Elders (which might suggest the Aboriginal style of burning).

12.4 Space and Consciousness

In the Melacca Swamp Conservation Area the representation of space is *queer*. I adopt the semantics of queerness attributed to the morphing of natural beings as Karen Barad uses it for the description of particles of matter, which she calls *critters* (Barad 2012). In the swamps and along the coasts, a queer kind of space seems to refuse to be represented, spatial features escape the organization offered by standardized tools and written languages. This qualitative space cannot be appropriated—if appropriation means exact description, value attribution, and reliable control. According to the population living in the area of Hotham Cape, "the land is flat at the horizon, where it is reconciled with the sky." The flatness of the horizon is the only geometric shape that remains constant and stable throughout the frequent upheavals in the shapes of territories and waters. It thereby assumes an ontological position, that of a primary referent, a position normally held by the reliable landmark.

[5] To access the up-to-date map of the occurring fires, see https://securent.nt.gov.au/alerts. Access 19 October 2020.

Despite this evident complexity in organizing a stable set of coordinates, the Aboriginal populations have been surviving and living in the swaps and deserts since time immemorial, and there is no record of individuals getting lost, unless the lost ones were very young and still untrained in the recognition of the signs. But which signs? According to old local informants: "Those old men sang for us, and they made the tides come right to us;" "they [the Elders] know the way through the land," and they are able to teach it. But they have to be met in person to actually speak and reveal their knowledge (Wutharr, Karrabing Film Collective 2016, min 5'50"– 10'40"). They have to be seen, but in order to see the Elders, they have to be met, and to meet the Elders it is necessary to get lost in the swamp. The Elders do not appear just anywhere, they cannot be invoked nor chased after. They have to happen, along with their longstanding knowledge of space. This apparently describes a looped pattern in the very possibility of knowledge acquisition, at least in the acquisition of a usable form of knowledge. But the evidence of the Aboriginal people not getting lost even in the absence of visible signs invites external interpretation. For example, according to Gregory Bateson "…it may well be that consciousness contains systematic distortions of view which, when implemented by modern technology, become destructive of the balances between man, his society and his ecosystem" (Bateson 1972, 447); and also, "The problem of coupling man through consciousness with his biological environment is comparable. If consciousness lacks information about the nature of man and the environment, or if the information is distorted and inappropriately selected, then the coupling is likely to generate a meta-random sequence of events" (Bateson 1972, 450). His reference is to the existence of a qualitative knowledge of space (and environment) that remains embedded in a sort of common consciousness, shared by the traditional dwellers but not by others, which may emerge without the need of maps. The ultimate possibility of obtaining spatial mapping and spatial orientation is probably there, nearer than it seems, but the possibility of gaining access to it is mediated by a state of mind, a peculiar disposition, a belonging. Such belonging is embodied in the discourses of Aboriginal people in the scenes of *Wutharr*, and by the elusive presence of the Elders that functions as a consciousness detector.

Thus, the main issue in the production of a "useful" traditional knowledge of space is shifted from the "individual acquisition of information through the *encounter and vision* of the Elders" to an issue of "communication, transfer and sharing of the knowledge" that has been individually acquired by this *encounter and vision*. Maybe the "communication," (i.e., transfer and sharing) can unfold via some more *visual* communication? The question of course opens up a series of more difficult questions: How can a state of mind be shared? Which is the drive to let common consciousness emerge in visible terms?

In most Aboriginal languages, a crucial term is used to denote the notion of being in touch with the land and with rivers, plants, and animals, feeling their presence and knowing their law, their inner functioning, their past and their time. There is wide debate on the translation of this complex concept to the English "dreaming," since the concept encompasses philosophical positions, religious beliefs, and natural

knowledge. It is impossible to report the debate here, but the premise is necessary before continuing to use the term hereafter.

According to Bruno David (David 2002), the term "dreaming" is an approximate English translation of the Aboriginal concept of "being and knowing" that has no equivalent in Western languages. Despite its approximate effectiveness in conveying the fullness of the idea, *Dreaming* is widely used to translate several ontologically dense words used by different Aboriginal groups, each one referring in a different way to an ancestral time when the ancient spirits shaped the cosmos, determining it with a law (*rom*) and a knowledge (*marngithirri*). The law, another crucial Aboriginal term, continues to organize the world into the present. But the Dreaming has no beginning nor end. Dreaming happens in a timeless period related to the beginning of the world, an age when all the animate and inanimate things obtained their defining features or footprint (*djalkiri*), a dimension of time that can explain how the world rose from emptiness and tells how all entities that shaped it are still in deep interrelation. As for many other Aboriginal qualities, the Dreaming is often misunderstood in terms of duration, and it is attributed to a sort of historical time; but the timely notions of duration and beginning do not account for the meaning of this entity. The Dreaming is not a long past era, nor does it start or end, but rather remains as a continuous and pervading essence: "One cannot 'fix' the Dreaming in time: it was, and is, everywhen" (Stanner 1979, 39).

Aboriginal people kept passing on their own notion of the Dreaming through customs and ceremonies such as storytelling, body painting, songs, dance performances, and artwork, succeeding in maintaining the awareness of their relationship with the past through visual engagement. The visual mark of the footprint (*djalkiri*) is not just the meeting point between the ancestral body, the human body, and the world, but it is also the element tracing connections between places and relationships between people; it visualizes the movement, develops the narratives, formulates the names, and reveals the itineraries to be retraced in the songs and in the moves of the dances.

Aboriginal spirituality is in a way superposed and undistinguished from Aboriginal knowledge, in the sense that both mind frames converge in the notion of Dreaming with their sense of timelessness, turning it into something material, pervading and organizing the world of the Aborigines to this day (Stanner 1979).

12.5 Landscape Dreaming

"The idea of 'sign' is thoroughly Aboriginal. Anthropological testimony on the point is overwhelming. The verbal concept may be lacking (though roundabout phrases with that meaning are common). But most of the choir and furniture of heaven and earth are regarded by the Aborigines as a vast sign-system" (Stanner 1979, 131).

"Anyone who, understandingly, has moved in the Australian bush with Aboriginal associates becomes aware of the fact. He moves, not in a landscape, but in a

humanized realm saturated with significations. Here 'something happened;' there 'something portends'" (Stanner 1979, 131).

Places and events are inseparable, they are qualities happening and leaving signs on the land that are at once spatial (marks) and temporal (memories). This holistic vision is reflected in the lack of the notion of time as an abstract concept in Aboriginal language, as well as the lack of the notion of history as the unfolding of events over a spatial-neutral background. The beginning of events and the formation of geographic sites are also inseparable entities: they both tell the story of the profound interrelation that matches people with things, being all perceived as elements of the same time–space. The strong link between humans, places, and nature derives from the creative events that (still) generate the cosmos: creative events, or indeed, the Dreaming. The condition of Dreaming produces an order that "…naturalizes the social and socializes the natural" (David 2002, 21), in a sort of surprisingly Cartesian view where thinking (here: Dreaming) is enough to generate existence. The landscape Dreaming is a generative co-evolutionary process that links spatial elements to the people, and the people to natural features, in a pervading genealogy that includes geographical names, works of art, maps turned into storytelling (Fig. 12.4).

The Dreaming also addresses the essence of social life, inscribing social structures in spaces through the attribution of regulations and roles, through obligations to the clans, and through the land's needs to be interpreted and respected. By talking to the Aboriginals "we learned that the desert is crisscrossed with Dreaming tracks, and that people's lives are part of these tracks because people are born into the stories and places of Dreaming sites and song lines" (Rose 2011, 14).

It is essential to stress that the Dreaming implies a sense of continuity of living for the land and its features, which explains the relevance and respect for the environment payed by all Aboriginal communities. Creation myths say that after the ancestor spirits dreamed the world, they transformed into natural elements—trees, stars, rocks, rives, etc.—remaining in many areas across Australia, which became sacred sites. Waterhole Dreaming, Fire Dreaming, Rainbow Serpent Dreaming, and similar spatial

Fig. 12.4 Left: Louise Nangala Egan, "Water Dreamings," Warlukurlangu Artists Aboriginal Corporation. https://www.aboriginal-art-australia.com/artworks/louise-nangala-egan-water-dreaming-puyurru-1a/. Courtesy of the artist. Right: Shannon Jangala Robertson, "Water Dreaming," Warlukurlangu Artists Aboriginal Corporation. https://www.aboriginal-art-australia.com/artworks/shannon-jangala-robertson-water-dreaming-puyurru-1a/. Courtesy of the artist

references are land signs that can be seen. Thus, the spirits of the ancestors did not disappear, but rather passed on to all those elements of the local space and fauna which gradually have become totems, each according to the different Aboriginal communities, in a never-ending reality.

The signs are hence visible, as they can be seen by special and initiated men, but also through artwork representing them. In their works in fact, Aboriginal artists convey the idea that land can not be owned or traded, for it has a spiritual value that displays its connection to the human identity. If the artwork succeeds in grasping the characters of the Dreaming ancestors during the creation process, the spirits of the creators can be renewed, homage is paid to the land to which the community belongs, and in this way, through the artwork, the signs become potentially visible again. The artwork stands to remind the present generations that the natural world itself enables the Aborigines to connect to the Dreaming.

In this cosmology each part of the landscape is identified with a specific Dreaming spirit ancestor, a correspondence that allows the development of a thorough knowledge of the natural world acquired while fostering a sensitive relationship with it (Fletcher 1994): a relationship made of memory and recognition, filled with mutual responsibilities and obligations aimed at the natural world's survival and protection, via all the practices permeating the everyday life of local Indigenous people, in a cooperation between the people's law and the land's law. Social order and territorial understanding are here mutually constructed.

The definition of geography shifts from mapping the Earth towards the mapping of world experiences: following the Dreaming stories and events, it defines the landscape as a network of connections and spaces as engaged realities, detaching from the Western idea that territories are mere stages upon which life takes place (David 2002).

The result is a mosaic of sociocultural plus territorial links, all of them generating identity according to a precise logic of existence (i.e. the Dreaming). Aborigines define who they are through the recognition of values inscribed in the land, thus producing a self-view and a worldview that frames the human experience within an everlasting dimension of temporal and spatial continuity (David 2002, 58; Duxbuty 2010).

12.6 Emptiness and Control—*You Can't Map a Story*

The Australian territories with the lowest population density, like the Northern Territory and Western Australia, are areas that used to be represented as empty spaces in colonial maps. Emptiness implies being devoid of meaning and lacking relevance, easily available for exploitation, not presenting any actor or force of resistance. In terms of mapping, these areas were represented as voids (Fig. 12.5).

Actually, each apparently empty area from a human point of view is permeated with significance and dense with signs, being the result of the dreaming spirits'

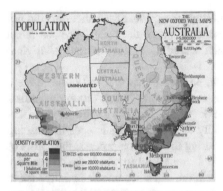

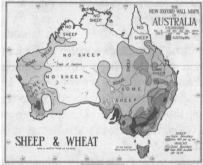 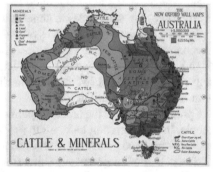

Fig. 12.5 The new Oxford Wall Maps of Australia, 1920. Top: population density. From Taylor, Thomas Griffith & George Philip & Son. [192-?]. *The new Oxford wall maps of Australia.* Oxford University Press. http://nla.gov.au/nla.obj-234325111 (Last accessed February 25, 2021); Bottom left: Sheep & Wheat. From George Philip & Son & Taylor, Thomas Griffith & Beckit, H. O. [192-?]. *The new Oxford wall maps of Australia.* Oxford University Press. http://nla.gov.au/nla.obj-234331946 (Last accessed February 25, 2021); Bottom right: Cattle and Minerals. From Taylor, Thomas Griffith & Beckit, H. O. 192-?]. *The new Oxford wall maps of Australia.* Oxford University Press. http://nla.gov.au/nla.obj-255201355 (Last accessed February 25, 2021)

ongoing creativity, which provides the territory its morphological features in the form of narratives and relational stratifications, but also landmarks (Capuano 2017).

In this context mapping become a narrative process more than a graphic endeavor, and it unfolds in a collective story. Maps grow more and more complicated as the result of on-land living experiences that stretch back in time and continue. The storytellers are the real owners of such narrative maps, the so-called traditional owners, those who never get lost in the swamps.

The kind of map resulting from the mediation between story and experience is more an "event" than a material object; the trails drawn onto its "pages" are more a sequence of experiences in time than lines connecting places in space. Landscape, its elements, and its inhabitants have been the main source of inspiration for Indigenous traditional artists and storytellers for ages; the morphology of places displays the visible traces left by the ancestors, who have shaped it through their long presence in a biunivocal transformative relation. The ecological foundation of the Aboriginal

sociocultural life consists exactly in this deep interrelation of presence (in space) and action (on space).

The earliest Aboriginal art can be dated back to more than thirty thousand years ago. The ritual elements of this old and continuous cultural heritage now constitute the basis of a symbolic language, combined in a complex network of significant patterns, which unfold in visible ways before the Aboriginals' eyes (Australia Council for the ARTS 2007). The symbolic language inscribed in the landscape represents, and at the same time molds, the connections governing the universe, but the persistent coexistence of natural elements represented together with a few repeated abstract symbols has made it hard to interpret the universal message conveyed by Aboriginal art forms. These seemed to convey an idea of native realism referred to their specific natural context; instead, the symbolic language aimed to provide universal meanings, and it is still referred to the bonds among all elements of the world (Morphy 1991). Aboriginal conceptions of art are all-comprehensive and unitary, going beyond the vision according to which the artistic product reflects the artist's view. Aboriginal rock-art, like other Indigenous art production, challenges any subjective approach to the representation of life forms, and contains repeated collective elements in multiple combinations: for this reason, it has been long targeted for as poor and simple, an assembly of randomly combined elements. Actually, the necessity of conveying an incredibly broad vision of the world order brings a relevant notion to the forefront: everyone could be considered an artist, all members belonging to an Aboriginal community could depict their own perception of the world in terms of the shared symbolic system, and thus share their Dreaming. The Dreaming becomes collective when it is enacted during the ceremonies, in the combination of different staging practices, like singing, dancing and painting, in that context perceived as a whole artistic expression. During the ceremonies, the individual Dreaming becomes publicly visible, thereby becoming a collective Dreaming and hence a shared representation of a land: this may happen through the narration of the images of a journey in a rhythmic cadence, marking pauses and movements, connecting all being along its trajectory, thereby unifying yet differentiating each group (Munn 1996).

The drawings associated with the Dreaming are literally attached to the ground, engraved in rocks and made up with sand, becoming integrated in the landscape in the form of spatial marks, materialized in new geographical features. In order to continue to preserve their knowledge marked in space through geographic signs, Indigenous artists have entrusted their art to storytelling, usually including moral and ethical values in the stories, such as good behaviors (for the land), and correct use and survival (of the land). The interpretation of the narratives vary greatly according to the aim and the audience, but the underlying message is always consistent.

Thanks to the Dreaming narratives, each one telling the story of a precise physical and cultural landscape, the domain of the visual arts was provided with a rich array of themes and matters, all of vital importance for the Aborigines. Most relevant for our discourse is that the Dreaming narratives became proper features of the locations where they happened, changing each location forever and compelling the communities to acknowledge *that* story in *that* place (Henry 1999). In order to remain capable of recognizing one place, all the narrations referring to that place must be

known. A place without a Dreaming risks being forgotten, but luckily there is not such a place. Each artistic expression—in form of rock-art, dance or song—becomes one visible element on a multi-layered invisible map, and each place has at least one visible layer.

Among Aboriginal tribal artistic expressions, rock-art represents the first means of marking the land, and also an extremely powerful tool of social expression, spatially inscribed and profoundly grounded in the earth. This way, artistic practices developed not just as aesthetic or symbolic exercises, but rather as performing actions with a social function: to communicate the truth of a place. These practices altered the geographical forces of a territory by laying them with the socio-political implications of the Aboriginal communities (David 2002). It is worthwhile to notice that such emerging interplay between geology, humans, and arts pushes us far from the local sphere, toward a global, Anthropocenic framework.

According to David (2002, 70), the stunning value of rock-art lies in its ability to "socialize" the land using recognizable symbols, so externalizing the Indigenous knowledge onto the landscape, as well as engaging the landscape as an acting agent in the Aboriginal communities' social system. This process enables people to negotiate the land's values, and it still does, turning rock-art into a major player in the determination of a territory's identity (Habibis at el. 2016).

Every style and theme express a specific kinship and a unique territorial link: that is why artists from the same place tend to choose—among the many styles—the one in accord with the reality and character of their own place. The place itself dictates to the artist the way it wants to be represented. Artists are aware of the fact that each engraving and painting encompasses a story that will not be ignored—a story that will affect the discourses related to land ownership, to land preservation, and to the ongoing relationship with the ancestors.

For its high communicative and assertive value, creation—and most of all, the use of traditional arts—has been always strictly normed by the communities and circumscribed within Aboriginal socio-political conventions (Altman et al. 2002). This closure undoubtedly influenced in a reductionist sense Western settlers' reception of both the Australian landscape on one hand and Aboriginal art on the other. Once again, the link between land, humans, and the universe emerges as a holistic trait only accessible to who belongs to the place; the artistic representations become the comprehensive expression of the sense of belonging to a clan and to its space, as well as the expression of desire (or demand) to respect the ancestral beings inhabiting a location.

If the ancient symbols of artwork have helped modern Aboriginal people know and understand the space they live in, letting landscapes be seen as canvas onto which their culture and knowledge were inscribed and transmitted over the centuries, contemporary rock-art is still fostering the Aboriginal vision according to which today's reality is a network of interdependent references, none of which can be altered or subtracted without altering the whole picture.

Early modern conceptions and visualization of Australia, depicted in maps until the 1920s as an empty space of neutral and open landscapes, have prevented explorers from grasping the messages engraved on the space's features by visual arts, and the

processes of mapping the Northern Territory, developed in the central decades of the twentieth century, were begun from scratch as if nothing was known or existed before. But these newly processed maps are still (bound to remain) incomplete.

12.7 Mapping Knowledge(s)

The major environmental transformations that have recently reshaped the world heavily affect the Northern Territory of Australia. Storms and extremely dry seasons occur with increasing frequency, the tides grow more and more unpredictable, with unexpectedly high and low floods, and the flora distribution and the entire ecosystem are dramatically challenged by extinction.[6] Fires due to dry seasons have an impact at a large scale and they become less and less controllable. National and international programs have been set up to tackle the general environmental crisis of the Aboriginal lands,[7] and efforts have been made to trigger the direct involvement of local communities in the management and implementation of the Adaptation and Mitigations programs (IPCC 2014–2020, Assessment Report 5, Working Group II, Pearson and Gorman (2010).[8] One possibility is unfolding through the setting of "participatory planning frameworks and procedures that can navigate and mediate the diverse epistemologies and validity claims encountered at the interface of different forms of knowledge" (Izurieta et al. 2001, Robinson et al. 2016). Here we see an evident issue of knowledge matching, emerging from the need of mediating among distant knowledge systems. The basic assumption acknowledges a difference in the epistemologies involved, which is a deeper than a mere difference in the mapping processes or a discrepancy in the environmental priorities. It is more than a difference in understanding, as each knowledge system requires its specific epistemological premises and relies on its epistemological tools. The outcome is a difference in the practice of vision, which is exactly the core problem when mapping on small scale the Northern Territory's open and wide spaces, characterized by low population density and high density of "events." The mediation Robinson refers to is a cultural process, moving toward a potentially convergent picture—but still a combined and fragmented one—to be set at stake in the awareness of the reciprocal advantage.

Epistemological mediation is necessitated when the overwhelming distance between worldviews exits in the divergence between the qualities, the criteria, the

[6] For a list of threatened animals by the Northern Territory government, see https://nt.gov.au/enviro nment/animals/threatened-animals. Accessed 19 October 2020.

[7] For a list of programs dealing with the environmental crisis of the Aboriginal lands, see https://www.environment.nsw.gov.au/funding-and-support/nsw-environmental-trust/gra nts-available/protecting-our-places/grants-awarded-and-project-summaries. Access 19 October 2020.

[8] Here we might note that the AR5 by the IPCC II Working Commission, introduced social concerns into the environmental assessment, but at the same time focused on adaptation strategies rather than tackling mitigation and more controversial issues. For further information, see https://www.ipcc.ch/working-group/wg2/. Access 19 October 2020.

"entities," and the "events" considered relevant to the purposes of the map by the various contributing actors. In principle, the mediation process might develop toward the involvement of non-written and non-databased information, letting in oral and visual information patterns, mostly communicated by storytelling. But even before such deep epistemological divides are tackled, the partnerships that engage Indigenous people and their knowledge systems are challenged by other practical and urgent questions concerning the primary issues of rights and agency (Johnson et al. 2007; Rose 1996). The context in which the mediation is developed affects its content and power relations. The set-up of institutional conditions that enable a fair cross-cultural co-production of knowledge has been a focus of growing interest and inquiry, since the reciprocal recognition represents the basic stance to obtain a shared vision of plans and decisions of common interest (Walker et al. 2013). Heterogeneous interventions have attempted to introduce and implement working conditions that escape pre-constituted frameworks, but here the reasoning framework shifts from an epistemological to an institutional one, and it falls beyond our current interest. Nevertheless, negotiating key challenges such as power imbalances, insufficient and uncertain information, and the apparent incommensurability between state-driven and Indigenous-driven approaches to environmental knowledge are crucial premises for the success of the mediation process. The failure in the identification of fairly recognized roles casts wide credibility gaps in the entire mediation process and its outcomes, which is reflected in the dis-acknowledgment of the representations of space—even when somehow co-produced—and in the dis-acknowledgment of the resulting initiatives of environmental management.

On the other hand, a high potential is still associated with mobilizing the Indigenous knowledge in the interest of environmental risk assessment, and the relevance of the response is never questioned. The need to pinpoint one more possible mediation ground favors the research of a different kind of visual processing, one which may remain somewhat immaterial and abstract, in a sort of pre-visual state of vision: this is mental mapping. Indeed, when referring to "mapping" in this context we might have referred from the beginning to the open-ended process of adapting heterogeneous "mental maps" to each other, never letting them fully become maps, which are highly questionable objects. Mental maps can be mentally combined and superposed, as elements of a dynamic flowchart drawn in the immaterial space of knowledge. Mental mapping produces, once again, narrations, but in this case the pattern to adopt in order to encourage the externalization of such negotiated mental visualizations may emerge from a comparative methodology.

Before the Aboriginal experience discussed here, participatory mapping with Indigenous communities has been an important means of incorporating Indigenous rights and knowledge about the environment into science-based maps (Chapin et al. 2005). In the Northern Territory hybrid technologies including geographic information systems (GIS), mental mapping, artistic expression, and ground mapping of traditional territories have been promoted and implemented with the participation of local communities, hoping to foster the emergence of the common and shared "vision." But for the Indigenous community these conversations included issues

about equitable land right decisions, access to natural resources, and notions about local species and environmental signs (Walsh and Mitchell 2002).

When referring to the outcome of such mediation processes, many authors speak of "actionable knowledge" (Kirchhoff et al. 2013), "working knowledge" (Barber et al. 2013), "situated knowledge" (Nygren 1999), and "multiple evidence base" approaches (Tengö et al. 2014). All the definitions refer more or less explicitly to the need for an interpersonal collaborative process, but they also address the precariousness of the result, so precarious as to require one extra adjective to be precisely defined (working, situated, actionable). Apparently, this reinforced attribution of meaning is meant to highlight the difficulty in bringing a plurality of knowledge sources and types together, but the definitions actually manifest suffering due to the supposed epistemological weakness of the resulting knowledge, developed only as "problem based" or "solution oriented." The underlying implication is that a coherent and complete knowledge system does not refer to its practical application, whereas here the emphasis is on the provisional character of the knowledge obtained. Actually, I rather disagree on the theoretical weakness of a "problem-oriented" or "solution-based" kind of knowledge, since this is emerges as deeply integrated into a wider knowledge system, and fully oriented at understanding locally an entire world system.

12.8 On the (Visual) Superposition of Epistemologies

The beginning of a participatory cartography process triggers a set of requests and premises by all actors that need to be precisely articulated from the start. In the case of the Northern Territory of Australia, the disputed emptiness of space is materialized in terms of land ownership, a non-settled condition shown by the cadastral register that allowed many criticalities to emerge due to the lack of property data. The first issue to address can be defined as "Land use and its historical occupancy studies," a matter requiring the acquisition of horizontal and vertical surveying data about the people living in the given place: who lives there now (horizontal survey), when their story of habitation there started (horizontal and vertical surveys), and whose ancestors left "visible" marks on the land (vertical survey). A complex analysis that hopefully converges in establishing "who can speak" on behalf of each specific land.

Strictly related and yet separate is the second issue: the need to report on maps describing "resource use" of specific land. Maintaining direct access to land resources such as water, flora, and vegetation might not be the prerogative of the present owners, since the right to access might have been owned by ancient people now relocated elsewhere but still claiming it. Access to indirect resources, such as housing and the economic benefits deriving from existing services, might also require the consideration of the history of owners and their respective rights. A negotiated understanding on these historical and economic aspects of resource use is meant to assess "who makes what with land, and for whom." Such a network is reflected in the accountability of each people. Rather amazingly, referring to Indigenous rights, it is still

possible to find statements like, "If the land only hosts hunter-gatherers, who have no resource needs related to any specific land, they cannot claim any land property and no use of the land in any strict sense." On the contrary, "where some agriculture is practiced, resources mapping included fixed land spots" (Greer 2018). Clearly, a sharp worldview based on property and descending ownership rights is not projected onto the maps when referring to Aboriginal people.

A third issue introduces the question of "memory:" the memory of the entire community is reconstructed through the map by the collection of biographic information from all community members. The resulting map is therefore a dual mnemonic tool to maintain and collect memory, as well as a place to give memory a visual representation. As a consequence, the map's language is far from linear, for example a place may contain more hunting area than capturing spots, and still it is represented on the map as "belonging to the hunters," a label which tells a story rather than describes the land.

The material realization of participatory mapping in an era of GIS is a creative enterprise that allows the use of compasses, poems, and images together, all in dialogue through the visual sphere, with varying levels of emotional involvement. If 3-D modeling, photomapping, and transects may appear as scientific devices introduced into the participatory process by Western participants, it is necessary to report that double-perspective visions such as those in transect images are also present in Aboriginal art (Fig. 12.6).

The participative map/artwork becomes rich in information, directly tied to lifestyles and evoking cultures, but it easily turns into a figurative place of mediation and discussion rather than an agreed-upon representation (AIATSIS 1996). The process might appear more important than the result, since it is configured as a place for epistemic confrontation.

Several authors stress the backlash potentially embedded in the participative process—for example, the risk of exchanging (Aboriginal) participation for (institutional) legitimation, once the local communities are involved in the process. If a top-down approach is maintained during the final map production, despite the multiple talks, exchanges, and reports, the outcome will once again display an imbalance of power. Eventually, whoever draws the final map decides for all.

On this last assumption there coexist a few epistemic nuances among geographers, weighing the ultimate accuracy of the participatory approach that consider irreducible worldviews into equal account. On the technical side, emphasis is often placed on the compatibility of spatial technologies and traditional thinking. Doubts emerge on whether and how GIS can usefully store and manipulate traditional knowledge

Fig. 12.6 Left: the mountain/vertical view, and the Well/horizontal view. Artlandisch, https://www.aboriginal-art-australia.com. Right: "3 dry waterholes." Kurun Warun, https://kurunwarun.com/

(Duerden and Keller 1992; Johnson et al. 2007). It has been suggested that "GIS has the ability to reflect a worldview held by many Aboriginal people, a vision that celebrates a holistic rather than reductionist conceptualization of environment" (Johnson et al. 2007, 4). An opposite position is expressed by Rundstrom (1995, 45), who writes that "the Western or European-derived system for gathering and using geographical information is in numerous ways incompatible with corresponding systems developed by Indigenous peoples." And GIS technology, when applied cross-culturally, is essentially a tool for epistemological assimilation, and as such, is the newest link in a long chain of attempts by Western societies to subsume or destroy Indigenous culture (of the Americas) (Basso 1988).

12.9 Arts in Vision

While the instability of daily weather can be experienced at an individual level, and changes in the weather can be accounted for within one lifetime, climate change unfolds over a time scale too large to become part of the individual experience. Climate changes escape the individual's perception, they are difficult to comprehend and connect in appreciable ways with measurable human parameters, for its effects are distant in time and size, and still highly unpredictable.

Urban populations, as well as local communities, develop an alienating attitude when exposed to the overwhelming proliferation of scientific data and statistics describing the invisible and announcing unimaginable climate events (Sheppard 2012). A feeling of helplessness and the inability to act may take hold, introducing a worrying distance of perception between the potential relevance of individual action and the ineluctable trend of society's impact over the environment. Scientific data brought as evidence by institutions and experts alone, despite being robust and disquieting, may result in not being effective enough to encourage major changes in individual and collective behaviors (Schaefer and Schlichting 2014). The risk of a growing emotional distance between what data say and what can actually be seen and perceived at individual level curtails the relevance of potential changes to life as it is performed today. The "here" and the "now" may not seem so threatened as data try to say.

Completely reversing the process of Aboriginal artists' productions, a set of alternative patterns may help to cover that emotional distance by articulating some of the complex data describing climate change through arts and vision. New space–time stories can become the frame to present climate data, focusing on the ways spaces are perceived by people and how the changing environment is sensed. Artistic visual language have the potential to engage society in emotional and experiential trajectories that promote a non-quantitative awareness, and hinting or suggesting virtuous behavioral and cognitive change.

Far from being a purely imaginative or aesthetic activity, drawing on the work of artists and art commentators, visual art forms becomes integral elements within the pattern of communication between meanings, perceptions, and measurements. In the

context of Climate change research, works of art offer emerging ways of imagining and encountering the transforming environment, allowing imaginaries to interface with technical representations as evidence no less relevant. Visual language is able to traverse a realm of uncertainty, present ambiguities and multiple possibilities, and engage viewers in an open process of speculation and interpretation.

Joint research by artists and scientists draws upon a vast array of information, from scientific data and reports to private reveries and shared reflections; an epistemic heterogeneity which allows the artwork to operate along diverse intellectual and intuitive spheres, while it generates alternative means of imagining and knowing. In such encounters with different patterns of vision, the viewer is invited to recall personal experiences—to evaluate and reinterpret the same work over again—in a process of recursive thinking and re-construction of meanings that tacitly incorporates the participatory practices and goes reflectively beyond them.

In this framework, the urban space is also behaving a living environment, almost a person who keeps speaking and telling the communities its history through its names and songs, its paintings and dances (Rose 1996). Similarly to what happens with the execution of an Aboriginal painting, a song, and a dance which make reference to a place—or rather, make the given place "happen," activating its visual and spoken history, the urban space requires the interpretation and mediation of the "performers" and the active participation of the public, whose involvement adds emotional layers to the technical map and witnesses its participation and concern towards the "activated" place.

When a community member has a dream, and the knowledge revealed to the dreamer is meaningful, it can be integrated into the collective repertoire. The inclusion of the dream revelation in the knowledge system, however, involves a long process of collective and competitive interpretations among all members of the group, who negotiate their responsibilities, authority, and ownership of the ancestral knowledge in question. Basically, a dreaming does not belong to the dreamer, but rather to the entire clan or tribe, who can interpret its real importance. It is precisely this "participatory" process of interpretation that allows the transformation of the Dreaming from an individual experience to a collective and narrated map.

In each Aboriginal group, the, language, names, songs, dances, and paintings are connected and similar, since they refer to the actions performed by a single ancestral being along its journey on their land (Tamisari 2002). Each place is different, as it is characterized by unique actions, names, and past events. In other words, ancestral journeying establishes an open network of relationships among groups and territories that can be navigated and appropriated both every day and in ritual contexts, bringing to the fore and privileging some connections over others according to the needs and demands of specific socio-political circumstances.

The singularities of space are perceived, once again, through vision and direct experience. As Tamisari writes, "the efficacy resides in visibility, of a world that can be known only by being seen, heard, smelled, touched, experienced and lived. Visibility must thus be intended in terms of perception and affect, a modality of knowledge that goes beyond the 'prosaic' or 'profane' sense of vision and speaks of one's bodily participation in the world" (Tamisari 1998, 5–6). This kind of vision

covers the distance between imaginaries and trajectories, epistemologies and practices, in a complex reciprocal experiential relationship, in a participation of people *with* the land, and with everything else in the environment.

References

AIATSIS. 1996. Map of indigenous Australia. https://aiatsis.gov.au/explore/articles/aiatsis-map-indigenous-australia. Accessed 20 Oct 2020.

Altman, John, Boyd Hunter, Sally Ward, and Felicity Wright. 2002. The Indigenous visual arts industry. In *Competition and consumer issues for Indigenous Australians*, eds. Jon Altman and Sally Ward, 64–101. Canberra: Australian Competition and Consumer Commission.

Australia Council for the Arts. 2007. *Protocols for producing Indigenous Australian visual arts*. https://www.australiacouncil.gov.au/workspace/uploads/files/visual-protocols-for-indigenou-5b4bfce4b0333.pdf. Accessed 20 Oct 2020.

Australian Government, Dept. of Environment and Energy. 2019. Quarterly Update of Australia's National Greenhouse Gas Inventory: March 2019. https://www.environment.gov.au/system/files/resources/6686d48f-3f9c-448d-a1b7-7e410fe4f376/files/nggi-quarterly-update-mar-2019.pdf. Accessed 20 Oct 2020.

Barad, Karen. 2012. Nature's queer perfomativity (the authorized version). *Kvinder, Køn & Forskning* 1–2: 25–53.

Barber, M., S. Jackson, J. Shellberg, and V. Sinnamon. 2013. Working knowledge: Characterising collective indigenous, scientific, and local knowledge about the ecology, hydrology and geomorphology of Oriners Station, Cape York Peninsula, Australia. *The Rangeland Journal* 36 (1): 53–66.

Basso, Keith H. 1988. "Speaking with names:" language and landscape among the Western Apache. *Cultural Anthropology* 3 (2): 99–130.

Bateson, Gregory. 1972. *Steps to an ecology of mind*. Chicago: University of Chicago Press.

Capuano, Cristiano. 2017. *Breaking the silence. Itinerari dell'arte indigena contemporanea nell'Australia metropolitana*. Bologna: ARTYPE aperture sul contemporaneo.

Casey, Edward S. 1996. How to get from space to place in a fairly short stretch of time: Phenomenological prolegomena. In *Senses of place*, ed. Steven Feld and Keith Basso, 13–52. Santa Fe: School of American Research Press.

Chapin, Mac, Zachary Lamb, and Bill Threlkeld. 2005. Mapping indigenous lands. *Annual Review of Anthropology* 34: 619–638.

CSIRO and Bureau of Meteorology. 2015. Climate change in Australia: Technical report. CSIRO and Bureau of Meteorology, Australia.

David, Bruno. 2002. *Landscapes, rock-art and the dreaming: An archaeology of preunderstanding*. London: Leicester University Press.

Dove, Michael, and Jessica Barnes. 2015. *Climate cultures: Anthropological perspectives on climate change*. New Haven: Yale University Press.

Duerden, F., and C.P. Keller. 1992. GIS and land selection for native claims. *Operational Geographer* 10 (4): 11–14.

Duxbury, L. 2010. A change in the climate: New interpretations and perceptions of climate change through artistic interventions and representations. *Weather, Climate and Society* 2: 294–299.

Fletcher, C. 1994. *Aboriginal self determination in Australia. Australian Institute of Aboriginal and Torres Strait Islander studies, report series*. Canberra: Aboriginal Studies Press.

Grant, D.B., G. McCamley, D. Mitchell, S. Enemark, and J.A. Zevenbergen. 2018. *Upgrading spatial cadastres in Australia and New Zealand: Functions, benefits & optimal spatial uncertainty*. Melbourne: RMIT University.

Greer, A. 2018. *Property and dispossession. Natives, empires and land in early modern north America.* Cambridge: Cambridge University Press.

Habibis, Daphne, Penny Taylor, Maggie Walter, and Catriona Elder. 2016. Repositioning the racial gaze: Aboriginal perspectives on race, race relations and governance. *Social Inclusion* 4 (1): 57–67. https://doi.org/10.17645/si.v4i1.492.

Harvey, K.R., and G.J.E. Hill. 2001. Vegetation mapping of a tropical freshwater swamp in the Northern Territory, Australia: A comparison of aerial photography, Landsat TM and SPOT satellite imagery. *International Journal of Remote Sensing* 22 (15): 2911–2925.

Henry, Rosita. 1999. Performing place: Staging identity with the Kuranda Amphitheatre. *The Australian Journal of Anthropology* 10 (3): 337. https://doi.org/10.1111/j.1835-9310.1999.tb0 0029.x.

Ingold, Tim. 1993. *Environmentalism: The view from anthropology.* London: Routledge.

IPCC. 2014. *Climate change 2014: Impacts, adaptation, and vulnerability. Part A: Global and Sectoral Aspects. Contribution of Working Group II to the Fifth Assessment Report of the Inter-governmental Panel on Climate Change.* Cambridge and New York: Cambridge University Press.

Izurieta, Arturo, Natasha Ellen, Tanya Stacey, and Johanna Karam. 2011. *Guidebook for supporting participatory monitoring and evaluation of jointly managed parks in the Northern Territory.* Darwin: Charles Darwin University.

Johnson, Jay T., Garth Cant, Richard Howitt, and Evelyn Peters. 2007. Creating anti-colonial geographies: Embracing indigenous peoples' knowledges and rights. *Geographical Research* 45: 117–120. https://doi.org/10.1111/j.1745-5871.2007.00441.x.

Karrabing Film Collective. 2016. *Wutharr, saltwater dreams.* IFFR 2020. https://iffr.com/en/2020/films/wutharr-saltwater-dreams. Accessed 21 Feb 2021.

King, Philip Gidley. 1801–1802. *Matthew Flinders – Journal on HMS 'Investigator', vol. 1, 1801–1802, 1801–1802.* New South Wales State Library, Call No. Safe 1/24. https://www.sl.nsw.gov.au/collection-items/matthew-flinders-journal-hms-investigator-vol-1-1801-1802. Accessed 21 Feb 2021.

Kirchhoff, Christine J., Maria Carmen Lemos, and Suraje Dessai. 2013. Actionable knowledge for environmental decision making: Broadening the usability of climate science. *Annual Review of Environment and Resources* 38: 393–414. https://doi.org/10.1146/annurev-environ-022112-112828.

Livingstone, D. 1993. *The geographical tradition: Episodes in the history of a contested enterprise.* Hoboken: Wiley-Blackwell.

Martin, Geoffrey J. 2005. *All possible worlds: A history of geographical ideas.* New York: Oxford University Press.

Morphy, Howard. 1991. *Ancestral connections. Art and an Aboriginal system of knowledge.* Chicago/London: The University of Chicago Press.

Morris, Barry. 1988. The politics of identity: from Aborigines to the first Australians. In *Past and present. The construction of Aboriginality,* ed. Jeremy Beckett, 63–85. Canberra: Aboriginal Studies Press.

Morris, Barry. 1989. *Domesticating resistance. The Dhan-Gadi Aborigines and the Australian state.* Oxford: Bloomsbury.

Munn, Nancy. 1996. Excluded spaces: The figure in the Australian Aboriginal landscape. *Critical Inquiry* 22 (3): 446–465.

Northern Territory Government, Parks and Wildlife Commission. 2014. Adelaide River Conservation Reserves: Joint Management Plan August 2014. Department of Environment, Parks, and Water Security Management Plans. https://depws.nt.gov.au/__data/assets/pdf_file/0006/249036/Adelaide-River-Conservation-Reserves-JM-Plan-August-2014_final.pdf. Accessed 21 Feb 2021.

Nygren, Anja. 1999. Local knowledge in the environment–development discourse: From dichotomies to situated knowledges. *Critique of Anthropology* 19 (3): 267–288.

Pearson, D.M., and J.T. Gorman. 2010. Managing the landscapes of the Australian Northern Territory for sustainability: Visions, issues and strategies for successful planning. *Futures* 42 (7): 711–722. https://doi.org/10.1016/j.futures.2010.04.008.

Robinson, Catherine J., Kirsten Maclean, Ro Hill, Ellie Bock, and Phil Rist. 2016. Participatory mapping to negotiate indigenous knowledge used to assess environmental risk. *Sustainability Science* 11: 115–126

Rose, Deborah Bird. 1996. *Nourishing terrains. Australian Aboriginal views of landscape and wilderness.* Canberra: Australian Heritage Commission.

Rose, Deborah Bird. 2011. *Wild dog dreaming love and extinction.* Charlottesville: University of Virginia Press.

Rundstrom, Robert A. 1995. GIS, indigenous peoples, and epistemological diversity. *Cartography and Geographic Information Systems* 22 (1): 45–57. https://doi.org/10.1559/152304095 782540564.

Russel-Smith, Jeremy, Cameron Yates, Andrew Craig Edwards, and Grant E. Allan. 2003. Contemporary fire regimes of Northern Australia 1997–2001: Change since aboriginal occupancy, challenges for sustainable management. *International Journal of Wildland Fires* 12 (4): 283–297.

Schmidt, Laurie J. 2018. Scientists assess potential for super greenhouse effect in Earth's tropics. NASA Global Climate Change. https://climate.nasa.gov/news/2534/scientists-assess-potential-for-super-greenhouse-effect-in-earths-tropics/. Accessed 19 Oct 2020.

Schaefer, Mike S., and Inga Schlichting. 2014. Media representations of climate change: A meta-analysis of the research field. *Journal of Environmental Communication* 8 (2): 142–160. https://doi.org/10.1080/17524032.2014.914050.

Sheppard, S.R.J. 2012. *Visualizing climate change. A guide to visual communication of climate change and developing local solutions.* New York: Routledge.

Stanner, W.E.H. 1979. After the dreaming. In *White man got no dreaming: Essays 1938–1973*, ed. W.E.H. Stanner, 198–248. Canberra: ANU Press.

Tamisari, Franca. 1998. Body, vision and movement: In the footprints of the ancestors. *Oceania* 68 (4): 249–270.

Tamisari, Franca. 2002. Names and naming: Speaking forms into place. In *The land is a map: Placenames of Aboriginal origin*, ed. Luise Hercus, Flavia Hodges, and Jane Simpson, 87–102. Canberra: Pandanus Books.

Tengö, M., Eduardo S. Brondizio, Thomas Elmqvist, Pernilla Malmer, and Marja Spierenburg. 2014. Connecting diverse knowledge systems for enhanced ecosystem governance: The multiple evidence base approach. *Ambio* 43: 579–591. https://doi.org/10.1007/s13280-014-0501-3.

Walker, Ryan, Ted Jojola, and David Natcher. 2013. *Reclaiming indigenous planning.* Montreal: McGill-Queen's University Press.

Walsh, Fiona, and Paul Mitchell. 2002. *Planning for country: Cross-cultural approaches to decision making on Aboriginal lands.* Alica Springs: IAD Press.

Elena Bougleux holds a PhD in Theoretical Physics (University of Florence and MPI for Gravitational Physics, Potsdam) and she is Associate Professor of Cultural Anthropology at the University of Bergamo, where she teaches Anthropology of Science at the PhD Program on Transcultural Studies in the Humanities. She carried out extensive ethnographic research in scientific and industrial laboratories (Berlin, Bangalore) and in post-industrial urban contexts (Berlin, Buenos Aires). Her main current interests are in the Anthropology of Science, Environmental Anthropology and in Climate Change Studies, analyzed from cultural and social perspectives. She has published *Costruzioni dello Spaziotempo. Etnografia in un centro di ricerca sulla fisica gravitazionale* (Sestante 2006), *Soggetti egemoni e Saperi subalterni. Etnografia in una multinazionale del settore dell'energia* (Nardini 2012), *Antropologia nella Corporation* (CISU 2016), and over 50 articles in national and international scientific journals.

Correction to: The Transformations of Physico-mathematical Visual Thinking: From Descartes to Quantum Physics

Enrico Giannetto

Correction to:
Chapter 8 in: M. Valleriani et al. (eds.), *Scientific Visual Representations in History,*
https://doi.org/10.1007/978-3-031-11317-8_8

In the original version of the book, the affiliation of Enrico Giannetto has been changed to "Dipartimento di Lettere, Filosofia, Comunicazione, Università di Bergamo, Bergamo, Italy". The correction chapter and the book has been updated with the changes.

The updated original version of this chapter can be found at
https://doi.org/10.1007/978-3-031-11317-8_8

Index

Printed in the United States
by Baker & Taylor Publisher Services